How Do I . . .
Set the Tone On-Set?

Go to LaunchPad and find out: macmillanhighered.com/filmmaking

NAME: **David Gordon Green**
TITLE: Director
SELECTED CREDITS: *Manglehorn* (2015); *Joe* (2014); *Prince Avalanche* (2013); *Pineapple Express* (2008); *All the Real Girls* (2003)

The first day of production is crucial to any director's success when making a movie — it's the day that sets the tone for every day that follows. This can be especially tricky when moving from one project to another — something familiar to filmmaker David Gordon Green, who has directed comedy, drama, action, and fantasy on films big and small. Green offers his thoughts on what happens the first day on-set in a video interview available only on the LaunchPad for *Filmmaking in Action.*

Discover:
▶ If how communication and tone in the collaborative process are cemented
▶ Why every set is not the same, even with similar crew members
▶ How Green varies his approach based on the material he's working on
Visit the LaunchPad for *Filmmaking in Action* to learn more — and to explore how you might use this advice.

How Do I . . .
Motivate the Camera?

Go to LaunchPad and find out: macmillanhighered.com/filmmaking

NAME: **Mandy Walker**
TITLE: Cinematographer
SELECTED CREDITS: *Jane Got a Gun* (2015); *Tracks* (2013); *Australia* (2008); *Shattered Glass* (2003)

As discussed in this chapter, camera movement is every bit as important as dialogue when it comes to helping your audience understand key story points and characters. Camera movement should be just as motivated as an actor's movement. Cinematographer Mandy Walker talks about this in a video interview available only on the LaunchPad for *Filmmaking in Action.*

Discover:
▶ Why you might want to work out camera moves as early as preproduction
▶ How Walker worked with the grip department to find a solution to a complex sequence in Baz Luhrmann's *Australia*
▶ What you might do to relate camera movement to enhance your story's impact
Visit the LaunchPad for *Filmmaking in Action* to learn more — and to explore how you might use this advice.

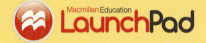

get even more online.

Macmillan Education **LaunchPad**

LaunchPad for *Filmmaking in Action* offers a full digital package of valuable resources, including the How Do I...? videos, interview videos, case studies focusing on industry professionals, chapter-specific directories of resources, and more.

macmillanhighered.com/ filmmaking

ADVICE FROM PROFESSIONALS IN HOW DO I…? VIDEOS.

Each chapter includes a **How Do I…?** feature that profiles a Hollywood professional and offers a corresponding video on LaunchPad for *Filmmaking in Action*. Exclusive interviews offer real advice to aspiring filmmakers. The participating directors, writers, producers, editors, designers, and other industry insiders have worked on movies ranging from blockbusters to indies, including *Star Wars*, *Fight Club*, *Pineapple Express*, *Nebraska*, *Winter's Bone*, *Prince Avalanche*, *Alice in Wonderland*, *The Rock*, and many more.

ACTION STEPS EXPLAIN HOW IT'S DONE.

Processes from all areas of filmmaking are broken down into simple, easy-to-follow **Action Steps** boxes, giving you the tools you need to succeed at any stage of your filmmaking career.

FILMMAKING IN ACTION

YOUR GUIDE TO THE SKILLS AND CRAFT

Adam Leipzig
Chapman University, Dodge College of Film and Media Arts

Barry S. Weiss
Member, Academy of Motion Picture Arts and Sciences

with **Michael Goldman**

Bedford/St. Martin's
A Macmillan Education Imprint

Boston • New York

For Bedford/St. Martin's

Vice President, Editorial, Macmillan Higher Education Humanities: Edwin Hill

Publisher for Communication: Erika Gutierrez

Developmental Editors: Jesse Hassenger, Stephanie Ventura

Senior Production Editor: Peter Jacoby

Production Associate: Victoria Anzalone

Marketing Manager: Tom Digiano

Copy Editor: Jamie Thaman

Indexer: Kirsten Kite

Photo Researcher: Christina Pompa

Director of Rights and Permissions: Hilary Newman

Senior Art Director: Anna Palchik

Text Design: Maureen McCutcheon

Cover Design: William Boardman

Cover Art/Cover Photo: © Insight Imaging/Getty Images

Composition: Graphic World, Inc.

Printing and Binding: RR Donnelley and Sons

Printed in the United States of America.

0 9 8 7 6 5
f e d c b a

For information, write: Bedford/St. Martin's, 75 Arlington Street, Boston, MA 02116 (617-399-4000)

ISBN 978-0-312-61699-1
ISBN 978-1-4576-8471-5 (Loose-leaf edition)

Acknowledgments

Art acknowledgments and copyrights appear on the same page as the art selections they cover. It is a violation of the law to reproduce these selections by any means whatsoever without the written permission of the copyright holder.

About the Authors

Adam Leipzig

Adam Leipzig is the CEO of Entertainment Media Partners, which provides informed guidance for independent media companies, financiers, and producers, and is the publisher of *Cultural Weekly* (www.culturalweekly.com). Adam teaches at Chapman University's Dodge College of Film and Media Arts, at UC Berkeley's Haas School of Business, and he is a member of the Producers Guild of America. He has overseen more than 25 movies as producer, executive, or distributor, including *March of the Penguins*; *Dead Poets Society*; *Titus*; *Honey, I Shrunk the Kids*; *Amreeka*; and *The Story of the Weeping Camel*. Adam served as president of National Geographic Films and as senior vice president at Walt Disney Studios, and in each of those positions was responsible for the movie industry's most profitable film of the year. He is the author of *Inside Track for Independent Filmmakers: Get Your Movie Made, Get Your Movie Seen*, a how-to manual for students and professionals with tips for solving the problems most faced by emerging and independent filmmakers. Adam loves to hear from his readers; contact him at Adam@AdamLeipzig.com.

Photo by Ann Fishbein

Barry Weiss

After completing his MFA at the USC School of Cinematic Arts, Barry worked on some of the most profitable, award-winning projects of the last 20 years. In the roles of animation executive, producer, and collaborator with Sony Pictures, Warner Bros., Nickelodeon, and Turner Pictures, he has achieved an unparalleled record of success. Barry was instrumental in the creation of two animation studios, leading the teams that created the animated characters for the *Stuart Little* and *Spider-Man* franchises, plus characters for 20 additional films, such as *Open Season* and Academy Award nominee *Surf's Up*. He is credited on 62 films and shorts, two of which have won Academy Awards and eight additional nominations. Barry is also an Emmy Award winner and began his career as a tour guide at Universal Studios.

Photo courtesy of Sony Pictures Imageworks

Michael Goldman

Michael Goldman is a veteran entertainment-industry journalist and author, who has penned seven books, including his work coauthoring *Filmmaking in Action*. Among these are the *New York Times* best seller *John Wayne: The Genuine Article*; *Clint Eastwood: Master Filmmaker at Work*, an authorized look at the legendary director's filmmaking techniques; and *Reality Ends Here: 80 Years of USC Cinematic Arts*, the definitive history of the world's oldest and most famous film school. He is a frequent contributor to *American Cinematographer* magazine and writes for a host of industry publications, newsletters, and websites, including *CineMontage*, *SMPTE Newswatch*, and *Post* magazine. Michael served for many years as senior editor of the famed industry trade journal *Millimeter* and, before that, as an editor at *Daily Variety*. In his work over the years, Michael has interviewed many of the world's leading filmmakers across all disciplines. Learn more at his website, www.hollywood-scribe.com.

Photo by Tony Donaldson

Preface

Filmmaking is changing. In an era when the art and science of last year's Academy Award–winning accomplishments are quickly discarded in favor of newer processes, tools, and thoughts for the coming year's movies, instructors teaching the introduction to film production course are tasked with a difficult challenge: to provide students with a solid foundation of the century-old principles of filmmaking, coupled with the ability to use tools, technologies, and production centers that transform on a day-to-day basis. At the same time, they are striving to motivate students and instill the importance of storytelling in all films.

Before we started this project, we found that a comprehensive introductory text for film production did not exist—at least not in the form we wanted to see. We believed the time had come for a film production textbook that keeps students up-to-date on today's digital filmmaking techniques and also discusses every aspect of film as an art form, as well as its commerce, as the industry is undergoing a seismic shift. It became our goal to bring the cutting-edge wisdom of top professionals into the hands of today's students—empowering the next generation of filmmakers. And we wanted to bring our breadth of experience to film students everywhere.

In the pages of this book, we draw on our experiences in the film industry, as well as the experiences of others during this digital revolution. Our team consists of Adam Leipzig, who has been a part of the film industry through his long career of supervising movies, from *Dead Poets Society* to *March of the Penguins*, the latter of which found unprecedented success while he was president of National Geographic Films. Barry Weiss has shaped the technical and aesthetic rules of filmmaking and pushed them into new areas during his fifteen-year tenure as senior vice president of the Academy Award-winning Sony Pictures Imageworks. He was one of a handful of members chosen in 2003 by the Academy of Motion Picture Arts and Sciences to reconstitute the Science and Technology Council of the Academy, where he served as chairman of the Public Programs and Education Subcommittee and currently serves on the executive board of the Short Films and Feature Animation branch. Finally, Michael Goldman has years of experience as a journalist and author covering all aspects of the filmmaking industry, and interviewing many of the world's leading filmmakers. Together we have worked on over 100 films and with tens of thousands of film and digital video artists, scientists, craftspeople, educators, and executives.

It is our mission with this book to address the real-world situations students will encounter in their first classroom project and throughout their careers, building on the following principles:

▌ Film and video have become the most important form of communication in our time. To engage the world productively and to be contributing citizens, film majors and non-majors alike must attain essential video literacy, in creation and understanding of this most important medium.

▌ The film industry thrives on communication, collaboration, and the ability to improvise.

▐ Understanding the foundations of film and video will help students identify where they want to focus their future studies and how those areas fit into the overall process and art form.

▐ The digital revolution has made filmmaking more democratic and also more complex. Enormous, expensive productions and micro-budget indies share many of the same production principles, and it is important for students to understand these principles as they apply to all scales of filmmaking.

Like the films we love, we want this book to engage the reader with a good story, well told. For this book, that means synthesizing contributions from award-winning, working filmmakers; a contemporary perspective that students can relate to; and a wealth of information and resources. These elements are presented in the book's innovative features.

Features of *Filmmaking in Action*

Informed guidance about all areas of filmmaking

From our extensive careers in Hollywood, we don't just know the technical logistics of making movies; we understand the challenges of storytelling and the complexities of the film business. This is why *Filmmaking in Action* offers a deeper, more immersive approach to filmmaking. For example, Chapter 11, Editing Skills, offers an overview of the technical process, while Chapter 12, Telling the Story through Editing, provides perspective on using that process to create effective, memorable moments in a film's story. Cinematography, lighting, sound, and design receive similarly dynamic attention throughout the book. We also walk readers through important preproduction stages, such as pitching and screenwriting, and key postproduction concepts, such as distributing and marketing. In short, *Filmmaking in Action* covers the skills, craft, and business of film in a single detailed yet accessible book—with the up-to-the-minute expertise to back it up.

Advice from professionals in How Do I...? videos

Each chapter includes a **How Do I...?** feature, which profiles a Hollywood professional and offers a corresponding video on LaunchPad for *Filmmaking in Action*. These are exclusive interviews of filmmakers offering real advice that students can use. These directors, writers, producers, editors, designers, and other industry insiders have worked on movies ranging from blockbusters to indies, including *Star Wars*, *Fight Club*, *Pineapple Express*, *Nebraska*, *Winter's Bone*, *Prince Avalanche*, *Alice in Wonderland*, and *The Rock*. Together, their advice forms an expert crash course in all facets of filmmaking.

Action Steps help students succeed

The authors break down processes from all areas of filmmaking into simple, easy-to-follow **Action Steps** boxes, giving students the tools they need to succeed, whether they're working on their first student film or beginning their professional career.

A full spectrum of information, hints, and tips

Recurring boxed features encourage students to look at filmmaking from different and productive angles: **Tech Talk** discusses the hardware filmmakers will encounter in the classroom and on the job; **Business Smarts** explains the ins and outs of

financing and deal making; and **Producer Smarts** provides big-picture examples of the producer's role. All three boxed features appear throughout the book's chapters, providing a variety of perspectives on technology, business, and production management. *Filmmaking in Action* also includes marginal tips related to the subjects at hand, packing the book with practical, accessible instruction.

An engaging, eye-catching design

Filmmaking in Action has the welcoming look of a contemporary magazine or trade journal, delivering important information in a concise, visually literate manner. The design includes a wealth of images, from film frames to shot diagrams to behind-the-scenes production art, all of which bring key concepts to vibrant, colorful life.

Resources for Students and Instructors

For students and instructors, LaunchPad for *Filmmaking in Action* at macmillanhighered.com/filmmaking

Available packaged at a discount with *Filmmaking in Action* or available for purchase separately, LaunchPad features a rich library of videos featuring Hollywood professionals giving students an exclusive look at how they do their jobs—and offering career advice. Highlighted in **How Do I...?** boxes throughout the book, these videos offer practical, firsthand, and entertaining advice, expanding on each chapter's topic for today's digitally savvy film students. The LaunchPad for *Filmmaking in Action* also includes additional case studies, featuring interviews with professional filmmakers, a directory of chapter-specific resources, and information on important digital tools students need to know about.

For instructors, the Online Instructor's Resource Manual

The downloadable Instructor's Resource Manual recommends methods for teaching the course and includes chapter overviews, questions to generate class discussion, ideas for encouraging critical and active viewing, a list of must-see movies for any film production student, and sample syllabi. Instructors who have adopted LaunchPad for *Filmmaking in Action* can find a full instructor section within LaunchPad.

Print and Digital Formats

For more information on these formats and packaging information, please visit the online catalog at **macmillanhighered.com/filmmaking/catalog**.

LaunchPad is a dynamic platform that dramatically enhances teaching and learning. LaunchPad for *Filmmaking in Action* includes an online ebook version of the textbook, videos, activities, quizzes, and instructor's resources—all on a single site. LaunchPad features a student- and instructor-friendly approach, organized for easy assignability in a simple user interface. Instructors can create reading, video, or quiz assignments in seconds, as well as embed their own videos or custom content. A gradebook easily allows instructors to review the progress for a whole class, for individual students, or for individual assignments, while behind-the-scenes clips and videos enhance every chapter of the book. LaunchPad can be packaged at a discount with *Filmmaking in Action* or purchased on its own. Learn more at **macmillanhighered.com/launchpad**.

***Filmmaking in Action* is available as a print text.** To get the most out of the book and gain access to the extensive video program, package LaunchPad at a discount with the text.

The loose-leaf edition of *Filmmaking in Action* features the same print text in a convenient, budget-priced format, designed to fit into any three-ring binder. Package LaunchPad with the loose-leaf edition at a discount.

The Bedford e-book to Go for *Filmmaking in Action* includes the same content as the print book, and provides an affordable, tech-savvy PDF e-book option for students. Instructors can customize the e-book by adding their own content and deleting or rearranging chapters. Learn more about custom Bedford e-Books to Go at **macmillanhighered .com/ebooks**.

Acknowledgments

The authors would like to express our everlasting gratitude to the staff at Bedford/St. Martin's and the entire Macmillan family for their vision in seeing the potential of this project and for their ceaseless efforts, patience, and hard work in making sure it made its way to your classroom. As first-time textbook authors, we were in the hands of the education publishing industry's finest team, including Joan Feinberg, Denise Wydra, Erika Gutierrez—who has been our rock from beginning to end—Simon Glick, Jesse Hassenger, Noel Hohnstine, Peter Jacoby, Mae Klinger, and many others at Bedford/St. Martin's, without whose efforts this book would not exist.

Our heartfelt thanks go to Stephanie Ventura, our day-to-day editor, psychologist, supporter, and taskmaster. Stephanie's unique style molded a raw idea into a meaningful book. Congratulations to Stephanie who had two beautiful babies, Lucas and Charlotte, during the course of creating this edition.

We owe great thanks to a wide-ranging group of industry professionals who saw the wisdom in supporting this project by lending decades of experience to the chapters through interviews, advice, and review—including award-winning filmmakers, executives, technical wizards, marketing geniuses, and others who directly or indirectly contributed to this textbook and the online materials that go along with it, whether or not their words appear with attribution. They include Richard Abramowitz, Michele Ashford, Autodesk, John Bailey, Lon Bender, Jim Bissell, Ben Burtt, Julia Camara, Russell Carpenter, Jerome Chen, Jerrica Cleland, Cherien Dabis, Willie Dawkins, Paul Debevec and the team at the University of Southern California's Institute for Creative Technologies, Chris DeFaria, Patrick Sheane Duncan, Jake Eberts, Mindy Elliott, Steve Elzer, the team at Entertainment Partners, John Fasal, Lucy Fisher, Sid Ganis, William Goldenberg, David Gordon Green, Jon Gunn, Don Hall, Catherine Hardwicke, Robert Hoffman of Technicolor, Rob "Mr. Format" Hummel, Gale Anne Hurd, Laura Kim, John Knoll, Marvin Levy, Skip Lievsay, Andy Maltz, Gary Martin, Tom McCarthy, Alex McDowell, Tim Moore, Jim Morris, Walter Murch, David Nochimson, Dennis O'Connor, Daryn Okada, Jeff Okun, Jeannine Oppewall, Paul Ottosson, Amy Pascal, Jacob Pinger, Ken Ralston, Brett Reed, Eric Roth, Gary Rydstrom, Nico Sabenorio, Adrian Seery, Dean Semler, Nigel Sinclair, Sony Imageworks, Robert Staad, Jack Taylor, Technicolor, Jesús Salvador Treviño, Mandy Walker, Warner Bros., Douglas Wick, and Lulu Zezza.

We lost track of how many Academy Awards and other major achievements this illustrious group has collected among them, but collectively, they've notched another achievement by helping us accomplish a key goal for this work: to provide you with precious, firsthand knowledge, insight, and experience from the highest levels of the filmmaking industry, across all disciplines. Their contributions of time and ideas illustrate a bedrock reality of the modern industry: those fortunate enough to be part of it feel a genuine and heartfelt commitment to helping build and inform the generations that will follow in our footsteps.

Along these lines, we also thank the major guilds, unions, and industry institutions that lent their support and resources to us with open arms: the Academy of Motion Picture Arts and Sciences, including the Margaret Herrick Library and the Science and Technology Council; the Producers Guild of America; the Directors Guild of America; the American Society of Cinematographers; the Visual Effects Society; the Previsualization Society; the Writers Guild of America; the Editors Guild; and many more.

A special shout-out to the graduate student crew from Chapman University's Dodge College of Film and Media Arts for doing a masterful job in producing, shooting, and editing the extraordinary videos you will find on the book's Launch-Pad site, as well as producing some of the special photographs found in the textbook itself: producers Molly McKellar and Lex Stathis, cinematographers Tommy Oceanak and John Manning, sound recordist Mohit Kakkar, editor Nathan Grout, and composer Raghav Murali. And a special thank you to Barbara Doyle, chair of the film division, for making this possible.

Our gratitude also goes out to the incredible faculty reviewers from institutions around the country, who evaluated early drafts and helped us continue to hone chapters even after we thought they were done. Our work benefited greatly from their educational insight. They include Jacob Agatucci, Central Oregon Community College; Hubert Stanley Anderson, Georgia State University; Jack Anderson, California State University–Long Beach; Marc Boese, Florida State College at Jacksonville; Lily Boruszkowski, Southern Illinois University; Michael Calia, Quinnipiac University; Michael Chaney, Savannah College of Art and Design; William Christy, Ohio University–Zanesville; Thomas Cook, Keene State College; John Cooper, Eastern Michigan University; Nefin Dinc, SUNY Fredonia; William Donaruma, University of Notre Dame; Mary Phillips Duke, Lee University; Marie Elliot, Valdosta State University; James Forsher, Seattle University; Joseph Fortunato, Arizona State University; Sasha Waters Freyer, University of Iowa; Chuck Gloman, DeSales University; Rustin Greene, James Madison University; Michael Hofstein, Savannah College of Art and Design; Michael Hoggan, California State University–Northridge; Matt Jenkins, Cameron University; Tammy Kinsey, University of Toledo; Warren Koch, Azusa Pacific University; Shara Lange, East Tennessee State University; Dennis Lanson, Endicott College; Jamie Litty, University of North Carolina–Pembroke; Carey Martin, Liberty University; Thomas McHardy, James Madison University; Rachel Morgan, Lawson State Community College; Ray Niekamp, Texas State University; Josh Overton, University of New Orleans; Anthony Pemberton, Montclair State University; Julia Peterson, Bergen Community College; Geoffrey Poister, Boston University; Phillip Powell, Valparaiso University; Stephen Price, University of Central Missouri; Christopher Reed, Stevenson University; Tom Rondinella, Seton Hall University; Kristen R. L. Shaeffer, Chatham University; Andrew Sharma, Salisbury University; Jay Start, University of Pennsylvania; Sarah Stein, North Carolina State University; Chris Strobel, Northern Kentucky University; Jes Therkelsen, California State University–Fresno; Lakshmi Tirumala, University of Cincinnati; Evan Wirig, Grossmont College; and Kelly Wittenberg, Missouri Western State University.

Photo editor Christina Pompa did an exceptional job finding just the right images to go with our words.

We thank Neal Lenarsky and Adam Bauman for bringing us together, and for introducing Barry to our fellow Macmillan author, the late Jon Rogawski, whose kindness, generosity, and support helped generate Bedford/St. Martin's interest in this book in the first place. Jon's publisher, Craig Bleyer, helped give this project wings.

Special thanks from Adam Leipzig: The movie business attracts some of the most creative, passionate, visionary people on earth, and I've learned from everyone I have worked with, along with a vast number of international filmmakers who have taught me through the magic of their movies. Two people have been my mentors, even though they didn't know it at the time. Jeffrey Katzenberg agreed to hire me at Walt Disney Studios when I was unschooled in film and had only worked in theater; he showed me how movie studios can operate with integrity and excellence, and the best ways to support creative filmmakers. Jake Eberts, who passed away while I was working on this book, was a great producer who became a great friend. He educated me about independent filmmaking and financing, the continuous aspiration for quality, doing business with utter transparency, and how all the pieces come together. Barry Weiss and Michael Goldman have been extraordinary and committed collaborators; this book is a true team effort.

I've been part of many families in my lifetime, all of whom supported me and with whom I have grown: the families at the Los Angeles Actors' Theatre and the Los Angeles Theatre Center; the families at each movie company where I've worked—Walt Disney Studios, Interscope Communications, and National Geographic Films, where I both learned and put into practice many of the principles described in this book; the families created by every film I've worked on, which provided the real-world practicalities involved in crafting art along with great camaraderie; my mother, Lily; my brother, Matt; and especially Lori Zimmerman and our two remarkable children, Chloe and Amara, who were the first to be able to visualize this book when I told them about it years ago.

Special thanks from Barry Weiss: First of all to my co-authors, this has been quite an odyssey and one that I am glad to have shared with you. I also want to thank my film educators at Northwestern University, Dana Hodgdon and Michelle Citron, for developing my early interest in this medium, as well as the current dean of the School of Communications, Barbara O'Keefe, for her support during my alumni years; and the Chicago Board of Rabbis, who took a chance on me as an intern and later as a producer, providing me with the opportunity to win my first Emmy Award—a mere twelve hours before I graduated college. The University of Southern California's School of Cinematic Arts cemented my desire and education to work in film, especially two of my early mentors—the late professors Dave Johnson and Art Murphy—so my thanks go to them and, of course, to current dean Elizabeth M. Daley, who has served as a great resource and mentor for over two decades. Thanks also to my numerous film school colleagues, from whom I learned, and continue to learn, a great deal.

I've had the privilege of working with many of the industry's finest, but none of that would have happened without my professional mentors and colleagues: at Disney, Jack Yellin; at Warner Brothers, Chris DeFaria; at Hanna-Barbera, David Kirschner, Bruce Johnson, Shelly Rabinowitz, Jane Barbera, and of course the legendary Joe Hanna and Bill Barbera; and at Sony and Turner Pictures, Amy Pascal, Tim Sarnoff, Bob Osher, Don Levy, Ken Williams, and the greatest physical production man on the planet, Gary Martin, who has been my mentor for over 25 years. They don't name the largest sound stage in Hollywood after you when you retire unless you are the greatest, and Gary, you will always be the greatest. All of you have given me key opportunities and guidance throughout my career and continue to be dear friends, colleagues, and supporters.

To my fellow Academy Members, as well as the incomparable staff of the Academy of Motion Picture Arts and Sciences, it is truly an honor to be counted among you. Your support and contributions to this project were priceless. A special thanks to David J. Steinberg—children's book author, producing partner, and, most impor-

tantly, lifelong friend. David, your guidance and undying friendship literally turned us into brothers (or at least actual distant cousins) for over three decades.

Writing a book of this scope does not happen in a vacuum. You cannot accomplish this without dear friends, and so my thanks also go to Joey Stern and Mark Kirshner, whom I've known practically my entire life and who have been best friends to me in every sense of the phrase. And, of course, my family; a project like this takes a large toll on one's family, so I want to thank my brother, Lennie, for his moral support, and my dear children, critics, and confidants—Nathaniel, Daniel, Simi, and Eli—who allowed me to spend countless hours away from them and supported every sacrifice. My in-laws, Jewell and Cliff Fraser, also lent a hand in keeping me normal throughout this process.

Perhaps I would not be writing this without the support of my parents, Lisa and Irving Weiss, who bravely supported me when I changed from "our son the doctor" to "our son the filmmaker." I want to thank God not only for allowing my father to survive the Holocaust but also for giving him the strength, courage, and wisdom to rebuild his life and then build his family. Those traits inspire me and guide me in everything I do, and he has supported me in every way a father could support his son. So I would like to dedicate this book to my family, especially my late father. Dad, I know you are smiling down on us. Of all the things in my life that I have accomplished and am proud of, I am most proud of being your son.

After writing all these words, I cannot find any that would suffice to acknowledge my wife, Lorye. I am the luckiest person on the face of the earth to have her as a wife, best friend, counselor, and cheerleader through thick and thin. She is my muse, a very talented and creative chef, and my soul mate. Thanks for loving and supporting me and raising four of the greatest children I know.

Special thanks from Michael Goldman: Most everyone has already been mentioned, but I still have to single out my co-authors, Barry and Adam, for generously inviting me into a project they had been gently nurturing for years, and then graciously allowing me to co-parent their long gestating "baby" to maturity, with full parental rights and responsibilities. Guys, the faith and trust you have shown in me is humbling—it was a most pleasurable collaboration.

Special gratitude also to the entire team at Bedford/St. Martin's for treating me so well and respecting the unique wants, needs, and complications that arise in the life of a book author, but particularly to Simon Glick, for bringing me into the project seamlessly; Stephanie Ventura, the kindest, gentlest, yet most effective book editor I have yet worked with; and Jesse Hassenger, for keeping business and logistical headaches to a minimum so that we could maintain our steadfast focus on our educational mission.

Thanks to my lawyer, Jeffrey Morgan; thanks to my mom and stepdad, Lynn and Lionel, for their never-ending support; and humble gratitude to my stunningly gorgeous wife, Bari, for the love, support, and unyielding tolerance you show in putting up with a cranky writer every day and every night. My good fortune in having found such a partner is beyond description. But most of all, a special thanks to my two sons, Jake and Nathan, not only for cheering me on but for everything you have taught me—and continue to teach me every day. One key lesson my boys have taught me over the years—and co-authoring this book only reinforced it, as I discovered so much about what is needed to communicate meaningful ideas to the next generation—is that those of us tasked with teaching or guiding others are the real beneficiaries. What we get back from our children or our students far outweighs anything we can possibly give them. I will always be grateful to you both.

Brief Contents

Contents

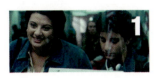

Telling the Story with the Camera 149

Lighting Skills 177

Qualities of Light 178

Shadows and Contrast 179

Directional and Diffused Lighting 182

Measuring Lighting 182

Exposure 183

Approaches to Exposure 184

Elements of Exposure 184

Exposure in Action 185

▮ **Action Steps:** Solving Exposure Problems 186

Color 187

Color Temperature 188

White Balance 188

Lighting Gear 189

▮ **Action Steps:** Lighting Safety First! 189

Lighting Instruments 190

Exterior Lights 190 ▮ *Interior Lights* 190

▮ **Tech Talk:** Don't Blow that Circuit! 191

▮ ▶ **How Do I . . .** Light with Minimal Tools? 193

▮ **Business Smarts:** Renting Lights 194

Mounting Equipment 194

▮ **Producer Smarts:** How Much Is Enough? 195

Diffusers, Gels, Filters, and Cookies 195

CHAPTER 8 ESSENTIALS 198

Telling the Story through Lighting 199

Style, Planning, and Preparation 200

▮ **Action Steps:** Planning the Lighting 201

▮ ▶ **How Do I . . .** Light for Mood? 202

Three-Point Lighting 203

▮ **Action Steps:** How to Set Up Three-Point Lighting 203

The Lighting Ratio 204

Continuity and Your Lighting Triangle 205

How Much Light? 206

Adjusting the Lights 207

▮ **Producer Smarts:** How Long Will Setups Take? 208

Outdoor Lighting 208

Adjusting for Weather and Time of Day 209

Practical Outdoor Setups 211

Indoor Lighting 211

Lighting Diagrams 211

Practical Indoor Setups 213

PART **THREE** PRODUCTION GLUE 249

Visual Effects and Animation 297

PART **FOUR** — FILMMAKING AND BEYOND 323

Marketing and Distribution 325

Careers in Filmmaking ₃₄₉

"Making a film is a bit like switching off the light in the room and trying to navigate around by touch and feel and smell."

– Steve McQueen, director of *12 Years a Slave* (2013), *Shame* (2011), and *Hunger* (2008)

The Big Picture

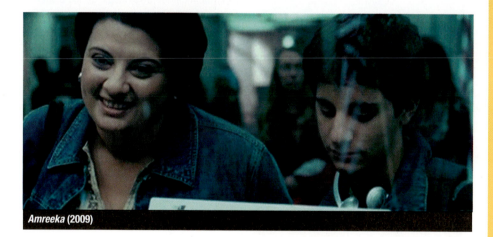

Amreeka (2009)

Cherien Dabis made her presence felt even before she came up to the stage. Ninety-seven minutes earlier, the house lights had dimmed and her first feature film, *Amreeka*, began its premiere screening. Starting in Palestine's West Bank and moving to suburban Chicago, *Amreeka* tells the story of an immigrant mother and son finding their way in a new land, America. As the final credits rolled, the audience rose to its feet with wild cheering as Cherien stepped to the microphone. She could barely contain her emotion as applause echoed through the theater.

Amreeka's crowd-pleasing premiere took place at the 2009 Sundance Film Festival, an annual event in Park City, Utah, that has come to represent the epicenter of independent movies. Each year, Sundance screens more than 100 feature films and more than 50 shorts, selected from over 12,000 submissions by filmmakers worldwide. To be selected by Sundance is a high honor; to be seen by an even wider audience is an achievement reserved for only a few Sundance films.

Amreeka cleared that hurdle as well. It went on to achieve national theatrical distribution—the first film by a Palestinian American director to attain this milestone—and was nominated for numerous awards worldwide, winning many of them. Cherien herself collected the coveted International Federation of Film Critics Prize during the world-renowned Cannes Film Festival,

following an eight-minute standing ovation for *Amreeka* when it screened there.

How did this happen? Just a few years before, Cherien had been in a class like yours. Born and raised in Omaha, Nebraska, she studied creative writing and communication at the University's of Cincinnati, and then applied to the master's program at Columbia University's School of the Arts. There, Cherien began the first draft of the screenplay that would become *Amreeka*. She

worked on it tirelessly for five years before she acquired the necessary skills and garnered the financing and production support to finally get the movie made.

Amreeka is an immigrant story—a tale of people exploring a world that is new to them and somehow, against great odds, finding their way. In similar fashion, filmmakers at all levels—and all film projects—must navigate a path through what is, initially, an undiscovered country. This is even truer in your case, as filmmaking students launching into the journey for the first time. Without guidance, examples, and study, the terrain is forbidding, and a place where you may easily lose your way. Informed with knowledge, practice, and mentoring, however, it can be a rich and exciting universe, full of the most creative people on the planet, sharing stories in their richest incarnations with audiences that hunger to be enlightened and entertained.

Along the way, every person's path will be different, and Cherien's path won't be yours. As you will discover from the many people who tell their stories in this book, everyone follows a different muse and takes his or her own uniquely personal filmmaking journey. But that is one of the great attractions of a filmmaking career—those many paths, and the collaborators you can join forces with to create a cinematic sum greater than any single part along the way. If you get lost on one road, there are many others you can try. Eventually, if you work hard enough and maintain your focus, you will find an opportunity to move in the direction of your greatest skills and areas of interest. But first you need to learn about the possibilities that exist, and ground yourself with some core fundamentals you can use as a compass when the waters get choppy, as they certainly will. That is the purpose of this course and textbook: to provide a wide understanding of the filmmaking process, so that you can begin to discover for yourself which path you will want to continue on once you embark on the next phase of your journey.

© National Geographic/Courtesy Everett Collection.

Why Make a Film?

In the history of human communication, no method of sharing information has spread as quickly or has had the ability to reach more people than the video revolution of the last decade or so. Suddenly, with the democratizing impact of consumer-affordable digital tools—video cameras on people's phones, for instance—and the groundbreaking development of YouTube in 2005 in concert with the broadband revolution that made it possible not only to make content formally and informally but also to share it with virtually everyone at the click of a few buttons, anyone could make a video and share it. Today, in fact, more than one billion people visit YouTube each month.[1]

These realities don't make all those millions of people shooting and uploading videos "filmmakers," of course, but they do give you the opportunity to become one if you want it badly enough. Unlike what filmmaking students of generations past faced, the tools are largely affordable and within your grasp, as are the means to collaborate on the work and share it, too. And because you are fortunate enough to be in this course, you now have the opportunity to gain a solid foundation for doing these things using methods and techniques that have been used for generations to produce thought-provoking and escapist cinema in any and all genres.

But none of that will answer the question of why you would *want* to make movies. Everyone's personal motivations are his or hers alone; however, one fundamental reason shared by many great filmmakers is fairly straightforward: you have a story, something to say, and the best way for you to do that is through filmmaking. It might be something artistic, avant-garde, humorous, political, thought provoking, breathtaking, terrifying, or courageous, but whatever the message, the use of moving images is a particularly compelling way to say it. You may wish to tell a story, document a piece of history, bare your soul, or reveal the mysteries of someone's character. Or perhaps you simply want to make people

Tip READ THE INDUSTRY

To expose yourself to how the world's leading filmmakers and their collaborators work, communicate, and interrelate, read industry trade publications in as many different disciplines as you can. Virtually every major discipline has one or more major trade publications for industry craftspeople, and the industry guilds often publish their own, as well.

A popular YouTube video re-creates a musical number from *Frozen* (2013).

laugh, make them cry, freak them out, or titillate them. The artistic, creative, and emotional reasons for wanting to make films are endless, but there is no doubt that moving images are the most boundless, unrestricted way to go about expressing whatever it is you want to express. Your film, for example, may be only 15 seconds, so you can upload it to Instagram in a heartbeat, or it may be 24 hours long, as was Christian Marclay's art movie about movies, *The Clock* (2010). Your movie may be in black and white or color, composed of typical moving images, as in most films you've seen, or made up of still pictures, as was Chris Marker's *La Jetée* (1962). Your film may be full of music, talking, sound and fury, or silence, like *La Fée aux Choux,* which was the first narrative movie, directed by Alice Guy-Blaché in 1896.

The point is, moving imagery is the one medium that allows you to cross boundaries, combine formats, create the visually stunning, experiment liberally, and follow classical patterns all at the same time; to follow strict rules and break others from one moment to the next; to raise a ruckus and silence a room; to blind your audience and make them strain to see what is going on; to offer them a clear vision of what you are trying to say, or to leave them scratching their heads, interpreting your work. In this respect, moving images can be more impactful than novels because they take you to two, three, and sometimes four dimensions of vision, sight, and interpretation. Therefore, if you are interested in visual storytelling and artistry, making a film is an excellent and compelling way to express yourself at a minimum, not to mention the fact that it involves a suite of artistic disciplines that might just land you a career along the way—or, at the very least, greatly improve your artistic and intellectual understanding of both storytelling and the world around you. In other words, filmmaking is unique, and a lot of fun besides. Of course, it is also something that is extremely hard to do well, as we shall discuss throughout this book.

Before we get to that, however, what, exactly, do we mean by the word *film*? The precise word *film* originally referred to strips of celluloid on which images were recorded; in the past decade, as you will learn, these celluloid strips have largely been replaced by digital cards and hard drives. However, we think of *film* as the product of your work, not the medium on which it was recorded. For the purposes of this book, and for the entertainment industry at large, we define a **film** quite simply and generically as a series of moving images intentionally constructed to tell a story. Whereas *film*, *movie*, or *video* are words now often used interchangeably, in this book we will be somewhat traditional and mostly refer to the product as *films* or *movies*—terms that we feel imply greater ambition and intention than *videos*, which refers to products generated both by those with artistic intent in today's digital world and by those without.

Thus, there are, as we have suggested, myriad reasons to make a film. But are there reasons *not* to make a film? Yes, indeed. As you will learn, if

La Jetée (1962)

La Fée aux Choux (1896)

you do not know what you want to say, do not know who your audience is, or have no interest in or patience for collaborating and trusting others to help you achieve your vision, you should put down your camera and think seriously about what you are doing. Making a movie requires considerable effort from, ideally, a team of people with diverse talents, and if your purpose and ultimate viewers are not clear at the outset, it's likely that the work will go to waste because no one will see it. Fortunately, with this book, you will learn how to avoid this circumstance.

Beyond the conventional way we think about movies—as stories we watch for a few minutes or a few hours—the principles you will learn in this course will be essential for your success in any career you choose. Film communication now permeates every aspect of our lives, from corporate communications and television commercials to music videos, interactive games, educational materials, and much more. In any job you will have, your ability to make a film will make you a more valued employee; and if you choose to become an entrepreneur and work for yourself, filmmaking skills will be great assets for communicating your vision to colleagues.

In other words, filmmaking, one way or another, is going to be a part of your future, so you might as well learn how to do it right. (See Action Steps: Getting Started—What You Need to Make a Short Film Right Now, below.)

ACTION STEPS
Getting Started—What You Need to Make a Short Film Right Now

Don't want to wait? Go make a short movie to develop some fundamental experience right away. Don't worry about technical details, your lack of experience, or final quality. No matter the outcome, you only learn this craft by doing it. Here's how to get started in eight basic action steps:

1 **Know what story you want to tell.** Who is the main character? What will happen?

2 **Write it down.** Every movie needs a script, even if the script is only one page. Develop your main story as simple bullet points in the form of a basic treatment, and then evolve that into a short script.

3 **Make a plan.** Evaluate your script. Who will the actors be? What will they wear? Do they need any props? Where will you shoot? How many people do you need to help you? Make a list of things you will need, and then formulate a strategy for making sure you have everyone and everything you need.

4 **Get your gear.** For most basic short pieces, you can shoot with your mobile phone if necessary. Because you have limited resources and training, try to shoot outdoors or in interiors that can be lit from the outside to avoid worrying about lighting and other complexities, which we will discuss later in the book. In any case, figure out what you will need equipment-wise, whether it's a mobile phone or gear your school may provide, and organize it.

Continued

Tip **GET OUT THERE AND NETWORK**

Attend film festivals, local screenings, panel discussions, and trade shows whenever you can. Don't underestimate the educational and networking value of attending events, meeting industry people, and making it clear that you would like to tap their brains. Your film education will take place as much outside this classroom as inside it.

Practice
WHERE ARE THE MOVIES?

As you just read, film communication can happen anywhere. Find three examples of film communication in everyday life that do not come from traditional television, movies, computers, or mobile devices. Share them with your classmates, and explain how the moving images you encountered were used to influence and communicate. Note how many different examples the class came up with.

Continued from the previous page

5 **Shoot the scenes.** Follow the script and make sure you have captured all the scenes and parts of scenes—close-ups of your main characters, wider shots to reveal where they are, and sound so you can hear what they are saying.

6 **Edit it together.** First, edit each scene internally, stringing together the different shots so that they clearly communicate what is happening. Then, edit the scenes in their story order. Use the most rudimentary consumer-based editing software that you can access on your mobile device, your personal computer, or that your school or friends can supply.

7 **Add finishing touches.** Is the dialogue clear? If not, perhaps you need to rerecord a line. Does your movie need music? titles?

8 **Show it to your friends.** How do they react? Do they understand the story and relate to the characters? Don't be afraid to adopt their notes, if they make sense to you. Is the movie you made similar to the movie you imagined?

Three Filmmaking Principles

As you have learned, at its core, filmmaking is about getting your message and story across to your audience. It is not about the equipment you are using, such as cameras and microphones; it is about your approach to your work, regardless of the tools. As technology advances, equipment changes, yet the approach to filmmaking has remained remarkably constant in its 120-year history.

For this reason, we do not overly emphasize specific makes and models of gear. That information is readily available from your instructor, across the web, and from the various industry resources we are recommending you investigate. The reality is that as you begin your filmmaking career, you will use whatever equipment you can get your hands on. As previously suggested, the greatest technological breakthrough of the digital era is the simple fact that it is, by its nature, democratizing—there is no reason not to attempt to make a movie as a student based on lack of access to technology. Consumer, "prosumer," quasi-professional, and high-end gear all exist in the same universe now, and from the phone in your pocket to the finest digital cameras on the market today, there are tools you will be able to procure for your early efforts.

Therefore, it makes sense for you to first focus on foundational principles: collaboration, emphasis on story and character, and problem solving.

Collaboration Every film is a team effort. British director Paul Greengrass (*Captain Phillips*) calls filmmaking "a group activity" that requires "a common purpose" from everyone participating in its creation.[2] No movie of any length or consequence is made entirely by just one person. Even if it were possible for one individual to write the script, hold the camera, record the sound, act the roles, edit the images, and output the movie, there would still be the interaction between the filmmaker and his or her audience. A movie, in a sense, isn't fully a movie until it has been viewed and an emotional connection to the audience has been established. Therefore, there is no such thing as a solitary filmmaking experience—you have to involve, rely on, and consider other people's talents and viewpoints throughout the process.

 PRACTICE WITH SHORTS

As you launch into learning the basics of filmmaking, don't underestimate the value of short films, experimental pieces, and technique practice, even above and beyond official class assignments. As with any endeavor, practice makes perfect, whether you are attempting to shoot, light, design, edit, or do any of a number of other functions.

Even in their construction, films comprise the greatest collaborative art form the world has ever known, involving layers of multiple elements, woven together at different times and in different ways to create a greater whole, much like a puzzle. Movies can't be thought of in the same way as books (author and paper) or paintings (artist, paint, and canvas). Filmmaking is a more *layered* art form. Actors and set painters, costumers and writers, drivers and choreographers, stuntmen and technicians, photographers and electricians, carpenters and fact checkers, musicians and editors, directors and producers, and many others— these folks in endless configurations are required to produce movies.

You, of course, are students, with little in the way of resources, and huge demands on you to take on more roles than would be the case on a professional production, both out of necessity and as part of your learning process. Still, even in your situation, you will need to find help when you can. In this class, even with fewer overall collaborators, you will rapidly come to understand and appreciate the benefits of teamwork to realize your film.

Because so many people and skills are involved, good filmmaking requires excellent communication skills and sensitivity to the talents and requirements of every craft involved. In this course, you will learn about the many collaborators who make a movie, explore their skill sets, and develop a useful vocabulary to use when working with them.

Emphasis on Story and Character Movies are, by their basic nature, about something. As you will learn in Chapter 2, most films can be summarized with a log line that starts, "It's about . . ." Therefore, as we will emphasize more than once, every choice you make as a filmmaker must be in service to the main characters and their story. This principle will allow you to make wise decisions when you are under the pressured realities of production.

FIND YOUR COLLABORATORS

In your hunt for filmmaking collaborators, your first route should be through this class and your school's resources. Additionally, keep in mind that there are various websites that cater specifically to the independent filmmaking community, including some that try to connect students and young people in search of filmmaking experience on real projects, such as www.spidvid.com, www.filmzu.com, and www.filmsourcing.com.

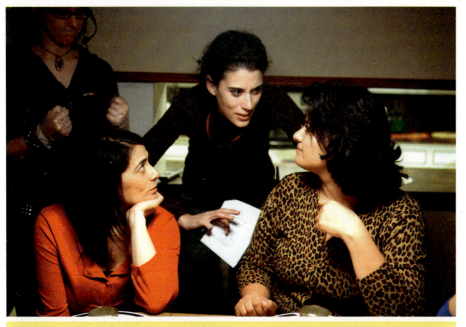

Writer-director Cherien Dabis collaborates with cast members Haim Abbas (*seated, left*) and Nisreen Faour (*right*) during production of *Amreeka* (2009).
© National Geographic/Courtesy Everett Collection.

For example: If you have time to capture only one shot, should it be of a beautiful sunset or of your main character's face at an emotional moment? Correct choice: The character's emotional reaction.

If you have a choice between making the story absolutely clear and leaving it to chance whether the audience will understand what's going on, what should you do? Correct answer: Make the story clear.

If you can afford either to shoot for one extra day or to rent a fancy camera with lots of special features, what should you pay for? Correct decision: The extra shooting day.

Your primary obligation to your audience is to communicate the story well, so they will be able to understand and empathize with your characters. If you do that, the audience will forgive technical imperfections. Plus, you'll be doing better than many first-time filmmakers! In this book, we frequently return to the importance of story and character to make sure your movie meets your audience's needs.

Practice

COLLABORATION AND STORY

Work in three teams to build basic elements of a movie story. Team One must create two characters and invent a relationship between them. Team Two must take those characters and come up with a basic conflict or issue that impacts their relationship as a central plot point. Team Three must take these elements and choose two environments or settings in which the events take place. Then, bring the teams together to hone, massage, and integrate all these elements into one movie story. The idea is not to write a perfect story but to learn how to work with others to achieve your creative goal. What did you learn about collaboration in this exercise? What does it reveal about the creative process?

Problem Solving Two things are certain on every movie project: there will be uncertainty, and things will periodically change from your original plan. Even if you only have a few hours to shoot your class project, something will eventually go wrong, and it will not always be what you expect. The level of uncertainty and unexpected problems increase with the scale of your film, and bigger films always face bigger problems.

In this book, we focus heavily on ingenuity and problem solving. We cannot teach you how to solve every problem, because problems, by their nature, are unpredictable. However, we can teach you how to deploy a mental attitude, generosity of spirit, and certain flexibility that will make the problems you encounter solvable, or at least allow you to formulate alternatives when circumstances require you to move in a different direction from where you were expecting to go.

A special feature of this book—How Do I . . .?—is devoted to teaching you how to develop the tools you will need to solve problems. Found in every chapter and online at LaunchPad for *Filmmaking in Action*, these video interviews reveal how filmmaking professionals solved common problems on real-world projects, and challenge you to think about what you might do when confronted by the unexpected yourself (see How Do I . . . Get My First Movie Made?, p. 12).

Six Filmmaking Viewpoints

The three core principles of filmmaking (collaboration, emphasis on story and character, and problem solving) might be thought of as the superstructure of the filmmaking process: no movie happens without them. Now let's turn to the "construction crew"—the people who actually get the movie made. These are the people you don't see, the people who are not the actors, yet it is these people whose viewpoints and actions determine the overall experience that filmgoers will enjoy—or not enjoy, as the case may be.

As student filmmakers, you will frequently have no choice but to take on many of these jobs yourself. On most of your initial projects, you will certainly handle

multiple creative, managerial, and logistical roles simultaneously. Still, the *viewpoints* brought to the filmmaking whole from these distinct spots on the horizon remain and are crucial to the final product. You will need to learn what these roles are and either how to assume them yourself—by thinking the way these craftspeople think when working on a production—or how to collaborate successfully with those who do. Most likely, you will end up with a combination of the two.

With that said, here is a look at the important filmmaking roles and the corresponding viewpoints that go along with them.

Producer

The **producer** brings all the elements of a film together and supervises all the people. Producers are responsible for the creative outcome of the movie and for accomplishing it on time and on budget. In your school, you may be your own producer, or a classmate may take on the job. In the professional world, major productions frequently have multiple producers due to the complexity of the work and the responsibility of raising money for the film. Indeed, it is difficult for any one producer to have the expertise, time, and resources to manage all the many complex areas of a multimillion-dollar production by him- or herself. But even at that level, there are usually one or two producers responsible for the entire endeavor. No matter who is filling this role, the producer's viewpoint is wide, encompassing everything in the five basic phases of any movie's life cycle: development, preproduction, production, postproduction, and distribution/marketing. (See Producer Smarts: Congratulations, You Are a Movie Producer!, p. 11).

Writer

The **writer** imagines the story and its characters, and transforms them from mere ideas into a tangible, physical screenplay that can be shared with others. You might be your own screenwriter, or you might work with a classmate in crafting the script. The writer's viewpoint is all about the people on-screen and what happens to them: the narrative and its actors. A well-written screenplay is the lodestone from which all creative ideas will flow when producing a movie.

Director

The **director** is the most important single individual on a film set, as it is primarily the director's vision that is represented in the final product. Directors select the script they want to shoot; choose the actors and primary creative collaborators; and make countless key creative, technical, and logistical decisions during the filmmaking process. The director's viewpoint is both immediate and long term: it's about making minute-by-minute choices that achieve the best result in service of what the completed movie will look like.

Editor

The **editor** assembles the film that has been shot, finding the best way to tell the story and convey character by selecting images and sounds and placing them in a specific order designed to enhance the emotional impact of the director's creative intent for the material. Editing is the only craft that is unique to movies; it had to be invented for filmmaking to take place. The editor may be thought of as the "second writer" of the movie, after the screenwriter, and is frequently considered the director's single closest collaborator on movie productions. The editor's

Tip **READ, READ, READ**

Read biographies and autobiographies about famous filmmakers to learn about the mind-set, creativity, and unique and fascinating conditions that formed their filmmaking viewpoints and helped them achieve their cinematic success.

viewpoint is immensely practical; he or she must work with what images and sounds are available, crafting the best film story possible.

Image and Sound Crew

The artists who create what you see and hear belong to many different professions: directors of photography, production designers, sound designers, camera and sound crew, visual effects designers and supervisors, animators, music composers and supervisors, and many others. Although their specific tasks and how they are executed vary, their overall agenda is uniform: to design, capture, and create the visual imagery and sound experience of the movie. Their viewpoint begins at the conception stage—What should this look and sound like?—and extends through the actual accomplishment of the look-and-sound vision, down to the finest details.

The Audience

The difference between this course and a media studies or film theory course is that we are guiding you to make movies that people will want to see. We believe that you are always making your movie for an audience, not for yourself. No matter what your role on the film, you must always think about the audience and how you are communicating with them: Will they understand what you are trying to say? Will they relate to the characters? Will the story make sense? In a professional production, the audience will watch the movie on screens across the world; for this class, your audience may be your instructor or your fellow students. The audience's viewpoint is the prevailing one in all filmmaking, and the audience's judgment is the ultimate arbiter of a film's success. Therefore, although your audience may have nothing specific to do with the physical production of your movie, they are included in this section to remind you that their viewpoint and emotional response are important things for you to evaluate while you are making your film— very possibly the most important.

Beyond the six key viewpoints, every film has certain limitations imposed by the context in which it is being made. For this course, your limitations will be set primarily by your instructor: you will have a deadline, and you may have to make your film in black and white or color, obey a time limit, use only certain equipment, or be limited on whom you are allowed to ask for help. Even at the movie-studio level there are restrictions, which frequently involve running time, rating, casting, release date, and budget. We'll call these limitations, collectively, **oversight**. At the same time, oversight provides you with guidance, expertise, and resources; without the benefit of your school, for example, you might not have the camera or lights with which to make your movie. The point of oversight is to set boundaries and allocate resources for any production within the context of those boundaries.

The Filmmaking Path

Whether you are accomplishing your class project in two days for no budget or spending two years and $200 million making a studio blockbuster, you will need to follow the same basic path in taking your initial idea from your brain to the

Tip WATCH LOTS OF MOVIES

Watch at least one classic film a week every month for the entire term of this class. (The American Film Institute publishes a list of the "100 Greatest American Films" at www.afi.com/100years/movies10 .aspx.) Watch with a critical eye, paying attention to the discipline or disciplines you are studying at the time: directing, cinematography, editing, production design, and so on. Take notes about the things that catch your eye, or tricks and techniques that you would like to emulate or at least learn more about. Why do you think these films have stood the test of time to be recognized as "classics"?

Practice
COMPARING VIEWPOINTS

As you read about the different viewpoints involved in filmmaking, some of them may have seemed familiar to you. That's because these viewpoints have analogies in other aspects of life. Have you directed a group of people? written a story? edited or commented on someone else's work? Certainly, you have sat in an audience and been impacted by moving images or live performances. Practice thinking about these filmmaking viewpoints by selecting one or two that you have experienced at some point in the recent past, and share, discuss, and compare those experiences in small groups.

Congratulations, You Are a Movie Producer!

If you glance at the table of contents, you will see there is no separate chapter on producing. Although we discuss many of the producer's managerial tasks throughout the book and in these Producer Smarts sections, we do not focus specifically on this one job alone. Why not? Our reasoning is that a producer needs to know about every aspect of filmmaking; thus, every chapter in this book is, to a degree, a producing chapter. At the end of the day, the producer bears final responsibility for all business and creative aspects of a movie. In this class, although you may not have anyone who is officially credited as a "producer," the functions that a producer handles must still get done, whether you are making a one-minute class assignment, a short film, or a full-length feature. Here are some basic considerations:

▌ Calculate your limitations. How long can the film be? What resources are available in terms of time, budget, equipment, actors, locations, costumes, and props?

▌ Plan the production carefully to achieve the best creative outcome by making sure that the script is in good shape, that everyone involved is properly suited for his or her role, and that there is a reasonable schedule.

▌ Manage the day-to-day, or minute-by-minute, operation of the shoot by making sure that everything—and everyone—is ready and that there is a list of priorities, so that if something needs to be cut or plans change, the movie will still work without it, and if something needs to be added, you will have a plan for how you are going to do it.

▌ Be a supportive friend in the editorial and finishing process by verifying that there are resources at hand and by being an adviser on creative decisions.

▌ Share the film with a representative sample of the audience as early as possible, to get an objective reaction, so that the director and editor still have time to improve it before the deadline.

▌ Make sure the film is screened under optimum conditions—in an appropriate setting and for the right audience.

▌ Support your team creatively and emotionally throughout the process.

printed page to a polished movie that an audience can watch and, if you did your job right, relate to. Logistics, details, and nuances will grow and shrink in importance during a project and from project to project depending on a host of factors (see Business Smarts: Taking Care of Business, p. 15), but this basic filmmaking process will be the key to getting you where you want to go.

This journey is the focus of this textbook—not only identifying the steps you need to take but also examining how you can logically go about taking them in a creative and meaningful way. Loosely speaking, the basic components of a movie include recording and combining for eventual display the following elements:

▌ Images, including the use and manipulation of light and darkness

▌ Movement

▌ Sound

How Do I . . .
Get My First Movie Made?

Go to LaunchPad and find out: **macmillanhighered.com/filmmaking**

NAME:	**Cherien Dabis**
TITLE:	Writer/director
SELECTED CREDITS:	Selected Credits: *May in the Summer* (also star, 2013); *Not Another Word* (short, 2013); *Amreeka* (2009); *Make a Wish* (short, 2009)

As you start down your own filmmaking path, it's helpful to hear the stories of some of those who have already taken the journey. At the beginning of this chapter, we told you about one of those people—Cherien Dabis—and the effort, time, and struggle she went through to complete and sell her feature film *Amreeka*. Dabis talks more about getting her first movie made in a video interview available only on the LaunchPad for *Filmmaking in Action*.

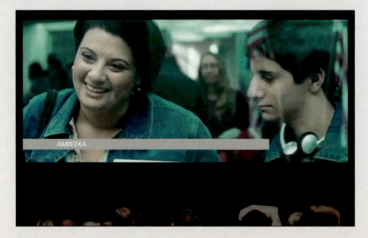

AMREEKA

Discover

▌ How Dabis struggled to figure out what her *Amreeka* story should be about

▌ How she went about finding a producer and funding

▌ What kind of industry resources and institutions she recommends for other first-time filmmakers

Visit the LaunchPad for *Filmmaking in Action* to learn more—and to explore how you might use this advice.

- Passage of time

- Sequences positioned in strategic order to tell the filmmaker's intended story

- Composition of the images with additional elements and manipulation to enhance emotion, create worlds, increase attention, please the senses, and improve continuity of the story[3]

As you have probably guessed, however, there is a lot more to it than these simple descriptions indicate, which is why we have broken down these lessons in the following ways, designed to direct you down this creative path. You will need to stop at various way stations along the road and plant your flag before you can move safely and effectively to your next milestone.

- **Concept and Preparation:** Part One represents the first stop in the journey. Once you've figured out what story you want to tell, you need to develop the idea, develop the characters and plot points, and transform it into a workable screenplay. After that, you need to learn the basic skills of directing and managing a production so that you can launch into *preproduction* and beyond, starting with the crucial phases of conceptualizing and designing the movie you want to make, and determining an action plan and budget of how you are going to make it.

- **Image and Sound:** The chapters in Part Two are designed to teach you the basic technical and creative skills you will need to launch the project into *production*, so that you can capture the images and sounds necessary to tell your story. Note that we use the word *necessary*—it will not be enough to simply

The Wolf of Wall Street (2013)

Training video

Promotional video

You might work in the film industry in any number of capacities throughout your career: on a major motion picture, training video, or promotional video, among other possibilities.

learn how to use a camera or sound recording system. You will need to learn to use those skills strategically to tell your story. That means developing a keen understanding of how to use your camera, lighting tools, and sound-capture tools to acquire the specific elements required for your story. We have broken the camera and lighting lessons into two chapters each—one to teach you basic technical skills, and the other to teach you basic creative skills. The last chapter of Part Two covers sound.

■ **Production Glue:** In Part Three, we examine the crucial *postproduction* process of editing, also in two chapters: the myriad of technical skills necessary to be a good editor and, more importantly, the many ways you can advance your storytelling agenda by creatively weaving together the elements you have filmed or otherwise created to make a seamless whole. In the modern digital-filmmaking world, postproduction processes involving visual effects and animation continue to grow in importance, adding new and improved ways for filmmakers to combine real and synthetic elements with image and sound capture, as well as the editing process. We examine many of these processes in the last chapter of the section.

■ **Filmmaking and Beyond:** Part Four centers on the fact that your filmmaking job is not done once your film has been edited. We explore options you might pursue to get your film in front of audiences so that you can establish that core relationship that makes your movie a success: the bond between your story and the audience watching it. To do this, you need a level of understanding of film marketing and distribution, as well as a look at the many resources available to you for learning more about filmmaking and the people, tools, skills, and career options within this unique industry—all topics we will leave you with before this course is finished.

On the subject of careers, it is worthwhile as you go through this course to understand that there are a myriad of potential career choices within the larger film industry, and only a small percentage of them directly involve making movies. There are commercials, music videos, corporate videos, training videos, web videos, interactive videos, video games, apps for mobile devices, and lots more to choose from. And within these areas, there are disciplines and subdisciplines and related and semirelated areas. In our concluding chapter, we offer additional insight on some of these areas and potential career choices, leaving out those categories that do not directly involve the physical act of making a film or video, such as food, transportation, safety, and accounting.

But whatever direction you choose to go in, having a solid overview of the entire filmmaking path can only help you. These are highly transferrable skills that can fit into various aspects of your life. Enjoy the journey that begins when you turn the first page on the path we have discussed. The cool thing about filmmaking is that you never know exactly what you will discover when you get to the end of the path—with one exception: whatever it is, it will be your own creation.

Tip START A LIBRARY

Start a film library—but don't just include films. Actively search for, analyze, learn from, and seek to be influenced by any form of moving-image media that impresses you: movies, television shows, commercials, music videos, web videos, industrial videos, animation, ride films, museum pieces, montages, and so on. Collect this material when you can, organize it into a library, and use your growing library as a tool to both inspire and teach you techniques or concepts as you launch your filmmaking career. You may find yourself turning back to this library to find inspiration when your creative process stalls.

Practice

WHAT MADE THE MOVIE?

What was the last film you saw? Using it as an example, select one particular aspect of the filmmaking work, such as editing, music, cinematography, costume design, or location choices. In a short paper, give your opinion on how this particular discipline contributed, or did not contribute, to the overall success of the film, and why. Later, after going through the specific chapter and corresponding lessons in class on that discipline, revisit your essay, and see if your views have either changed or evolved.

Taking Care of Business

As you dive into your film education, we will continually emphasize the joys of this creative form of expression. However, as previously noted, we will also be covering a host of managerial tasks. Now is a good time to take note of the fact that linked inexorably to these managerial tasks are various business-related issues that pertain to film productions of all sizes and shapes.

Even those business-related tasks that will not particularly impact your early student efforts are ones that, at some point in your film education, you will need to have a basic awareness about. If you move on to work in some capacity in the film industry, one or more of these issues could become central to your work. Therefore, periodically in this book we will address some of these business issues; explain why they are important; and discuss the fundamentals of what you need to know to make sure to protect yourself, your work, your crew, your equipment, and the environment in which you will be working.

For now, we want you to have a heads-up that this course is not only about your creative vision, making your masterpiece, and following your filmmaking dreams. That certainly can be the place you end up if you pursue your film education with the right mix of brains and passion, but the business side of this creative work needs your attention also. Indeed, one of the most important immediate challenges you will face as film students involves figuring out ways to separate and balance the creative and business sections of your brain so that both get proper attention and work in harmony to achieve the greater goal that lies before you: learning the fundamentals of filmmaking.

Filmmaker's Emergency Kit

- A good set of headphones. Speakers on a laptop or mobile device are not very good. To experience any movie well, you need to hear it in its full glory, and so you need quality headphones.

- Still cameras and audio and video recorders. Whether on your phone or separate devices, these allow you to record reference images and sounds wherever you go as you begin to develop student films.

- A subscription to a streaming service like Netflix or a DVD movie collection. "Classics" are classic for a reason; they contain a creative storehouse of filmmaking knowledge. The more you experience the vast creative library of movies, the better you will be as a filmmaker yourself, as you discover your own preferences.

- IMDB.com and other informational and movie websites. IMDB lists credits for almost every movie that has ever been released in the United States. Likewise, the-numbers.com or boxofficemojo.com provides box office performance information.

CHAPTER 1 ESSENTIALS

- Moving images and the modern digital technology and workflows used to create, combine, edit, and distribute such imagery make filmmaking the most liberating and open of all art forms. This offers you the opportunity to express your creativity in literally endless ways, learning skills and techniques that will benefit you in many fields, whether or not you end up in a filmmaking career.

- The foundational principles on which all filmmaking endeavors are based are collaboration, emphasizing story and character above all else, and developing an ability to problem-solve in multiple scenarios.

- There are six viewpoints that collectively bring a film story together. Those viewpoints involve the perspective of the producer, the writer, the director, the editor, the image and sound crew, and the audience, which must connect emotionally with the filmmaker's efforts to make the movie experience complete.

- All movies, no matter how simple or complex, must follow a basic filmmaking path on their way to completion. That path includes a process of designing, capturing, manipulating, editing, and finalizing images, sounds, and other elements, to tell a story that incorporates characters, the passage of time, conflict, and more in order to link a filmmaker's point of view with an audience's emotional response.

KEY TERMS

Director	Film	Producer
Editor	Oversight	Writer

CONCEPT AND PREPARATION

Where do you even start? A movie feels like such a big undertaking, an immense, creative machine with multiple moving parts—actors and dialogue, cameras and microphones, emotion and story, and so much more. If you tried to make a list of all the things needed to make a film, you'd quickly get overwhelmed.

Luckily, you don't need a list, because movies are not made in one gigantic sweep. Instead, they are crafted piece by piece, moment by moment; if you think of films as being like buildings, you could say they are built brick by brick.

In the next chapters, you'll learn the initial steps. Like a building, a film must start with a strong foundation, which, for filmmakers, is the script. Without a strong script, the movie can't be strong; it is always easiest and least costly to make sure things work on the page before you move to the stage. Scripts allow directors and designers to envision the film, scene by scene, character by character. As each collaborator joins the project, the movie begins to take shape. When you build a building there is a linear progression as to

how things are built. First, there is a foundation, followed by wood frames, plumbing, electrical, a roof, etc.

With the director's and designers' input, the script starts to turn from a document into physical reality. The creative team's combined vision becomes the basis for determining how the film will actually be planned, shot, edited, and completed. This is what a production manager schedules and budgets before the film gets the final go-ahead—the green light to go into production.

"The hardest part of any story is to figure out the point of entry where your story begins.**"**

– Robert Towne, screenwriter of more than thirty-five films, including *Chinatown* (1974), *The Firm* (1993), and *Mission: Impossible* (1996)

Start with the Script

Chinatown (1974)

KEY CONCEPTS

▐ Good movies start with good ideas, and there are many ways to discover good ideas.

▐ Theme, story, and character are the building blocks of film narratives.

▐ When writing a screenplay, you need to follow a specific standard.

▐ Revising your script many times is a normal and necessary part of the process.

When Robert Towne began writing *Chinatown*, considered by many experts to be among the most finely structured screenplays of all time, he thought about the theme that would resonate in every scene. The story would be about Los Angeles's history, water rights, corruption, and power. At first Towne considered writing a detective movie. However, as his creative process deepened, he realized that a detective movie wasn't enough; he wanted to explore the theme of what crime really means. He would have his characters discover how land and community are destroyed as they encounter the disturbing, transgressive reality of modern cities springing into being.

He resolved to write a film far larger than a mere detective story, even though a detective would be its main character. Towne composed more than twenty outlines, each with thick, scene-by-scene descriptions. This gave him a view of most of the story. Then he scribbled one-sentence summaries of each scene on sheets of paper, so that he could cut them up and paste them on the door of the study where he and the director were working. They rearranged the scraps of paper over and over until they arrived at an order that worked. Towne then began crafting the scenes, fleshing out the characters and their actions through dialogue and dramatic moments.

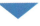

Towne had turned down a lucrative studio job to write *Chinatown*; Paramount had offered him $175,000 to pen an adaptation of *The Great Gatsby*. Instead, Towne chose his passion project and grappled with the script for 10 months. He was rewarded when *Chinatown* won the Academy Award for Best Original Screenplay.

Towne's experience in writing *Chinatown* is a model for writing any film, big or small: build your idea; decide on your themes and characters; organize the structure; and work, work, work. The written word is the first road map for all successful movies, from 2-minute classroom projects to 15-minute thesis films, from 30-second commercials to epic-length features. Even documentaries begin with a written description of their subject matter. Completely visual films, including silent and animated movies, also begin with words.

Words are a way of describing your vision for the project, and they help make sure you and your collaborators are literally on the same page. Words are also the most cost effective way to test your storytelling and visual ideas, because it is always better to test your filmic imagination in a document, to make sure it is what you want and communicates that vision to others, before you start spending time and resources actively producing the movie.

In this chapter, you'll explore where stories come from, how to imagine characters, and the formats that work best to convey your ideas for the screen. You'll also discover the way scripts are refined until they are ready to be shot, a process that's called *development*. You'll learn how to do all this for your class project, which resembles the way many smaller, independent films are made, and also how writing operates in larger studio movies. No matter what scale you are working at, whether in school or on a Hollywood lot, good writing starts with a character the audience can identify with. As you begin, a blank canvas awaits your imagination; you are about to describe the movie you want to make. The suspense builds, and you ask yourself, What will happen next?

Where Do Ideas Come From?

An idea for a movie is more than just a thought: it must have at least one character, a conflict, and some kind of story. Like all narratives, movies have three elements: the teller of the tale, the tale itself, and the audience to whom the tale is told; in many ways, the audience is the real center of attention.

It's a good idea to begin by thinking about your audience, and yourself in relation to them. Who are you making the movie for—your class, people at your school, or perhaps a wider audience? Who are these people, and what will they enjoy? This isn't so much a matter of pandering to the audience, or putting your own deep passions on hold for the short-term gain of making something that will get a good grade or "sell," but acknowledging a fundamental principle of the entertainment enterprise: the word *entertainment* comes from the same word as *intertwine*, which means that bringing people together is a core value in what you are attempting. You must tell a story worth sharing, and care deeply about satisfying the people with whom you are sharing it.

There are two categories of ideas: those that come entirely from you, which are called original ideas, and those that are inspired by material you discover. Both are fertile ground for compelling movies.

Original Ideas

If you think of an idea for a movie yourself, it is called an **original idea**. That means it originated with you. This original idea can become the basis for all kinds of projects: movies, television shows, graphic novels, short videos, interactive

games, books, and plays. An idea is just the beginning of something; how you choose to extend it creatively is based on your particular talents and your audience, what you are trying to communicate, and the medium that best suits the idea itself. In the case of your class project, you will be seeking a story that can be well told as a film, which means it should have strong characters, contain compelling visual elements, and be able to be told in a relatively few number of minutes.

As you come up with original ideas that you think may have screenplay potential, however, make sure you pause and take note of the difference between having an original idea for a story and how you specifically express the idea with your screenplay. As we will discuss later in this chapter, you will need to register and copyright your screenplays to protect them from being copied or stolen. But the raw conceptual idea itself, in most cases, is not what you will be trying to protect as much as the specific way in which you have expressed it with your story. For example, anyone is free to try and write a story about a historical event like the Iran hostage crisis or a mythical figure such as Hercules. But if your specific story comes anywhere close to the form or structure or characters, dialogue, or nature of the specific story owned by the studios that released *Argo* in 2012 or the *Hercules* action-adventure film of 2014, you may likely find yourself facing a lawsuit you would just as soon avoid. While it is not our place or purpose to give legal advice in this book, it is important that you be aware of this distinction.

The best original stories come from your own awareness—the people, relationships, and actions you have observed, lived, and taken. You need life experiences, sometimes deeply personal and emotional ones, to understand the story you want to tell and to be able to express it well. This doesn't mean you have to live everything in order to write about it: no screenwriter has ever lived in Renaissance England, but there are many movies that take place there. However, to write effectively about anything, you need to understand the human emotions and motivations of the characters, which means you need to be sensitive to your own life story and emotional responses.

Coming up with original ideas can seem difficult, and you will probably consider and reject several of them before settling on one that merits the time and effort you'll spend on your class film. There are many ways to explore movie stories—try some of the techniques in Action Steps: Brainstorming Ideas on p. 22.

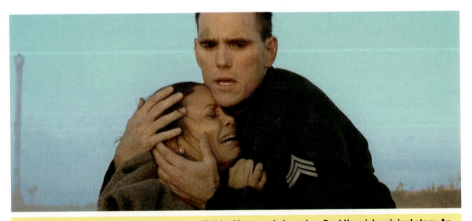

Crash (2004), screenplay by Paul Haggis and Bobby Moresco, is based on Paul Haggis's original story. An unconventional film made outside the studio system, *Crash* won Academy Awards for Best Picture, Best Original Screenplay, and Best Editing.

Beginning with an original idea has several advantages. The first is that you are not relying on another person's work. You do not need to contact anybody to get permission to use an idea that is yours. (In any event, it would be unethical—and illegal—to use someone else's work and base your movie on it, unless the original author has given you permission.)

Another attribute of an original idea is that it can bring something new to the screen and be more fun for the audience. You have probably experienced movies that feel overly familiar, like a copy of something else. Audiences are bored with derivative work. They want and deserve something fresh, and they're looking to you to provide it for them. Even if your theme or setting is familiar, your actual plot and characters can bring a fresh take to that theme.

ACTION STEPS

Brainstorming Ideas

Sometimes it seems as though our minds are just filled with ideas—until we need to come up with one for a class project! Here are five effective ways to break through the brainstorming barrier.

1. **Create a mind map.** A movie-idea mind map is a diagram that begins with a character, incident, or place at the center, and then marks everything that comes off of it, like the spokes of a wheel. Each spoke can generate its own spokes as well. This puts your thoughts on paper, so you can look at it and discover the most valuable nuggets.

2. **Use the 10-minute trick.** It doesn't seem daunting if you don't have to do it for very long. Set your alarm for 10 minutes and write down as many movie ideas as you can in this short burst of time. You'll be amazed by how many you will come up with!

3. **Remember your best stories.** Is there a story you find yourself telling over and over because it's always funny or interesting or emotional? That story could be the basis for your class film; the fact that you tell it often means you probably already have a structure for the narrative.

4. **Keep a journal.** Always have a place to jot down thoughts as they come to you, and record at least one notable experience or character you meet every day. If you begin your journal now, at the beginning of the term, it will be filled with ideas by the time you need to select your project idea.

5. **Do it with friends.** Set a specific time (and a time limit, usually 30–60 minutes) to talk about ideas for a particular character or incident with your classmates. During the session, resist the urge to critique contributions in order to encourage creative flow, free from judgment or negativity. Make sure someone in the group makes an audio recording of what is said, as written notes can be incomplete and memories are not often accurate.

Source Material

If you base your film story on something that someone else has created, then it is called an **adapted screenplay**, and the place where the story came from is called **source material**. Source material can take many forms. It could be a graphic novel

like *300* by Frank Miller; a comic book like *Spider-Man*; a work of literary fiction like *Winter's Bone*, *Slumdog Millionaire*, or the *Lord of the Rings* trilogy; a nonfiction history like *Band of Brothers*; a television show like *Star Trek* or *The A-Team*; or even another movie, like *The Ring*, which was adapted from a Japanese horror film. Source material can also come from newspaper or magazine articles; for example, *The Soloist* (2009) had its origin in a series of articles published in the *Los Angeles Times*.

Screenplays adapted from source material are among the most honored films in Oscar history. This is likely because the source material has already created the characters and the world in which the story takes place, endowing them with a multitude of interesting details, which makes the writer's job different if not easier. Even when a story is based on historical events, the screenwriter may be asked to adapt the work from a written history, because a book can bring together a great deal of research as well as a point of view on the material. Such was the case with the film *Captain Phillips* (2013), which was a true story with a screenplay based on an autobiographical book.

Adaptation, though, can be a tricky challenge for a writer. Books and interactive games—two popular sources for film adaptations—can take 40 hours or more to read or play to the end. How, then, to compact all that narrative into a feature film of two hours, or even a shorter movie? Obviously, in an adaptation, much material will need to be cut, but time constraints are only the most obvious of adaptation's challenges. The most fundamental difference between film and these other sources is that film storytelling inherently appears more *objective*, whereas novels and games are more *subjective*. In a novel or game, the reader or player can get inside the conscious experience of the main character—hear his or her thoughts and feel the interior monologue. In a film—even a film that has first-person voice-over narration—the main character is objectified because the audience sees him or her as an object of study.

A good example of this difference can be found in the novel *Push* by Sapphire and the film *Precious* (2009), adapted from it. The novel is written in the first person, in the voice of Clarice "Precious" Jones, an obese, 16-year-old African American girl who is pregnant with her second child. Although she is barely literate, Precious manages to convey her story, and the reader comes to know and empathize with her completely relatable desire to live her life with freedom, safety, and

Tom Hanks, as Captain Richard Phillips, faces off against the Somali pirate Muse, played by Barkhad Abdi, in *Captain Phillips* (2013). Billy Ray adapted the screenplay from Richard Phillips and Stephan Talty's autobiographical book, *A Captain's Duty: Somali Pirates, Navy SEALs, and Dangerous Days at Sea*.

Precious, portrayed by Gabourey Sidibe, dances with flair in her first fantasy sequence in _Precious_ (2009).

dignity, and to better herself against tragic odds. Of course, one of the literary tricks of the novel is that we never see Precious. Told in the first person and lacking images, readers are able to create their own mental image of what Precious looks like and make her relatable to their own experiences and viewpoints.

In the movie version, the filmmakers had to cast an actress in the lead role, creating a real image of Precious that wasn't available in the book. The challenge, then, was how to reconcile how the external world views Precious with her own internal life as described in the book. To allow viewers into Precious's head, screenwriter Geoffrey Fletcher invented fantasy sequences, providing a visual understanding for how Precious sees herself—graceful, beautiful, and empowered. The film screened at multiple festivals, did well at the box office, and won the Academy Award for Best Adapted Screenplay. Sometimes the key to adaptation is taking a completely unique creative approach—one not found in the original material.

Intellectual Property

When dealing with any kind of adaptation, you must make sure you have the original creator's permission to adapt the underlying work. That's because all creative works are **intellectual property**—a legal term that means that creative works can be owned in the same way you can own a camera or a mobile phone. When you write a script in a professional setting, it is a best practice to make sure you can prove it is yours and when you wrote it, in the event someone later *plagiarizes*, or steals, your work. In the entertainment industry, this is done by either copyrighting your work or registering it with the Writers Guild of America, which is the professional organization for screenwriters, or both. (You don't need to be a member to register your work.)

Although it is important to protect yourself against plagiarism, it's also important to understand the concept of plagiarism. In order to prove plagiarism, you must prove that the offender had *access* to your work, which is why you must keep careful records about who has access to your material. Otherwise, it is quite possible that someone else came up with the same idea or story as you; indeed,

many stories have strong similarities even though they were not stolen from someone else, especially adapted screenplays that often rely on different source material to tell the same story. All writers are describing versions of the same basic reality, so it is no surprise that stories often have common elements, albeit expressed differently.

Rights and Title Just as you should care about protecting what is yours, other people will care about protecting what is theirs. For example, if you want to base your class film on a story someone else wrote, you need to ask permission. If you get permission, it is called a **grant of rights**. Any grant of rights should be written down and signed by both parties because memories are imperfect and friendships can easily fray. This is not a needless complication; in the Hollywood landscape, studios have spent millions of dollars to acquire rights to big franchise characters like Superman and the X-Men, and some rights holders have similarly spent millions of dollars going to court when they thought their rights were being infringed. In today's digital world this can apply to almost anything, even a landmark building, whose owners vigilantly will assert their rights to those iconic or trademarked images.

Because of digital distribution technologies, it is important to have all rights in a project in order to make a film—and in order to secure financing for the movie. "All rights" means everything: the right to make a movie, a television series, a series of books, interactive games, webisodes, and anything else. In fact, the legal language in rights contracts often contains a phrase that says the rights include "all rights now known or hereafter contemplated, for dissemination in all forms, on all devices, and in all media now known or hereafter devised, on Earth and throughout the Universe." No one can say the movie business doesn't think highly of itself!

When there is a clear link between the source material and works that derive from it, this is called the legal **chain of title**. "Title" simply means the right to do the work. For example, if you write a script, you own the title to it. If you give a director permission to make a movie of your script, you must also give the director title to make the movie, which is best done in a written document. Imagine a chain with many links, and you want to make sure the chain does not have any "broken links," or places where there is not a continuous flow of rights from one

Tip **REGISTER AND PROTECT**

You can protect your ideas, and prove that they originated with you, by registering them with the U.S. Copyright Office (www .copyright.gov) or with the Writers Guild of America (www.wga.org).

Man of Steel, **Warner Bros.'s 2013 continuation of the Superman franchise, was subject to lengthy legal battles over rights. The courts decided in favor of the studio only eight weeks before the film opened. Studios spend tens of millions of dollars to acquire rights to well-known franchise characters—and millions more defending their rights in court.**

party to another; this is chain of title in action. Chain of title emphasizes that the act of writing is in fact the act of creating intellectual property—property that is real, needs to be protected, and has legal status.

Fair Use Although you need to be cautious about using others' work, at times it is possible to do so under a legal doctrine called **fair use**. Fair use, which is actually written into U.S copyright law, means that you can use parts of other works in certain ways. For example, it is generally safe to do a parody or satire of another work—you can usually do a parody of a Hollywood movie as long as it is clear you are doing a parody.

It is also fair to quote short passages from other works when you are critiquing or commenting on them. Here's a fair quote: "The distinction between what is fair use and what is infringement in a particular case will not always be clear or easily defined. There is no specific number of words, lines, or notes that may safely be taken without permission." Here's the comment: That quote is from the U.S. Copyright Office's documents, and we're using it fairly. But the quote itself underlines the fact that the standards for fair use are hazy and vague, and may be applied on a case-by-case basis.

You or your friends may have had experiences in which you uploaded a video to YouTube only to have it taken down because it contained copyrighted music. It may seem fair to use the music, and maybe you only used it for a few seconds, but if the copyright holder complains, YouTube will take it down.

What are the best ways to deal with the uncertainties of fair use?

▌ Request and obtain written permission if you can.

▌ Learn your school's policy on fair use.

▌ Ask your teacher how the situation is usually handled in this class.

Ⓟractice

COMPARING AN ADAPTATION

Choose a film that has been nominated for Best Adapted Screenplay. (You can find the most recent nominees at oscar.go.com/nominees.) Familiarize yourself with the source material, then compare it to the film. Find five things the filmmakers changed when adapting the source material into a movie. What do you think about the changes? Would you have done anything differently?

Theme, Story, and Character

Effective movies command the audience's attention, compelling them to sit up in their seats and *want* to watch. That's because the best films view story and character with a thematic perspective, just as Robert Towne, in writing *Chinatown*, committed to an exploration of what crime means, not just a simple detective story.

How can you elevate your project to this level? Ask yourself why the movie exists—that is, what larger question is it trying to answer? Your response will reveal your film's **theme**: the big-picture thesis that illuminates something about the human condition and provides a universal take-away for the audience. A theme can be a statement or even a question.

Here are some examples of themes:

▌ Love conquers all.

▌ Is it possible to be a just person in an unjust world?

▌ Friendship matters more than money.

Themes sometimes sound trite, but you will find that all great movies have them.

As you consider your theme, make note of the amount of time you'll have to tell your story. Your class project may be two to five minutes. Theatrical films generally run about two hours. Television series on advertising-supported networks are 44 minutes for a one-hour episode and 22 minutes for a 30-minute episode after the time for commercials is deducted. YouTube's maximum upload is 11 hours, but users will often click away from a video in a few seconds if it doesn't capture and hold their interest.

Capturing audience interest from the first frame and holding it until the last is what will make a film entertaining, and the most effective way to accomplish this in such a highly focused medium is by telling the story of specific characters in a well-constructed *structure*.

"It's about Someone Who..."

When a woman, who has obsessively dedicated herself to the art of ballet, gets the chance of a lifetime to star in Swan Lake, *she has to confront her inner demons . . .*

After two teenage kids, being raised by their lesbian moms, discover who their sperm-donor father is, they decide to arrange a meeting . . .

Batman must emerge from a self-imposed exile to confront a masked terrorist bent on taking over Gotham City . . .

All great films start with a character the audience can identify with, then present that character with a challenge or problem; these are the two factors that merit audience interest and can make a film entertaining. A character is the main person the story is about—or the main thing, as in the case of an animated movie like *Wall-E* (2008). The main character does not have to be likable—in the film *Captain Phillips* (2013), for example, the main character is gruff and abrasive—but must be someone the audience can relate to or, in other words, must be someone the audience will want to spend some time with.

A one-sentence description of the movie's story is called a **log line**. The preceding examples are log lines for, respectively, *Black Swan*, *The Kids Are All Right*, and *The Dark Knight Rises*. Log lines are used as shorthand in the entertainment industry to identify projects, and they closely mimic the way audiences will talk about a film. Ideally, a log line would be very similar to what you would tell a friend if the friend asked you, "What's that movie about?" In the preceding examples, the log lines describe the main characters and what they will encounter in less than 30 words. Let's pick them apart to see the four key aspects of a successful log line and film story.

1. The main characters: a woman; two teenage kids; Batman

2. The characters' context, or situation they find themselves in as the story begins: obsessively dedicated to the art of ballet; being raised by their lesbian moms; emerging from self-imposed exile

3. What triggers the story, also called the **inciting incident**: gets the chance of a lifetime to star in *Swan Lake*; discover who their sperm-donor father is; to confront a masked terrorist

4. What's going to happen: has to confront her inner demons; decide to arrange a meeting; protect Gotham City

The log line will be used to summarize your project if you enter it into competitions or film festivals, as the SEO (search engine optimization) description if you post it online, and to attract investors if one day you seek financing for it. You will also see log lines as the short descriptions of movies on services like Netflix, iTunes, and Hulu. If you can't boil your movie down to an efficient log line that accomplishes the four key elements, you probably need to do some more work crafting your story and thinking about your characters before you start writing.

Structure

Because a film is a highly concentrated experience—a distillation of a story's key moments—storytelling *structure* plays a crucial role. **Structure**, when used to describe a story, means the order in which the story is told, or the way the scenes are set next to each other to form a coherent whole.

A. *Black Swan* (2010)

B. *The Kids Are All Right* (2010)

C. *The Dark Knight Rises* (2012)

Structure is important for all films—especially short student films, in which following a formal storytelling structure often means the difference between an emotional and riveting experience and one that is boring and easily dismissed.

The most frequently used structure in filmmaking is the three-act structure. The three-act structure is not a rule, and of course many dramatists have not followed it. Ancient Greek dramas have only one act. Shakespeare wrote his plays with five acts. But all successful stories, whether they are formally broken up into three acts or not, have the basic attributes of the three-act structure, which roughly translates into beginning, middle, and end. This is a fundamental necessity for class film projects, too.

The beginning, or setup, of your movie should introduce the main character, or **protagonist**, and the challenge or crisis he or she will face in order to achieve some specified goal or objective. Often the challenge is personified in another character, called the **antagonist**.

In the middle, the main character needs to engage in one or more actions that confront the antagonist and move in the direction of the goal. In a well-structured story, each action is more important and has higher stakes than the one before, but the main character doesn't achieve the goal yet; in fact, at the end of the middle, or second act, it often looks as if the antagonist will prevail.

In the third act, the main character must confront the greatest challenge; vanquish the antagonist once and for all (unless you are planning a sequel); and, in so doing, achieve the goal that was described in act one. Often the resolution in act three occurs because the protagonist realizes that he or she no longer wants what seemed so important in the first act; this movement in a character's desires or values is sometimes called the **character arc**. An example might be a story in which the protagonist wants fame and fortune in the first act, only to discover, in the third act, that love is what matters.

The third act carries a special burden: it is the key ingredient to a commercially successful film. Marketing research has shown that the last act of a movie is what audiences remember most, and if those final minutes fulfill the audience's expectations, they will have an overall positive impression of the movie. Of course, this doesn't mean that the film must finish with a happy ending, and that all issues must be resolved and "tied up with a bow," because life isn't like that; creatively and commercially successful films, however, conclude at a place of satisfying resolution and closure. This is often referred to as "what happens in the last reel"—a reference to the fact that movies literally used to be transported on separate film reels. Legendary film executive Louis B. Mayer, one of the founders of MGM studio, reportedly said, "There are only two things that are important in a movie—the first reel and the last reel. And the first reel doesn't matter so much."

The three-act structure closely follows the form of the hero's journey described by mythologist and storyteller Joseph Campbell in his classic book *The Hero with a Thousand Faces.* In the hero's journey, he is often reluctantly called to take action to protect a kingdom or the entire world in the first act. When the hero begins his adventure, which is the beginning of the second act, he is involved in a series of battles, quests, or self-discoveries. At his lowest point, the hero suffers a crushing defeat and is killed either in fact or metaphorically, but his spirit rallies and he is resurrected (in the third act); he engages in a final battle with the antagonist and returns home with the world or the kingdom restored or rectified.

A typical feature-film screenplay is 120 pages long. The first act is in the first 30 pages, the second act is pages 31–90, and the third act is the last 30 pages. As

Tip HOW TO START A LOG LINE

It's especially effective to begin a log line with "When," "After," or "During." These words lend a feeling of action.

Tip THIRD-ACT PROBLEMS ARE FIRST-ACT PROBLEMS

If you have trouble figuring out the third act, it's probably because the first act isn't right yet. Go back to the first act and make sure you have spent enough time giving detail to characters and establishing the primary conflicts.

FILMMAKING

Three-act structure

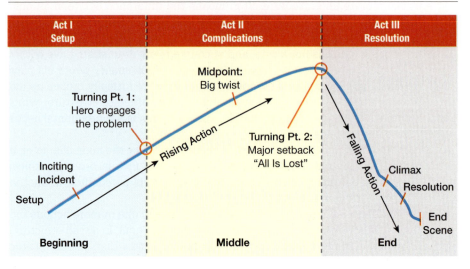

you can see, the second act is the longest, and successful screenwriters often break the second act down into smaller sections to keep it manageable and exciting.

A five-minute student film might have a five-page script; the middle two to three pages will be the second act, and the first and last pages will be the first and third acts, respectively. In this compressed format, there is less time to flesh out complexities of theme, character, and plot. You will need to find efficient visual mechanisms to convey key information to the audience, and you should try to keep the plot simple and direct. In storytelling terms, short films most closely resemble the literary form of the short story, which announce their theme, quickly set up character and situation, and often rely on a plot twist or significant character transformation in the last paragraphs.

Although the three-act structure is a useful tool, and certainly a concept all screenwriters should be familiar with, it is by no means a strict requirement of good writing. For every writer who follows the three-act structure, there is another who passionately protests its programmatic efficiency, its substitution of creativity with formula, and its tendency for making movies predictable. Like most tools, it is best to think of the three-act structure as a valuable guide or starting point that can also be discarded when the demands of character and storytelling take over. In fact, in the best stories, the structure seems to take care of itself. (See Action Steps: How to Avoid Writing a *Bad* Student Film, below.)

ACTION STEPS

How to Avoid Writing a *Bad* Student Film

Some people say, "There are three kinds of student films: long, too long, and way too long." That's your first tip: be concise. The most successful student films embrace their brevity and do not overstay their welcome.

Here are six more tips you can use as you are crafting your screenplay to avoid making a bad student film:

❶ **Don't tell a conventional love story, especially if it's about your recent breakup.** We've seen it before. If you're going to make a love story, make it *different*!

❷ **Don't try to string together disconnected incidents or to tell a "slice of life" story—because those aren't stories.** A story has scenes that build on each other and move forward as the characters seek to achieve their goals.

❸ **Don't strive for natural-sounding dialogue.** Great movie dialogue is made up of heightened and concentrated speech. Quentin Tarantino's films are a good example.

❹ **Start each scene as late as possible, and get out of it as soon as possible.** Begin in the middle of the action, eliminate the fluff, and end with the audience wanting to know what happens in the next scene.

❺ **Lose the music montages and dream sequences.** You won't have time for an effective montage in a short film, and dream sequences are overused. Concentrate on what the characters want, and show it in dialogue and action.

❻ **Don't choose a story about making a movie, trying to make a movie, or otherwise trying to express yourself as an artist.** You are expressing yourself as an artist by making your movie—now go tell a great story.

Practice

WRITING LOG LINES

Log lines are notoriously difficult to write and perfect. The key is *not* to tell the movie's story. Instead, you need to do the following:

▌ Engage the listener

▌ Introduce the main character or characters and where the story takes place (also when the story takes place if not present day)

▌ Tell what the big problem is going to be

▌ Make it interesting—leave the listener curious about what happens next (Question: "And then what?" Answer: "You've gotta see the movie to find out!")

Try writing log lines for three movies you've seen, plus for three original ideas.

Writing and Screenplay Formats

It is an irony—comic or tragic, depending on your point of view—that almost all writers dislike writing. They like "having written"—but writing is often compared to purgatory. In fact, writers are well-known procrastinators, and they will do almost anything to avoid the act of putting words on the page. This is especially true in the film world, because writing is the loneliest profession in the industry. Every other filmmaking craft has strong elements of teamwork and collaboration, whereas the craft of writing is solitary. Many successful screenwriters work in teams, or have groups of other writers who form a core support group, in an effort to ameliorate this inherent dilemma. You may be able to work with a writing partner in your class, but even if not, you can still cheer one another on as you work your way through the writing process.

Writer's block is a common term used to describe the difficulty of writing. Writers confront the blank page in different ways. Techniques include keeping a strict schedule of "writing hours" or requiring oneself to produce a certain number of pages each day. In addition, many writers develop a highly ritualized set of activities that allow them to get their writing to flow, whereas others adopt more prosaic approaches. More often than not, the best course is simply to jump in and start writing. A writer's draft is a purely personal experience until he or she chooses to share it with a reader—a thought that need not be foremost in anyone's mind when the writing process begins. Once a writer has produced a first draft, it is much easier to revise and turn it into a workable draft.

Tip SAY IT OUT LOUD

If something important happens in the action, refer to it in dialogue as well. That way, people who only read the dialogue will know what's going on.

Each project has its own rhythms and writing requirements, which affect the writing process. Refer back to the number of pages in each act. Next time you watch a feature film, take a brief look at the time when you think each act ends. You will be surprised to see that the first act ends at about one half-hour into the film and the second act ends at about an hour and a half in to the film.

Always remember that writing is a craft that improves with practice and can be taught and studied. (See Action Steps: How to Get Started Writing Your Script, below.) Though the "right" way to write is the way that works best for you, screenwriters over the years have developed a conventional formatting style that best expresses characters, dialogue, action, and visual descriptions. Because scripts are not ends in themselves—rather, they are like the architect's drawings that describe a building—these formal conventions help readers visualize what the writer imagines.

Most screenwriters use free specialized writing software called Celtx, a free online program called Scripped, or Final Draft, which has a cost. These and other programs come with templates that automatically format for movies, television, animation, and other presentation requirements. However, since movies are a visual medium, and a good rule of writing is "show, don't tell," let's illustrate what the screenplay form looks like.

Tip SCREENPLAY TIMING

One page of a screenplay = one minute of screen time

Practice

SCREENPLAY FORM

Watch a brief scene from a movie, and transcribe it using screenplay format. Notice what you put in dialogue and what you describe in action, setting, and so on.

ACTION STEPS

How to Get Started Writing Your Script

Before you start writing scenes and dialogue, try these five action steps. They will help you stay focused and ensure that your first draft is a good starting place for further development.

1 **Pick a title.** You can always change it later, but having a title will make your movie feel more concrete.

2 **Decide on your theme, and write it down.** This will become your touchstone; every scene should relate to the theme, and if you're ever confused about what should happen next, or what a character should say, the theme will give you inspiration.

3 **Write your log line.** This will also focus you. If you have trouble writing the log line, take the time to make it clear and workable before you start to write.

4 **Write the outline.** Some writers like to make a graphic illustration of the story, with large boxes for each act, and smaller boxes for each scene. Others like to make bullet points or notes. But no matter where you begin with the outline, complete it with a formal outline document, listing each scene, who is in it, and what happens.

5 **Look at the outline to see if the structure works.** Reorder the scenes if necessary.

Now you're ready to start writing the script!

FADE IN:

A script typically starts with these words: FADE IN.
Scripts are always written in 12-point Courier font,
single-spaced. Margins are 1.5 inches on the left (to allow
for 3-hole punching) and 1 inch on the right. Start with
where we are:

EXT. LOCATION—NIGHT

That's called a "slug line." It is followed by a
description of the location. EXT. means exterior. If it
is an interior location, you would write INT. You always
specify the time of day (NIGHT, DAY, EVENING, SUNRISE).
These cues are important for the other departments in
creating the look and feel you envision for the scene.

Descriptive actions are always separated with a double
line space. There should rarely be more than two or three
sentences in each paragraph, and each paragraph should only
contain one descriptive idea.

Descriptions should be brief and direct. Write what you
want the audience to see. Don't go into long, descriptive
details—readers tend to skip over long descriptive sections
like this one.

Each time you introduce a new CHARACTER, put the
character's name in capital letters, followed by a brief
description, such as ANNIE, a stunning brunette, running
with her briefcase under her arm, trying to avoid SIMPSON
(rakish, 30s), another pedestrian.

 ANNIE
 When a character has dialogue,
 the character's name is
 indented 3.5 inches from the
 left. Dialogue is 35 characters
 wide (3.5 inches in 12-point
 Courier font), indented 2.5
 inches from the left, and left
 justified.

 SIMPSON
 (if there is action
 accompanying the dialogue,
 it is indented 3 inches from
 the left and is enclosed in
 parentheses)
 And this is where the dialogue
 goes again.

Continued

 ANNIE
 Always refer to characters by
 the same name throughout the
 script.
 (if there is action in the
 middle of a character's
 dialogue, it goes here.)
 And then the dialogue resumes.

An action that follows the last line of dialogue in a scene
is called putting a "button" on the scene. It gives the
reader a sense of closure.

INT. LOCATION #2—DAY

Describe the new location.

Please note that you did not write CUT TO before the new
scene. Cuts are always assumed and should not be written
because they clutter the reading experience.

 ANNIE
 Now the characters talk again.

 SIMPSON
 Most of a screenplay's work is
 done in the dialogue.

 ANNIE
 The little, uh, natural kinds
 of things people say give away
 character.

 SIMPSON
 (waving his fingers in the
 air)
 Like in the theater!

 ANNIE
 (pushing his fingers away)
 Thank you, Mr. Wikipedia.

 SIMPSON
 But there's another reason most
 of a screenplay's work is done
 in the dialogue.

 ANNIE
 Why's that?

 SIMPSON
 It's easier to read. See how
 your eyes glide right down the
 page?

```
                    ANNIE
          Yeah, it's not blocky and dense
          like all those description
          paragraphs up there.

                    SIMPSON
          Not to mention that many people
          who read scripts—

                    ANNIE
              (interrupting)
          Be nice ...

                    SIMPSON
          —are generally lazy and skip
          the descriptive paragraphs
          anyway!
              (smiles)
          Nice? No. True? Yes.

                                   DISSOLVE TO:
```

INT. SIMPSON'S BRAIN—GRAY AND MURKY—BUBBLING NOISES

Lightning sparks between the neurons! See how a screenplay can take you anywhere?

"Dissolve To:" is a transition line. It is indented 6.5 inches.

When you have reached the end of your screenplay, you write these words, also indented 6.5 inches:

```
                                   FADE OUT.
```

FILMMAKING

Tip **LOOK FOR WHITE SPACE**

After you have finished your draft, look at it on page view. If you don't see a lot of white space, you have overwritten. Often times a writer may add white space to emphasize a key moment in the screenplay.

Development

It's extremely rare for a first-draft screenplay to be ready to shoot; in fact, in your authors' collective careers, which span hundreds of movies, it has happened exactly once, and even then, the writer did revisions to attract casting and to customize the script to budget and location demands. Rather, scripts are written and rewritten, with input from constructive readers, directors, actors, and producers; this process is called **development**. The purpose of development is to refine the script so that it represents as precisely as possible the plan for shooting; even with a class project, good script development is the most essential element for ensuring a good movie.

Developing Your Script

There are three great reasons to develop your script through several revisions to get it as polished as possible and to take development seriously. First, even though writing is hard, it requires far fewer resources than does shooting or editing. It is much cheaper—actually free!—to revise a page than to reshoot a scene.

Second, a bad script never makes a good movie. Most films that fall short of excellence do so because their scripts were not good enough in the first place and did not go through sufficient independent scrutiny and feedback. Therefore, even if you are working on a project for yourself to direct (and produce and star in and write the songs for), you need to create a process for personal development to make your screenplay excellent. Such a process involves trusted friends and advisers who have experience reading scripts and commenting on them, who can be encouraging and give honest feedback, and who can be relied on to tell you the truth even when it is painful. Good writers are always helped by sensitive readers' responses, and all writing involves rewriting. (See How Do I . . . Respond to Script Notes?, p. 37.)

The third reason development needs to be taken seriously is because it involves business matters and intellectual property rights. Unfortunately, many first-time writers agree to work with writing partners, independent producers, and independent companies without a clear understanding of the business aspects of these relationships. In these instances, friendships are frequently damaged and projects, on the verge of getting made, get stopped dead in their tracks because of disputes over rights, ownership, and payment. It is *always* a good idea to have a written agreement about your project if you are working with anyone else, even if there is no money initially changing hands—and even if it is just for a class project and you memorialize your agreement by exchanging emails. For some of the elements typically found in a writer's contract, see Business Smarts: A Writer's Contract on page 38. Remember: a verbal agreement is worth as much as the paper it is written on!

The Studio Development Cycle

Film studios have a much more formal and rigorous development process than you'll follow in class—a process that not only offers some perspective on what happens when millions of dollars are at stake, but also expands on why intellectual property rights, which you learned about earlier, are so important. Studios begin with a legal process of getting rights. Often, they will purchase, or **option**, the intellectual property rights in a given work (screenplays written independently, video games, or any other kind of intellectual property), which means the

How Do I ...
Respond to Script Notes?

Go to LaunchPad and find out: **macmillanhighered.com/filmmaking**

NAME:	**Julia Camara**
TITLE:	Screenwriter
SELECTED CREDITS:	*Unsolved* (short, also director, 2014); *Open Road* (2013); *House Cleaning* (short, also director, 2012); *Area Q* (2011)

Writing a script is a lot like weaving a quilt—you need to merge different threads together, including characters, emotions, plot points, setting, time period, action, and dialogue. There is no single way to get this done, but students and professionals alike need meaningful input to determine how their scripts can be improved. As a writer-director and graduate of a professional screenwriting program, Julia Camara has a lot of perspective on how to absorb notes into her work, which she shares in a video interview available only on the LaunchPad for *Filmmaking in Action*.

Discover:
- When it is OK to be defensive while receiving criticism—and when to listen
- How Camara suggests "maneuvering through" a difficult notes process
- How script notes ultimately helped her projects

Visit the LaunchPad for *Filmmaking in Action* to learn more—and to explore how you might use this advice.

A Writer's Contract

If you're going to write for or with someone else, you need to have a contract—a written legal document that clearly explains what everyone has agreed to. Seek competent legal advice on any contract before you sign it, especially if it is a professional screenwriting contract, which usually runs 30 or more pages long and contains rather sophisticated provisions.

Following are some common points a contract will include:

- **If you are writing with someone else** (a writing partner). Who owns the material? If someone buys it, how will the money be split? How will writing credit be determined? If you come to a creative parting of ways in the future, what happens?

- **An option** (an agreement to purchase something in the future). For example, in independent films, a producer might option a script for one dollar for 12 months. (Producers and studios may option material for much more money, too.) That would mean the producer pays the writer one dollar and has the right to buy the screenplay sometime during the next 12 months. An option must specify the time period and the purchase price. Sometimes, options have a renewal built in, which means the option period can be extended for a pre-agreed-to time for a pre-agreed-to price.

- **Purchase price** (what the writer will be paid to sell rights to the script). The purchase price typically consists of immediate cash plus back-end money, or a percentage of future profits, *if any.* Note that most films don't make a profit.

- **What happens if the movie isn't made?** Do you get the project back? After what period of time? Would you have to repay some or all of the money in order to get your project back?

- **Writing steps.** If a writer is hired on an open assignment, the writer will be contracted for one or more writing steps. These steps may be a first draft, a revision, or a polish—levels of work defined by the Writers Guild. The writer will be paid some money on commencement of each step (at the start of writing) and the balance on delivery of the final step (when the script is turned in).

- **Credit.** If you are working on a non–Writers Guild movie, your contract should specify your writing credit and how you want to be credited on-screen, in posters, or in advertisements. Typically, the writer's credit is placed immediately before the director's credit, and the writer's contract will specify that the writer's name must be the same size, boldness, and typeface as the names of other people getting credit. If the Writers Guild is governing the project, it has the sole power to determine writing credit; the producers or the studio have no say in the matter.

- **Rights.** You'll need to state that the work is entirely your original creation—that you own the work—or, if the work is an adaptation, that you have been given the rights to the underlying work. If your script is purchased, you will be selling all of your rights unless you negotiate to retain some rights. Writers are sometimes able to retain certain rights, such as novelization or live-stage rights, but this is uncommon.

- **Sequels and remakes.** Your contract may address whether or not you need to be offered the first crack at writing any projects based on your original work and if you will have any share in the profits from those projects regardless of your writing involvement. This stipulation is very important if your script ultimately becomes the basis for a hit studio franchise.

studio will pay a certain amount of money for the right to develop that project for a given period of time. When that time is up, the studio must either purchase the rights—in which case the studio will own the rights forever—or let the option go, in which case the rights will revert, or go back, to the original owner. This process is formally known as having your project put into **turn-around**.

Sometimes studios acquire rights to a story based on the writer's **pitch**. A pitch is a meeting in which the writer tells the film's story. The pitch generally has two forms—short and long. A short pitch, which may be given over the phone by the writer's agent or a producer, is two to three minutes and is enough to determine if there is interest. The long pitch, given in person by the writer, is 15 to 20 minutes and gives the whole story of the film. Although few projects sold as pitches ever get made into finished movies, studios still buy them occasionally, especially from established writers with whom the studio has a preexisting relationship, or if it is based on a recent, major worldwide event.

Another way studios obtain rights to a story is through script submissions, but these kinds of submissions can be tricky, as studios are often faced with lawsuits from people who believe the studios stole their idea. Studios will not even look at unsolicited submissions; you will get your screenplay back in the original sealed envelope that you sent it in, with a formal letter stating the studio's policy of not accepting unsolicited submissions. To give themselves some protection, studios accept script submissions only from recognized entertainment agents or attorneys, because these legally authorized writers' representatives understand the industry's business practices—especially the fact that many projects are similar to many other projects—and will counsel writers not to pursue unfounded plagiarism claims.

Even though studios restrict the ways they receive new material, they still face the daunting process of evaluating the 25,000 projects that are submitted to them each year. Because the volume of submitted screenplays is so large, studios employ teams of executives whose initial task is to determine whether each project is commercial and meets the studio's needs. These executives are assisted by *story analysts*, who read the projects and write *coverage*: a brief summary and commentary on each project. When executives decline a project, they say they are "passing" on it. The vast majority of scripts are rejected, both because of the sheer volume of them and because to say yes to a project entails a considerable commitment of time and finances.

If the executives believe the project should be acquired by the studio, they will pitch the project to upper management. If management concurs and a business arrangement or deal can be made, generally with a writer's agent or attorney, the studio will put the project into development; all studio business deals with writers are governed by the studios' contract with the Writers Guild. Each studio has between 100 and 200 projects in active development, and another two to three hundred projects that are inactive, or "on the shelf."

Studio development involves a close collaboration between the writer and the executives developing the project. Generally, there is an initial meeting during which the writer pitches a vision for writing or revising the project, and several meetings may follow in which the characters and story are discussed in greater detail. The executive may consult with upper studio management in an effort to ensure that the project's direction will ultimately be to their liking. (See Producer Smarts: How to Work with the Writer, p. 41.)

When the writer turns in a draft of the script, the studio executives read it and decide if they are going to continue with the project and, if so, whether they will

Tip WRITE FOR MOVIES, PITCH FOR TV

Most successful studio movies are based on source material or scripts written independently by writers; very few start as pitches. In contrast, most television series start as pitches.

continue with the same writer. If the answer to both questions is yes, the executives will prepare **studio notes**, which provide a road map for the writer to follow in a script revision.

The studio may also decide to replace the writer, an event that happens frequently—especially on most films that eventually get made. In this case, the first writer's contract is terminated, and the project becomes an **open assignment**, meaning that the assignment is open for a new writer to work on it.

The studio may also decide to abandon the project entirely. Because studios have many projects in development even though they only make about 20 films per year, more than 80 percent of development projects are eventually abandoned. The average time a project is in development until it is either abandoned or given a green light (formally committed to production) is three years. Some projects move much more quickly, whereas others have been in development for 20 years or more before getting made. For this reason, studio development is often called "development hell" by writers, producers, and executives alike, with a knowing sense of irony about the arbitrary and lengthy nature of the process. On the other hand, it is a process that works best for the studios because it gives them security to know that a very large budget movie will have a script that the senior executives at the studio like.

Practice

SHORT PITCHING

This group exercise is best done with at least four people. Each of you should come up with a three-minute pitch for a full-length feature you might make one day. Then, for each pitch, the group should give reactions and notes on how to make it better. This process is a good model for what writers actually go through in studio notes/development sessions.

Forrest Gump was in development for nine years before it got made. Although that may seem like a long time, *On the Road*, the film adaptation of Jack Kerouac's landmark novel, was in development for more than 30 years.

Forrest Gump (1996)

On the Road (2012)

How to Work with the Writer

Producers play a crucial role in shaping screenplays, even if they may not write any of the words themselves. That's because producers often find and hire writers, and take the lead in giving notes to steer the development process. As a producer, when you're working with a writer, follow these constructive practices:

- Before writing commences, review the outline and offer feedback. The writer will be grateful if you can help ensure that the structure is sound.

- Offer to read scenes and give comments while the script is being written if the writer wants that kind of feedback.

- When the draft comes in, read it carefully and make notes. Pay attention to character, dialogue, plot, story structure, theme, rhythm, and flow, and also to whether the writer has called for any scenes that are beyond your project's budget or will be difficult to shoot. Then, meet with the writer to discuss the script and possible revisions. Always start with compliments and stress what is working well before delving into areas that need improvement.

- Afterward, it's helpful to follow up with a written memo summarizing the conversation and what the writer will do next. It is hard for writers to remember everything that is said during a development meeting; they're often focused on defending their first draft. The written memo will help them stay on course and remember what revisions they need to accomplish.

If the director has already been selected, make sure to include him or her in these steps, too.

Writer's Emergency Kit

- Pen and notepad, to record ideas as they occur and great bits of dialogue you hear in conversations, and an audio recording app for your mobile device to record meetings and thoughts on the fly

- A willingness to put your emotions and viewpoints out for public display

- A library card

- Screenplay software, and a way to back up your work with a hard drive or cloud-based storage

- Writing itself. When everything falls apart, the thing you can always fall back on is your craft. No one can take that away from you

CHAPTER 2 ESSENTIALS

▮ Film ideas may either be original or come from source material; they are intellectual property, and your creative rights and those of others must be protected and respected.

▮ Well-made films are well structured, weaving theme, plot, and character into a compelling narrative.

▮ Easily accessible software programs will make your script look like a script by helping you with the proper format.

▮ Development—the process of revising the script with other stakeholders in the film—perfects the script and gets it ready for production.

KEY TERMS

Adapted screenplay
Antagonist
Chain of title
Character arc
Development
Fair use
Grant of rights

Inciting incident
Intellectual property
Log line
Open assignment
Option
Original idea
Pitch

Protagonist
Source material
Structure
Studio notes
Theme
Turn-around

> **"I always want to make films. I think of it as a great opportunity to comment on the world in which we live."**
>
> – Kathryn Bigelow, director of *Point Break* (1991), *The Hurt Locker* (2008), and *Zero Dark Thirty* (2012)

Directing

Argo (2012)

KEY CONCEPTS

- The director is responsible for the principal creative and technical attributes of the film.

- The director must choose a solid script and build a team of good people to delegate creative responsibilities to.

- Planning and preparation are crucial. Planning doesn't eliminate the possibility of new ideas and "happy accidents" when you're shooting; in fact, planning allows time and space for them to occur.

- Directors adopt different leadership styles and aesthetic approaches depending on the story they're telling and the people with whom they are working.

- After you're done shooting your scenes, the tough, finishing work begins: editing your footage and telling the story with the shots you actually have.

Ben Affleck had to get out of town.

His first two movies, *Gone Baby Gone* (2007) and *The Town* (2010), had been set in his hometown. "I had to get out of Boston and stop making movies there, at least for one movie, otherwise no one would ever consider me for a movie that took place south of Providence," Affleck told *Rolling Stone*. "I honestly felt like I would kind of end up being pigeonholed as Boston Crime Guy."[1] That's when Affleck decided to direct *Argo*, a political thriller set in Iran during the 1979 hostage crisis, which won the 2012 Best Picture Oscar.

He got out of Boston, but he didn't go alone. Affleck surrounded himself with seasoned talent, many of whom had worked on more movies than he had. Rodrigo Prieto, the cinematographer, had more than 40 films under his belt, including *Amores Perros* (2000), *Brokeback Mountain* (2005), and *Babel* (2006). Production designer Sharon Seymour had worked on more than 25 movies, including Affleck's first films. Composer Alexandre Desplat had scored more than 140 titles, including *The King's Speech* (2010) and movies in the Twilight and Harry Potter series. Editor William Goldenberg had cut more than 25 films, including *Seabiscuit* (2003), *Gone Baby Gone* for Affleck in 2007, *Transformers: Dark of the Moon* (2011), and right after *Argo*, *Zero Dark Thirty*, which he coedited with

Dylan Tichenor in 2012. Ben Affleck "understood exactly what he wanted to do from the day he started shooting,"[2] recalled Goldenberg, who won the Academy Award in 2013 for Best Achievement in Film Editing for *Argo.*

Affleck and his producing team had assembled a team of virtuosos, just as you would do if you had to assemble a symphony orchestra. Indeed, making a movie is often compared to an orchestra, with the director as the conductor. All the orchestra members are exceptional musicians in their own right, of course, but have you ever heard an orchestra try to play without a conductor? The violins might drown out the piccolos, and the timpani might hit its thunderous boom at the wrong moment. Only with the conductor in charge can the orchestra play harmoniously, in the same tempo, and with the appropriate dynamic, emphasizing just the right musical phrases at the right times. That's because the conductor has prepared every part of the symphony and is therefore in a position to lead all the players.

As the director, you'll begin your work way before the first word of dialogue is spoken, and you won't stop until your movie is in front of its audience, long after the last scene is shot and the last set is struck. Throughout, you'll rely on four guiding principles: (1) faithfulness to the story being told, (2) practical common sense, (3) your ability to collaborate and empower your fellow artists, and (4) following your gut in order to execute your vision for the material.

If your image of a director is someone who sits on a canvas-backed chair and calls out "Action" and "Cut," your image needs an upgrade; in fact, that's as true today for student films as it is for big studio productions. It should go without saying that every director is required to be a great visual storyteller with a keen eye for detail. Today's director must also have a good working knowledge of every aspect of filmmaking, from communicating well with actors and telling the story, to budgeting and financing, to planning design and visual effects, to marketing and promotion. Moreover, today's director must feel comfortable leading a disparate team of people with a variety of skills in a multidisciplinary, multimedia environment in which there may be differing, if not competing, agendas of what the film should be.

The Director's Role

In the films you will be making, and in feature films and shorts, the director is the principal creative force. The director's role begins with the selection of what movie to make in the first place. In the professional world, producers or studios offer movies to directors, and some directors actually develop projects for themselves, much as you will probably do in this class. Then, during preparation and production, directors are peppered with literally thousands of questions, from the seemingly trivial ("Should she wear a gray shirt or a blue shirt?") to the monumental ("We have to wrap this location in 45 minutes! What can we cut?"). The director must have answers to all these questions, which is why good directors prepare their work carefully and fully in advance. The best directors answer these questions with an assertive yes or no. Those definitive answers come from their knowledge and intimate vision of what they want. A director whose answer is "maybe" or "show me five choices and I'll pick one" will adversely affect the schedule and budget and is subconsciously ceding his or her vision to others.

Just as directors must answer key creative questions, they are also responsible for the principal technical attributes of the film, such as selecting the aspect ratio (see p. 122) or deciding if the story will best be served with handheld cameras or with cameras that move with mechanical precision. These tasks are often best done in collaboration with fellow students or, for professional films,

with department heads (see p. 52) to whom the execution of these decisions will be delegated.

Although the director drives a film's vision, that does not necessarily mean that a film is the "director's film." The best films are strong collaborations and also bear their director's indelible personal stamp. In the 1950s, film critics advanced the *auteur theory*, which held that the director is the "author" of a film in the same way that a writer is the author of a book. This perception is still common and can be seen in the credits of many movies, which may include a card that says, "A Film by…" with the director's name. Naturally, this causes some consternation among others involved, especially writers and editors. The most evolved view, which will become clearer as you come to understand all the skills required to make a movie, is that the "author" of a movie is the strategically collaborative process masterminded by the director.

Directors maintain a close working relationship with producers. Because the producer must balance each film's creative needs with its time and budget constraints, the director will confer with the producer on every important decision. Of course, this balancing act is tricky—particularly in this class, since you are likely acting as both director and producer for your film. Producers try to give directors what they want and also set boundaries and limits when necessary. A good producer will find a way to achieve what's most important for the director's vision, even if it is a bit of a compromise, given the resources available at hand; a good director will accept this reality (see Producer Smarts: Producer and Director, a Working Relationship, p. 46).

Directors also often play another role: psychologist-in-chief. A director must consider the emotional needs of the department heads (or fellow students, in your case) and members of the cast, which may entail settling occasional conflicts. A good director has a welcome ear and an open door but does not let the psychology of the moment distract from the main focus: shooting the picture. Directors should not let themselves get drawn into drama but should rise above it while still maintaining a working relationship with all involved. Therapy can take years, and when you're shooting a movie, you don't have years. The best advice is to put an emotional bandage on any conflict situation and, except in the most extreme circumstances, get through the shooting schedule no matter what.

Because feature film directors have so much prestige, many people who study film dream of becoming directors. Without in any way diminishing the importance of the director, one of our aims in this book is to elevate and illuminate all the other creative people who contribute to the filmmaking process. After all, not everybody who wants to be a director can become one. In addition, not everyone is suited to become a director, in terms of technical skill, creative reach, or personal ambition. Directors, in truth, must be generalists. Some people—most people—are better suited to specialize and master just a few things.

The role of the director is, ultimately, a wide-ranging one, and directors create a variety of content: feature films and shorts, television shows, sportscasts and newscasts, commercials, and promotional videos, to name a few. This book focuses on student films and feature films and will prepare you to direct many kinds of content. It will also help you determine what kind of director you might become, as different directors have different aesthetic and leadership styles—something we'll discuss in more detail on page 58.

Tip LISTEN TO ACTORS

Many of the best directors are profoundly good listeners. They draw out actors to express themselves, which often makes the actors' onscreen performances more compelling.

EMBRACE HONESTY

Producers always have to be honest with directors, especially when delivering bad news that something the director wants cannot be achieved. This will give the director and producer more of an opportunity to solve the problem together.

SMARTS

Producer and Director, a Working Relationship

In the filmmaking universe, the producer is the chief executive in charge of any production. The entire crew reports to the producer, and technically, the director works for the producer, too. Generally, the producer's involvement predates the director's, and the producer holds ultimate responsibility for making sure the project is completed as scripted, as planned, on schedule, and on budget.

However, unless the producer is also the film's sole financier—which almost never happens because most movies are too expensive for one person to finance—the director has more actual creative authority; this is a practical fact of life, as it is the director's creative vision that needs to get on-screen, and it is most efficient for the director to make the key decisions. But the responsibility for the production still falls on the producer's shoulders, and this split of one person being responsible (the producer) while another person holds authority (the director) can create differing agendas.

The best producers recognize that their job is to foster an environment in which the best work can be done, and creativity and excellence can thrive. This begins with a close collaboration with the director and a clear understanding of what the director wants. Certainly, good producers have strong creative sensibilities and, as needed, tactfully advise directors on story, scene, and other matters. But in feature films, producers recognize that the director must make the final decisions—within the agreed-upon parameters of the budget and schedule, of course.

Seeing Your Project through a Director's Eyes

The director's first step is to choose a solid script and build a team of good people to delegate responsibilities to. For your class film project, you may not be able to assign all the necessary jobs out—you may be writing the script, casting a friend in a lead role, and doing all the production planning yourself. Regardless, think about your movie as if it were a real-world gig. This will allow you to see the project through the eyes of the director. With these eyes, you'll be able to read the script in a new and practical way.

Practice

DECISION MAKING IN THE MIDDLE OF PRODUCTION

What if you can't have everything? Directors face this problem in almost every movie, when time or money is short. To practice how you'd respond, watch a feature or short film with your classmates, and then try to come to a decision on what scene you would cut if you had to choose one. Give clear reasons to justify your decision. Would any other scenes need to be changed if you cut the scene?

Getting the Script and Working It

Even if you wrote the script yourself, try this thought experiment: Walk out of the room, shut the door, open the door, come back into the room, and see the script waiting there for you. Sit down and begin to read it. Imagine that you have just been offered this script to direct. Will you accept the offer—yes or no?

Choosing your material is the single most important decision you will make as a director, even more important than casting your actors. Make sure that the script works, that the emperor is always wearing clothes. The material you choose defines you as an artist; it says what you are interested in, how you see the world, and what you deem worthy of your and the audience's time. By saying, "I will direct this script," you are stating that this project reflects some part of your identity and personal vision that you want to share inti-

previsualizing (as we will explain in Chapter 13) how the final shot should look, you will be better technically prepared for how to shoot it correctly the first time.

13.

Also shoot with alternate dialogue for TV coverage

CASELY
(a look of surprise)
Shit.
— *CU gun*

Casely falls. She shoots him two more times and he dies. *WS*

Roxie catches her reflection in the mirror, her face framed by make-up lights. *Angle across Roxie to mirror + CU Roxie*

no tears

INT. THE ONYX - NIGHT

The chorines undulate across the stage. *Dance number matches violence of the shooting. WS + tracking shots, lots of CU's of hands, feet, faces so we can cut it wildly*

ENSEMBLE
JAZZ...

ENSEMBLE (CONT'D)
WHOOPEE...

ENSEMBLE (CONT'D)
HOTCHA!

INT. ROXIE'S APARTMENT - BEDROOM - NIGHT

Roxie drops the gun and stares into the mirror, bewildered and suddenly frightened. We FADE OUT. *mirror's POV of Roxie*

INT. ROXIE'S APARTMENT - BEDROOM - NIGHT (LATER)

flash bulb
A police PHOTOGRAPHER takes a picture of the corpse, while a FORENSICS MAN dusts the mirror for fingerprints.

high angle?

PHOTOGRAPHER
Why you botherin', Sal? This one's all wrapped up. *(Keep it subtle, don't over-play it)*

The photographer straddles the body, leans down for a close shot of Casely's startled expression.

photographer's POV

PHOTOGRAPHER (CONT'D)
I hear it's a new city record. From killing to confession in an hour flat. *hand held camera*

He drops the sheet back over Casely's face. We move with him through a gridlock of cops to the parlor, where Sgt. FOGARTY is taking down a statement.

SGT. FOGARTY
...and where'd you get the murder weapon? *Discover Roxie as photographer discovers her*

Now Roxie is crying

Courtesy of Miramax.

An example of how a script from *Chicago* (2002) might have been marked up (*top*) and a scene from the final film described in the script (*bottom*)

Continued

Continued from the previous page

7 **If you are going to direct a particularly complex film or a period movie, you might also highlight costumes/wardrobe, music, sound effects, hair and makeup, vehicles, animals, and other unique aspects of the story.** This will help you communicate with the people who will be assisting you in those areas. Again, your notes should not just be a shopping list; they should reveal why each element is needed to tell the story.

8 **You may want to sketch simple *storyboards*** (see Chapter 4, p. 90) or pictures to describe a specific camera setup or framing choice.

Now you will be ready to discuss the movie with your collaborators: the actors, cinematographer, producer, and others who will help you realize your vision. You will understand the emotional movement of the story, and also the little pieces—the gears of the clock—that make it function. In rereading the script many times, you will have defined your own vision, and you will be in a position to *direct* your cast and crew toward that vision. You will be prepared for the looming discussions about budget and schedule. You will be able to make clearer decisions about whom you want to cast, how you want to shoot the scenes, and what the sets should look like. Although your creative collaborators are very important, it is your job to guide them (while being open to their ideas); you do not want to be a "picker"—someone who relies on the crew to offer different creative choices and then picks one. You will also begin to sense the appropriate editorial style for this particular story and better understand what type of material you need to bring back to the editing room.

Casting Actors

Good performances are the lifeblood of a film. Practically any other aspect of a film can be less than optimal, but if the actors play their parts well, the film as a whole can succeed—and vice versa. You can have brilliant performances with poorly designed shots, and the movie will work, but great camera angles won't save bad acting. To that end, directors often say that 90 percent of their success is based on good casting. **Casting** traditionally means selecting actors for their roles.

A professional production might be *cast-contingent*, which means that unless certain actors agree to participate, the movie won't be made. If the production needs to find actors, the **casting director** will assemble a list of actors who may be right for the roles, and will bring them in to audition for the director. The casting director's job is to know the pool of acting talent and keep an eye out for emerging performers. Casting directors also keep good relationships with actors' agents and managers and often assist in making deals for actors' services (see Business Smarts: Agents, Managers, and Lawyers, p. 53). However, in a student production, you will probably be your own casting director.

If you know the actor's work, you may simply offer the role, which means that if he or she says yes, the actor has the part with no audition necessary. But if you have not worked with an actor before, or seen a great deal of that actor's work on-screen, it is important to hold an audition (see Action Steps: The Audition Process, p. 51). Acting on film requires different nuances than does, say, acting on stage. The filmic tools of close-ups and editing allow actors to be subtle; film acting is more about *being* than *doing*, as opposed to stage acting, in which actors

must project their emotions to an arena of people. Theater-style acting can feel forced and cheesy on-screen.

You should always video your auditions, because the way an actor appears in the room may not convey itself the same way on-screen. The best film actors have an emotionally transparent quality; their limpid emotions draw the audience in, compelling the audience to empathize and identify with them. You can't always see this in person, but movie charisma instantly becomes apparent when seen on-screen. (In fact, some directors only look at auditions on video—instead of in person—because they don't want to be prejudiced by personal interactions.)

It's customary to have another actor read the scene with the actor you are auditioning. For each role you are casting, use the same reading actor in the opposite role so that you have a clear picture of the auditioning actor's performance. Once you have held your first round of auditions, you will typically call back your top choices for final rounds. In these **callback auditions**, you will probably ask the actors to perform longer scenes, and you will try different combinations of actors to find just the right chemistry for your story, because the chemistry between acting partners greatly influences the outcome of each scene.

How do you communicate with actors? Specifically and respectfully. If you have never taken an acting class, you should. Even a few acting lessons will give you a window on the process an actor must go through, because an actor's job may be one of the most difficult on a film production. Actors must stay in a state of intense concentration, summon up their characters at a moment's notice and in the short bursts of camera takes, repeat exactly the same action over and over again for multiple takes, and say the screenwriter's dialogue as if it were their own, often in an order that's nonsequential from the script. Actors must create complete characters with whole lives, using only the tools of their imagination and the character's few scenes in the script.

Never forget that the actors may be relying on real, often deeply personal, emotional experiences from their lives to help them build their performance. As the director, you must get what the story needs while being sensitive to the actors, who may literally be baring their souls to the world. Even if a movie is about only one character, the movie does not show every moment of that character's life—something the actor must know in order for the role to be convincing. The most important thing an actor needs to know is, *What does my character want right now?* Sometimes this is obvious from the script, but in the best screenplays, the character's intentions are more subtly rendered; as in life, well-written characters don't always tell the whole truth. Your job, as director, is to be able to answer questions for the actors; to be able to work with them no matter what kind of actors' training they practice; to assure them that the set is a safe place for them to display emotions, whether they are dramatic or comedic; and to guide them to discover the characters themselves.

ACTION STEPS
The Audition Process

The following steps are appropriate for a class project or a low-budget movie:

❶ **Break down the characters in the script.** Identify them by name, and write a one-sentence description of the role.

Continued

Continued from the previous page

2 **Announce that you are holding auditions.** Post a notice, and provide a way for interested actors to schedule their audition time. Possible places to post your audition notice include online casting services, local theaters, and drama schools. Use trained or professional actors, if possible.

3 **For first auditions, allow 15 to 20 minutes per actor.** For callbacks, allow 30 to 60 minutes, depending on the role. Stick to your schedule, and respect the actors' time. See everyone you have asked to audition, even if you are positive the first audition gave you the actor you need. Not only is it the professional thing to do, but you never know what the actor in the waiting room will offer.

4 **Video the auditions.** If you see a lot of people, this will help you remember them and also see how they appear on-screen. Always have the actors state their names on the video.

5 **Give actors at least one day's notice, so that they have time to prepare.** When the actor comes in, introduce yourself and take a moment to explain the movie and the character's role in it. This is called *setting up the scene*. Then ask the actor to perform the scene.

6 **Now ask the actor to make a performance change.** This is called *making an adjustment*. You might ask the actor to consider what happened to the character immediately before the scene starts, to pick up the pace, or to try the scene with a different intention. Asking the actor to make an adjustment accomplishes two things: it lets you see how much variation or texture the actor brings to the role, and it gives you a sense of how you might work with the actor by seeing how well he or she follows your direction.

7 **After you have made your decisions, first call the actors you want to cast.** Confirm that they are available and have accepted their parts before you call the other actors who auditioned. For most student films, whether or not an actor is available for shoot dates is actually the very first question asked.

8 **Call the actors who did not get cast.** Although actors never want to hear they didn't get the parts they auditioned for, it is far worse—not to mention unprofessional—if you never call them at all. Hearing the words "I'm sorry, I decided to cast the role differently" is something actors must unfortunately get used to. You, as the director, or your producer or casting director, should make a personal call to each actor you didn't cast. Best to do it with grace and kindness—you may want that actor for your next project.

Selecting Department Heads

Just as you take care in choosing the right actor for each role, so, too, must you select your behind-the-camera colleagues with care. The director's most important collaborators are the director of photography, the production designer, the editor, and, on films with significant visual effects, the visual effects designer or supervisor. When we include the producer in the mix (who, as stated earlier, is the one who usually chooses the director), this cohesive group forms a production's

Agents, Managers, and Lawyers

If you pursue filmmaking at a professional level, you will do business with agents, managers, and lawyers. (You might even become one yourself.) Your first encounter with an agent or a manager may be when you are casting an actor who has acted professionally. Agents, managers, and lawyers are collectively referred to as *representatives*. Agents and managers represent actors, directors, producers, composers, and people from many other fields, who are called *clients*; most agents and managers specialize in one or two types of clients, such as actors or cinematographers. Agents offer career guidance, seek employment for their clients, and negotiate employment or business deals on their clients' behalf. Their work and business practices are regulated at the state level, and in most states, they must have a license to practice their work.

Managers generally have far fewer clients than do agents and offer more personalized guidance and career strategies. In most states, managers don't negotiate deals—they coordinate with agents or attorneys on business matters. Lawyers draft contracts and negotiate the finer, or more technical, points of most deals, often looking to the long-term implications of some contract provisions; only lawyers have the legal training to offer competent legal opinions, and everyone is well advised to consult a lawyer before signing any contract.

Agents and managers make their money by charging a percentage of their clients' earnings. This fee is called a *commission*. An agent's commission is typically 10 percent, whereas a manager's commission is typically between 10 and 15 percent. Lawyers generally work on an hourly basis, although in some areas of entertainment negotiations, they, too, will work on a percentage basis, in which case they will typically charge 5 percent.

"inner circle." These people (or functions, because you may be doing some of these jobs yourself for your class project) form the basis of the creative decision-making relationships.

In considering your possible department heads, focus on personal qualities as well as technical skills. A less-skilled technician often wins a job over a superior craftsperson purely on the basis of being easier to work with. As the director, you need to get a feel for the working relationship you might have with each candidate. Everyone is an artist in his or her own right, and you should treat each of your candidates that way. At the same time, their job is to make a great movie and not let their personal issues or egos get in the way. Choose people with whom you can have open and honest communication, who will not be afraid to tell you you're wrong, yet will still do what you need even if they disagree. Also, consider whether each person will interact well with the others. For example, the cinematographer needs to have a comfortable and trusting relationship with the actors.

The skills represented by typical department heads are covered in subsequent chapters; here, we'll look at some of the ways you should go about selecting your creative teammates and the most important criteria to take into account. Of course, each movie is unique and may require additional steps or considerations.

- Make sure they have been given an opportunity to read and study the script.

- Ask to see samples of prior work. You're not looking for dazzle and flash—you're looking for inventiveness and fidelity to the story. A designer or an

Tip **LISTEN TO OTHERS AND YOURSELF**

When meeting with your crew, present a clear, direct vision, which will give them the secure feeling that you are a leader. Listen to their suggestions and solutions, yet feel comfortable rejecting what doesn't match your intention.

editor who calls more attention to the design or the editing than to the story or the characters won't serve you well.

- Determine if their creative vision for the film is aligned with yours.

- Make sure they can work within your schedule and budget. Anybody can make something look great with a lot of time and money, but you need teammates who can achieve superior results fast and with little or no money. Look for people who come up with creative solutions to the problems they face, who can think on their feet, and who can adapt to changes quickly.

Practice

MARKING UP A SCRIPT

Using the techniques described on page 48, think like a director and practice marking up two pages of a script. You may either use a script of your own or find screenplays that have been produced as movies at www .dailyscript.com.

Planning and Visualizing the Shoot

Now that you have a solid understanding of the script and you've assembled your creative collaborators, it's time to get ready to shoot your movie. You need two plans: how you will get your scenes shot, and what the scenes should look like. Following are guidelines for planning the shoot and visualizing it.

Planning the Shoot

Even a one-day shoot can feel overwhelming when you start to think about everything that can go wrong and all the details you want to get right. Fortunately, there's a time-tested method to planning a shoot, and if you follow these steps, you are certain to emerge with a plan that is reasonable and coherent, and that permits you to understand your priorities.

1. If you can, assemble your cast and do a **table reading** of the script. A table reading is just what it sounds like: everyone sits around a table and reads the script aloud. This practice is common in theater productions and should be used more frequently in moviemaking because it gets the actors comfortable with their roles and also gives the director important information about how scenes play for emotion, comedy, and character revelation. It is also one last chance to make sure the chemistry of the entire cast works.

2. Based on your script work, you should already have a good understanding of which scenes are most important. *Balance* your shoot plan by making sure you lavish the most time and detail on the most important scenes. For example, a one-page exposition scene does not need the same amount of time or detail, or the same number of camera setups, as a scene in which a character dies.

3. Based on the rehearsal and your knowledge of what locations you'll be using, create a **shot list** for each scene. A shot list is the list of shots, or camera angles, you will need to be able to edit the scene later. You may want to discuss your shot list with your editor. Make sure you have more **coverage**, or extra camera angles, than you think you need because that will give you more options later, in the editing room. The assistant director will make sure scenes are properly scheduled, and during production, the script supervisor will keep track of everything that was shot and what still needs to be shot (see Support-

ing Positions, p. 62). You will also discover during production planning that in some respects, your initial shot list is actually a wish list of all the shots and angles you hope to get; some of these may be eliminated before you even start principal photography because they are too complicated, would require too much equipment, or would take up too much time and therefore cost too much to achieve (see Chapter 5: Production Planning and Management).

4. Create **floor diagrams** for each scene. A floor diagram is a map of where the actors will be and where the camera angles should be. This will tell you or your crew where the cameras will go and how they should move.

5. Some directors swear by *storyboards* (see Chapter 4, p. 90), whereas other directors prefer a less-formal approach to thinking through each scene. Storyboards are sketches of important moments in the scene, rendered in frames, as if you were reading a comic. You may find them useful for describing the action to your designer and photographer.

6. If your movie is going to involve any kind of visual effects, make sure your previsualization and visual effects partners are close collaborators in this process. For example, if you're going to use green screen to drop in a background outside a window, your photographer must arrange the lighting so that the effect looks realistic. (You'll learn more about this in Chapter 8.)

7. Remember that when you are shooting, you won't have an infinite amount of time, and some things are bound to take longer than you hope—the unexpected *will* occur. Have a backup plan . . . plus a backup for the backup plan. Know in advance what you can cut if you need to; know what you can work around or accomplish in a shorter amount of time if you get stuck. Although every moment of a film is important, not every moment is a key moment—a moment when the audience should gasp, cry, or laugh.

Visualizing the Shoot

Whereas planning the shoot is a technical exercise, visualizing it is a creative one. You'll want to run the movie in your mind, seeing it from different angles, trying and discarding mental versions of various ways to approach each scene. At every step, you must ensure that your visual style is consistent with the message of the script and that it advances the emotional truths of the characters.

Once your vision has formed, discuss it with your collaborators. They need to know what you are trying to accomplish—besides needing to make plans for the shooting days, they might add something to your thoughts.

Following is a checklist of the seven most important things to consider as you visualize your film. Much more detail on each area awaits you in subsequent chapters.

1. What format will you shoot your movie in? (See Chapter 6: Camera Skills.)

2. How will the *mise-en-scène*, or visual elements of the movie, tell the story and properly set the stage for the characters' journey? To put it another way, what will the movie look like? (See Chapter 4: Conceptualization and Design.)

3. How will you use the camera? Will the camera move with the action, or will it stay in one place and observe it? Will the camera be steady, which feels solid and in control, or shaky and handheld, which feels tense and documentary-like? Will you use long lenses that emphasize the characters at the expense of

Tip KEEP YOUR WRITER AND EDITOR CLOSE

It's a good idea to have your editor and screenwriter on hand as you visualize your movie. The editor can help you make sure you're planning with the final outcome in mind; the screenwriter can create alternative scenes in case your initial vision can't be accomplished.

their environment, or short lenses that keep the characters in the context of the scene? (See Chapter 7: Telling the Story with the Camera.)

4. How will you frame your shots? What will go into the frame—and what will be kept hidden, out of frame? (See Chapter 7.)

5. What's the right coverage style? Will the story best be served in long takes, or short takes that are edited together? Does the story—and your budget and time constraints—allow for multiple cameras and many takes, or will you have to move quickly through the scenes? (See Chapter 7.)

6. What kinds of transitions will you have between scenes? Most great films have great transitions. Will you cut, dissolve, or wipe? Do you want the shot at the end of one scene to match the composition of the first shot of the next scene? Some of these choices require substantial planning to create the seemingly effortless effect you may imagine. (See Chapter 12: Telling the Story through Editing.)

7. Are there visual effects or stunts? How will they be used? Are they going to be created on-set, be added later, or be a hybrid of both techniques? (See Chapter 13: Visual Effects and Animation.)

To answer each of these questions, you'll involve your producer and key members of your production team. All of these elements are interrelated and affect several departments' workload and the budget overall (see Chapter 5: Production Planning and Management).

Practice

SET YOUR SHOT LIST AND PRIORITIES

Using a screenplay from a classmate or from www.dailyscript.com, create a shot list to get enough coverage of one scene. Then rank the shots in priority order, with the understanding that if you don't have time for everything, you will shoot the most important coverage first.

On the Set

The moment you step onto the set as a director is the moment when the film you intend to make intersects with the film you actually make. You will need to understand: each scene from the vantage of characters' actions as well as camera angles, costumes, and hair; how each scene links to the scenes that came before and the scenes that will come after; how much time there is left to get all the coverage needed; and how the visual effects will be added effectively to the master shot. You must also be prepared, with a visual effect shot, to provide descriptions to your cast of what the final shot will look like. The actors literally may be performing on a completely vacant stage or with a character that will be added later—you, as the director, will need to fill in the gaps for them, so they can perform believably in such situations (see Chapter 7, p. 172).

Of course, directors don't always do all of this alone. They are supported by key positions: the assistant director and the script supervisor. You may find, however, that you will be playing both of these roles while on your student movie set.

Regardless, the way you approach directing will have a huge impact on the environment on the set as well as on the film itself. With that in mind, let's look at some different styles of directing.

How Do I . . .
Set the Tone On-Set?

Go to LaunchPad and find out: **macmillanhighered.com/filmmaking**

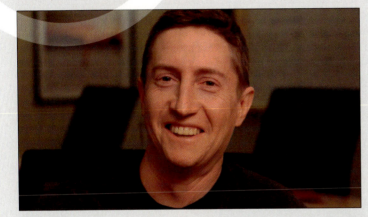

NAME:	**David Gordon Green**
TITLE:	Director
SELECTED CREDITS:	*Manglehorn* (2015); *Joe* (2014); *Prince Avalanche* (2013); *Pineapple Express* (2008); *All the Real Girls* (2003)

The first day of production is crucial to any director's success when making a movie—it's the day that sets the tone for every day that follows. This can be especially tricky when moving from one project to another—something familiar to filmmaker David Gordon Green, who has directed comedy, drama, action, and fantasy on films big and small. Green offers his thoughts on what happens the first day on-set in a video interview available only on the LaunchPad for *Filmmaking in Action*.

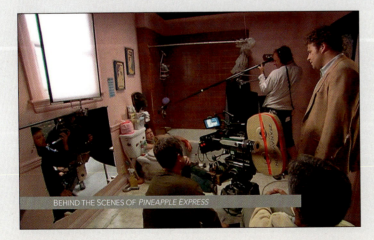

BEHIND THE SCENES OF *PINEAPPLE EXPRESS*

Discover

▪ How communication and tone in the collaborative process are cemented

▪ Why every set is not the same, even with similar crew members

▪ How Green varies his approach based on the material he's working on

Visit the LaunchPad for *Filmmaking in Action* to learn more—and to explore how you might use this advice.

Different Styles of Aesthetics and Leadership

Current models of production favor collaborative directors, because there are so many disciplines and skills involved in filmmaking, sometimes overlapping each other. These directors believe that good ideas can come from anyone on the production, and it doesn't matter who the idea came from because ego isn't important—the film and its story alone are important. Autocratic directors, like all autocratic people, are less enjoyable to work with, and often develop poor reputations among their colleagues.

As we've mentioned earlier, in addition to establishing the atmosphere for the entire production, the director determines the visual storytelling style that's right for the movie. Some directors care much more about a movie that looks good, even when the story doesn't call for, or does not need, highly wrought visuals. Sometimes audiences care more about one than the other, and this is often genre dependent. An action movie without a great look won't meet audience expectations, whereas a personal drama isn't as dependent on visual style. As an example, we may contrast *S.W.A.T.* (2003) and *Once* (2007). *S.W.A.T.*, directed by Clark Johnson, was a $70 million studio action movie, based on a television show. Although it performed well with audiences, grossing over $200 million worldwide, critics panned the movie as being thin on story and lacking dimensional characters. *Once*, in contrast, was an independent Irish movie directed by John Carney for $150,000. The film is sometimes out of focus, especially in the first reel, and the

SHOW, DON'T TELL

On-screen, show, don't tell. Actions and visuals often convey more than dialogue. You are making a movie, not a radio show.

One director, two styles: In *Raiders of the Lost Ark*, director Steven Spielberg created a movie experience that emphasized fun. He chose brightly lit settings and short scenes that propelled the action forward. Thirty-one years later, in *Lincoln*, Spielberg selected dark, somber scenes, lit as if by period candlelight. *Lincoln* focuses on backstage political deal making instead of action sequences; it is 35 minutes longer than *Raiders of the Lost Ark*.

Raiders of the Lost Ark (1981)

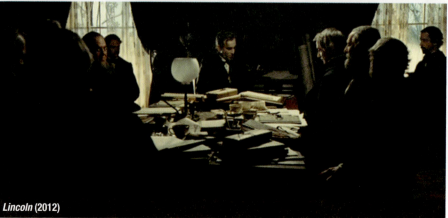

Lincoln (2012)

dialogue can be difficult to understand. Regardless, the reality of its love story and the charm of its music held audiences and critics enthralled, and the movie made $19 million worldwide. Dollar for dollar, *Once* is both more artistically and more commercially successful than *S.W.A.T.*

With so many different approaches to the art of directing, the best way to determine your personal style is to learn from the examples of others and watch a lot of movies, which will give you an opportunity to examine different directing approaches (see the list of essential movies on the *Filmmaking in Action* LaunchPad). Good directors allow their style to be guided by the story; for example, Steven Spielberg directed both *Lincoln* (2012) and *Raiders of the Lost Ark* (1981), and the styles of those two films could not be more different.

One way to discover your style—and the style that's right for the film you're about to direct—is to ask yourself a series of questions:

▮ How should the movie look—gritty or crisp? vibrant colors or faded colors? Will I shoot in color or black and white?

▮ What will the characters look like—their costumes, hair, and makeup? How can I use the way they look to say something about them and the story?

▮ How long should the movie be?

▮ Who am I making the movie for? To whom am I telling this story?

▮ Do I want the audience to understand everything as it happens, or should some parts of the story be mysterious at first, and only be explained later in the film? At the same time, how can I make sure the audience really understands everything I want them to understand?

▮ Do I want to tell the story with many short takes or with a few long takes?

▮ Should the actors be completely accurate with their lines, or should I allow them freedom to do some improvising?

▮ Do I want the set to feel calm and controlled, or full of creative chaos?

▮ Should the story be told in chronological order, or can some scenes play out of sequence?

▮ Would you pay to see this movie?

By responding to these questions with answers that are authentic to yourself and to the story you will shoot, you will come to the set with the beginnings of a directorial approach. Then, as with all crafts, you will discover your true style as you do the work.

Working On-Set

Of course, no day on-set will be typical, and directing a movie means preparing for the unexpected to occur. But there is a time-tested process most directors go through during production. We'll approach this process as if you are shooting an independent movie; the same course of action applies to your class project, except that you will have less time to shoot and you may be wearing a few more, or even all, the hats.

Even though you have planned the entire movie, you should spend concentrated time at the end of each day preparing what you will shoot the next day. Because you may be shooting your script out of sequence, make sure you place

Tip COUNT YOUR SETUPS

The amount of time you spend shooting is determined not by page count but by the number of setups you're trying to get. Make sure your ambition for setups is reasonable. Every change in the camera's location costs time and money.

these specific scenes within the chronological context of the whole story. This is as important for your communication with the actors as it is for the look and feel of the sets and lighting. Develop an idea of how you will want to *stage the scene*—where the actors will be in relationship to one another and their surroundings.

On the morning of your shoot, meet on the set with your production designer and director of photography at least an hour before the actors arrive. You should make sure the set meets your approval; if it doesn't, request changes that are possible within your limited time frame. Also, inspect any props the actors will use to ensure they are correct and functional.

The director of photography will want to know how you envision shooting the scene, so that camera and lights may be put in place. At this point, you may only have a general idea. You should discuss the emotional and storytelling purpose of the scene with the director of photography, who will use this information to propose some approaches to coverage.

Next, call the actors in for a rehearsal. They will not yet be in their costumes or makeup. Ask the crew to step back—generally out of the stage area and out of the actors' sight lines, so the actors can work with less distraction. The actors may have some questions, and you should answer them. You should know what each character wants at each moment of this scene and have a clear understanding of what happened to each character before and what will happen immediately after. This is important information for the actors to hold on to as they determine the best way to approach the scene. (To learn more, see Action Steps: How to Work with Actors, p. 61.)

Run through the scene with the actors, making sure to adjust how they move about the set—when they cross from one place to another, pick up a prop, or sit down. This is called **blocking**. Your script supervisor (see p. 63) will take notes on the blocking as you approve it.

Once the rehearsal is done and you feel good about the actors' readiness, ask the director of photography and sound recordist to come over and watch the actors do a final run-through as a **technical rehearsal**, which is for blocking more than performance. This type of rehearsal allows the director of photography to finalize light and camera positions and to practice complicated physical camera moves, and the sound recordist to determine the best way to capture the actors' dialogue, while the actors leave the set for costumes, hair, and makeup.

When the actors and the lights are ready, it is time to shoot the scene. Make sure everyone and everything is in place. You or your camera operator will call out "Camera!" and make sure the camera is recording. Your sound technician will call out "Speed!" which means sound is rolling. Then you, the director, will indicate that the actors should start the scene (you may call "Action!" or let them know in some other way) a few moments after all the recording devices are going, to allow for some "heads," or extra footage that may be needed in editorial. This is now the actors' cue to start the scene. When the scene is finished, keep shooting for a moment, to ensure you have a little extra footage at the end of the scene, or "tails," for editorial purposes, and then let everyone know the take is over. (Many directors call "Cut!")

Next, you'll actually repeat the process all over again. You'll go through the same steps and the same scene to get variety in the actors' performances. An exact replay of the same scene is known as a **take**. While filming, you will add "print it" after you call "cut" to note that this is the version or take of the scene you think may be the best. It is often hard to judge on the set how the actors' performance will play on-screen, especially in the context of the finished movie. For that reason, you should have the actors put some variations into their perfor-

mances—larger as well as subtler, more dramatic as well as more comedic. Don't ask them to make changes just for the sake of change, of course—you still want them to be true to their characters—but you want to give them the opportunity to explore some layers of their characters on camera, and you want to give yourself and your editor the chance to make changes in the editing room as you're assembling the movie. Multiple takes are done not only because of technical errors or dissatisfaction with an aspect of the scene. *Shooting a scene today is all about creating options in the editing room tomorrow.*

In addition to looking for variety in your actors' performances, you will repeat the scene to attain different camera angles. Generally, the first takes you shoot will be wide shots, called *master shots*, in which the whole scene is visible. These master shots establish the set and the characters' actions. After you are satisfied with your master shot, you will redo the scene for additional angles, such as close-ups and over-the-shoulder shots (see Chapter 7).

At some point during the day—generally at lunch or at the end of the day—you will look at *dailies* and communicate with your editor. **Dailies** refer to footage previously shot, either from the day before or, given the speed of today's digital workflows, sometimes even from earlier that same day. The editor will immediately start thinking about how to cut the scene. In fact, the editor may even begin roughly editing it on-set moments after the scene has been shot, the advantage being that you can end a day or even more importantly, leave a location, fairly satisfied that you have recorded everything you need. The editor will also alert you if there's any coverage you missed, in which case you could shoot it immediately. If the editor doesn't volunteer such comments, make sure to ask: you might be able to get some more shots the next day, but once you're in the editing room, chances are you won't be able to go back to shoot material you're missing. You do not want to "fix it in post" or, worse, be forced into staging a costly reshoot weeks or even months after the entire cast and crew have moved on.

If your film involves visual effects, you will also need to collaborate closely with the previsualization team during shooting, perhaps even allowing them to take key measurements on the set or location for later use during the visual effects process. The visual effects supervisor will typically be on-set and may even be able to show you instant rough examples of how the day's scene will look when finished. This is done by taking a feed off the video camera and marrying it to a virtual set—that is, a set that exists only in computer rendering, not in physical form. You'll learn how such techniques work in Chapter 13: Visual Effects and Animation; for now, simply enjoy the magical awe of being able to look at what you just shot and imagine it in a visual virtual reality.

Tip STAY SAFE

A film's director must maintain a working atmosphere of respect and safety. In the rush to get scenes shot and "make the day," people sometimes take shortcuts and compromise safety. *Don't let this happen.* If an accident happens on the set, the director is ultimately responsible. Lives have been lost, and well-known producers and directors have faced criminal charges and seen their careers ruined when this principle was not respected.

ACTION STEPS
How to Work with Actors

Just as every actor has a different style, so does every director. You will find the style that best suits you and the actors in your movie. At the same time, most successful directors follow these steps to help actors give their best performances:

1 **Know the script**. It's your job to understand the script fully, especially the dialogue. You should have a clear understanding of who the characters are and what each line of dialogue means. If an actor asks, "Why would I say that?" you should be able to answer.

Continued

FILMMAKING

Continued from the previous page

❷ Talk and listen. Talk with the actors, and listen carefully to what they have to say. Most actors will do preparation: they'll come to the table with ideas about their characters. Take the time to listen to their feelings and observations, and pay special attention to things they feel uncertain about. This is when you can share your vision of the characters and clarify problems for the actors by discussing the characters and their relationships in more detail.

❸ Rehearse. Most directors begin by having the actors read the scene aloud, although some directors and actors prefer to "put the script on its feet" right away and use movement to work out the scene. There's no right or wrong choice—do what works best for you and your cast. The important thing is that rehearsal makes performances better.

❹ Create a positive environment. It's your job to create a safe, nonjudgmental space so that the actors can do their work, which is emotional and vulnerable. You set the tone and mood by the way you behave; for example, if you're directing a comedy, keep everything light, fun, and cheerful.

❺ Help the actors define their intentions. Acting is largely about playing intention; an *intention* is what a character wants at each moment in a scene. Intentions may change during a scene, but an actor can only play one intention at a time. You should make sure the actors understand their intentions clearly.

❻ Give feedback and encouragement. If something isn't working, it is often best to take the actor aside and discuss it privately; you don't want to embarrass anyone. And when things are going well, give profound encouragement by word or deed—one well-known director laughs extra loud to let the actors know a scene is especially funny.

❼ Scale the performance to the way you'll shoot the scene. Inexperienced actors often overact—that is, their performances are big and corny. Remember that subtle performances often play well on camera, especially in close-up.

❽ Keep the dialogue open. Don't stop communicating once the cameras roll. Instead, check in with your cast as often as you check the shot. Sometimes actors make important character discoveries on the spot, and you will want to take full advantage of their process.

❾ When shooting, don't cut off an actor's performance, especially if it is an ad lib or something improvised. Often, some of the most memorable moments come from an actor's inspiration while in character during a scene. Keep the camera rolling to capture these moments.

Supporting Positions

Although you will likely be doing many of the tasks described in this section yourself, on a film of some scale the director is supported by two key positions: the assistant director and the script supervisor. **Assistant directors (ADs)** hold the most stressful job on the set. They must coordinate all the necessary elements to shoot a scene. The lead AD is called the first AD, and there may be one or more

second and third ADs reporting to the first AD, depending on the complexity of the production.

First ADs begin work in the preparation stage and are responsible for breaking the script down into scenes and figuring out the best way to organize the shooting schedule; this involves coordination with all other departments (see Chapter 5: Production Planning and Management). On a shooting day, the first AD is the first person to arrive and the last to leave and, in between, keeps the entire company in sync with what needs to be ready and when, solving numerous problems along the way. The first AD also keeps an eye on the clock, calling for meal breaks and making sure crews don't go into overtime without the producer's approval; plus, on large productions, it is often the first AD who calls "Action!" The first AD is simultaneously the director's confidant, shield, and taskmaster.

If present on a production, second and third ADs have specific areas of responsibility. For example, they may be in charge of overseeing principal cast members or organizing crowds in crowd scenes. People who enjoy being ADs thrive at being in the center of swirling activity and forging order out of apparent chaos.

The **script supervisor** creates the collective written record of the production, ensuring a film's *continuity* (see Chapter 7, p. 169). The script supervisor will usually be seen right next to the director, taking detailed notes of everything each actor is doing during each take. If an actor forgets when she picked up a glass of water, for example, the script supervisor will give the answer; such detailed accuracy is essential for making sure that actions and dialogue match in multiple takes. The script supervisor also carefully follows the dialogue in the script, making notes to ensure that each line has been shot from all necessary camera angles, as well as noting any new lines of dialogue that have been added or changed, and lines that have been deleted.

To keep all this information organized, script supervisors have developed a unique form of notation. After the scene is shot, the script supervisor gives these notes to the editor, to be used as a reference in assembling the film.

Practice

HOW WOULD YOU SHOOT THIS SCENE?

Select a scene from a class project or from www.dailyscript.com. Your assignment: design three different ways to block and shoot the scene. Which works best for the characters? for the overall arc of the film's story? Why?

Working the Movie You Just Shot

As exhausting as being on-set and shooting may be—12- to 16-hour days are typical for directors—it is matched by the emotional ups and downs of the editorial and finishing steps that follow. On the set, you were running as fast as you could, trying to shoot as much footage as possible, to give yourself options in the editing room. Now, as you step into the editing room, you confront the inevitable: the difference between the film you set out to make and the movie you actually shot.

This part of the process involves two activities: collaborating with people who will help you finish your film—the editor, the visual effects supervisor, the composer, and the person who does the final color correction so that your film looks the way you want it—and getting to the point where the movie is *locked*, or finished. For your project, you may find that you are your own editor and finishing team, or you may have fellow students who are your collaborators in these areas. And, depending on how your project came together, where you're shooting it, and how it is being distributed, you may or may not be the one to decide when it is done.

Tip REMEMBER THE THREE MOVIES

Experienced directors come to realize there are three movies: the movie you plan to make, the movie you shoot, and the movie you realize you actually made once you get into the editing room.

Finishing the Movie

Although your class project may not require all of the following steps or functions, they are a good way to think about the process of finishing your film. These steps will also prepare you for directing an independent feature.

1. **Review the editor's assemblage.** Shortly after you finish shooting, the editor presents an *editor's assembly*—all the scenes of the movie strung together. If you are editing the movie yourself, this will be your first step. (See Chapters 11 and 12 on editing.)

2. **Prepare the director's first cut.** Now you, as director, begin to work with the editor to shape and craft your movie toward its final form. Whereas the editor's cut contained everything (and may have a running time of two to three times longer than the final film), the director's cut will be much closer to the eventual final running time. For a feature film, the director's cut may take six to twelve weeks to prepare.

3. **Screen for the studio, financiers, or friends.** After you've finished the director's first cut, you will screen the movie. If it is a feature film, you will screen it for the people who financed the movie. You will probably screen your class project for your teacher or a group of friends whom you can trust to give you honest feedback. All you're looking for at this point is feedback. The movie is not finished.

4. **Preview and do additional editing: the next round.** For your class project, you will probably repeat this process one or two times: showing the movie to friends, making some changes, and then showing it again. If you are making a professional movie, you will screen it for preview audiences to gauge how the film works for people who have no prior knowledge of it.

5. **Record additional dialogue.** Sometimes dialogue can't be heard, or you decide you need more dialogue to make a scene work. If either of these is the case, you would do some ADR, which stands for *additional dialogue recording*. ADR is common on movies and often saves scenes and makes information clearer. We will discuss this topic further in Chapter 10: Sound.

6. **Do any reshooting.** If you discover you don't have all the footage you need to tell the story well, and ADR won't solve your problems, you may have to shoot some additional material—that is, if your budget allows it and your actors and location are available. For this reason, it's always important to stay in close communication with your editor while you are shooting, always asking, "Do I have enough for you to cut the scene and have alternatives?" It is much easier to get everything the first time than it is to reshoot.

7. **Add in and perfect visual effects.** You may have been using simple or temporary visual effects in your early screenings. As your edit progresses, add in and perfect visual effects until you are satisfied with them or until time or money runs out. See Chapter 13.

8. **Add music.** The composer will play you a preliminary version of the score, so that you can give your input about how to marry your images to the music. You may also use songs or prerecorded tracks. You need to be aware that you cannot use music you don't own, which means you can't legally use a song you hear on iTunes unless you obtain the rights first. However, your school may

have a library of public domain or licensed music that you can freely use. We'll address music and these related issues in Chapter 10.

9. **Do your final sound mix and final color correction.** Once your picture edit is locked, you will put all the sounds together in the proper balance, and then make a final color adjustment so that the images on the screen look the way you want them to.

10. **Add titles, credits, and graphics if needed.**

For most class projects, you won't go through all of these steps. Recording additional dialogue or reshooting scenes may simply not be options. However, it's important to keep in mind that all of this finishing magic is possible, and it's the end product that counts; you want your movie to be as good as it can be when it is done.

"Final" Cut

But *when* is it done—when you run out of time or money? when you think the movie's right, no matter how long it takes or how much it costs? when your teacher says it's time to move on?

You may have heard the phrase *final cut*, referring to the final version of a movie, which is sometimes called the *final master*; it is the version the public will see. **Final cut**, however, has two connotations: whereas one relates to power, the other relates to time. In the first connotation, final cut is the director's authority to have complete artistic control over the movie. This means the director may determine what scenes are in or out, the running time, the rating, and every other aspect of the completed film. Such authority is rarely granted to directors; at any given time, there are less than a dozen professional feature film directors in the world who exercise this level of control.

In the entertainment business at large, true final cut typically rests with the financiers, or the studio, in almost all cases. Why? Because filmmaking is a business, and a movie's financiers want to make sure they have a reasonable opportunity to recover their investment and make a profit. For example, investors who believe they are financing a G-rated family film don't want to end up with an R-rated movie.

LISTEN TO YOUR AUDIENCE

Listen to your audience carefully, and watch for their signs of engagement or lack of interest.

Often movies go through multiple cuts—and sometimes they wind up distributed to the public. Ridley Scott's *Blade Runner* (1982) has been released in its original, compromised theatrical cut; a longer 1992 "director's cut"; and a tweaked "final" cut in 2007.

More commonly, a director might have *conditional final cut*. In this circumstance, a director may exercise authority over the finished movie so long as certain conditions are met, such as a specific running time or rating. In your school project, you will likely have conditional final cut authority. Your instructor may set certain parameters, and as long as you observe them, you may finish your movie as you like. If you don't, your privileges may be taken away from you, or you'll have some other consequence, like a poor grade. Common classroom parameters are based on minimum and maximum running times, shooting in color or black and white or with specified equipment, using dialogue or not, and maintaining a predetermined budget.

The second, more practical, connotation of *final cut* refers to time: at some point, you have to share your movie; in this sense, final cut simply refers to the final version of the movie—the version you had when everyone stopped working on it. Films, like all art forms, are works of passion and toil; as such, although they can be worked infinitely, there is always a due date or a release date. At that point, the film is "locked" so that the release version can be screened. *Star Wars* director George Lucas is reported to have said, "A film is never finished, only abandoned," but he was paraphrasing French poet Paul Valéry, who said the same thing about poetry, and Valéry, in turn, was paraphrasing Leonardo da Vinci, who said the same thing about art.

Indeed, today, movies need never be "final"—they are only made final, or abandoned temporarily, at discrete moments in time. George Lucas, for example, continues to revise and create new editions of his *Star Wars* films. It is common for movie studios to release the "unrated" or "extra scene" versions of movies for home video in an effort to increase sales with tempting offers of forbidden or tasty fruit. Everything can be upgraded and revised in the course of time; everything can be remixed or become part of a mash-up, extending its creative life (and potential for earnings) into the indefinite future.

Yet for the filmmaker-artist, pressing the "save" icon and voluntarily abandoning a movie is a good thing: that's the time to move on and start your next film.

(P)ractice

WORKING WITH THE EDITOR

Editors approach movies in a very practical way: they are concerned with what has actually been shot, not with what was planned. Therefore, editors are directors' storytelling collaborators and often suggest narrative changes the director had never envisioned. Working in pairs and using a film you have seen in class, take turns playing editor and director. As the editor, suggest a different way of ordering the scenes in the film; as the director, consider if the editor's ideas could work.

✚ Director's Emergency Kit

- A backup plan, including more efficient ways to shoot any scene and possible scenes to cut if you fall behind schedule
- An intimate knowledge of the script, which will allow you to answer questions from the cast and department heads
- The ability to speak to people in their own language: talk to actors in acting terms, designers in visual terms, and editors in terms of story
- Staying calm in the face of chaos and pressure in order to focus on getting the shots the movie needs

CHAPTER 3 ESSENTIALS

▌ On a feature film, the director's role is to be the creative and technical leader, and to make ultimate decisions.

▌ As the director, you must first read the script carefully from different perspectives and make notes. Next, focus on casting. All the while, strive to have effective communication with cast and crew.

▌ Plan everything in advance, to give yourself time to deal with unexpected events on the set and to allow for "happy accidents." At the same time, make sure your visual style is consistent with the message of the script.

▌ The best directors are collaborative and choose a visual style that's right for the story and characters of the particular film they're working on. On-set, they follow a logical and consistent working process and rely on the support of other members of the department, such as assistant directors and script supervisors.

▌ After shooting is complete, explore the story further through the editorial process. Be sure to preview to audiences as you refine and finish your film.

KEY TERMS

Assistant directors (ADs)	Coverage	Shot list
Blocking	Dailies	Table reading
Callback auditions	Final cut	Take
Casting	Floor diagrams	Technical rehearsal
Casting director	Script supervisor	

DIGITAL EXTRAS

Visit the LaunchPad for *Filmmaking in Action* to access:

▌ Links to useful websites, including the Directors Guild of America, the DGA Assistant Director Training Program, Women in Film, and diversity programs for development of minority directors

▌ An exploration of the differences between movie and television directing

macmillanhighered.com /filmmaking

> **"There is no such thing as a paint- and construction- and decoration-free narrative film. If you do that, it's a documentary."**
>
> **– Jeannine Oppewall, veteran production designer, whose films include *The Bridges of Madison County* (1995), *L.A. Confidential* (1997), *Pleasantville* (1998), *Catch Me If You Can* (2002), and *Seabiscuit* (2003)**

Conceptualization and Design

Catch Me If You Can (2002)

KEY CONCEPTS

❚ You will need to learn the basic principles of design and composition, and the concepts behind properly placing elements in a frame to best serve the story. This includes shapes, textures, size, scale, color, and more.

❚ Break down your screenplay and examine your resources to identify basic factors that will impact decisions about locations, sets, props, set pieces, and more. Among the most important of these will be the story's time period, geography, and locations, as well as the nature of your characters.

❚ A major tool will be previsualization techniques, ranging from simple sketches or storyboards to detailed digital animation to illustrate placement of elements, actors, cameras, and lights.

When Jeannine Oppewall discussed production design concepts with Steven Spielberg for his 2002 film *Catch Me If You Can*, it didn't take long to realize her principal challenge would involve designing what she calls "a color arc" to help Spielberg tell the story of a con man's rise and fall through the film's narrative sections.

"Steven talked a lot about how the character Frank [Leonardo DiCaprio] started off ignorant and inexperienced, and then through a series of events, he learned how to practice his craft of passing false checks, got better at it, and then his

life got more lively," says Oppewall, a Hollywood production designer with over 35 major feature films to her credit. "Then, he was caught, and his life became dull again. To interpret that visually, I decided to have him start out in a relatively monochromatic world, without many wild colors. Slowly, we would build up color and put more life into his environments, and then when he is at the top of his game, having the most fun of his life, that is where we would have the brightest colors in the movie. Later, when he is caught and in prison or in FBI custody, the colors become

monochromatic and predictable again. It was a particularly controlled color arc to match what was going on in the story."

In production designer Jack Taylor's case, an initial examination of the script for the low-budget, independent film *Atlas Shrugged: Who Is John Galt?* quickly made clear that his principal challenge would be the issue of how to balance ambitious locations described in the script—the final movie in a trilogy based on the controversial Ayn Rand novel—and an extremely limited budget. Among the complex locations that the script required, for example, were an airplane crash site in a mountain forest, a mining cave, a mysterious energy-generating motor that lies at the heart of the plot, and a helicopter pad overlooking a glittering nighttime cityscape.

Taylor—a protégé of legendary production designer Henry Bumstead, who has worked for Clint Eastwood and Martin Scorsese, among others—says budget and logistics required the production to film on 71 location sets in just 18 grueling days, exclusively in the Los Angeles area. After some calculations, he quickly concluded that he would need to find an average of four workable location settings per day that could be transformed into different places, while also accommodating equipment and catering trucks, base camp, and crew. Thanks to his experience and exhaustive hours of research, Taylor eventually decided he could group the aforementioned four illusions together in a single location to be shot on a single day—at the Griffith Park forest area in the middle of Greater Los Angeles.

"I realized Griffith Park could be made to look like it was anywhere in the Colorado Rockies, so it became the area we made into the crash site,"[1] Taylor explains.

A few steps away, under some cedar branches along a hiking trail, we were able to place the "Motor Generator Monolith Temple" as described in the script [and Ayn Rand's novel], and just up the nearby Park Service access road was the Forestry Department's Helipad that they use to land water-dropping helicopters. Wouldn't you know it, the helipad

overlooks the sprawling Los Angeles basin for the night shot we needed with the towering buildings of downtown Los Angeles as a backdrop. And not far away, within company shuttling distance, were the Bronson Canyon caves, which were a perfect location for laying rail track for mining carts, as the script also required. [The same caves can be seen in the final sequence of John Ford's *The Searchers* and were used as the entrance to the Batcave on TV's *Batman*.]

The point of these examples is that both designers, above all else, dedicated themselves to meticulous analysis of their respective scripts, detailed research, location scouting, and a keen understanding of the role physical space and color play in telling cinematic stories. Taylor emphasizes that the production designer typically must, in low-budget filmmaking, "wear many hats. I had to be deeply involved in location selection and be responsible not only for the look and world environment that the characters of the picture inhabited, but also for the physical ability of the production company to be able to make the product on time, and within reasonable budget parameters."

In other words, it is not enough to be an accomplished artist, as Oppewall and Taylor are. You also need to emulate their considerable skill at pounding the pavement, strategically examining nooks and crannies of all sizes and descriptions, and constantly seeking out ways to balance what is aesthetically pleasing with what is efficient and both logistically and financially feasible.

Though your individual circumstances and skill level may be different, design will prove crucial for your first student film and your wider film education. Author Vincent LoBrutto describes production design as a discipline that "renders the screenplay in visual metaphors, a color palette, architectural and period specifics, locations, designs, and sets."[2] More simply, we might say that production design is about creating the environments necessary to tell your story.

In truth, however, production conceptualization and design is the most collaborative of the crafts. It involves, to one degree or another, the need to incorporate construction, props, locations, costumes, cinematography, lighting, sound, visual effects, graphic design, and even hair and makeup—or at least it interrelates with these departments over time. Learning the fundamentals of design will also help you understand what it takes for different craftspeople to do their jobs successfully, and how to think creatively and logistically at the same time. If you take the basic principles and strategies we will now discuss, and combine them with a proactive effort to widen your own education about art and design, train yourself to become more research oriented, and dedicate yourself to serving your story's advancement with every visual decision you make, you will achieve viable sets and locales for your films.

The Principles of Design

This is not an art class, and you are not reading an art textbook; why, then, is it useful to pause and learn some of the basic, art-related principles of production design, many of which emanate from the theatrical world?

Primarily, it's because a baseline goal when producing a movie is to ensure that all the things you want to be seen by viewers will, in fact, be seen as you intended, and anything you want hidden will be invisible. At the foundational level, then, you are attempting to figure out three things: how to use the physical space you have available to you, how to design sets for that space, and how to arrange elements on those sets to maximize creative success. Even when you are making a 3D movie, you are essentially conceptualizing and composing a 3D image on a two-dimensional surface. Where you place people and elements, where you want to draw the viewer's eye, where you want light and where you want darkness—these are all directly related to how you want the viewer to react, and the mood you want to evoke. These goals seem fairly simple and straightforward, but in fact, the more fundamentals of design you can master, complicated though they may be, the more success you will have in reaching such goals. Indeed, understanding these principles will help make you a better filmmaker in the long run, even if you have no desire to go into production design specifically, simply because you will have a better sense of how to use space and collaborate with other artists.

To be sure, you will need to do some exploration in other disciplines to get this education. Art, photography, theater, and literature are all areas in which you will learn about proportion, scale, composition, depth, color, and so on. But the basic fundamentals we will now discuss will serve you well as a solid foundation for those ongoing lessons.

Design Composition Elements

In Chapter 7, we will analyze elements of good composition as they relate to cinematography—strategies and principles for positioning people and objects for the purpose of framing images through the lens for maximum balance and impact. This essentially involves how two-dimensional space will be organized in the frame. Before we get to that lesson, though, you need to think about composition as it relates to production design. Not surprisingly, the two areas in which composition is crucial—cinematography and production design—are interrelated. A key part of the production designer's job is to make sure elements are designed and arranged in such a way that the director and cinematographer can position or reposition people, objects, crew, and equipment to execute their visual plan for

framing and executing shots. Without proper placement and spacing of elements on a set, filmmakers will have a hard time getting composition right.

Thus, from a design point of view, *composition* involves the proper design of spaces for filming, and the design and placement of elements on sets and locations behind—and all around—actors and other principal focal points. Keep in mind that the actor is typically the most important element in a frame—anything that competes with or dilutes the presence of your actors is usually to be avoided. The notion of designing a space to aid composition is subtly different from the notion of *arranging* elements in particular ways for particular shots—that is a subject we will discuss in the next section. Meanwhile, you may hear other terms that refer to the same concept as composition—*form* or *ordering*, for example. But whatever term you use, the point is, you need to get a plan together for how you want to structure spaces in every scene in your movie.

Remember that many important compositional concepts come out of the art and theatrical worlds, but their essential roles, in most cases, are similar or even identical when applied to moving-picture imagery. The most important concept of them all is the idea of *space* and how to use it. How you give the illusion of physical space or space between elements impacts how depth, size, and proportion are perceived by the viewer, and thus plays a direct role in the emotional impact of scenes. Cinematography and lighting are crucial to representing space in movies, but so is production design. In design, the term *positive space* refers to space that is filled with objects of some type. *Negative space*, as we will elaborate in Chapter 7, refers to wide, open space that remains empty until used by actors as they move from one position to another. There are also the concepts of *shallow space* and *deep space* in design. When two objects are placed on a set and photographed with very little depth, whereby elements or people occupy almost the same positions, it is called shallow space, resulting in a flatter image. When one element is in the foreground and the other is in the distance, it is called deep space because that juxtaposition gives the illusion of distance.

Beyond those basic definitions, however, you need to think about how your use of space is helping, or hurting, the story. Usually, if you have competing ideas or are undecided about how to use a space, your best bet is to simplify things—strip away clutter and only use colors that invoke the intended mood.

Other important compositional categories for you to understand as you strive to properly execute design include the following:

- **Center of interest.** This is sometimes called "point of emphasis." As either name implies, the idea revolves around the notion that every frame in a motion picture has a specific area where the filmmaker wants your attention directed. In this sense, it's the most important part of the frame. Therefore, your design must accommodate what you want to emphasize in each shot. This might mean adding certain elements, like color or contrast or *props* or *set pieces* (see p. 75), or avoiding things that would distract from an actor or some other non-design-related element. Every element must have a purpose in adding to the characters or the story.

- **Harmony and contrast.** Similarly, these concepts out of the art world involve composing frames with matching or similarly shaped elements to avoid a distracting contrast, unless, of course, such contrast is a creative choice. Thus, you would want pieces of furniture to match or be similarly shaped or textured to achieve harmony, and you would mismatch them if you wanted to achieve contrast.

- **Value.** This refers to the differences between light and dark in a design—that is, the contrast between black and white elements: the larger the value, the wider the contrast in shots.

▮ **Balance.** This characteristic involves achieving some form of equality in terms of shapes, forms, colors, and so on, in a frame. Production design can be crucial in helping to achieve balance, so that the viewer's attention is not unintentionally directed to one part of a shot over another.

▮ **Line.** In frames, this term refers to shapes that essentially create a visual path for the eye to follow, usually toward the main focal point of a frame. Lines can therefore be patterns on walls, run in any number of directions, be of different thicknesses or textures, or not even be physical at all. Deliberately choreographed movement or blur can create lines, and visual illusions that mimic movement can also be incorporated.

▮ **Shape.** In design, shape is exactly what you think it is—two-dimensional areas with specific edges to them, generally classified as either geometric shapes or organic shapes. In either case, with good design, shape can be used strategically. If a table is shaped like an oval or an octagon in a particular scene, it is because filmmakers decided that the shape would work best in terms of drawing the viewer's eye to the primary element in the frame.

▮ **Color.** The foundation for all color-related goals, even those finalized in postproduction, begins on-set, because color is a major tool in implying or enhancing different moods and emotions in cinematic stories. Thus, for production design, the term *color* refers primarily to specific hues and other properties, such as temperature, brightness, and saturation. (See Action Steps: Choosing a Color Palette, p. 77, and Tech Talk: Color Theory in Design, p. 76, for more on choosing a color palette and understanding the properties of color.)

▮ **Form.** In design, this term refers to three-dimensional objects that have a certain volume and thickness to them, and that can be lit or shaded in particular ways to create three-dimensional effects from certain angles.

▮ **Texture.** Although viewers can't physically enter movies and feel textures, they can subtly see them when elements are correctly designed. Texture is all about the quality or feel—smooth, rough, jagged—of object surfaces. Remember, it only matters how the set looks on screen. If your set calls for granite floors, you don't necessarily need real granite. Very often, expensive materials and textures can be replaced with paint.

▮ **Size/Scale.** Different sizes or differences in scale can evoke moods and emotions in viewers; therefore, size variations among elements are frequently used in production design. Keeping with the theme of simplification, you should typically apply scale in accordance to the theme or mood of the scene or the character's situation. If the character is lonely, lost, or overwhelmed, consider using a very large space to dwarf the actor. If the character feels trapped or claustrophobic or eager to escape a situation, think about including low ceilings to make the space feel more oppressive.

▮ **Rhythm.** In design parlance, rhythm refers to making certain elements recur or show up in some kind of regular pattern.

Mise-en-Scène

The specific arrangement of elements on a set goes hand in hand with the overall design and use of the space itself. The French term **mise-en-scène** has been brought over from the theatrical world to express this concept. Mise-en-scène

Tip USE PAINTS

You can learn a great deal about color combinations simply and inexpensively by purchasing a set of watercolors or acrylic paints, blending them together in various ways, and then painting simple blocks of different colors and shades, or degrees of the same color, on a piece of paper. Pick a basic mood, such as joy or sadness, and try to create colors that express those feelings. This exercise will come in handy when you are trying to match mood and colors while designing sets.

Tip AVOID PURE WHITE

Generally, with digital cameras, it is not a good idea to film characters against pure white walls, as clothing and certain colors can cause artifacts (undesired changes in the way an image looks) against white backgrounds. If you have a creative reason to use a white wall, take that into consideration when costuming your actors, and make sure you do not use a flat lighting scheme.

FILMMAKING

Out of the Past (1947) uses noir-style lighting as part of its mise-en-scène. Courtesy Everett Collection.

Tip **DO YOUR HOMEWORK**

Watch movies and study film history. The best way to learn production design is to examine the work of leading directors and designers; the world of film is chock-full of this kind of work.

refers to the display of every visible element in a frame—from the architectural structure to the paint on the walls down to the smallest props, and everything in between—with the notion being that everything visible has a purpose and is there to reinforce the point of the scene or aid viewers in figuring out, or contextualizing, the story's details based on what they see and how it's arranged.

In that regard, there are certain factors you need to think about in terms of how elements will be arranged. These include the following:

- What or who will be dominant in the shot?

- What type of shot and camera angle will be used—wide shot? close shot? (See Chapter 7).

- How will you be framing the shot?

- What should be the dominant color in the scene?

- Form—will the set be open or closed? Will actors or elements be framed within a window? a door? an archway?

- Where will characters be placed, and how will they be moving—in other words, how will you be blocking the scene? Will they be facing the camera? each other?

- Depth—what kind of space will you want between characters and major elements? Will you need to emphasize any particular background elements?

These and other factors are reasons why storyboarding or digital previsualization, as we discuss on page 88, can be valuable in helping filmmakers visualize elements in relationship to one another and in relationship to the camera and lights, even helping to block out basic camera moves and angles. But no matter

what method you use to "see" these elements coming together, you need to understand the function of each of these design-related elements:

▌ **Decor and props.** On a professional project, a separate **art director**, working for the production designer, will handle the creation of decorations, or **set pieces** (items that are not actually used but are part of the environment in which events take place), and **props** (items that characters will be physically interacting with and using). In this class, you will be figuring these things out for yourself. To accomplish your own mise-en-scène, move your thinking beyond simply "finding stuff that looks good" to thinking about each element's significance and usefulness. Will a decorative item reflect a character's lifestyle or beliefs, such as a crucifix on the wall if the character is religious? Will another decoration indicate the character's economic status or environment he or she is confined in? Will it indicate conditions or events, such as bars on windows or bullet holes in walls?

▌ **Costumes and makeup.** Logically, the purpose of a costume is to clothe a character according to that character's specific characteristics in order to enhance believability. In professional productions, costume design, makeup, and hair design are all separate disciplines, whereas you will have to handle these issues yourself. In either case, costumes, makeup, and hair eventually all need to be integrated with production design. Thus, the nature, color, patterns, texture, and placement of clothing on the actor are part of mise-en-scène—part of the larger arrangement of visual elements on your set. Therefore, you need to think about your overall design when considering costumes and makeup, rather than addressing them independently.

▌ **Lighting.** Lighting sits at the heart of successful cinematography because of how its skillful use can contribute to emotional reactions from the audience. This is why we have devoted two chapters to the discipline (Chapters 8 and 9). Lighting impacts numerous other disciplines—production design, in particular. Simply put, light and design need each other. Design can help enhance or obstruct or manipulate light on-set, and light can help display or enhance designs or, alternatively, hide flaws, among other things. Along these lines, veteran director and production designer Catherine Hardwicke strongly urges students to study lighting in paintings and photographs. "What direction does the light come from?" she suggests you contemplate. "Don't forget, light can expand space—even small sources of light at the far end of a room, or deep in the distance, can add great depth and production value." In Chapter 9, we discuss *high-key light* and *low-key light*—both of which are important complements to design. High-key lighting reduces shadow and thus reduces tension; therefore, it is used in environments that are designed for those moods. Low-key lighting, by contrast, is a strong-contrast lighting approach designed to heighten tension with darkness and shadows. Orson Welles's *Touch of Evil* (1958) and Carol Reed's 1949 *The Third Man* (which starred Welles) perfectly illustrate how light and design can be united in tense stories. Having a close synergy between design, lighting, and camera positioning can also help you save time and money in the design process by eliminating elements that will never be seen in the frame.

▌ **Human beings.** In Chapter 3, we had the larger discussion of how to direct and use actors for maximum effect, and we have already mentioned costuming and the impact that has on design. But the physical attributes of your actors and

tech TALK

Color Theory in Design

We discuss various aspects of color's role in cinematic presentations in Chapter 8, including such general notions as the idea that the more colorful an environment, the warmer it appears, and the less colorful, the colder or more sterile it appears. Color theory represents an entire academic discipline beyond this book's scope, and you will benefit from educating yourself about it in more detail beyond this course. From a production design point of view, focus not only on how to create or select particular colors for particular elements but also on how other elements will impact or be impacted by those choices. What factors influence or change colors or cause them to clash, contrast, or match up nicely with one another?

The principles of color theory can assist you with these questions. *Hues* (predominant color attributes), *luminance* (brightness), and *saturation* (intensity) are terms you should familiarize yourself with, because you will be considering them as you make color selections. Colors you choose can grow brighter, duller, distracting, more appealing, or confusing to the eye depending on various factors. In terms of filmmaking considerations, here are a few areas that directly impact color on-set:

- Lighting, as noted here and in Chapter 8, directly affects how color and physical elements appear to the camera and recording medium you are using.

- Smooth surfaces tend to make colors more saturated, and dull surfaces tend to make them less saturated.

- Dark backgrounds make foreground colors appear lighter, white backgrounds make foreground colors appear darker, and background and foreground colors can have a visual impact on the intensity of one another on the big screen.

- Warmer colors (reds, oranges, and yellows) tend to translate to more upbeat emotional responses from viewers. They also tend to make objects appear smaller and thus are often used closer to the camera. Cooler colors (blues, greens, and purples) tend to evoke less empathetic emotional responses and make objects look larger; therefore, they are often used for objects meant to be perceived as being far away.

- Some colors can evoke specific emotions, such as sexuality or anger in the case of red. White often suggests calm and simplicity, black often suggests evil or fear or deep mystery, and so on.

how they are placed and moved in scenes is also part of the mise-en-scène paradigm. In this respect, the concepts of **typage** and **frontality** come into play. Typage involves using actors based on facial or body features, almost a stereotype of sorts, but not only for purposes of story points. Typage can also be used to enhance design ideas—people with Asian features to enhance Asian environments, short or tall people to fit properly into certain fantasy environments, and so on. Frontality refers to the idea of staging an actor so that he or she faces the camera directly. This might be done if the actor is in a scene meant to make viewers feel they are part of the same world as the events they are seeing on the screen. If the actor is facing the camera, elements around him or her may need to be specially arranged.

- **Depth.** Earlier, we defined the term *space* as it relates to production design. Visual elements can be arranged to form shallow space or deep space. Those

decisions connect directly to mise-en-scène considerations; the placement of elements will obviously be very different if your major points of focus are far away from one another in the frame rather than extremely close together.

ACTION STEPS

Choosing a Color Palette

In Chapter 11, we discuss various aspects of manipulating color to achieve creative goals in postproduction, but it is important to remember that the more you get right in the design phase, the less digital color manipulations you will need to worry about later. As you design your film, keep in mind that color is one of the designer's primary tools in helping to convey various aspects of a story's time frame, location, character traits, emotions, moods, and motivations.

Also, remember cinematography as you choose a color scheme. Study what colors will look good when captured in the light you plan to use with the cameras you plan to use, and keep in mind that certain colors will render differently depending on the film stock or digital camera system you use, how you light the scene, and what format you are outputting the images to. For example, any form of water can take on any color based on how it is lit, time of day, or the filter choices by the cinematographer. The design choice of the water's color will greatly influence the emotion of the shot. (Chapter 8 gives helpful insight into some of the strategic ways you can use various types of color gels on lights and filters on camera lenses to influence color tone, range, and saturation in-camera.)

Here are some tips for choosing and working with a color palette:

1 **Select a general color palette.** This is not a hard-and-fast conceptual rule, nor is it about executing perfect color coordination. Rather, it is a useful guideline—a way of making sure everything captured by the camera stays within your story's world. When thinking about your palette, pay attention to colors used in photos, movies, magazine articles, and other materials. If they relate to the era and story themes you are putting together, evaluate if those color schemes would be applicable to your material.

2 **Keep color choices consistent.** Be sure that they support the characters and environments you are photographing. If your movie is based on comic book material, you might use a comic-strip-inspired color palette. If you are making a film noir piece, you will probably gravitate to blacks, browns, grays, and anything else that looks good in low light. If you are making a lighthearted romantic comedy, you will likely want to keep the movie within the confines of bright, cheery colors and how they will appear on-screen.

3 **Do color tests.** Use paint and fabric swatches, actual paint, or colored markers to experiment with combinations, examine options, and study various colors.

4 **Create a color script.** A color script is a series of color drawings that show the design arc of the story from the perspective of color. Simply by looking at where the "cool colors" and the "warm colors" are placed, you can see the ups and downs of the story arc as visualized by the production designer.

How Do I . . .
Use Design to Tell a Story?

Go to LaunchPad and find out: **macmillanhighered.com/filmmaking**

NAME:	**Alex McDowell**
TITLE:	Production designer
SELECTED CREDITS:	*Man of Steel* (2013); *Watchmen* (2009); *Charlie and the Chocolate Factory* (2005); *Fight Club* (1999); *The Crow* (1994)

Many people think of production design as what's on the surface: the design of various elements we see in movies. But as veteran production designer Alex McDowell notes, it's more about the "connective tissue" that holds all those design elements—environments, objects, and characters—together. McDowell talks more about using production design to enhance a movie's story in a video interview available only on the LaunchPad for *Filmmaking in Action*.

Discover:

- How designs for *Fight Club* became an extension of the screenplay
- How production design can offer solutions to narrative requirements
- Why what's on-screen in a movie is not always as important as the reasoning behind what's on-screen

Visit the LaunchPad for *Filmmaking in Action* to learn more—and to explore how you might use this advice.

Design Plan

With the aforementioned design principles in mind, formulate a workable plan for how you will go about designing your film's locations, sets, backgrounds, and other environments. Similar to other aspects of filmmaking, this starts with breaking down your script (see Action Steps: Design Analysis, below). During that process, you will reach conclusions about what scenes will require locations to shoot in, and which ones you will either need or want to build sets for. Then, you will dig deeper and decide what locations should be dressed up or altered in some way, and what set pieces and props you will need.

After you evaluate your story, think about which of these choices are realistic and which are not—what you *can* and *can't* actually do—and how you can either tailor your resources for what is on the written page of your script or strategically write something that you know will fit your resources. For example, if you know you will have no crew, and you have no construction experience or funds for buying materials, then obviously you will need to focus on finding existing locations rather than building sets. On a professional production, you would make these types of decisions in partnership with a production manager—the person responsible for evaluating proposed locations from a logistical standpoint—as we will discuss in Chapter 5. For now, at the student level, you will likely be solely responsible for considering the balance of your creative needs with your logistical limitations while evaluating this delicate location versus sets paradigm.

In fact, because of resource limitations, student filmmakers most typically film on location, rather than trying to afford stages and build sets. However, even if that is the case, you will almost certainly still need to build, paint, or otherwise change *something*. Thus, the fundamentals of figuring out and allocating resources, scouting locations and dressing them, and building sets or set pieces are just as important for you to learn as are the principles of art and composition.

ⓟractice
ANALYZE A SCENE

Watch William Wyler's classic 1959 film, *Ben-Hur*, with special attention to the important four-minute "The Race Goes On . . ." scene, which takes place following the film's famous chariot race, when the dying Messala meets his vanquisher, Judah, as he lies on his deathbed. (You may also be able to find the specific scene on YouTube or elsewhere online.)

In the scene, take note of the production design in general, and the concept of mise-en-scène in particular. Write an essay describing in as much detail as you can how production design concepts came together to advance the emotional impact of the scene, from the smallest props and decorations to the colors, use of light and shadow, and so on. Note that there is no perfect description for all of this, but the sequence exemplifies how a set can be physically designed and a space used and lit so that the grand total of all the elements is far greater than the sum of the individual parts, which is, of course, the whole point of the mise-en-scène concept.

ACTION STEPS
Design Analysis

The screenplay is the first indicator of what the foundation for your production design needs will be. Following is a rundown of basic factors in your screenplay that will directly impact your design plan. It's important for you to develop an awareness of these factors within your story before you can properly move on to the research phase and then begin designing sequences, because some, if not all of them, will influence virtually every design decision you make:

❶ **Time and Place.** These are probably the most obvious considerations when you first review your screenplay. If your story is a period piece or takes place in a unique locale, that will directly influence many design parameters, from costumes to architecture to colors to doorknobs. But keep in mind that the trick is in the details: you will need to make notations about the kind of details you must research for the era and locations your story requires.

Continued

Continued from the previous page

2 **Define Characters.** A character's personality, lifestyle, and personal needs directly impact, as they would in real life, that character's living, working, or recreational space. Evaluate and make notations about each character's personality, economic situation, age, and so on. Think of what kind of residence that character could logically afford or have access to.

3 **Light.** When evaluating your script, think *practically* about what kind of lighting the story will require. We have already discussed the value light can have in aiding production design, both generally and creatively, but you also need to think about light with specificity, as it relates to your story. On page 88 we examine previsualization, which can include particular lighting setups when feasible, but before you get to that point, breaking down your screenplay can help you determine what your overall lighting needs will be. After all, every locale other than a pitch-black room needs to have some kind of illumination. Scenes can be lit naturally, by sunlight, moonlight, or ambient light through windows; by source lights built into the set; or by movie lights, as we discuss in Chapters 8 and 9. Movie lights can be expensive and are not always feasible, particularly for student productions. So examine the script to start understanding what *kind* of lighting each scene might require and how you might fulfill those requirements. Will you need rooms with big windows? Can you illuminate scenes with practical lamps that are part of the design, forgoing movie lights? These are things you can notate when you first evaluate your script, long before you get into detailed research and design work.

4 **Color Palette.** On page 77, we discussed issues related to choosing a color palette in detail. Keep that discussion in mind as you break down your script, and search for the mood of every scene to help your design plan along; the mood of the events in the story will help you determine colors, so make notations about those sorts of things as you analyze the script.

5 **Dynamic Space.** As you read the script and make general notes about locations and sets, consider specific ways that you could make them as dynamic, interesting, and logistically feasible as possible. A boxed-in, four-wall room limits possibilities and actor movement, and should therefore only be used if the story demands it. If your options are limited, consider whether a certain space would allow you to establish depth with windows or glass doors. (See pp. 73–76 for more on the arrangement of people and elements within a particular space.)

6 **Feasibility Factors.** As you break down the script, think about resources and what is—and is not—practical. Are the locations or sets described in the screenplay even feasible? Will some of the elements called for require permits or bring about other complications? Should you consider rewriting scenes to ease some of these limitations? We discuss some of these logistical matters in more detail shortly, but you should start thinking about their impact on your design agenda as you begin to break down your script.

Research and References

After you have broken down your script to determine your overall project needs, you will begin meticulous research to find elements and solutions for strategically executing the design. As we have urged, you can, and should, do constant general research, and labor always to train your eye to notice light, shadows, textures, shades, fabrics, and other subtle things in the world around you and in great art and photographs; this kind of training will inform your decision-making process when you begin to design a particular set or location.

But general research isn't enough. You need to get specific—we want you to research potential visual qualities of every scene, location, interior, and environment. By "researching" them, we mean going out into the world and attempting to find direct or indirect visual references that evoke the environment in question. If you are shooting a scene at a circus, head to a real circus. If you have a sequence in a parking garage, study parking garages.

And by "going out," we mean exactly that—go out and study, and don't default to relying exclusively on the Internet. The web is a valuable and free research tool that students of earlier eras did not have access to. Yet veteran production designers insist that if you rely too heavily on it, and do not go out and physically examine real-world colors, fabrics, materials, and textures yourself, you will not be nearly as informed as you should be in making quality design decisions (see Producer Smarts: Dumpster Diving, p. 83).

Therefore, strategically collect and organize reference photos, magazine and book clippings, drawings, paint and fabric swatches, and so on. You should also create sketches or take photographs that relate to the types of environments you will be featuring in your film. If you have locations picked out, walk those locations, and take photos and room measurements, and draw sketches to keep a fresh frame of reference about each space.

As you collect this material, you must organize it. Some designers organize it into alphabetized files, others into binders or reference books that apply to each scene or location in a movie. Catherine Hardwicke calls these "look books"—essentially organized files or binders of relevant visuals and data that apply to all the locations in your film. These become your template for figuring out a final design for each location.

Keep in mind, however, that your binder or files may consist of more than just photos and sketches. They could also contain color options, swatches, paint chips, diagrams, notes, comparison imagery from different eras and sites, close-up photos of props and furniture, pieces of wood or fabric, and so on. Once you get the hang of it, you will be able to boil things down even further and collect reference material with more specificity. For example, you could look for the following:

- Different versions of similar places (restaurants, office lobbies, kitchens, parks); perhaps later you will prefer one over the other, or perhaps you will mix and match elements from the different versions you have studied

- Different exteriors visible in windows, depending on whether your setting is urban, rural, domestic, or foreign

- Reference materials of similar locations that are lit differently—with more or less exterior light or interior light only

- Examples of different kinds of furniture—more modern or more vintage, in good or bad shape, in a wide range of colors, and so on

- Comparisons or before/after imagery of the same place, or side-by-side comparisons between photos and drawings or paintings

- Imagery of locations empty and with people in them, so that you can study how people will interact with props and set pieces and impact the configuration of the space

These are just a handful of examples. There is no limit to what you can collect or how you can organize it, as long as your organizational method is efficient. Remember, as a bonus, these types of look books will outlive your project and eventually join a personal research library that you will likely find useful if you pursue filmmaking in the future.

Locations

Detailed script analysis and extensive research should lead you to a general understanding of when and why you would be best served shooting on location, and when you would ideally want to build sets to achieve particular shots. When all factors are equal, for most movies, the notion of reality, or at least believability, is central to connecting with audiences. This is one reason location shooting is often ideal; a real location, when dressed and shot properly, almost always feels more realistic than a fabricated set. Of course, all factors are not always equal, particularly when it comes to resources. Regardless of what level on the filmmaking hierarchy you are on, location shooting can be, in many cases, more affordable than renting a stage and building elaborate sets, at least when extensive travel is not involved. The complications of building sets and working on sound stages are a high bar for you to clear with few resources as film students. Therefore, as you pursue a filmmaking education, you are likely to be shooting on lots of real locations over time. Keep in mind, however, that a "location" could be your backyard or classroom or driveway. Such everyday places close to home are sites you should seriously consider if they can be made to fit with your story. Don't discount them—you can radically alter and highlight even the most mundane patch of grass if you need to.

To get started, you first need to know what to look for when scouting locations that will work practically and creatively. In the professional world, **location managers** take the lead in this effort, but they do so in close collaboration with the director, production manager, and production designer, who frequently join them on location scouts.

As student filmmakers, take extensive notes when you scout locations. One glaringly obvious factor does not need much elaboration: investigate from the outset whether it is even possible to get permission, or an official permit if required, to shoot there. Although it is true that many students and independent filmmakers shoot "guerrilla style" in public locations—simply showing up with camcorders, filming with minimal setup or crew, and departing as quickly as they came—understand that operating that way can be disrespectful to the general public frequenting that area at best, and downright illegal at worst. And creatively, shooting in that style may end up giving your narrative material a documentary feel that is not intended. Get permission or go somewhere else.

producer SMARTS

Dumpster Diving

Many of the most important furnishings seen in the apartment of the Lynn Bracken character (played by Kim Basinger) in the 1997 noir classic *L.A. Confidential* were found in a consignment store in Palm Springs, according to Jeannine Oppewall, the film's production designer. She likewise found the dining room table featured in certain scenes of *The Bridges of Madison County* (1995) "in the front window of a used furniture store maybe an hour from the set"—a table Oppewall used again for a particular set in *L.A. Confidential*. Over the years, Oppewall has even put her own furniture, and the furniture and possessions of friends and crewmates, into feature films she has designed.

In that respect, Oppenwall says, "production design is a shameless profession—we will beg, borrow, steal, and go anywhere to find something useful." In other words, even professional productions severely limit resources and require ingenuity on the part of the production designer and his or her team to find appropriate set pieces. That's good news for you, the film student, since you will likely have no budget of substance to work with, and yet, like professionals, you will need props and set pieces that fit your stories like a glove.

Therefore, as many designers suggest, go anywhere to find what you need, bargain hunt, and innovate. Think like a producer—you need not spend a sizable amount of money to furnish typical sets. This is an area in which you can most likely find what you need within the confines of your budget. Flea markets, garage sales, pawn shops, antique shops, estate auctions, consignment stores, junkyards, online sites like Craigslist where you can find used goods, neighbors' houses, and even your own home most likely contain most, if not all, of what you need. Jack Taylor freely admits to having gone dumpster diving in his career, even loading discarded items on street corners into his vehicle if he felt they had cinematic use.

Additionally, you will find that many prop and costume shops that normally service the entertainment and theater industries will offer special deals, discounts, and even free items to student productions out of a desire to promote their businesses and lure the next generation of potential customers.

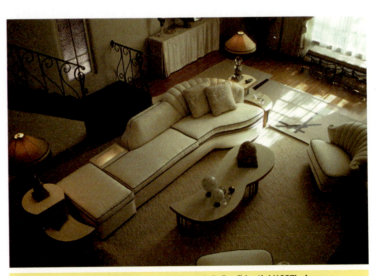

This overhead shot of a living room set from *L.A. Confidential* (1997) shows a variety of props and set pieces.
Courtesy of Jeannine Oppewall.

With that said, here are other fundamental factors to consider:

▮ **Tweak your script to match what's available.** If resources dictate that you will only be able to shoot on campus or at your home, then there is no sense searching for a medieval castle to shoot in. You will either have to create that element with *stock elements* (images you can purchase from somewhere else) or visual effects, or go without it. If you're preparing your story and you learn that there is a gym on campus you think you can shoot in as well as a local public park, set scenes in similar locations, so you can use what you have at your disposal.

▮ **Consider large spaces.** For interior work, select large spaces with high ceilings and multiple doors or windows when you can, even if you are designing a small space. The advantages of shooting in a spacious environment are great, the cinematic tricks available to make the space look smaller on-screen are plentiful, and you will likely have opportunities to repurpose the space. Among its advantages: high ceilings and doors and windows you can maneuver through make it easier to fit people and equipment in and out of the space, and they enhance options for moving your camera.

▮ **Environments change.** As you examine locations, keep in mind season, time of day, weather, and that human or animal activity can change the look or structure of an exterior environment. Study the location at the approximate time of year and time of day when you would expect to be shooting. Find out if construction or seasonal events will change the environment in any way before you will be able to shoot there. Also, examine and measure natural or artificial light when scouting the environment, take pictures, and shoot test footage if you can. You must be certain that you will be able to do what you need to do when you return there days, weeks, or months later. In particular, for exteriors, spend enough time at the location to track the sun: take note of when the area is in full sunlight, part sunlight, and total shade. This will help you plan what time of day to use the location.

▮ **Hear the location.** Because you will likely be recording audio in the location, you need to study ambient noise there. Test levels and learn about local traffic patterns, whether animals or children frequent the area, and so on. Test echo patterns, as discussed in Chapter 10, and record test sound there with the same equipment you will be using when shooting. Also, if you are planning to use wireless microphones, make sure there is no signal interference in the area.

▮ **Logistics.** The first, most basic thing to check is whether enough power supplies are readily available in the area for you to use freely, or if you will need to bring generators or extra batteries to the site. While you are at it, test some potential setups of how you would like to position cameras and microphones. You should also determine whether an exterior location is too grueling for your equipment, since electronic cameras and audio technology can be sensitive to moisture, wind, dirt, sand, and heat. Other logistical issues include parking; walk-up accessibility; access to food, shelter, and bathroom facilities; Internet or cell-phone connectivity; cooperation of the neighbors; and security.

There is one other factor to consider in deciding whether or not to shoot on location and, if so, how to go about finding those locations: time. It can be time-consuming and laborious to drive or fly, even if resources permit it, to various locations for hours, days, even weeks on end, to find spots that work best for you. Once again, think like a producer: if what you are looking for is exceedingly rare or unusual, and you expect it won't be easy to find, you will need to calculate the time and resource benefits of searching for that location versus coming up with a plan for building a set for it.

Sets

There are many reasons to build sets rather than shoot exclusively on location, particularly when there is no accessible location available to you. Another reason might be when complete control of lighting is needed for a visual effects scene. It can sometimes be more cost effective to shoot on a stage rather than risk the vagaries of a location shoot, as light control is a dominating factor for that kind of material. More generally, you typically have more control over light, weather, power, and other logistical issues on a set.

As noted earlier, one of the drawbacks is that you may have a hard time achieving the same level of realism that you would on location. Another obstacle revolves around resources. To build sets, you first need to find a place to build them—a sound stage usually, although you can creatively employ warehouses, basements, airline hangars, or garages for low-budget projects. Procuring permission and affording the cost of renting a sound stage can be difficult. Second, you need raw materials and proper equipment. Third, you must possess the design, construction, and paint skills necessary to build sets, as well as the ability to get the work done in a safe and efficient manner.

Still, one way or another, you will eventually have to build a set of some type. Let's look at a handful of foundational issues you need to address when planning sets:

- **General design.** Using sketches, storyboards, or digital tools to previsualize your set (see p. 88), design not only what you generally want it to look like but

PREDESIGN WHEN YOU CAN

Predesign for technical requirements whenever possible, particularly electrical needs. Sometimes—when building walls, for example—you will need holes strategically cut to permit power cord access.

CARRY A LOGBOOK

When ramping up a production, carry a design logbook and routinely make notations in it of design elements in the real world, in your own environment, or in movies or other media that you encounter. Examine buildings, rooms, and furniture, and either make notes about interesting characteristics or take photographs.

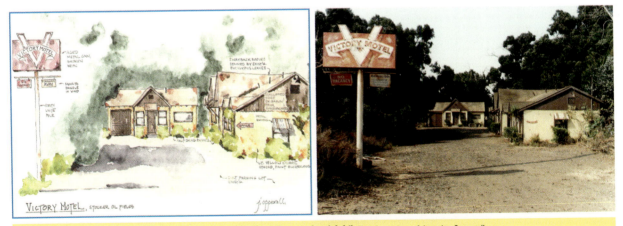

A sketch of a set for *L.A. Confidential* (1997, *left*) and its final, live version (*right*) Sketch courtesy of Jeannine Oppewall.

FILMMAKING

Tip **MAKE A STRIKE PLAN**

Think about cleanup: Have a strategic plan in mind to strike, or dismantle, the set efficiently, and neatly dispose of all elements when you are done shooting. Certain materials can be stored and reused, others returned, others thrown away, and still others recycled. You need to research what, if anything, you are required to do with materials, especially with regard to possible hazardous waste, when you are done with them, and to plan the logistics of their removal early on, not just when you are done shooting your movie. In Hollywood and around the country, there are many companies that specialize in doing just this.

also how you want it to function—where cameras and lights will go, for example. Depending on your tools, skill level, and experience, your design may be a full-on blueprint. But even if your skills don't permit that, be as specific as you can in terms of noting the size of the space you think you will need, remembering to include space for any important creative or logistical elements. Ideally, you will eventually create a **floorplan**—a map of the stage from above, so that you will be able to see all elements and their locations before you build anything.

▍ **Finding a stage.** This can be tricky, because renting a stage or studio space is often expensive. However, your school may offer facilities in the cinema or theatrical departments that you can arrange to use. Likewise, community centers and religious institutions may have space you can "borrow" during off hours, as long as you sign liability waivers and clean up when you are done. Or, in some cases, depending on the size and scale of your movie and sets, you can build in a garage, on a porch, in a field, in a barn, on a blacktop, and so on.

▍ **Construction plan.** On a professional project, a **construction manager** puts together a construction team and builds sets for major projects. Construction managers have reams of specialists to assist, ranging from carpenters, stagehands, painters, plasterers, grips, **set decorators** or **dressers** (tasked with procuring and placing all props and pieces that are not connected physically to a set), **prop masters** (in charge of finding and preparing all primary props), and **greenspeople** (who handle all plants on the set). You may need to head up

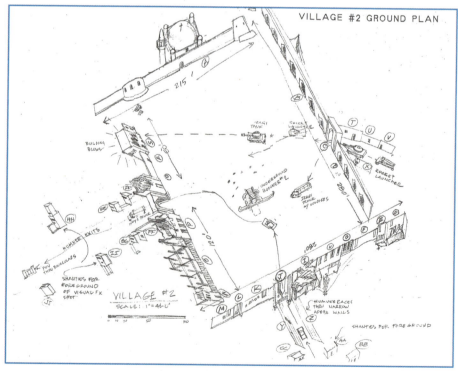

Ground plan for a set for *Three Kings* (1999)

Courtesy of Catherine Hardwicke.

Common Set Structures

Certain structures are commonplace on film sets and actually derive from the theatrical world. It is useful to familiarize yourself with these basic elements and nomenclature:

- **Flats.** This term refers to two-dimensional pieces of scenery you will be painting. Often, flats are little more than a material, like canvas, stretched over wooden frames. They can be anchored to the floor, lashed together, and used in all sorts of combinations. Flats can be kept standing straight up with various methods, including those as simple and inexpensive as weighting them on the bottom of the outside portion of the wall with sandbags. Keep in mind that this form of construction likely won't work for scenes in which people or objects need to interact directly with the wall, as the fabric on a flat may not be strong enough.

- **Platforms.** These are simple layers of wood used to add height to an area of the stage, such as when depicting one room being a few steps higher than another in a house or giving the illusion of having gone up steps.

- **Wagons.** These are platforms with wheels attached for purposes of moving them, as needed, around a stage. Wagons can be elaborate, even motorized, and run on tracks.

- **Turntables.** Sometimes called revolves, turntables consist of a circular platform designed to spin. Actors, entire sets, or portions of sets can be placed on them.

- **Cutouts.** These are thin pieces of material cut in such a way as to mimic a pattern or outline on an object, a wall, or a building. Often, cutouts are attached to flats to represent patterns of a design or element meant to be seen on a set.

- **Drops.** These are made from painted canvas or other material hung from above, and they are often used to create the illusion of a distant background element, such as a cityscape or night sky.

- **Scrims.** These are a form of a drop—large, typically unpainted, and often loosely woven or opaque so that they alter the properties of light when photographed from particular angles.

- **Cycloramas.** These are curved walls frequently built out of plaster but sometimes made of large pieces of fabric painted, hung, and lit in a particular way to give the illusion of a night sky or another wide, open space. "Cycs," as they are often called, can also be giant green screens or blue screens for visual effects purposes.

- **Projections.** As the name suggests, still or moving images projected live onto a background, such as a cyclorama or a flat, can be used to conjure background or distance illusions on set.

some or all of these tasks yourself, but unless you have a lot of time to prep or very little to build, you'll need a crew of some type. Turn to classmates and friends for help building key elements (see Tech Talk: Common Set Structures, above). In addition, it's a great idea to consult with a construction expert or professional at some point about the finer technical details of building sets. Obviously, keep safety in mind at all times, and understand that certain types of work in certain types of locations—and certain equipment—require permits and/or licensed experts to handle.

Tip **PREDESIGN WHEN YOU CAN**

When searching for locations, keep in mind the likely limitations of your shooting schedule and resources. If you find two locations for two separate scenes that you love but they are two hours apart, will you have time to schedule different days to shoot at each? Traveling between the two will eat up a large chunk of a shooting day. A better idea is to find your most complex or important location first, and then hunt for related locations nearby. Alternatively, see if you can dress one location in different ways, to stand in for different places. If you need to show interiors of two different homes, for instance, try to find one home in which you can use different rooms for different characters.

■ **Building only what's necessary.** Think economically when figuring out what sets you will need, and keep in mind that a wealth of cinematic tricks exist that may permit you to film on partial sets—a wall or door frame, for instance. If a scene is extremely brief, it doesn't make sense to spend a lot of time or money on an elaborate set. For scenes in which you will be shooting in only one direction, you might be able to get away with not building a complete set, if portions of the set will not be captured on camera. If that is the case, only build or decorate the portion of the set from the direction you will be filming. For example, if you are using camera angles that never show the ceiling, then the ceiling does not need to be realistic—or even finished. Conversely, if a lengthy scene absolutely requires 360-degree coverage, apply what resources you have for set design and construction to those scenes above all others. Reuse sets when you can. You might be amazed how a few props and some paint can transform a hotel lobby into a business office.

Practice
FINDING ELEMENTS

Read and evaluate a complete scene from any screenplay, compile a list of set pieces and props you would need to film the scene, and explain why each of them is necessary or at least useful to advancing the cause of the story and achieving the emotions intended by the writer. Then, put together a miniature "look book"—photographs, sketches, paintings, books, other movies, color swatches—that you would use as reference material for designing the look of that particular scene.

Previsualization

We have discussed the principles of good design; how to make a design plan; your options for finding and using locations; and planning and building sets. However, at some point during all these stages—and even after them, as you enter production and are actively planning specific shots—you will benefit from doing some kind of **previsualization**, or **previs**, work. The term *previsualization* can refer to state-of-the-art 3D computer animation, hand-drawn storyboards, simple sketches, paintings, simple models, stick figures drawn on napkins, and just about any other kind of conceptual art you can manufacture to help visualize individual elements, designs, themes, shots, camera moves, camera angles, complex visual effects, and any other images you will eventually need to create. The idea is to give yourself and collaborators a clear guide, or template, for what those elements will look like in the end and if they will physically fit in the space you are using.

Thus, in filmmaking, we often use the term *previs* loosely—it is not a linear process that takes place at one particular point during a project's life. Rather, it is a process that is used whenever it can be helpful. It helps production designers certainly, but it also helps directors, cinematographers, visual effects artists, and many others as they plan their work, while they do their work, and when they are trying to solve problems during those stages. In this sense, previs has become in recent years an important component of making big-budget films containing significant effects and stunts. Entire companies have emerged dedicated solely to the idea of helping filmmakers use computer animation and other visual effects' techniques to conceptualize complicated sequences.

Student filmmakers will have a hard time hiring previsualization companies or doing complex computer graphics previs work in most cases, but with affordable

off-the-shelf tools available, even simple digital previs is within your grasp. You can use techniques such as storyboarding, sketching, and making concept art to help you design sets and elements, but over time, you will learn to use these digital tools throughout the entire filmmaking process. For production design, in particular, they will be most helpful to you only after you have a firm understanding of the basic design principles, planning, requirements, and options that we have examined earlier in this chapter. That is why we have saved the previs discussion for last.

Sketches and Storyboards

Sketching shots and designs by hand is as old as motion pictures themselves, and the term *storyboards* has been around since at least the 1930s, when it was popularized at Walt Disney Studios as a tool for making animated films. For decades, studio artists there and elsewhere would draw comic-book style panels depicting various scenes in animated movies, and then film them "flipbook style," creating so-called **story reels**, or **animatics**, and even adding music, dialogue, and effects in order to create templates for filmmakers to follow as projects moved along. Over time, the concept was adopted by live-action movies.

Today, previs options have branched out into numerous areas, including doing everything on a computer. However, one way or another, even if you later plan to digitally previsualize shots or sequences, you will need to incorporate the idea of manually sketching out at least some key ideas into your design approach once you have done meaningful research. There is no single right way to do it, nor is there a requirement to be particularly artistically talented or detailed in your sketches. In fact, some designers warn against overloading storyboards and sketches with minute detail to the point where you've added more than you can feasibly execute or

LOOK TO COMICS

You can make your storyboards effective by using simple comic-book techniques—speech or thought bubbles, wiggly lines for movement, pencil shading, ovals, coils, cylinders for bodies, and so on. As long as the meaning of your storyboard panels can be understood by merely looking at the pictures, you will have created useful storyboards.

Storyboard panels illustrate visual plans for a sequence in *Twilight* (2008).

Courtesy of Catherine Hardwicke.

Concept art sketches for *Red Riding Hood* (2011)

Courtesy of Catherine Hardwicke.

stifled creativity regarding other possible options. Often, professional designers prefer to go with simple hand-drawn pencil or watercolor sketches.

At the prime level, there are two categories of sketches that you will need to concern yourself with. The first is **concept art**. Basically, these are relatively detailed drawings or diagrams that you create as reference templates for costumes or sets for yourself or other artists tasked with building those elements, frequently drawn in pencil, charcoal, or marker. When feasible, create concept art for all major characters, costumes, and sets to help you design the movie more efficiently.

Next, you will want to create storyboards. **Storyboards** are often used to visualize entire films or sequences as individual frames or shots, essentially as hand-drawn panels created to resemble comic books. Depending on your skill, time, and resources, they might be extremely detailed or little more than stick figures or shapes. But either way, their goal is to illustrate how you see characters, sets, and objects interacting in particular environments. This will help you design shots and camera angles and lighting setups later, and it will make it easier to move, solidify, and organize various design ideas along the way. Storyboards will also help you understand what you will and will not actually have to create, because they let you see what area of a set and what backgrounds will be in shots, and which will not.

Ideally, after you approve your storyboards, you will be able to make even more detailed drawings or blueprints of sets based on what you've come to understand from your research and your analysis of your storyboards. At that point, you have guides for building sets and set pieces, when necessary. Here is a list of the various storyboard approaches:

- **2D concept drawings.** These are highly detailed hand drawings that specify particular elements in great detail.

- **2D storyboards.** These are essentially hand-drawn, comic-book style panels, with as much detail as you need to plot out shots or sequences.

- **Animatics.** This is the result of 2D storyboard panels being assembled in order and filmed; animatics provide a sense of movement and story order to your previs work.

- **Photomatics, or photo storyboards.** Here, instead of drawings, you use photographs of your actors or people, places, and things that generally resemble your story ideas and assemble them together to give you an idea of designs and concepts you want to implement. You might even take friends or classmates to sets or locations and pose them in key places, photograph them, and use those rough templates as storyboards for some of your shots.

- **3D storyboards.** As with 2D storyboards, these are panels created to plot out your shots and sequences, but they are created on a computer, rather than drawn by hand, and are combined with other panels on the computer.

- **3D animation.** Here, you roughly animate shots or sequences with basic movements and other elements to help you better define how you might design and choreograph a scene. Some form of 3D animated previs is quite common for visual effects sequences.

In the next section, we will discuss some of these digital previsualization techniques in more detail. But for hand-drawn storyboards, even if you don't have the artistic talent to produce compelling, professional-level sketches, the web is full of dozens of resources for learning basic drawing and storyboarding skills. Don't let your lack of drawing skills inhibit you from eagerly pursuing concept art and storyboards. As Jack Taylor noted, even rudimentary drawings will "get your mind going" as the design process picks up steam, and that can only help your project.

Digital Previs

Digital previsualization of shots, sequences, even entire movies, has been growing in sophistication and popularity in Hollywood since it first evolved in the late 1980s out of computer-aided design (CAD) technology used in the architecture world and the then-nascent computer-generated imagery (CGI) industry. Today, many filmmakers are commissioning extensive 3D animation to plot out complex sequences down to the last detail. Although you won't have the time, resources, or experience to do that kind of work at first, you will have access to affordable yet powerful 3D tools, as we discuss in Chapter 13, with which to do some fairly simple previs work if you put your mind to it (see Tech Talk: Digital Storyboard Tools, p. 95). In some situations, straightforward 3D imagery can give you a better perspective on what the shot's design and technical requirements will be, and how it might work from different angles.

For production design, digital previs can be particularly helpful in allowing you to reach conclusions about what elements you will be able to build and shoot practically and what elements you will need to create on the computer. Particularly for action sequences, car chases and crashes, and explosions, filmmakers

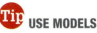
USE MODELS

Besides using sketches, you can also benefit by using simple scale models as a previs technique, giving you a three-dimensional view of your design. You don't need expensive materials and deep model-building experience to accomplish this. You can build rough representations of your sets out of cardboard or other readily available materials, and you can paint them to enhance the illusion.

Previsualization (*top*) helps effects-intensive films like *The Amazing Spider-Man 2* (2014) map out their action sequences (*final version on the bottom*).

The Amazing Spider-Man 2 © 2014 Columbia Pictures Industries, Inc. All Rights Reserved. Courtesy of Columbia Pictures Marvel, and the names and distinctive likenesses of Spider-Man and all other Marvel characters: ™ and © 2014 Marvel Entertainment, LLC & its subsidiaries. All Rights Reserved.

have found that they can more safely and affordably create those shots digitally. But even so, they need to design each and every element—from walls and cars to flying glass, smoke, and fire—just as they would for real-world elements, and previs is central to succeeding in that regard.

As we've noted, digital previs can also help plot camera moves and lighting placement in great detail. If, for example, you will be shooting actors in front of a green screen on-set, you can figure out long before productions starts what the digital background that will replace that green screen will look like by experi-

The *Sin City* films (2005, 2014) use an extreme version of set extension, where most of the settings, sets, and backgrounds are created digitally from bare-bones live-action footage.

menting with different designs, including colors, textures, and patterns, during the digital previs process.

Indeed, digital previs is crucial in the growing trend toward combining real-world elements with digital elements through "construction" of entirely **virtual sets** or **set extensions**. Virtual sets—used either when productions cannot afford or do not want to travel to locations or build sets, or for stylistic reasons—involve shooting with a green screen and later surrounding the actors with CG environments. Set extensions are used when filmmakers build partial sets, and then combine them with virtual "extensions" that complete the illusion. While the digital age has made this easier to do, the technique of creating matte paintings on glass and combining them with minimal footage from the set is almost as old as the art of filmmaking itself. Like real sets, virtual sets or set extensions require intimate design. The computer allows unprecedented experimenting in this regard. You can change backgrounds, colors, and shapes; add or remove signs, cars, text, and doors; and so much more.

Digital previs allows you to view the sets you are designing in three dimensions and in greater detail than a hand-drawn storyboard can provide. As the creator of the film and its production designer, you will hopefully already have a good, three-dimensional vision of the movie in your head. But the ability to work with that image using sophisticated software on a computer, show it to others and get their input, and then revise it rapidly has been a major breakthrough.

An added benefit of doing digital previs is that it involves many of the same tools and techniques as visual effects work and, in some cases, will allow you to create portions of digital assets that you will be able to build on later, when you strive to create the eventual 3D image, rather than starting over. If you previs a building, for instance, the basic wire frame and possibly other elements may serve you well when you begin doing visual effects work on the scene involving that building.

Here are the basic steps you will go through if you choose to do digital previs work on your movie:

1. Create a list of scenes or shots that you intend to previsualize, with brief notes about what you need and want from each shot and its significance. If you are previsualizing the entire sequence, you will list every frame you need. If you are conceptualizing it and want to create a digital template for designing the entire scene, you might only list the most crucial shot in the sequence.

2. Doing digital previs does not mean you should forgo storyboards, or at least the use of rough sketches. Start with sketches of key sequences or shots, and then use them as reference material for creating your digital previs material. Alternatively, if sketching is simply not something you feel you can accomplish, go to your locations and photograph environments and specific elements, or even have friends or fellow students roughly act out some blocking for your sequence and take pictures of that, and use those photos as storyboard equivalents.

3. Similar to the process described in Chapter 13 for animation and visual effects, you will use your animation software to create a rough version of the 3D environment you are designing, and block out where characters, elements, and possibly cameras and lights should be placed. If you are previsualizing primarily for blocking and camera movement, your buildings and designs will

Ⓟractice

STORYBOARD EXPERIMENT

Identify a shot or sequence from your screenplay, and using techniques discussed in this chapter and any methodology you prefer, create some storyboards or shot sketches. You can hand-draw them, download and use a free version of SketchUp (www.sketchup .com) or a trial version of another digital storyboard tool, or use editing or CG software tools already in your possession. The visceral quality of your artwork is not important at this stage, just its creative usefulness. Experiment with a few different designs and setups; when you come up with something you like, write an essay about your experience— what the challenge of your scene was, what you tried to accomplish with your storyboards, and what you learned about previsualization from the experience.

be rudimentary at best—perhaps even just blobs or blocks. For design speci-ficity, you will need far more detail, but only for the particular elements you are concerned with in a shot. Therefore, you will likely not need to take all the 3D material in each shot through the traditional animation steps described in Chapter 13.

4. Instead, you will render out CG images as soon as you have the minimal amount of detail you need to previsualize your sequence adequately. Depend-ing on your needs and resources, you may do a rough render and then, after making adjustments, re-render for greater nuance, detail, or other refinements to some elements, such as costumes or architecture. The point, however, is to go only as far as you need to in order to make your design or filming decisions, rather than to pursue near-final-level quality.

5. Eventually, once you have the 3D previs material at the level you need, you will edit the shots together in the order you want to view and share them. But you may also wish to print all or some of them out and mount them on walls or boards in your workspace for easy reference, as is frequently done with hand-drawn storyboards.

Digital Storyboard Tools

There is now a wide range of useful and affordable computer tools designed specifically to help you create sophisticated storyboards and previsualize action, blocking, lighting, and camera moves, among other things. Here are a few popular ones:

▮ **SketchUp** (www.sketchup.com). This is a 3D drawing product with a low-end free version, in addition to more powerful versions at reasonable prices. Sketchup is designed for you to use as if you were sketching on paper, and you can certainly do rough blocking and design with it.

▮ **FrameForge** (www.frameforge3d.com). This tool is specifically designed for moving image previsualization work, and can help you draw rough storyboards, do layout, and create rough animation and blocking, among other things.

▮ **StoryBoard Quick** and **StoryBoard Artist** (www.powerproduction.com/index.php). These tools, from the same manufacturer, are both digital storyboard crafting tools. StoryBoard Quick is designed for simple storyboard generation, whereas StoryBoard Artist adds animation and extensive revision tools, among other things.

▮ **Photoshop** (www.photoshop.com). Long available to consumers and professionals alike, Adobe's famous graphic design software is quite useful for manipulating scanned images, photos, and 3D images, and can be used for storyboard creation, among other design-related tasks.

▮ **Poser** (http://poser.smithmicro.com). Poser is a well-known tool for simple design and animation of virtual characters, rather than environments.

Designer's Emergency Kit

▮ Drafting paper/sketchbook
▮ Pencils and markers
▮ Tape roll with different kinds of tape
▮ Dulling spray and other spray paints that can darken surfaces
▮ Sponges for mottling paint
▮ Cleaning supplies for cleaning surfaces
▮ Scissors or X-Acto knife
▮ Digital still camera
▮ Camcorder
▮ Compass
▮ Maps
▮ Tape measure
▮ Laptop with graphics software or CGI software installed

CHAPTER 4 ESSENTIALS

▮ You need to study the fundamentals of good design and staging. Learn about the use of space, color
palette, balance, harmony, lines, textures, shape, form, size, and so on. Then, examine issues related
to arranging elements within those spaces—creating things like props and set pieces, developing an
overall sense of decor, and figuring out how to place and use those elements wisely.

▮ Strategically analyze your screenplay—scene by scene, shot by shot—and come up with a design
plan for how you want to use the spaces you have available: whether you can use real-world locations
or build sets, how you want to arrange elements within those spaces, how you want to design each of
those elements, and how you want to light and shoot them. Extensive research is crucial for launching
this process.

▮ Find ways to previsualize how you want to design and arrange things. Methods typically revolve
around creating concept art and storyboards for key sequences, and using computer storyboard or
animation tools to visualize the shots in three dimensions, allowing you to experiment with design and
technical options before you commit to them. This will be useful as you proceed with the construction
of sets, the dressing of locations, and the detailed planning of shots.

KEY TERMS

Art director
Concept art
Construction manager
Floorplan
Frontality
Greenspeople
Location managers

Mise-en-scène
Previsualization (previs)
Prop masters
Props
Set decorators (dressers)
Set extensions
Set pieces

Storyboards
Story reels (animatics)
Typage
Virtual sets

"The execution of the initial plan and any backup scenarios should always follow the writer's words and the director's vision within the constraints of the budget."

– **Tim Moore, veteran production manager and producer, whose films include *Flags of Our Fathers* (2006), *Gran Torino* (2008), *Invictus* (2009), and *American Sniper* (2014)**

Production Planning and Management

The Climb (2002)

By 2002, Tim Moore was a seasoned production manager, line producer, and producer of independent movies and television projects, but still about a year away from joining Clint Eastwood's team as a regular unit production manager and, later, co-producer. He was co-producing a small independent film called *The Climb* in Provo, Utah, responsible for setting up the schedule for a particularly grueling day of filming on the side of a snowy mountain in the middle of winter. By then, Moore was well-versed in the need to weave backup plans into his schedule, and it was a good thing.

"The first day, we built a camp on the side of the mountain in the snow, on a glacier," Moore recalls. He continues:

The night before, it snowed, and when we tried to get up to our set, we couldn't even reach it, even with help from the ski patrol. So we took the crew and equipment down the mountain and set up to shoot the scene in the parking lot, and we tried to do it, but it started snowing again, and it was way too hard to shoot there. Luckily, we knew about a warehouse about three miles away and we took everything down there—it was a plan we had ready to go, just in case. That day, we went to three different locations, and ended up in the warehouse, putting tents up on a stage [in the warehouse], and shot the scenes inside [the tents]—about eight pages. We made our day, and later went back and got the outdoor coverage that we needed. Did we think we would ever need to use that plan? No, but you always have to have things ready to go.

You have to think things out and not panic. There will always be an incident somewhere on every picture that will cause you to have to change your plans. It might be minor or it might be huge, but you have to be ready for it.

In Moore's case, he had experience, resources, and a team ready to help him execute his backup plans; the point, however, is that he had those backup plans to begin with. They were part of his schedule and, for that matter,

part of his budget. His team had strategically developed a series of options for what they would do in certain situations that would allow them to complete their shooting days on time and on budget, and that made all the difference in the world on that particular project. In other words, they had a plan, and their plan worked. On that project, or on any project—be it professional or student—filmmakers' chances of success are directly linked to their ability to strategically plan and organize.

But what exactly does "plan and organize" mean when it comes to filmmaking, and what does it particularly mean at the student level, where resources are few and experience is limited?

"The lower the budget, the fewer the resources, the more important planning becomes," insists independent producer/director/writer Jon Gunn, whose directing credits include *My Date with Drew* (2004, as codirector) and *Like Dandelion Dust* (2009). "Lack of planning will limit you, and prevent you from accomplishing the things you need to make your movie everything you want it to be. So it's important to think ahead about various scenarios and possibilities—for instance, having a backup location in case it rains the day you are scheduled to shoot outside, or having a plan for consolidating 10 shots into three

if you run out of time. These things are always smart, especially when you don't have money. Scheduling and budgeting are their own art forms, and they are particularly important when you are on a limited budget."[1]

Therefore, think of your schedule and budget combination as *the Plan*. The Plan is an initial realistic road map of how your movie will be brought to life—physically, technically, financially, and sensibly. It is far more than an estimating tool; it becomes the *practical definition* of how your story will be created. In effect, the Plan *becomes* your movie: the road, the car, the engine, the steering wheel, and even the finish line far off in the distance.

In this chapter, we will look at how a film's schedule and budget work in synergy as two sides of the same coin, and how they are created and managed. We'll examine what it will take to manage your production, including organizing production tasks and finding help and insight for organizing them; understanding the principles and technical aspects of creating, revising, and managing a shooting schedule; mastering the principles of building a movie budget and managing resources; and, perhaps most important of all, learning how to be personally *resourceful* along the way.

Management Overview

You may be the only person in charge of making and managing the Plan for your student film, or you may have help from friends, fellow students, family members, or even complete strangers eager to get experience. No matter what, production management tasks are plentiful at all levels of filmmaking, and strategies for dealing with them must be put into place. These tasks include creating and updating the aforementioned schedule and budget; managing the day-to-day logistical matters related to acquiring and moving cast, crew, and equipment from one location to the next; feeding people and getting expenses paid; solving problems as they arise; managing money; and answering to your professors or investors, if there are any.

In the professional world, these activities are handled by a seasoned production management team, which can include any number of producers who handle various executive, financial, management, or logistical tasks, in collaboration with more hands-on department heads on a day-to-day basis. As we discussed in Chapter 1 (see p. 9), the lead producer is the ultimate manager and decision maker on a movie project, and on student projects, that person is you, no matter how you divide up the work or whom you bring in to collaborate with you. But from a basic, nuts-and-bolts, daily-grind point of view, the most crucial management authority

on the production will be the **unit production manager**, or **UPM**, sometimes called the **line producer** or **co-producer**, although these exact titles have more rigid and official (and not always identical) meanings on professional productions and across different mediums, such as film as compared to television. This is because of how they are classified as union jobs by the Directors Guild of America. On union shows, the line producer will likely be more involved in creative matters, such as casting, actor contracts, and script changes, whereas the UPM will stay focused largely on physical production issues: crew hiring, transportation, permits, scouting, business matters, schedules, budgets, department heads, and so forth. For the student work you are doing right now, these job distinctions are not a significant concern, as they will likely be melded into a single position or split up based simply on what is feasible with few resources, but you should be aware such distinctions exist as you advance in your film career.

In terms of basic duties, the UPM is the chief strategist/problem solver when it comes to day-to-day production management work. The person handling those duties will carry ultimate responsibility for making sure the project is completed on time and on budget. You will likely be handling this job as well on most of your early student films, but you might eventually bring in others to assist you on some or all of the UPM's responsibilities—either formally or informally. But no

SOFTWARE CAN HELP

One of the most commonly used management tools for most filmmakers at any level is Movie Magic Budgeting and Scheduling software, but there are many others, such as Microsoft Project, FastTrack Schedule 10, QuickBooks, not to mention common Excel spreadsheets.

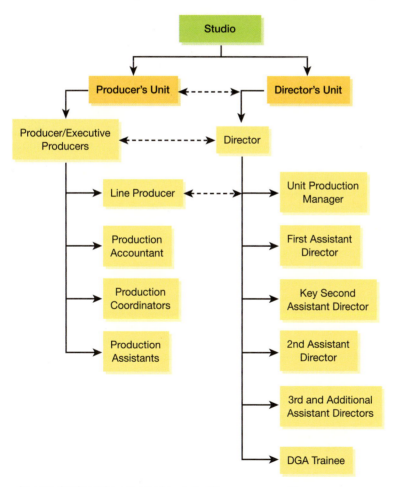

An organizational flow chart of a production management team

matter how you split up the work, among the UPM's responsibilities will be the following:

- Organizing actor and crew contracts, if any

- Negotiating union contracts, if any

- Arranging location scouts and permits, if any

- Securing releases and interacting with local authorities for permissions and on safety issues

- Scheduling and budgets

- Interacting with department heads

- Organizing crew meals and transportation

- Solving logistical problems

The UPM must balance the intersection between money and the creative vision during production. Thus, a UPM not only needs to be proactive and anticipate problems before they arise, and then be ready with a contingency plan when they do, but also needs to know when and where to compromise. The job requires excellent communication skills, a gift for multitasking, and the conciliatory approach of a diplomat embarking on an international peace treaty when faced with issues that can arise between the creative team and the crew (see Business Smarts: Business, Insurance, and Legal Requirements, pp. 101–102).

Typically, the UPM is too busy handling business matters, filling out paperwork, pondering upcoming logistical challenges, or dealing with problems or crises off-site to manage moment-by-moment affairs during production. On professional films, that job therefore falls to the assistant directors, with the first assistant director (first AD) serving as "the general on set," according to Tim Moore, and often two second assistant directors directly below the first AD. As discussed in Chapter 3: Directing, the assistant directors track each day's shooting schedule against the production schedule; prepare daily call sheets (see p. 110); and ensure that the set is running smoothly, moving the director and crew into all the setups planned for the day, with actors and crew positioned according to your plan and needs.

Again, you likely won't be hiring a team of people this extensive and structured for your student project, but even with limited resources, it's always a good idea to get help when you can, particularly where the business and management side of the project is concerned. Filmmaking is, after all, a collaborative art. You have to be honest about your strengths and weaknesses. If you do not have much business experience or are not an organized person, challenge yourself to find help filling in those gaps. As Jon Gunn advises, "If you know someone who is well organized, detail oriented, good at negotiating, or who has experience planning events, they could be very helpful on an independent film. A parent or family friend or neighbor might be able to arrange food or parking or negotiate for a location. There are a lot of tasks to be handled, and there are undoubtedly people you know who would be willing to help you, so don't be afraid to ask."

Tip YOU CAN'T DO IT ALL

Aggressively seek help and delegate jobs—don't try to manage all details yourself. Much of producing a movie with few resources involves gathering your production management team in whatever form it takes each day and regularly distributing lists of action items to everyone, from crucial issues to the mundane.

Practice

BUILDING A TEAM

Presuming you have absolutely no funds to pay anyone for anything, take a student project you are developing or investigating, or one you would like to work on in the near future, and write a two-page description of how you would propose putting together a production management team for that project, and how you would delegate responsibilities. The proposal does not necessarily have to reflect what ends up being your final plan, though it could end up being a nice template, but it should be a realistic and logical description of the people you believe you could actually access and bring into the project to play specific managerial roles.

Business, Insurance, and Legal Requirements

Among the least enjoyable but most important aspects of filmmaking are certain business, insurance, and legal requirements, which may or may not apply to you as student filmmakers but which you need to know about in order to figure out if they will impact your work. Failing to do your due diligence in these areas, and to adequately fill out paperwork and keep proper records, could end up costing you money, involve you in legal entanglements, and delay or even ruin your project. Therefore, investigate and learn more about the following issues:

▌ **Releases.** These permit you to film and show certain individuals, places, and logos in your movie. Corporate logos, such as the famous Apple logo, are intellectual property. Someone owns them, and they only appear in movies when someone pays for the right or otherwise secures permission. If your movie is not a profit-making venture, it might not matter, but you need to be sure. What if your film later ends up on YouTube?

▌ **SAG-AFTRA (Screen Actors Guild–American Federation of Television and Radio Artists), other union considerations, and Workers' Comp.** Union agreements are needed to allow you to use union personnel on your project. Most likely, for a small, not-for-profit student film, you may not want to use union personnel, but you should still know the rules at your school and in your area, and the status of any actors you cast. If you cast an actor with a SAG-AFTRA card, you may end up having to pay that person union rates. Even for non-union individuals who aren't being paid, the law may require workers' compensation insurance or other types of coverage for anyone working on-set, depending on the state

you're filming in. Various craft unions and guilds also define many of the crew positions, as well as their respective pay rates, how many need to be hired, conditions of work, the number of hours they can work, required breaks, and so on. You need to understand what union requirements are in the area where you are filming in order to know if they will, or won't, impact your student production.

▌ **Permits.** As discussed elsewhere (see Chapter 4, p. 82), you may need location permits from local authorities to film in certain places, but you might also need certain fire and safety permits for particular kinds of stunts or effects work, or to have certain kinds of crew or equipment or numbers of people in certain locations. You may need local authorities to authorize such things, and you may have to pay for a fire or police official to be present during filming of such sequences.

▌ **Damage protection insurance.** As the name implies, equipment and vehicle rental companies often require filmmakers to carry this kind of protection to cover damage to equipment rented from them. Location permits are frequently granted only on the condition that you also carry insurance to guarantee that any damage to property is covered. Sometimes companies that specialize in film production offer special entertainment packages that cover all forms of damage throughout principal photography for low-budget films.

▌ **Comprehensive general liability insurance.** Likewise, special coverage or signed waivers of coverage will often be required before you will be granted permits to stage

Continued

Business, Insurance, and Legal Requirements, *continued*

dangerous or complicated stunts or pyrotechnic effects. This kind of insurance can be quite expensive, and students may not be able to easily purchase it or even acquire it through their film school policies. In any case, your school likely won't approve you moving ahead with stunts that are too dangerous—nor should they.

▪ **Copyrights.** This involves registering your work with the proper authorities, identifying you and any partners or financiers as the legal owners, so that no one can later copy or steal the work (see Chapter 2, p. 24). Copyrights require paperwork and fees to be filed. But you also need to check with your school and find out who will own the copyright to your student film—you or the school?

▪ **Contractual responsibilities.** You need to read and understand all contracts before signing them, and most, if not all, may require legal advice. For instance, if you have anyone providing financing or offering distribution on the condition that you complete your movie by a particular date, you may be required to pay for a **completion bond**— another form of insurance—to guarantee your film will be finished.

▪ **Other Insurance.** On a film of even modest size, your insurance package may also include: *E&O*, or errors and omissions coverage, which provides protection in case you unintentionally infringe a known piece of copyrighted material; coverage for the budget of the film in case of the death or inability of an actor during production; and additional protections you may discuss with your insurance broker.

Many schools around the country can and do help with these issues. Some of them, in fact, already have standard deals in place with entities such as SAG-AFTRA, whereby union actors can perform in student films for special rates and under certain conditions. In addition, some also offer certain basic types of liability insurance for projects done through the school. In some schools, you may have already paid for your portion of this insurance as part of your tuition fee package or through some other arrangement. Your school may have an office that offers special guidance on such matters, as well as how to apply to festivals, pursue distribution opportunities, and so on. Therefore, your first stop in sorting through these complicated matters needs to involve asking your professor or film department administration office for guidance.

Network through this class, your professor, your film department, your school, your friends and family, and be aggressive about reading industry trade publications and going to industry events, trade shows, screenings, and panel discussions, where you can meet people, ask questions, and seek advice. It doesn't matter if these people have any previous experience or involvement in the film world. What matters is their skill set and whether or not you think they can help you manage your project.

Scheduling

The notion of any schedule is based on specific needs and goals, and is designed to permit you to move through your tasks as quickly and efficiently as possible.

However, when it comes to making a movie, the schedule is the yin to the budget's yang; you can't design a reasonable budget until you have first created a logistically feasible schedule. And if you don't have a schedule and a budget, you can't make your movie—no matter how cool your idea is, how well written your script is, or how awesome the visuals in your head are.

This means that after finding a story and developing a script that you like, one of the first things you must do is sit down and break your script apart—far beyond any analysis work you or your departments heads, if any, might do to address specific aspects of a production, such as visual effects or production design. This is necessary because you need to make an initial overall estimate of the size, cost, and logistical needs of your entire production. Initially, these factors may be educated guesses, and may even be predetermined or guided by your instructor. In the professional world, they will be carefully calculated by professional producers and UPMs.

Once you have broken down the script, you will build a preliminary **shooting schedule**, which is essentially the plan for shooting particular scenes on particular days in particular places with particular people and in a particular order until you have the material you need to go into postproduction and edit it all together into a movie. Not only will you need to prepare the shooting schedule with backup scenarios and alternative options in mind, but you will need to take the time to analyze the schedule you have created and revise it multiple times before heading out and shooting anything.

Script Breakdown

In some respects, breaking down the script is similar to the art of marking up your script, as discussed in Chapter 3. In other ways it resembles how you or a department head concerned with one particular area of the production would analyze the script, as described in Chapter 4. Here, however, your job is global, not local, so to speak—it involves the entire production's needs and resources, and therefore, you have to go a lot further. Also, unlike how the director might mark up the script, this job is less of a creative one. Rather, it involves applying some cold, rational business considerations to your creative endeavor. In this case, your script evaluation work is all about scheduling and budgeting—finding affordable ways to move people and things where they need to be, when they need to be there in the most cost effective and logical order to give yourself the opportunity to make your creative vision a reality and not just a pipe dream.

Therefore, the overall **script breakdown** involves a series of formal steps in which you go through the script and identify key elements for each shot or scene. Key elements are, in essence, every person, place, or thing that you will need to schedule or otherwise allocate resources to in order to have them available and ready to go on your designated shooting day. Knowing these things, in turn, will help you ascertain how many shooting days you will likely need. Once you have this information, you can calculate what money and other resources you will need to spend, which will allow you to determine if your schedule is in fact feasible given your resources and timeline for completing the project. If it isn't, you will at least have a working foundation for scaling it back.

If, for example, you know you only have a 10-day window for production, and your breakdown and preliminary schedule tells you that you will need 20 days, it will immediately become obvious that something in your project needs to be scaled back. If you don't follow the basic procedures for breaking down your

Script Breakdown Sheet

XXXXXXXX	Chicago	XXXXXXXXXXXX
PRODUCTION NO.	PRODUCTION TITLE	BREAKDOWN PAGE NO.

Scenes: 14-16 Page 13	Roxy Shoots Casely	13
SCENE NO. SCRIPT PAGE NO.		SCRIPT PAGE NO.

Roxie shoots Fred Casely and police investigate.
Also a cutaway to the chorines/ensemble.

DESCRIPTION

1

PAGE COUNT

Roxy's apartment and stage

LOCATION NAME

Yellow	Orange	Pink
1 Roxy Hart	1 Casely is shot	1 Roxie's Apartment - Night
10 Fred Casely		2 Roxie's Parlor - Night
20 Ensemble/chorines	**EXTRAS/SILENT BITS**	3 The Onyx Stage - Night
26 Sgt. Fogarty	Yellow	
27 Police Photographer	1 Gridlock of Cops: (How many?)	
28 Forensics Man (Sal)		
? Body Double For Casely?		

Green	Black underline	Red underline
1 Roxie shoots Casely	1 Gun	1 Mirror
2 Squibs and blood for Casely	2 Period camera and flashbulbs	2 Makeup lights
	3 Police forensic kit Incl. duster	3 Fingerprints
	4 Sheet for body (from room or police?)	
	5 Note pad and pencil for Sgt. Fogarty	

Blue underline	Asterisk*	Orange
1 Casely's suit rigged for squibs	1 Corpse makeup	1 May need set playback for ensemble/chorines

Boxed	
1 Camera move from bedroom to parlor. Discuss with D.P.	1 Will probably need more than one shooting day and at least one set prep. day
2 Note lighting change to D.P.	2 Check with prod. designer to make sure all elements match period
	3 Will Casely play the body with makeup or will it be a dummy?
	4 Check with set dressing on number and placement of fingerprints
	5 Will need armorer and set safety for gunshots

How a breakdown sheet might look, in this case using *Chicago* (2002) as an example

script, a problem of this sort might take you by surprise, causing you all sorts of complications in short order. The basic procedures to follow:

▌ **Line the script.** For this step, you literally mark up a physical script, or use specialized scheduling software, to call out key elements you will need to account for in your schedule: locations, actors, extras, vehicles, animals, makeup, props, costumes, visual effects, and so on. Pay attention to script

This page of the script for *Chicago* (previously seen in Chapter 3, p. 49) has been marked up with the kind of notes a production manager might use to keep track of various elements of the production. Courtesy of Miramax.

notes about time of day and setting, and instructions about whether scenes must be interior (INT) or exterior (EXT)—and notice that we used the word *must*. As you go through the script, you need to calculate places where you might be able to change an interior to an exterior, night to day, or vice versa, in order to make the best use of your limited shooting days. Maintain the script instruction when the story *needs* you to, but when there is wiggle room, decide what is best for the schedule and resources and base your decision on those factors. Along the way, as we discuss in Chapter 4, these notations will indicate where and when you think a stage can replace a location, when one location can double for two or more locations, when you can use a visual effect or a simple camera or an optical technique to avoid a location or complicated set, and so on. This kind of thinking is crucial in schedule building.

▌ **Fill-in breakdown sheets.** Transfer the information you have broken out when you lined the script on a scene-by-scene basis to individual **breakdown sheets**, representing each scene in the movie. A professional breakdown sheet (such as the one on p. 104) features spreadsheet-style category boxes for each element, so that the data you port over from elements you flagged when you lined the script will ideally flow into appropriate categories—"cars" will end up listed under "vehicles," and "guns" will end up under "props," and so on. Depending on the software you use and your degree of sophistication, you can assign unique numbers for characters, scenes, props, and locations and then cross-reference them to make it easy for you to find elements and determine the frequency with which they appear in the story as you set out to budget for them. This provides you with the equivalent of a database that delineates elements for every scene, which you will need to take into consideration when creating a schedule.

Once you have breakdown sheets for every scene, you can easily calculate how many elements different scenes share in common, so that when you are ready to build your shooting schedule, you can make plans to shoot similar pieces of different scenes involving the same location, actors, props, or other elements at the same time, to make the best use of your resources. To be most efficient, assign headers to each breakdown sheet that include, at a minimum, the script page; the scene number or name; the number of pages; the location; and whether it is a day, night, interior, or exterior scene.

▌ **Create lists or boards.** This step involves sorting the information on the breakdown sheets to provide a visual representation of the different categories of elements so that an actual shooting schedule can begin to take shape. In the pre-digital era, this tool was known as the **production board**: a graphical display of breakdown-sheet information on a series of thin, color-coded cardboard charts, often called **production strips**, that the production manager would manually sort and mount on a large production board for the entire production management team to see and use, moving the strips around to form a rudimentary schedule. In some low-budget situations, independent filmmakers have even been known to use index cards. Today, scheduling software, such as affordable tools like Movie Magic Scheduling, have largely replaced physical boards or strips, but the idea is the same—to identify and arrange elements in such a way as to be able to build a shooting schedule. One of the beneficial things about today's online world is that you can easily create and inexpensively share simple spreadsheets and other documents online using Google Docs and other similar tools.

Out of your breakdown sheets, especially if you use the right spreadsheet or scheduling software, it is fairly easy to sort and generate accurate and handy lists of related items, typically sorted in order of their expected cost. On professional productions, the most important lists are typically people and locations, since movie stars usually eat up the most money, and the availability of locations can frequently impact many aspects of your entire schedule. As a student filmmaker, you can evaluate which list will be most crucial and compile your lists according to your priorities. In any case, you will typically generate prop lists, wardrobe lists, vehicle lists, equipment lists, and other specialized lists, such as a list of visual or practical effects. These lists can be as detailed as you want or need them to be, and are a handy tool to help you both budget for particular items and, later, keep track of, and procure, those items. Essentially, you will be sorting out lists based on your project's needs. In a student production, virtually everyone will likely be volunteering his or her time. Therefore, al-

though they might not be costing you much money, figuring out whom you will need—cast, crew, and support—and when, will be your biggest scheduling challenge. After all, in addition to scheduling around your project's needs, you will need to schedule around *your cast and crew's* limited availability, as well.

Shooting Schedule

There is no way around the fact that creating a shooting schedule is an art that takes time and experience to learn how to do skillfully. As we have already cautioned, a wide range of factors can impact it and force you to change it, often on the fly, requiring you to make as many contingency plans as possible when creating the schedule, as we will examine below. But if you boil things down, your basic *goals* for scheduling are as follows:

▮ Schedule so that you can capture what you absolutely must capture to complete your movie. Note that this is a far different thing than capturing everything you might *want* to capture. In other words: prioritize and make hard and often difficult choices along the way.

▮ Be as efficient and flexible as possible.

▮ Be as realistic as possible—don't attempt things that simply lie outside your resource capabilities.

▮ Always prepare as many backup options as you possibly can (see Action Steps: Be Prepared, below).

ACTION STEPS

Be Prepared

When scheduling a shoot, consider different scenarios and build various options into your schedule as backup plans should conditions require you to suddenly shift gears. Seasoned filmmakers recommend thinking about the following as you put your schedule together:

❶ **Make sure any permits or releases have been identified and taken care of long *before* your shooting day.** Film history is littered with stories of shoots held up by union violations, fire or safety violations, or people showing up where they don't have permission to be. Have all paperwork in order before you go anywhere.

❷ **Constantly analyze weather's potential impact on each of your exterior locations and schedule**, or at least make notes about what you would do on shooting days at those locations if you were rained out. Monitor the weather and stay in communication with your cast and crew, so that you can give them as much advance warning as possible if the time or location or scene to be shot the next morning will need to change.

❸ **When feasible, arrange for what is known as a *cover set***—an accessible interior or covered location that you keep available to shoot at in the event bad weather or something else cancels shooting at an exterior location. Keep in mind that a cover set could be set up in a garage, a basement, your home, or in a location near your exterior location.

Continued

FILM MAKING

Continued from the previous page

4 **If at all possible, schedule weather-dependent exterior shooting days early in your shooting schedule,** so that if you do get rained out, you might have time to return there, or at least to get exterior shots to combine with material you captured at your cover set.

5 **When scouting or arranging permission to shoot in a particular location, such as a restaurant, talk to your contact about an alternative day and time,** beyond the agreed-upon day and time, when it might be permissible for your team to show up with minimal notice. If you run into an exterior day ruined by weather and know you have permission to be in the restaurant that same day, you can save an entire day of shooting, but you won't know that if you haven't had that conversation well in advance.

As you sort your strips or use your scheduling software, you need to plan what you calculate, not only the time it will take to shoot each scene but also the time it will take to set up and shoot on-set and, if necessary, to move from set to set or location to location. Obviously, you won't know precisely how long it will take to get each shot, capture each sequence, or finish each scene until you actually do it, because it will depend on how many takes and how much coverage you end up pursuing; how your equipment, cast, and crew perform; how well communication works on your set; what unforeseen circumstances you encounter; and how you deal with such things. However, as noted in Chapter 2, each page of a final, locked screenplay typically equates to about one minute of screen time; thus, roughly one-quarter of a script page is going to take up about 15 seconds of screen time. Therefore, in most cases, it won't be terribly efficient for you to spend an entire shooting day on a quarter page of your screenplay.

What *does* make sense is to plan your easiest-to-shoot scenes first, as a practical way to get your cast, crew, and sets ready before you segue into more complicated work later in the week. It's not unusual to schedule a day to prep a set and then shoot two or three quick scenes on the set on one day, and then schedule several rigorous pages to be shot on that same set the next day. The set will be prepped and ready on day two, and thus there is a natural progression between these two shooting days.

In fact, on low-budget films, you may shoot three or four pages over the course of 10 or 12 hours.[2] Generally, your pace is a function of your resources. The more money and time you have, the more deliberate you can afford to be. If you only have the luxury of a single day on a location, then logically everything your script says should be filmed in that location needs to be scheduled for that particular day. If all of those scenes won't fit into that one day, and there is no possibility of rearranging the schedule for returning there, then obviously you will need to cut something out. Therefore, your scheduled shot list should be a priority list, ranging from what is most important to what is least important, and not just in terms of shots but also in terms of coverage (see Chapter 3, p. 54). Decide when you can live with one angle or less coverage or fewer takes and move on.

Here are some other logical guidelines to keep in mind when preparing your schedule and determining how to order your shoot:

■ If your project's schedule allows formal rehearsal days during production, schedule them at the beginning of the week and start shooting on Wednesday,

Tip **TRIM YOUR SHOOTING SCRIPT**

Continually and dispassionately examine your script and schedule for scenes and shots you think your movie can live without—material that may be pretty or interesting, but that does not have a significant influence on your narrative. Schedule shooting for that material last, and cut it out if you fall behind schedule or need to switch to something else on a particular shooting day.

so that everyone comes into the first day of shooting fully prepared, and you leave yourself the following weekend to make changes if they are required.

▪ It is rarely a good idea to film your movie in linear script order, particularly at the low-budget level. You need to schedule your shoots around access to your locations, actors, and other resources; you can put it all together in the editing phase.

▪ If particular actors are only available on certain days, use your scheduling software to print out what is called a *day-out-of-days schedule* for that individual, and try to select days when you can shoot all material involving that actor, even if it is from different scenes.

▪ We suggested in Chapter 4 that there are many advantages to shooting in places you have access to. Among these advantages is the possibility of increased scheduling flexibility. If you have a family member or dear friend with a house on the beach that they will permit you to use, change scenes that take place in the country to the beach unless there is a strong creative reason that would prevent it. For student films in particular, much of a typical story can be told by shooting in places you already have access to and are quite familiar with. Working in places you know, or in places you have been given access to by people you know, will frequently mean you can get more time there, or at least be able to work more efficiently there, thus adding more options to your schedule.

▪ Schedule as much of the shoot to take place in one location, or in locations close to each other, as possible. The fewer moves there are between locations, the shorter time shooting will take, and the more you will be able to accomplish. If you have found a great old mansion in the country to shoot at, try to arrange to use the yard or surrounding grounds for your exterior work.

▪ Apply what you learned during location scouting (see Chapter 4, p. 82). Learn everything you possibly can about where you are going and what typically goes on there at the time of day you will be there. For instance, if you have permission to shoot in the bleachers at a high school football field, and the bleachers are adjacent to a parking lot, know what time the parking lot starts filling up with noisy cars. If people start arriving at 9 a.m., schedule filming on the bleachers first thing, at 8 a.m., so that you can have a quieter environment and better sound for that scene before you move on to your scenes on the football field.

▪ Any time you can combine tasks, you will be ahead of the game. Be alert to identifying days when you can kill two birds with one stone, so to speak—shooting scenes you had initially pondered taking care of later in your schedule because you will have extra cameras available for other scenes on different days, or will already be at a comparable location. Plan sequences to be captured on particular days based on logistics and feasibility.

▪ Have a list of alternative shots or sequences or establishing material you could shoot at the same location, or other tasks you could take care of, if setup for a particularly complicated scene is taking too long—things you can get done while you are waiting to get other things done.

Tip KEEP YOUR FILES

Even when your project is finished, organize and file away any important documents connected to it. If an injury or a legal dispute ever occurs related to the project, your records could prove useful. Therefore, it is always important, even on a small student film, to have an efficient record-keeping system during production, and a smart filing and archiving system afterward. On a studio project, you will be required to turn such documentation over to the studio on completion.

Practice

CREATING A BACKUP PLAN

Create two schedules for shooting what is supposed to be an exterior scene in your student film: one, the basic plan; and the other, the backup plan. Describe the scene, actors and crew needed, and location, and type up a simple morning shooting schedule. Then, presume there is a good possibility of rain that morning. Come up with a new schedule and plan for the same sequence. Will you have a cover set prepared? (If so, describe the details.) Will there be an available interior near the original exterior location and a creative way to move the scene inside and still make it work? Will you have an alternate scene that could be shot in the rain? Explain your plan, schedule, and justification for your decisions.

FIGURE 5.1

In this example of a shooting schedule, you will see that many elements are specifically enumerated, including actors, props, costumes, and set dressing.

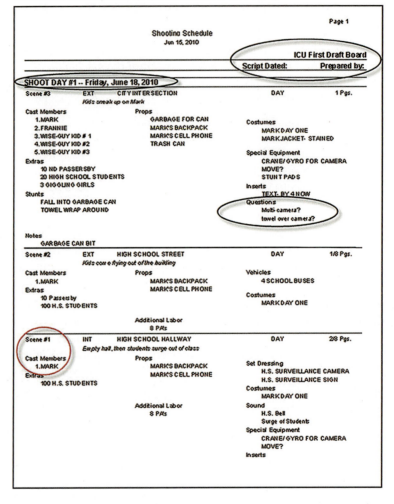

The shooting schedule will ultimately be used to generate the daily **call sheet**, a document that delineates each shooting day's operational plan in detail, informing everyone involved where they are supposed to be and when; what equipment, costumes, or props will be needed; what scenes will be shot, and in what order; and so forth (see Figure 5.1). Additionally, a typical call sheet will list important ancillary information, like what the day's weather is expected to be like, parking information, emergency cell-phone numbers, meal times or options, and hospital or doctor information. Often, the first assistant director is responsible for generating each day's call sheet, subject to the producer's and the director's approval. Today, making call sheets is a relatively easy and inexpensive thing to do, thanks to several types of online and mobile apps now available, including Doddle, Pocket Call Sheet, and Shot Lister.[3]

Budgeting

As noted, you first need to create a preliminary schedule in order to construct a realistic budget for your production. A movie budget is essentially the financial

representation of what you expect it will cost to execute that schedule and deliver the elements you are planning to create to make your movie. This is why we have emphasized that the two go together—if one changes, the other will likely change with it. That is why, like your schedule, your budget will evolve over time. And that is also why, in some cases, you may—as some studio productions do—initially design alternative budgets to account for different scenarios or possibilities that could come to fruition later.

As student filmmakers, your primary goal in making your movie is not (yet) the same as the primary goal of Hollywood studios: the almighty profit motive. However, at a foundational level, you still need to be able to figure out if you can afford to make the movie you have designed. But we have also emphasized what is obvious—that filmmaking is a creative endeavor. And you are students, with few resources. Therefore, many things in your screenplay will be left to a different sort of creativity to determine how you will execute them: creativity built around how cleverly you allocate and use scarce resources. As students, you will examine your resources, tailor the plan to what is feasible, and then budget for it. The creative importance of the scene and what you can afford to do with it will help you come to some budgetary conclusions about it.

It is crucial to remember: Your budget is not the creative *limiting* factor. It is the creative *defining* factor. Whether the budget is $100 or $100 million, it is still a finite number (exceeded by at least 10 percent in many cases). You and your team will have to figure out how to squeeze every penny out of whatever that finite number is to tell your story.

Whatever choices you make, there will be some kind of cost associated with them, even if those costs are bottom-of-the-barrel minimal. The cost of anything you might want to do, from getting a camera to clothing, transporting, or feeding actors, are all *potential* costs. As students, you will most likely be doing some of the jobs on the set yourself. Other jobs, such as acting and camera work, will be handled by volunteers. Even so, these volunteers will all need to be fed. Cars or trucks will need gas. If you don't have a camera, you will need to borrow, buy, or rent one. Anything that you actually spend money on—even pennies—will end up being a *hard* cost, which you will need to account for somehow. You will need to monitor these costs and adjust for them. Therefore, it is essential that you create a budget document in order to follow these costs and make sure that you don't spend more than you have—an eventuality that could grind your project to a halt, not to mention potentially land you in financial hot water. This budget document is not about making rough estimates; it is about notating *everything* you will need to make the movie, ascribing real costs to each element, and detailing how those costs are going to be covered. In this section, we will review how to make up such a budget document, how to resourcefully reduce costs or find work-arounds when you have no resources, and what the basic terminology and concepts are for movie budgeting.

Budget Document

Film budget documents generally have a standard format, and the important thing to remember is that the more detail included in your budget, the more accurate it will be and the better off the project will be. With basic skills, you can create a budget document using an Excel spreadsheet, but a wide range of budget template software tools are available at low or no cost across the Internet, including many tailored specifically for movie production. Whatever tool you use, the general format will look like this:

FIGURE 5.2 Sample budget top sheet

ICU
Student Name

DIRECTOR:
PRODUCER: LOCATION DAYS:
 STAGE DAYS:
SCRIPT DATED: TOTAL SHOOT DAYS:
START DATE: UNIONS:

Acct#	Category Description	Page	Orig	Total	Var
1100	STORY & SCREENPLAY	1	$0	$0	$0
1200	PRODUCERS	1	$580	$704	$124
1300	DIRECTOR	1	$780	$904	$124
1400	CAST	2	$1,272	$1,843	$571
1500	ATL TRAVEL & LIVING	3	$0	$0	$0
	Total Above-The-Line		**$2,632**	**$3,452**	**$820**
2100	PRODUCTION STAFF	3	$3,100	$4,426	$1,326
2200	BACKGROUND ACTORS	4	$696	$845	$149
2300	PRODUCTION DESIGN	5	$1,260	$1,509	$249
2400	SET CONSTRUCTION	6	$0	$0	$0
2500	SET DRESSING	6	$3,280	$3,404	$124
2600	PROPS	7	$7,695	$7,819	$124
2700	WARDROBE	9	$1,155	$1,279	$124
2800	MAKEUP & HAIR	10	$680	$804	$124
3100	SET OPERATIONS	11	$4,910	$5,159	$249
3200	SET LIGHTING	12	$3,710	$3,959	$249
3300	CAMERA	13	$24,261	$24,510	$249
3400	PRODUCTION SOUND	14	$3,310	$3,559	$249
3500	LOCATIONS	15	$6,625	$6,625	$0
3600	TRANSPORTATION	16	$5,315	$5,315	$0
3700	PROD FILM/ DATA MANAGEMENT	17	$800	$800	$0
3800	FACILITIES	17	$0	$0	$0
3900	SPECIAL EFFECTS	18	$0	$0	$0
4200	TESTS	18	$200	$200	$0
	Total Below-the-Line Production		**$66,997**	**$70,215**	**$3,218**
5100	EDITORIAL	18	$11,900	$12,522	$622
5200	MUSIC	19	$0	$0	$0
5300	POST PRODUCTION SOUND	19	$0	$0	$0
5400	POST FILM / DATA MANAGEMENT	20	$0	$0	$0
5500	TITLES & OPTICALS	20	$0	$0	$0
	Total Post Production		**$11,900**	**$12,522**	**$622**
6100	INSURANCE	20	$0	$0	$0
6300	LEGAL	20	$0	$0	$0
6400	GENERAL	21	$0	$0	$0
	Total Other		**$0**	**$0**	**$0**
	Grand Total		**$81,529**	**$86,189**	**$4,660**

Movie Magic Budgeting

▌ **Top sheet.** This is essentially a cover sheet that summarizes the budget document's major categories and lists the bottom line, or total cost of production. The **top sheet** is the first thing that financiers, studio heads, or—in your case—possibly your professor will review to get a sense of where your money is being allocated (see Figure 5.2). A complicated professional top sheet would likely list everything by department (camera, grip, transportation, office, second unit). As a student filmmaker, depending on the complexity of your project, you might also break things down that way. At a minimum, make your top sheet a fairly simple summary page that lists your **hard costs** (things you absolutely must find a way to pay for, such as gas, food, camera rental, and location fees), no-cost items, and all funding sources and amounts, thus providing a simple mathematical illustration of how much you need to spend juxtaposed with how much you are taking in. If there is money left over or an even zero at the bottom, you are in relatively good shape; if there is a negative amount resulting as your bottom line, you had better start revising your plans immediately.

■ **Above-the-line costs.** Detailed breakdown pages will follow that will further delineate costs based on category, with above-the-line costs coming first. **Above-the-line (ATL) costs** refer to the generally more expensive costs of studio films—usually talent costs in the form of producers, actors, directors, writers, rights acquisition, and sometimes very highly paid craftspeople. On a student film, ATL costs may be minimal, since you are not typically paying much, if anything, to actors and are likely producing and directing yourself.

■ **Below-the-line costs.** As you might expect, **below-the-line (BTL) costs** refer to the day-to-day costs of crew and equipment required for the physical production of the movie. These would include cameras, set construction, and tape or digital media. On a student film, if you have any extensive costs at all, they will likely come out of the BTL category.

In all budget documents, it is best to itemize your ATL and BTL costs. On the professional level, this can run on for thousands of lines and dozens—sometimes hundreds—of pages. Each line will account for one crew member, item to be rented or purchased, or supply to be consumed; the daily or weekly rate for the item; how many hours, days, or weeks it will be used; what scenes it will be used for, and the costs per scene or location in many cases; and the subtotal for that item. Each line of detail also ties to the schedule. Taxes (such as sales taxes) and *fringes* (such as Social Security payments, state disability insurance, union-mandated health and pension benefits) and other fees will have their own lines and sections; there will be categories for what currencies are being used or transferred, as well as a host of minute details that would be of interest only to studio or bank accountants. Also, in the modern era of digital filmmaking, visual effects can be so large and complex and eat up so many resources that they frequently go through their own, entirely separate scheduling and budgeting process.

Obviously, not all of this will apply to you right now. Still, this *approach* is the only real way that you, and anyone you are responsible to—your professor or school, financiers, family, partners, or friends—can know how your resources are being used; more importantly, since you are students, it is the only way you can possibly learn proper principles and procedures for motion picture budgeting. Though this may never become your passion as a filmmaker, if you ever hope to participate in producing your own work at any future level, having this knowledge will serve you well.

Be Resourceful

One of the positive things about making low-budget movies is that reality can lead to better creative choices, and not only where the on-screen narrative is concerned. As students, you have the opportunity—indeed, the requirement—to be ultra-resourceful on the business side of your project as well, and by definition, that resourcefulness requires a level of creativity and even panache. The better you get at figuring out ways to insert zeros into the "costs" column on your budget document, the more success you will eventually find at being an innovative and free-thinking, out-of-the-box filmmaker.

And when we say "resourceful," we mean in terms of finding ways to get jobs done and equipment and materials procured without spending money. There is an art to developing the skill of finding low- or no-cost labor, equipment, props, locations, costumes, and so on, and you will only get better at it over time. However, there are some tried-and-true shortcuts and tips that independent filmmakers

Tip REMEMBER POSTPRODUCTION

When crafting a budget, don't shortchange postproduction, particularly sound effects. On low-budget projects in particular, it is likely that production sound will be far less than pristine and will need sweetening or looping and, more likely than not, sound effects added to make your illusions come to life. Prioritize limited resources based on the most essential things, and work backward from there. At the most rudimentary level, getting enough coverage and corresponding elements to tell your story well is what is absolutely essential, but you will need resources for postproduction as well.

have used for generations that you can consider, depending on your project's needs (see also Action Steps: Planning Crew Meals on a Tight Budget, p. 117). Among these are the following:

■ Write or revise your script specifically to adhere to your budget and locations.

■ Thoroughly research what your film school and other organizations offer students in terms of gear and resources, and inquire as to whether you can partner with the school or others on ownership of your film's copyright, as discussed earlier in this chapter. Your school or other "investors" may chip in equipment, funds, or other resources in return for an ownership stake in the movie (see Producer Smarts: Finding Funding, p. 116).

■ To the degree you need to bring in crew in different disciplines, such as cinematography or editing, if you do not already have access to equipment, try to lure people who own their own equipment. This is particularly helpful with your cinematographer, editor, and location mixer.

■ Inquire about discounts and free rentals of equipment for student filmmakers from equipment rental houses and local businesses. Some rental houses will also lower costs based on shorter-term rentals.

■ Take advantage of free or low-cost cinematography, lighting, scheduling, and budgeting apps that are readily available to consumers, as well as specialized apps for other disciplines that are often low cost and tailored to the filmmaking community.

■ Follow our advice in Chapter 4 and use furniture and set pieces from your own home and the homes of friends and family members.

■ Use homes, property, and business locations of friends and family as shooting locations if available. Figure out if an area in your own home, your garage, or a warehouse or storage space that you have access to could be converted into a stage, if needed.

■ Have cast, crew, classmates, friends, and family provide hair and makeup services—you already likely know people with good skills in these and similar areas.

■ Trade credits and appearances of people, logos, businesses, and places for the right to shoot in locations or for labor, food, and equipment from locals in the town where you are shooting.

■ Search for unsigned or unproduced local musicians in your school or community who are looking for exposure, and put their music in your film—and even get their help scoring the film—in return for exposing them to a wider audience and letting them promote your use of their work for their own needs.

Remember: all such items, even if coming to the project at no cost to you, need to be listed on your budget document and tracked. You may owe someone a credit in return for the resource or future revenue if the movie earns any money down the road, or you may need the information for tax purposes later on.

How Do I . . .
Manage My Production's Details?

Go to LaunchPad and find out: **macmillanhighered.com/filmmaking**

NAME:	**Lulu Zezza**
TITLE:	Production manager
SELECTED CREDITS:	*Nine* (2009); *The Reader* (2008); *The Nanny Diaries* (2007); *Tortilla Soup* (also co-producer, 2001)

The business side of making a big studio film has two basic but glaring similarities to what you, as a student filmmaker, will need to grapple with. First, big-shot Hollywood producers never think they have enough money to make their film, and neither will you. Second, you both will need to figure out how to make it all work out anyway. Professional production manager Lulu Zezza talks about the details of production management in a video interview available only on the LaunchPad for *Filmmaking in Action*.

Discover:
- Why even seemingly mundane details matter
- How to keep those details from overwhelming you
- What kind of systems Zezza uses to keep her processes straight

Visit the LaunchPad for *Filmmaking in Action* to learn more—and to explore how you might use this advice.

Finding Funding

We have discussed how to be resourceful in terms of finding people, equipment, and services you won't have to pay much—if anything—to procure. However, a far more complex art involves the world of real film financing. There are certain pathways that exist for student filmmakers to find ethical methods to raise funds for projects under particular conditions. Obviously, the most feasible way for students to obtain funding is to enter a student competition or earn a scholarship or grant through their school or any of a number of national and international student film competitions.

Additionally, there is nothing to stop an enterprising student from holding fund-raising activities in the real world, or online through crowdfunding sites like Kickstarter. Thousands of student and independent film and video projects have raised funds and been produced this way. Also, you might offer a credit or equity stake in your movie to anyone who might want to give or lend you money to make your movie, but you should seek out competent legal and financial advice beyond the scope of this book before you go down the road of borrowing money. But what is a student filmmaker to do when winning a competition or raising large sums aren't feasible options?

While motion picture financing can be an arcane and confusing world, at a minimum you should strive to understand the basic concepts of how things work. Some of these often-used financing methods may not be viable for you yet. At your level, we are not urging you to seek out investors or borrow money, but rather to start learning how the financing game works for future reference if you are interested in continuing your filmmaking education. (Please remember that you must always have professional legal and financial advice before seeking financing on any film.) Well-established methods for financing major projects typically include the following:

- **Seed investors.** These people simply believe in a project and expect to get a return somehow. Typically, these investors provide "seed money," a small amount of up-front money to develop a project or to begin filming. Filmmakers might use that seed money to make a short trailer out of the early footage, often called a *sizzle piece*, for the express purpose of selling other investors on the project's potential. Though often risky for the investor, it is the most typical way students get outside funding help beyond the possibilities of grants or scholarships.

- **Nonprofit foundation and government grants.** Under certain conditions, these grants are sometimes applicable to student filmmakers.

- **Tax incentives and rebates.** If projects bring business to other states or countries, they can sometimes be given tax breaks or cash rebates in return for shooting there.

- **Presales.** This involves a method of providing financing in return for the right to distribute the film in different countries before it is even made (preselling the rights).

- **Debt financing.** This means getting a bank loan, to provide immediate cash the production can use. The loan will be paid back when tax incentives, rebates, or presales contracts are paid in full—plus interest to the bank, of course.

- **Co-productions.** These are collaborative productions, where two or more companies jointly produce the movie, with each company putting in financial and other resources.

- **Private equity financing.** This allows private individuals or organizations to invest cash in return for partial or full ownership of the film.

ACTION STEPS

Planning Crew Meals on a Tight Budget

Professional filmmakers say if there is one basic, logistical matter a young filmmaker should not overlook in scheduling and budgeting a movie shoot, it is the issue of food and meals for cast and crew. Although this may seem insignificant, in point of fact, even on a small production, food can turn into a major line item on a budget. And just as important, failure to schedule time for meals and provide a way to conveniently access food can directly impact efficiency—simply put, the old adage that an army (even a small one) moves on its stomach is true, particularly in filmmaking. This is especially true in the world of student filmmaking, in which most of the people helping you are volunteers. Feeding these people and thus keeping them content may well be the only tangible benefit you can provide them during production.

Therefore, here are some simple and basic tips about getting the crew fed in an affordable way, and scheduling meals in such a way as to improve efficiency on-set:

1 **Depending on conditions, try to schedule your shoot to begin after breakfast or end before dinner.**

2 **Strategically schedule only those actors and crew members you know you will need during mealtimes.** Even though your lead actors may be needed all day, your roomful of extras can be released before you need to feed them.

3 **Check with local restaurants and markets in the town and near the locations where you are filming**—some will provide deals or discounts for student productions if you approach them and make special requests, or negotiate to put their restaurant, market, sign, or logo in your movie.

4 **Keep snacks on-set.** Whereas the big studios have whole departments devoted to on-set food catering—craft services— affordable snacks, such as veggies, chips, and crackers, can be made readily available to large groups at very little expense when you buy in bulk at wholesalers such as Costco.

5 **Cook for your crew.** If you or a spouse, significant other, classmate, sibling, parent, friend, or colleague have great cooking skills and the time, it can frequently be far cheaper to whip up large batches of tasty dishes and cart them over to the set than to pay for restaurant or catered food.

Practice
IDENTIFY HARD COSTS

Create a sample film budget for a short student film based on a simple three-day movie shoot using software you may already own or can easily acquire. The budget can be from a real project you are currently developing or an example of one using numbers for resources you think you could realistically access. The point of the exercise is to identify what absolute *hard costs* you think you would have to incur to make a short student film like the one you are envisioning. What expenses are there simply no way to avoid—food? gas? camera rentals? travel? location fees or permits?— and how much will those expenses cost you? Research such costs in detail.

✚ UPM's Emergency Kit

- Budgeting and scheduling software tools
- Near-set office space for posting schedules and daily reports
- Petty cash
- Charged cell phone
- Extra batteries and chargers

- Walkie-talkies
- Readily available contact information for local police, fire, and permit authorities; local labor guilds; and medical facilities
- Fueled vehicle with navigation system

CHAPTER 5 ESSENTIALS

▍ Organizing a movie project means putting on a producer's hat, creating a production management team, and delegating management tasks to that team. Someone acting in the capacity of unit production manager (UPM) will play essential roles in this process.

▍ The UPM will painstakingly line the script, identifying every element that needs to be scheduled or budgeted; organize those elements into detailed breakdown sheets; and create schedules and lists that allow you to efficiently figure out timelines and costs for each of those elements during the budgeting process. The UPM will also generate detailed shooting schedules, as well as call sheets that will serve as daily guides for every crew and cast member.

▍ Even with low resources, detailed budgets that delineate above-the-line and below-the-line costs are essential not only for business purposes but also creatively, in order to let you know what elements of your story are feasible to execute, and enable you to move your plan forward and avoid a stalled or derailed project. Resourceful independent filmmakers can reduce or eliminate costs, but they will still wind up with hard costs they will need to develop financing plans.

KEY TERMS

Above-the-line (ATL) costs	Hard costs	Shooting schedule
Below-the-line (BTL) costs	Line producer (co-producer)	Top sheet
Breakdown sheets	Production board	Unit production manager (UPM)
Call sheet	Production strips	
Completion bond	Script breakdown	

Having written your script, visually planned your movie, created a budget and production plan, and shaped your film from the director's viewpoint, you are now ready to start shooting. Today, we think of this period—the period traditionally known as the production phase—as image and sound capture.

The following section is one of the most technical in the book. Your movie can only turn out well if you do a good job getting the visual and audio recordings you need, so you can complete the marriage of imagery and sound into a final work; therefore, you need to understand how machines and systems related to image and sound capture function. We'll share the technological underpinnings of filmmaking, because they affect how you operate your cameras, lights, and microphones, and then get you started on practical work: using the tools you need to make your movie. If you have a special curiosity about even more technical information, we've included special Tech Talk features in some chapters.

As you begin the production, or image and sound capture phase, it is most important to recognize that the machines

PART 2

IMAGE AND SOUND

you will be using are just tools—extensions of your eye, your hand, your ear, and your creative spirit—tools that, when properly employed, will bring to the screen the audiovisual information of your story. For example, a microphone is just a device that turns sound into electric signals. A camera, at its foundation, is nothing more than a box with a hole that lets light in so that you can capture and record moving images.

Let the shooting begin!

> **"The excellence of the image really has to come from the excellence of the intent."**
>
> **– Christopher Doyle, cinematographer for over 60 films, including *Hero* (2002)**

Camera Skills

The Wrestler (2005)

Maryse Alberti started having serious fun with cameras when she was 12, and by the time she grew up to be a cinematographer, she'd played with every kind of camera she could get her hands on. But when director Darren Aronofsky asked her to shoot *The Wrestler* (2005), she wasn't sure what kind of camera she should use.

The story of a washed-up wrestler looking for a comeback had to be gritty and tough, but the wrestling scenes would be highly choreographed. "I was willing to work very simply, and Darren wanted to give a lot of freedom to the actors,"[1] Alberti said; therefore the camera and lighting couldn't get in the way. Although Aronofsky needed the camera to get close to the action and follow it effortlessly, the film still had to look like *a movie*, not a haphazard video; it needed the *feel*

of cinema—a dark moodiness, textured lighting, and compelling, memorable images.

What camera did Alberti work with? A Super 16mm film camera: the workhorse of student films before the digital revolution, and a format that was invented nearly one hundred years ago.[2] Lightweight and flexible, a 16mm camera is easy to hold in your hands, and you can move it naturally, mimicking the movement of turning your head to see something when it catches your attention.

What camera would Alberti use on her next movie? That would depend on the movie. "I'm there to serve the story,"[3] she says.

Like Maryse Alberti, you have likely been exposed to cameras since you were young, and today the camera in your smart phone is your constant companion. Now it's time to expand your knowledge in two important ways. You're about to learn how to use different tools on more sophisticated cameras, and you'll discover how to use cameras with greater *intent*—the premeditation that comes from carefully conceiving the story you want to tell, designing an ideal series of shots to convey that story, and figuring out how to achieve those shots with different image capture tools.

In this chapter, you'll study the process of image capture and learn which details you need to iron out before you begin shooting. In doing so,

KEY CONCEPTS

- The screens on which your film may be seen—including movie and TV screens—have specific height-to-width ratios, so you will need to "shoot to fit" and sometimes make allowances for different sizes.

- Digital cameras capture images electronically with optical sensors and record their images on a variety of media, such as SD cards and hard drives.

- Film cameras capture images through a photochemical and mechanical process and record their images onto reels of celluloid.

- All cameras need lenses to capture light and place it on a recording medium, and different lenses bend light in unique ways, allowing for an almost infinite amount of ways to compose images.

- Accessories that support and move the camera are fundamental tools that let you capture action in the most compelling cinematic way.

you'll examine aspect ratios—one of the hard-and-fast specifications of the filmmaking craft that is rarely discussed but crucial to the final outcome of your effort. Next you'll explore the different screens on which your movie may be seen—everything from a movie screen to a television to a laptop to a mobile phone. With an understanding that the final product—what will be on the screen—is what you're after, you'll move to the start of the process: how to acquire the images you will eventually see on a screen or screens of differing formats. Digital technologies and film are two recording media on which

images can be captured and stored; you'll discover how they work, and evaluate the cameras and systems that produce visual images. You'll also learn about lenses, which change the way shots look, and examine the equipment you can use to support and move the camera.

The five key concepts on the previous page are what you'll need to understand if you choose to become a **cinematographer** or **director of photography (DP)**—interchangeable terms for the person ultimately responsible for making sure a movie is properly photographed.

Your Screen Is Your Canvas

As a filmmaker, the screen is your canvas, whether you're making a movie for a tablet, a television, or a big cinema screen. You are responsible for understanding how the canvas can be used. At times, you will be required to use it in a certain way—for example, when you are hired to do a job, such as to make a television commercial, for which specific images need to be captured exactly as planned. At other times, you will have more authority and will be able to exercise more creative freedom in your choices. Either way, it is up to you to make the film look as if every image in every shot is the right one needed to develop the characters and tell the story. Your goal is to make the film work and to give the audience a seamless experience (see Producer Smarts: Creative Discussion about the Look of the Film, p. 127). To achieve a quality final product, it always helps to know where you are headed; the first thing to figure out is what shape your final film will be. This is called the *aspect ratio*.

Aspect Ratios and Formats

Just as a painter needs to decide what size and shape a painting should be, the filmmaker must determine what the film should look like. The first consideration is the film's *aspect ratio*. The word *aspect* means "appearance," and a *ratio* compares two things. The **aspect ratio** is the relationship between width and height of the screen image. But unlike a painter, who can stretch a canvas to any size and even decide if it will be higher than it is wide, the filmmaker has few choices. Movies come in standard sizes, which have evolved and changed over the last one hundred years. These standards are often called **formats** because they have clearly defined size and shape characteristics. (Later in this chapter, you'll encounter the word *format* used in terms of cameras; the important thing to remember is that a *format* is just a way of saying that something is standardized.)

Figure 6.1 shows how the same image looks different in different aspect ratios. You'll see that with a smaller aspect ratio, the image looks more square, and as the aspect ratio widens, you can see more information on the sides.

Your choice of aspect ratio will be driven by both creative and commercial considerations—what will look best artistically, and where your film is going to be distributed (see Action Steps: Shooting for Multiple Formats, p. 124). For example,

FIGURE 6.1 The same image in different aspect ratios

1.33:1 (4×3): Old television standards; also the way videos look on most mobile phones when they are held vertically. *Some* mobile phones and tablets automatically shoot in this ratio.

1.44:1: IMAX or giant screen aspect ratio.

1.66:1: Aspect ratio of 16mm film; also common in Europe.

1.78:1 (16×9): This is the HD video standard, and the best aspect ratio to use for YouTube videos; also the way videos look on most mobile phones when they are held horizontally. More mobile phones and tablets automatically shoot in this ratio.

1.85: U.S. movie standard.

2.00:1 (2×1): Sometimes used in music videos.

2.40:1: Widescreen cinema standard (this aspect ratio is 2.40 in the modern era, but is sometimes referred to as 2.35, as that was the official widescreen aspect ratio prior to 1970), also commonly referred to as anamorphic.

Chris Pritchard/Getty Images.

if your film is destined to play in cinemas, you can shoot in 1.85 or 2.40 aspect ratios. But if you're planning to show your movie on a YouTube channel, you'll want to shoot it in YouTube format (1.78). Wes Anderson's 2014 film, *The Grand Budapest Hotel,* uses three different aspect ratios to indicate different time periods, and it is a perfect way to explore the ways aspect ratios change how much of a scene you can see.

Although some cameras have settings that give you a choice between *wide screen* and *standard* formats, what the camera manufacturer means by these words isn't always the same as what's standard in filmmaking. You need to shoot something in each format and look for yourself, or check the manufacturer's specifications manual. On mobile-phone cameras, "widescreen" simply means 16 × 9. (Aspect ratios are often described as "this number by that number." It is simply another way of explaining the ratio. In this example, 16 × 9 is another way of saying 1.78 [because 16 ÷ 9 = 1.78].) In movies, the ones you see in the cinema, **widescreen** is anything wider than 1.85—that is, wider than a cell-phone screen— and conveys a sense of epic scope.

Widescreen is often used for stories that have large-scale scenery or settings: movies that take place in nature or in eye-popping, invented worlds, or movies that depict the extreme loneliness of characters dwarfed against a landscape. Widescreen can also make more intimate movies feel less claustrophobic; if a movie takes place entirely in confined spaces, a widescreen approach can give the film a sense of scale, making a "small movie" seem large. Widescreen can seem grandiose, whereas a narrower format, such as 1.33, can direct the audience's attention more toward the characters and their relationships with one another than on their relationship to the film's physical setting.

Tip **PROTECT FOR MULTIPLE FORMATS**

If your film is going to be shown on any kind of large public screen, it must be formatted to at least 1.78 (1.85 is typically the standard for a studio film). However, it will also need to be watchable on mobile devices with a 4 × 3 screen. Solution: Protect the 4 × 3 frame, so that nothing important happens at the extreme edges. When shooting, mark your viewfinder with tape to see where the 4 × 3 area will be. You may have to make small compromises on how you frame the shot to accomplish this.

ACTION STEPS

Shooting for Multiple Formats

Sometimes you may need to either capture your images so that they can be displayed in different formats or manipulate the imagery after you've shot it so that it works on different-size screens.

1 **Shooting multiple versions.** You may need to shoot multiple versions of a scene (also known as *coverage*), as when you are creating content for an interactive game that might be played on a TV screen (16 × 9) or on a mobile device (4 × 3), or when you must sanitize explicit or offensive imagery or dialogue so that it can be shown to a general audience. This will also give you more choices in the editing room. You need to know what your final format is going to be, and be prepared in case your movie will need to finish in more than one format.

2 **How to fix things if you only have one version.** If a film is shot in one aspect ratio but will be shown on others, there are four ways to fix the problem.

 A. **Letterboxing** puts a black bar above and below the frame to preserve the original aspect ratio. For example, if a movie is going to be shown on an IMAX screen and you want to preserve a 1.85 aspect ratio, you would place black horizontal space above and below the image on IMAX's 1.44 screen. This is commonly done when showing a 16 × 9 film on a 4 × 3 screen.

B. Pillarboxing puts black bars on the right and left of an image. You'd use this if you wanted to show a 4 × 3 film on a 16 × 9 screen.

C. Windowboxing, a combination of letterboxing and pillarboxing, completely wraps the film in a black frame so that its entire aspect ratio will be preserved.

D. Another fix is **panning and scanning**—a process in which the film is altered for the screen by recomposing shots to make sure the audience can see what is happening. For example, if a film was shot in 2.40, and important information happened at the edge of the frame, the film would be panned and scanned for each scene, shot by shot, before it could be shown on television.

While panning and scanning may seem to be a practical fix, it is expensive and time-consuming, and it is disdained by many filmmakers as it alters the original composition, depriving the audience of seeing the work as the filmmaker carefully composed it. Some filmmakers demand that their movies be shown in their original aspect ratio on all devices, which means that their films need to be letterboxed. However, letterboxing makes the image quite small on mobile devices, so movies formatted this way may be less appealing to consumers.

Special Formats: 3D Stereoscopic and Giant Screen

We've explored the conventional size and shape of most films, but there are two important formats that fall outside the norm: *3D stereoscopic* and *giant screen*. These formats have gained increasing popularity in recent years, and there are more than 50,000 3D stereoscopic–enabled cinema screens worldwide. A small but growing number of student filmmakers are now experimenting with 3D, aided by offers of inexpensive equipment rentals from certain equipment manufacturers and the encouragement of the International 3D Society, among others.

3D stereography is a process that creates a visual illusion of dimensionality by showing two different images, one for the right eye and one for the left eye, mimicking the way our eyes perceive depth with *stereoscopic vision*. There are numerous methods for achieving this—depending on your resources, equipment, and skill level, it can be achieved during production with stereoscopic image capture, or it can be "created" in postproduction using sophisticated processes. Either way the concept is the same. Two images are recorded or created simultaneously, one for each eye; the images are filmed or manufactured from slightly different positions or perspectives, just as a person's eyes see from two slightly different positions. The images are then projected separately onto the same screen. To the naked eye, when combined on-screen, they look blurred and out of alignment. But special 3D glasses worn by the viewer align everything and direct each image to the correct eye, where the brain pieces them together to give the illusion of depth. Recent advances in technology have brought 3D films into the mainstream: Better cameras and rigs permit more seamless capture of 3D imagery on set or in the field, and better postproduction tools tweak that imagery as needed; new tools and processes take 2D imagery and convert it into a finished 3D movie during what is sometimes called the **dimensionalization** process; and the widespread availability of improved digital projectors make it much less expensive to show 3D movies at higher quality.

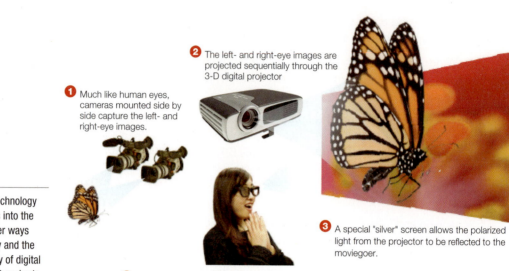

1 Much like human eyes, cameras mounted side by side capture the left- and right-eye images.

2 The left- and right-eye images are projected sequentially through the 3-D digital projector

3 A special "silver" screen allows the polarized light from the projector to be reflected to the moviegoer.

4 The two images are viewed by the moviegoer wearing 3D glasses that decode the circular polarization to create the experience of depth.

3D stereography

Recent advances in technology have brought 3D films into the mainstream with better ways to capture 3D imagery and the widespread availability of digital projectors that make it easier to exhibit.

Cinema projector: Getty Images/Alejandro Mozo. Butterfly: Lisa Thornberg/Getty Images. Camera: Uli Hamacher/Getty Images. Flower: Daisuke Morita/Getty Images. Woman in audience: zhaolinghe/Getty Images.

If your film will be shown in 3D, your creative challenge is to use the added depth in your canvas, sometimes referred to as *z-depth* or *z-axis*, to enhance character and story development and not simply as a gimmick. At present, how studios are using 3D in feature films seems to be divided on this point. Some 3D films hardly add any storytelling value—they simply add the technique for its "wow" value by throwing things out at the audience, such as in *The Three Musketeers* (2011). Others—like *Avatar* (2009), *Hugo* (2011), and *Gravity* (2013)—use 3D to its full dramatic potential, carefully controlling the depth of objects or people on set for creative purposes. In these instances, 3D expands the visual vocabulary. *Hugo,* in particular, was notable because it was one of the first and most respected studio feature films to seamlessly incorporate 3D into a non-action-oriented, dramatic story.

Giant screen is an inclusive term that applies to IMAX and other large-format theaters, planetariums, theme parks, and dome theaters that make the viewing of a movie more immersive, with the screen filling the audience's entire field of view (and sometimes more). IMAX is a brand name for movies made in a format created and controlled by the IMAX Corporation; it now includes both the traditional IMAX giant screens and some larger multiplex screens that have been retrofitted to incorporate some elements of the giant screens. There are more than eight hundred IMAX venues worldwide. Full IMAX films are projected either digitally or on film that's twice the size of a normal film frame, and have an aspect ratio of 1.44:1 (though many IMAX screens, particularly the less gigantic ones, play movies in other aspect ratios, too). The great drawing power of IMAX is its size—the largest IMAX screen is one hundred feet wide. Many studios *tentpole* movies (see Chapter 14, p. 344) are enlarged to play on IMAX screens simultaneously with their release on conventional screens because they create a different viewing experience for the audience—a premium experience that some people will pay more to see.

ⓟractice

WORKING WITH ASPECT RATIOS

Go back to the storyboards or shot sketches you created for Chapter 4. Overlay a frame of 1.85 and 2.39 aspect ratios on the sketches. Is important information missing when you change aspect ratios? Redraw a key shot so that the important visual information will be seen no matter which aspect ratio might be used. This will inevitably result in some creative compromise.

Creative Discussion about the Look of the Film

One of the producer's most important jobs is to help the director clarify the look of the film and to work with the director and the cinematographer to make sure it can be achieved. We'll spend a lot of time talking about film looks or styles in subsequent chapters; one area of a film's look that directly relates to the camera is the *resolution* of the images.

Resolution refers to how highly detailed each frame is—or isn't. Perfect clarity and detail is not necessarily an important quality for an image. At times, you may want the image to look *un*detailed. For example, a grainy black-and-white image may imply a certain era or mood. The level of detail and clarity is just one of the visual qualities a master cinematographer is able to control with intent and precision; collectively, all of the image qualities make up the texture of the image experience. However, if your film is intended for a giant screen, you need to make sure the images are recorded in the highest resolution possible; if not, the

images will suffer when their size is doubled to convert to the larger format.

Other important image qualities, all of which can also be controlled, are *color rendition* (the ability to show color), *tonal value* (the ability to show shades of gray), and *contrast* (the sharpness of the difference between black and white). Each of these image qualities can convey a storytelling or emotional value; for example, a lot of color may suggest an experience that is more vivid than everyday life: a musical, for example. A lot of contrast may suggest suspense and foreboding, as is common in horror or suspense films. Good producers talk about these creative issues at the beginning of the preparation stage, so that everyone can get on the same page and assemble the right equipment to create the right look and design sets, props, and costumes to support that look. Many studios or producers employ quality checkers, to ensure that all that hard work is being properly projected at your local theater.

Image Capture Media and Machines

Once you've made key creative decisions about aspect ratio and what the visuals should look like, it's time to decide the best way to capture the movie's images. In other words, now that you know what the shots should look like, as you learned in the production design and conceptualization phase (Chapter 5), you can determine how to create the shots.

There are two capture media on which images are recorded: *digital* and *film*. Each has its own attributes, and each records and stores visual information differently. As illustrated in Figure 6.2, film captures images through a photochemical process. Light rays strike the entire surface of the film and pass through microscopic layers that record three colors: red, green, and blue. Digital media captures its images through an electronic process. Digital cameras currently record images with sensors. The sensors themselves are made up of microscopic *photosites* that capture photons of light. Since digital sensors are color-blind, red, green, and blue filters ("lenslets") must be placed over each of the microscopic photosites. The filtered light recorded by each of the photosites is then interpolated and the image is then mathematically reconstructed into full color. Because of the need for electronics to transfer the information from each photosite and build the photographed image, it is not possible for the entire surface of a sensor to capture light. The percentage of total

FIGURE 6.2 Film capturing images

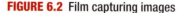
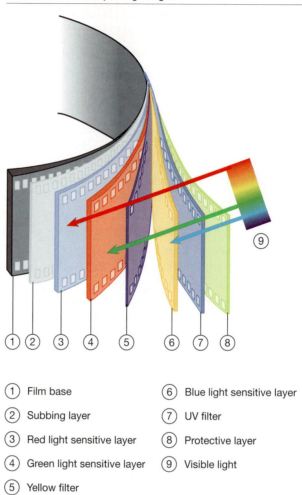

① Film base	⑥ Blue light sensitive layer
② Subbing layer	⑦ UV filter
③ Red light sensitive layer	⑧ Protective layer
④ Green light sensitive layer	⑨ Visible light
⑤ Yellow filter	

area in which a sensor is sensitive to light is called the *fill factor*. Photographic film essentially is 100 percent sensitive to light, and therefore has a native fill factor of 100 percent. With digital imagers, there are areas where no light is captured at all because there are no photosites there. The greater the fill factor of an image capture device, usually translates into greater dynamic range.

The difference between film and digital media, and their corresponding technologies, explains why film can capture more light than digital media can, resulting in dramatically higher dynamic range. It is also one of the reasons why images captured on film and digital media look different from each other. For example, grain, which you see as tiny wavering dots on the screen, may occur in film because of its photochemical process, but grain does not occur naturally in digital; in fact, some digitally shot movies add "grain" as a computer-generated effect to match the look some people expect from movies.

Digital and film motion picture cameras work differently, but they have one thing in common: they are boxes with lenses that focus light onto a medium or device that will capture what the lenses see. Both kinds of cameras take a series of images very quickly, and each image becomes a frame of the finished movie. (To understand why individual still frames make your brain see motion, see Tech Talk:

tech TALK

What Are You Seeing?

How do images get onto a screen, and what makes them seem like they're moving? A single shot is made from many still frames (or still images). When you see a movie in a cinema, your brain is tricked into thinking you are seeing moving images. In fact, you are seeing a series of still images flashed so quickly that they appear to move. These images are being shown at *24 frames per second*. This is the long-standing industry standard minimum frame rate for cinematic presentations.

That paradigm is slowly starting to shift, however, as some prominent directors are experimenting with higher frame rates now that new digital camera technologies are capable of shooting at faster speeds, and industry governing bodies are currently engaged in long-term studies regarding the creative impact and technical requirements necessary for making and projecting movies at frame rates higher than 24 frames per second. That is one of many exciting debates about changes and transitions going on in the world of digital cinema right now, and there are exciting new creative possibilities looming as a result. But, for the foreseeable future, 24 frames per second is likely to remain an industry standard, even as other options are worked into the discussion. In any case, **frames per second** are called **fps**. With a conventional motion picture projector, a shutter in front of the projector lamp spins around, making light flash through the frames of film. A single frame flashes, then the film advances and the next frame flashes, and so on. Between each frame, there is blackness, but it is so fast your eye does not notice it. A digital projector operates differently, with no "blanking" between the images, but the illusion is achieved the same way, with individual images at 24 fps. A television shows images at 30 fps, and mobile devices show them at lower rates. (Television sets in the United States actually broadcast images at slightly less than 30 fps—there's a difference of about 1/100th of an fps. That's not a difference you can see, but you may notice it when you are editing. We'll cover this in more detail, and tell you what to do about it, in Chapter 11.)

What Are You Seeing?, above.) In addition, their end product is the same—the creation of an image.

In the case of film, the captured image recorded on film is a negative or reverse of what the actual scene looks like. Open an image in Photoshop, choose the Invert command, and you'll see what a negative image looks like. Because of the analog photochemical nature inherent in the film process, creating images is a constant workflow of negative to positive and back to negative again, and then back to positive again. This was precisely how motion picture release prints have been made since the mid-1970s. The most valuable film element in a film workflow is that original negative that first recorded the scene in the camera. In the case of digital cameras, the image created is a positive from the start, and stays that way, as it isn't burdened by the negative/positive workflow of film.

In this book, we define a **negative** as the original images as they were captured, images that are easy to manipulate; although a negative contains captured images, these images can be changed considerably. For example, from a good negative you can turn day to night, correct mistakes, add backgrounds and other visual effects, or change colors. Digital cameras create what has come to be known as a *digital negative* that's stored in a hard drive in a highly manipulable form. (To be considered a negative, the data cannot be in a format that can be easily degraded, such as a JPEG or a QuickTime file.) Film cameras create a physical film negative on a piece of celluloid.

Tip STORE WHAT YOU SHOOT

Whether you're shooting on film or digital, storing and safekeeping what you've shot is of primary concern. Some cinematographers never let the memory cards or exposed film reels out of their immediate control, escorting them to wherever they need to go—whether by ground transportation or plane!

The ability to store, archive, and later recall the negative is a topic of much debate and voluminous research. Film negative, properly stored and maintained, has a viable life span of approximately a hundred years. Digital media, however, is not so long-lived. "From MP3 players to cell phone cameras to the Internet, digital technology has made our lives easier, more fun and—online pet videos aside—more productive," the Academy's Science and Technology Council wrote in a recent report. "But as anyone who has ever suffered the heartbreak of a hard drive crash or tried to watch home movies recorded in a now obsolete format knows, there is a dark side to storing information digitally."[4] The "dark side" is that digital images have an undetermined life span, and there is no sure way to archive and store them; in fact, many digital images have already been lost forever.[5] We'll explore some possible solutions in Chapter 11.

The concept of the negative is so important that an entire movie is sometimes called a negative, and having a movie is often referred to as "holding the negative" or "having a negative." No matter how you make your movie, when you are done, you will have a negative, too. Because negatives can be created digitally or on film, let's start with how most people make them today—with digital cameras.

Practice

COMPARING SHOTS

Compare a movie shot on film with a movie shot on digital—for example, *The Dark Knight Rises* (2012), which was shot and finished on film, and *Man of Steel* (2013), which was shot and finished digitally. Can you see aesthetic differences between them in terms of the nature and quality of the imagery? If so, what differences do you detect? Which do you prefer, and why?

Digital Cameras

A digital camera is one kind of image capture device. Light comes through the lens, but instead of hitting and exposing film, it hits an **optical sensor**. The sensor translates the light to ones and zeros, and then that information is recorded to a hard drive, memory card, or similar device. The big variable with digital cameras is in how the information is sensed and how it is recorded. In order to understand that, first you need to understand how light turns into numbers.

How Digital Cameras Work

In a digital ecosystem, everything is expressed with a one or a zero. Each one or zero is called a *bit*. Groups of eight bits become *bytes*; the small, single points from which an image is displayed are called **pixels**. The quality of a pixel's color is determined by the number of its bits. This is the *bit rate*, the number of bits per pixel. More bits make it possible to create more subtle and diverse color representations. Optical sensors differ in the number of bits they can sense. The more professional the camera, the more bits it sees, providing you with the ability to capture more visual information.

Because the number of pixels per frame (and therefore bits per frame) is immense, digital image information is frequently *compressed* when it is recorded in digital video. **Compression** means that the recording software doesn't record every bit of every pixel for every frame. Instead, it records only new information, skipping any repeated information. The software for doing this is a compression code, and you can think of it as a translation program that turns the uncompressed information into a new compressed language. Of course, to understand the information, to read it back again, you need to translate it back with a decompression code. The term for this whole translation process is **codec** (from *co*mpressor, *dec*ompressor), and different systems use different codecs.

Since you will want to have as much freedom as possible in the editing room, you want to capture as much visual information as you can, which means *uncompressed* information is more desirable than compressed information. Of course,

Canon digital camera

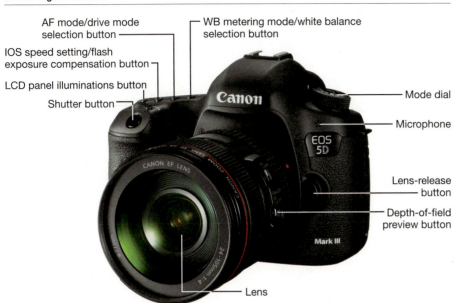

AF mode/drive mode
selection button

WB metering mode/white balance
selection button

IOS speed setting/flash
exposure compensation button

LCD panel illuminations button

Shutter button

Mode dial

Microphone

Lens-release
button

Depth-of-field
preview button

Lens

Courtesy Canon.

the problem is that uncompressed information takes up massive amounts of digital storage space that will impact every department that uses the uncompressed images as they have similar storage issues. Every production needs to figure out how to address this issue, which entails decisions regarding cost, physical space, set size, weight limitations, the quantity of lights needed, power requirements, and the need for air conditioning. The production management team (along with the cinematographer) will undertake a cost-benefit analysis in order to come to a decision. They will also evaluate how much information they can afford to capture, as more information usually means less decision making on the set but increases the amount of decision making that will need to be made during editing.

Of greatest concern now, though, is how the image will appear. Digital cameras are often advertised with their number of *megapixels* (one million pixels). That number is determined by multiplying the number of pixels wide by the number of pixels high. For example, an iPhone with 8 megapixels is 3264 pixels across by 2448 pixels high (3264 pixels × 2448 pixels = 7.99 million pixels = approximately 8 megapixels). However, just because a camera has more megapixels does not mean it produces better-quality images. There are technical differences in the way optical sensors operate.

The best way to evaluate how an image will really look is to shoot something with the camera and look at it on a calibrated, or properly standardized, digital screen. The human eye is incredibly discerning. On professional shoots, various camera tests are done before production begins, as different digital sensors or different film stocks will produce different images under the exact same lighting conditions.

Types of Digital Cameras

Beyond varying numbers of megapixels, digital cameras come in three categories: consumer, professional, and **prosumer**, which is a hybrid of the first two. In recent years, the distinction between consumer and prosumer cameras has diminished

Tip RAW VS.
UNCOMPRESSED

RAW or well-done? You may see a setting on your camera for RAW image capture. RAW means just what you think—the image information hasn't been processed, or "cooked." When you keep your data in RAW format, you maintain the ability to process it—to cook it or transform it—later, in the editing stage. So is RAW the same as uncompressed? Not entirely. Some cameras compress visual information when the visual information enters the lens; others compress the data simply by putting it into the RAW format. But RAW is as uncooked as you can get.

How Do I . . .
Prepare the Camera?

Go to LaunchPad and find out: **macmillanhighered.com/filmmaking**

NAME:	**Jacob Pinger**
TITLE:	Camera operator and cinematographer
SELECTED CREDITS:	*The LEGO Movie* (2014); *Spirit Town* (short, also writer/director, 2014); *Brooklyn Nine-Nine* (pilot, 2013); *Project Runway* (10 episodes, 2006)

No matter what level of the filmmaking food chain you are on, failure to do camera prep will cost you one way or another. Jacob Pinger knows this well, having shot and operated cameras for a wide variety of productions, from TV comedies to reality shows to feature films. Pinger talks about the importance of preparing the camera in a video interview available only on the LaunchPad for *Filmmaking in Action*.

Discover:
- Why camera prep is necessary even for short or small shoots
- How camera prep affected Pinger's work on *The LEGO Movie*
- What "thorough camera prep" means to Pinger—and what it should mean to you

Visit the LaunchPad for *Filmmaking in Action* to learn more—and to explore how you might use this advice.

because some professional technologies have become cheaper, and now many consumer cameras have near-professional features.

There are, however, significant differences between consumer and professional cameras, with prosumer models having several cost-saving compromises in their design. The most important differences are the quality of the lenses and the ability to change them (consumer models have a single non-changeable zoom lens, whereas prosumer DSLR cameras and professional cameras allow you to change lenses), the bit rate amounts, the ability to record data in a compressed or non-compressed format, and the number and sophistication of manual controls, which are the camera functions you can change yourself. (Examples of functions that can be automatic or manual include setting a camera's *focus* and *exposure*, concepts we'll explore later in the chapter.)

Optical sensor

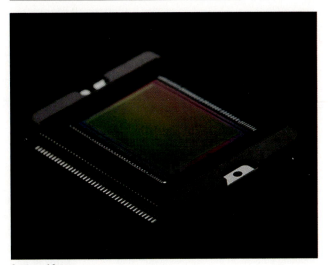

Courtesy of Canon.

Although almost all consumer cameras have manual controls, most people don't take the time to learn how to use them. However, *learning how to use manual controls is the single most important (and fun) thing you can do.* When your camera is on automatic mode, the camera's internal software makes decisions for you about how each image will look. These are the very elements you want to control, as they are important storytelling tools you do not want to leave to chance. (See Action Steps: Using Your Digital Camera, below.)

The future of digital cameras is smaller size, with modern small and inexpensive GoPro cameras as prime examples of where this trend is heading. Even professional cameras are shrinking, with the RED Epic now weighing only five pounds and able to be held with one hand.

 FOCUS UP

The right way to focus: With your camera and zoom lens on a tripod and your subject stationary, zoom in as close as possible. Adjust the focus until it is sharp. Now pull back on the zoom to the framing you want. Your subject will now be in focus whether you are zoomed in close or zoomed out wide—unless you change the distance from the subject to the camera, in which case you will need to refocus.

ACTION STEPS

Using Your Digital Camera

You may already feel comfortable with a digital camera by your side, but in the time-pressured experience of shooting a movie, sometimes even the most familiar activities seem complicated. Using this checklist will ensure that you don't forget anything and that you're ready to shoot.

1 Slide the tripod mount into the base.

2 Turn the camera on with the power button.

3 Insert the SD memory card.

4 Plug in the microphone cable.

5 Position the view screen so you can see it easily.

6 Using the menu, disable automatic controls. You'll learn how to use the camera best if you experiment with the manual adjustments.

7 Set the aperture, ISO, and shutter speed (see pp. 141, 135, and 142, respectively, for more information on these variables).

8 Focus on your subject.

9 Zoom in or out as needed.

10 Check your framing, and begin shooting by pressing the start/stop switch. Stop shooting by pressing it again.

Practice

USING YOUR CAMERA

Even if you've been using a camera for some time, you probably haven't had to do it exclusively with the automatic controls turned off. Choose a very simple scene—perhaps just shooting outside on the campus quad—and shoot some practice runs. Practice an even pan across the scene; a slow, controlled zoom to an object or a person; a fast but steady zoom; a tracking or handheld shot in which you go from interior to exterior locations and the reverse. Try each with a variety of ISO, aperture, and shutter-speed settings, and make note of how they affect the lighting and focus when you look at the material you've shot.

Film

Although you may not have the opportunity to use a film camera in this class, you'll be a better filmmaker if you know how film works, because it is the basis for the aesthetic and technical standards that have shaped the moviemaking experience.

Film is actually a film—a plastic or celluloid strip—coated with a light-sensitive chemical emulsion. When light, focused through the lens, strikes the film, a photochemical reaction takes place that records the image. As you learned in the Tech Talk box on page 129, movies create the illusion of motion by taking a succession of still images and projecting them rapidly; these images are recorded at 24 frames per second (24 fps). In order for film cameras to record at 24 fps, the film itself has perforations on either side, called **sprocket holes**. The sprocket holes allow gears to advance the film through the camera one frame at a time. Each time a frame is recorded, the shutter opens and light strikes the film medium; then the shutter closes, and gears advance the film to the next frame so the process can repeat.

Panavision film camera

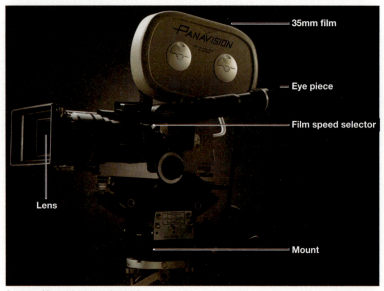

35mm film

Eye piece

Film speed selector

Lens

Mount

Courtesy of Panavision International, L.P.

Film Formats and Film Stock

Film comes in two customary formats—**35mm** and **16mm**, which refer to the width in millimeters of the filmstrip. Smaller formats—8mm and **Super 8mm**—were commonly used as consumer recording media until the widespread adoption of video cameras. Although 8mm formats are not used by general consumers anymore, they have found a home with professionals looking for a more homemade feel or period quality imagery, and with some consumers for recording personal events, such as weddings. In addition, music video directors and some film directors occasionally use 8mm for special sequences. Film also comes in 65mm, which is used for higher resolution

on giant screens, or when added details are needed to create better visual effects shots.

Film is simpler than digital video, even though its ability to create imagery is as complex and in some cases superior. Film technology is well understood, and DPs have over a century of working knowledge on which to draw. Film imagery comes about through two phases: (1) recording, during which the image is captured in the camera, and (2) processing, during which the shot film is taken to a laboratory where chemical processes are applied to the physical film so that the image can be seen and used. Because both of these phases can be individually controlled, film is a fully handcrafted medium and allows its users almost infinite flexibility in capturing and rendering imagery. (See Action Steps: Using a Film Camera, p. 136.)

Unexposed film can be purchased from a film supplier and is called **raw stock** or **film stock**. There are different kinds of film stock, which respond to light in different ways. Some film stock produces more vibrant greens or more vibrant reds, some stock has more or less contrast, and other stock is specially adapted to low-light photography. A film stock's sensitivity to light is called *film speed*, and it is indicated by **ISO**, ASA, or EI numbers, ranging from low to high. (ISO refers to the International Organization for Standardization, ASA refers to the American Standards Association, and EI stands for *exposure index*. The numbers are numerically the same and can be used interchangeably.) Higher ISO films are more sensitive to light, which means they can capture images with less available light; this film stock is called *fast*. Lower ISO film requires more light to capture an image, and it is called *slow*.

In professional filmmaking, ISO numbers will generally range from 50 (slow) to 500 (fast). In a bright-light situation, cinematographers will typically use a slower film; in a low-light or nighttime situation, they will use a faster film. For decades, Kodak and Fuji were the two principal producers of raw film stock for motion picture production. In 2013, due to the industry's digital transition, Fuji opted to discontinue making motion picture film, leaving Kodak as the sole provider of high-end stock for making movies. Today, new stocks continue to be developed by Kodak that allow far better resolution in low-light conditions while still keeping a fine grain. Additionally, since most studio films are *scanned* (converted into high-resolution digital files) during the editing and visual effects steps, newer film stocks provide better visual information for the scanning process.

The size of the film stock determines the size and technical requirements of film cameras, meaning that cameras are categorized by the size of the film in use—35mm, 16mm, or 70mm (giant screen or IMAX). Unlike digital cameras, for which there are distinctions among consumer, prosumer, and professional models, all film cameras are capable of delivering professional-quality images. However, only professional film cameras have the ability to change lenses, and until recently, they had far more lens choices than digital cameras. Interestingly, among the lingering legacies of film cameras are these kinds of lens choices. Many modern digital cameras are now being engineered so that they can be outfitted with traditional film-camera lensing systems that filmmakers have valued for generations.

Some film cameras, such as the Panaflex, are getting smaller and lighter to operate. Still, many digital cameras are smaller because film itself is a fixed physical size, and there is a size below which film cameras cannot be built. In fact, many professional film cameras are quite heavy. The Millennium camera body alone weighs 17.2 pounds. Add to that a 1,000 foot magazine (the box that holds the film reels on the camera), where the raw stock is held (12 lb.); an extension eyepiece (4.7 lb.); a matte box (5 lb.); a focus-assist unit (2 lb.); a follow focus and rods (3 lb.); a big prime lens (5 lb. or so); and the film itself (4 lb. or so), and you're up to 50 pounds!

BUYING FILM

When purchasing film for a project, make sure that you purchase all of your film in advance from the same manufacturing run or batch. There can be subtle variances within the same film stock from different batches.

How Film and Film Cameras Work

Film cameras load their film in reels. A standard reel of 35mm film is 1,000 feet long and will run for 11 minutes. The reel was established as a standard length to provide simplicity in film equipment and shipping of actual film. After one reel is used, the camera must be stopped and a new reel loaded. At this point, you (or the first camera assistant) always *check the gate*—the small rectangular opening through which the film passes when it is exposed to light. Sometimes small pieces of celluloid can break off in the mechanical movement of the film, creating streaks or hairs on the negative. If the gate is clean, the production can move on; if the gate is not clean, it is cleaned with orangewood sticks or compressed air and then the scene is reshot. The fact that film cameras must be reloaded and checked regularly may seem like a disadvantage—and sometimes it is, especially for directors who like to leave digital cameras rolling for up to an hour at a time. On the other hand, many cinematographers and directors feel they get better acting performances because of the urgency film creates; there is a creative energy on the set when film begins to roll, a creative energy made stronger by the realization that each take, each shot, is precious and finite.

Film cannot be seen until it is developed; thus, it is impossible to see what you have shot until the film comes out of the lab. (See Tech Talk: Go Negative!, p. 138.) If there is a problem with the footage, usually a lab technician will call the DP. The production team will then inspect the film to see if the scene needs to be reshot or digitally repaired through a film restoration or visual effects process.

As you learned in Chapter 3, footage that comes out of the lab is referred to as *dailies*. Traditionally, dailies are **telecined** (transferring and converting film images for video viewing), so people can watch them without a film projector. Since film cameras do not record sound (unlike cell-phone and consumer digital cameras), film sound must then be synchronized to the picture (see Chapter 11 for more on this discussion). To enable synchronization, a crew member *slates* each take by physically clapping a stick to the top of a board (known as the slate) to create a sound. The **slate** lists the shot (based on the number established in the breakdown sheets) and *take number*, or the number of times the shot has been recorded, beginning with take 1. The editorial team will use the sound and synchronize it with the physical action of the stick coming down to "sync up" each reel. In the vernacular of filmmaking, a reel that has been synced is said to have been "sunk."

FILM MATH

Film Math for One Standard 1,000-Foot Reel: Based on a camera running at 24 frames per second with 16 frames in every foot of film: 1,000 feet × 16 frames per foot ÷ 24 frames per second ÷ 60 seconds per minute = 11.1 minutes running time before you will need to change magazines. Note that when working with a digital camera, you will not be limited to such short run times generally—one of the advantages of digital touted by many aficionados. On the other hand, that reality only works if you have sufficient recording media storage space to keep going. You will likewise have to stop at some point and change recording cards or hard drives periodically. How much recording media you will need, and how long you can record at one time before swapping media can vary greatly based on several technical factors that are beyond the scope of this book. Just as you would make sure to purchase enough film stock to cover your entire project, make sure you have enough recording media to shoot each day, and a detailed workflow plan for backing up and downloading that material so you can use that media again the next day.

SLOW MOTION

Slow motion is created by shooting more frames per second, or running the film through the camera faster (also known as "overcranking"). When the images are projected at normal speed, the action appears to move more slowly than normal.

ACTION STEPS

Using a Film Camera

A film camera functions in much the same way as a digital camera, with the important difference being that it captures imagery on physical film instead of digital ones and zeros. If you're using a film camera, your instructor will give you step-by-step instructions on how to load film into its magazine, the compartment that holds the film as it runs through the camera. After that, follow these steps and you'll be ready to go:

1 Mount the camera on its base.

2 Load film into the magazine and thread it through the camera's mechanism or gears.

3 Mount the film magazine on the camera.

4 Select your lens and mount it.

5 Looking through the viewfinder, frame your shot.

6 Using a light meter measure the light hitting the object or actor you are going to shoot (see Chapter 8), determine your aperture and shutter speed, and set them.

7 Focus on your subject by dialing the focus ring. Measure your distance to the subject with a cloth tape, and use that measurement to get your focus near-perfect (the focus ring has distance markings).

8 When you're ready to shoot, start filming by turning the switch on. To stop filming, turn it off.

 FAST MOTION

Fast motion, or time-lapse, is created by shooting fewer frames per second, or running the film through the camera more slowly (also known as "undercranking"). When the images are projected at normal speed, the action appears to move faster than normal.

Lenses

We've just learned how images are recorded and about the cameras that make this possible, but how do the images arrive in the camera in the first place? Every camera, whether digital or film, relies on light coming through a *lens*. The **lens** is a piece of specially shaped optical glass at the front of the camera. It is the most important part of any camera (see Action Steps: Taking Care of Your Camera and Lenses, below). Everything else on the camera is called the camera body. The lens is the camera's eye; without the lens, the camera cannot see. It is important to note that there are tools and techniques for altering the color, intensity, and quality of the light passing through the lens using various types of lens filters that are widely used around the industry. We will discuss those during our discussion on light in Chapter 9. For now, let's focus on the basic kinds of lensing systems, and there are a great variety of them, although they are all controlled the same way. Four elements establish the "vision" of a lens: *focal length*, *focus*, *aperture*, and *shutter angle*; together they determine the qualities of your images, including how you manage the *depth of field*. We'll look at each of these in turn.

Practice

LOADING A FILM MAGAZINE

Using a roll of film that has already been exposed, practice threading the film in the magazine and closing the magazine properly. After you have mastered this technique, practice it inside the light-tight changing bag, which keeps all light away from the film while your hands do the work by feel. Remember that after closing the magazine properly, it is common practice to use light-blocking photographic tape to seal the seams of the magazine. This ensures that no light can get in through a miniscule crack or slightly dented magazine.

ACTION STEPS

Taking Care of Your Camera and Lenses

1 **Keep the protective case for your camera and interchangeable lenses with you at all times.** Always put the camera and lenses back in their cases when you are traveling. A small jolt in a car or truck can cause a lot of damage if the camera or a lens falls on the floor.

2 **Never clean your lens by blowing on it or using a handkerchief or shirt.** Breath has moisture, which can damage your equipment. Use a can with compressed air to blow away dust, and if you use a cloth or cleaning fluid, use one that has been specially treated for use on lenses.

3 **Avoid moisture or water condensation.** Especially if you're in an environment with significant temperature changes, pack your camera and lenses with a cloth diaper in the case. It will soak up any nearby moisture—plus, it's cheap, reusable, and environmentally friendly!

Go Negative!

The film used in making motion pictures is called *negative film* because it creates a negative image—an image that is reversed for light and dark and complementary color to complementary color, from what the eye sees. The image from a negative frame of film can be viewed by scanning it into a digital medium, or it can be photochemically printed to become a positive image. The negative, however, must be kept protected from physical harm and handled as little as possible—it is the one and only original recording of what you captured in production. By nature of the photochemical process, every copy made from the negative is of lesser quality than the original, and duplication also submits the original film negative to potential damage. In comparison, a digital negative is theoretically the same quality no matter how many copies are made from the original information, although some cinematographers have noticed a drop of some bits or pixels in the transfer process—whether that is due to general reproduction procedures or specifically related to tools and workflow methodologies is the subject of some debate across the industry. In either case, though, you want to preserve and protect your original negative or recording, and work subsequently only with copies throughout the rest of the filmmaking process.

Focal Length

When light enters the front of the lens, it is curved based on the lens's shape and then focused onto the optical sensor or piece of film. The distance between the end of the lens and the point at which it focuses on the optical sensor or piece of film is called the **focal length** and is measured in millimeters. A lens with a *shorter* focal length bends light more strongly; it brings closer objects into focus and allows a wider view of the scene. A lens with a *longer* focal length bends light more weakly; it is able to focus on objects that are farther away and shows a smaller area of the scene.

For professional filmmaking, using 35mm cameras or their digital counterparts, a normal lens has a focal length between 35 and 50mm. This is because the human eye has a focal length of 43mm, so lenses in the 35–50mm range closely represent the way we see the world. A lens shorter than 35mm is called a **wide-angle lens** because it captures a wider-than-normal field of view. A lens with a focal length of 85mm and above is called a **long lens** or a **telephoto lens** because it magnifies the scene and lets the camera see things that are farther away.

All professional cameras (and many DSLR and prosumer cameras) allow you to change lenses. *Interchangeable lenses* are important for cinematographers because different lenses allow for greater creativity in capturing images. Let's take a look at how each of these lenses affects what the camera sees (see also Figure 6.3 on the next page).

Wide-angle or short-focal-length lenses

- 8mm image, or fish-eye lens

- 21mm image

- 27mm image

FIGURE 6.3 The same images as captured by 65mm, 35mm, 16mm, and 8mm (fish eye) lenses

The longer the lens ("long" lenses have higher numbers), the closer the image appears. The shorter the lens, the more you see, and the sides of the image curve to encompass even more in the camera's view.

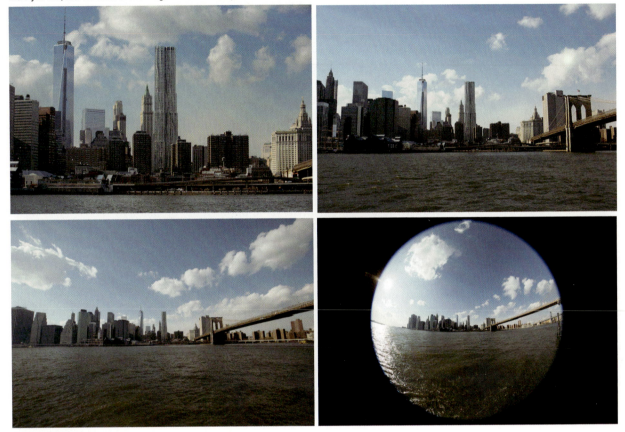

Courtesy of Canon.

Normal-focal-length lenses

- 35mm image

- 50mm image

Telephoto or long-focal-length lenses

- 100mm image

- 200mm image

- 400mm image

- 800mm image

- 1200mm image

The types of lenses described here fit into two categories: prime and zoom. A lens with only one focal length is said to have a fixed focal length and is called a primary lens, or **prime lens**. If you want a different focal length, you must replace one prime lens with a different prime lens. However, primes are

useful because they are relatively lightweight, extremely sharp, and allow a great deal of light to come through even in low-light conditions. For this reason, most primes are considered *fast lenses* that may require less light on set or at your location.

A lens with a variable focal length can zoom in and out and is therefore called a **zoom lens**. All consumer and most prosumer digital cameras have the ability to zoom, but they do so differently. *Optical zooms* actually use the optics of a movable lens to make the subject appear closer. Conversely, a *digital zoom* uses internal software to enlarge a portion of the image, making it appear larger. With a digital zoom, there is degradation of quality, and the picture may seem to break apart. Use an optical zoom for the highest quality image.

You can also take advantage of special lenses to produce unique imagery:

- **Anamorphic.** An **anamorphic lens** "squeezes" a wide-screen image onto a 35mm piece of film. The image is then "un-squeezed" with a projector fitted with another anamorphic lens.

- **Ultra-wide angle**. An **ultra-wide-angle lens**, or **fish-eye lens**, has a focal length of 15mm or smaller. It shows the whole scene but often visibly curves the edges. If the director wishes, the curves can be corrected digitally or by using a lens that has built-in correction.

- **Macro**. A **macro lens** gets crisp images of very small subjects and can focus from as little as one or two inches away. (A normal prime lens needs to be about 18 inches away to focus on a subject.)

Finally, if you're using certain DSLR cameras, you can take advantage of the *Four Thirds (4/3)* standard, which consists of interchangeable lenses that work on several different DSLR camera bodies. These lenses are thinner and lighter than their traditional counterparts, and are specifically designed to produce the optimum image on the digital sensor of compliant cameras (the sensor on these cameras is a 4/3" sensor). Olympus, Leica, and Panasonic are the major manufacturers of cameras that work within this standard.

The PCZ (Panavision Compact Zoom) lens offers focal lengths from 19mm to 90mm, and weighs just over seven pounds.

Courtesy of Panavision International, L.P.

Focus

The term **focus** has two related meanings. The first is *attention*—what you want the audience to concentrate on. The second is technical and has to do with clarity—what has sharp edges and what is blurry? At its most basic, mechanical level, the focus of any lens is set by turning the focus ring to make sure the most important part of an image is sharp.

If you've never used a manual focus control before, now is the time to turn off the automatic focus and learn how to do it yourself. Automatic focus is acceptable if you're not very experienced or if you are in an in-the-moment documentary action situation, but manual focus is usually preferable because it allows you to demonstrate your creative intention of where each shot's focus should be. Autofocus also has some significant drawbacks, especially in low-light situations.

To focus your camera manually, adjust the focus control ring; a follow focus attachment will make it easier on your hand. Most digital cameras with pull-down view screens have magnifying focus functions, which allow you to magnify an area of the shot and focus precisely on it. This may be helpful, although many view screens are difficult to see when you're in a high-light situation, such as broad daylight. In these cases, you may want to drape a black cloth over your head, enclosing the screen so you can see it more clearly.

Focus is a function of the distance between the lens and the subject. To get precise focus, camera operators often use a tape measure to get an exact number by measuring from the focal point on the lens to the object. Most focus rings have distance markings on them, which correlate to the distance at which a subject will be in sharp focus.

When photographing people, the sharpest focus should generally be on the center of the eye closest to the camera. If you shift the focus in a single shot, in order to draw the audience's attention first to one thing and then to another, this is called a *rack focus*. Rack focus is often used to generate suspense; for example, you might focus on a person who's hiding in the foreground, and then rack focus to reveal a predator lurking in the background. (See Action Steps: Rack Focus and Depth of Field, p. 143.)

Key Factors: Aperture and Shutter Angle

Focus is also affected by two other factors: the **aperture**, or amount of light permitted through the lens, and the **shutter angle**, or the duration the lens is allowed to capture light. The interplay between aperture and shutter angle affects the way an image looks. Lighting also comes into play, especially the white balance on digital cameras, and you'll learn about that in Chapter 9. Aperture, shutter angle, and other camera functions can seem confusing and counterintuitive—the chart on page 144 has everything in one place and should make it easy for you.

Shutter angles and exposure times

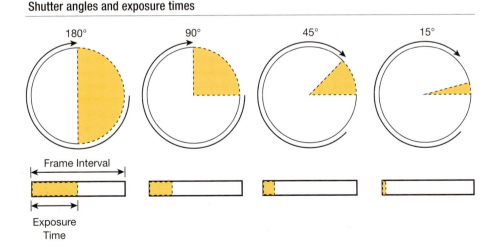

Aperture is controlled by adjusting a variable ring that sits behind the focus ring. This ring is also called the **iris**, and like the iris of your eye, it can get larger or smaller. On automatic settings, the iris adjusts its size automatically. In motion picture and television productions, the DP determines the desired iris setting, or *shooting stop*, and relays it to the first camera assistant, who sets the iris on the lens to the desired aperture. The size of the aperture is measured in **f-stops**. F-stops typically range in number from 2.8 to 32, and the larger the f-stop number, the smaller the amount of light allowed through the lens; for example, an f-stop of 32 is practically a pinhole.

Shutter angle is the amount of time during each frame that light is present for image capture. It is the same as *exposure time* for each image frame, or the *shutter speed* on a still camera. It is called shutter angle because the shutter is a circular disc, and the open slice of that disc—like the slice of a pie—can be larger or smaller. A shutter angle of 180 degrees is typical; that means the pie is half-open and half-closed, and the image will be exposed for 1/48th of a second.

Depth of Field

Skinnier shutter angles allow quickly moving action to be shot without blurring. Big apertures allow a lot of light into the camera but also reduce the sharpness of the image. If you want every object in the frame to be in focus, use a great deal of light (much more than you could stand in daily life) and a very small aperture opening with a skinny shutter angle. The quality of this focus is called **depth of field**. When everything in a frame is in focus, it is called *deep focus*. When only one specific plane is in focus, it is called *shallow* or *narrow focus*. Adjusting the depth of field is an effective way to make a storytelling point in your film, because deep focus puts a character in the context of the scene as a whole, whereas shallow focus emphasizes a subject's importance while everything else around it is blurry. (You'll learn more about what this and other techniques mean for story and emotion in Chapter 9.) In stereoscopic 3D photography, the variables are multiplied because you are using two lenses and recording two images. (See Action Steps: Rack Focus and Depth of Field, p. 143.)

Orson Welles was known for his pioneering use of deep focus, as shown in this shot from *Citizen Kane* (1941).

In the crew race scene from *The Social Network* (2010), DP Jeff Cronenweth used shallow focus to fix the eye on one set of characters in the 2.35:1 frame.

ACTION STEPS

Rack Focus and Depth of Field

Learning how to rack focus and control the depth of field takes some practice, but they're important techniques to master. Fortunately, the steps are fairly straightforward.

Rack Focus

1. Position your camera on a tripod.

2. Using a measuring tape, measure the distance to each of the objects you will want to focus on. Most professional lenses have markings on them from which the measurement to the object should be taken. For example, if there is a one person in the background and another in the foreground, measure the distance to each of their eyes.

3. Note these distances on the focus ring. You may wish to mark them with a pencil on a small piece of blue, removable camera tape.

4. By moving the focus from one person to the other, you draw the viewer's eye to each person. This is called *racking focus*.

Depth of Field

You can achieve shallow depth of field using three separate techniques.

1. Using a telephoto lens, place the camera closer to your subject, and open the aperture wide.

2. When there's an effective distance between your subject and the background, move the camera back, zoom in all the way, and focus on your subject.

3. Using a fixed-focus lens, open the aperture wide, and increase your shutter angle.

Rack focus

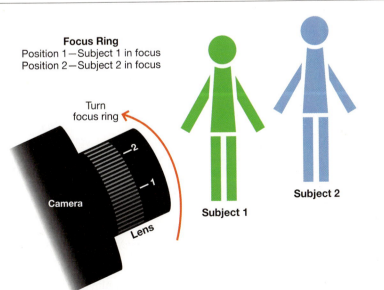

Focus Ring
Position 1—Subject 1 in focus
Position 2—Subject 2 in focus

Turn
focus ring

—2

—1

Camera

Lens

Subject 1

Subject 2

FILMMAKING

By the Numbers

Which is more, bigger, or faster—a higher number or a lower number? It's not always obvious. Here's a cheat sheet:

F-stops	• Lower number = bigger aperture = more light gets in • Higher number = smaller aperture = less light gets in
Film speed (ISO)	• Lower number = less sensitive to light = you need more light to get the shot • Higher number = more sensitive to light = you need less light to get the shot
Lenses	• Lower number = wider angle = you seem farther away and see more of the scene = use for wider shots • Higher number (longer lenses) = smaller angle = you seem nearer and see less of the scene = use for closer shots
Shutter angle	• Expressed in degrees of a circle • Normal is 180 degrees = 1/48th second • Higher number of degrees = longer image exposure time; very high numbers (up to 360 degrees) can result in streaking or blurring, which may be used for dramatic effect • Lower number of degrees = shorter image exposure time; may be used for capturing very fast action
Speed of motion (frames per second, or fps)	• Normal speed motion = 24 frames per second (fps) • Slower motion = more fps; for example, 48 fps makes motion appear half the speed of actual motion • Faster motion = less fps; for example, 12 fps makes motion appear twice the speed of actual motion

Practice

CHANGING EMPHASIS WITH DEPTH OF FIELD

Following the Action Steps on page 143, set up a series of three objects, three feet apart. Position your camera at one end. Practice depth of field changes by opening your aperture to the lowest number (most open position) and focusing on the middle object. Now, close your aperture to the smaller opening (highest number) and try it again. Finally, move your camera back farther, and zoom in as close as possible to the middle object. Can you adjust focus so only it is in focus, and the front and rear objects are out of focus?

Supporting and Moving the Camera

When you're working with different lenses, especially telephoto lenses that make subjects appear closer, you'll find an unfortunate side effect: every little move or shake of the handheld camera seems amplified. Sometimes this is a good effect because it makes the shot seem real or like a documentary; however, it can also be distracting and pull the audience out of your movie's story. Fortunately, there are a variety of accessories that allow you to support the camera easily, so that the image remains stable, and that help you to move the camera smoothly in order to capture the shots you're after. The crew members responsible for operating or assisting with the tools to move cameras are the **grips.** Following are some of the more common ways to support and move the camera:

▌ **Tripod.** Also called "sticks," this is the most basic way to control camera movement. On a **tripod,** you can swivel the camera up-and-down or right-and-left, and the tripod structure will hold it steady.

▌ **Steadicam.** A **Steadicam** is a special harness that fits on the cameraperson's body and holds a digital or film camera. It has counter-

Types of camera mounts

A. Courtesy of Freefly Systems. B. Courtesy of OConnor, www.ocon.com. C. Courtesy of the Steadicam Division of Tiffen. D. Courtesy of J.L. Fisher. E. Courtesy of MSEGRIP.com/Matthews Studio Equipment. F. Photo by Bob Thomas Sports Photography/Getty Images. G. Courtesy of www.Supertechno.com/www.Techodolly.com. H. Courtesy of Highviz Photography. I. Courtesy of Pacific Motion Control, Inc./PacificMotion.net.

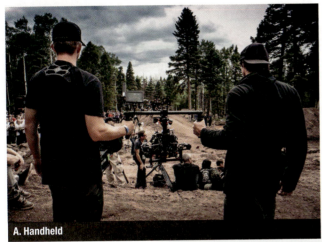

A. Handheld

B. Tripod

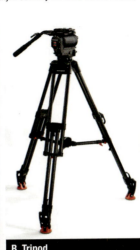

C. Steadicam

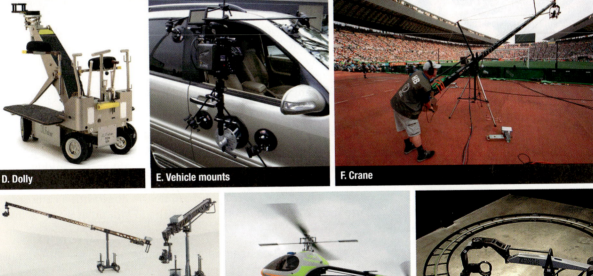

D. Dolly

E. Vehicle mounts

F. Crane

G. Technocrane

H. Helicopter mount

I. Motion control

weights and a balancing mechanism, so the camera person can run or walk and the camera motion will appear smooth and fluid.

▌ **Dolly.** The **dolly** is a fixed track—it looks like a small railroad track—which can be straight or curved. The camera and the camera operator ride on the dolly track; a dolly shot can be used to track smoothly alongside an actor who is

walking or running, or it can be used to push in or pull back from an actor who is standing in one place.

- **Vehicle mounts.** Cameras can be mounted on anything that moves. There are specialized mounts, or fixtures, that can attach a camera to a moving car or motorcycle.

- **Crane. Cranes** come in a variety of lengths—from as little as 25 feet up to 85 feet. The 85-foot crane weighs four tons and has counterweights to keep it from toppling over. In all cases, the camera is mounted on the top of the crane; the camera may be remote-controlled. A crane shot allows the camera to get up high to survey the whole scene, swoop down onto the action, or pull back and away to give a dramatic feeling or emotional perspective.

- **Technocrane.** A Technocrane is a combination of a crane and a dolly. A remote-controlled camera is mounted on the top of the crane, and the crane has a cart with wheels that can be pushed along a dolly track.

- **Helicopter mounts.** Helicopter mounts include equipment that will attach a camera either to a full-size helicopter or to a miniature, remote-controlled drone that can fly in, around, and over the action—one of the coolest toys in a cinematographer's bag of tricks.

- **Motion control.** Motion control connects the camera and the lens adjustments to a computer, so that camera motion can be precise and repeated exactly; for multiple takes of a shot, the computer moves the camera. Motion control is always used for heavy visual effects shots, in which multiple images need to be created for separate layers or versions of the same shot. Motion control can be a particularly expensive technique and, with digital alternatives now available, is not used as frequently as it once was.

- **Wire mounts.** Wire mounts permit the camera to be suspended on cables. Pioneered in sports television coverage, this tool allows the audience to get intimate with the action by placing the viewer right in the middle of it. As opposed to a crane, this rig is used when the shot requires the camera to be moved over a long distance. This could not be done with a cameraperson on the ground; a wire-mounted camera can zip around at up to 35 miles per hour!

Sometimes, of course, the camera must not move—for example, when an image needs to be completely static. In these instances, the camera must be mounted on something rock solid. It is impossible to hold the camera steady with your hands; you will always end up with small, perceptible movements. A camera that is static is said to be *locked off*, and a tripod is an excellent tool for locking off the camera. Locked-off shots are often used for establishing shots and for shots that will be adding extensive visual effects. They are also used in places where the story is better told by the action moving within the frame rather than by the frame of vision moving. Many comedies, for example, show the actors moving while the camera remains stationery, thereby emphasizing the actors' physical comedy. (You'll learn more about the relationship between shots and storytelling in the next chapter.)

Tip USE A WHEELCHAIR TO DOLLY

Low-budget dolly trick: Have the camera operator sit in a wheelchair and aim the camera. A second person can push the wheelchair from behind to track the action.

Tip STEADY YOURSELF

When operating a handheld camera, use your free hand to hold the elbow of the arm holding the camera, with the elbow of your free hand wedged against your hip. This will help keep the shot and camera steady. And don't forget to turn off the function on a digital camera that automatically steadies the shot; it may correct movements you actually want.

Practice

USING YOUR TRIPOD

The tripod is the most basic and important tool for supporting a camera. Put all three legs together and extend them to the same length, then spread them out. Point the forward leg toward the action. Stand between the tripod's two rear legs, with your forward leg directly in line with the lens and the action. Hang a camera bag or a sandbag over the tripod to keep it stable.

SMARTS

The "Camera Package"

Whether you go to your school's equipment check-out room or, on a professional production, to a rental house, you'll be getting a *camera package* to make your movie. Even the pros do not typically own their own equipment, because great gear costs a lot, and its maintenance can be expensive.

Here's what to look for if you're renting or borrowing a camera package:

▌ Make sure you know what you will need. It will generally be easier to get everything from one vendor—camera, lenses, cables, and lighting equipment. Not only will this save you money (the more you rent, the more you save), but it will save you the transportation trouble and expense of picking up and returning gear to multiple locations.

▌ Call around and get competitive bids. There could be a wide variety of prices, depending on how much equipment vendors have on hand at a given moment.

▌ Check out the equipment carefully before you accept it, and make sure it is in proper working condition *before* you leave the rental facility. (It's a good idea to bring at least one other person with you.) Anything that comes back broken will be your responsibility, whether it's your fault or not. (See How Do I . . . Prepare the Camera?, p. 132.)

▌ Look for deals, and don't be afraid to negotiate. Some rental houses have weekend specials—you get your gear on Friday, return it on Monday, and they only charge you for one day. Some give discounts for student productions. Ask what they can do to help you; most will try to accommodate you and work within your budget.

The tools described here are used frequently in studio movies, and different versions of them are increasingly being used in student productions. They should be obtained as part of the entire equipment order for your movie, which means you will need to think through in advance what you need—and what you can afford—to tell your story well. (See Business Smarts: The "Camera Package," above.)

✚ Camera Pro's Emergency Kit

▌ A first-rate tripod, so the camera can be absolutely motionless when you need it to be

▌ Canned air for blowing dust off lenses and out of cameras

▌ A cloth diaper or desiccant packets to keep cameras and lenses moisture-free

▌ An extra camera battery; you don't want to run out of juice while shooting

▌ Chargers with adapters that plug into every kind of electrical socket all over the world

▌ Phone numbers of good tech people at the rental house where the equipment comes from—so you can call them the instant something breaks or doesn't work properly

▌ A large variety of different types of camera tape and markers

▌ An accurate measuring tape to measure the distance from the camera to the object being filmed

▌ A director's viewfinder, which is essentially a zoom lens that helps define the choice of lens, angles, and coverage. It is also used by the DP to help plan shots on-set before moving the camera equipment

▌ The American Society of Cinematographers manual. A student version is available

CHAPTER 6 ESSENTIALS

■ The format and aspect ratio of a film is determined by creative and commercial concerns. Even if you are shooting in one aspect ratio, it is important to protect the frame or shoot alternate shots for other aspect ratios in which your film may be seen.

■ Digital cameras capture optical data and store it on memory cards or hard drives, for editing and visual manipulation later in the filmmaking process. Only by using a digital camera's manual controls can you experience its full potential as a creative tool.

■ Film cameras record images through a photochemical process, which is more cumbersome and expensive than digital, while sometimes offering greater creative control and higher image quality.

■ Lenses determine what the camera sees. There are two kinds: primes, which have fixed focal lengths, and zooms, which have variable focal lengths. You can also use a wide variety of specialized lenses to achieve specific effects.

■ Although cameras can be handheld, you will get steadier shots and smoother moves by using accessories and specialized rigs to support and move the camera.

KEY TERMS

16mm
35mm
3D stereography
Anamorphic lens
Aperture
Aspect ratio
Codec
Compression
Cranes
Depth of field
Dimensionalization
Director of photography (DP)
 (cinematographer)
Dolly
Film
Focal length
Focus

Formats
Frames per second (fps)
F-stops
Giant screen
Grips
Iris
ISO
Lens
Letterboxing
Long lens (telephoto lens)
Macro lens
Negative
Optical sensor
Panning and scanning
Pillarboxing
Pixel
Prime lens

Prosumer
Raw stock (film stock)
Resolution
Shutter angle
Slate
Sprocket holes
Steadicam
Super 8mm
Telecined
Tripod
Ultra-wide-angle lens
 (fish-eye lens)
Vehicle mounts
Wide-angle lens
Widescreen
Windowboxing
Zoom lens

> **"Images, not words, capture feelings."**
>
> – Sven Nykvist, Academy Award–winning cinematographer, whose more than 120 films include *Cries and Whispers* (1972), *The Unbearable Lightness of Being* (1988), and *What's Eating Gilbert Grape* (1993)

Telling the Story with the Camera

Skyfall (2012)

KEY CONCEPTS

- The building blocks of film language are a set of basic shots, which cover the action from far and medium distances and at close range.

- Each shot has a particular perspective on the action, which is conveyed through the camera's angle, or viewpoint.

- A good shot is well composed, which means the visual elements are well balanced in the frame and adhere to principles of good aesthetics.

- Visual storytelling functions in close collaboration with picture editing to provide different narrative possibilities as the film is being finished and to preserve continuity—the illusion that everything in a scene is happening in real time—with careful control of lighting.

"So why do you need me?" James Bond (played by Daniel Craig) asks Q, the inventor of espionage devices, in the movie *Skyfall* (2012). It's a question Roger Deakins wondered himself when director Sam Mendes asked him to be the cinematographer on the film. Deakins, despite his lengthy resume, had never shot a spy thriller before. "I must say that action is not so much of a thrill as capturing a performance," he said about the experience on his popular website.[1]

But the director didn't want a conventional action movie. The James Bond series is the longest-running franchise in movie history. Could *Skyfall*, its 50th anniversary production,

reinvent the main character for a new, global audience?

Deakins, a 10-time Academy Award nominee, came up with a visual answer to this question. He decided to shoot *Skyfall* like a Western,[2] where the action plays out in long takes in the frame, rather than the conventional action-movie approach done with multiple cameras, which, in Deakins's opinion, looks like "an incoherent mess of shots without any particular structure or point of view."[3]

The result? *Skyfall* looks and feels unlike any of its predecessors, and it became the most successful James Bond movie in history, grossing over $1 billion worldwide, with Deakins making a significant visual contribution to that result.

That's why the movie needed him. Or, as Q responded to James Bond's question, "Every now and then a trigger has to be pulled." Indeed, a bit of dialogue fitting for a Western.

In Chapter 6, you learned about the tools for capturing imagery—cameras and lenses—and how they function. In this chapter, you will learn how to use them creatively: how they serve a filmed narrative. As the director of photography, you will work in close collaboration with the director and production designer, or you may be your own director and cinematographer on your class film. The relationship between the cinematographer and the director is the closest of creative marriages—so much so that a few professional directors actually do double duty at times and work as their own DPs, too. Among the well-known directors who have done this for entire movies or sequences within movies are Steven Soderbergh, Stanley Kubrick, James Cameron, Peter Hyams (who began his career as a DP), Ridley Scott, David Fincher, Debra Granik, Chantal Akerman, and Peter Jackson.

When the director and the DP are two different people—which is most often the case in professional productions—they will spend a large part of their time on the set side by side, and the DP's role involves both diplomacy and organization. The DP not only has to find ways to get the shots the director wants with the time and money at hand, but also needs to find the best way to communicate with the director in any given situation.

As the cinematographer, every choice you make affects the moviegoing experience—how the camera moves (or doesn't move), where people and objects are placed in the frame, and how much of the scene you let the audience see (or how much you don't let them see). Even when you are making these choices, you'll be mindful of limiting factors—such as time, budget, scheduling, and what's physically possible where you are shooting—and giving the director and editor plenty of choices for shaping the story when they are in the editing room. In this way, visual storytelling is a skill that combines the most theoretical concepts of imagery with the hard-nosed practicality of getting a day's work done. Few filmmaking tasks combine these realities in as formidable a way, or must balance them so carefully on a minute-by-minute basis.

Although all aspects of filmmaking are related, the interconnection is especially strong between storytelling with images and two other areas: lighting and editorial. Lighting and color determine how we feel about film imagery. To set up your shots effectively, you'll need to light them well—and you will learn about that in Chapters 8 and 9. Editorial assemblage of individual shots (Chapters 11–12) completes the visual storytelling you begin in this chapter. Taken together, telling the story with the camera, lighting it properly, and editing the shots into sequences form a trio of visual language; you begin your study of it here.

Basic Shots

Basic shots are the building blocks of visual grammar. If you think of a scene as a sentence, you can consider individual shots the words in the sentence. Each shot must have a reason for being there, and it needs to convey important information to the audience. As a cinematographer, you have a responsibility to get enough shots to make sure there are different ways to assemble the scene in the editing room (see Chapter 12). Indeed, the entire process of image capture can be thought of as executing your vision while preserving your future options for different editorial and visual effects as the entire story comes together.

As noted in Chapter 3, getting the shots you need is called *covering a scene*, or ensuring that you have *coverage*. The cinematographer needs to know the editing style the director will want to achieve before deciding how to cover a scene. What kind of pace should the scene have? Will the scene be intimate or more clinical?

Will the actors be moving around or staying in the same position? Different editing styles require different shots; some directors prefer to do scenes in long, single-camera takes, while others like to put together scenes with lots of short bits of imagery. As with every other aspect of filmmaking, the process is outcome-oriented; you start by conceptualizing what you want to finish with.

How can you "see" a scene? First, ask yourself if the audience should experience the scene objectively or subjectively. In an *objective* scene, the camera is a neutral observer, similar to a journalist viewing the action. In a *subjective* scene, the camera experiences the action through the eyes of one of the characters and imparts that character's emotional state to the action. Next, you'll determine the distance from which the camera will see things: from far away, which places the characters and action in the context of their surroundings; from a middle distance, where you can see most of people's bodies as they interact with others; and at close range, where you can see the fine details of faces and motion. These three distances correspond to the three basic shots—long shots, medium shots, and close-ups. We'll look at them as large categories, and examine the variations that provide nuance in the way they convey information. These basic shots comprise the standard approach to making certain a scene is well covered. Although you won't typically use all of them at once, you'll need enough of them to cut the scene together.

Long Shots

Long shots are valuable for setting characters and places in relationship to the world they're in. Images of a person walking down a deserted city street, where you see boarded-up buildings along the sidewalks, is an example of a long shot, as are images of a little house on a wide-open prairie. Following are names and explanations for the three most common long shots:

- **Establishing shot.** The **establishing shot** sets up the location where the ensuing scene will take place. It should be wide enough to capture all the important architectural, or landscape, details. For instance, in a wedding scene, the establishing shot would show the outside (exterior) of the church; for a campfire scene, you'd want to shoot the surrounding countryside, with the campfire visible in the distance. Establishing shots are particularly useful as transitions between scenes or sequences.

- **Wide shot/master shot.** A **wide shot** is a shot that shows all or most of the actors. Typically, the **master shot** is a wide shot of the entire scene, which you can always cut back to or use as reference when you cut in for closer shots. The master is often shown at the start of the scene to establish the geography of the environment and the relative positions of the actors to one another (the *blocking*, which you explored in Chapter 3: Directing). Many situation comedies such as *Talladega Nights* (2006), use a wide shot to put characters in the context of everything that's going on around them.

 SHOOT THE MASTER FIRST

Shoot the master shot first; that way, you'll be sure you have captured the entire scene. Later, when you shoot closer shots, you'll match the lighting, action, and blocking in the master shot.

A wide shot establishes the dinner-table scene in *Talladega Nights* (2006).

▌ **Extreme wide shot.** An **extreme wide shot** differs from a wide shot in that the actors will appear much smaller, perhaps taking up as little as 20 percent of the frame. Although it serves much the same function as a wide shot, the extreme wide shot can also be useful in creating a sense that the environment is more of a character in the story, or perhaps to show the powerlessness of the actors against their environment. A science fiction story, in which the actors must grapple with a strange alien world, might make good use of extreme wide shots; they are also staples in epic adventures, as you can see in films like *Lawrence of Arabia* (1962), and traditional Westerns, such as *The Searchers* (1956).

An extreme wide shot captures the epic scope of *Lawrence of Arabia* (1962).

Medium Shots

Medium shots bring you closer to the action, but not too close—and for that reason, they're the most common shot in films. They let you see the entire action of the scene and some of the background where the action is taking place. A character pulling a cell phone from her pocket, or two characters sitting and talking on a park bench, would both be well-covered in medium shots. There is no hard-and-fast rule for what differentiates a medium shot from a long shot—it's a fuzzy dividing line. In this book, we take the view that long shots emphasize the place more than the characters, and medium shots move in to focus specific attention on the characters and the action. Following are names and explanations for the five most common medium shots:

▌ **Medium shot.** While everything in this category is a medium shot, a classic **medium shot** is composed to start at the actor's chest and move up to the head. This medium shot feels familiar and objective, because it is how we usually interact with other people—standing or sitting near enough to see their chest and head without getting in their face. You'll use a medium shot to explore an actor's emotional state without the subjective, manipulative quality of a close-up.

A medium shot in *To Kill a Mockingbird* (1962)

▌ **MCU, or medium close-up.** Slightly tighter than a medium shot, the **MCU** starts at the middle of the chest and goes up to the top of the head, sometimes cropping the actor's face at the hairline. An MCU doesn't have the forcefulness of a close-up, but it still brings focus to the actor's eyes and facial expression.

MCU in *City Lights* (1931)

▌ **Full shot.** A **full shot** frames a single actor from head to foot. This shot is useful for showing the clothing that the actor is wearing. You might employ a full shot to emphasize a costume change—for example, when a bride-to-be tries on her wedding dress for the first time—but otherwise, full shots should be used sparingly, as they can be difficult to cut to and away from.

A full shot in *Patton* (1970)

■ **Cowboy.** The **cowboy** is *tighter*, or *closer*, than a full shot and will generally cut an actor off just above the knees. It is called a "cowboy" because it is frequently used in Westerns to show someone who is wearing holsters. Because a person's hands hang just above the knees when the arms are at rest, a cowboy shot is useful if you want to emphasize how the actor is using (or not using) hand gestures.

A cowboy shot in *High Noon* (1952)

■ **Two shot/three shot, and so on.** These shots refer to the number of objects—usually actors—in them. Typically, the framing of any of these shots is close to the edges of the actors' backs and will not show as much of the environment as a wide shot or master. It's a good idea to keep the camera at eye level with your actors. A **two shot** or a **three shot** is useful for capturing an intimate discussion in a single shot.

DON'T CUT UP YOUR ACTORS

Don't frame a shot in which an actor is cut off at the joints (knees, ankles, wrists)—it will look as if part of the body has been cut off.

A uniquely composed three shot in *Chinatown* (1974)

Close Shots

A close shot brings you right into the action and emotion of a scene; here, the actor's face fills the screen, and you feel deeply, personally connected to the character. In this way, the close shot is the opposite of the long shot: the long shot is *objective*, and the close shot is *subjective*. Directors often choose close shots for

the most powerful, impactful moments of storytelling, and they are standard shots in movies that center on relationships. Close shots of actions or objects are narrative devices that tell the story in visual terms, and they often don't need any dialogue to make their point.

Following are names and explanations for the three most common close shots:

▋ **Close-up** (tight vs. loose). A **close-up (CU)** starts at the top of the shoulders and includes the actor's head. As the shot moves in closer on an actor, it is said to be getting *tighter*. As the shot moves back, it becomes *looser*. Close-ups are especially useful for movies that will play on any screen other than a cinema screen—televisions, tablets, laptops, and mobile devices. When you're shooting for a small screen, close-ups create a sense of intimacy with the actors and convey emotion well. They are also an important tool for emphasizing details and plot points—for example, the close-up of the doorknob turning, the email opening, the money being stuffed into a suitcase, all give the audience essential information so they can follow the story.

A loose close-up in *Django Unchained* (2012)

▋ **Extreme close-up** ("choker" and "haircut"). An **extreme close-up (ECU)**, or **big close-up (BCU)** will frame out the shoulders and will often not even show the top of an actor's head. It is often called a "choker" when the shot cuts into the actor's neck. When the shot is so tight that it also chops off a bit of the top of the actor's head, it is called giving the actor a "haircut." Some directors use ECUs to convey moments when an actor experiences extreme emotion or must make a big decision. An ECU in a mystery or suspense story may signify that the actor has just figured out an important clue. The shot often focuses on the actor's eyes, which are primary acting tools for conveying emotion.

▋ **Insert shot.** An **insert shot** (usually a close or a tight shot) captures some important detail in the scene. For instance, if an actor pulls a gun from his or her pocket, the director may want an insert shot of the gun as it is revealed. You should shoot inserts of any physical detail that's significant for the characters—for example, a letter (you'd cut to it as the actor is reading the letter) or a gun (you'd cut to it as the actor pulls out the gun to threaten someone). Inserts can also be used as *cutaways*—shots the editor can use to break up or shorten the main action of a scene.

If you think creating all of these shots is time-consuming, you are right! Accomplishing a series of setups for each scene might take

Tip WATCH THE BACKGROUND

When shooting inserts, make sure the background behind the featured object is consistent with the scene. In the example of someone reading a letter, the insert on the letter should be shot from the actor's perspective, with the actor's fingers visible holding the letter, and perhaps, beyond the letter's edge, a part of the room where the letter is being read. Nothing says "fake" more than an insert that's inconsistent with the rest of the scene.

Practice COUNTING THE SHOTS

As you've just learned, every shot takes careful planning to set up. Using a 30-second commercial as an example, count the number of shots (setups). Then, list the kind of shot each one is (master shot, close-up, insert, and so on).

anywhere from half a day to two or three days for a particularly long scene. (See How to Shoot a Scene, p. 170.)

Another way to cover a scene would be to do it in a single shot. The battlefield scene in *Atonement* (2007) is a good example of a complicated scene shot in a single take. The single shot is thrilling because it conveys a sense of scale and movement, but it also requires a lot of time to rehearse and choreograph and has potential storytelling risks. When you shoot a scene in pieces, you have the ability to shorten or lengthen the scene, and moments within the scene, and to orchestrate its movement in editorial to reflect character and storytelling dynamics. When you shoot a scene in a single shot, you have to live with it as it is.

Camera Angles: How You View the Scene

You've just learned a series of basic shots, each of which is an example of *what* the camera sees. When you decide the angle of each shot, you determine the *viewpoint* from which the camera shows the scene to the audience. Each camera angle, or viewpoint, is part of your visual language that tells the audience about the characters, their story, and the emotion of the scene. Following are the 10 most important shots associated with specific camera angles:

- **Low-angle shot.** A **low-angle shot** is one in which the camera is placed below the characters' eye level. In this shot, the camera must be angled to look *up* to see the action. This gives the appearance of characters looming over the camera and puts them in a position of power. You might choose to shoot dangerous characters from a low angle to emphasize how menacing they are.

Low-angle shot in *Slumdog Millionaire* (2008)

- **High-angle shot.** A **high-angle shot** is one in which the camera is placed above the characters' eye level. In this shot, the camera looks *down* on the action, often putting a character in a meek or powerless position. High-angle shots can also suggest objectivity and scale by placing the characters in the context of their surroundings.

- **Eye-level shot.** In **eye-level shots**, the camera is placed at eye level with the actors, usually between five and six feet for adult actors. An eye-level shot does not draw attention to itself and conveys the action in a natural, *objective* fashion; it suggests that the audience, as an outsider, is observing the scene. When using eye-level shots, choose between *close (tight)* or *far (loose)* eyelines. A close versus far eyeline refers to how close an actor faces toward the lens while looking at an off-camera subject. An actor with a *close eyeline* looks very close to the lens, as if the off-camera subject were right next to the camera. An actor with a *far eyeline* looks well away from the lens, as if the subject were far away from the camera.

▌ **Bird's-eye view.** Also referred to as the **overhead shot**, the **bird's-eye view** is shot above the action and looks straight down on it, from a very high angle. It makes the characters appear insignificant in the context of their surroundings.

Bird's-eye view (overhead) shot in *Goodfellas* (1990)

▌ **Dutch angle.** Usually the camera is placed parallel to the ground or horizon line; however, the **Dutch angle**, also called the *oblique* or *canted shot*, tilts this view and places the camera at an oblique angle to the horizon—now the images are on a diagonal. Dutch angles suggest instability, danger, strangeness, and suspense. You'll often find them used in horror and suspense films or in a sequence in which a character experiences a physical or psychological change—as when a character is intoxicated or having an emotional breakdown. A classic film that uses Dutch angles to great effect is *The Third Man* (1949). (See Action Steps: Low-Budget Dutch Angle Trick, p. 159.)

Dutch angle in *The Third Man* (1949)

ACTION STEPS

Low-Budget Dutch Angle Trick

You don't need fancy equipment to get a professional-looking Dutch angle—you just need the camera and your tripod.

1 Remove the base plate from the tripod and install it on your camera at a 90-degree angle.

2 Tighten it firmly, and then slide the camera onto your tripod.

3 You can use the tripod's tilt lever to create a Dutch angle.

USE POV CORRECTLY

Point-of-view shots must be taken from the perspective of the character whose point of view it is. If you start with a character's POV shot at a wider angle and then move in closer, it tells the audience that the character is observing a detail or noticing something important, or that the filmmaker is emphasizing something.

■ **Point-of-view shot.** A **point-of-view (POV) shot** shows what the actor is seeing during the scene. It is often shot with a handheld camera to give a sense of movement that mimics the way a character might be looking at something. POV shots are subjective and must be from the eye level of the character whose point of view it is. POV shots draw the audience into the action and into the mental and emotional state of the characters. They're especially effective in suspense sequences, when a character is looking around corners for possible danger; in dialogue sequences, to "get inside the heads" of the characters as they listen and react to one another; and as inserts and cutaways, to reveal what a character sees or discovers. In the example of the insert shot of the gun (p. 155), you could shoot the same in-

FIGURE 7.1 Diagram of a reverse shot

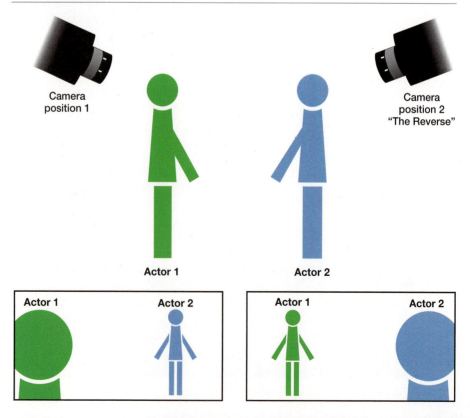

sert with a handheld camera from the subjective angle of another character; in this way, you'd communicate that the character has spotted the gun.

▮ **Over-the-shoulder.** The **over-the-shoulder (OTS)** is an extremely common shot that includes two actors engaged in dialogue. The actor nearest the camera is called the *foreground*, or downstage, actor; this actor's back will be to the camera (his or her face will not be visible), and the shot will include the actor's shoulder. The actor who is facing the camera (and who is the main subject of the shot) is called the *upstage* actor and is framed in a medium or loose close-up shot. The OTS is an important shot because it can help establish the relationship (both physical and emotional) between two characters by linking them in a single shot. Use OTS for two-person dialogue scenes; just make sure to shoot both sides (over the shoulder of each actor). When you shoot OTS Actor A toward Actor B, then turn around to shoot OTS Actor B toward Actor A, it's called a **reverse shot**, as seen in Figure 7.1. (See also Action Steps: Dirty vs. Clean, below.)

▮ **Wide lens close-up vs. long lens (telephoto) close-up.** You can shoot a close-up with different lenses, and the lens choice can make a dramatic difference. A **wide lens close-up** "stretches" the actor's features and exaggerates the distance between the actor and the background. In visual language, this allows the camera to be close on the actor and still emphasize a sense of aloneness or isolation. The **long lens close-up** compresses the actor's facial features and brings the background closer.

▮ **Profile shot.** A **profile shot** can be a close-up or a wide shot—what's important is profile *image*, which conveys the intensity of the actor's gaze or the sculptural quality of the actor's face. You set up a profile shot by making sure that the actor's eyeline (the actor's look direction to the off-camera subject) is at a 90-degree angle to the lens.

▮ **Three-quarter back shot.** This shot views the actor from nearly behind; however, the camera will still see part of the actor's eyebrow and ear. (When an actor wears glasses, the shot will often focus on the frames.) The **three-quarter back shot** often conveys that an actor is deep in thought. As with the profile shot, this shot can be a close-up or a wide shot.

Practice

OBJECTIVE AND SUBJECTIVE SCENE WORK

Using a one- to two-page, two-person scene as material, shoot it two ways: first, in a single shot in which both actors are in the frame; second, with POV shots from the position of each of the actors. The first version is an objective view of the scene, whereas the second version is a subjective view of the scene. Play back the footage and observe how the scene's meaning is altered. What does each variation convey? Decide which angle (objective or subjective) best tells the story and emotion of the scene you've selected.

ACTION STEPS

Dirty vs. Clean

A medium or close-up shot that includes a foreground actor, such as an over-the-shoulder, is called *dirty*. A shot that does not include any other actor in the frame is called a *clean* shot. How do you shoot them, and when would you want the shot to be dirty or clean?

❶ **For a dirty shot**, focus on the main actor, and include some of the other actor's face or body in the shot (enough so it's clear that the second actor is making the shot "dirty"). This shot emphasizes the emotional or spatial relationship between the two characters.

Continued

Continued from the previous page

2 **For a clean shot**, isolate the main actor. No one else should be visible in the frame. This shot emphasizes only the main actor.

3 **Pro camera move**: go from dirty to clean in one shot. This move starts with a dirty shot, then pushes in to the main actor until the shot is clean. Use this move when you want to show that something important is happening to the main character—for example, a moment of revelation, an emotional change, or a glimpse of recognition.

Composition

Whereas camera shots and angles provide a way of seeing what's in a scene, **composition** is the craft of arranging people, architectural details, and objects *inside the frame* so that they look good. As you learned in Chapter 6, every motion picture image is bound by horizontal and vertical limits, which form the image's frame. In order to compose images inside the frame, you'll need to explore what "looking good" means, discover the core principles of artistic composition when the camera is still or in motion, and learn to use the right lens to get what you're after.

As you learned in Chapter 4, previsualization can be used to determine the composition of the shot before you arrive on-set, saving valuable time and money by anticipating the setups needed and the best order in which to achieve them. Referencing the previsualization stage will also serve as a way to take into account the visual effects that will be added later, and ensure that the composition on-set accommodates them. However, it is not a substitute for you, as the director, to look through the camera viewfinder on set to make sure the DP is capturing the composition you want.

What Is Good Composition?

There are two answers to this question, one of which can override the other if creative needs require it. The first answer is that a well-composed shot includes well-balanced visual elements and appropriate lighting and color, and occurs when framing, blocking (movement of actors), lens, focus, and movement of the camera all work together in a perfect whole. The second answer is that a good shot can actually be anything, so long as it best tells the story at that particular moment in the film. So, as with other so-called filmmaking rules or principles, the basics of good composition can be altered or skewed if you have a strong enough, story-driven reason for doing so. Most often, though, following the principles of good composition will help your story, so you need to understand and appreciate them in order to properly comprehend when to follow them exactly and when to alter them for well-thought-out creative reasons.

Good composition, then, does have core aesthetic principles—principles that go far back in the history of painting and visual art. Note also that there is a natural connection between many of these principles and some of the fundamentals of production design that you learned about in Chapter 4. After all, to compose an orderly image, you need to account for the elements within it individually and collectively. Also, it often takes no more time or money to compose a shot well than it does to shoot haphazardly, with no regard for visual aesthetics. Therefore, one way to make class projects and low-budget movies look superior is to pay attention to these 10 elements of good composition:

1. **Observe the rule of thirds.** Imagine your frame is divided into thirds along both the *x*- and *y*-axes; your subject should be on one of the lines. In a close-up, the eyes should be on the upper horizontal line. The **rule of thirds** will give all of your images a sense of visual balance, because our eyes naturally look first to the upper middle third of the film frame, and then look around to see the rest of the image.

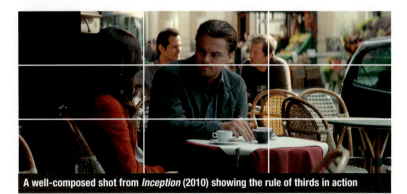

A well-composed shot from *Inception* (2010) showing the rule of thirds in action

2. **Give the right amount of headroom. Headroom** is how close the top of the frame is to the actors' heads. A shot will have a lot or a little headroom and will generally (but not always) stay consistent for all actors in a scene. Headroom can convey a lot about a character. When you give characters the right amount of headroom, they will seem to inhabit the scene comfortably; if you purposely give them little headroom, you're suggesting that they are uncomfortable in the scene, and you can use this composition technique for dramatic effect. Although a comedy will usually have more headroom than a drama, there are no hard and fast rules.

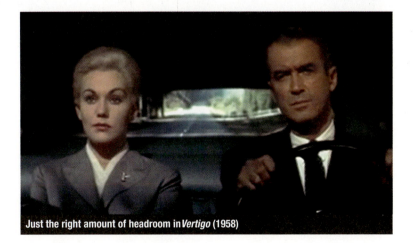

Just the right amount of headroom in *Vertigo* (1958)

3. **Provide negative space.** Frame ahead of your character so that there is **negative space** (space that is not filled) where the character's eyes are looking (this is called giving the character **eye room**, or **look room**), or where the character is walking (this is called giving the character **lead room**). Negative space is important because it allows you to direct the audience's gaze to what's most significant in each shot. In the shot from *The King's Speech*, the audience is naturally directed to King George VI's face; the shot is also

artistically composed and looks far more interesting than if his face were dead center in the frame.

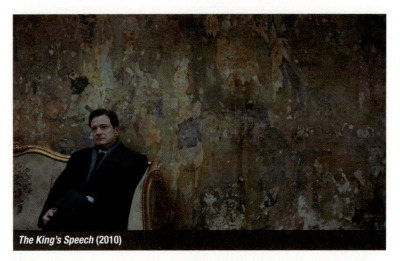

The King's Speech (2010)

4. **Use mass and color to your advantage.** The audience's eye will be drawn to a massive object—one that takes up a disproportionate amount of screen space—and an object that's strongly colored. This is sometimes called the Hitchcock Rule, after legendary director Alfred Hitchcock, who framed his shots so that the size of a person or an object in the frame was proportional to its importance at that moment in the story. In a classic shot from *North by Northwest* (1959), the plane is less important than the main character, who is in danger.

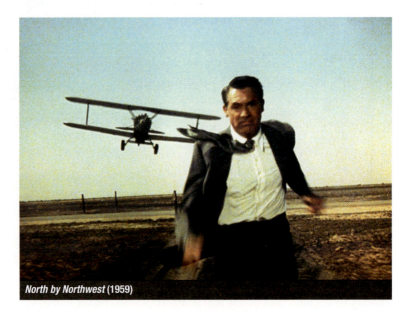

North by Northwest (1959)

The Artist (2011)

In the example from *The Artist* (2011), the actor in the foreground attracts attention because of his size, and his mass is balanced with negative space in the rest of the frame. In the example from *Black Swan* (2010), the white dress with pink-hued lighting contrasts with the rest of the frame and focuses the audience on the dancer. Wise costumers choose colors to highlight important characters and important moments (see Chapter 4, p. 76).

Black Swan (2010)

5. **Avoid center punching** (putting the important subjects directly in the center of the frame), to create a more interesting look. Instead, place the subjects toward the edges of the frame. This is called *weighting* (or *justifying*) the frame to the left or right, and it is a matter of storytelling and personal taste; symmetrical frames are generally less exciting than unsymmetrical frames. That said, there are exceptions that would call for center punching the subject—for example, if you want to emphasize ideas of symmetry and balance.

6. **Decide on foreground elements**—any objects that are positioned between the camera and the main subject of the shot. Although foreground elements

can refer to an actor, as in an over-the-shoulder shot, they more commonly take the form of some object or piece of set dressing, such as a window frame or a chain-link fence. The foreground object is generally out of focus, but it can be manipulated through the use of a zoom.

Hugo (2011)

7. **Play the diagonals.** Imagine each shot as a series of lines. Diagonal compositions are more dynamic than flat ones, and they help direct the audience's gaze where you want it to go.

8. **Angle the camera sparingly and always on purpose.** The audience expects the frame of the camera to be level with the ground. If you use a tilted angle, or Dutch angle, tilt the angle approximately 10 to 20 degrees.

9. **Keep composition consistent all the way to the end of the scene.** If the actors are moving and the camera is moving with them, keep the same amount of lead room. If the actors' blocking repositions them during the shot, make sure the shot stays well balanced at both the beginning and the end of their movements. Akira Kurosawa's *High and Low* (1963) is one of the best-composed movies ever. When you watch the film, you will see how the blocking is so carefully staged that no matter how the actors or the camera moves, each shot stays perfectly composed.

High and Low (1963)

Composition Outside the Frame

You've just learned about what you can see inside the frame, but what about what you can't see? A good producer will know how to guide the director and cinematographer to leave some things out of the picture.

Producers generally keep some actions out of the frame for three reasons:

1. It's cheaper. If you only *hear* violence rather than see it, you won't have to make expensive prosthetics and have wardrobe prepare multiple changes of bloody clothes. If you see the train station but only hear the train pulling in, you won't have to find a train.

2. It broadens the audience. On-screen graphic violence and sexuality can be off-putting to some audiences, or it can push a movie to a more restrictive rating. To keep the possibility of a PG or PG-13 rating, instead of an R rating, a producer should always make sure to get shots in which graphic action takes place outside the frame.

3. It's more effective. The imagination is a powerful tool; it's often more compelling to imagine something than to witness it. For example, you're watching a battle scene: if you see the hero thrust her spear at an opponent who's off-screen, and you *hear* the sickening squish of metal entering flesh, you'll know what happened; your imagination will make it just as violent as you want it to be. Similarly, have you ever noticed that scary movies become scarier when you are seeing the characters in close-up? That's because you can't see what's outside the frame, surrounding them, where the monster may be lurking. What you *think* might be there is scarier than what you see! Hitchcock, of course, was the master of this methodology. Another classic example, indirectly inspired by Hitchcock, is *Jaws* (1975). In the first shark attack you never see the shark, just the terror of its victim. In fact you don't see the entire shark until almost two-thirds of the way into the film. (Of course, director Stephen Spielberg reverted to this approach in part because of technical difficulties he encountered with his mechanical shark, which limited its capabilities, but he has told interviewers over the years that this was a serendipitous problem, because it made the frightful nature of the movie better when he was forced to veer off into a Hitchcockian direction.)

10. **Keep distractions out of the frame.** The exception to this rule is if you want the audience to notice something a character is not aware of (see Producer Smarts: Composition Outside the Frame, above).

You won't be required to observe all of these principles in every shot. In fact, almost every movie will use or break each of the rules of good composition at least once. You can also apply these principles to the difference between shooting people and shooting objects (see Action Steps: Shooting People and Objects, p. 166).

FILMMAKING

ACTION STEPS

Shooting People and Objects

Shooting people is different from shooting things. Most of the time, objects don't move, and they are not the main characters in a story, whereas people generally move and drive the action forward. Because of this difference, you need to be specific about placement and eyelines.

1 **Placement.** It is usually boring to place an actor in the dead center of the frame. Asymmetrical framing—balancing the actor's form with negative space on the other side of the frame—is more appealing. When you do place an actor dead center, it conveys primacy and prominence; this may be combined with a low angle, making the actor appear more powerful and heightening the effect. You can follow the same rule with objects, except that you can place objects at the center of the frame more frequently, especially for cutaways and inserts (see p. 170).

2 **Eyelines.** As previously mentioned, you'll typically shoot actors from eye level or close to eye level—some directors find that exact eye level is too directly challenging for the audience, and in most cases, you get the best view of the actor's eyes shooting just below them. On the other hand, objects are customarily shot from the eyeline of the actors in the scene.

Composition in the Moving Frame

More often than not, your camera will be in motion—smaller motions as characters engage with one another, and larger motions to cover actions and more complicated scenes. As the camera moves, the framing of the scene moves with it; a good cinematographer will pay attention to composition all the way through every camera move and usually do a rehearsal of the move first.

In Chapter 6, you learned about the tools that allow cameras to move—dollies, cranes, Steadicams, and anything with wheels on which a camera can be mounted. Now you will learn to use these camera movement tools for storytelling. Camera moves and setups enhance narrative flow and character development and help convey feelings to the audience. Sometimes, when a camera moves fast alongside action, it creates a sense of speed and power. At other times, when the camera gently comes close to a character's face, the audience might think the character suddenly understands something. In yet another instance, if the camera swoops away or moves higher, expanding the frame wider to give a view of the entire scene, the audience gains a sense of greater perspective.

Because camera movements can occur at any speed, they are inextricably linked to *time*. A fast move creates a sense of quickening or an exciting pace, whereas a slow move may enhance suspense; alternately, the move may be so slow and subtle that the audience only perceives it through an unconscious emotional response.

Following are the six most important camera movements, and their visual language meaning for character and plot:

■ **Pan.** A **pan** moves the frame on the horizontal axis—from right to left, or left to right. It is useful for following action, for tracking a character that is moving

Tip **USE CONVERGING LINES**

Use converging lines to make your shots more dynamic. The classic converging-lines shot features railroad tracks disappearing into the distance. A wide-angle lens will emphasize converging lines.

from place to place, and for revealing an important piece of visual information. Mount the camera on a tripod to accomplish a pan.

▌ **Tilt.** A **tilt** moves the frame along the vertical axis—up or down. You can use a tilt to follow the action from the foreground to the background, or vice versa, or to let the audience notice something significant. Mount the camera on a tripod to accomplish a tilt.

▌ **Tracking shot.** A **tracking shot** moves with the characters or the action. Often you'll position the camera ahead of the characters as they walk or run, moving at the same pace and always staying a consistent distance from the characters. Tracking shots should feel effortless; typically the audience won't be aware that the camera is moving because they're focusing on the actors' movements. You can do a tracking shot with or without actual camera track equipment (see Chapter 6). You can track actors with a handheld camera or a Steadicam. If you use a camera track and mount the camera on a dolly, the shot can also be called a **dolly shot**.

▌ **Push in** or **pull out.** These shots move along the depth axis, and they can be accomplished with a dolly and track, a handheld camera, or a Steadicam. A *push in* moves the frame toward the character's face, giving the sense that the character suddenly understands something or is about to take some kind of action. A push in to an object emphasizes the object's importance. A *pull out* creates anticipation that the character is about to do something important, with the frame widening so that the action can take place.

▌ **Zoom.** A zoom pushes in or pulls out along the depth axis, and moves the frame without moving the camera. That's because a zoom is accomplished with a special zoom lens (see p. 140). Due to its special nature, a zoom is able to travel much farther along the *z*-axis than a camera can move without a zoom lens. Keep in mind there is a crucial storytelling difference between a dolly shot pushing in and a zoom zooming in. A dolly push-in changes the perspective and size relationship between the main actor and the surroundings; a zoom-in does not.

PAN BEFORE ZOOMING

When combining a pan or tilt with a zoom, start the pan or tilt a fraction of a second before you start the zoom for a more professional look.

▌ **Crane.** A *crane shot* uses a crane (see Chapter 6) to move the camera from a high angle to a low angle, or from a low angle to a high angle. If you start at a high angle and then move down into the scene, you set the stage for the action. This shot is often used at the beginning of movies or sequences. If you start at eye level and then move up to a high angle, you convey perspective and completion; this shot is often used at the end of sequences, or as the final shot of a film.

KEEP THE HORIZON LOW

Don't let the horizon cut though the actors' heads. Generally, the horizon line should fall at the actors' shoulders or below.

To make the best use of your camera moves, follow these two important steps:

1. Begin with a static frame for a few seconds, perform the camera move, and then end on a static frame, which you should also hold for a few seconds. In editing, you can always cut into or out of the shot while the camera is in motion, but a well-framed, stationary image at the beginning and end of each shot will give you much more flexibility in the editing room (see Creating Images for Continuity, p. 169).

2. Begin each camera move from a less comfortable position, and move toward a more comfortable position. This creates a sense of story progression and emotional drive. For example, you may begin the shot on a car door (uncomfortable

because of the camera angle and because it doesn't reveal much information), then move up to include the driver coming out of the car (comfortable because the actor is well framed and the camera move reveals who has been driving the car). In another example, the shot would begin with an open door (uncomfortable because of the suspenseful angle), and then move into the room to discover a writer sitting at her desk (comfortable because we now know who is in the room).

Composition and Lenses

As you have already discovered from your exploration of lenses in Chapter 6, the choice of lens is fundamental to how each shot is composed. Because different lenses will allow you to show more or less of a scene and will place actors in greater or lesser context with their surroundings, you should stick to the following sequence:

1. Set up your preliminary camera position.

2. Select the lens that best conveys the story point or emotion of the scene.

3. Compose the shot by shifting actors and background objects, or by adjusting the camera position to achieve the visual balance you're looking for.

4. In almost all cases, bring the camera to the actor (or the action), instead of bringing the actor to the camera—this feels more cinematic and exciting.

Just as focal length affects composition, so do depth of field and focus choices (see Chapter 6, pp. 140–143). When choosing between deep or shallow depth of field, make sure the image is well balanced; obviously, in deep-field focus, you must take into account the balance of the entire scene. In the image from *The Wizard of Oz* (1939), for example, Dorothy is in focus while the rest of the scene is not; the shot is composed so Dorothy has obvious prominence.

Racking focus can also be used to define your composition and to change the audience's attention, revealing new insights or showing something the au-

The Wizard of Oz (1939)

dience had not noticed before. To accomplish a shot like this, you would use a tape measure to make sure you turn the focus dial accurately to each point that needs to be in focus. On a professional production, this is the focus puller's job. (See Action Steps: Low-Budget Hacks to Make Your Student Film Look High Budget, below.)

ACTION STEPS

Low-Budget Hacks to Make Your Student Film Look High Budget

No money? No problem. With a little resourcefulness and little or no money, you can use these tricks to make your shots look high end.

1 Use a director's viewfinder—an inexpensive handheld zoom lens you can look through—to help visualize the composition.

2 Put a carpenter's level on top of your camera to make sure it is framed straight.

3 Mount small cameras (often called lipstick cameras because they are about as big as a tube of lipstick) on different rigs—a rig is anything you can attach the camera to, such as a broom handle or a helmet. *Actioncams* (such as the GoPro) are designed just for this purpose; some even feature Wi-Fi, so you can monitor the shot on your mobile device.

▶ractice
STUDYING COMPOSITION

Choose three still frames from any movie or video (a film, a television episode, or a YouTube video), and analyze them according to the principles of good composition you have just learned. Are they well composed? poorly composed? Explain why. If you would like to study some examples of well-composed films, try these: *Citizen Kane* (1941), *Singin' in the Rain* (1952), *Lawrence of Arabia* (1962), *High and Low* (1963), *The Godfather* (1972), *Mother* (2009), and *Winter's Bone* (2010).

Creating Images for Continuity

When the audience watches a scene, it feels as though everything is happening chronologically—the long shot establishes the scene, the medium shots allow them to see the action more clearly, and the cuts back and forth between the actors let them learn more. Of course, in reality, each shot has been carefully set up and shot at different times, sometimes even on different days or at different locations. The process of making every shot in a scene match in time and action is called maintaining **continuity**, and you need to take this into account as you plan your setups so that the editor can cut the scene properly to achieve seamless continuity in your end product. (You'll read about the editing process in Chapters 11 and 12, and you learned about the script supervisor's role in maintaining continuity in Chapter 3.)

To make sure your film has continuity, you will want to verify that the lighting matches the master shot—this is crucial, especially when you are shooting outdoors and the sun shifts or the clouds change the light, or if the story sequence involves visual effects. In addition, every time you set up a shot or move the camera, you and the director should consider how the film will be edited. Ask yourself the following:

▮ Do I need this shot to tell the story?

▮ Do I have all the coverage I'll need—all the bits and pieces, such as close-ups, reaction shots, and inserts?

FILMMAKING

■ Have I shot enough coverage that the editor will have options in the editing room?

■ Or do I want to purposely limit the editor's choices by limiting the coverage?

Deciding how to shoot each scene is the most important day-to-day collaboration between the cinematographer and the director, and in the best films, this relationship is a close, creative marriage. With this relationship in mind, let's learn the classic way to shoot a scene and make sure that your images will cut together properly.

How to Shoot a Scene

There are many ways to shoot a scene. What follows are basic steps for what we might call "classic coverage"—a shooting style that developed in Hollywood decades ago and is still used today because it is practical and efficient, and keeps continuity in mind. Of course, different directors have different approaches, and some choose to break from the classic coverage paradigm; this is fine, as long as the approach you take works for your story (see How Do I . . . Motivate the Camera?, p. 173).

1. Start with the master shot, which should be a wide shot covering the entire scene, with all of the actors in the scene, and covering all the dialogue and blocking. By definition, a master shot has built-in continuity—because there are no cuts, the action is continuous. Once you have shot your master, your job is to match all action to it. As you learned in Chapter 3, on a professional production, the script supervisor takes careful note of everything that has previously been established to avoid matching or continuity errors. In addition, having your master "in the can" means that you may be able to be cost efficient with your other shots (see Business Smarts: How Many Shots Do You Need?, p. 174).

2. Now shoot group shots (two shots and three shots), followed by close-ups, over-the-shoulders, POVs, and reaction shots. Vary the size and angle of each set of shots; this makes your film look more interesting and makes it easier to cut together.

3. As you shoot the closer shots, make sure the action overlaps so that you'll have flexibility in cutting. It is better to leave the camera running on an actor's close-up for the entire scene, even if he or she has only one line; by doing so, you are getting reaction shots and the dialogue shot at the same time, and it will all be in continuity.

4. Avoid brief shots. They take a long time to set up and are difficult to integrate editorially.

5. Always shoot pieces for inserts and cutaways, as well as additional shots of the set from different angles without the cast, to give the visual effects department additional flexibility, when feasible. As you'll recall, inserts are close-ups of important story elements, often taken from the POV of a character—for example, a close-up on a cell-phone screen as someone is reading a text message. Cutaways are shots the editor can literally cut away to in order to modulate the pace of a scene. For example, good cutaways might be close-ups of food being prepared for dinner, such as the stew simmering on the stove. Hand gestures also make excellent cutaways.

Tip **KEEP YOUR EDITOR CLOSE**

If possible, have the editor on-set with you when you're shooting key scenes, or at least consult with her or him (if you are not the editor). That way, there will be another perspective to help make sure you get enough coverage to cut the scene together. If you are shooting digitally, the editor can also sometimes do a quick assembly of the scene to make sure there is sufficient coverage.

6. When shooting pans, tilts, and zooms of objects, begin with a static shot, do the camera move, and end with a static shot. Without cutting, reverse directions (for example, if you started panning left-to-right, now pan right-to-left), and still without cutting, do the move both slower and faster. This will give the editor maximum flexibility.

Don't Cross the Line!

Whenever you shoot a scene, there is an imaginary line that separates the camera and the action. As long as you know where that line is and you stay on your side of it, all the shots will be in continuity because they will have the same screen direction: the actors will maintain the same right-to-left relationship. If you go on the other side of the line, right and left directions will be swapped, and the shots won't cut together any more. This is known as "crossing the line," and the principle is called the **180-degree rule**.

The 180-degree rule sounds confusing, but it is relatively simple in practice. In Figure 7.2, you can see the imaginary line, with actors on one side and the camera on the other. Every camera position on this side of the line will be fine. If the camera operator crosses the line, the shots will be out of continuity. See Chapter 12 for more on how the 180-degree rule similarly influences how you use the editing process to tell your story.

FIGURE 7.2 The 180-degree line separating the actors and the camera

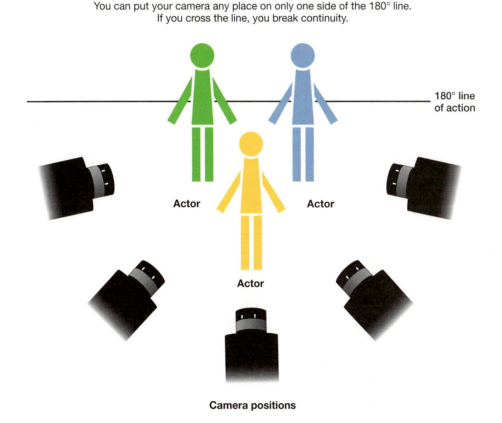

You can put your camera any place on only one side of the 180° line.
If you cross the line, you break continuity.

180° line
of action

Actor

Actor

Actor

Camera positions

Eyelines, Visual Effects, and Animation

You'll learn how to create visual effects and animation in Chapter 13; for now, you just need to know that sometimes you'll make a movie with these elements. The visual effect may be a view out a window—a window that's painted green on the set; the animation may be a digital character interacting with the actors. In either case, when you're shooting real actors who appear to be relating to elements that are not really there, you must be scrupulous about keeping your eyelines correct. If you don't, the scene won't work when you get to the editing room because the shots won't match, and the continuity of the scene will be broken.

This process requires careful planning and is one of the reasons we emphasize that postproduction actually begins *before* preproduction in well-produced movies. By the time you start shooting your actors peforming on set, you need to know, for instance, where the horizon line will be in the window example, or how tall the mouse will be in the case of *Stuart Little* (1999), a technically pioneering film that was among the first to seamlessly introduce an animated character to the live-action world, where he interacted throughout the story with real actors.

Tip VIRTUAL CINEMA-TOGRAPHY IS LIKE REAL CINEMATOGRAPHY

Everything in this chapter applies to virtual cinematography as well. Virtual cinematography is generally employed in animated films or in visual effects sequences for which most, if not all, of the elements are created in the computer. Camera moves and recomposition are done after completion of shooting, as a result of the editing process.

Practice REVERSE-ENGINEERING HOW TO COVER A SCENE

Pick a movie scene that's at least two minutes long. Pretend you are the cinematographer. Make note of each shot (these are the setups you will need to cover the scene). See if you can design how you would set up each shot to replicate what's in the scene.

Where's Stuart? In this scene from *Stuart Little* (1999), Geena Davis appears to share the frame with Stuart, even though the mouse was a visual effect and was obviously not there when the scene was shot. The visual effects crew, working in collaboration with the camera department, had to make sure the actor's eyeline would be correct, and so they developed two solutions: one high tech, one low tech. In the high-tech solution, the director used a laser pointer synchronized to the camera's shutter to indicate where Stuart would be. The cast learned to "love the dot" since that was their primary frame of reference on set for imagining where Stuart would be. A low-tech solution was to take a stuffed mouse toy about Stuart's size and place him on the end of a stick. A crew member moved the stick and the actors focused on the puppet mouse. The device was affectionately known as "Rod Stuart"!

How Do I . . .
Motivate the Camera?

Go to LaunchPad and find out: **macmillanhighered.com/filmmaking**

NAME:	**Mandy Walker**
TITLE:	Cinematographer
SELECTED CREDITS:	*Jane Got a Gun* (2015); *Tracks* (2013); *Australia* (2008); *Shattered Glass* (2003)

As discussed in this chapter, camera movement is every bit as important as dialogue when it comes to helping your audience understand key story points and characters. Camera movement should be just as motivated as an actor's movement. Cinematographer Mandy Walker talks about this in a video interview available only on the LaunchPad for *Filmmaking in Action*.

AUSTRALIA

Discover:

▌ Why you might want to work out camera moves as early as preproduction

▌ How Walker worked with the grip department to find a solution to a complex sequence in Baz Luhrmann's *Australia*

▌ What you might do to relate camera movement to enhance your story's impact

Visit the LaunchPad for *Filmmaking in Action* to learn more—and to explore how you might use this advice.

How Many Shots Do You Need?

Every time you set up a shot it takes time—and time is always short on a movie set. There is constant tension between getting every possible shot and getting just enough to finish the scene and move on to the next one. Therefore, every shot is both a creative decision and a business decision.

The number and kinds of shots must be planned for, long before you get to the set—shot planning needs to be part of the budgeting process, as you learned in Chapter 5. The director of photography should have a thorough discussion with the director about what kind of coverage the film needs. Then, the director of photography can make a list of the necessary equipment (cameras and lenses, plus the ways to support and move the camera—see Chapter 6). If possible, it is generally a good idea to include a bit more equipment than is absolutely necessary, in the event something breaks or someone has a brilliant idea and needs additional tools. In fact, if you have a particularly complicated shot or one that will be nearly impossible to do twice, the director and director of photography will plan for that shot to be done with multiple cameras, if feasible. Each camera will be assigned to cover a different shot type.

During the shooting period, you will work with the director and the first AD to determine the best shooting order of scenes in a given day. It is often good business to get the most important shot first—so you'll know that you have it—and then move down the shot list in priority order (see Chapter 5: Production Planning and Management). You also have to pick which scenes need the most shots and which ones can be less complicated, to keep your budget and time spent reasonable. For example, a fight scene may require a lot of shots and will therefore take more time to shoot and require more equipment—the close-ups on punches, inserts on bloody noses, and *POV shots* (see p. 158) are all important for the pacing of the scene. A simple "walk and talk" scene that could be covered in one *tracking shot* (see p. 167), may be fast or slow to accomplish, depending on the amount of rehearsal required and the intricacy of camera moves.

➕ Cinematographer's Emergency Kit

▪ A reference book of imagery that can inspire the look of the film. Images can be from other movies, photographs, graphics, or paintings. When you're not sure how to capture a scene, go back to your image collection for inspiration.

▪ The editor's cell-phone number, so you can make sure you're getting the coverage you need.

▪ Your own list of the specific lenses, apertures, light meter readings, and angles you have used to cover a scene, in case you need to go back and do reshoots.

CHAPTER 7 ESSENTIALS

▌ Every film finds its own visual language to convey character, story, and emotion. Mastering basic shots is essential for understanding filmmaking grammar and telling stories well.

▌ The camera can be positioned at different angles, with each angle revealing different information and helping to progress the story in a unique way.

▌ Good shots are aesthetically pleasing because they are well composed. You must take shot composition into account when your camera is stationary and when it is in motion.

▌ When you're capturing images, you are striving for photographic continuity, and you must provide options for editing. Therefore, get plenty of coverage, and grab inserts and cutaways.

Key Terms

180-degree rule ("the line")	Full shot	Pan
Close-up (CU)	Headroom	Point-of-view (POV) shot
Composition	High-angle shot	Profile shot
Continuity	Insert shot	Reverse shot
Cowboy	Lead room	Rule of thirds
Dolly shot	Long lens close-up	Three shot
Dutch angle	Low-angle shot	Three-quarter back shot
Establishing shot	Master shot	Tilt
Extreme close-up (ECU) (Big close-up [BCU])	Medium close-up (MCU)	Tracking shot
Extreme wide shot	Medium shot (MS)	Two shot
Eye-level shots	Negative space	Wide lens close-up
Eye room (Look room)	Overhead shot (bird's eye view)	Wide shot (WS)
	Over-the-shoulder (OTS)	

"**No film or digital technology can 'see' the way the eye sees, so cinematographers must know how to light to create that impression.**"

– Vilmos Zsigmond, Academy Award–winning cinematographer of Close Encounters of the Third Kind (1977), The Black Dahlia (2006), The River (1984), and 80 others

Lighting Skills

Can a cinematographer paint with light the way an artist creates light with oil paints? Dutch artist Johannes Vermeer was known as a master of light. He came to his mastery slowly and honestly over the course of his career, repeatedly painting the same room. He experimented with how light looks in the morning and in the afternoon; he learned to focus light by pulling back a drape and to diffuse light with a sheer curtain.

Although Vermeer left only 37 paintings, art historians speak with certainty about his intention and technique: so studied and so practical. His repetition of visual elements—a room, a window, a curtain—demonstrate the careful planning and focus on details that went into each painting.

Many respected cinematographers have studied Vermeer, along with other great classical artists. Cinematographers today rightly see themselves as followers in the grand tradition of painting with light, a tradition that reaches back centuries. And cinematographers use many of the same lighting techniques that classical artists used: the sun as a primary source of illumination, fabric to focus or soften the light, and other approaches—some of which you will learn in the next two chapters.

We asked master cinematographer Russell Carpenter, who won an Academy Award for his

Johannes Vermeer, *Lady Writing a Letter to Her Maid* (1670)

Buyenlarge/Superstock.

work on *Titanic* (1997), to reflect on the use of light in Vermeer's 1670 painting *Lady Writing a Letter with Her Maid.* Russell studied the painting carefully.

"Ah, Vermeer," he began.

Along with Caravaggio and Rembrandt, Vermeer has influenced more cinematographers than can be told. He's one of the very first forefathers of modern cinematography. This work of art looks so beautiful, real, and well composed, and yet I think it's full of lies, as is the work of any good cinematographer. Even though it looks like both figures are lit by the same light, they aren't—because light doesn't work that way. There's so much to learn from Vermeer!

(To see Russell Carpenter compose a plan for how he would light the scene in this painting, go to the LaunchPad for *Filmmaking in Action.*)

In your class projects, you will experiment with lighting as you seek to put on-screen a vision of light that has begun in your mind's eye. First, you'll discover how light finds itself in contrast and shadow, and how you can measure light. Next, you'll learn how to capture the way light actually looks with proper exposure. Finally, you'll explore color, color temperature, and how to make light appear white in your movie. With these principles in mind, you will start using lighting gear to illuminate outdoor and indoor shoots, and then be able to apply your skills to telling a story using light in the chapter that follows.

Qualities of Light

Cinematographers attempt to capture light as we see it or imagine it; at times they create illusions with extensive artificial lighting, which, when shot and finished, look completely natural. Due to the process by which cameras acquire images, whether on digital sensors or on film, the light you see with your eye will not be exactly what the camera records. Therefore, it takes a special understanding of light to create illumination that appears the way you want it to—whether natural or highly stylized. It is equally important to know how the human eye and brain combine to process imagery.

Meanwhile, forget what you think you know about light, because what you know is what your eyes tell you. Actually, you see what your brain tells you, because image processing takes place in the visual cortex, the largest system in your brain. The eye sends signals along the optic nerve to the brain—after the eye has automatically adjusted for the amount of light and the relationship of colors it is taking in. This process is similar to setting the ISO and aperture, which we studied in the last chapter, and setting the white balance, which we explore in this chapter. When the visual cortex receives these signals, it processes them in terms of color and pattern, always correlating them to colors and patterns with which we are already familiar. You have learned everything you know about color and light by the age of six; after that, the brain compares visual stimuli to information you've already stored.

You see the world in three-dimensional space, and photography creates the illusion of three dimensions on the surface of the screen. Yet when you're watching a movie, you are not overwhelmed by the sense that the world you're seeing is flat, even though, factually, it is. This is the result of *lighting*—the manipulation of contrast and color to create the illusion of depth on a two-dimensional plane.

This is true even with 3D filmmaking technologies, because in a 3D movie, the screen is still flat. 3D creates an illusion of depth using parallax viewpoints, as discussed in Chapter 6, but it is still an illusion on a 2D surface, and contrast and color are still the fundamental mechanisms that cause the illusion of depth.

All movies use some form of lighting, but as we explore the subject, we will draw on examples from well-known movies that showcase *great* lighting. You may wonder why you should spare the time and expense involved in achieving great lighting rather than just making sure your shots can all be seen. Great lighting is one of the best ways to distinguish your low-budget project, and we will show you some simple (and inexpensive) techniques for achieving a professional look with a strong, artistic point of view.

Just as master cinematographers learn from master painters, you can learn from master cinematographers how great lighting comes from shadows, contrast, exposure, and color. These are the visual qualities that will make an immense difference in how the audience reacts to your movie.

Tip COLOR HELP FROM THE ACADEMY

What will it really look like? The Academy Color Predictor can come to your rescue. Developed by AMPAS, it will help you visualize how lights, cameras, and filters affect what you're photographing. Download the free app here: www .oscars.org/science-technology/ council/projects/colorpredictor/ index.html.

Shadows and Contrast

When you look at an object, you perceive its shape and texture because of shadows. At first an object may look like a circle because it has no shadows. With shadows, it becomes a ball; now it has depth.

The shadow that falls across the ball in Figure 8.1 is called an *attached shadow*, meaning that you see the shadow on the object itself, as if it were visually attached to the object. As a cinematographer, you can adjust the lighting to make an attached shadow reveal shape and texture. For example, you can light the ball with a single light coming straight at it, so there will be little or no attached shadow; by doing so, the ball will look like a simple circle. Or you can illuminate the ball with an extremely angled light, in which case the attached shadow will reveal the dimples and texture of the ball.

The shadow that the ball casts on the ground is called a *cast shadow*. Cast shadows put the object in the context of its surroundings. In Figure 8.2, the cast shadow shows that the ball is resting on the ground, not flying through the air. Cast shadows often come from sunlight, so they help us infer time of day: a long cast shadow suggests late afternoon, and a tiny cast shadow indicates midday.

Shadows are closely associated with visual contrast. **Contrast** is defined as the visual difference between light and dark. You can think of contrast as looking at the difference between the shadows. More contrast means less shadows; less contrast means more shadows.

Black-and-white photography is the perfect place to begin when observing contrast and how it works. In black-and-white photography, there is only gray. "White" is not really white, and "black" is not really black. If you look at your laptop screen when it is turned off, it is displaying the blackest black it can produce; however, it is really a faint gray. In the same way, if you look at a movie screen *before* the movie starts, the color of the screen is the whitest white the screen can show—and yet, it is less white than the paper this page is printed on. But when the movie begins, your eyes adjust: you interpret the darkest areas as black and the lightest areas as white.

In black-and-white imagery, all the shapes you see—people, rooms, buildings—are defined by gray, or, in other words, by shadows. Let's look at still images from two black-and-white movies.

The still from *Touch of Evil* (1958) has more contrast than the still from *Raging Bull* (1980). Simply put—it has less gray tones and more extremes of black and white. Compare the man's coat at the center of the frame (*Touch of Evil*), which has no definition—it is all

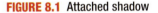

FIGURE 8.1 Attached shadow

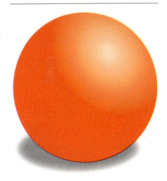

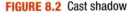

FIGURE 8.2 Cast shadow

FILM MAKING

Touch of Evil (1958)

Raging Bull (1980)

black—with the phone on the wall (*Raging Bull*), which reveals its corner through the light glinting off it—there is some gray; it is not all black. Black is the absence of all light; white is the combined presence of every visible light in the spectrum.

In these examples, each cinematographer had a choice to make, and each chose differently. Russell Metty, who shot *Touch of Evil*, wanted to show a world where there was quite literally a high contrast between good and evil characters; he accomplished this visually, shot by shot, just as screenwriter and director Orson Welles accomplished this through dialogue and acting choices. Michael Chapman, who shot *Raging Bull*, wanted to show an ambiguous world where motives and characters are complex; he accomplished this visually by creating images that are far grayer than strongly black or white.

300 (2006) is about as contrasty as a color film can get. Its visual style emulates the Frank Miller graphic novel on which it was based, and there is little gradation

In *300* (2006), densely saturated colors and strong visual contrast convey its primal storyline.

Less color saturation and reduced contrast are the visual representation of humans' complicated evolution in *2001: A Space Odyssey* (1968)

in color. For example, notice the dark hair on the adult characters—it is completely black, without variation or highlights. As with *Touch of Evil*, *300* is a story in which there are few ambiguities: the good characters are good, the bad characters are bad, and cinematographer Larry Fong's strongly contrasted imagery emphasizes this storytelling approach.

In comparison, study the ape's fur in the still from *2001: A Space Odyssey* (1968), in which there is a lot of definition and shades of brown. The contrast level of this movie is not extreme. Geoffrey Unsworth, the cinematographer, chose a less-contrasted look to make this film—which concerns the complexities of human evolution—feel approachable and realistic and to deepen its sense of ambiguity. The final sequence of *2001* remains one of the most ambiguous and discussed movie endings of all time.

As these examples illustrate, contrast conveys meaning. More contrast typically suggests that the characters have more definitive decisions to make and that the world they inhabit offers stark choices and is dangerous. Less contrast implies that the characters have less moral certainty and that the world they live in is more nuanced and real. Superhero movies generally employ more contrast than do most character dramas; even though they both may be shot in color, the good

versus evil world of superheroes is more black and white (more contrast), whereas the subtle world of a family has more shades of gray (less contrast).

Directional and Diffused Lighting

Thus far, the lighting you've learned about has been **directional lighting**, which means it comes from a clearly defined source, such as a lamp or the sun. Directional lighting is, by its nature, harsh and specific; it has sharp edges, casts sharp shadows, and has rapid *fall off*, which means its intensity diminishes quickly beyond its area of focus. For example, if there is a floor lamp in your room, you'll notice that it makes a sharp circle of light on the floor, which is defined by the boundaries of the lampshade, and that the light falls off quickly beyond the circle. If you stand outside in bright sunlight, you'll see that your shadow is crisply defined.

But what if you want softer lighting, which is more even and, therefore, less directional? This second type of lighting is called **diffused lighting**. If you're standing outside and clouds pass over the sun, your shadow will nearly vanish as the light loses its sharp edges, yet the whole scene will be clearly illuminated. This is an example of diffused lighting in action.

As a cinematographer, you will use both directional lighting and diffused lighting, depending on what you are shooting. Most films and television productions use directional lighting in a majority of their scenes. Commercial and fashion photography often use diffused lighting to create a glossy, smooth lighting ambiance, without high contrast and sharp shadows. Later in this chapter, you'll learn about different tools you can use to achieve diffused lighting.

Measuring Lighting

Whether lighting is direct or diffused, it can be measured with a **light meter**. Light meters show light intensity, which is measured in foot-candles. A **foot-candle** is a standard unit of measure (like a quart or a pound) and is defined as the amount of illumination one candle casts on a surface one foot away. The metric (or Standard International) equivalent is the **lux**, which is the amount of illumination one candle casts on a surface one meter away; one foot-candle is approximately 10 lux. Many light meters immediately translate foot-candles into f-stops, which you learned about in Chapter 6, and will give you an f-stop reading based on the shutter speed and ISO you have entered.

There are three kinds of light meters: *reflected light*, *incident light*, and *spot*.

Reflected-light meters measure the overall light in the entire scene by displaying average light. The light meter in a digital camera is a reflected-light meter, and it is generally useful when the contrast you're trying to achieve is not too high. A handheld reflected-light meter is more accurate; you should hold it next to the camera lens to get the best information. Any reflected-light meter will indicate if there is sufficient **baselight**—enough light for the image-capture medium to register an image properly.

When there are extreme differences in lighting levels, as, for example, when there is a lot of light flooding through a window and not much light in the room, the "average" reflected light will probably not give you the look you want—some areas will be either too light or too dark.

An **incident-light meter** solves this problem by measuring light at a specific place in the scene. A cinematographer will often walk to a certain spot on the set and take a reading with the incident-light meter to make sure the camera's f-stop is correct. An incident-light meter measures the light that is *incoming* toward your subject. For that reason, you hold it where the subject is, face it outward, and

read the amount of light. For example, you always want to make sure the actor's face is properly lit, and an incident-light meter will help you make sure you have given the actor sufficient light.

But what if you want to find out how much light is reflected from a specific subject? This is useful because it's the light that will actually come to your camera. For this you need a **spot meter**, which measures the amount of reflected light in a specific area of a shot. You hold it like a rifle scope and "sight" what you wish to measure, such as an actor's face; the reading in the spot meter will tell you if the actor's face has enough light.

DSLR cameras, which began as still cameras and evolved into video cameras, have spot meters built in. However, cameras that are designed as video cameras do not, and for these cameras, using light meters is essential. On professional shoots, cinematographers use a specialized video monitor to check lighting levels. Here is the process:

▌ Look at the shot in the monitor to see how it appears overall.

▌ Check the waveform information on the monitor, which displays specific aspects of the video signal, to see if there is enough luminance (brightness) and if the blacks and whites are acceptable. (See Chapter 11, p. 271.)

▌ Check the **vectorscope** setting, which allows you to visualize the levels of color hue and saturation in a graphic format. (See Chapter 11, p. 271.)

▌ Use color bars to make sure the colors appear accurate. (On professional productions, the monitor is carefully calibrated to make sure the impression of color and contrast is accurate. Color bars approximate this calibration.)

▌ Use a handheld light meter to double-check and confirm lighting levels.

▌ Shoot a test. This is advisable in extreme, if not all, lighting setups.

Practice

TAKING MEASUREMENTS

Using as many of the light meters as you have available in your class (reflected light, incident light, or spot), take light measurements in both an interior and an exterior setup, recording the f-stop from each measurement. Then, using the automatic meter on your camera, take note of the f-stop the camera recommends. Are the camera's automatic meter and your handheld meters giving you different information? Explain why or why not.

Exposure

Exposure is the total amount of light that falls on the image-capture medium; it is the means by which contrast shows itself. Only with balanced exposure can you create the contrast and level of visual detail you're aiming for; otherwise, your images will be too dark (underexposed) or too bright (overexposed), and you won't be able to see all the details.

To manipulate exposure, cinematographers follow these four basic steps:

1. Take accurate lighting measurements of the entire scene, as well as the specific person or area that is to be the focus of the scene.

2. Know the sensitivity of the capture medium. For digital video, this means setting the ISO. For film cameras, this means using a film stock with an ISO that's right for the scene.

3. Adjust the camera's f-stop.

4. Adjust the camera's shutter speed.

Tip **EXPOSE THE FACE**

The most important part of any scene is the actor's face. In general, if the face is well exposed, the rest of the scene can be over- or underexposed, and the audience will forgive you.

Approaches to Exposure

Is there a "correct" exposure? In its classical sense, correct exposure means that you can see everything you want to see—there is a balance between *highlights* (whites) and shadows (blacks), and a good range of *tones* (color gradations) in between. The other way to think about correct exposure is what's correct for the scene—what exposure best conveys the character and the story at that particular moment in the movie? Occasionally, for specific creative reasons, a scene should be overexposed or underexposed. See Figures 8.3–8.6 for examples of different exposures, in both color and black and white.

Elements of Exposure

To achieve the exposure you're aiming for, you have to understand all the variables at play. You've already learned about f-stops and ISO—two variables that control the amount of light that reaches the image-capture medium, and the sensitivity of the image-capture medium itself. You've also learned that a handheld light meter is an essential measurement tool for achieving a desired exposure level.

Here are the other important variables that govern exposure:

- **Luminance** is the light that reflects, or bounces off, things. Light-colored objects have more luminance, whereas dark-colored objects have less luminance. You will be able to measure luminance with your light meter and also use reflected, luminant light to add to the lighting in your scene.

- A **foot-candle (fc)** is the measure of lighting intensity, as noted. Your light meter will give a readout in foot-candles. The more foot-candles, the brighter the object—meaning it is giving off, or reflecting, more light.

FIGURE 8.3 Balanced exposure

Gregg Toland was one of Hollywood's greatest cinematographers; in addition to *Grapes of Wrath* (1940), pictured, he shot *Citizen Kane* (1941). In this well-exposed image, you can see every detail in Henry Fonda's face.

FIGURE 8.4 Balanced exposure

Wally Pfister captures Leonardo DiCaprio's face perfectly in *Inception* (2010).

- **Exposure index (EI)** is a measure of the amount of light to which your film or optical sensors are being exposed. It is related to ISO, but they are two separate measurements, as the EI is a mixture of shutter speed and aperture. Knowing the EI will allow you to create the correct exposure. Most digital cameras will allow you to set the EI, and you can enter EI information into your light meter.

- The **latitude** of your image-capture medium tells you how over- or underexposed your shots can be and still have enough detail to look good. Having more latitude means that your image can have a wider range of contrast between light areas and dark areas and still show details. On the other hand, a medium with narrow latitude cannot "see" details at the extremes of brightness or darkness. Color negative film generally has wider latitude than digital sensors.

Now that you've learned the different elements that control exposure, let's see how they work together in action.

Exposure in Action

Exposure is a matter of measurement as well as creative judgment, and the more you practice it, the better you get (see Action Steps: Solving Exposure Problems, p. 186). Let's take one example that frequently frustrates cinematographers: two characters are sitting in front of a window having a conversation. Clearly, the light is coming from the window. The director wants to see both sides of the characters' faces—not just the side that's lit by the window—as well as what's going on outside the window.

If you rely only on the incident-light meter reading or the automatic setting on your digital camera, you'll miss the mark. The window will be "blown out" and just look like a white rectangle; you won't be able to see anything outside. The characters will be silhouettes—dark forms against the bright window—and you won't be able to see their faces. This won't work at all.

The problem must be solved both aesthetically and technically. The aesthetics will come from discussions between you and your director, to decide on the right look for the scene. The technical solution comes from understanding how the

FIGURE 8.5 Intentional underexposure

Greig Fraser deliberately underexposed images in *Zero Dark Thirty* (2012), a thriller about SEAL Team Six's mission against Osama bin Laden. This technique gives the film a sense of realism and emphasizes the gritty reality of a nighttime military operation.

FIGURE 8.6 Intentional overexposure

Roger Deakins's deliberately overexposed the suburban landscape in *A Serious Man* (2009) to emphasize its artificial happiness and how its blinding brightness oppresses the main character.

FILMMAKING

Inside Llewyn Davis (2013)

Tip **USE LIGHT, NOT A DIAL**

Your digital camera will have a dial, menu setting, or button (which may also be called *gain*, *boost*, or something else) that allows you to make the image appear brighter—but it will also make it less sharp and grainier. It's better to add more light than to play with the brightness dial, because the seemingly simple fix of jacking up the ISO or gain setting can result in a strikingly bad image full of digital "noise."

digital sensor or film stock reacts to extremes of light and dark, and, therefore, how to set up the lighting.

To get the proper exposure, you'll want to take accurate incident-light meter readings from every part of the scene. In the pictured image from *Inside Llewyn Davis* (2013), directed by Joel and Ethan Coen, cinematographer Bruno Delbonnel handles exposure well, which means you can see many details: both sides of the coffee cup, both sides of the characters' faces, the window and what is happening across the street. (He used a 35 mm film stock with a wide latitude of light sensitivity, which helped him capture this range of bright to dark.) The scene outside the window is bright, as would be appropriate for a sunny day, but not so bright that it overwhelms the rest of the scene.

How could you achieve this result? The main challenge is to balance your exposures between inside and outside. First, you'd set up your lighting with the main source of light coming through the window, and additional light coming from the room at the right of the frame. There is also some luminance bouncing off the wall behind the actor. Now take spot meter readings at all the important places in the scene. If the reading on the left side of the actor's face is f11, for example, on the right side it may only be f4.8. The window side of the tea cup may be f5.6, with the room side of the teacup at f2.8. When the incident-light meter is placed at the window, it might show f16. To balance all the choices, a cinematographer might then set an f-stop of f8 and an EI of 400 to produce this shot.

ACTION STEPS

Solving Exposure Problems

Lighting can be like Goldilocks in "The Story of the Three Bears"—often too much or too little, and hard to get "just right." If your lights are on a dimmer, you may be tempted to raise or lower their intensity, but if you do, you'll get an unwelcome surprise: dimming photographic lights changes their *color temperature* (see p. 188). Therefore, you're better off using other techniques to achieve the amount of light you want.

❶ Change the lamp to a higher or lower wattage. Let the new bulb warm up for several minutes until it gets to its full color temperature before taking your new meter reading, especially if you are using a fluorescent lamp.

2 **Reposition the light.** To get more light, point it directly on the subject or bring it closer. To get less light, move it farther away from the subject; point it slightly off the subject; or even bounce it off a reflector, wall, or ceiling. A light's intensity is the inverse square of its distance to the subject; for example, a lighting instrument that is twice as close will be four times brighter, and if you double the distance of an instrument from its subject, it will be one-quarter as bright in the subject area.

3 **Some lights have levers that allow you to focus them into a tight spotlight or a wide floodlight.** If you have one of these lights, adjust the focus lever to increase or decrease the light's intensity.

4 **Use diffusion media to reduce intensity**, or remove it to make the light brighter.

Color

Just as tempo conveys meaning in a song, color conveys meaning in cinematic storytelling, and it can be used a number of ways to provide different moods and feelings. But what is color, and how can you achieve the color you want?

Let's start with the natural color of light. If you go outside on a sunny day, you generally aren't aware of the color of light—it seems transparent, like the air we breathe. In fact, the light from the sun, what we might call white light, is made up of all the colors of the visible spectrum.

You can demonstrate white light in the studio by using the three primary light colors: red, green, and blue. When focused separately, as different spots on the wall, you'll see three distinct colors, but when you bring them together, you'll see white light in the center, where the colors combine. Where different colors intersect, you'll find additional colors: red and green light combine to make yellow, red and blue combine to make magenta, and green and blue combine to make cyan. This gives us a good and simple definition: **color** is the way we see the visible spectrum of light.

One of the ways you can distinguish your student film is to make creative color choices and control the color. This will give your movie a more professional look. As two extreme examples of specific color choices, the *Underworld* movies (2003–12), in which the main characters are werewolves and vampires, appear overwhelmingly blue to give a feeling of cool otherworldliness, whereas red tones predominate in *Midnight in Paris* (2011) to convey warmth and romantic fantasy.

Practice

PLAYING WITH EXPOSURE

Shoot test close-ups of an expressive actor. Explore the limits of exposure and how you can control it. See how far you can overexpose and underexpose the shot and still see relevant details of the face—the eyes and facial expression. Record your exposure settings so you can review them when you watch the test shots.

The *Underworld* series (2003–15)

Midnight in Paris (2011)

FILMMAKING

In addition to making choices about color, you may also want to control the amount or intensity of color. Although you will be able to adjust color during post-production color grading, which you'll learn about in Chapter 11, you should make the fundamental coloring decisions during previsualization, then adhere to them during photography. Here are three ways to describe amounts of color:

■ *Saturated* color means that the colors are very intense. If you were a painter, you would be adding a lot of pigment to your base medium to make the reds intensely red, the blues intensely blue, and so on.

■ *Desaturated* color means the amount of color is minimal—you might describe desaturated colors as looking "washed out." Using saturated and desaturated colors are choices of style; they do not convey a realistic look but emphasize psychology and mood.

■ *Naturalistic* color falls between saturated and desaturated colors; a DP using naturalistic color is trying to represent colors the way they normally are perceived in everyday life.

In order to achieve the color look you want, you'll need to learn about the science of light: that light has a "temperature" and how to make sure the white light you see with your eyes is what the camera sees, too.

Color Temperature

Have you ever taken a picture under fluorescent lights, only to discover that the people turned green in the photo? or noticed that the sun's light in the late afternoon casts a glow that looks more red than the sun at high noon? That's because all "white" light is not created equal, and what appears white is really a range of different colors of light—it's just that our eyes normalize to make white lights in different settings appear the same.

The difference between seemingly white lights is measured in **color temperature**. White light that has more blue in it has a higher temperature; white light with more red has a lower temperature. Light temperature is measured in the *Kelvin (K)* scale. On a clear day, the sun at noon has a temperature of 5500 K. A *tungsten lamp*—one of the workhorse lighting tools you'll be using, which approximates indoor lighting—has a temperature of 3200 K.

Based on what color temperatures mean, you can tell that sunlight is bluer (higher kelvin temperature) and tungsten light is redder (lower kelvin temperature). Therefore, if you want to supplement natural light, you'll have to choose between lighting instruments that are more suited to outdoor or indoor lighting when you're shooting your film. Within a scene, light temperatures don't have to match precisely—you can have lights that are 3200 K, 3100 K, and 2800 K, and the lighting will work. But if you try to mix lights with color temperatures that are not close, like sunlight and indoor light in the same scene, the lighting won't work well.

Once you have made sure your lights are close to each other in color temperature, you'll still be faced with a vexing problem: how can you be sure that the light you see as white will read as white on-screen? Fortunately, there's a solution.

White Balance

If you're using a video camera, it will have a switch that allows you to choose "daylight" or "indoor" light. That's the camera's approximation of what natural white should look like in average daylight or indoor lighting. However, in filmmaking, nothing is average, and you're better off using the switch's third position: manual.

GELS CHANGE TEMPERATURE

You can change the color temperature of any light source by putting a colored gel in front of it (see p. 196).

ALWAYS WHITE-BALANCE

Always white-balance on something that is truly white—even a T-shirt, if necessary. White-balancing on something that is not pure white, such as a cream-colored wall, will throw off the color of the entire scene. You also need to white-balance every time you change lighting setups or locations—something that's easy to forget. Try adding it to your camera checklist, along with checking your batteries and SD cards or film stock, to help you remember.

With manual **white balance**, you'll aim your camera at a standard white card, or even a normal sheet of white paper. Using the manual switch and the instructions on your camera, you'll set this white card as the white of white light in your scene. That way, when you look at your footage, everything will be the correct color. You need to white-balance every time you change locations or change lighting setups, to make sure you are recording white correctly.

If you are using a film camera, you will need to choose a film stock that is white-balanced for your scene. When you use daylight-balanced film, the sunlight will appear white. When you use tungsten-balanced film, the indoor electric lighting will appear white. When using a digital camera, white balancing happens through the camera settings; when using a film camera, white balancing depends on your choice of film stock—it has nothing to do with the camera at all.

Practice
MEASURING F-STOPS

Using an incident-light meter, measure the foot-candles or f-stops at different places around your classroom, using only the lights in the room and any window light. How would you set the f-stop if you wanted to shoot a wide shot of the entire room? Would you need a different f-stop if you were shooting a close-up?

Lighting Gear

Now that you understand how light works, how do you actually work with lighting? You do so by using lighting instruments and different media, such as gels or filters, to change their color and intensity. Before you race to plug in the Pro-light, however, you need to observe safety precautions. Your safety, and that of your crew, must always be of paramount concern (see Action Steps: Lighting Safety First!, below, and Tech Talk: Don't Blow That Circuit!, p. 191).

ACTION STEPS
Lighting Safety First!

Follow these seven rules to stay safe using lights on-set:

1 **Always use gloves, and never try to feel how hot a light is by touching it.** Lights get hot fast, so much so that they will burn you even if you touch them quickly or brush against them. Allow them to cool completely before packing them up. Also, *never touch a lamp with your fingers.* The fingerprints, even though you cannot see them, will leave a residue that will cause the lamp to overheat and potentially explode.

2 **Never put a lighting instrument near flammable materials, like drapery.** Hot lights can cause fires.

3 **Always use the correct heavy-duty extension cords and cables,** as lights draw a lot of power.

4 **Always turn off and disconnect lights** from the power source before moving them.

5 **Always steady lights by weighting their base with sandbags.** Because lights are often set up on poles, they are top-heavy and can easily fall over.

6 **Use a *screen* or other *diffusion media*.** Lights that don't have a lens in front of them are "open faced" and need to have something in front of them to protect cast and crew in case one of the lamps explodes.

Continued

Continued from the previous page

7 **Stay away from water.** Just as you wouldn't take a toaster into a bathtub, you shouldn't use lights in the rain or where there is water touching the electrical equipment. If the equipment gets wet, turn lights off at the power source and protect them. Don't use them again until they are completely dry.

Tip TURN OFF PRACTICAL LIGHTS

Practical lights are the lights you might find already on your location set—overhead fixtures, table lamps, and the like. It is your job to light the set—not to use the lights that may already be there. Therefore, if you are using a *practical* location, you will typically turn all practical lights off before you do your lighting setup. In some locations, a skillful lighting designer may intentionally build a scene's light around practical lighting, or, in collaboration with the production designer, may build special film lights into practical-looking fixtures that are visible in the shot. Never leave a practical light on in the shot unless you have strategically planned to incorporate its illumination capabilities into your lighting plan.

Lighting Instruments

As you'll remember from Chapter 2, screenplays always indicate if scenes are *exterior* or *interior*. One reason for this is that the lighting changes depending on where you are shooting. Following are some of the more common lighting instruments you will use in both situations:

Exterior Lights

- When you're outdoors, the sun will always be your key daytime light. It is clear and powerful, but it can also be fickle when clouds pass over it or as its angle changes late in the day. What's more, sensitive digital cameras can also capture enough illumination from the moon and the stars to rely on them alone on some night shoots.

- **Reflectors** are lights you don't need to plug in. They are generally made of reflective material, like flexible aluminum foil, but you can use anything as a reflector, even a white flat from the theater department or a white piece of poster board. A reflector bounces sunlight back onto a scene, and you can angle it where you want. Its light is diffuse, unlike that of direct sunlight, which is sharp.

- *HMI (hydrargyrum medium-arc iodide) lights* are extremely bright and produce light that's around 6000 K—close to the color of sunlight. They can work to supplement sunlight on a cloudy day or provide exterior fill. As with all professional lights, you can attach **barn doors**—four metal flaps that you can open and close to focus the light to your target area. HMIs are big, heavy, and hot, and they draw a lot of power. Although most schools don't have them, you will see them used routinely on many professional productions.

- *Balloon lights* are helium-filled balloons made of special materials that contain certain kinds of glowing lamps and can be used indoors or outdoors, with quick setup, to light large areas.

Interior Lights Many schools will have the first four lights on the following list, and you can produce good results with them (see How Do I . . . Light with Minimal Tools?, p. 193, and Business Smarts: Renting Lights, p. 194). This list also includes other lights you may be able to access, as well as some inexpensive rigs you can make yourself (see Producer Smarts: How Much Is Enough?, p. 195).

- The *Lowel Omni light* produces hard light; it is a flexible tool that provides key- or backlight.

- The *Lowel Pro-light* is a tiny, efficient powerhouse, producing clear, even light with hard edges. It works well as a fill (see Chapter 9, p. 203) or as an *accent light*, which means you can focus it on one aspect of a scene to make it stand out more. You will use barn doors to focus the light.

tech TALK

Don't Blow That Circuit!

Lamps are measured in watts; power is measured in amps. Most homes and commercial buildings have circuit breakers that are rated for 15 or 20 amps, but you should always check the circuit breaker when you're on location to see how many amps are in each circuit. How can you know when you're drawing too much power and might blow out a circuit? Use this simple formula: WATTS ÷ VOLTS = AMPS.

Let's use the number 100 for volts. (Household current in the United States is supposed to be 120 volts, but it can actually vary from 105 V to 120 V; in most of the rest of the world, it varies from 200 V to 240 V.) If you're using lighting instruments that total 1500 watts, then 1500 WATTS ÷ 100 VOLTS = 15 AMPS. That's already at the maximum capacity of most household circuits, so you'll need to use another circuit or an external generator if you need more power. Overloading a fuse in an older building can result in a serious fire.

- The *Westcott 500-watt constant light* produces a soft general light, perfect for portraits or green-screen work. Its color temperature is 5400 K, which means it is balanced for sunlight.

- The *Westcott Spiderlite* comes with a range of possibilities. It is useful for lighting backgrounds, and it features interchangeable tungsten (interior) and fluorescent (daylight-balanced) lamps. You can use it to light a background or a green screen.

- The **Fresnel spotlight** is the workhorse of studio productions. It produces a bright, hard light, and with a slider, you can adjust the beam from a tightly focused *spot* to a widely focused *flood*. The difference between the intense center of this light and the light around the edges is called **falloff**. In spot position, the falloff is rapid; in flood position, the wider light beam is more diffused, so the falloff between the center and the edges is said to be slow.

Tip **BEWARE SUDDEN BRIGHTNESS**

When a tungsten or incandescent bulb suddenly gets brighter, it is about to burn out.

- *Inkies* are small, three-inch Fresnels. They are lightweight and easily positioned for touch-ups and accents.

- *Tungsten spotlights* are spotlights powered by a tungsten lamp, which offers the highest amount of brightness in the smallest possible fixture. **Tungsten lamps** have been used in filmmaking for more than 50 years and burn at 3200 K, which is why interior lighting is sometimes called "tungsten balanced."

- **Floodlights** cover a wide area with even light and produce little or no shadows. The most popular floodlights for filmmaking are **softlights**, which are small and

This shot uses a fluorescent light manufactured by Kino Flo, one of the most popular providers of movie and TV lighting.

FILMMAKING

portable. Softlights shine light indirectly—their lamp is hidden from view and pointed at a reflector, so the reflected light is cast on the scene.

▌ *Fluorescent lights* are specially made for film and video. They come in panels and can be mounted on stands or set at floor level; they are incredibly flexible because they will fit in small spaces and cast bright, steady light, with little falloff. Fluorescents are favorites due to their ease of use and wide coverage area; plus, because they draw less power than quartz or tungsten lights, they stay cooler and don't heat up the room. Photographic fluorescents come balanced for either indoor or sunlight temperatures.

▌ *China balls* are spherical paper lanterns used for overall illumination. You can put indoor- or daylight-balanced lamps in them.

▌ A *soft box* is a frame that fits around a lamp. The frame is black on all sides and has diffusion media on the front (discussed later in the chapter), making the light soft and even, with little falloff. Soft boxes are also used for overall illumination but can be more specifically directed than fluorescents or china balls. Lighting professionals will frequently build specialized soft boxes or groups of soft boxes to hold clusters of lights for particular scenes or effects on major motion picture projects.

▌ *Reflector umbrellas* mount in front of a light; the light points to the reflective interior of the umbrella, and the open umbrella bounces the light onto your subject. The light is soft, diffuse, and even. Reflector umbrellas are a staple of portrait work.

▌ *Bouncers* (or *bounces*) are anything you can bounce light off, to diffuse its sharpness and make it more even. A bouncer may be a piece of white, heavy-duty card stock mounted on a stand. You can also use a light-colored ceiling or wall as a bouncer.

▌ *LED lights* are not a specific type of lighting gear—they are a smart and eco-friendly alternative to quartz, tungsten, and fluorescent lamps. Most of the gear mentioned in this list can be fitted with LEDs, and LEDs can also be formed into particularly useful shapes, such as light panels that are square or rectangular. LEDs can be temperature-balanced close to sunlight or indoor light, but they cast light at a slightly different temperature than traditional lamps; therefore, once again, make sure you white-balance. LED lights first gained popularity in the live theater and are now commonly found on television and film sets. LED panels come in a variety of sizes, are relatively inexpensive, and last a long time (you won't have to worry about replacing burnt-out bulbs). You should always test

Lighting LED in action

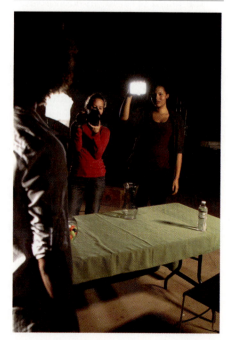

How Do I . . .
Light with Minimal Tools?

Go to LaunchPad and find out: **macmillanhighered.com/filmmaking**

NAME:	**Willie Dawkins**
TITLE:	Gaffer and lighting technician
SELECTED CREDITS:	*Parks and Recreation* (2012–14); *Brothers & Sisters* (2009–11); *Eagle Eye* (2008); *The Rock* (1996)

As we have discussed in this chapter, the strategic use of lighting is central to good filmmaking. As student or even professional filmmakers, you may not have unlimited amounts of lighting gear at your disposal. But veteran gaffer Willie Dawkins points out that you don't need that luxury to create strong lighting. He talks more about using minimal lighting technology in a video interview available only on the LaunchPad for *Filmmaking in Action*.

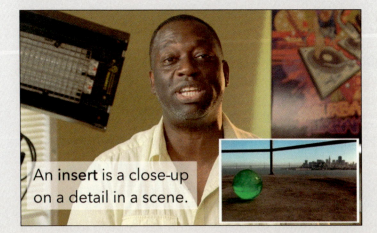

An **insert** is a close-up on a detail in a scene.

Discover:
▍ Why skills matter more than tools do

▍ How one or two lights can make a subject look great

▍ How Dawkins used a minimal lighting setup to get results for Michael Bay's action film *The Rock*

Visit the LaunchPad for *Filmmaking in Action* to learn more—and to explore how you might use this advice.

Renting Lights

There may be times you want more lighting equipment than your school can provide. In these cases, a local lighting rental company can come to the rescue. Many professional camera stores also rent lighting gear, along with cameras and lenses.

Rentals can be costly, but there are some tricks that can help you get a better deal.

- Develop a relationship with the rental company before you need them. You'll usually get a better deal if you have been a consistent customer.

- Use the equipment that's not in demand. Professional photographers have highly specialized needs, whereas you may need only a few lights—and any lights will do. Be willing to take what's readily available; it will be cheaper.

- Rent on a weekend. Because most professional film crews take the weekend off, they return their rental equipment on Friday afternoon and don't come for it again until Monday. Many rental companies will give you a two-days-for-the-price-of-one deal on the weekend, as long as you get the gear back Sunday night or very early Monday morning. And you don't mind working on the weekend, do you?

LEDs with the specific digital camera you are using. Each camera sees LED lights differently.

- *Practicals* (or *household fixtures*) are lights that are in the shot. As mentioned earlier, you can use them for primary lighting—especially with DSLR cameras, which do very well in low-light situations—or for accent illumination. Because they are practical, they will not burn at predictable color temperatures; thus, white-balancing is a must. Practicals may include the following:

 - Lamps and ceiling lights (incandescent bulbs have a color temperature of 2800 K)

 - Cell phones

 - Computer screens

 - Streetlights and vehicle headlights

 - Christmas lights or rope lights, which can be coiled up to produce a soft, warm light that fits into a tight space

Mounting Equipment

Lights can't be positioned by themselves—for this you'll need special equipment. There are a variety of stands, arms, and clamps that allow you to place lights exactly where you want them. Here are the most common ones:

- **Light stands** can be either straight pipes that fit into weighted bases or metal rods that have tripod legs attached. The metal rods often telescope up and down, allowing you to adjust the height. Some have casters so they can be rolled; however, when any light stand is in its permanent position, place sandbags at its base to make sure it doesn't tip over.

- **Boom arms** can be attached to many light stands and poles to extend their reach.

How Much Is Enough?

The speed of a shoot is often governed by the speed of the lighting: how long will it take the cinematographer to set up the lights, or if something unexpected comes up, is there enough extra equipment to solve the lighting problem?

Speed is an important issue for producers because it is directly related to budget. As you learned in Chapter 5, Production Planning and Management, if your shoot can stay on schedule, you can generally stay on budget. If not, you sink into budget deficit with every day you fall behind. Cinematographers try to solve this potential problem in two ways: by having an extra person or two on the crew, and by carrying supplementary equipment in case a lighting instrument breaks or the director suddenly decides to switch locations. In other words, the cinematographer should always be prepared.

But preparation, too, has its costs. An extra crew member adds to the budget in terms of salary, food, and transportation; extra equipment adds to the lighting rental budget. It is typical for the cinematographer to ask for more than may be needed, and likewise typical for the producer to try to pare things back.

What's the solution? Find a happy medium. Luckily, you don't have to commit to lighting equipment rentals for an entire shoot—you can rent by the day or week. You can also bring an extra crew member on for only a day or two. On big days, with lots of extras and a complicated location, it's a good insurance policy to overspend a bit on the lighting package to make sure there will be no delays. When you're dealing with smaller and more contained shooting environments, you can afford to take the risk and go a bit leaner.

- *C-stands*, or century stands, come equipped with three legs for stability plus a boom arm that can be adjusted to a variety of angles. C-stands are often used to hold reflectors or bounce cards.

- *C-clamps* and *alligator clips* secure lights to stands or pipes. C-clamps are used for heavy lights, whereas alligator clips are used for less-heavy instruments. Alligator clips also can attach bounce cards and reflectors to stands and poles.

- The *lighting grid* is the name for the crisscross pipes suspended above a sound stage. In a studio shoot, you will hang most of your lights from the grid.

- Any light attached by a C-clamp to an overhead grid must have a **safety chain**, or a secondary chain, around it connecting the light to the grid in case the clamp fails. Safety precautions in the mounting or suspending of lights are crucial, and those serving in the roles of lighting grips have a serious responsibility in this regard.

Diffusers, Gels, Filters, and Cookies

Just as Johannes Vermeer used curtains to manipulate the quality of light in his studio, cinematographers use a variety of materials to change the quality and color of the light. Some of the more common lighting materials you may work with include **diffusion materials**, colored gels, filters, and cookies.

This effect is similar to the change that happens when clouds pass over the sun. Anything that gets between the light source and the subject can be a

FILMMAKING

Grid cloth

Harsh sunlight on this actor's face is being softened by a grid cloth. Because of its widely spaced weave, grid cloth is silent in the wind and won't create sound problems.

Tip PRACTICAL TEMPERATURES

You can get 5500 K and 3200 K lamps that screw into conventional lighting fixtures, so that the color temperature is right if you use practicals.

Practice

USING LIGHTING GEAR

Spend some time with your school's lighting gear. Get to know the different instruments, lamps, cables, connectors, and controls. Some instruments may run on 220-volt current instead of standard 120-volt household current. Make some combinations: which instruments can go together and not overload a single 15 amp circuit?

diffuser. *Grid cloth*, *nets*, and *silks* can be used to diffuse sunlight. They come in different thicknesses (full, half, and quarter), which allow lesser or greater amounts of light to pass through.

Colored gels are sheets of plastic that change the color of light. They do not add color; rather, they absorb opposite wavelengths. For example, a red gel will absorb blue and green light and only let through red wavelengths; thus, the light will look red. Although you can use theatrical and party gels, which come in a wide variety of colors, to create extreme color effects, gels are most often used as an essential tool for changing lighting temperature when you have a mixture of indoor and outdoor light.

CTB (color temperature blue) gels raise the temperature of tungsten lights to 5500 K, the color of sunlight. CTO (color temperature

Cookie cast

You don't need special tools for this do-it-yourself cookie. Here, the DP has created a web of tape in front of the light *(right)*, creating the pattern of a window frame behind the actor *(left)*.

orange) gels lower the temperature of sunlight to interior, or 3200 K. In the shot from *Inside Llewyn Davis* we looked at earlier (p. 186), the cinematographer would have used one or two layers of CTO gels on the window to lower the light temperature so that it balanced with the interior lighting setup.

Filters are like diffusers or gels, except they are round pieces of glass that screw onto the front of the lens of a lighting instrument. Filters can change the visual palette by enhancing or subtracting colors, increasing or decreasing definition and contrast, or making the image sharper or hazier.

Cookies are metal panels with shapes cut out of them. The resulting light casts a pattern, just as leaves cast their shadows on the ground in a forest. Cookies are useful for creating texture and identifiable shadows, such as a window frame.

⊞ Lighting Pro's Emergency Kit

▌ Extra heavy-duty extension cords

▌ Leather gloves for handling hot instruments

▌ A fan or hair dryer for drying out wet electrical gear before you plug it back in

▌ Clothespins to attach gel and diffusion media

▌ Rolls of *blackwrap*—heavy-duty foil that has been painted black and can be shaped around lighting instruments to focus the beam or prevent light "seepage"

▌ The free color predictor app for your iPad or iPhone

CHAPTER 8 ESSENTIALS

- Lighting for film is an art and a science, creating the illusion of three-dimensional space on a flat screen.

- Exposure is governed by luminance, light intensity, the right exposure index, and the latitude of your image-capture medium—as well as your creative choice about the best f-stop.

- White light comes in two varieties: sunlight, which has a color temperature of 5500 K, and indoor light, which has a color temperature of 3200 K. When you set your white balance, you ensure that what you see as white light will look white on-screen and that the colors will be accurate.

- As a cinematographer, you have many lighting tools to choose from, whether you are outdoors or indoors, as well as different media to change or modify the lighting result.

KEY TERMS

Barn doors	Exposure	Luminance
Baselight	Exposure index (EI)	Lux
Boom arms	Falloff	Reflected-light meters
Color	Filters	Reflectors
Colored gels	Floodlights	Safety chain
Color temperature	Foot-candle	Softlights
Contrast	Fresnel spotlight	Spot meter
Cookies	Incident-light meter	Tungsten lamps
Diffused lighting	Latitude	Vectorscope
Diffusion materials	Light meter	White balance
Directional lighting	Light stands	

"**I always feel if I can nail the black tones, the rest of the film is going to fall into place.**"

– Bradford Young, cinematographer for *Ain't Them Bodies Saints* (2013) and *A Most Violent Year* (2014)

Telling the Story through Lighting

The Godfather (1972)

There had never been a studio movie as dark as *The Godfather* (1972). Not dark as in grim and violent, although it was that, at times—dark, as in very little light. It was a visual style choice that originally became necessary to obscure the use of prosthetic makeup, and then shaped the entire storytelling approach for the now-classic film.

One of the problems with prosthetic makeup is that it shines, which makes it look fake and unlike real skin. One solution: light from the top instead of from the sides, so there's no shiny reflection. "A lot of what I did with overhead lighting came out of necessity of dealing with Marlon Brando in a given kind of makeup," the late cinematographer Gordon Willis recalled.[1] Actor Marlon Brando, who won the Academy Award for his portrayal of aging Mafia patriarch Don Corleone, was only

47 years old when he made the film. He wore heavy prosthetics, designed by the legendary, late makeup artist, Dick Smith, to create a jutting jaw, weighty jowls, and a thinning hairline.

"It was an example of designing something to make one person work, and it was extended throughout the rest of the movie." Willis noted. "I got a lot of criticism because they said, 'Well, we can't see Brando's eyes.' There were times in some of his scenes where I *deliberately* did not want to see his eyes, so that you saw this mysterious human being thinking about something, or about to do something, but you didn't really know what the hell was going on."

Willis's creative choice fused perfectly with director Francis Ford Coppola's vision, and the resulting film, full of deep blacks and rich earth tones, became an instant masterpiece and won the Academy Award for Best Picture.

In Chapter 8, you learned the basic tools you need to craft lighting. In this chapter, you will discover how to fuse art with that craft—how to employ the qualities of light to convey story, character, and emotion. In the final analysis, a movie can survive poor lighting and photography if the characters and story are excellent, but excellent visuals won't make a bad story work. The

KEY CONCEPTS

▪ Once you determine the film's visual style, you will need comprehensive planning and preparation to execute it well.

▪ Outdoor scenes use natural light, though not exclusively, and you will need to control constant variations in sunlight and weather.

▪ Indoor scenes have their own unique requirements, and you will have near-total control of the lighting.

▪ You must be prepared for the special lighting situations you will encounter, including low light and lighting for people with different skin tones, among others.

FILMMAKING

best movies, however, like *The Godfather*, combine both: visual artistry and storytelling magic.

Your job as cinematographer will be to understand lighting principles and rules fully, and then feel comfortable breaking the rules when the movie you're working on demands it. The first question you'll confront, and discuss with your director, will be a matter of style.

Style, Planning, and Preparation

How should the movie look, and what will you have to do to photograph the vision in your mind's eye? In Chapter 8, you learned how to control shadows, contrast, light intensity, exposure, and color. Now, using these tools as your paintbrushes, you will begin to design what the camera should see.

There is a continuum that may be used to describe how movies look. At one extreme is the *realistic* look, which tries to replicate how we normally see the world. Realistic movies don't call much attention to their visual style, because the style is presented as fact, not fiction—even though, of course, you will use much art and technique to achieve a look that appears unadorned. At the other extreme is a style we might call *expressionistic*, in which the look conveys an altered reality, complete with heightened or desaturated colors, subjective viewpoints, and lighting that would not normally occur. (See How Do I . . . Light for Mood?, p. 202.)

Neither style is right or wrong; the correct style is the one that best conveys emotion and story. Nor must your film hew to a single stylistic choice—many films contain elements of both realism and expressionism, and comfortably shift along the continuum of style as the story develops. (See Action Steps: Planning the Lighting on the next page.)

You explored directional lighting in Chapter 8 (p. 182); all directional light must come from somewhere. Among the most important choices you will make is whether the lighting in your movie is *motivated* (or *justified*), and by what sources. Realistic films always have motivated lighting—the light comes from a source that is visible, such as the sun, a window, or a lamp. In expressionistic lighting, the light source does not have to be justified.

In *Requiem for a Dream* (2000), actor Ellen Burstyn plays a character driven to the edge by her drug addiction and paranoia; the expressionistic lighting is not justified from any source in this scene but perfectly conveys her unhinged state.

Whether your lighting style is realistic or expressionistic, or has variations along the way, it needs to stay consistent within each scene. Although this is sometimes difficult, in that different parts of a scene may be shot on different days, it is essential to maintain the illusion of continuity.

ACTION STEPS
Planning the Lighting

Once you have determined the style of lighting, you have to make it happen. This is where theory meets practice, and planning is essential. Follow these steps to plan your lighting:

① **Do a scout** (sometimes called a *recce*, short for the military term *reconnaissance mission*). Go to the place where you will be shooting to get a sense of what you'll have at hand and what you'll need to bring. If it is an outdoor location, where and when does the sun rise and set? Are there trees or buildings that will create shadows at different times of the day? If it is an indoor location, are there windows? Are there existing lights you will need to avoid or might be able to use?

② **Plan your circuits.** Will you have enough power? If it is an outdoor location, is there a power supply nearby, or will you need to bring a generator and electrical cords long enough to ensure that the generator's noise is not picked up by the sound recording? With an indoor location, you may still need to bring a generator if there is not sufficient power and circuit capacity for the lights. (See Chapter 8, p. 191, on amps and circuits.)

③ **Make a list of everything you'll need.** The list must be comprehensive, including lighting instruments as well as stands, cables, sandbags, clamps, gels, diffusion media, spare lamps, a generator, and so on. You'll want to bring extras if you have them, in case a key piece of equipment breaks during the shoot.

④ **Check the truck.** When you load the truck before going to the set, double-check everything against your list.

⑤ **Check the weather three times when you are planning for an outdoor location.** Even before your scout, check the long-range or historical forecast; it will tell you expected conditions far in advance. Then check the forecast the night before and the morning of your shoot, to make sure you are fully prepared.

⑥ **On the day you'll shoot the scene, communicate with the director to make the lighting setup easier.**

 A. Work with the director to make sure the actor's blocking doesn't require lighting changes. This will speed up the shooting day (see Producer Smarts: How Long Will Setups Take?, p. 208).

 B. To keep things efficient, make sure you always shoot on the same side of the *line* (see Chapter 7, p. 171). If you can keep the same line in one scene or a group of scenes, you will be able to keep the same lighting with only minimal adjustments, saving precious time.

How Do I . . .
Light for Mood?

Go to LaunchPad and find out: **macmillanhighered.com/filmmaking**

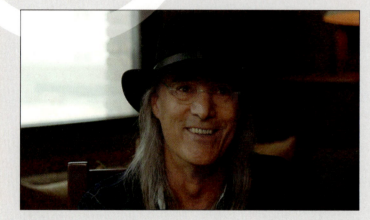

NAME:	**Russell Carpenter**
TITLE:	Cinematographer
SELECTED CREDITS:	*Ant-Man* (2015); *21* (2008); *Charlie's Angels* (2000); *Titanic* (1997); *True Lies* (1994)

Beyond the science and technology involved, motion picture lighting depends on your ability to match the mood and emotion of your project's scenes. If your lighting aesthetic fails to match your story's mood, the audience will notice—and be taken out of the movie or TV show. Cinematographer Russell Carpenter talks about shooting a crucial scene in *Titanic* in a video interview available only on the LaunchPad for *Filmmaking in Action*.

Discover:

- How lighting mood affects a story
- How Carpenter used minimal lighting to illustrate the emotional state of Kate Winslet's character in *Titanic*
- Why resources matter less than storytelling does

Visit the LaunchPad for *Filmmaking in Action* to learn more—and to explore how you might use this advice.

Three-Point Lighting

Let's play with lighting. Imagine you are on a set with an actor; there is one light, and it is pointed at her. The light illuminates the actor from one direction, causing attached shadows to fall on her face and a long shadow to cast behind her.

This main light is a directional light, because it comes sharply from a single direction. It is also the main light in the scene and is thus called the **key light**. This is not an attractive way to light an actor, because it is harsh and unrelenting. Unless that is the creative choice you want to make, you'll need to add other lights: **fill light** and **backlight**. The fill light is positioned on the side opposite the key light, and the backlight is placed behind the subject. Combined, these three lights form the basic construct of all lighting plots, and are often referred to as either **three-point lighting** or the **lighting triangle**. (See Action Steps: How to Set Up Three-Point Lighting, below.)

Three-point lighting is as much a matter of concept as practice. For most of your on-set lighting work, you will probably use two-point lighting (key and fill lights) or even one-point lighting (key light only). Yet understanding the concept behind three-point lighting gives you an instant sense of what each light position may accomplish and provides a ready vocabulary with which to communicate with your director and crew.

For example, now that you know what a key light is, can you find the key light in the scenes from *Touch of Evil* and *Raging Bull* (shown in Chapter 8, p. 180)? In the frame from *Touch of Evil*, although the main source of light is not seen, it is clearly supposed to be a ceiling light that would be in the upper left, out of the frame. In the frame from *Raging Bull*, the main light source is supposed to be the hanging light bulb. For the audience to accept that the action is really taking place, the primary light source must be motivated from some place that would make sense in the context of the scene, and in both of these examples, it does.

ACTION STEPS
How to Set Up Three-Point Lighting

❶ **Prepare the scene, determine the angle for the master shot, and set up your camera.** By doing so, you'll know where the lights can be positioned so that they stay out of the frame.

❷ **Decide what direction the strongest light should be coming from.** For example, it could be coming from a window, from an overhead light, or from the sun. That's where your key light will go.

❸ **Place your key light so that it is the primary directional light.** If you are outdoors on a bright day, you can use the sun as your key light.

❹ **Place your fill light at an approximate 90-degree angle to the key light.** The fill light will even out the attached shadows on the actors.

❺ **Set up the backlight behind the actors, to separate them from the background.** This creates definition and the sense of depth, and makes a little halo around their heads. The backlight should be directed so that it does not shine into the camera's lens; also, don't overdo it—a little backlight goes a long way, and too much can make a shot look artificial.

FIGURE 9.1 A simple illustration of three-point lighting

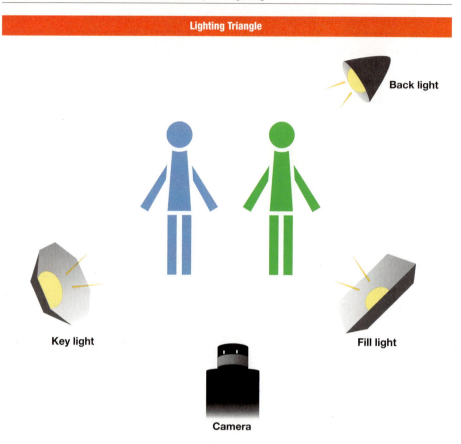

The Lighting Ratio

Three-point lighting is a basic concept. In the following sections, you'll discover several lighting possibilities you can use once you have a strong understanding of how the lighting triangle works—possibilities that expand the triangle and give it many variations. But first, let's take a look at one way you can create different looks without changing the triangle at all; all you need to do is adjust the *lighting ratio* between two lights in the triangle.

The **lighting ratio** is the difference in intensity between the key light and the fill light. By experimenting with the lighting ratio, you can achieve different amounts of contrast in your three-point lighting. On any given project, you will choose the amount of contrast that feels right for the particular story you are telling. Using the examples we looked at in Chapter 8 (see p. 181), the film *300* has a large difference in intensity between the key light and the fill light; the difference in intensity in *2001: A Space Odyssey* is much smaller.

In Chapter 6, you learned about the f-stop on your camera. The f-stop is a way to quantify the lighting ratio and, therefore, a way to quantify the amount of contrast when you're shooting.

Which of the examples in Figures 9.2–9.5 would work best for the film you'll shoot for this class?

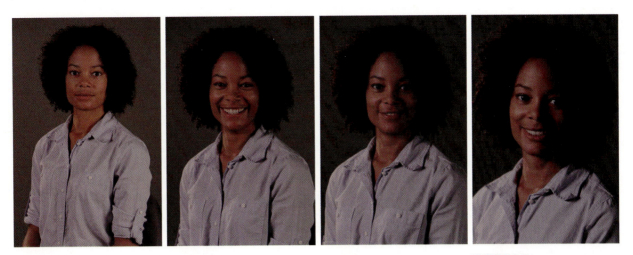

FIGURE 9.2

The key light and the fill light are at the same intensity, so the ratio is 1:1; therefore, there is little contrast. There is no difference in the f-stops.

FIGURE 9.3

There is a 2:1 ratio between the key and fill lights, and a 1 f-stop difference between them. This ratio is often used for close-ups.

FIGURE 9.4

There is a 4:1 difference between the key and fill lights, indicating a 2 f-stop difference between them.

FIGURE 9.5

There is an 8:1 difference between the key and fill lights, indicating a 3 f-stop difference between them.

Continuity and Your Lighting Triangle

As you will recall from Chapter 7, *continuity* makes the audience believe that each scene is part of a single, continuous event, and that the different camera angles are all being shot at the same time. Of course, this is rarely the case. In practice, you will shoot one setup, then move the camera, shoot another angle, and repeat the process. Sometimes different angles will not even be shot at the same location, as, for example, when you shoot a wide master at a hard-to-get practical location, and then must move into a studio for close-ups or insert shots.

Your job as DP is to make sure the lighting never varies from what you have established in the master shot, so that the audience never has the subconscious feeling of "Hey, that doesn't look right," or "Why doesn't the lighting match?"

If the lighting doesn't match, you've probably made a mistake and inadvertently changed your lighting triangle. Your key light should always come from the same direction, and your fill and backlights should match.

You have great flexibility in adjusting your master shot lighting triangle in order to fit the style needs of the story; your creative decision will be the lighting ratio for each scene. A *high-key* lighting triangle has a lighting ratio at or near 1:1, as a comparison of key light and fill light. **High-key lighting** casts even lighting across an entire scene; it also has the advantage that lights don't require much resetting when you move your camera for new angles. High-key lighting feels brighter and happier than other lighting; for this reason, it is frequently seen in comedies and television sitcoms.

Low-key lighting has a more extreme lighting ratio between the key and fill lights—perhaps as much as 8:1 or 10:1. Low-key lighting emphasizes shapes,

Tip **HIGH AND LOW**

It may seem confusing, but *high-key* lighting has a *lower* lighting ratio, and *low-key* lighting has a *higher* lighting ratio!

contrasts, and contours, and heightens dramatic tension and mood. Most scary movies use low-key lighting to increase suspense, and you'll often see low-key lighting in dramas as well.

The use of high- and low-key lighting is not dictated by genre. Many movies use both kinds of lighting triangles in different scenes, depending on what is happening to the characters.

How Much Light?

The amount of light you throw on a scene does not equal the amount of light your camera captures. As you learned in Chapter 6, you control the amount of light that falls on the optical sensor or film by adjusting the camera's f-stop. In other words, you could have a very bright scene and make it look dimmer with a higher f-stop, or have a dim scene and make it appear brighter with a lower f-stop.

As you adjust the lighting levels, you will also be impacting the depth of field with which you can shoot the scene. You learned about depth of field in Chapter 6, and how it contributes to storytelling: a shallow depth of field isolates objects or characters; a deep depth of field—which puts everything in focus, whether near the camera or far away from it—gives the audience a broader viewpoint on the entire scene.

To achieve deep depth of field, you need to let a small amount of light into the camera, such as an f-stop of 16 or 22. This means you will need to overilluminate the scene, throwing much more light than would be normal, for the scene to appear realistic and for the camera to capture sufficient detail at every distance. Conversely, shallow depth of field can be achieved with less light and a more open lens, which will have a lower f-stop number.

In any depth of field choice, you will frequently face an exposure dilemma: some elements of the scene will be at one f-stop, and others will be at a different f-stop. There are different approaches to this problem. One is to adjust the lighting levels, moving from a low-key to a high-key style, which will even out the exposure variance. If you make this choice, you need to make it at the beginning of the scene and keep it consistent as you change angles.

The other choice is to adjust your camera's exposure for the most important element in the scene—the character or object that, from a storytelling perspective, should be the prime intention of the frame—and to light that character or object properly. This cre-

High- and low-key lighting is used at different times in *The To Do List* (2013).

ative choice, which is both an exposure and a lighting decision, will keep you from falling into the trap of averaging your exposure between elements, which results in none being properly exposed.

Adjusting the Lights

Once you are on-set, whether outdoors or indoors, setting up the lights is a multistep process (see Producer Smarts: How Long Will Setups Take?, p. 208). You may do it the morning of your shoot or—in the case of large and complicated locations, which will require a lot of lighting equipment—a day or more in advance. This is called *pre-rigging*.

On your student film, you may be the only one to work on all facets of lighting. In a large studio feature, the electrical and grip departments work with the cinematographer to achieve the desired look, and it's helpful to know the names of each job function. The **gaffer** has traditionally been the head of the lighting department, responsible for designing and implementing the lighting plan and electrical power needed to supply it, which is why the gaffer has also been referred to as the head electrician in charge of lighting. More recently, the person in charge of lighting has often been credited as the chief lighting technician on major Hollywood productions. Either name refers to the person responsible for the film's lighting plan in modern filmmaking. (The name *gaffer* dates to nineteenth-century England, where it referred to the supervisor of a work crew.) The **best boy (electrical)**—the gaffer's key assistant—is usually on the electrical truck, dealing with such logistics as equipment, crew schedules, and rentals. **Electrical technicians** set up and control the electrical and lighting equipment, from lighting instruments to electrical generators and other sources of electricity that may be used.

Lighting grips are also part of the lighting crew. They specialize in rigging everything related to lighting—from adjusting set pieces to putting the camera into the correct position to setting up flags, bounces, and silks. Note that lighting grips might sometimes be a separate team from the camera grips that we mentioned in Chapter 6, although on a student production, the same small team may be required to do all rigging work for lights, cameras, cables, and more. (The word *grip* has its origins in nineteenth-century theater, where workers had to "grip" the scenery and curtain ropes.) The **key grip** heads the grip department and works closely with the DP to set up and break down the elements for lighting. The **best boy (grip)**—the key grip's main assistant—also keeps the grip truck and equipment organized. **Dolly grips** set up and take down dolly track, camera dollies, and cranes, and push the camera along the dolly track for tracking shots. Whether working for the electrical or grip department, the job of best boy, whose name dates from the old apprentice system and refers to the master's oldest and most experienced apprentice, is not gender specific.

Once your lights are set up (*rigged*), you will do a preliminary focus, setting your key, fill, and backlights, and any other spots or specials. This means adjusting the position of the lights so that they illuminate the scene as you want it. Always start with your lighting triangle and build outward from there; background lighting is a good addition, because your main focus is to light the actor, not the set. At this point in a professional production, the director still hasn't seen the set—you are just getting things ready for the director's approval.

Now it is time to show the director what you've done. The director may ask for some adjustments and may further explain how the scene will be blocked, which will help you ensure that the lights are well placed. Usually at this point, the

How Long Will Setups Take?

A cinematographer can make a production swift and fun—or long and dragged out. That's because there is a wide range in how DPs see visual choices and how they choose to light scenes. One DP can light a scene in 30 minutes with a few instruments; another will take half a day and use dozens of instruments to set up lighting for the same scene. It's all a matter of creative approach and, of course, money. In the best-produced films, lighting design choices jibe well with the film's budget and time constraints; when that doesn't happen, it can be a disaster.

Producers must be savvy. Before hiring a DP, the producer needs to check both the quality of prior work (by watching previous films) and the DP's work habits. If the DP historically takes a long time to set up lights and get ready for the shoot, the producer needs to make sure the budget and schedule make allowances. Sometimes the time is worth taking; the director may be visually oriented and care a great deal about gorgeously lit images, which are intrinsically time-consuming. However, if that isn't consistent with the film's resources, the producer will be wise to take the slow-moving DP off the list and come up with some alternatives.

Practice

IDENTIFYING THE LIGHTING

Using the last film you watched in class as an example, identify instances of the following:

- Realistic lighting
- Expressionistic lighting
- High-key lighting
- Low-key lighting

Tip BRING ACTORS TO THE LIGHT

Especially in natural-light situations, remember that it is always easier to bring your actors to the light than to bring the light to your actors. Talk with the director about staging a particular scene so that the light will best illuminate the characters and fit the emotional moment.

director will call a rehearsal with the actors, and they will do the formal blocking of the scene. Watch the blocking carefully so that you can reset lights, if necessary, to work for the scene.

You must also pay special attention to where the actors will spend most of their time during the scene. Your previous focusing of the lights was only approximate; now, with the real actors in place, you can fine-tune the lights to their specific heights and positions. You may place tape marks on the floor so that the actors can "hit their marks," and the lights will be there for them. Many professional productions excuse the main actors at this point and use **stand-ins**, who must be the same height and physical build as the actors they are doubling. The stand-ins will remain in place as long as it takes for the cinematographer and lighting crew to adjust the lights. Although this may seem excessive, it is actually quite efficient: while the stand-ins are working with the lighting crew, the principal actors will be getting their hair and makeup ready for the shoot.

Outdoor Lighting

Making a movie outdoors presents special opportunities and challenges. On the one hand, you have an abundant source of light from the sun and, on clear nights with a camera that operates well in low-light conditions, the moon. On the other hand, you are subject to changes in the weather, and—unlike with fixed lights—the sun moves over the course of the day, so continuity can be difficult to maintain. You can address these challenges by paying close attention to weather conditions, using equipment to handle time-of-day changes, and employing specific setups to meet the needs of the story.

Adjusting for Weather and Time of Day

In daylight photography, the sun will always be your key light. When the sky is clear, the sun will be harsh and strong, which means your images will be high contrast: you'll notice strong shadows around noses and eyes. How can you counteract the contrast if you don't want it? You can use any of the following methods, or employ them together:

▪ Use stretch silks or scrim between the sun and the actors. The diffusion media will flatten the sunlight and reduce shadows.

▪ Set up reflectors to bounce the sun's rays back, throwing a fill light on the actors. Reflectors are lightweight, inexpensive, easy to set up, and—best of all—don't need electricity.

▪ Add strong fill lights to counterbalance the sun's light.

On the other hand, when the sky is overcast or cloudy, or if fog rolls in, the light will be even but flat. In this case, you will probably want to *increase* the contrast by adding fill light, either with electric lights or reflectors.

You should also organize your shot list carefully, and make sure to white-balance as the daylight changes. Shadows alter direction as the sun arcs through the sky; light in the morning is different from light at midday, which is different from light at evening. Shoot your wide shots at the time of day that's appropriate for the story; it will be easier to cheat the lighting when you move in for close-ups. Of course, if your schedule permits, overcast days, sunset, and dawn provide great mood and free production value! **Magic hour**, which is the time between sunset and dusk, or dawn and sunrise, is a short but remarkable time for filming. It is called magic or golden hour as shadows are gone, and the natural lighting ratio between the background and foreground is very small. Professionals always check the weather carefully when shooting outdoors, because a sudden rainstorm or windstorm can be extremely dangerous (water and electricity are a deadly combination) and can damage equipment.

If a scene takes place at night, or is a scene that will have extensive visual effects added, most cinematographers will prefer to shoot at night or in a studio setting, where lighting can be meticulously controlled. There is also a technique called *day for night*, which involves shooting during the daytime with a deep-blue filter on the lens and further darkening the image in postproduction. However, day for night has fallen out of favor; the sun's strong shadows can give it away, and audiences don't respond well to obvious fakery, so there is no point using the technique unless you have a great deal of expertise with it.

It is quite possible to shoot night for night, especially as many digital cameras capture excellent images even in low-light conditions, but it also requires great skill to make night lighting look convincing and not artificial. The following four techniques can create masterful night exterior shots:

▪ Motivate the light whenever possible, using the moon, streetlights, car headlights, or light streaming out of windows.

▪ Supplement the motivated key light with carefully controlled fill lights. You'll probably want to gel them blue.

▪ Backlight is essential to separate the actors from the nighttime environment. Backlights provide a fringe of light that defines the actors' shapes.

Tip **REMEMBER TO WHITE-BALANCE**

Even when shooting in daylight, don't forget to white-balance (see Chapter 8, p. 188). The sun's color temperature changes throughout the day. On a clear day, sunlight will be 5500 K at noon, but it can rise to 7000 K when clouds roll in. It will be 2500 K at sunset and sunrise.

Tip **HOW TO USE THE SUN**

Try positioning the actors so that the sunlight is not directly in their eyes, which will cause them to squint, but *almost* directly in front of them.

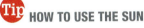

Practice

OUTDOOR LIGHTING

Shoot test footage of an exterior daytime scene. Practice positioning the actors at different angles to the sun. If you have access to scrims or silks, shoot more test footage with the diffusion media to see how it flattens light on the actors' faces.

▌ Don't forget to light the background; at night, if you don't light it, you won't see it. Background lighting also creates a sense of depth and identifies the actors as situated within a large, outdoor environment.

As with all scenes you'll be shooting, testing the look of night shots is essential. Until you see the result (on a playback monitor or on film), you cannot be certain that your night lighting will appear natural instead of contrived.

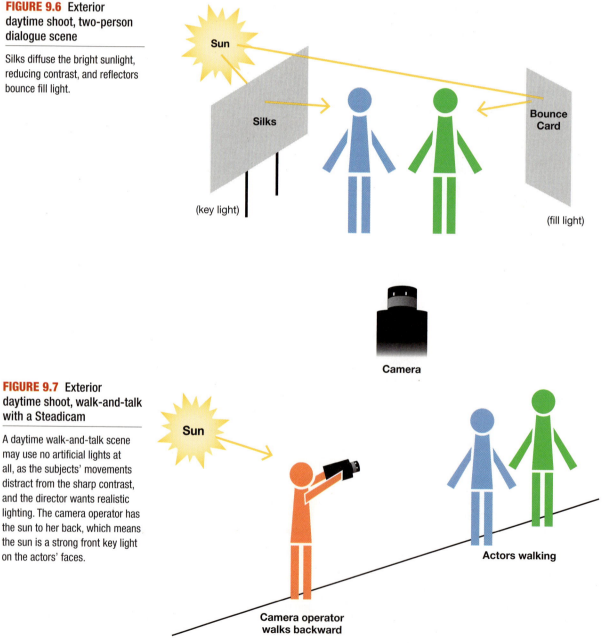

FIGURE 9.6 Exterior daytime shoot, two-person dialogue scene

Silks diffuse the bright sunlight, reducing contrast, and reflectors bounce fill light.

FIGURE 9.7 Exterior daytime shoot, walk-and-talk with a Steadicam

A daytime walk-and-talk scene may use no artificial lights at all, as the subjects' movements distract from the sharp contrast, and the director wants realistic lighting. The camera operator has the sun to her back, which means the sun is a strong front key light on the actors' faces.

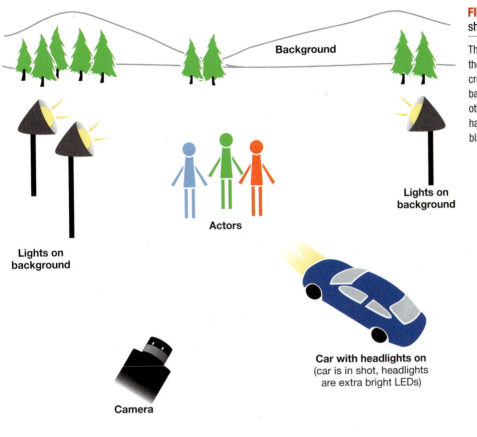

Background

Lights on background

Actors

Lights on background

Car with headlights on
(car is in shot, headlights
are extra bright LEDs)

Camera

FIGURE 9.8 Exterior night shoot, three-person scene

The key light is motivated by the car's LED headlights. The crew has meticulously lit the background so you can see it—otherwise, they may just as well have shot this scene against a black drape!

Practical Outdoor Setups

When you approach outdoor cinematography for the first time, it can seem daunting. Regardless of the amount of equipment you have, you can adapt these setups for your class projects.

Indoor Lighting

Most cinematographers love indoor lighting because it gives them absolute control, whether the scene is actually supposed to take place indoors or whether it is on a sound stage dressed to look like an exterior. However, with great control comes great responsibility: indoor lighting uses far more equipment, and is trickier than exterior lighting.

As is true whenever things get tricky, it's best to have a plan; a DP's plan is called a **lighting diagram** (or **light plot**), which is a drawing of how the lights will be positioned, analogous to an architect's drawing of how a house will be built. Let's look at how lighting diagrams work, and then learn some practical applications of interior lighting.

Lighting Diagrams

Although lighting diagrams are occasionally used for outdoor shoots, they are nearly always used, and meticulously followed, for interior work. That's because

FILMMAKING

FIGURE 9.9

Using only four lights, this setup provides proper lighting for two actors in this scene. The back light is reflected off the back wall to give the actors added dimensionality.

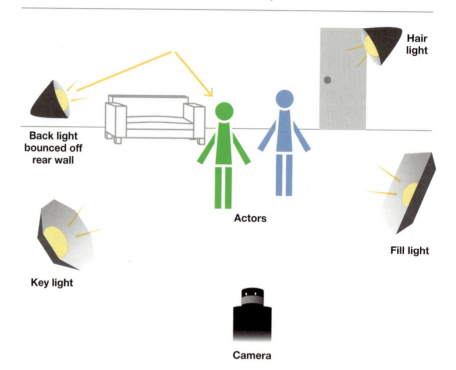

Hair light

Back light bounced off rear wall

Actors

Fill light

Key light

Camera

indoor scenes require special time-consuming rigging, meaning that the lighting crew needs to plan well in advance to have the equipment and person power on-hand. On student productions, it is customary for the DP to hang lights alongside the crew—or for the DP to *be* the crew—whereas on professional productions the DP may arrive on-set after the crew has already finished the pre-rigging.

Lighting diagrams also offer an opportunity to study how lighting instruments work together to compose well-intentioned images. Figure 9.9 shows a lighting diagram for an interior scene. In more complex setups, the DP will include eye lights—light positions to reflect off the actors' eyes. The eyes are the most expressive part of the human face, and you will want to make sure they "read" well.

As you can see from the annotations, both diagrams accomplish the same idea of a lighting triangle: key light, fill, and backlight. The studio film is able to use more lights to achieve specific spots and accents in the scene; the resulting lighting will be deeper and more modulated. Your lighting diagram will probably be closer to the student film version, although you may be able to pick up some extra instruments; in that case, the studio approach will give you ideas on how to make your student film look much more professional.

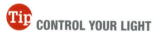 **CONTROL YOUR LIGHT**

When you're working in a practical location, take control of light: turn off the existing lights and use your own. Only add existing lights if they will work for your movie.

Practical Indoor Setups

Although lighting diagrams offer a bird's-eye view of light design and are indispensable for communicating with your crew, they are difficult to visualize—you can't know exactly what lighting will look like just by seeing the diagram, just as it is hard to know what music will sound like just by reading the musical score. Like music, lights must be "played" to be understood.

Your first step is to set up your camera and select the frame. Until you know what will be in the shot (and what won't be), you can't know where to light. By setting your frame boundaries first, you also save time and money, because you won't waste resources illuminating elements that will not be in the finished film.

The indoor setups in Figures 9.9–9.12 are among the most common ones you'll experience, and by studying how they look, you can start making plans for your class project. Figure 9.10 uses the concept of bouncing light; using walls, ceilings, or white cards as bounces is an easy and inexpensive way to create fill and an even baselight level.

LIGHT BY EYE

The most important thing is to know how to light by eye. Use the light meter, but develop the sensitivity and experience to know what the shot will look like on the recording medium (film or digital).

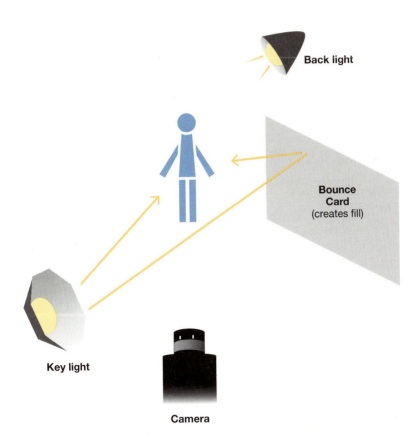

Back light

Bounce Card (creates fill)

Key light

Camera

FIGURE 9.10 Interior day, one actor

Much can be done with only two lights in this simple setup. The key light is placed at a 30-degree angle to the actor's eyeline; a reflector bounces light from the other side to provide fill. The backlight visually separates the actor from the background.

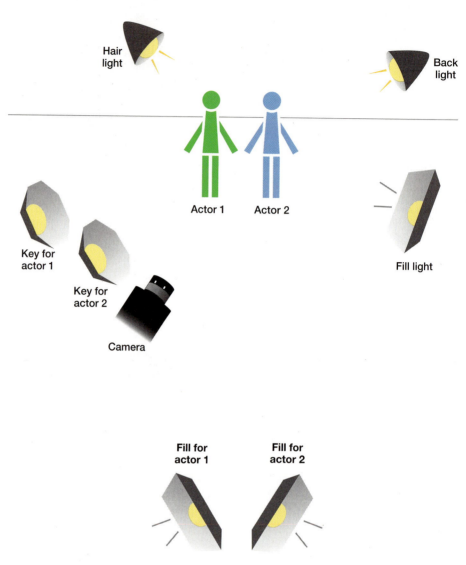

FIGURE 9.11 Interior day, two actors

There are two key lights, side by side—one for each of the actors' faces. The fill, back, and hair lights combine to give the actors definition and contrast (5-light setup).

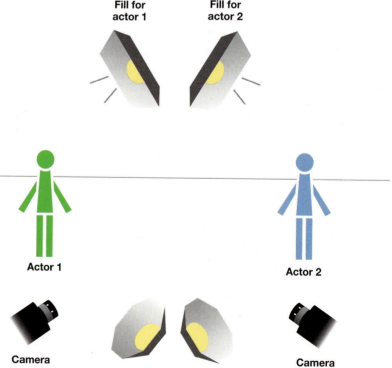

FIGURE 9.12 Interior day, two-person scene

The lights are set up so that it will be easy for the DP to shoot in two directions—first the angle on one actor, then the angle on the other. There are two key lights and two fill lights, one set for each actor. The DP has adjusted the lighting levels so that there will be visual continuity no matter where the camera is positioned; setting the lights in this way also saves time, because the director can move quickly from one angle to another.

Practice

INDOOR LIGHTING

Try reverse-engineering the lights in a scene from a favorite film. How would you accomplish the same look?

Special Lighting Situations

By now you have learned how to tell the film story with basic exterior and interior setups. However, you will also encounter special circumstances that don't precisely fit any of the standard setups. In this section, you'll discover how to execute lighting for low-light and mixed-light situations, for actors with varying skin tones, for scenes in which the camera is moving, and for visual effects. For all special situations, make sure you schedule time to test your lighting solution to make sure it works, so you can make adjustments if it doesn't.

Low Light and Mixed Light

Digital cameras do an exceptional job of capturing images in *low-light situations*, in which there is just a small amount of available light, such as night shoots and scenes using only practical lights. These techniques will maximize the amount of light that falls on the optical sensor and improve the quality of your images:

▪ Shoot with a wide lens when possible. A wide-angle lens captures more light than a long lens captures.

▪ Decrease the shutter speed to compensate for dimmer light.

▪ You may be tempted to increase the gain or brightness control, but don't—doing so will make the image grainy and noisy.

What do you do when you have both natural sunlight and artificial light in the same shot? You'll recall from Chapter 8 that the color temperatures of sunlight and artificial light are different, and you can only white-balance for one color temperature at a time. A typical *mixed-lighting* situation is when you need to shoot people inside a room but next to a window. The sunlight will be 5500 K, whereas the interior light will be 3200 K. Even when you supplement the sunlight with artificial lights shooting through the window—generally a good idea if you have them, because it gives you more control—those lights will be sunlight-balanced, unlike the temperature of the room lights. If you don't match the temperature of the lights, your colors will be incorrect. Here are the three possible solutions:

▪ Cover the outside of the window with CTO gel (see Chapter 8, p. 196). This will lower the sunlight to 3200 K, the temperature of interior light.

▪ Put CTB gel (see Chapter 8, p. 196) on the interior lighting instruments, which will raise the temperature of the tungsten lights to 5500 K.

▪ Don't use tungsten interior lights. Instead, use interior lights that are daylight-balanced to 5500 K.

With any of these techniques, the color temperatures will match, and you will get a good-quality image.

Skin-Tone Variations

People have a wide range of skin tones, from very light to very dark. If you're shooting a scene with actors whose skins tones are all roughly the same, the lighting in the scene can be even, and the images will look good. However, you still need to be aware of how complexion affects detail.

With a constant amount of light at the same exposure, lighter things reflect more light (Chapter 8, p. 184) and therefore show more detail than darker things. This is true of people as well as objects. Therefore, if you are shooting a scene

Tip **USE AVAILABLE LIGHT**

When shooting in low-light situations with only practical light, such as headlights, matches, or computer screens, make sure you color-balance with the exact lighting that will be available when you shoot. Otherwise, your actors will turn strange colors!

Tip **GEL, THEN LIGHT METER**

When working with mixed-lighting situations, do your light-meter reading *after* you install the gel—it will cut your f-stop by at least a full stop.

with lighter-skinned people, you may find that you need to decrease the amount of light by a quarter f-stop to get the right look. Note that you won't decrease the camera's exposure—that would result in the clothes, background, and other details being underexposed. Instead, you would simply decrease the level of the key light.

Similarly, if you are shooting a scene with darker-skinned people, you will need to increase the amount of light by a half or a full f-stop. Once again, you're not changing the camera's exposure, which would overexpose other elements of the scene.

The situation becomes more complicated when you have lighter- and darker-skinned actors in the same scene. Now you have some actors who might need a full f-stop more light than other actors. You can address this simply by adding more lights, such as key lights, which can be individually controlled to increase illumination on the darker cast members.

Lighting for Movement

Sometimes the director wants to accomplish a lot of action in a single take, with the camera moving along with the actor across a large area. Good advance communication is essential—which is why it is important for the director to draw a blocking diagram (see Chapter 3, p. 60). By doing so, the DP will have ample time to make sure the set can be properly lit. In a studio production, the lighting crew might spend three days rigging a big location with hundreds of lights, a luxury you won't have on your class project.

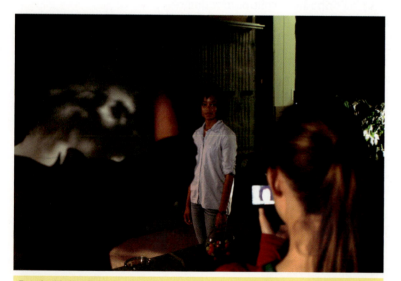

Even in this low-light situation, the actor is easy to see because of the key light coming from the left, and the backlight, illuminating the wall behind her, which separates her from the background.

The best solution when time and budget are tight is to use a few instruments that disperse light over a wide area. You can overlap the lights from each side of your lighting triangle, so, for example, as the actor moves, the key light in the first position becomes the backlight in the second position. Another solution is to use fluorescents or LED strips that cover a large location with only a few instruments.

Lighting for VFX and Animation

Visual effects (VFX) were once the exclusive province of expensive productions; however, you will find you can do compelling VFX yourself if you learn the right techniques. You will learn about green screen, compositing, and other effects and techniques in Chapter 13. Most of these effects will involve two parts—the live-action element and the digital element that will be added later. Green screen and plate work are the most common lighting situations you'll need to master for the live-action part of your VFX shots.

When shooting elements for VFX work, always keep a record of the lighting so that you can match it later. Your notes on color temperature and lighting ratios will help ensure the effect is as seamless as possible; the best effects don't look like effects at all.

1. **Using a green screen.** A *green screen* is a background that is colored green; during postproduction, the green screen is substituted for another color or background. When lighting a green screen, the background must be even and well illuminated, so that the green field is all the same color for compositing later; fluorescents are especially effective for this purpose. When lighting an actor against a green screen, it's important to match the lighting to that of the final designed image, which means you need to know what you want in advance. Don't overlight a green screen, or you will get *green spill*—green light reflected back on the actor. To minimize green spill, you can also move the actor farther away from the green screen.

2. **Using plates.** *Plates* are shots of any location—practical or virtual—to be used in later compositing. It is typical to shoot plates of principal locations as reference material and in case some scenes need to be composited later, even if they were not part of the original plan. A plate should be shot with a *locked-off camera* and with *the highest resolution possible*. A plate should be lit exactly as you would light the scene if actors were present, and your record of lighting measurements will be essential when actors are composited into the scene later.

3. **Virtual lighting.** Keep in mind that many VFX shots include light that has been manufactured, added, or augmented digitally using computer software, as we will discuss further in Chapter 13. When doing that kind of work, on a computer-animated film, for example, all of the principles we have discussed here apply. The difference is that the software will ask you what lighting style, tool, and position to choose, and you will apply it via the computer rather than using a real-world lighting instrument. But the aesthetic outcome is intended to be exactly the same. Indeed, a growing industry trend is to have traditional live-action cinematographers and gaffers participate in designing, executing, or consulting for the lighting of animated films. Acclaimed DP Roger Deakins, for example, has consulted on lighting in recent years for award-winning animated features like *WALL-E* (2008) and the *How to Train Your Dragon* series (2010, 2014).

Practice
SPECIAL LIGHTING SITUATIONS

This section contains four special lighting situations: low light and mixed light, skin tone variations, movement, and visual effects. Select one and practice shooting it.

🧰 Lighting Pro's Emergency Kit

- A camera sling bag, which gives you easy access to lenses, filters, and other light equipment when you are on the go
- A neutral density 0.9 filter (ND9), which reduces the amount of light entering the lens, allowing sensors to cope with bright conditions. An ND9 is also useful for looking at clouds to predict their movement—which affects lighting—without getting blinded. (You should never look directly at the sun, even if the sky is cloudy.)
- Gaffer's tape. It can do almost anything.
- A warm-weather hoodie for when you are doing night shoots

CHAPTER 9 ESSENTIALS

■ After determining the look with the director, the DP must carefully plan and adjust lighting, which will
preserve style and storytelling continuity.

■ When lighting outdoors, because the sun and weather change during the day, the DP uses equipment
to modulate the natural light.

■ Indoor lighting, which offers great creative control, usually requires a lighting diagram to make sure
lights can be properly positioned.

■ Special lighting circumstances are common on many films, such as low- and mixed-light situations,
actors with varying skin tones, a moving camera, and VFX shots. Each has its own solutions, which
should be camera-tested before principal photography.

KEY TERMS

Backlight	Gaffer	Lighting ratio
Best boy (electrical)	High-key lighting	Low-key lighting
Best boy (grip)	Key grip	Magic hour
Dolly grips	Key light	Stand-ins
Electrical technicians	Lighting diagram (light plot)	Three-point lighting (lighting
Fill light	Lighting grips	triangle)

"**There are so many approaches to sound, but remember this—sound is a conduit for emotion above all else. In a movie, sound is a key tool for creating and conveying an emotional response.**"

– Gary Rydstrom, legendary award-winning sound designer for many films, including *Terminator 2: Judgment Day* (1991), *Jurassic Park* (1993), *Saving Private Ryan* (1998), and *Finding Nemo* (2003)

Sound

Drive (2011)

Ronald Grant Archive/Mary Evans/Everett Collection.

When Lon Bender, cofounder of Soundelux, and colleague Victor Ennis teamed up to build the sonic portions of Nicolas Winding Refn's 2011 film *Drive*, a simple glance at the script might have led one to believe their work would focus mainly around the art of enhancing spectacular cinematic car chases. The movie, after all, offers the tale of a Hollywood stunt driver whose driving skills are all that separate him from a violent fate.

But the sound designers quickly realized that the film's emotional success was not related to the car chases themselves; rather, they discovered that the emotional link between the action and the audience lay in the psychological nature of the piece, and that sound could be used subjectively to aid that agenda. What the protagonist (Ryan Gosling) was hearing, and sometimes not

hearing, *inside* his vehicle as the pressure mounted told viewers about the character's point of view during extended stretches without dialogue. During those stretches, Bender and Ennis gave personality to the vehicle itself— as a character that could interact sonically with the driver.

"We wanted to play with the audience's perception of quiet and loudness and tie that into safety and risk," Bender explains. "And so we took creative license and were subjective with all the sounds of his car, from tires rolling on cement to the creaks of the seats, and most importantly, the heart of the car, which was represented by the sound of the engine, both in terms of story points and the mental attitude of the driver."[1]

Thus, Bender and his team used "quiet and surprise" during the start of the film's opening chase—a sequence that begins subtly. They made the vehicle "a fish among sharks," Bender says, with police cars being the sharks. In those moments, the car's engine is almost inaudible, and we hear only a quiet pulse from the musical score and tires rolling on cement. When a police helicopter spots the vehicle, all that changes, and—in Bender's words—the engine suddenly "growls to life" as a tense chase ensues, with "an explosion of sound" between the dueling engines of the car and the helicopter.

KEY CONCEPTS

▪ Having a fundamental understanding of **sound design** is central to understanding and executing all related sound tasks to better serve your story. In designing sound, audio elements must play one of three roles: narrative, subliminal, or grammatical.

▪ The primary soundtrack elements you will need to plan and execute during production are dialogue, sound effects, and music.

▪ The recording process for sound during production involves capturing production sound on-set—usually dialogue—as clearly and cleanly as possible, and effects sound on locations and special stages.

▪ Much of the soundtrack will be shaped in the postproduction process, from recording special Foley sound effects, additional dialogue, and music, to editing and mixing.

The root lesson is simple: as with visuals, sound—no matter how spectacular, unique, or intense—has no value in a film if it does not advance the cause of the story. At the professional level, people like Bender design, shape, and supervise the execution of that sonic approach, often starting long before image capture begins and continuing until the soundtrack is married to a film's visuals. Sound designers of that caliber will have a team of professionals in specific categories helping to execute that vision. As students you will likely be doing much, if not all, of this work yourself, so you will need to place yourself in the position of sound designer, fully understanding the purpose and nature of sound as a storytelling tool—that is, how good filmmakers use sound to complete the *total* story experience. You'll discover that designing sound is sort of like solving a puzzle; it's just that you first need to create the sound puzzle pieces before linking them together.

Sound is one of the most technically challenging disciplines. Luckily, you have the opportunity to learn about it at a time in history when the tools and options available to you eclipse what was available to your predecessors. Simultaneously, workflows and crew composition are rapidly changing; you will need to keep up with such changes as you move further into the sound world.

As filmmaking students, you need to grasp the time-honored principles and methods of designing and executing a compelling soundtrack. This means you should become as sonically attuned as you are visually attuned—you need to not only observe the real world but also listen to it. You need to comprehend sound-design fundamentals and the creative possibilities they offer, including the differences between natural sounds and manufactured sounds, and how each can be used in motion pictures. You should understand the tools and techniques available to record *production sound*, sound effects, dialogue, *Foley*, and so on, and know how to edit and mix those elements together.

You should also learn as much as you can about the acoustics, physics, and basic methodologies for engineering and measuring sound. As you explore both the technical foundation and creative uses of sound in this chapter, you'll discover that the two go hand-in-hand. Put them together, and you will come to understand what sound can do for your project creatively—how to "knit it all together," in the words of Lon Bender.

Principles of Sound Design

As noted, **sound design** is the hub to which all sonically connected tasks are connected. But it wasn't until sound designers Ben Burtt and Walter Murch executed breakthrough design work on *Star Wars* (1977) and *Apocalypse Now* (1979), respectively, that the art of sound design was permanently elevated to a status equal to image design for moving pictures. Murch, in fact, received the first-ever sound designer movie credit for *Apocalypse Now*; until then, the term had been used in stage productions but never in a motion picture.

There are core concepts related to the designing of a film's soundtrack that you need to understand before you move on to learning the basics of recording elements of dialogue, adding effects, or editing or mixing anything. Among these principles, you need to take both a micro and a macro view of the work simultaneously. You must determine what specific elements you want or need—dialogue, effects, *Foley*, *ambient sound*, library sound, music, and so on. Then, you must decide on what your parameters can be—how many channels, what special sounds (a spaceship, an alien) you will need to create, while being realistic about what your resources will permit you to include. Will you need a com-

poser and a full-on musical soundtrack? Will you need to license music? What are the *acoustics* of the places where you will be recording sound? What technology will your budget and personnel permit? Your resources will certainly impact what you can do sonically, but the clever manipulation of sound will permit a smart filmmaker to solve problems while conserving resources (see Producer Smarts: The Sonic Business, p. 222).

When making your decisions, *always* focus on the end game—that is, what is best for the story. Your decisions about all other matters must emanate from that single goal, and no sound should be gratuitous. Never wed yourself to a sound or a technique merely because it is cool or because you can do it. Ask yourself, should I do it, does it further the story?

Also, remember that sound is an exceptionally collaborative art. Even if you are multitasking and in charge of everything on your student project, you will need to incorporate input from possibly a professor, a director, an editor, other crew members, actors, and even friends, as well as input from test screenings. Revisions will be inevitable, and you should be open minded about this reality and not try to execute your sonic vision in a vacuum.

Modern sound designers generally categorize the roles that sound plays in a movie in three ways, as explained by longtime designer, engineer/inventor, and professor Tomlinson Holman (developer of the high-fidelity THX cinema audio standard, originally on behalf of the Lucasfilm Company, with THX standing for the original name, Tomlinson Holman Experiment). In his book *Sound for Film and Television*, Holman described these three categories as "narrative," "subliminal," and "grammatical."[2]

The narrative role of sound revolves around its basic storytelling goal—to help the audience understand where to look or how to feel at any given moment. The subliminal role involves using the medium to have a more subtle emotional impact over time—often, an impact audience members do not consciously comprehend. This happens when sounds are mixed together in such a way that the listener cannot separately identify and analyze each but, when combined, they impact that viewer nonetheless. Finally, sound's grammatical role involves its use to emphasize specific timing or events in the story—indicating the end of a scene, a dramatic pause, and so on.

Good sound designers understand the different ways they can use the medium to fulfill these roles. These are not technically straightforward concepts to master; rather, they involve the way you as a filmmaker *think about* sound. With these principles in mind, we now take a look at the first step in your sonic journey: evaluating your script and formulating a sound plan.

Practice

HOW SOUND IS USED

Choose a movie you like. Watch it with a pad and pen in hand, making notes about how sound is used narratively, subliminally, and grammatically in the film. Give three key examples of each type of use, explaining the sound and where and when it was used, categorizing it, and defending/explaining your categorization.

Walter Murch has served as a sound designer, re-recordist, re-recording mixer, and a picture editor during his career and is considered a leading authority on both disciplines and how they need to work together to properly tell stories.
Courtesy of Studio Ichioka.

The Sonic Business

Sound is a discipline ripe with opportunities for good producers to expand stories beyond the physical screen's four corners and simultaneously stretch resources. Planning sound before image capture can often save money and time, or create visual ideas for alternative ways to approach image capture. As students, you will obviously be limited in how many extras, animals, or props you can use, if any, or how many digital artists you can employ. The clever use of sound to illustrate what is "obviously" going on beyond the camera's lens can reduce your budget and logistical requirements considerably without harming—and, in fact, often helping—your storytelling.

The hysterical use of coconut shells being clapped together—seen on-camera—by the comic geniuses of Monty Python to represent the clop-clop of horse hooves in *Monty Python and the Holy Grail* (1975) takes the concept to absurd heights. And yet, even there, when plainly satirizing that their production had no budget for horses, the Python guys advanced their story. They showed characters hopping along, making horse noises; and given the nature of their humor, after the initial laughs it hardly seemed out of place. They rightly anticipated that viewers would readily accept that they were supposed to be riding horses; thus, the production directed resources to other things.

So think about how many extras, animals, machines, and props you can afford; which things you can create digitally; and which things you can strategically use sound effects to highlight instead. Does your audience need to see an explosion in your story, or could they simply hear it? While monitoring your overall budget, make sure audio resources have not been given short shrift if you need sound to compensate for other limitations. Make sure you have considered the physical placement of sound crew and equipment on-set, as well as a plan for the separate recording of sound effects or the licensing of library sounds. If you use the "dimension of sound" effectively enough in this way, and if your story happens to be good enough, your audience will be just as enthralled as if you spent seven figures.

Planning Sound Design

As you begin your sound design, you need to first swear an oath to two principles we have already discussed. First, every decision you make will be driven by a passionate need to advance the story's point of view and connect emotionally with your audience above all else, and second, you will determine at every stage along the way the purpose of every sound you choose. Will it have a narrative purpose? a subliminal purpose? a grammatical purpose?

If you adhere to these basic guidelines, no matter what method or tools you use to plot your sonic agenda, or how many resources you have or don't have, you will have a good chance of achieving your ultimate goal: making a good movie that connects with its audience.

In this section, we discuss how to plan the three prime elements of any motion picture soundtrack: dialogue, **sound effects** (basically any sonic elements, whether recorded live or manufactured on a stage or studio, outside of music or dialogue), and music. The reason for discussing, for design purposes, dialogue and sound effects in the same section is that they are the two elements you will be recording or capturing raw on-set or at a location out of the "real world," even if you will be combining or manipulating them during postproduction. Music, on

the other hand, is an element you will need to manufacture entirely out of your creative aesthetic; thus, we will discuss it separately.

Dialogue and Sound Effects

Your first task is to mark up your script in detail for sound opportunities. (See Action Steps: Annotate Your Script for Sound Opportunities, p. 224.) Good sound design occurs in preproduction. The execution of the sound design happens during image cature and postproduction. At first glance, you may presume there is little to plan regarding dialogue—after all, the words are on the written page, and they are what they are. However, if you are also the director, or you have influence with the director, show initiative by evaluating dialogue from the point of view of the greater soundtrack. Are there lines that could be removed or changed to favor a particular sound effect or musical effect that could provide or enhance the same emotion or impact? Are there lines that could clash with a sound or background noise that the script also calls for? If so, point out such discrepancies and debate what needs to be changed—the words, sound effects, or both. Indeed, remember that entire films or extended sequences of films have been made without any dialogue at all, and yet they convey emotion and advance the story effectively. A classic modern example of this is the opening 20-minute sequence of the Pixar computer-animated film *WALL-E* (2008). Keep the old adage in mind: it's better to show—or, in this case, evoke through sound—than simply tell. Many times the absence of an expected sound can also be a key story point, such as a "silent" scream.

Second, as it relates to both production dialogue and sound effects, think about *acoustics* (see p. 227) and, to a degree, the physics of sound as you evaluate the script. Are there sounds called out that likely won't work in the location or set being planned? Will special equipment or procedures be needed? Is it likely dialogue from those portions of the script will need to be rerecorded in postproduction? (See ADR, p. 241.) Since the primary goal of recording dialogue is clarity, calculate if anything in the script might interfere with that, and if so, preplan a solution. Have a clear understanding of where you will be recording, and once locations are known, visit, study, and—yes—*listen* to them to better understand what opportunities or limitations they may offer.

Third, Walter Murch suggests examining the script from the point of view of transitions between scenes. He tries to think of sound in this regard as "a fabric, like tweed or silk," over which he can run his sonic hands, so to speak, to "feel" how a change from one scene to another might need to transition sonically. "If the audience is ever aware of sound, it is at transition points," Murch states. "That is where sounds start and stop. That is where the audience will appreciate sound more consciously than at other moments in the film."[3]

Fourth, scour the script for opportunities to "discover new things," in the words of Gary Rydstrom. The script offers up all sorts of "jazz" you can riff off for creatively interesting recording, editing, or mixing ideas that were not specifically called for in the story but that have the potential to enhance it.

Along those lines, think about the environments in which your scenes will play out. Background sounds and environmental noise need to be logical and believable, unless you have a particular story reason for exaggerating or eliminating them. Similarly, real things, like a car or an animal, need to sound exactly as they do in the real world for audiences to accept them as "real." Even if not "believable," per se, you can create your own reality with sound by using it to evoke a specific emotion that plays on audience expectations. In the movie *Airplane!*

Tip **BUILD A DATABASE**

As production moves forward, sound elements will evolve and change; along the way, build a database of your notes and any library or temp sounds you have found. Include sounds from other movies that you like or would consider emulating.

(1980), for example, filmmakers created a great sonic joke by always using the sound of propellers whenever we were supposed to hear what are obviously jet airplane engines.

Finally, be proactive and experiment. After organizing your plan, roam around, recording sounds you think could have relevance to some portion of your story or to a slice of the mix or a particular sound effect. A trip to the mall or to the beach may well evoke an idea about a particular sound. If you have a recording device, record it; if you don't, come back and record it later. You never know when it might come in handy.

ACTION STEPS

Annotate Your Script for Sound Opportunities

As you examine your script, try to match the rhythm of individual scenes with sounds that improve the audience's understanding of what they are seeing. Be sure to cull through your script multiple times to fully understand the sonic opportunities within. Here are key concepts to consider:

1 **Focus** on which sounds you want to be "big" and which sounds you want to be "small" in each sequence.

2 **Identify** where you will need narrative sounds, subliminal sounds, and grammatical sounds. If the script mentions an ambulance, for example, you will obviously need ambulance sounds, even if they are not spelled out in the script. Think about how the world actually sounds in places where your story takes place, making note of sounds you need for those locations.

3 **Search the script** for "hooks" into sounds—locations, sets, and props that provide opportunities for sounds that will enhance the story.

4 **Take note of sound directions** in the screenplay. Good writers offer specific descriptions regarding important plot-related noises.

5 **Look for moments** of rest between dialogue and big music or effects, where you might be able to do something special or add environmental or ambient sounds or strategically use silence.

6 **As Walter Murch advises, examine transition points between scenes**, and contemplate how you will move out of one sound arena and into another.

7 **Avoid clichés** and feeling as though you must always do the obvious. Not every person walking down the street has to make a noise; not all rainstorms start with a crack of thunder. Only include a sound if there is a good reason for doing so.

8 **Plan for the edit and the mix**, as well as what equipment you will need during production and postproduction, so that your strategies will be fully formed by the time you need to execute them.

9 **As you strategize for the mix, ignore old stereotypes** suggesting that dialogue should always be mixed loudest, then music, and then effects. Make your plan based solely on what you believe will be best for the story.

The Music Plan

There are so many ways to use music that filmmakers who are not careful can wind up overwhelming the movie. At the same time, music is a central component to storytelling. It does not, however, come with a lot of ready-made rules about how to employ it. The design of a musical track and the use of music to further your narrative is thus largely a gut process, which we expand on in Chapters 11 and 12. But for now, understand that there are different categories that music traditionally slots into in a movie.

Depending on your material and desires, you may need a musical **score**, which you or a colleague will write or license, or both. (See Business Smarts: Licensing Music, p. 226.) Within that larger umbrella, you will possibly need an **underscore**—music the viewer realizes is added by the filmmaker to accompany the story in a thematic way. Or you may need **source music**, which is music that seems to be part of the environment within the story—coming from a radio or television, for instance. In such cases, it's a good idea to familiarize yourself with a few principles, if not actual hard-core rules, of how to use motion picture music. Later in this chapter, we discuss how to record and edit these elements.

The first of these principles should be quite obvious: break down the script for musical cues and options, just as you do for the use of dialogue and effects. Try to get a sense of how you want to use music. If you are making a thriller or a horror movie, you will come to different conclusions than if you are making a romantic comedy. If you are making a period film, you will obviously be selecting music from the era you are portraying.

Also, be particularly careful about spotting where music should come in and go out of your story. In some ways, such choices can be as important as composing the music itself. Bringing music into a scene too early or ending it the wrong way can distract viewers from the narrative or cause them to miss important dialogue or effects.

Another principle to consider is whether the music you are contemplating "matches" your images emotionally. One way to figure this out is simply to listen to it first without your images playing along, and then with them. The tune may not necessarily feel related to your story topic when you hear it by itself, but when you hear it with the images on a big screen in front of you, your sensibility may be totally different. Indeed, when composing new music, professional composers typically write melodies to match or enhance the mood of specific scenes, and when the music is actually recorded, conductors usually watch the film being screened as they conduct musicians.

Also, think about the edit and mix early on in order to make sure music, dialogue, and effects won't clash, forcing difficult decisions to be made later on. You need to remember that your big orchestral-swell moment will need to recede at some other moment. It's better to give some thought to those moments early on rather than facing your big score off against your big sound effect and waiting to resolve the clash until the end of the process, in editing.

Another reminder: as you try to match music to images, pay attention to the grammatical role of sound. It is no accident that the term used for this is *grammatical*, because you essentially need to

Tip PLAN SOURCE MUSIC EARLY

Don't forget to plan for source music early on when you evaluate your script; where there are televisions, radios, computers, or musicians in a scene, some kind of music might be required.

Practice
KEEPING YOUR EARS OPEN

As we have emphasized, a key aspect of being able to understand, design, and use sound in motion pictures is to strategically train yourself to understand real-world sound better. That means you have to . . . listen. Train yourself to take mental or actual notes when you hear a cool or unusual sound—a revolving door, an elevator shaft, and so on. With that in mind, your task is as follows: (a) Go on a "listening trip." Hunt for interesting real-world sounds you might not have noticed before you started exploring the world of sound. (b) After your listening trip, keep a log for one week, jotting down at least five particularly interesting sounds you hear each day. (c) Make notations about how the sounds you discovered could be used in a motion picture. Record them if you can, and write summary bullet points detailing how they could be used creatively. Keep your notes—you may need these sounds for real in the future!

Licensing Music

Preexisting music represents intellectual property (see Chapter 2, p. 24). Someone else owns it, and you aren't going to be able to use it unless a deal is struck to the owner's satisfaction. Plus, unlike other forms of intellectual property, previously recorded music sometimes has two copyrights—one that relates to the song itself and one that relates to a specific recording of the song. You may therefore need to deal with the vagaries of copyright law, licensing, and royalties to legally use preexisting music. As such, this area can be a minefield, and you might need to hire a lawyer if you are determined to license music at that level.

As student filmmakers, you likely don't have resources for that. You might think that since your student film is just an academic exercise, with no attempt to earn profit, why worry about licensing? Think again: there could well be a legal restriction on when, how, or if you can use someone else's preexisting music. For instance, even if all you are doing is taking your movie to festivals, you may need a specific *film-festival license* to get your film accepted. If you want rights to a song but not to the recording, because you intend to hire musicians to cover it, you may need what is called a

synchronization license. If you want both, you may need a *master use license* as well. If you want to later create and release a movie soundtrack, there are still more licensing issues involved.

Fortunately, you do have other options. You can avoid such entanglements by creating original music yourself; buying stock music at low cost from online music libraries; hiring local friends or talent seeking exposure to create original music for your project, sometimes in return for little more than credit and the right to promote the work they did for your movie; and so on—often at no financial cost whatsoever.[4] Many schools also have agreements with stock music companies that will enable you to use their music tracks for free or for little money.

Still, the point is to be educated on such matters; do your due diligence, and use industry resources if you need them. The three main music-licensing agencies are BMI (www.bmi.com), ASCAP (www.ascap.com), and SESAC (www.sesac.com); another respected service that helps filmmakers navigate the clearance minefield is the Rights Workshop (www.rightsworkshop.com).

use music as grammar to move your story's highs and lows along: as exclamation points, commas and pauses, definitive periods, quotation marks, and the like. This grammar is used to emphasize timing or have some kind of dramatic impact at a certain point. Most of us have watched the classic shower scene in Hitchcock's *Psycho*, but try *listening* to it sometime. That scary scene is chock-full of composer Bernard Herrmann's musical slashes designed to heighten fear and surprise.

You also need to consider a few practical matters in the context of your resources. In a professional environment, you would have a composer and music crew assisting you. However, as a student, you will have to make such decisions yourself. Therefore, be willing to make rational judgments. Are you capable of writing music yourself, or do you have access to someone who can? Can you find

a way to hire a professional composer? Do you know how to search music in libraries or online? Will you have resources to license that music? Do you have backup options if you cannot?

While you sort things out, you will frequently use **temp tracks**—essentially, music you do not yet have official permission to use in the final product but which you use to help set a mood during the first stage of editing. In the professional world, temp tracks are quite common, although in recent years, with the advent of digital workflows and online licensing, final music commitments are often made earlier in the process.

Still, no matter what music you use, when you choose it, or how you acquire it, remember that music and filmmaking are both emotional arts. When you put them together successfully, you have made a major advance. Don't shortchange the role and importance of music, but don't overdo it either.

Sound Recording

Now that you have learned how to design and plan sound, it's time to head into the real world and live-record the elements you need. At the base level, the categories of elements you will record are straightforward:

- **Production sound**, which has traditionally come to mean recording on-set dialogue of actors speaking during principal photography, including pauses, silence, or **room tone** during dialogue sequences.

- **Effects sound**, which consists of any elements you think you might want to use—alone or with other elements—to enhance your story beyond dialogue and music.

- **Postproduction sound**, which includes any elements you realize you need after filming is over, such as voice-over narration, repair or addition of more dialogue, location and manipulation of *library sounds* (sounds that you have on hand in your own "sound library" or acquire from another library), and music.

In this section, we will focus on production recording and effects recording, including some of the tools involved in these processes. We will delve into postproduction recording techniques and requirements, along with other aspects of postproduction sound—including music—later in the chapter.

Recording Best Practices

Before you ponder specific recording tools, methods, and situations, keep in mind some general but important best-practice concepts for recording sound:

1. Put your primary focus on *what* you are recording and *where* you are recording. Understanding these things will help clarify *how* you should record it.

2. Study the **acoustics**—the properties of a room that determine how sound will travel within it—of your location and how they might impact your recording plan (see Tech Talk: Acoustics, p. 228).

tech TALK

Acoustics

Anyone interested in motion picture audio can benefit from a good foundational understanding of the acoustical properties of sound—that is, how it travels around a room. Here are a few basic, but crucial, concepts about room acoustics:

▪ Direct sound path versus reflected sound path: Put simply, **direct sound** is what comes, as the name implies, directly from the source of the sound—an actor's mouth or a prop, for instance. **Reflected sound** results when direct sound bounces off walls, floors, ceilings, and so on.

▪ How sound reflects depends on recording-environment surfaces. Generally speaking, hard surfaces like glass or metal produce better, more active sound—often called *live sound*—because those surfaces have reflective properties. Soft materials like carpet or furniture absorb sound and therefore "deaden" the acoustics of a room—hence the term *dead sound*.

▪ *Close perspective* sound features a higher amount of direct sound.

▪ *Distant perspective* sound features a higher amount of reflected sound.

▪ **Echo** is the reflected sound one hears after a sound bounces off an object far away, giving listeners time to mentally distinguish it from the original sound. It is used frequently in music and motion pictures and can be recorded live or created/manipulated in the final mix under certain circumstances.

▪ **Reverberation,** or **reverb,** is a sound effect sometimes confused with echo. In fact, reverb involves the bounce-back of a sound from a nearby reflective surface to its source so quickly that it is heard in combination with the original sound to create a prolonged, decaying effect. Reverb is used in music and motion picture mixing and can be created artificially in the final mix with special machines or can sometimes be created naturally in the field.

3. Record dialogue on a separate track when possible, so you can separate it from sound effects and ambient noise. Isolating dialogue elements gives you a better chance to fix dialogue later on, should it become necessary.

4. Capture *presence* by continuing to record after the scene is over, so you record the "sound" of silence. Silence sounds different in every room, and you may need such elements, often described as *room tone*, when you do sound editing (see p. 239).

5. Make strategic use of available downtime to record **ambient** (background or atmospheric) **sound** or **wild sounds** (random elements recorded separately from picture elements) beyond what you are required to record.

With all that in mind, remember the following, more specific technical requirements for good recordings:

1. Depending on resources and creative preferences, decide early on whether you want to record sound to camera via physical media or to an external device, like a hard-disk recorder or even a laptop computer. If you are using a relatively modern device, audio captured in-camera is already synced with the picture and thus will be easier to coordinate later, during editing. However, that choice will likely limit how many channels you can record, whereas an

off-board device offers the ability to record multiple channels in many cases. This decision can potentially impact what you record and where you go to record it.

2. Consider using an *external microphone* over your camera's on-board mic, even if you are recording directly to your camera's media. Although there are exceptions, camera microphones tend to be inferior to stand-alone mic technologies (see p. 234).

3. Always test equipment before you arrive on-set or on location, and again before recording begins. Make sample recordings in the style and setup you plan to use when capturing the real thing, play back and analyze them, and make adjustments as needed.

4. Bring equipment to assist in unanticipated situations, such as high-wind environments. Always carry a **windsock**—a foam cover to fit over your microphone to help reduce wind and other environmental noises from impacting your recording.

5. Always carry a **boom pole** (or **boom arm**)—essentially a long pole that can lift a microphone above, below, or to the side of the action (see Action Steps: Using the Boom, below). Using a boom greatly increases recording options, as we will discuss later.

6. Always wear headphones to monitor audio quality and sound levels, and to make adjustments to **gain**, or sound levels, as needed.

7. Remember that you need to transfer sound from the capture medium to a backup medium or directly to an editing environment—or both—to get it moving for postproduction. For security's sake, when feasible, the transfer process should happen in the field (see p. 237).

8. Keep a detailed log of sounds you have recorded: what order they are in, whether they have been backed up, where and when they appear, and other important details.

9. If your recording was done on media and machines separate from the visual recording, you should also log *slate* information (see Chapter 6, p. 136) for each take in order to keep track of **timecode**—a numeric code used as a tool to synchronize audio and video. One way or another, you need a sync point you can use to match dialogue with picture later on. Digital timecode, a traditional clapboard slate, or even having a crew member loudly clap his or her hands just before a shot commences are all methods of ensuring that a sync point exists on all your tracks.

Tip MAKE YOUR OWN BOOM ARM

If you have no professional boom arm, improvise by making one out of a broomstick, metal pole, fishing pole, microphone stand, or light stand.

Tip GET A CONTACT MIC

Contact mics are designed to attach to surfaces, pick up vibrations through objects, and convert those vibrations to sound. They are excellent field tools for recording sound effects.

ACTION STEPS
Using the Boom

The use of a boom microphone is quite common in film production, and understandably so—you can follow the actor and acquire a pristine recording without getting microphones in the shot. But using one can be tricky, which is why it's best to get someone to help by acting as the *boom operator*. To have a successful boom-operating experience, you must do the following: *Continued*

Continued from the previous page

❶ Attach a directional *shotgun mic* (see p. 236) to the boom arm using a **shock mount** (a mechanical shock-absorbing fastening system that connects and stabilizes two instruments to prevent vibrations), wrapping the cable around the boom arm so that it doesn't get in your way.

❷ Cover the mic with a large windsock or windscreen.

❸ Make sure you have cables of the correct length to allow you to move comfortably around the set and, typically, a grip to help make sure the cable is unencumbered.

❹ Discuss with the DP and director how the shot is meant to be framed and lit, so that you can choreograph yourself by deciding which side of the actor to stand on—and how far away—to ensure that you stay out of the shot and avoid casting shadows.

❺ Discuss with the production mixer the choreography you have decided on to ensure your planned mic placement is compatible with the recording strategy.

❻ Ask the camera team and actors to do a quick run-through to make sure you have established the correct positioning.

❼ Place the boom either above or under the outside frame of the shot, with the mic extended about two to three feet above or below the actor's mouth. Give yourself enough leeway to be outside the frame in the event the camera operator alters his or her framing plan.

❽ Remain as still and quiet as possible beyond your choreographed moves as the shot is executed; most important, try to maintain your distance and posture while actors are speaking in order to avoid uneven sound levels.

❾ Be in shape and stretch, because you can easily fatigue doing this sort of physical work.

The boom operator keeps the boom out of the camera frame, and positions it to capture the actors' dialogue. The "fur" on the mic reduces wind or air noise, so the dialogue track will be clear.

How Do I . . .
Fulfill Sound Requirements?

Go to LaunchPad and find out: **macmillanhighered.com/filmmaking**

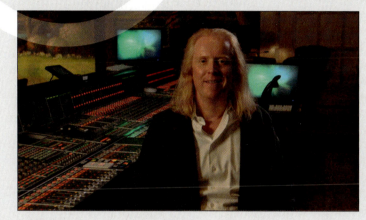

NAME:	**Paul Ottosson**
TITLE:	Sound designer
SELECTED CREDITS:	*Fury* (2014); *Zero Dark Thirty* (2012); *The Hurt Locker* (2009); *The Exorcism of Emily Rose* (2005); *Spider-Man 2* (2004)

Like lighting and camera movement, sound design must serve a movie's story. Award-winning sound designer, sound editor, and rerecording mixer Paul Ottosson has applied this philosophy to his work with major directors, including Kathryn Bigelow, Sam Raimi, and Roland Emmerich. Ottosson talks about his process in a video interview available only on the LaunchPad for *Filmmaking in Action*.

Discover:

▮ What Ottosson first thinks about when he reads a script for a new project

▮ When and why he records some sound elements on location and others elsewhere

▮ What elements might be combined for a single sound effect

Visit the LaunchPad for *Filmmaking in Action* to learn more—and to explore how you might use this advice.

Production Recording: Dialogue

As noted, production sound involves the capture of dialogue during principal photography. That work is normally handled by a recordist, most frequently credited as a *production mixer* because, on-set, he or she may well be recording more than one mic or channel while using a portable *field mixer* and digital recorder (see p. 237) to acquire the cleanest possible dialogue recording. The recordist will likely use a portable sound cart containing the field mixer, recorder, and lots of recording media: mics, cables, level meters, headphones, laptop, and possibly specialized equipment.

The goal of the recordist is to make sure there is a high **signal-to-noise ratio**, meaning no background or ambient noise or other distracting or distorting sounds bleed into the dialogue track. This goal can be challenging because sets are often crowded and noisy, with less than optimal acoustics. Indeed, for possible postproduction use, production mixers frequently ask for silence on-set and record **room tone**—a unique, barely audible hum, buzz, or low tone that exists in many locations due to natural phenomenon or mechanical infrastructure.

The production mixer also chooses which microphones and sound recorder to use, and will monitor and report to the director any audio problems. Thus, he or she should have a good foundational understanding of the physics of sound and microphone technology: how sound travels, bounces, or can be muffled or obscured; what *decibels* are too low or too high for comfortable hearing; and so on.

Often, the production mixer relies on the aforementioned **boom microphone**—a mic suspended in front of or just above the actors as they speak—while trying to keep the microphone, boom, and their shadows out of the camera's field of capture. Depending on logistics and creative needs, the most prominent alternative to recording via a boom mic is to clip a small *lavalier mic* on the actor in such a way as to make it invisible to the camera (see p. 236).

Regardless of which microphone is used, mic placement is crucial. Placing the mic directly in front of the mouth can pick up natural clicks and pops and breaths from the actor. A rule of thumb is to maneuver the mic between one to three feet in front of the actor, just above or below mouth level, but that is not an exact science, and each situation requires different placement choices. Remember: the distance between the mic and the speaking actor impacts the volume of what is being said. The further the distance, the lower the recording will turn out. If the person speaks softly, or if there is significant background noise, the mic needs to be closer to the actor's mouth.

Keep in mind that the production mixer is there to get the desired creative result as clearly and efficiently as possible. Thus, he or she must speak up when there are situations that might interfere with this goal. For instance, if a character is speaking over an explosion or gunshot, dialogue may not record clearly. Therefore, the production mixer might ask the director if there is time to record **wild lines** as soon as the scene has been shot. That essentially means asking the actor to repeat the line right after the scene finishes, so that a clean recording will be preserved.

You won't immediately master all these skills. It will be a gradual process to fully learn how to use the properties of sound to full advantage when recording dialogue, with some mistakes along the way. That said, none of the problems you encounter should be caused by a failure to have the best equipment you can access, good backup strategies, a solid knowledge of basic mic placement, and the know-how to properly use whatever recording device you have available.

 GET CONSISTENT LEVELS

Besides making sure the levels are consistent on your recording device, make sure there is a consistency to your levels throughout the entire field-recording setup.

Recording Sound Effects

Sound effects, by their nature, represent a particularly wide category but also a highly creative one. Depending on your skill level, resources, time, and creativity, you can potentially go anywhere to record sounds you think your postproduction team will need. You might take recording trips to sets and locations separate from principal photography and even to other locales. In fact, most industry professionals proclaim strongly that, when possible, you *need* to record in the real world. As Gary Rydstrom says, "That's the discovery part, the cool part—you never know what you will find." A simple recognition that unique sounds can be captured and used to good effect simply by being enterprising and open minded is important to your creative success. Indeed, Rydstrom emphatically insists that "any recording trip that does not include a surprise is not a good recording trip."

Thus, Rydstrom's mentor, Ben Burtt, famously recorded traffic on a Los Angeles freeway through long pipes, and later turned the resulting recordings into the humming sound of the "speeder" bikes in *Star Wars*. Your job when recording effects is to apply such initiative to your project. At the same time, though, you have a specific mission related to your particular story, limited time and resources, and a need to adhere to your story's requirements.

As such, recording trips should be thoroughly and logically planned out. Your breakdown of the script and research into locations will cue you about where you need to go to record your sound effects—a train station to record a train, for example. Other ideas will emerge from your creativity—a junkyard, your own backyard, and so on. Pay attention to the section on Foley (p. 243) to get a clearer understanding on just how creative you can be in sound.

As you head into the field, you will be carrying similar equipment to what you used for production recording: a wide selection of mics; booms; a *field mixer* with a *VU or peak meter* (see p. 234); a *preamp*, a *compressor*, and other specialized equipment when feasible (see p. 234); recording media; quality headphones; cables; and helpful supplies, such as a notepad and Sharpies, spare batteries, a laptop or external hard drive for backup, and supplies to clean and repair your recorder. Be as diligent as possible about testing your equipment, checking settings, and having backup strategies—such preparations could spell the difference between success and disaster.

Beyond equipment, you might bring along props for experimental recording work—pipes, tubes, hammers, bells, and the like. You might also carry blankets, pads, and pillows in case you find yourself in a space where sound is too live and you need to deaden it somewhat.

Also, if possible, bring an assistant with you. Sound assistants are crucial on major projects, for loading, unloading, and setting up equipment; providing support and backup; pulling cables and placing mics; operating booms; and more. Even if you can't hire someone, ask a fellow student or friend to help out.

Assistants are particularly helpful because simply recording sound is not enough. You are a data manager in the field. You must label tapes, cards, hard drives, or whatever media you bring; take care in your file-naming conventions; log sound takes with a sound report or sound-take number; and make sure you have backed up everything to other media before leaving the location.

Recording Levels

A big part of your responsibility when recording sound involves setting and controlling the recording volume. Virtually all modern sound recorders and cameras

with audio capabilities will have similar audio controls, usually called the **pot** (short for **potentiometer**) or **fader**, with which you control the sound level, sometimes called gain.

Most modern digital recording devices also have **peak meters**—instruments that read the volume level—typically going from a negative number all the way up to 0 dB, which, ironically given the zero, represents the highest level the device can measure. The abbreviation dB stands for **decibels**, a unit for measuring the intensity of sound, and the marking **dBFS** represents **decibels full scale**—maximum peak levels for decibels on digital systems. Older analog devices may have **volume-unit meters**, or **VU meters**, which express the same idea of monitoring the signal but are not as precise—they provide the average sound level but do not indicate peak levels.

Either way, you generally want to record at the loudest possible level without going as far as zero—in other words, loud, but not too loud. Also, when feasible, maintain the same level all the way through the recording as much as possible. However you adjust things, try to be consistent on all tracks—do test recordings before rolling for real. Find a level that works, and stay there unless you have a good reason for changing it.

Also, some recording systems offer **automatic level control**. As the name suggests, these devices automatically control and maintain gain: boosting it when the signal is too low and lowering it when levels are too high. Be careful in using automated controls in *any* creative endeavor like filmmaking because you delete human judgment and creativity from the equation once you choose settings. Plus, some automatic systems do not handle sudden noise changes well, so if you are going to use automatic level control, test the system thoroughly. In any case, do not become overreliant on your meters for adjusting sound levels—there is no substitute for listening closely. In an action scene, for example, where dialogue, sound effects, and other noises might collide, you will have peaks and valleys, whispering and shouting. You need to strategize carefully and consider whether you should record at lower-than-typical levels as protection against level surges during such scenes.[5]

Other technologies audio professionals use to control recording levels include **limiters**, which are separate automated systems that activate if volume levels rise sharply, making them helpful in such scenarios as the action scene just described; **compressors**, which can, depending on the model, work with a recorder or microphone to compress the sound's dynamic range if levels spike too high; and **preamplifiers** (**preamps**), which usually connect to a microphone to boost a low signal before that signal is sent to the recording device.

Microphones

Obviously, any sound recording requires some kind of microphone. Generally, you have two choices: using a built-in mic on your camera or, preferably, using an external mic that connects to your camera or audio recorder via a cable or wirelessly via a transmitter. The external mic option is often preferable because, in most situations, it provides better sound quality than most built-in mics.

Your mic will either capture a signal that is then directed to the camera's onboard media—tape, solid-state card, or hard drive—or connect to an external recorder or **mixer**, a device that will give you the opportunity to adjust sound before recording it permanently to your storage media (see p. 237 for more on recording equipment). At a minimum, a good working knowledge of the basic concepts of *transduction* and *polar patterns*, and the different types of microphones that result from these concepts, will be useful, because that knowledge will help you make wise choices about which mics to use in different environments.

At the base level, microphones are transducers—devices that convert energy from one form to another. Mics capture sound waves—*acoustical energy*—and turn them into *electrical energy* as signals that can then be recorded. When sound waves hit a microphone's **diaphragm**—the actual transducer—it vibrates. The device turns those vibrations into electrical energy. At the other end, the electrical energy is converted to an audio signal by the receiving device.

There are, however, methods of transduction besides using an actual diaphragm-style mic, and that is how we get different categories of microphones. **Capacitor microphones**, **electrical condenser microphones**, and others use different forms of transduction to send the signal. **Dynamic condenser microphones** are quite common in the movie world because they are generally rugged in the field. Condenser mics have an electrical capacitor built in to simulate a diaphragm; be aware, however, that because of this design, they do require their own power supply.

There are other important issues related to how microphones pick up, convert, and relay audio signals, including **frequency** (the rate at which a sound repeats), **frequency response** (how effective an audio device is in transmitting an audio signal after receiving it), **amplitude** (the maximum range of a signal when measured from a particular average), and decibel level. But for now, the key concept is the polar pattern, also called the **pickup pattern**. The mic's polar pattern, based on its design, determines from which directions it can pick up sounds—in other words, how sensitive it is. This concept is commonly called, for obvious reasons, **directionality**.

Some mics are designed to capture sound from a broad-ranging area. Others are extremely sensitive and are designed to pick up only a narrowly defined range of sound, which is useful when you are trying to capture a specific sound in an area filled with background noise. Thus, like camera lenses, different mics have different uses. With that in mind, here's a quick look at the most basic types of microphones—all nicknamed based on their polar pattern design.

▎ **Omnidirectional.** These mics pick up sound coming from any angle or direction with equal clarity and are therefore considered to be good general-purpose microphones. They work especially well when you are recording large groups of people and want to capture the overall sound.

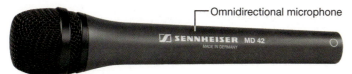
Omnidirectional microphone

Courtesy of Sennheiser Microphones.

▎ **Bidirectional.** This design allows sound capture from the front and back, not the sides.

▎ **Cardioid.** This microphone's pickup pattern is designed to capture a wide area of sound directly in front and to the side of the mic, but very little behind it. Its name comes from the heart-shaped polar pattern demonstrating its pickup strength. Cardioids are useful for pulling in the sound of a particular source in front of you while avoiding unwanted sources behind you.

Bidirectional microphone

Courtesy of Audio-Technica, AT4080 Ribbon Microphone.

FILMMAKING

Courtesy of Sennheiser Microphones.

- **Hypercardioid.** These mics are similar in pattern to the cardioid, but with a narrower, more targeted front range and the ability to pick up a narrow range of sound directly behind the mic.

- **Shotgun.** This design is tubular—designed to have a very strong sensitivity to anything directly in front of it. Shotgun mics are therefore used for recording only what you are directly aiming the microphone at—hence the name shotgun.

Cardioid microphone

Hypercardioid microphone

Courtesy of Audio-Technica, PRO 25ax.

Shotgun microphone

Courtesy of Sennheiser Microphones.

Those are the basic categories of microphones based on pickup patterns, but the other key issue relating to mics involves their placement for recording purposes. We have discussed handheld and boom microphones, but as mentioned earlier, it's frequently necessary to attach a microphone to a person or an object. The most common mic for placement on actors is the **lavalier microphone**, which gets its name from the fact that it can generally be attached to a person's lapel, hidden from camera view. Lavaliers are small and are often used with wireless transmitters to make them easier to hide on a person. They are used to pick up the voice of single individuals and are therefore useful for television news, sports, documentaries, and reality shows. They can be designed with any polar pattern, but most lavaliers are omnidirectional or

Tip **ATTACHING LAVALIER MICS**

When attaching lavalier mics to clothing, run tests to make sure they are not picking up vibrations from friction with the clothing. There are a wide range of clips and mounting technologies available for attaching lavaliers.

Dylan McDermott gets ready to shoot a scene. The lav mic on his right lapel will pick up his voice. Because the sound recordist has positioned the lapel mic so we can see it, this shot will probably be a close-up, with the mic out of the frame.
Photo by D Dipasupil/Getty Images for *Extra*.

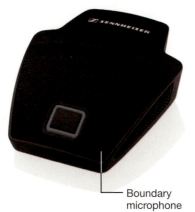

Boundary
microphone

Courtesy of Sennheiser Microphones.

cardioid. Manufacturers offer a huge range of wireless microphones of all types and polar patterns.

Another category is the **boundary microphone**, sometimes called a *pressure zone microphone*. This is a small, flat mic that can be attached to a flat surface. Its purpose is usually to record multiple people or musical instruments when conditions don't permit mics to be situated near each actor.

Recording Equipment

Along with a microphone, you need a safe and reliable way to record your sound. This typically involves the use of a digital recorder in combination with a **field mixer**—a portable battery-powered mixing device that allows the recordist to combine multiple mic signals and mix them into a single output signal in the field. The idea is to capture sound directly to your recorder if you are only recording a single audio source, or to take multiple-source audio signals and send them to the field mixer to combine before sending the signal on to the recorder.

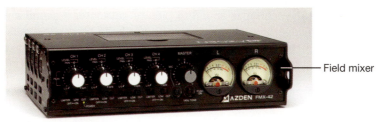

Field mixer

Courtesy of Azden Corporation.

You can simply record right to your camera's source media or go from the field mixer to the camera if you do not have an external audio recorder. But either way, you need to have conceptual familiarity with capturing and mixing multiple channels of audio. Sound recorders can capture audio on all sorts of media these days, ranging from analog tape to digital hard drives, solid-state cards, or optical disks, such as CDs or DVDs. For decades, analog field recorders were used to capture sound on quarter-inch tape, and later **digital audiotape** (**DAT**), but the digital audio recorder has largely taken over today.

The current generation of digital recording technologies offers dozens of options, including small, handheld devices that provide rich sound at consumer-level costs. Such devices produce sound as digital files and save them to the recording media. You can also record to a laptop or desktop computer, iPad, or smartphone with a wide range of recording apps.

Keep in mind, however, that the world is awash in audio file formats, and many of them compress original data to make it more manageable. During your testing phase, you need to pick not only your recorder and recording media but also your file format and how much compression you can accept. The general rule of thumb is, if you have enough storage space, or enough media, you want to record with as little compression as possible. A good modern recorder will likely give you the option to record uncompressed or to choose which **data compression**

Tip **KEEP LEVELS SIMPLE**

Keep in mind that the more audio tools you connect during recording, the bigger the chance of level problems if you do not carefully set each device to the same levels. Keep it as simple as possible, and make sure levels are consistent on all machines.

FILMMAKING

Practice

RECORDING SOUND EFFECTS

Sound effects can sometimes benefit from experimentation and fearless creativity. With that in mind, grab a recording system with a connectable microphone and experiment with ways you can have fun shaping sound. Point the mic in the wrong direction; insert it in a tube or a pipe; attach it to something that moves or vibrates or shakes; or try anything else out of the ordinary that you want to try, as long as you are careful not to ruin the equipment—especially if you don't own it!

Write a short essay explaining the results—what worked and what didn't to create a usable or interesting sound—and propose how you might use such sounds in your film.

scheme you prefer, such as the popular MP3 format used by consumers or BWF (Broadcast Wave Format), popular in film and television production. Compressed audio can sometimes work fine, but be careful when choosing a recorder to pick one that gives you options and is not limited to a low data rate.

You also need to thoroughly read your recorder's manual and test it before you head into the field. Know what its limitations are and what its settings will permit you to do. Among the setting choices, you will need to make decisions about the *sample rate* and *bit depth* you prefer, the file structure and compression scheme you want, how to name your files, and so on. **Sample rate** refers to the rate at which the digital recorder "samples" the signal being recorded. **Bit depth**, as discussed in Chapter 6, is essentially the flip side of the sample rate, impacting a signal's resolution rather than its recording level. With high-end equipment, you get many options in these areas. For now, you will likely be limited in what tools are accessible to you, but always choose the best sample rate and bit depth available. As a general rule, the higher the sample rate, the better quality your recording will be; keep in mind, however, that the sample rate options available to you may depend on the recording technology you are using, and that the higher the rate, the more data storage will be required. The same concept applies when you increase bit depth—you can improve quality and lower noise in the recording, but you increase the amount of data you need to process and store in the field by doing so.

As mentioned, take care to log everything—including timecode, if possible. Logging timecode means labeling data with the specific time that it was recorded, making it easier to synchronize sound to picture data later if sound and picture were recorded on separate devices. If you do not have timecode available, then slating the shot will be your method of manually creating a sync point to match up sound and picture.

In this frame from *Nebraska* (2013) the timecode at the bottom allows the editor to log and identify the shot.

Postproduction Sound

After all that work designing and recording sound, you now need to put it together into a cohesive final product. Welcome to the audio postproduction phase! Basically, you must improve what you already have, add more where you need it, and stitch it all neatly together. In audio, however, "post" doesn't refer only to editing and mixing. Rather, the post process also includes creation or acquisition of any additional elements not already in your possession. This means recording

tech TALK

Mixing Consoles

The **mixing console**, or mixing board, is the tool used to bring in different sound sources and, as the name implies, mix them together, controlling different channels and frequencies to produce your desired blend. Whether you have the resources and ability to use a powerful stand-alone mixing console or are doing the mix in Pro Tools or some other software platform, here are some basic ideas to understand about functionality:

- The board will accept numerous *input channels* of audio.

- Each channel is controlled with a *channel strip* that uses a fader (level controller) to adjust volume by moving the control up or down.

- Channels can be combined together into *buses*, which are essentially networks for uniting two or more channels and then sending them somewhere else. Two of these are the *mix bus*, which is the board's main output, and the *monitor bus*, which is the signal that goes to the monitor's speakers.

- You will be able to send whichever channels you want to include to your master mix. There is usually a control called a *master fader*, which you will use to control the levels of all combined channels.

- As you combine various channels into your final mix, you will be able to use controls on the board to adjust gain, equalization, panning from left channel to right and back again, muting, the fading of some channels in favor of others, the addition of audio through microphone input, and more.

Even if you cannot afford to use a high-end professional mixing board, you can learn the ins and outs of a basic mixing console through affordable software equivalents and online manuals.

narration, if needed; using the *ADR* process for additional, revised, or redone dialogue (*looping*); acquiring and manipulating prerecorded or library music or effects; creating and recording *Foley* effects on a specially configured stage; and recording music.

Editing and the final mix will be your final audio tasks, once all elements and a locked picture are in hand. Essentially, the **sound editing** process can be thought of as finalizing individual audio elements in a coherent way and combining those elements in each category—dialogue, effects, and sound. **Mixing** can be thought of as the process of doing the final manipulation, enhancement, balancing, and control of the assembled audio track and all its elements, down to characteristics of the audio signal itself, to create a finished product that can be matched to the picture during the final mastering process.

Typically, the *sound designer* or *sound supervisor* will supervise editing and mastering on major projects, but the go-to person in post will be the *sound editor*, with technical help from *sound engineers*. On large projects, there is usually a separate *dialogue editor*, *effects editor*, and *music editor*. These individuals conduct **spotting sessions**—meetings intended to make final decisions about the needs and specific placements of sound effects and music, and to figure out what dialogue manipulation, if any, will be required. As students, however, you will likely learn and perform all these functions yourself.

For doing such work, you will need some kind of **digital audio workstation** (**DAW**). A DAW can range from an ultra-expensive professional mixing console to apps for your personal tablet. In fact, on smaller projects, the power of affordable

Tip SOFTWARE OPTIONS

There are a plethora of editing and mixing tools ranging across the consumer and prosumer space—technologies like Apple's GarageBand, Tascam's Portastudio, Adobe's Audition, and even various freeware and shareware.

nonlinear editing systems is now so impressive that some filmmakers do sound edit-ing and mixing on the same editing platform they use to cut the picture—most fre-quently some version of Avid's, Apple's, or Adobe's NLE platforms (see Chapters 11–12). When feasible, however, particularly if your mix will contain numerous com-plicated elements, you may prefer to use a stand-alone audio editing/mixing DAW of some type, with the industry standard at all levels being Avid's Pro Tools, a powerful platform that allows you to edit, mix, and perform other functions as well (see Tech Talk: Mixing Consoles on the previous page). As you segue into editing and mixing, no matter what tool you use, make sure you have addressed some basic consider-ations (see Action Steps: Prepping for Editing and Mixing, below). In the sections that follow, we cover the fundamentals behind these stages in the post chain.

ACTION STEPS

Prepping for Editing and Mixing

Before you actually begin editing and mixing your film, there are some important questions to ask yourself:

1. **How will you be transferring sound from the capture medium to your editing environment?** Whether you have already imported it from your shooting medium to your Avid, or you will design another path for your data to travel into your editing system, do not process or manipulate the signal in any way as you make the transfer. Import what you originally recorded, back it up, and worry about manipulation once you begin editing and mixing.

2. **Do you have a proper environment in which to work, with quality speakers or headphones to monitor the work?** A good listening environ-ment is crucial to attaining a great final mix.

3. **Do you have some kind of robust mixing-console technology**—a software system or stand-alone mixing board into which you can input or transfer other audio sources, either as imported files or through hardware connections?

4. **What method will you use for evaluating data to make sure it is com-patible,** at the right bit depths and formats, as mentioned in this chapter (see p. 238)?

5. **What is your goal for the final product?** How many audio channels do you want to end up with? In what format or viewing platform(s) will your movie be distributed? Its final destination will directly impact how you mix the movie.

6. **Likewise, what is your plan for organizing original elements** so that they can be reaccessed and remixed if a new version of your film, such as a foreign-language version, needs to be created?

Dialogue Editing

Dialogue is the most important aspect of a soundtrack for the simple reason that it's the primary tool for telling the audience what characters are doing, thinking, and feeling. Without clear dialogue, everything you are trying to do creatively will be compromised. The goal is for pristine dialogue, so that you have fewer prob-lems and more options.

That said, the simple reality is that production recordings of dialogue frequently end up less than pristine for a variety of reasons. The job of the dialogue editor is to fix dialogue sections that need help. Thus, the process of editing dialogue tracks is nuanced; you need to clean up every piece of dialogue as much as it requires—removing extraneous noise, lowering or removing room tone, improving levels, or adjusting unclear words—but you need to do it in such a way that the quality of the performance is preserved or even enhanced. And, of course, you must make sure dialogue synchronizes with picture properly.

The ways to do this are numerous, depending on your technology, skill level, and creativity:

▌ You may need to *split dialogue tracks*: isolate dialogue from every other sound and, in some cases, create a group of dialogue tracks to accomplish this. For example, if you are using voice-over narration, you will want to hand that off to the mixer as an isolated track he or she can then cleanly manipulate to fold nicely into the rest of the track.[6]

▌ You may need to search for and eliminate editing noises that are not readily audible after you make cuts, such as tiny sounds caused by connecting two audio components together. This is called **scrubbing**.

▌ You may need to adjust levels on entire tracks or portions of tracks. If you have dialogue recorded in stereo, for instance, one channel or the other might have been recorded at a higher level. The process of **summing** involves using your mixing board to raise or lower the level of one channel to better match the other.

▌ You may need to go back to your archive of production sound and hunt for **outtakes**, or pieces previously trimmed out during your edit, to find chunks of dialogue you can use to replace something that doesn't work right.

▌ Plan for sections you simply cannot repair properly in the edit so that you can arrange for ADR work to be done to create replacement dialogue—this is called **cuing** a line for ADR. Many editors build libraries of usable outtakes and room ambiance sounds they can use during this phase. Room noise is useful when you add ADR pieces, so that they sound like they were recorded in the same place.

▌ Engage in noise-reduction work, meaning improving frequency ranges and altering **equalization (EQ)** of the signal or filtering the signal. More of this work will be done in the final mix for the entire edited track, but in dialogue and effects editing, you often need to adjust signals and reduce or alter noise for particular clips in order to prepare that clip for the final mix.

ADR

The **additional dialogue replacement (ADR)** process will be scheduled after you have cued what pieces of dialogue need to be replaced. ADR is frequently called **looping** because, in an earlier era, actors would speak lines to match how they moved in particular scenes that played repeatedly in a "loop" in the studio.

Today the process is less cumbersome, although usually actors still watch their images on a screen and listen to original production dialogue on headphones. The goal is to redo a line while matching, as much as possible, the original movement of the lips.

Tip **CONSISTENT MICS**

Try to mic and record characters in the same conversation the same way—using the same type of mic positioned the same way, the same recording levels, and so on. Otherwise, you may need to put each actor's voice on a different dialogue track, then put them back together after some cleanup. If basic levels and sound quality appear the same on your instruments, you can keep both voices on the same track, and the end result will likely sound more organic.

There can be problems with ADR, and so you should carefully evaluate when you really need it. Some filmmakers believe it's better to live with a modest flaw in the recording quality of a clip if they have the performance they wanted and can advance their story agenda with the production track. When using ADR, keep in mind that some actors have a hard time synchronizing their lines with what they did originally. Indeed, legendary sound editor Randy Thom has suggested that the mere attempt to have an actor re-create the energy and ambiance of their on-set performance will sometimes come up short.[7] Still, ADR is used often, and when it is, it is typically recorded in a specialized studio where clips are played back for the actor.

Frequently, the ADR team will also be responsible for recording background crowd chatter, known in the industry as **walla** (because it used to be common for extras playing crowd members to mutter the made-up word "walla" during recording). Because the goal is to record the murmur of crowd noise, no specific words are required.

In any case, the dialogue editor will make sure that any ADR or walla elements are properly recorded and timed to synchronize with their corresponding picture elements.

Sound Effects Editing

From a technical standpoint, the process of editing sound effects is similar to that of editing dialogue. You will be using many of the same tools and will be involved in splitting effects' tracks, removing unwanted elements and combining others, scrubbing, summing, solving problems, and so on.

The difference is mainly creative and philosophical. With dialogue, you are generally trying to maintain, preserve, and improve an element generated by someone else—an actor—on-set. With sound effects, you are trying to *create* final elements yourself, using raw elements either already acquired or that you will find or create yourself via the use of libraries and the Foley process, among other methods.

Eventually, you will manipulate and process sound effects in different ways, with the express purpose of furthering the story. Even mundane sounds, when crafted properly and mixed into the final soundtrack, can have a profound impact on storytelling. "A bird, for example, can be made to make sounds in direct connection to something going on between two romantic characters," Lon Bender suggests.

As such, the sound effects editor's work may well begin before the dialogue editor's work; based on the sound-design plan, he or she may have been collecting elements since the production's earliest days to create specific effects, like a ship's engine. Many top editors, in fact, have extensive databases of material they have been collecting for years. Part of the job involves knowing how to efficiently create or find something the track needs.

The job also requires smart data management. With effects, there can be reams of elements involved in every scene. To put it all together and hand it off for the final mix, you need protocols for knowing where everything is, including logical file-naming conventions. For every sound element, give it a proper name that is logical to search for. "Loud crash," for instance, is not as specific, and thus not as helpful, as "loud crash when statue falls from roof." You can then insert these sounds into your database in more broadly named folders. Thus, you might have an "explosion sounds" folder, a "zoo animal folder," and so on.

Tip LOG SOUNDS

Make your daily life a recording adventure. Take your recording gear with you wherever you go—you may find interesting sounds you will use one day. Keep the sounds and log them in a meaningful database; some of them will come in handy when editing sound effects.

For each file, log all corresponding information, or metadata, of note. Metadata can tell you how big the file is, where and at what time it was recorded, who recorded it, the machine that was used, what scene it was intended for, if it was from a library, if it needs to be licensed or if some other permission needs to be procured, and so on.

Foley

The **Foley** process refers to the artistic manufacturing of sound effects that directly match action within the picture. Unlike other areas of filmmaking, Foley has not radically changed in recent years. Yes, digital recorders are different from recorders of the analog era, but at its core, Foley is created as it has been since an artist named Jack Foley invented the technique in the early days of sound.

Foley does not take place until the film is locked, the point when no further changes in the imagery will be made, and you know specifically what scenes you need what kinds of effects for. It involves recording trained artists, called **Foley walkers**, as they "perform" effects in a choreographed way with the moving-picture image using special props on a special stage. A **Foley mixer** is usually the person recording the sounds.

A typical Foley stage can look like a junkyard and is often decidedly low tech outside of the recording equipment. This is because the most believable sounds are "real" sounds. Therefore, Foley artists connect real-world props with real-world surfaces in particular ways to create certain sounds. The stage floor may be divided into sections, each with a different surface or texture that the artist will use at various times. There could well be a wood-floor section, gravel or sand, carpeting, metal—even a pool of water. They may have coconuts to bang together to emulate the sound of horses, or boxes of Corn Flakes to dump on the floor to simulate the sound of a person walking over a crunching surface. They may have rubber and brick walls to throw things against.

When you hear a character in a movie in boots walking over crunchy snow, that sound was almost certainly created on a Foley stage. It's a creative and fun technique, but quite difficult to perform because artists have to closely synchronize their movements with what is happening on-screen. But if you do it right, it can add ultrarealistic sounds to your movie.

Music Editing

In essence, music is entirely a postproduction enterprise, even though the design, potential writing, recording, or collection of music may well begin in a project's earliest phases. That's because the creation and manipulation of music to fit the movie's beats is done separately from filming and cannot fully come together until it can be synced to an edited picture. We have already discussed the design and planning approach to music. In Chapter 12, we delve further into how to use music creatively to drive your emotional agenda. For now, let's take a look at how to record and edit music.

You may have been trying out different kinds of temp music tracks to get a feel for what *kind* of music works with the material during the editorial process. Once you have some idea what you are looking for, decide whether you want music recorded live, manufactured using digital tools, or imported from preexisting sources. You will likely engage in a search for existing material or ways to manufacture music from digital sources, such as some of the music-creation software packages now available that offer simple melodies and sometimes allow you to

purchase loops of prerecorded music bits. For anything that needs to be scored from scratch, the composer will take charge of writing it, working closely with the director, and the general direction of the score will develop from there.

During spotting sessions, **cue sheets** or **timing sheets** will be generated, showing every location where a musical cue will be required and how long it should be. The cues will be numbered for each reel of the film and defined as simple score material, transitions, bridges to take the audience out of one scene and into another, or *stingers*—short collections of musical notes designed to emphasize something specific going on. This will be a stage of experimentation, debates, and changing minds. Filmmakers will try different tempos, beats, volumes, and styles over the same sequence to see which one best fits the material. Eventually, a score emerges.

Major projects then take the finest musicians available to a state-of-the-art scoring stage and record these pieces of music. However, assuming you can't afford a full orchestra or studio scoring stage, you can record music any number of ways with whoever serves as your music editor and music mixer, and with as many mics strategically placed as resources and skill level allow. Generally, record multiple instruments onto multiple tracks, or discrete audio channels, to permit richer mixing options later.

Eventually, you will deliver cues to your music editor, preferably with time-code embedded in the track or with a separate log made of the timecode to more accurately help you sew pieces into intended locations. Using Pro Tools or some other platform, the editor then cuts in the music according to your finely crafted road map. Like any good editor, he or she will make adjustments, such as volume level and cue positioning to better match the editor's pacing; some material will get dropped, and other material will be manufactured and weaved in; and so on.

During the process, you will have dozens of techniques available to you for bringing music in and out of sequences, including **fading** (gradually increasing or decreasing the sound of music over a scene), **cross fading** (transitioning out of one cue by bringing it down and into another by simultaneously bringing it up), **filtering** cues (increasing higher frequencies while limiting lower ones), and adding effects.

Art of the Mix

The industry's digital evolution has provided the opportunity for you to be far along with the mix by the time you officially get to the **final mix** stage—the place where all audio elements will be locked and combined into a final soundtrack. Some professionals now combine editing and mixing chores themselves, since workflow and technology paradigms have changed. That is likely to be the case on your student project. However, remember that the mix is a final pass. Your operating agenda is to be as efficient as possible while achieving creative goals. After all, mixing is a unique process because it is at once a creative art and a technically complex endeavor.

At some point, you will need to split all tracks by category, sometimes referred to as **stems**, in preparation for the mix. Usually the editor generates a group of tracks for dialogue, a group of tracks for sound effects, and a group of tracks for music. He or she will lay the tracks out, or order them, in a visual pattern on a computer screen, which the mixer can then use as a map through Pro Tools or another system.

Once that is done, the mix begins. Generally speaking, this will be the final step—not only in the audio chain but also in the movie's production. It could be

Tip USE YOUR SCHOOL

Make sure to check out your school's music department. You will often find a wealth of resources from orchestra to composer to facilities, with fellow students all-too eager to help with your project.

either a long, laborious process, or the strategic tweaking of a soundtrack that's nearly done. Either way, you need to understand the fundamentals of mixing.

At the core level, you must *balance*, or mix, everything together properly. This is where you make creative choices on what sounds to emphasize or deemphasize as you bring all sounds together with finished visuals. To do this, play back all edited tracks synchronized to your picture, and while you watch and listen, the **sound mixer** (or *rerecording mixer*) will adjust the signal, frequencies, and effects as needed. He or she will establish final levels in the mix, put the soundtrack through the EQ process (adjusting frequencies as needed), and filter the sound. Filtering is really a step down from the EQ process—limiting or cutting out some frequencies altogether if they introduce unwanted noise into the audio signal. Then, the mixer will finalize or process any special sound effects, such as reverb.

Because you may wind up with dozens or even hundreds of tracks, many projects include a premix. This basically allows filmmakers to start combining effects or dialogue tracks so that it will be easier to unite already combined larger groups of tracks with music and dialogue in the final mix.

At the end of the mix, you will generate what are called *deliverables*—finalized, locked pieces of the audio track that, when combined, become the complete soundtrack. On a studio film, there are often legal requirements regarding what the deliverables must be, and it is typically the responsibility of the *postproduction supervisor* to make sure these requirements are met. At the student level, those deliverables may be defined by your professor or department and can vary depending on where and how you will be exhibiting your film, what your resources are, and who will be helping you create the final master: the pristine final version of your movie—either a film negative or a secure digital file from which all other versions will be produced. At a minimum, they will include the following:

1. The *primary mix*, which is the output from your mixer that can be attached directly to the locked picture. What format this will take depends on the workflow you are using and the mastering method you have chosen.

2. *Mix stems*, which are the broken-down individual pieces of the mix—dialogue, effects, and music. These stems are all put together in the primary mix, but you also want to supply them as separate pieces in case there are mastering issues to resolve, and also to use for trailers and other promotional clips from the movie.

3. *Compressed files*, just in case you will later produce a version of the mix for streaming or another presentation at a lower bandwidth than the original.

There are other delivery possibilities, such as if you are finishing the movie to film, which will require a film print of the soundtrack alone to marry with a master image print, called the *printmaster*. But with digital mastering and exhibition taking over, it's unlikely you will deal with this process as a student.

Regardless, here are a few final tips to keep in mind as you dive into the mix:

1. Understand your project's intended destination—where you exhibit the movie will impact how many channels you mix. You will have more dynamic-range options if it will be a

Practice

DOING THE FOLEY

Find a garage, basement, or quiet room and bring the best recording equipment you can find, along with a volume-off clip from any film you choose. Bring props that will help you make the sounds required in the clip you have selected.

If you have no big screen, play the clip over and over on your laptop or tablet, and practice making the sounds of the person or object in the clip. Experiment with recording yourself providing the required sound effect *in sync with the picture*. See how long it takes for you to master the concept, and make note of what you did right and what you did wrong.

theatrical release; for broadcast or webcast, you will have far less. Dynamic range is essentially the ratio between the softest sound and the loudest sound—you normally can't go too high or too low. But the better/louder your exhibition format will be, as in a theatrical presentation, the greater the range between the two that you can experiment with. You may also need different versions of the film for different destinations, and thus you may need to mix the movie more than once.

2. Compressors and limiters are often used in the final mix, as they are in production recording. They are, in fact, one way to reduce dynamic range. If used correctly, the compressor will limit a signal's peaks to avoid crossing certain aural thresholds. These are valuable tools and worth your while to learn.

3. Background or room noise may continue to cause problems, but there are many software solutions and apps now available to help editors and mixers further reduce signal noise. In fact, a range of filters, reverb tools, plug-ins, and other sound-effect technologies are now readily available as apps. Learn how they can help your mix.

Sound Pro's Emergency Kit

▌ Basic toolbox, not only for sound equipment but also because you may need to fix or manipulate props. Therefore, pliers, side cutters, screwdrivers, hammer, gloves, and soldering iron are essential.

▌ Electrical tape and hairpiece tape (available at beauty stores) for attaching lavalier mics to clothing

▌ Walkie-talkies

▌ Extra headphones, recording media, cables, adapters, batteries, and flashlight

▌ Pillows, pads, and blankets for muffling sound

CHAPTER 10 ESSENTIALS

▐ Serving a story's needs to emotionally connect to the audience is the guiding concept behind any sound work done on a motion picture.

▐ Every audio-related decision you make has to have a specific purpose—to serve a narrative, subliminal, or grammatical function in your story.

▐ The building blocks of a soundtrack involve recording production sound (dialogue), effects sound (other non-music or dialogue-related sounds), and music, as well as collecting other preexisting elements when needed.

▐ Your recorded pieces need to be put together in a multifaceted postproduction phase, which includes recording additional elements, editing and combining those pieces, and mixing everything together.

KEY TERMS

Acoustics
Additional dialogue replacement (ADR)
Ambient sound
Amplitude
Automatic level control
Bidirectional
Bit depth
Boom pole (boom arm)
Boom microphone
Boundary microphone
Capacitor microphones
Cardioid
Compressors
Cross fading
Cue sheets (timing sheets)
Cuing
Data compression scheme
dBFS (decibels full scale)
Decibels
Diaphragm
Digital audiotape (DAT)
Digital audio workstation (DAW)
Direct sound
Directionality
Dynamic condenser microphones
Echo

Effects sound
Electrical condenser microphones
Equalization (EQ)
Fader
Fading
Field mixer
Filtering
Final mix
Foley
Foley mixer
Foley walkers
Frequency
Frequency response
Gain
Hypercardioid
Lavalier microphone
Limiters
Looping
Mixer
Mixing
Mixing console
Omnidirectional
Outtakes
Peak meters
Pickup pattern
Postproduction sound
Pot (potentiometer)

Preamplifiers (preamps)
Production sound
Reflected sound
Reverberation (reverb)
Room tone
Sample rate
Score
Scrubbing
Shock mount
Shotgun
Signal-to-noise ratio
Sound design
Sound editing
Sound effects
Sound mixer
Source music
Spotting sessions
Stems
Summing
Temp tracks
Timecode
Underscore
Volume-unit meters (VU meters)
Walla
Wild lines
Wild sounds
Windsock

DIGITAL EXTRAS

Visit the LaunchPad for *Filmmaking in Action* to access:

▐ A conversation about sound with master sound and picture editor Walter Murch

macmillanhighered.com /filmmaking

PRODUCTION GLUE

Having shot your movie and made a successful production journey, you have captured the raw picture and sound elements you need—the puzzle pieces, so to speak. Now you need to put the puzzle together seamlessly.

That is what the following section is all about—the meat-and-potatoes of post-production. On the surface, it may appear to be a highly technical section—after all, you will be learning about data management and workflow; visual effects; animation; and, to start things off, the basic skills needed to do effective nonlinear editing. But as you will discover, it is among the most important creative sections of the book, and that is why we are calling it "Production Glue." Through the skillful use of editing, visual effects, character animation, and other postproduction techniques, you will come to learn how to link and manipulate the elements you captured on-set, and combine them with key synthetic or stock elements that you could not obtain during the image-capture process, to literally make everything match so that your narrative flows as you intend; how to fix or circumvent errors you

made in production; and how to seam-
lessly "glue" everything together.

There is an art to it, an art that you can
only perform effectively if you have a basic
understanding of the tools needed, and
how to wield them with confidence during
postproduction. With this section of the
book, you will learn how to make disparate
parts whole—essentially the art and sci-
ence of filmmaking. Don't be intimidated
by some of the technical challenges you
will need to eventually master as you
move through this section. You're about
to embark on an exciting phase in the
process—learning how to take the final,
advanced steps toward creating the cine-
matic art that motivated you to take this
course in the first place.

> **"The editorial workflow is in large measure determined by how the footage is shot, how sound is recorded, and how dailies are processed."**
>
> **– Mindy Elliott, veteran assistant editor of films including *Nebraska* (2013), *The Descendants* (2011), and *Snakes on a Plane* (2006)**

Editing Skills

The English Patient (1997)

Reflecting in the early 2000s on the huge success he found the first time he edited a major motion picture using an entirely nonlinear digital editing platform—earning two Academy Awards for his work on *The English Patient* (1997), one for sound editing and the other, the first ever given for picture editing using nonlinear technology—famed editor Walter Murch looked both back and ahead when contextualizing his beloved industry's transition from analog, linear film editing into the digital, nonlinear, random-access realm. In interviews with his friend Michael Ondaatje, author of the book on which *The English Patient* was based, Murch suggested that film editing was still in something of an in-between phase in terms of where it had been and where it might be heading.

On the one hand, Murch said, basic editing concepts had hardly changed at all. "Three things

you are deciding are: what shot shall I use? Where shall I begin it? Where shall I end it?"[1]

On the other hand, even at that early moment of the digital revolution, Murch was hungry for what he saw looming just ahead—a more democratic editing landscape in which tools were accessible, affordable, more powerful, and flexible: the kind of landscape, in other words, that is now available to you as film students. It's an environment Murch had been dreaming about since even before he and Francis Ford Coppola penned a paper in the early 1970s for Paramount Studios specifically proposing a digital nonlinear methodology for editing the original *Godfather* (1972).[2] At the time, such a proposal was rejected as unwieldy. After all, early nonlinear systems just being born around that time were massively expensive and required disk drives the size of household appliances. They were large, expensive, and cumbersome, and they relied on physical media (like videotape) for storage—a huge limiting factor.

Years later, following his *English Patient* breakthrough, Murch knew that even more freedom was on its way for editors. That dream came to fruition in 2003, when he became the first editor to cut a studio feature—*Cold Mountain*, for *English Patient* director Anthony Minghella—using a consumer-level digital system, Apple's Final Cut

KEY CONCEPTS

▌ Organizing is crucial. You first need to pick hardware and software for your nonlinear editing system (NLE), including a viewing monitor that will allow you to display images in the resolution you have chosen to work in. You will also need to devise a workflow strategy, including how you will log and ingest files, and what your storage and backup solutions will be.

▌ Once editing begins, you'll arrange clips into folders or bins so that you can efficiently cull through your options. You will use your *timeline* to view the entire project as you build it. The idea is to lay the project out visually in a linear fashion on your monitor and then move material in and out of it until you have your story cut together using a wide range of specific assembly techniques, transition methods, and different approaches to shortening, lengthening, or otherwise manipulating clips.

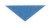

■ Finally, you need to concoct a strategy for finishing, or mastering, the final version of your movie safely. Along the way, you will learn about the power of the *edit decision list (EDL)*. If you use an offline workflow, the EDL will be the primary tool for assembling your final version with the highest quality images you have available. There are many other finishing tasks you will need to consider, such as color correction and text.

Pro (version 3.0). That's when the revolution went to phase two, opening the door for film students like you to be able to access professional-level editing tools, with those tools ported over from the desktop to the laptop.

The reason this history is relevant is that it provides context and a foundation for you to approach the discipline of editing as a beginner without being intimidated. Gone is the era where there was but one way to edit a motion picture— by cutting and splicing physical pieces of film together manually, frame by frame, sequence by sequence, reel by reel. It was a laborious and physically complicated process back then; editing as a purely creative endeavor was inhibited and a specialized task for real experts, not a discipline open to the masses.

Those days, and the early, equally awkward days of digital editing using physical media, are over. Now you can edit using tools you can afford, with a multitude of options and techniques to enhance your creativity; and, most important, you can do it in a nondestructive way, without disturbing what you had originally or what you have cre-

ated thus far. You, as film students, have been freed to be creative as editors from the very beginning of your careers.

In Chapter 12 we will discuss in detail just how creative you can be. But first you need to get organized, and to do that, there are new technical and organizational issues to grapple with in the nonlinear world. Editing rooms in the professional arena can often serve as highly complex networked data hubs for entire projects. In fact, it is not unusual to connect several editing systems at once, permitting multiple editors to work during increasingly shortened postproduction cycles. This also allows the director and editor to experiment with more variations in how imagery and sound for particular sequences can be assembled and eventually incorporated into the evolving final cut, which lives on the primary editor's system. Although things are simpler and more straightforward at your level, there are still core technical and organizational infrastructure issues you need to understand in order to design an efficient editing workflow that will work for your project.

Getting Started

Before editing anything, your first step involves setting up an efficient editing environment that takes into account your creative needs, such as what the purpose of your film is and what format you want to deliver it on. By arranging your available technology, resources, and environment correctly, you are improving your chances of creative success later.

The most important point about designing and organizing your editing infrastructure is to work backwards and plan things from the end to the beginning. By that we mean that every decision you make about how you will edit your film and organize your work needs to consider where you want to end up—that is, how and where you want to show your film. If you were shooting for a studio-level 3D presentation on a giant screen, then it stands to reason your editing infrastructure would need to be more complex and, thus, more costly. If your goal is to end up with a quality Blu-ray disc to bring your movie around to people as a calling card, then your process will be far less complicated. And if your goals are somewhere in between those two extremes, your decisions should reflect that final format.

You also should make sure your editing space is comfortable and ergonomically set up—after all, you will be spending a lot of time there. Among other things, it's a good idea to have a couch or extra seating for your director or others who will be giving you feedback, and for you to be able to lie down during a break in the midst of marathon editing sessions. You also need sufficient air condition-

ing in the room, not only for your comfort, but also to make sure your hardware does not overheat.

In terms of choosing that hardware to get started, you'll want to pick a platform that is both robust enough for your particular project and affordable.

NLE Hardware

A **nonlinear editing system** (**NLE**) is simply a computer workstation configured with special software designed specifically for editing moving images. What is revolutionary about the NLE concept is that it allows you to perform editing functions on digitized imagery without irrevocably eradicating original elements or ruining all the work you have already done. In other words, you can experiment creatively with an NLE system, and then you can export that material to physical or virtual media through off-board hard drives, thumb drives, optical drives, or other devices widely used to move data in and out of central computer systems.

Therefore, the components of an NLE system involve relatively powerful hardware and specialized software. First, let's look at hardware considerations:

Computer In theory, you *could* use any off-the-shelf computer you have available—desktop or laptop—as long as it has enough memory to run the software and sufficient memory and graphics capabilities to handle the clips you will be running through it. But for long-form projects, a personal computer may not have the computing power or memory you need. At the professional level specially configured computers with powerful editing software—often known as *turnkey systems* that are assembled with all relevant hardware and software components packaged together, tested, and professionally installed—are used exclusively for nonlinear editing applications.

As a student, you may not have access to a professional turnkey system, so you should strategically evaluate what computers are available to you. Laptops are obviously more mobile for editing on or near the set or while you travel. Desktops, on the other hand, can often be upgraded more easily with additional hard drives, video cards, and other hardware, and they easily connect to big monitors to allow you to better view material. We recommend editing on a desktop with a mouse when feasible, but if you are using a laptop, be sure to connect it to a larger monitor and use a mouse if you can. In either case, you always want to edit on a computer with the most memory and computing power available. Particularly if you are working on material at high-definition resolution, you will need a powerful processor or multiple processors to avoid rendering waits and slow performance. You may also use more than one computer, but if you do, be careful about file-naming conventions and data management, so that you will know which version of the cut is the latest as you move files around; these subjects will be discussed later in this chapter.

The other computer performance issue to consider is RAM (random-access memory). Certain editing functions with NLE software products need lots of RAM to function efficiently, and whatever software you use, it will likely come with a recommendation of the minimally acceptable amount. Remember, though, as with most software, "the minimum" that is acceptable is just that. You are always better off, when feasible, using a machine with more RAM than recommended.

Monitor For basic editing, many computer monitors, consumer monitors, or televisions can work with most modern editing software programs as a component of larger NLE systems—but that doesn't mean they will provide the best viewing

experience. For one thing, consumer computer monitors do not display color in the same way that broadcast monitors do. What this means is that although they are usually fine for viewing clips and using the editing interface, they will not show you the image as it would likely be seen in a broadcast or theatrical situation. For broadcast quality specifically, images on computer monitors can appear too dark or flat—neither of which is a major issue for the creative purpose of selecting editing transition points and making cuts, but they can be major issues for color grading (see p. 270) and evaluating the final version of your material to make sure it will be displayed as you, the filmmaker, have intended. Keep in mind, then, that the bigger the monitor is, the better, because part of editing creatively involves looking into the nuances of the image, blowing up images, and also having a clear and easy view of your entire **timeline**—the most important visual user interface within your nonlinear editing system (see p. 261). The better look you can get at images while editing, the more likely you are to come away with a good choice and a seamless cut.

Depending on resources, as you select a monitor, do the best you can with the issue of **color depth** (how many colors the monitor can display—bigger monitors generally have greater color depth), and also see if you can use two or more monitors instead of one, as many professionals do. If you can swing that, you will have a much better view of the entire timeline and isolated imagery, but of course it will require greater computer power. Ideally, try to have at least the best quality HD monitor you can get.

Cards and Devices A video graphics card is another important issue to consider. The graphics card contains a computer's graphics processing unit (GPU)—essentially a circuit board inside the computer with its own separate RAM, which controls the data's output to a monitor, determining how fast and how clear the image can be. Professional editors, of course, use the fastest graphics cards and accelerator hardware available. You may or may not have that inside your available system, or have the ability to upgrade it, but as you figure out how to configure your NLE, keep this issue in mind and find the best solution possible. Beyond all that, remember that because you need to move data in and out of your NLE, the more input and output ports your computer features, the better—USB, Ethernet, Thunderbolt, DVI, HDMI, and so on. On a desktop, you can potentially add ports using open expansion slots during an upgrade process.

NLE Software

Among the most exciting aspects of the nonlinear editing revolution is the fact that there is a wide range of NLE software systems that are affordable and accessible for consumers and students. Therefore, if you have even the most basic hardware, and you have set it up correctly, there is undoubtedly an NLE software tool available for you.

What factors should you consider before making your choice? Your computer's operating system is an important one. Some editing software tools only work within the Apple OS, such as Apple's signature editing product, Final Cut Pro. Others only work in Windows, but many run in both. In addition, many work best with a 64-bit operating system,[3] and obviously, everything functions better when you have more memory and RAM. The simple act of checking out your hardware and operating system capabilities should be among your first tasks.

Price is another obvious consideration, especially for student filmmakers. Despite the proliferation of more options than ever before, at the professional level, the vast majority of modern films are edited using some version of Avid's line of nonlinear editing platforms, to the point where it is fair to refer to Avid as the in-

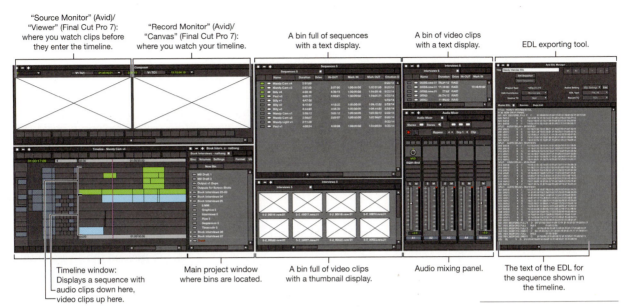

"Source Monitor" (Avid)/ "Viewer" (Final Cut Pro 7): where you watch clips before they enter the timeline.

"Record Monitor" (Avid)/ "Canvas" (Final Cut Pro 7): where you watch your timeline.

A bin full of sequences with a text display.

A bin of video clips with a text display.

EDL exporting tool.

Timeline window: Displays a sequence with audio clips down here, video clips up here.

Main project window where bins are located.

A bin full of video clips with a thumbnail display.

Audio mixing panel.

The text of the EDL for the sequence shown in the timeline.

dustry standard for professional editing. A smaller number of films use some version of Final Cut Pro (either a legacy version of the original version of the software or the radically revised Final Cut Pro X, rewritten for the OS X operating system in 2011, which is the only version that Apple now supports), particularly independent or low-budget films, while still others use Adobe's Premiere Pro system. But there are others that are used on projects of one type or another, including Sony's Vegas system and Lightworks. High-end professional tools from Autodesk and other manufacturers that professionals most often use for color correction, finishing, compositing, and certain other visual-effects tasks now also include strong NLE functions, but most of those are likely out of a student's price range.

As with many software products, some manufacturers periodically offer student pricing on lower-end versions of major NLE products. For example, Avid has offered a low-cost subscription to a student version of Media Composer in recent years. You should periodically check out the product sections of manufacturer websites to find such deals. Your school might also be able to offer assistance in securing special student pricing from major manufacturers. Furthermore, many programs have direct relationships with such manufacturers and may already have editing facilities—built on professional-level NLE technology platforms—available to you.

Additionally, there are even more budget-conscious options available, including freeware editing technology for download, and editing tools that come installed on consumer computers, ranging from Windows Movie Maker to Apple's iMovie, which incorporates some Final Cut Pro features. Lightworks offers a free version that can be downloaded, as do other companies—tools that range from ultrasimplistic to surprisingly sophisticated. Even platforms that cost significant money often offer free trial versions you can use for a short time to work on projects, familiarize yourself with features, and figure out if they are worth your while.

Whatever choice you make, each platform offers a somewhat different user interface, different keystrokes, different looks to the timeline, different options and functionality, and somewhat different nomenclature. Still, there are certain commonalities in how they operate, what to look for, and how to get the most out of them for practical editing work. Among those commonalities are basic features, graphic representations, or icons you are likely to find widely available across

"Avid, Final Cut Pro, and Adobe Premiere are all important for film students to be familiar with if they want to be well rounded and flexible," urges veteran assistant editor Brett Reed, who has worked on dozens of major Hollywood features. "All three have online tutorials, educational packages available at lower prices, and they all have active online communities where you can get excellent advice and sometimes even tech support for free in various online forums. Long before you edit an actual project, it is a good idea to go out and investigate these technologies and experiment with them whenever you can."

multiple systems. They all, for example, have a useful *undo* function—click on an icon or a menu, and your last edit never happened. Likewise, you will often see some kind of *playhead* graphic symbol when viewing clips—a symbol that moves across what is often called the *scrubber strip* at whatever speed you drag the playhead along, which is a useful tool for moving back and forth quickly to find what you are looking for. Similarly, you will typically find *jog* and *shuttle* controls, to allow you to move through clips a single frame at a time or at different speeds. You will probably find a *razor blade* icon you will use when making a basic cut, and controls you've become familiar with from using any standard consumer-level software, such as the *find* command, *zoom* tools, and *rollover* tools that tell you what a particular control is for when you put your cursor over it.

Organize a Workflow

Many technical nuances associated with importing, manipulating, and exporting files, and the nature of different formats and codecs, are beyond the scope of this book and the type of filmmaking work you will be doing for the foreseeable future. However, you do need to formulate a **workflow**—the basic plan for the series of steps you will use throughout the editing process to get files into your NLE system, back up and keep track of them, work on them, save them, and export the final product to your desired finishing media at the end of the process.

The lure of editing is the creative possibilities it offers filmmakers. But as the old saying goes, organization is the key to success. If you are spending much of your precious creative time searching for files, comparing versions, and worrying about lost or misplaced data, then logically you aren't being creative during those moments. The following phases are the ones you will follow on the path to getting organized and avoiding that eventuality. As noted elsewhere, in the file-based digital workflow era, there are dozens of options and degrees of sophistication to these processes. You need to figure out the simplest, most basic, and safest way to move your files into your system, but no matter what approach you adopt, it will include some version of the following steps:

Logging The process of deciding what material you want downloaded to your NLE system as possible elements to be considered while editing is called **logging**. Due to limits on storage space, and the need to be organized and not bogged down, it's rarely a good idea to download every single frame you shot.

Therefore, reference any records or notes you or your crew kept during production about what you shot, from a marked-up script to camera reports or informal notes. If feasible, you might also hook your camera up to a monitor before downloading anything and scan your footage take by take and scene by scene, looking for shots you definitely want to consider and taking note of the timecode, if it is available, to make it easier to find that material. As you scan your way through shots, write a report that lists the scenes, takes, basic descriptions, and timecodes of shots that particularly interest you. With many modern NLEs, you can do this during the download process by viewing footage and simply telling the software which shots you want. Many systems also include dialog boxes for you to manually input various kinds of *metadata* information about the clip.

Ingest Obviously, you will need to transfer captured image and sound files from your recording media to your NLE system's hard drive, so that you can organize and work on them. How you transfer the images to your computer depends on

what format and media you shot them in, what system you are using, and personal preferences. Among the possibilities are film, analog videotape, digital videotape, or—more likely these days—digital image files, either standard definition or high definition.

With modern cameras, you will typically apply settings as you shoot, telling the camera what file format you want the images to be translated into. This way, you will have established files on your recording media that can be seamlessly transferred to a computer via any of several types of digital interface connectors now available, or via a removable drive or solid-state card that plugs into your computer. In fact, there are currently dozens of ways via dozens of input methods to transfer digital files from a camera to your NLE, depending on your camera and how you configured your NLE system, as discussed earlier. You might end up using a standard USB connection, a FireWire connection, a faster Thunderbolt connection, or even HDMI or Ethernet technology for even faster data transfer. On the other hand, if you are still using digital videotape, you might have to connect a video tape recorder (VTR) to your NLE system.

You might also need one of several different kinds of capture cards, which are really circuit boards for your NLE computer that serve as an interface for ingesting different kinds of file formats into your system. Some of these technologies can also transcode a file from one format to another, convert the image up or down from standard definition to high definition, improve the speed of your computer's ability to do all this, and much more. For now, your goal should be to find the simplest, fastest, most straightforward way of moving captured image files to your computer.

Backup/Storage Another advantage of working in the digital era is the fact that large hard drives are relatively accessible. On any project, among your first steps should be the act of copying all media and source material to a redundant drive or set of drives of one type or another. If at all possible, keep those drives in a different location from where you are working for extra security. Depending on resources and logistics, you may even want to keep a RAID (redundant array of independent disks) system on-site—powerful, automated storage systems that are constantly backing up files while you work. They can range in price from under one hundred dollars to hundreds of thousands of dollars, depending on their size and degree of sophistication.

The other advantage that is available to you at modest cost is the fact that there are a wide range of consumer-based cloud storage services, such as Dropbox, and automated cloud-based archiving services, such as CrashPlan and Carbonite—that permit you to upload full or compressed individual files; copies of your entire NLE project and *EDL* (see p. 266); or, in some cases, a mirrored image of your entire hard drive in order to achieve security off-site in a relatively affordable manner. Other ideas include simply emailing yourself or a fellow student backup copies of the project at the end of each day.

Resolution As you import and organize material, the other thing you need to figure out is what resolution you want to edit your movie in, because resolution impacts the size of files and therefore how much work and memory your computer has to dedicate to rendering and dealing with them. This is where the terms **offline editing** and

Tip **ALWAYS AUTO-SAVE**

Remember to use the auto-save function on your NLE system to create an incremental backup on your hard drive at least every 10–15 minutes. That way, if you are faced with a power outage or nonrecoverable computer crash, you will not lose more than a few minutes of work.

Practice
BACKING IT UP

Figure out at least five different ways you can back up a basic video clip currently in your possession. The clip and its source or format do not matter for this exercise—it could be home video you took with your phone. The idea is to figure out ways to copy it and move it to multiple locations at the best quality possible as a security exercise. Use only the media, online services, cables, or other technology you have, without spending a dime or borrowing technology from others, and make sure the clip has zero chance of being lost for the foreseeable future. Write a couple of paragraphs explaining your choices, which of them would be useful in a basic nonlinear editing environment on a student project if the original source version of the clip were somehow eradicated, and why.

Stretching Resources

As a student, you need to keep things as affordable and logistically straightforward as possible while serving your project's needs as best you can. Here are a few important things for you to consider as you make workflow and technology choices:

- When building an NLE system, how do you balance your need to moderate cost with your need for the most flexible system available, so that it can help you get as much related work done as possible within the editorial suite? Because you can find cheap or even free basic editing software on the Internet, you need to evaluate whether that is a better move than forking out precious cash to purchase a more sophisticated system whose cost you might be able to amortize over several projects. Evaluate the trade-offs.

- Will your project be rendering-heavy? If so, have you accounted for that requirement with your hardware? Putting together an NLE system on your laptop is great, but if processing the images is continually slowing you down, you need to decide if you should find a way to get a more powerful computer, or even more than one computer. What will the cost be of working at a slower pace compared to purchasing or renting more equipment?

- Is all your equipment compatible? Do you have the right cables for the inputs and outputs on your computer? Have you done enough testing of systems and storage to have confidence that your infrastructure is in good shape for handling the project? Test and plan strategically to avoid spending valuable time dealing with unanticipated work-arounds at the 11th hour.

- Are there online resources and free technologies you can add to the mix to strengthen your hand? Are there tasks you can get help from classmates on—trading your services for theirs on specific aspects of the work?

- Do you have backup tools, stable power, and proper security? What is your backup plan if you lose power or suffer a hard-drive crash?

- Most important, is your plan viable for how you expect to finish? Will mastering your movie to your chosen form of media be served by your chosen workflow? You need to be confident in knowing that you can finish long before you start.

online editing enter the discussion. In essence, at this stage, you are deciding whether to edit material in its native resolution and file size—typically higher-quality files you imported into your NLE exactly at the size they were originally recorded and saved in, a process often referred to as using an "online workflow"—or whether to change files to a lower resolution, which more or less means a lower-quality format and a lower-quality look on your monitor, but which makes it easier for your system to work with image data during editing (offline editing). In that scenario, you will need to reassemble the movie using your original higher-resolution elements during the finishing stage, which is often called the "online edit," or the **conforming process**. (See Tech Talk, p. 267, for more on the distinction between offline and online editing generally, and p. 269 for a deeper look at a typical offline/online workflow, and also the difference between using an "online workflow" throughout and performing an "online edit" after the offline process. See also Producer Smarts: Stretching Resources, above.)

Organize the Assembly

Typically with most NLE systems, you first initiate a new project in the software, which sets up the job so that you can create and organize a timeline; access your material from a central location; create settings and shortcuts for keystrokes; designate where all edited material shall reside, and in what formats; and so on. The entire project then lives on your hard drive as a single *project file*, which is a fairly small file because it is essentially just a playlist that maps out the project and points to the actual, higher-resolution media files elsewhere on your hard drive. Those more substantial files that you will store on your hard drive include *source files*, which are original picture and audio files that you have imported from your camera and audio-recording system. Generally, source files live within your storage system, and your NLE "links" to them when it is time to go back and use source elements to finalize your movie (see p. 267 on online editing).

The other large files your NLE generates to live on your hard drive are *render files*, which are copies of source files after they have been modified or tweaked and then processed by your computer to reflect all changes to the original file. Remember that you may also be importing *associated media files*—separate media beyond your original camera footage, such as graphics, still photos, and music. As you start a project, most systems will guide you through a process of deciding where you want to keep all that media material on your hard drive. This spot is frequently called a **scratch disk**, although different platforms may use slightly different terminology. Often, you will be able to specify the format, frame rate, codec, and other characteristics of files either manually or using automated presets for commonplace digital camera formats.

In most systems, your organizational structure for tracking everything is designed and visible through your NLE system's *browser*, which is essentially a window or panel where you can store, track, move, and organize files, folders, bins, and other elements for your project. But most important, you want to properly name your files and set up **bins**—also called windows or simply folders—that contain all your chosen elements, takes, shots, and options for each scene in the movie in a fashion organized to your specifications for maximum efficiency in finding and using those shots as you launch into the editing process.

There are dozens of ways to organize files and bins depending on your preferences, your resources, and which NLE software you are using. Many leading editors have particularly arcane ways of doing this, whereas others keep it exceedingly simple. Do some experimentation with sample clips to figure out what methodology works best for you. (To see a video about how this works in practical film conditions, see the LaunchPad for *Filmmaking in Action*.)

Files and Bins

As you ingest image files and set about deciding where to put them so that you can use them efficiently, it's important to be particularly strategic about file-naming conventions. The basic rules of thumb in this regard reflect common sense. You want to describe a file in a way that is unique and detailed but also brief, logical, and specific with respect to what it contains. You should be able to get a very good idea what each file contains merely by reading the file name. Beyond that, here are a few simple guidelines:

▮ The names should be easy to spot when scrolling through a directory.

▮ You may want to use your script as the foundation of file names, following it scene by scene. You may even want to include scene and take numbers, or the

A bin full of sequences with a text display.

A bin of video clips with a text display.

Name	Duration	Drive	IN-OUT	Mark IN	Mark OUT	Creation D
Mandy Cam v4	2:57:00					5/22/14
Mandy Cam v3	2:57:00		2:57:00	1:00:00:00	1:02:57:00	5/22/14
Billy v4	4:39:19		4:39:19	1:00:00:00	1:04:39:19	5/22/14
Paul v3	4:05:21		4:05:21	1:00:00:00	1:04:05:21	5/22/14
Billy v1	4:47:02					5/22/14
Billy v2	4:12:22		4:12:22	1:00:00:00	1:04:12:22	5/22/14
Billy v3	4:44:20		4:44:20	1:00:00:00	1:04:44:20	5/22/14
Mandy Cam v1	3:05:12		3:05:12	1:00:00:00	1:03:05:12	5/22/14
Mandy Cam v2	2:59:07		2:59:07	1:00:00:00	1:02:59:07	5/22/14
Mandy Light v1	3:11:00					5/22/14
Paul v1	4:08:04		4:08:04	1:00:00:00	1:04:08:04	5/22/14

Interviews 6

Name	Duration	Drive	IN-OUT	Mark IN
00000.new.01	26:24:12	RAID		
00003.new.01	11:36:00	RAID		15:48:46:02
00005.new.01	27:62	RAID		
00000	26:24:12	RAID		
00003	11:36:00	RAID		

Audio Mixer

Stereo / Stereo / Bypass / Grp 1 / Clip / MID / EQ31-Bnd

A1 A2 A3 A4 Master

Interviews 5

5-2_00016.new.01 5-2_00017.new.01 5-2_00018.new.01 5-2_00019.new.01

5-2_00020.new.01 5-2_00021.new.01 5-2_00022.new.01 5-2_00023.new.01

A bin full of video clips with a thumbnail display.

Audio mixing panel.

The bin menu of an NLE program will include these features.

order of shooting, in the file name. If you shoot scene one, take one, think about including those identifiers in the name.

∎ Never include the word *final* in a file name—changes are often inevitable until the last minute. Therefore, use version numbers or that day's date, knowing that the largest number or most recent date is always your most recent version of a file.

∎ Add certain key words or short descriptors for specificity when it makes sense to do so.

∎ Update the date in the file name to indicate how recently it was changed.

∎ If multiple people are working on the material, add your initials at the end of the file name to indicate who worked on it last.

Finally, if your file format and software include the ability to input **metadata**—information about the file itself—into pre-generated information fields, don't fail to take advantage of that opportunity. Among the metadata notations that are important is the file's original camera file name. Because computer files can become corrupted, you might need to reimport a particular file from your original camera tape or recording media. In such cases, you will need to know what it was named originally—usually some sequence of numbers or letters that are automatically generated whenever a digital camera creates a new recording file.

Meanwhile, you also need to move files to bins within your NLE's browser environment to serve the goal of maximum efficiency. Generally, there are two leading schools of thought about organizing bins: you can organize material based on either the order in which it was shot or the order in which you intend to cut it. Many leading Hollywood editors organize content in cutting order—the order in which they envision they will be proceeding with each scene, in script order usually but not always—starting with wide footage and working their way to close-ups of each character for each take of each scene. Each take associated with the first shot in the scene will be located at the top of the bin, all the way through to the final shot in the sequence. The advantage of this for veteran editors is that it makes it easier for them to compare performances between takes as they sort through material during the cutting process. They can find, insert, and evaluate the first character reciting the first line from a wide angle, then do the same with a midrange shot and likewise with a close-up. This methodology allows them to view all takes in a row and thus more efficiently figure out which ones they prefer, without having to waste a lot of time searching for alternate takes to compare.

The downside of this approach is that it can be extremely time-consuming to set up bins in this way, so you will need to evaluate the potential time savings you can get against the labor-intensive work you will need to go through up front. Thus, on typical student projects, you may be better off organizing material in the order you shot it, typically by scene and take number. Timelines of many NLE systems offer the option to view graphic representations of clips, which will give you a fairly quick idea through ordered thumbnail photos about the type of coverage each clip entails—wide shot, close-up, and so on.

There are, of course, more detailed breakdowns you can do with your bins—and with specific folders within your bins—depending on how much time you have to organize them before you segue into the cutting process. As you make edits, you may want to create new bins to keep track of your first edit, second edit, and so on down the line. You might even have bins for each scene with original dailies, bins for those same scenes with each of your organized edits, and bins with related music and effects for those particular scenes.

Timelines

Most NLE systems use a window-based methodology for graphically displaying material you are working on in various ways, such as the aforementioned browser window. Another typical window, often called the **viewer** or **source monitor**, is used for marking clips while the editor is culling through material, and another, called the **record monitor** or **program monitor**, is used for basic viewing of edited sequences.

In virtually all NLE systems, the most important display is the timeline. This serves as the primary interface the editor will use to lay out chronological thumbnail representations of all tracks for all sequences from the movie in a linear, horizontal fashion across the monitor or monitors. You can zoom in on individual shots or scenes, and you can also zoom out to view how each sequence fits into the larger movie. The timeline essentially represents your movie exactly as you've cut it thus far, even though clips on the timeline are really just surrogates for the actual media files, which live within your storage system. These clips link directly to the portions of your original files that you will need when you finish the movie later on, as we discuss shortly.

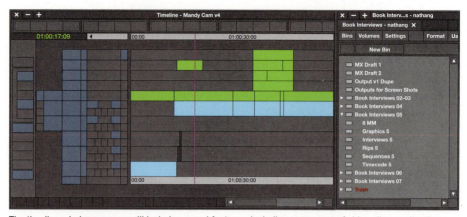

The timeline window you use will include several features, including sequences of video clips, audio clips below, and a window where you can see the bins for your entire project.

Keep in mind that most NLEs permit multiple video and audio tracks or layers, depending on your creative and technical needs. You can layer sound above picture, sound above titles, titles above picture, or picture on top of picture. If, for example, you are using back-and-forth cutaways from another event happening in the narrative, you might want to place the cutaways on a different video track on the timeline so that you can experiment with them before you need to bother with an *overwrite edit* (see the next page) in that particular spot.[4] You can make the cutaways longer or shorter to decide what you prefer without taking original shots off the timeline, and when you are happy, you can move the shot to the primary video track.

Also, not all NLE systems use a two-window layout, or all of the aforementioned nomenclature for the various tasks we have described. Some systems use just a single window, from which you can toggle back-and-forth between source elements and edited clips. In fact, there are numerous differences in terminology, layout, and other aspects among various systems. However, virtually all of them take the basic approach of offering some kind of visual representation via the timeline so that you can drag-and-drop clips, cut-and-paste them, or insert cut points; see what you like or don't like; and then save or delete what you just did. In other words, the timeline is the place where you will be able to keep visual control of your creative work in an organized fashion.

Once you have familiarized yourself with your NLE and set up your project, you will start marking clips and adding them to your timeline. Here are some basic pointers for interacting with your timeline:

- Search bins to find clips you want to start editing with, and bring those clips to the source monitor. You can drag the clips, use menus or keyboard commands, and so on—there are literally dozens of options for how to move material around depending on your system and preferences.

- The original raw clip is generally called the *master clip*. If you do not want to use the entire master clip, mark an **inpoint** and **outpoint** on the source monitor where you want the clip to start and finish. All NLE systems have different shortcuts you can use to program your keyboard for marking clips and performing other common editorial tasks easily. In fact, some NLEs, such as professional Avid systems, come with their own keyboards, which include special shortcut templates color-coded directly onto the keyboard.

■ Next, similarly mark an inpoint on your timeline—the place where you want the edited clip to go in your evolving cut. In many NLE systems, the clip within your timeline that you are currently dealing with is called the *destination track* or *target track*. NLEs often use tiny graphic shapes as *markers*, indicating places on the destination track where clips are to be inserted. As described earlier, you can drag clips from the source monitor to the program monitor in those spots, or otherwise command the NLE to copy the clips in question and paste them where you have indicated they belong on the timeline.

■ Typically, you will also be adding audio tracks you have previously organized (see Chapter 10). With many NLE systems, if you tell it that a particular audio clip belongs with a particular video clip, the system will automatically sync them together. Since your timeline typically has one or more video and audio tracks, which are visibly stacked on top of one another, you can efficiently apply particular audio to particular video clips. The system will likely give you options on how to visually display the audio track—often, as waveform images of the sound signal.

■ Depending on your NLE and workflow, you may need to instruct the system on what format to convert one clip or sequence to in order for the now-edited sequence to be the same frame size and frame rate throughout. Many NLE systems will do this automatically if you don't indicate otherwise by adjusting the sequence to the same format as the first clip you added to the timeline.

Technical Assembly Techniques

As you march forward, adding and subtracting elements to and from your timeline, you must keep in mind that the movement of clips will typically impact the clips around them. If you already have a series of shots linked together and want to insert a new clip in the middle of them, most NLE systems offer a couple of ways you can do it so that you impact the overall sequence only as you intend. You can add a shot with an insert, or a **splice edit**—a procedure by which all preexisting clips automatically move to the right of the new shot. Some NLEs also call this a **ripple edit** because it "ripples" all clips after the edit further down the timeline. In this scenario, the overall length of the sequence grows by the length of the newly added clip.

A different approach involves an **overwrite**, or **overlay edit**, which adds no additional time to the sequence. With this method, the NLE allows you to insert a new clip and simply overwrites all material already on the timeline from where the new clip starts to where it ends. With an overwrite, the length stays the same and there is no rippling—earlier clips remain where they were. Overwrites are useful not only because length is not impacted but also because the synchronized relationship between picture and audio of the existing portion of the sequence is not changed. However, you need to be skilled at doing it, or you can overwrite material you do not wish to remove from the sequence.

You can also remove shots from the timeline, thus linking two shots that were previously connected to the deleted shot. This is simply called a *delete* or an *extract edit*. Modern NLEs have functions that make it easy to delete clips and then restore them with little difficulty. Other key technical editing maneuvers are described in this section. Keep in mind that the most crucial of editing techniques—executing **transitions** (techniques for moving from one shot to the next)—lies at the creative heart of editing, and we will leave that subject for examination in Chapter 12. But for now, here are the important technical processes you need to learn about:

Tip MATCH FRAME COMMAND

Many NLEs have menus that allow you to view available *handles*, but others require you to figure this out using what is sometimes called the *match frame* command. To execute, place your cursor on the first frame of a clip, hit the Match Frame button, and then the original master clip appears so you can compare it to the piece you are using.

Tip MATCH PICTURE AND AUDIO CUTS

As you manually trim or add clips, remember to cut every track on your timeline by the same amount—both picture and audio. If you add or delete a video clip on a video track but not on the corresponding audio track, you will fall out of sync. Many NLE systems automate this process, but you need to make sure you "unlock" tracks to enable that capability on most NLEs; carefully read the manual so you know how to unlock clips and automate this process.

■ **Lift Edit:** A **lift edit** happens when you remove a shot but maintain the space it took up on your timeline with black frames, often called *filler* or *slugs* or *gaps*. This serves the purpose of holding space for a future shot while allowing other clips to remain in their original positions.

■ **Trimming Clips: Trimming** is the name for the process used to change the length of clips on the timeline. It is essentially used for making modest final tweaks as necessary. Various NLEs offer many ways to trim shots, including a special trim function that automates much of this process once you make certain decisions about the nature of the trim. (See Action Steps: Art of the Trim, p. 265.)

■ **Three-Point Editing:** This is the term for a process used to efficiently insert clips into your destination track. The name **three-point editing** derives from the fact that although there are four edit points involved, you only need to manually set three of them. The first two set the inpoint and outpoint on the source clip itself, and the third is the location on the timeline where you want to insert the clip. There is also an end point on the timeline where the clip will conclude—a fourth point—but that point is automatically calculated by the NLE.

■ **Snapping:** This term refers to one of the popular ways for moving existing clips on your timeline to different locations. **Snapping** is an NLE software tool whereby clips completely "snap" onto whatever other clip you place them next to in such a way that there is no minimal gap or space between the two clips you are linking together. The snapping function is also useful for marking clips or portions of clips for removal. You can snap your cursor to where the clip begins to easily place an inpoint, and then snap it to the end of the clip to place an outpoint.

■ **Stacking:** When you want to layer video images, you "stack" two or more clips on different video tracks within the timeline, a process called **stacking**. A simple example would be the placement of titles (see p. 268) over images. The titles would be placed in the top video track, and the picture on the bottom track. Many NLEs include a basic visual effects capability of allowing you to adjust clarity of the video image, so that the titles or other video track are visible when stacked.

■ **Sync Point Editing:** A method for overwriting a clip, **sync point editing** lines up particular elements within multiple video clips or between video and audio clips automatically. You might have a cheering fan at a ball game clapping in the sequence and want to better synchronize that shot with the sound of the crack of a bat. Some systems come with a tool to mark such spots and automatically bring those elements together.

■ **Replacement Edit:** In other cases, you might like the length and positioning of your clip but not the image itself. In those situations, you would mark spots where you want to replace the image, click on a replacement clip, and have it seamlessly take the place of the original image. This is called a **replacement edit**.

■ **Fit-to-Fill Editing: Fit-to-fill editing** is a technique you use if a clip is too short for the space you have available. In that scenario, you can mark inpoints and outpoints for the space, then instruct the NLE to minutely speed up or slow down the clip to fill the differential.

ACTION STEPS

Art of the Trim

A major part of editing video involves the need to cut or trim clips, or to extend their length for various reasons. Typically, with most NLE systems, a basic trim function will show you the last frame of one shot (the **tail**) and the first frame of another shot (the **head**) in two windows and allow you to shorten one or both. But there are many different methods for trimming clips, which is one reason why some NLEs offer functionality for storing for later access extra frames from either the head or the tail of a clip that you have already removed from the timeline. This is useful in case you need to restore the frame later for the purpose of executing a *dissolve* (see Chapter 12, p. 292), which might require extra frames to execute. Those stored extra frames are called **handles**, and although they are no longer visible on the timeline, the NLE can make them easily available to you. For instance, if you are executing a dissolve, you will need handles of half the number of frames of the entire dissolve, so if the dissolve is 20 frames, you will need a 10-frame handle. Many NLEs offer ways to make handles readily available for restoration as needed.

In addition, there are other handy methods for achieving your creative trimming goals in your NLE's toolbox. Here are some of the basic *kinds* of trims you need to familiarize yourself with:

1 **Roll Trims:** In this case, you add frames to the end of one shot and delete the same number of frames from the start of the next shot, which keeps the sequence length unchanged overall.

2 **Ripple Trims:** As discussed earlier, ripple edits can be used to push following clips down the timeline, lengthening the overall sequence. However, if you need to also shorten the sequence, you could shorten the end of the first clip to prevent the overall length from increasing. In that case, you could insert a clip between two clips, pushing the clip on the right down the timeline as before, but then you might also shorten the tail end of the clip you inserted, thus pulling the last shot to the left, tightening the clip up again.

3 **Slide Trims:** This is a technique for taking a clip and sliding it over adjoining clips to change its position on the timeline—the clip is not altered, but its location is changed.

4 **Slip Trims:** These involve using a different piece of a clip without changing length or position on the timeline. Slip trims are often used for subtle adjustments within a shot.

Ⓟractice

SETTING UP BINS

Design and type out a sample bin hierarchy for a single scene from a feature film you are well acquainted with. By "hierarchy," we mean list the bins from most important to least in the sense of your preferred order for editing a chosen sequence if you were the editor, and under each one, list any subfolders you would include that break elements of the scene down further. Make sure the bin names are clear and easy to follow. Remember to include bins for audio, effects, voiceover, or any other elements that would have their own track on a timeline. Add a paragraph explaining your breakdown and why you think it would be efficient in helping you find material from that particular sequence.

Finishing

After you put a cut together, you will screen the material, get input, and recut it until you arrive at a final product you are satisfied with. But even then, you are not quite finished, because your "final product" isn't really final per se if you edited in

How Do I . . .
Keep Track of Footage?

Go to LaunchPad and find out: **macmillanhighered.com/filmmaking**

NAME:	**Mindy Elliott**
TITLE:	Assistant editor
SELECTED CREDITS:	*Nebraska* (2013); *Girls* (4 episodes, 2012); *The Descendants* (2011); *Ugly Betty* (5 episodes, 2009–10)

Editorial is one of the most important departments on a movie project; as veteran assistant editor Mindy Elliott points out, it's the department that serves as the "caretaker of everybody else's work." Management of editorial workflow, then, is of the utmost importance. Elliott describes this process in a video interview available only on the Launch-Pad for *Filmmaking in Action*.

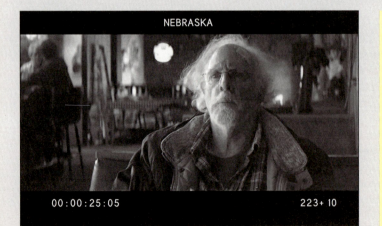

Discover:

▪ What the editorial workflow entails and why it's necessary

▪ How the workflow on *Nebraska* enhanced the movie's production

▪ Why organization can allow for more experimentation

Visit the LaunchPad for *Filmmaking in Action* to learn more—and to explore how you might use this advice.

tech TALK

Native Editing

On page 269 we discuss the basic issues involved in using an offline/online editing workflow process—essentially a two-pronged approach in which you create a detailed map for the final version of your work, and then separately build the final version by following that digital map exactly, using your final, high-resolution elements. However, within the sometimes-confusing nomenclature of the postproduction world, the term *online* can also relate to adopting a single-pronged process, often called using "an online workflow," with no offline involved.

This is often also referred to as *native editing*, because you conduct the process using original elements in their native high-resolution format as captured by your camera, or something very close to it. If your NLE might be slowed while working at full native-camera resolution, you can put files through a fairly straightforward software-based transcoding process to convert them to still high-quality but more efficient formats that are commonly used with modern NLE systems. These include Avid's DNxHD format, Apple ProRes, and GoPro CineForm. Many NLEs allow you to transcode within the system, or in some cases, you can transcode files as you import them into your NLE using one of several transcoding software programs. If you are using an Avid or a Final Cut Pro system, in many cases it will behoove you to convert the entire movie to ProRes or DNxHD before you start cut-

ting, and edit and finish the entire movie in that format. This will often give you a high-quality image at a low data rate and stand up nicely as a finishing format.

The option of using a native online workflow therefore presents a question: is a student filmmaker with limited resources better off adopting this approach or using a traditional offline/online methodology, as many professional productions still do today?

The answer frequently is that it will make the most sense for students to use an online workflow, since they will likely not have the resources to bring their movie to a mastering facility later. Many modern NLE systems have made this feasible for students because they are usually able to handle high-definition, 4K resolution, native files common to many modern digital camera systems; to input or output files in the aforementioned NLE system-friendly formats; and to automate much of the assembly process.

However, if you captured imagery at a much higher resolution, if you have lots of complex visual effects and other ancillary elements, or if you are lucky enough to have theatrical exhibition possibilities lurking in the wings, then an online workflow approach may not be best. In that case, you will likely need to offline first and then figure out a specific online methodology that best serves your exhibition plans for the material.

offline mode—a working method we will examine shortly. If that is the case, you have essentially created via your timeline a final portrait of all your editing decisions, not the final movie itself. In essence, what you now possess is the **edit decision list (EDL)**—a detailed list of all your editing decisions, usually generated automatically by your NLE system—which you will use as an exact road map for building the final version of your movie during the online process.

But even if you skipped the offline method and used an online workflow (see Tech Talk: Native Editing, p. 267) all the way through the editing phase, as opposed to an offline/online methodology, you may still not be totally done in that you may need to add or tweak finished visual effects, sounds, music, color, credits, or other finishing touches. Keep in mind that you will be dealing with the creation of some of these elements, such as titles and color correction, at some point during your editing process, as we discuss later in this chapter (see Action

Steps: Adding Titles and Graphics, below, and p. 270 for more on color correction). Others, such as sound and visual effects, entail separate creative processes, as we discuss in Chapters 10 and 13, respectively. But all of these elements need to eventually be brought together and incorporated into your final version so that, after everything is finished, you can finally output the whole thing to your mastering media (see p. 272). As students, you will likely be building a basic mastered version of the movie on tape, Blu-ray, or DVD, or existing as a so-called **digital master**—a file living on a hard drive.

At the professional level, all of these finishing processes are typically done by separate artists and facilities. But at the student level, you will need to execute them yourself before you can consider yourself finished with the editing phase. Although it is true that these processes are not considered "creative" editing chores in the same way as are the techniques we discuss in Chapter 12, they do involve improving the overall quality of your product—color, resolution, depth, clarity, and so on. The basic processes you need to understand include any or all of the points discussed in the following sections.

ACTION STEPS

Adding Titles and Graphics

Text is a radically unsung but hugely important component in movie making at all levels, for titles, subtitles, credits, and more. The methods for creating text and placing it over, under, or next to your images are almost unlimited if you have the right tools, resources, and experience. Here are some important tips about the most fundamental concepts to keep in mind as they relate to text:

1. **Use Basic Tools.** For much of your student work, most modern NLE systems have basic graphics and text-generator tools that will be sufficient, and they can usually even help you animate graphics or create 3D text. NLEs will often have a title tool that allows you to easily choose fonts, size, color, position, character leading, point size, and justification controls.

2. **Get Web Help.** Many editors also routinely find and download for free or low cost even more font options and graphics tools online. Such options are readily available across the web, but make sure such downloaded fonts are compatible with your particular NLE system.

3. **Don't Get Fancy.** If you get carried away with titles or credit sequences, or make them too bright, you may regret it. Although they give awards for stylized graphics and credits in the professional world, you need to understand that adding anything on top of video imagery means you will have more layers to combine—which translates to more work and more technical complications. Thick fonts usually work better than scripted or heavily stylized fonts.

4. **Be Careful Beneath Text.** Frequently, text placed over imagery needs some kind of graphic treatment or drop shadow inserted underneath it to prevent an overblending of text with the background image. Editors sometimes blur backgrounds underneath titles for this reason.

5. **Stay Consistent.** It is safest to build graphics in the same aspect ratio and resolution as the rest of your project. For sophisticated text or graphics, artists sometimes use software programs beyond their NLE that you may al-

ready be familiar with, like Adobe's Photoshop—tools that can create graphics for you to import into your NLE. However, you need to be careful; older NLEs may not be able to handle the color space and pixel aspect ratio of files created by some of those programs. Check your manual to learn what formats are compatible with your system.

Offline/Online Workflow

Now that we've discussed using an entirely native online workflow, let's examine the basics behind the other approach—using an offline/online methodology. The terms *offline* and *online* predate the digital editing revolution and were originally applied when editing was done tape to tape. But the terms continue to have relevance today. Now, they essentially refer to cutting a movie at a lower resolution (offline) with lower-quality versions of original files before reassembling them in better-quality native resolution (online). With this methodology, the offline represents a key step toward assembling the final version, whereas the online represents the actual construction of that final version. The online would typically include performing the final assembly of the movie and adding color correction, effects, and any other final touches until you have generated a final master.

When you cut offline, you need to decide what lower-resolution file format to convert your files to in order to enable better performance from your NLE. You will also need to learn how to use the EDL generated by your NLE as a precise guide for finalizing the edit during the online process (see p. 265).

In terms of file formats, since files with lower data rates take up less storage on your computer, you will want to convert files to a format that is of low enough quality so as not to strain your computer's speed and efficiency, and yet of good enough quality to be able to view your imagery so that you can make good editing decisions. Therefore, if you are working offline, you want to have your NLE copy original files to more compressed versions and edit using those.

Once you start offlining, your NLE will build the all-important EDL. The modern EDL is essentially a detailed, software-generated report that provides data or details on each important aspect of the editing process specific to the particular format used by the manufacturer of your NLE system. It essentially works like a map, guiding your system through the exact editing route you took when you cut the material originally. Although EDLs from different systems can vary, most will typically include an *edit number* to help you find original edits during the online process; *source reel* numbers, which tell you which original tape or file you will be able to find the higher-quality source material in; an *edit mode* number, which simply indicates if the edit was done on picture, audio, or both, and if audio, which audio channel; an *editor transition type number*, which refers to the type of cut it is (which you will learn about in Chapter 12); a *duration number*, representing the length of the transition in frames; and *playback* and *record in-and-out numbers*, which can also be called *source in-and-out numbers*. The playback number indicates beginning and

An edit decision list (EDL) is automatically generated by the NLE system. It displays the names of audio and video files shown in the timeline.

end points of the source material, and the record in-and-out number represents the timecode location on the master tape where you will be placing a particular edit.

On modern NLEs, after an offline edit, your online edit can often be largely a matter of linking low-resolution sequences in your timeline to the original, full-resolution files in your system. You will instruct the NLE to first unlink clips in the sequence from the proxy files you have been using, and then you will instruct the system to relink to the high-resolution source files. If you have organized things correctly and your source clips and proxy clips have identical timecodes, this process can be automatic—called an *auto-assemble*. A word of caution, however, about the EDL: generating an EDL depends on your original material having timecode. If you shot with a fairly modern digital camera system and set the system correctly, you should have accurate timecode readily available. However, if your timecode, reel names, or metadata is flawed for some reason, it is possible your EDL will be flawed, and thus your conforming process will grow more complicated. Therefore, make sure your camera will produce accurate timecode and metadata on your tape or image files during prep.

Color Correction

Whichever workflow you choose for editing and then conforming your movie, you will have to transition into a color-correction phase. The power of today's digital postproduction tools, including affordable NLE systems like the one you might be using, gives filmmakers increased ability to tweak colors generally, and the characteristics of color more specifically. Color manipulation is an important creative tool for filmmakers because it can not only correct obvious flaws or make basic changes (changing the color of a vehicle or a building) but also help you change minute details, enhance or tweak skin tones, change brightness and tone, maintain better consistency in look between shots, and alter the emotional impact of your story.

Broadly, the goal of color correction is to make your imagery look consistent throughout, so that the viewer is not distracted by sharp changes or unevenness in color tone. The caveat to that, of course, is that changes can be made with strategic creative reasons in mind. A few other basic tips regarding your color-correction goals include the following points:

1. Flesh tones on actors are crucial—they impact how viewers perceive, accept, and relate to actors. Generally speaking, warmer flesh tones are preferred, but you need to be careful with light-skinned actors—if you go too warm, their skin can look red or flushed. Cooler flesh tones are typically preferred when you want to make someone look darker or more sinister. Many *vectorscopes*—circular charts that give you visual color displays to examine color hue and other characteristics (see Chapter 8, p. 183)—within modern NLEs feature what is called the **flesh line**, which is a tool that helps you set proper skin-tone color more accurately.

2. You can increase saturation in images to make color more radiant or bold, or desaturate images for more muted colors. Indeed, many leading filmmakers play extensively with saturation and desaturation to create different looks—for example, extensive desaturation is used to make images look almost monochrome, akin to black and white in some extreme cases.

3. Keep in mind the concept of primary and secondary color correction. **Primary color correction** represents the work done to impact color throughout the entire frame, whereas **secondary color correction** refers to adjustments made to specific colors in specific parts of the image.

Color correction to achieve these kinds of things, and much more, can be a complex endeavor, and many of its nuances take years of practice to perfect. In fact, in the professional world, the final color-correction process that has grown widely ubiquitous is known as the **digital intermediate** (**DI**). Typically, the DI is done at a separate facility or with high-end color-grading software that literally allows artists to dig deep into individual frames of a movie to subtly adjust nuances of color according to the filmmaker's specifications. An artist called a **colorist** usually handles this work, and he or she works closely with the director and cinematographer to address color adjustments globally on the entire project. The power of the DI suite is such that prominent cinematographers often demand contractual terms that allow them to attend and participate in the DI session, because the careful lighting work that they do on-set can be severely impacted with this tool. Therefore, you need to be particularly careful and strategic in how you use color correction. Ideally, you are looking to extend, finish, improve, finalize, or tweak your cinematography, while striving hard not to fundamentally change it. You are unlikely to be able to afford a full DI session anyway, but your NLE is likely to possess fairly robust color-correction tools, affording you the opportunity to work with color during the finishing process in ways students of earlier eras never could; thus, you should strive to take advantage of them as far as your time and resources will permit.

Your most important color-correction tool will be your monitor, because results of your color work will only be obvious if you can properly see them. Obviously, use the best monitor for your entire editing process that you have available. Beyond that, your NLE software will include various video-signal monitoring tools, including most likely a *waveform monitor*, which can help you measure luminance (brightness) levels; a *vectorscope*; and possibly an *RGB parade monitor*, which will display red, green, and blue levels for you.

Color-correction tools can change a film's look, as with this frame from *The Grand Budapest Hotel* (2014).

On many systems, you can also set certain color controls to suit you, from fairly simple to complex. Like other aspects of nonlinear editing, color-control adjustments can be nondestructive—meaning you can try something creatively, and if you don't like the result, you can undo it with no harm done. Depending on your NLE system, you are likely to find controls to allow manipulation of the following color characteristics:

▪ *Color-balance* controls for efficiently adjusting predefined color-tone ranges in imagery

▪ *Curves*, a control to help you adjust particular tonal ranges on any single color channel you choose, "bending" color in that specific area without impacting color above or below it

▪ *Hue* controls for adjusting other specific attributes and the range of those attributes for a particular color

- *Levels*, a control for adjusting luminance

- *Saturation* controls for adjusting how intense particular colors are—sharper or more faded

- *Lift*, *gamma*, and *gain* controls for adjusting black levels (lift); adjusting mid-tones, which represent the subtle color range between shadows and highlights (gamma); and white-level highlights (gain). (Many NLEs use these terms, but nomenclature may vary on certain systems.)

- *Mask* controls for creating vignettes and other types of image alterations done with color shifts in specific viewing areas

- *Windows*, a control for defining a specific area within a larger image for color adjustments

Outputting a Master File

When you are done finalizing your movie, you must then export it as a master file to whatever media you have chosen. Typically, modern NLEs can automatically export files in different formats fairly simply, but you need to think about how you will be exhibiting your movie to guide your decision. Keep in mind there are all sorts of files and formats, and image quality will vary depending on which format you use. That choice, in turn, depends on your resources and what your end goal is for showing the movie. But generally, it's always a good idea to master your project at the highest possible resolution. You never know what potential exhibition opportunities will come your way, and you want a quality level that will allow you to exhibit in any possible environment or platform.

Here are some issues to consider about what kind of mastering file to create, how to create it, and what kind of media you may want to export your movie to. This can evolve into particularly technical areas at the high end of the industry, and you will need to learn more about those areas as you move forward in your filmmaking education, but for now, you will benefit from a general awareness of the following issues:

- If you offlined the movie, upgrade to original-resolution material before you output the file.

- If you used an online workflow but with a modestly compressed codec for increased efficiency, output your master with as little compression as possible. The visible quality change in doing this will be minimal, but if you think your project might get remastered for different types of exhibition in the future and thus experience future compression cycles, improving the original file makes it more robust during those cycles.

- Consider outputting a full-resolution master file with no compression at all. The difficulty of doing this is that the file size will be very large and you will need lots of storage media to hold and work with the material. On the other hand, if no compression is involved, anyone can play and view the movie on just about any kind of system in the future.

- Although the industry has largely moved to file-based workflows, videotape remains an option for distribution purposes. If you need to output to tape, be aware that depending on the videotape recorder (VTR) you are using and how it connects to and interacts with your NLE, there could be some minor reediting involved, although not to the extent of traditional tape-to-tape editing. Gener-

ally, it will usually be fairly easy to connect the VTR to your NLE and simply copy the movie from the NLE to digital videotape. The easiest way to do this is to connect the NLE and VTR, play back your movie from your NLE timeline, and *crash-record* to the tape deck, which is not controlled by your NLE. You simply hit record, play your sequence, and the movie is copied to tape. It is usually preferred, however, to have the NLE actually control the tape deck. In that scenario, the NLE will have a command function called *print to tape*, *export to tape*, or some variation thereof. In that case, you need to use a VTR that supports timecode, and you will have greater control during the recording process.

▌ However, if you want to create a high-quality master on videotape for possible broadcast or theatrical exhibition, you will need to rent a digital tape deck for the purpose of making sure elements are positioned correctly by timecode and that any minor flaws can be rectified. Often, you will want to use the tape deck to create an *assemble-edit* recording for this kind of work. Assemble-edit recording involves recording all video, audio, and timecode to videotape neatly. If your entire movie is in good shape, this is a simple process if you have access to a VTR. If you start and stop recording, however, there will be gaps or breaks on the tape between shots. In that case, you need to remember to roll back to the end of the previous shot every time you resume recording.

▌ If you are creating a tape master for possible broadcast, it is a good idea to include color bars and tone, or a slate, at the beginning of the tape. Bars and tone allow a broadcaster to make sure that they show the material matching the colors and audio levels you set. If you do add such elements, you should create them and, using the NLE, connect them to the start of your program, so that they are part of the finished product. (You can exclude them from your master if it turns out they are not needed by selecting the movie after that leader material and exporting without it.)

▌ If you want to master your movie to physical media, you will frequently choose DVD or Blu-ray disc. With a separate DVD disc recorder or a disc burner on your NLE computer, you can fairly simply, in most cases, compress and burn a copy of your master digital file onto a recordable disc. Essentially, that is a DVD duplication process, and nothing more. Keep in mind that if you want to author the DVD—meaning you want to add menus, extras, chapter lists, and so on—then you will need to use an authoring software application, of which there are dozens available for all computer platforms.

⊞ Editor's Emergency Kit

- Uninterruptible power supply (UPS) system
- Stable and secure high-speed Internet connection
- Off-board hard drive
- DVD burner
- Membership in online user groups, particularly for Avid, Final Cut Pro, and Adobe editing-related tools
- Registration for full technical support from the manufacturer of your NLE system
- Readily accessible manual for your NLE system, monitors, and any other important hardware

CHAPTER 11 ESSENTIALS

- Choosing, configuring, and learning how to use a nonlinear editing system that can work for your resources and creative needs will be your first editing task. You want to use the fastest available computer, highest-quality monitor, and the best editing software technology you can access. You must learn how best to use the NLE's timeline editing interface so that you can use a variety of technical editing techniques to link sequences together on your timeline to build a detailed map of your finished product.

- Your next technical challenge involves the various aspects of organizing a workflow methodology—figuring out how to digitize, store, back up, work with, finalize, and export image data files throughout the editing process, including deciding what kinds of file formats and resolution you will be doing all this work in. As part of this challenge, you must also design organizational methods for how to find and use material during the editing process, particularly when it comes to naming files and organizing them into folders or bins in a way that will maximize efficiency and creativity.

- You will need to engage in some kind of finishing process using your NLE to finalize your movie, bringing your final cut together with the precise color, effects, titles, and sound elements you have created. Once that is done, you need to output the final movie to your chosen mastering media, creating a master from which all future copies of your movie will be generated.

KEY TERMS

Bins
Color depth
Colorist
Conforming process
Digital intermediate (DI)
Digital master
Directionality
Edit decision list (EDL)
Fit-to-fill editing
Flesh line
Handles
Head
Inpoint

Lift edit
Logging
Metadata
Nonlinear editing system (NLE)
Offline editing
Online editing
Outpoint
Overwrite (overlay edit)
Primary color correction
Record monitor (program monitor)
Replacement edit
Scratch disk

Secondary color correction
Snapping
Splice edit (ripple edit)
Stacking
Sync point editing
Tail
Three-point editing
Timeline
Transitions
Trimming
Viewer (source monitor)
Workflow

"**If you put yourself into a scene, you can contribute to what the director is giving you. Be a collaborator, not just a pair of hands.**"

– **Michael Kahn**, editor of more than 50 films, including *Close Encounters of the Third Kind* (1977), *Saving Private Ryan* (1998), and *Lincoln* (2012)

Telling the Story through Editing

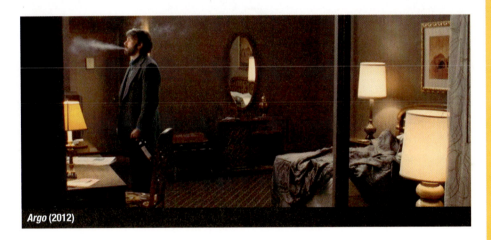

Argo (2012)

KEY CONCEPTS

▌As an editor, you are first and foremost a storyteller, responsible during the various phases of editing for weaving the disparate visual and sound elements created from the beginning of production into a cohesive, focused whole that viewers can both follow and connect to emotionally.

▌A good editor pays particular attention to tempo and pace, and how best to transition out of one scene and into another. A wide variety of time-tested techniques exist for making these types of transitions.

▌Good editors adhere to basic principles for cutting (180-degree rule, eyeline match) unless they have specific reasons for violating them, and they employ a range of editing styles. Do not attempt to adopt any one style as some sort of signature approach to editing; each story is unique and typically requires different combinations of styles.

Editor William Goldenberg found himself particularly challenged while trying to cut a scene in Ben Affleck's suspenseful drama *Argo* (2012), which tells the tale of a group of American diplomats attempting to escape Iran in 1979 at the height of the Iranian hostage crisis. This crucial two-minute scene featured no dialogue and no action, just the main character, Tony Mendez (played by Affleck), in a hotel room late at night, drinking, smoking, and silently pondering whether or not to disobey his superiors and initiate a risky operation to save the diplomats the next morning. The script required tension to build as Mendez silently pondered his options, but with no words and little action to use as

tension-building tools, Goldenberg had to adopt a subtler approach.

To solve the challenge, Goldenberg realized he had to focus on the character's physicality as he considers his dilemma. "I had to rely on Ben's acting—his facial expressions and body language," Goldenberg recalls.

He shot the scene about 10 times, with all sorts of different coverage, and put himself into a particularly emotional place each time. The whole idea was to access the character's emotions, to watch him agonize over his decision-making process. As the editor, I went searching for the right takes that showed the progression

of his thoughts as he makes up his mind. Each take I choose has a specific job to do. So that means I have to watch each piece of film, each take, and put myself into the audience's shoes and try to feel the way they would feel about it. I combed through footage until I found just the right moments, with the key moment being the one where he decides to disobey orders, and take the houseguests out of Iran. When you find key moments like that in the footage, you can use them to lift the tension in such a way that the audience is left feeling that what came before that moment was even more intense, and so, the overall scene's impact of building tension is that much greater.[1]

Goldenberg went on to win an Academy Award for his work on the film.

Story editing is all about searching for, and correctly using, those right "moments." As a high-profile editor of major feature films, Goldenberg had access to far greater resources than you will, including a talented technical team to set up his workflow, import and back up files, and organize data for him—a process strategically designed to allow Goldenberg to maximize his ability to stay focused on creative issues. But in another sense, his challenges were no different than yours will be when you sit in the editor's chair. Like Goldenberg's team, you will first have to address those technical issues discussed in Chapter 11. Then, like Goldenberg, you will have to focus on apply-

ing every ounce of creativity you can muster to tell the story in a way that audiences can connect with. This will require a mind-set adjustment, since you likely directed the footage you are now editing. What were precious shots to you as the director must now be scrutinized and deleted by you as the editor. You will need to remove your director's hat, put on your editor's hat, and examine the footage through an editor's eyes.

Giving yourself over to the project's creative needs in this way will be your primary editing challenge. Concentrate on using your tools and resources to become a storyteller first and foremost. Generally, as an editor, you will be painstakingly sequencing the best shots and related elements you can find into the order that best allows you to convey the progression of events in your story. But there is more to it if you want to be a great storyteller; you need to make sure logic and emotion are correctly balanced within the progression of events. And before you can get that far, you first have to learn the basic principles of picture editing, how to achieve continuity and transitions, how to pace a story, and how to find the right rhythm. To do that, you need to learn about different styles and techniques—continuity editing, the montage, overlapping editing, parallel editing, all the different types of cuts and transitions, and so on. This chapter will focus on helping you build a foundation for developing these skills as you start to pursue the mind-set of an editor.

The Phases of Editing

You have journeyed through production and shot your movie by now, and if you were thoughtful and did your homework, you kept the editing process in mind as you captured your elements. In fact, it is commonplace for the editor to start working on what is called the *assembly edit* or *first assembly* while filming is still going on, working on parallel tracks with production. Of course, on a student film, your timeline and resources may not make that feasible, but if you can, it is a great idea to get into your editing environment after your shooting day is done, watch dailies, and start the editing process as soon as possible.

Once you have shot all your elements, organized your editing infrastructure and sorted your dailies, logged your footage, and set up your bins as explained in Chapter 11, you will start with the assembly edit. Often initially handled by an assistant editor on professional projects, in an assembly edit you roughly organize footage on a scene-by-scene basis—putting preferred material for each scene into a general linear order and then into folders to make it easier to find later. You will likely not

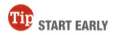

START EARLY

Among the reasons for starting the editing process as early as possible during production is that it will allow you to determine if you missed any crucial elements while shooting. From a practical point of view, doing so may afford you the opportunity to go back and capture that missing footage the next day to complete the edit.

even have temp music or effects yet. Rather, at this point, your main goal is to consider all the material available for each scene, pick the pieces you like the most, and begin arranging each scene according to how you want it to look. Keep in mind that many of these "rough draft" decisions will evolve or change as you move further into the editing process. Still, as with the rawest of elements, it's a good idea to save your assembly-edit material for reference even as you push forward.

Once you are confident you have an assembly edit in good shape, you essentially have a template to begin the more sophisticated editing of scenes and the linking of scenes and sequences together to create a seamless story. These stages of editing take place in the following order:

1. **Rough cut:** The **rough cut** is really a more refined version of the assembly edit, and note that when we say "rough cut," we really mean "rough cuts"—multiple versions of the rough cut. You may well spend a lot of time revising and re-revising elements within scenes, entire scenes, and the order of scenes as you push for a rough cut you are happy with. Indeed, the rough-cut phase is frequently the longest part of the editing process.

 Whether you are the director or are working with the director, you will be replacing shots and other elements based on the director's notes, your own notes, and suggestions from collaborators you respect—among others. This process entails reviewing scenes for timing and continuity issues, and deciding along the way to add, subtract, or otherwise tweak particular shots. Maybe your initial shot of a flag waving in the wind had too many lens flares in it, for instance. Your rough cut will eventually lead you to remove that first take of the waving flag and replace it with another. Or perhaps you will decide to take it out altogether. Or, if absolutely necessary, you will reshoot it. Often, totally new ideas or experiments are tried out and then either incorporated or discarded.

 You will also be addressing various technical issues, such as the syncing of picture and sound, and the periodic arrival of new or finished visual effects or sound elements. In visual effects–oriented movies or animated films, in fact, you may also find yourself creating temporary shots, or inserting other types of placeholding elements into the cut to allow you to figure out the timing of the shot and other intricacies of the final sequence while you wait for the

For *Prince Avalanche* (2013), David Gordon Green and his crew shot lots of B-roll footage to give them lots of imagery of the physical location they were shooting, thus providing additional elements for the editor to experiment with later.

Courtesy of Muskat Filmed Properties/Rough House.

Tip EXPERIMENT WITH YOUR ROUGH CUT

▪ During the early phases of your rough-cut process, use as much of your available footage to experiment with different options for each shot and sequence as you can. You shot the footage for specific reasons, so unless it is technically flawed, you have an obligation to see which different angles, lenses, and camera movements work best for those scenes.

▪ Don't worry about the exact length of your rough cut. Typically, your first version will be the longest, and one of your tasks during subsequent phases will be to trim and tighten the story. But during the initial editing phase, you want to see on-screen as much of the material you find compelling as possible before you begin contemplating where and how to cut things back.

Watch Yourself

Certain editing methodologies will bear the best results if you take your time, cull through your material in great detail, and experiment with numerous cuts and versions along the way, but as a producer with many other jobs to do, you know you can't spend *all* your time editing once filming is complete. If you do, you will miss deadlines, classes, other projects, and who knows what else. So, what's the middle ground between being creatively committed and thorough, and the practical issue of editing your movie on time and within your means? Here are a few ideas about walking this particularly fine line successfully:

1. **Think editing during production.** As discussed in Chapter 7, it is crucial that during production, you shoot with your eye and brain tuned in to the editing process by knowing what shots you think you will need and what shots you can do without—this mind-set is called "shoot to edit," and generally speaking, it's a great idea. You are unlikely to have time and resources for extended reshoots to pick up missing material, so your up-front plan and your shooting process will be central to your editing success. Similarly, religiously shoot masters and close-ups and reaction shots, even if the script does not always demand them, so that you can be assured of multiple options for virtually every scene when you get to editing. This is particularly useful if the scenes may require visual effects or animated elements, because extra coverage can save you time and aggravation and afford you more creative options if you later decide to make changes involving visual effects elements or animated characters. Likewise, shoot lots of environmental coverage and *B-roll* (shots that don't involve the main actors, that you can use as cutaways while you're in the editing room), and capture environmental

sound elements whenever you have time. The key is to maximize your options when editing by acquiring as many elements as you possibly can.

2. **Start early and seek help.** Draft others to help you get organized. Maybe you are editing the movie, but barter services with classmates or other students or friends to help you set up your edit room, digitize and back up material, label files, and organize bins. While they are performing some of those tasks, schedule your own tasks in an organized fashion and begin editing during production. That way, you can get yourself close to a rough cut by the time principal photography is over and you won't be starting the editing process from scratch. Get the foundation of your editing plan together *during* production.

3. **Take criticism.** Speaking of getting help, as you have cuts available, screen them as routinely as you can, and take seriously the input you get from strangers, classmates, friends, and family members, particularly if they do not know much about your project before they view it. Opinions from people who have not prejudged you or your work can often result in particularly valuable input. Furthermore, do not rigidly adhere to ideas that you discover are not being well received on a widespread basis. Rather than agonizing over something that does not appear to be working, change it and move on to the next thing. Along those lines, never fall so deeply in love with a shot or a sequence, no matter how well-executed it may be, if it does not work in the context of the story, that you just can't bear to remove it. If your editing process tells you it does not fit the narrative, take it out and move on. And remember the audience will not know what you cut. They are only interested in the best final story.

finished shot to arrive later in the process. It is common for such elements to come in without always being properly synced, or to fall out of sync, and so you also will be trying to find and fix such hurdles during the rough cut. Finally, it is often a good idea to let your editing points between scenes look rough or raw if you are collaborating with others on the rough cut, so that it is clear there is an edit point at a particular place and thus an opportunity to consider other options if the edit is not something you have finalized.

2. **Fine cut:** Whatever version of the rough cut you finally commit to is typically called the *first cut*. This does not mean the time for changes, or even experiments, are over; it simply means you have a cut that you are happy with as a foundation for building your final version. The process of building toward that final version now begins with your **fine cut**. Many professional editors advise that it is a good idea to take a brief break between the rough cut and the fine cut to allow your current version to sink in and to give yourself and any collaborators a pause before looking at it again, hopefully with fresh eyes and new ideas.

The fine cut is named as such because you are looking to make fine changes. You are not necessarily evaluating the entire film globally; rather, you are examining each scene and each cut in each scene to find out which you are unhappy with and to make tweaks where you think it's required. At this point, more notes will be addressed and more final music and final or close-to-final visual effects shots, if any, will be completed. Once you incorporate them, you may well formulate new ideas or see either opportunities or problems that were not previously visible. During the fine cut, you will address these issues. Likewise, during this period, it is typical to screen the film for friends, colleagues or fellow students, or even strangers. You may or may not have the resources to hold formal screenings, or *recruited screenings* (surveying or prequalifying attendees to make sure they fit your target audience), on a big screen or in a theater, but even if you don't, show the fine cut on the best monitor you can, find out what people who typify your audience think, and address their comments during further honing of the movie.

3. **Final cut:** Basically, when you and any colleagues (director, producer, or professor) like the fine cut, you will then need to work with whoever is handling your sound, music, and titles to get those elements the way you want them to be. Generally, when all of those people—or just you, if you are serving in all those capacities—are truly happy with the cut (or you run out of time to make any further changes), you will *lock picture*, meaning you will commit to making no more changes barring a dire emergency, and declare that you have arrived at a **final cut**. In the professional world and possibly in your class, very few directors have the true power of final cut. In most cases the studio or the backers of the film can demand changes in your final cut that must be addressed.

Of course, depending on your film's format—film or digital—and exhibition plans, you may still have more work to do to get your imagery into its final, high-resolution master form with final color correction, final visual effects or

Practice

SECOND-GUESS THE FILMMAKERS

Rent a DVD of a major motion picture that includes deleted scenes among the bonus material. Many classic films on DVD and Blu-ray include deleted sequences, including the famed "Mouth of Sauron" scene from *Lord of the Rings: Return of the King* (2003) and an extended dream sequence from *Terminator 2: Judgment Day* (1991). Watch the movie, and then check out the deleted scenes. Choose a particular scene that catches your attention, and write an essay explaining the scene and giving your opinion about why it was cut, whether you agree with the choice, what it would have added to—or taken from—the movie, and what your conclusion is about the studio's or filmmaker's choice to take it out. Most important, consider the emotional impact or lack of impact of the choice, and whether the scene would have helped or hurt the film's pace or coherence, or advanced the story. Would certain characters' motivations have been clearer or more muddled if it had been left in? Would your overall reaction to the movie have been altered one way or the other by its inclusion?

music, and other technical "sweetening" where needed, as discussed in Chapter 11; this is part of the finishing, or mastering, process. But as long as you have a final cut you are happy with, and have followed the steps outlined in Chapter 11 to generate an edit decision list and other elements for your mastering work, you will be able to breathe a sigh of relief that, at last, you have a completed movie to share with the world. If you worked hard enough on the process, there is every reason to believe you have a story that corresponds to the emotional beats you intended so long ago when you developed your script and dreamed of making a movie.

However, as you go through each of these phases, you will need to be savvy about how to tell your story if you ever hope to reach a final cut you can be proud of (see Producer Smarts: Watch Yourself, p. 278). Let's next examine how to find a pace, a style, and shot-cutting methods that will allow you to get there as you journey through the aforementioned phases of editing.

Find the Rhythm

As noted, there are important rules, techniques, and styles to consider when editing a movie, and we will discuss them shortly. First, however, you need to *think* carefully about developing a plan for how you want to pace your movie. Some of this is straightforward common sense—you would obviously not pace an action piece the same way you would a romantic comedy or a historical drama, for instance.

But what is "pacing" in terms of a movie's narrative to begin with? The simplest way to think about it is that when you pace a movie, you are varying the length of shots/sequences for strategic purposes—to help lure viewers to the filmmaker's desired emotional response at any given moment. Thus, generally speaking, a quick pace means you are looking for excitement, intense reactions, and anxiety out of your viewer. A slower or more leisurely pace means you want the viewer to be more thoughtful about what he or she is seeing.

Analyze the Material

Beyond the basics, however, consider the subtle impact of your pacing decisions. Even if you want action, too-quick transitions between scenes can cause your audience to lose interest if they can't keep up. If you transition too slowly, you can bore them and also lose their interest. Either way, if you consistently meet their expectations, you risk losing their interest because they will have the story figured out before you want them to. If you never meet their expectations, you risk alienating or disappointing them—and so on down the line.

Therefore, you need to decide on your editing philosophy as it relates to your specific story overall. This means

This sequence from *Dirty Harry* (1971) demonstrates that movie scenes do not need to play out in real time. The audience only sees the phone ringing in the phone booth, then Clint Eastwood running to pick it up, and then the shot of him answering the phone out of breath. All the in-between moments have been omitted.

poring over the script and watching *all* dailies, *every* take. Take notes and write yourself scene-by-scene bullet points for what you hope to achieve with each scene and each transition, and the emotional impact you want your audience to feel from each shot, sequence, or cut. Many editors say this process of immersing yourself in your story and its corresponding elements is the actual hard part of editing, and if you can master a working method of making yourself a road map, the other, more mechanical parts of cutting sequences together will be far less painful.

Where do you want to meet your audience's expectations? Where do you want to surprise or shock them? Where do you want to leave conclusions open for their interpretation? As many veteran editors advise, look for big issues or concerns: Is a particular scene repetitive, or could it be moved to a different location in the narrative? Is there a character that is superfluous and adds nothing to moving the story forward? These are creative issues to think about *before* you cut anything. You don't always need to have hard and fast conclusions to proceed—your feeling about the material may well evolve as you are editing it. But you at least need a beginning point of view, as well as a basic understanding of what you think your audience may be expecting. After all, how can you either meet their expectations or deviate intentionally from them if you have given no thought to what they might be expecting to begin with?

To find the right pace and rhythm for your piece as you study each scene and make your notes, ponder the core issues of *cause, effect, motivation, continuity,* and *logic.*[2] Every action or event you show in your film needs to have a reason for happening, and a certain logic to it—either real-world logic or logic within the context of the world you are creating in your story. Particularly in a fantasy, sci-fi, or animated film, your edit should set up the rules of that world. For example, the coyote can keep running off the cliff after the roadrunner, unless he looks down. This doesn't mean, however, that events always need to take place in linear order—that all depends on your creative intent. In crime dramas, for example, it is commonplace for viewers to see the results of the crime at the start of the show—police examining a crime scene or a corpse of someone who has been murdered—even though we won't get the details of how the crime happened, and who committed it, until much later. But even with that example, there is logic to it: a crime has been committed, and now we will be told the story behind that crime. One of the most classic examples is in *Sunset Boulevard* (1950), which starts out with the star of the film, William Holden, asking the audience if they want to know how his character wound up dead floating in a swimming pool.

More generally, though, logic should prevail even when your overall story structure is complex. How you get there, exactly, is the magic of editing. You do not necessarily need a detailed scene showing someone drinking to know in a different scene that the person is drunk. But what if someone is doing drugs? If you skip over showing some aspect of that reality, we might see the person inebriated later but have no idea if that is because he or she was doing drugs or was drinking, or if there was some other cause, such as illness. Therefore, you need to illustrate the cause in some fashion to have the effect make sense.

But what do we mean when we say an element has to "have a reason" for being there? Isn't modern cinema filled with all sorts of eye-candy action sequences and cool visual effects that add little or nothing to the narrative but that set audience tongues wagging?

Well, yes, and that's precisely the point. As a beginning filmmaker, this should not be your agenda. First, most of those movies are not necessarily ones you will remember with passion. You might remember the scene, or the shot, but will you be moved by the story? And second, by definition, if the audience comments on a

Tip ECONOMICAL CAUSE AND EFFECT

Although illustrating cause-and-effect is important, there are times when you should be economical in how you do it. You can, for instance, enter a scene or an event in the middle, when certain events have obviously already occurred. When properly executed, this approach will not impact the audience's sense of continuity, because what the audience does see will remain perfectly logical, even if joined midway through.

Tip CUT FOR EMOTIONAL IMPACT

As you analyze material, remember that the most important thing is how your cuts will end up impacting the viewer emotionally. Therefore, if you take the time and effort to identify those spots where emotional impact is crucial, it will be easier for you to decide the precise point at which to make the cut, how long to make the shot, and so on.

shot or an edit, even if they are being complimentary, that means they are thinking about something other than the story—in fact, they are outside the movie-watching experience altogether if they are focused on such matters. You want them thinking about story first, second, and always. In fact, editing-room floors throughout the history of cinema are littered with impressive shots, stunning effects, sophisticated dance numbers, and more—bits and pieces of famous motion pictures that were discarded for the simple reason that they did nothing to advance the narrative and frequently took away from it. The original opening scene of *Toy Story* (1995) was cut because of this, although the idea did wind up as the opening of *Toy Story 2* (1999). Such scenes, no matter how well crafted, come from "outside" the movie and therefore need to be removed. (Editors, both in film and in writing, frequently refer to this necessity as "killing your darlings," since they are periodically required to remove some of their best work from a movie.)

As discussed in Chapter 10, you will also be deciding where, how, when, and—most important—*why* you will or will not be adding music and other sound elements to various scenes. On a professional project, you will be working with an entire team of sound professionals to execute those sound decisions; on a student project, you will most likely be doing all that work yourself. In either case, it is during the picture-editing phase that you will make those decisions, and you will be inserting, for the time being, temp music and sounds to illustrate what you are going for in order to provide the necessary impact for you to continue wading your way through the editing process. At this point, it is important to reiterate that music is central to the building of emotion and tension in a motion picture—if you use it judiciously.

Thus, for both picture and sound elements, it makes a lot of sense to be analytical and almost clinically objective in terms of examining your available material and pondering the editing approach that best fits your material before and during the cutting process. By doing so, you will find yourself well on your way to organically figuring out the pace you want for your story.

Transition In and Out

Before we discuss the *types* of transitions you can use to tell your story (see p. 292), you first have to think about *where* and *when* you want there to be transitions to begin with—that is, where you want to place your *edit points*. Generally speaking, how does a beginning editor figure out when exactly to make a cut? Where is the "sweet spot" in terms of knowing *where* to insert a transition? And how do transitions work in the cinematic storytelling process anyway?

There is, of course, no single, all-encompassing answer to these questions, because it all depends on the specifics of the shot, the scene, the sequence, the story, and your overall creative intent. However, there is a general guideline you can keep in mind as you ponder where to place transitions: much of the time, it is a good idea to get into a scene as late as you can, and out of a scene as early as you can.

(see p. 292)

Tip DON'T OVERDO THE MUSIC

When making decisions about what kind of music, and how much, to add to your story—and where to add it—keep in mind that music works best in a dramatic narrative when it appears to be naturally occurring or has a specific reason for occurring. Therefore, be judicious in your use of music, and remember that there are many classic films that minimize or do without music entirely, including Fritz Lang's *M* (1931) and the Coen Brothers' *No Country for Old Men* (2007).

This scene from *The Bridges of Madison County* (1995) lets the conversation between Clint Eastwood and Meryl Streep play out naturally, without over-mechanical cuts.

"You want to be able to tell the story in the most economical way possible," advises William Goldenberg. "Each scene has a beginning, middle, and end, but you also have to worry about the overall arc of the story. So traditionally, you want to come into the scene at a high point and leave at a high point. If every scene is structured with the same beginning, middle, and end, that doesn't do much for maintaining a rhythm. But if you always ask yourself, for each scene, what is the latest I can get into the scene, and the earliest I can get out, then each scene will naturally come out [with a somewhat different pace] that works."

There are exceptions, naturally, where, for emotional impact, you will need to linger on an event. But Goldenberg's general point is that if you search for your first available opportunity to transition from one scene to the next, the mere insertion of the transition—provided you execute it properly—will create what he calls "a pop for the narrative drive," which keeps your film's pacing on track.

When it comes to transitions in conversation within a scene, insert them in places where they will aid and advance the overall pacing of your movie while impacting the viewer emotionally, acting in an organic, realistic way. Avoid monotone, mechanical back-and-forths, with cuts happening between two characters just as each one finishes his or her entire line of dialogue. This is a common occurrence in the work of inexperienced editors, but it isn't a particularly realistic way to cut, as it makes the scene seem unbelievable and thus boring. Keep in mind that people normally pause, speak over each other, glance about, get distracted, change the tone of their voice, and switch topics when engaging in real conversations.[3] (See Action Steps: Cutting a Conversation, below.)

Practice

DRAGNET REDO

Head to YouTube and examine the opening 2:45 of the following clip from a 1953 episode of the classic television crime drama *Dragnet*: youtu.be/U3IojvCVmzA. For years, editors and instructors have been using *Dragnet* as a show that exemplifies the kind of stilted, back-and-forth conversational editing style we have warned you to avoid. Watch this clip and then write your analysis or suggestions for how the editing could have been more interesting in terms of when transitions occurred or could have occurred, what elements could have been easily introduced to make it less stilted, and where you might have changed transitions or other elements to spice things up. There is no one right or wrong answer to this challenge—the idea is for you to understand how and why it is important to make conversations in your work look and sound more sophisticated and interesting than the kind of old-fashioned approach that was popular during the *Dragnet* era.

ACTION STEPS

Cutting a Conversation

In Chapter 10, we discussed how to edit dialogue. However, the film editor is the one who will combine sound and picture elements into full conversations in order to hold the viewer's interest and advance the story. Generally, putting a conversation together successfully means you have properly considered anticipation on the part of one or both speakers, their reactions, and whether your creative intent requires you to emphasize one actor over another visually. With all that said, how best can you pace a conversation? Here are some basic considerations:

1 As discussed, be intimately familiar with your script and how, exactly, the writer and director envisioned the conversation unfolding. Your script may even have directions about reactions and environment to consider.

2 Likewise, be intimately familiar with your available takes. On major features, the various takes the director wants the editor to consider among his options during the dailies process are called *circle takes*.[4] On your first student film, you should consider *all* takes. Watch and rewatch them, make notes about your favorites, and organize them into folders.

Continued

FIL**M**MAKING

Continued from the previous page

3 **Be cognizant of continuity.** Often, conversations are filmed over the shoulder, and you are usually going to want to obey the 180-degree rule (see p. 287). Generally, this means you will be cutting between shots of each conversant, unless your creative plan requires wide shots of both people in the same shot. Either way, search for the best performances that obey continuity, rather than putting in shots that are illogical when juxtaposed with other shots in the conversation.

4 **Consider the space, or gaps, between lines from each actor.** If you use different takes from each, there could be an awkward or uneven gap of time between when one person stops speaking and the other starts. It's not that you don't want gaps—such gaps, hesitations, brief moments of distraction, or waiting are normal in real-world conversations. You just want to make sure the gaps seem natural.

5 **Concentrate more on dialogue audio than the corresponding picture.** If performances are right and natural, this should be preferred over a take in which dialogue is stilted or weak, no matter which one has the stronger picture associated with it.

6 **Along those lines, if dialogue was recorded separately, always search for your best audio performance and include the best picture that does not conflict with it.** Remember that if you love the picture from a take in which the actor's moving lips are not visible, but you aren't crazy about the audio track from that take, you may have the option to add replacement dialogue later, as you learned in Chapter 10.

7 **Once you have your best audio-performance elements, commit to them and adjust picture elements while finalizing the conversation.** You might add inserts (a nervous man tapping the table with his thumb), cutaways (villains coming through the back door), or reactions from a picture point of view.

8 **You may also end up "rolling" initial picture edits to make the conversation look more seamless.** *Rolling picture* basically means using tools to lengthen a clip on one side of your edit and shorten the clip on the other side. Doing so does not change the length of the overall scene but can change visual focus or emphasis in the shot. Typically, when you roll the edit point forward in a shot, you are doing so to arrive sooner at what the speaker's reaction will be when he or she finishes talking and starts hearing the other person's reply. If you roll the picture backward, you are doing so to show anticipation on the part of the speaker just before or as he or she begins speaking—an eye twitch, a frown, a brow furrowing, and so on. *Split edits*, or *L cuts*, which we discuss later in this chapter, are useful for this kind of effect.

9 **Finally, keep in mind that much of the subtlety of editing a conversation depends on your creative desires as the filmmaker and thus will require some experimentation to get right.** You might, for instance, realize after a few tries that you need environmental music in the background, that your approach resulted in lip-sync problems, and so on.

 SLOW DOWN

Slow down and relax. There are so many creative and technical issues involved in editing a movie that some students tend to lose themselves in the impulse to tackle editing chores globally; focus on your current task only, and go one step at a time.

Editing Basics

Choosing a specific editing approach or style for your movie really just means you are deciding *how* you want to tell your story. Do you want to tell a linear story made up of equal parts beginning, middle, and end? Do you want to jump through

time, back and forth, with flashbacks and more? Do you want to tell the same story from two different points of view? Do you want to tell a looser story or series of stories that are directly connected to one another by little more than a theme or an idea?

These decisions depend on the nature of your story generally, the script specifically, the creative desires of the director (probably you), what picture and sound elements you have available, who your intended audience is, and what type of exhibition plan you have for the movie. No matter the answers to these questions, there is an editing style or methodology that will work for you. Once you pick your approach to the material, you can then figure out the specific types of transitions you wish to make along the way to executing your creative vision.

The Styles

Here's a basic rundown of the most common approaches. There are others, or hybrids of these and others—and for that matter, you may well discover an entirely new approach along the way. But understanding these basic methods is a big first step toward jumping into the fray for the first time:

- **Continuity editing.** Referring to the most basic and common method of telling a fairly linear story, **continuity editing** leads the audience through a specific sequence of events that eventually reach a logical conclusion. Often with this approach, the results are what the audience expects, which is why editors sometimes use a continuity approach for certain parts of the movie, and move on to other approaches when they wish to evoke surprise or conclusions the audience may not be expecting.

In *Rocky* (1976), Sylvester Stallone's Rocky Balboa relentlessly trains for his big fight over the course of many weeks, with the uniqueness of Philadelphia as the backdrop and a motivating piece of music ("Gonna Fly Now" by Bill Conti) driving him along. In this montage sequence, a crucial part of the story was told in a particularly efficient manner that also strengthened the audience's emotional connection to the story.

- **Relational editing.** Similar to continuity editing, **relational editing** places a greater emphasis on directly connecting scenes by establishing a specific relationship between them. A simple example of this is the connection of a shot of a baseball pitcher hurling a ball toward home plate to a shot of a batter taking a swing. Viewers will naturally expect that the shot of the ball being pitched will be followed by a shot of the batter swinging, and thus, there is a direct relationship between the two.

- **Montage or thematic editing.** With **montage editing** (**thematic editing**), editors are connecting images based on a central theme or idea to efficiently convey in-

FILMMAKING

formation or ideas in a concise and powerful manner. Therefore, unlike with many other approaches, there is often no attempt made with thematic editing to have events unfold in a strictly linear manner. The notion is built on a classical montage technique developed in the 1920s that later evolved and grew to influence commercials, music videos, and avant-garde filmmaking. But the montage is now frequently used in narrative filmmaking to compress time or summarize events at a particular point in the story (see Action Steps: Art of the Montage, below), often to relate to an overall theme. To comprehend the power of the montage to aid narrative storytelling, refer to the famous montage in the original *Rocky* movie (1976), shown on the previous page.

■ **Parallel editing. Parallel editing** is a technique in which editors interweave multiple story lines or portions of story lines. It is an approach frequently used in television, in which multiple characters and plot lines and subplots are commonplace. It is also an approach in which it is typical to vary the pace and rhythm of the overall piece depending on which story or characters are being followed.

■ **Time expansion or contraction (elliptical editing).** With this technique, time is frequently drawn out or pulled in for both creative reasons and to allow movies to achieve desired run times. For instance, watching a mobster unload a body from his car, drag it around back, and bury it is something that may well, in the finished product, begin with the mobster unloading the body and then cut to the finish, in which he is shoveling the last bits of dirt on the body in the grave he prepared around back. It is obvious what happened between the two events, and so editors can combine them and thus compress time in that particular sequence. On the other hand, if your story depicts a speaker talking on a stage while an assassin aims his gun and prepares to take his shot, you may want to expand time to build suspense. This method is sometimes called **elliptical editing** because the omission of pieces of the sequence results in the visual equivalent of grammatical ellipses.

■ **Post-classical editing (MTV style).** A more recent technique, **post-classical editing** is nicknamed **MTV style** because it became popular through its use on music videos and commercials in recent years. The basic approach involves particularly fast pace, rapid cuts, short shots, and more jump cuts than in classical techniques.

ACTION STEPS
Art of the Montage

Stylewise, the montage often involves the adding or mixing of as many shots as possible; keep in mind, however, that there are different *kinds* of montages. A *parallel montage*, for instance, involves cutting between different locations or events happening simultaneously, whereas an *accelerated montage* uses particularly fast or accelerating cuts to overwhelm viewers for creative reasons. Here are some basic ideas about how to construct a montage that meets your creative needs:

❶ **Feel free to experiment.** Continuity is not always your goal; your objective may even be to disorient or upset or briefly confuse viewers. Therefore, you may want to consider including opposing or clashing images, different-shaped images, symbols, specialized graphics, or even different colors.

Tip DON'T INSIST ON PERFECTION

Don't insist on perfect continuity. We have emphasized continuity and logic as crucial under many circumstances when editing. However, small differences or imperfections are likely to matter less to your audience than either performances or their emotional connection to your story.

❷ **Play with color tones, resolution, saturation, or contrast in the color-correction process.** Color can be a powerful tool in changing moods for viewers.

❸ **Mix shots up or juxtapose them,** meaning you should try combining images that have different screen depth or composition, or move radically between different types of shots—from close-ups to wide shots, and so forth. Similarly, the juxtaposition of ideas—young and old, big and small, happy and sad—is a part of montage editing that is particularly commonplace in commercial/marketing editing.

❹ **Freeze shots or use still images** to emphasize particular ideas.

❺ **Balance the volume of material you present for creative purposes with a realistic understanding of how much your audience can process.** Although the montage is often used to create a disorienting feeling, you still want to try to arrange elements in both space and time to be most meaningful to viewers. Thus, you should experiment with presenting your images in different ways—slower and more simply, faster and more complex—and see which allows viewers to better process your message.

❻ **Build the mixture of images to your main point.** If you show a caveman running in fear, men of different eras throughout history running in fear, and modern people running in fear, you are probably doing so to lead up to some point about why they are all running. Perhaps, for instance, your culminating shot or sequence of shots might show the planet exploding—making the point that the end has arrived, which would be a particularly good reason to run in fear, to be sure.

The Rules

As alluded to throughout this chapter, there have traditionally been certain concepts that some people view as firm rules for picture editing—rules they believe need to be adhered to for an edited narrative to look and feel right. Others contend that they are general guidelines that should be respected but that do not always need to be adhered to, depending on creative needs and other factors. Let's examine and contextualize these basic ideas before discussing when it is appropriate to make exceptions.

Some of these concepts are relatively ubiquitous, with the most common rule being the *180-degree rule*, as explained in Chapter 7. There, our emphasis was on how you shoot the elements, remembering to capture the conversational shots according to the rule's requirements, with the camera staying on one side of the conversation or the other throughout. But the idea will ultimately be applied, or not applied, in editing, because you may have chosen to also capture elements that do, in fact, break the imaginary axis line for any number of reasons. In editing, the concept is most frequently applied when doing continuity editing: if you follow the rule, you will always be choosing elements in a conversation that consistently keep one character frame left and one character frame right.

Of course, many notable filmmakers have violated this rule. When you flip the camera to the other side of the axis, it is called *jumping or crossing the line.* Thus, in editing, if you then proceed to show the action from the other side of the axis, that is called a *reverse cut.* For this and virtually all other editing rules, there can be good reasons to ignore them, and we will discuss some of those shortly. For the time being, understand that the 180-degree rule is a good basic guideline when

doing straightforward continuity editing—a way to make sure viewers are not disoriented or confused.

Another basic idea that is widely adhered to is the notion of the *eyeline match*, which, again, is seen most commonly on projects that use continuity editing. The idea with the eyeline match is that you want the audience to see the same thing that the character on the screen is seeing. Thus, it's a basic cut—a character gazes at something we cannot see, and you seamlessly cut to whatever he or she is looking at.

There are reams of other principles that are important for new editors to understand and consider when cutting a project, whether they intend to always follow them or not. Some of the most basic ideas come from famed film director/editor Edward Dmytryk, who wrote several filmmaking books, including a book on editing in which he laid down seven basic editing rules that most seasoned editors seriously consider to this day. Dmytryk's rules are as follows:

1. Never make a cut without a positive reason.

2. When undecided about the exact frame to cut on, cut long rather than short.

3. Whenever possible, cut "in movement."

4. The "fresh" is preferable to the "stale."

5. All scenes should begin and end with continuing action.

6. Cut for proper values rather than proper "matches."

7. Substance first—then form.[5]

There is logic to all of these ideas of particular value to the beginning editor. For instance, Dmytryk advises us to cut "in movement," simply because it is generally easier to hide an edit when the footage is moving, and thus blurred, than when it is static and clear. Similarly, a good way to begin and end with continuing action, he advises, is to simply overlap action cuts by three to four frames.

But of all Dmytryk's suggestions, the first and last ones may be the most important. Making a flashy or technically challenging or visually compelling cut merely because you can rather than because you need to in order to tell your story is just about the worst reason in the world to make such an edit. Likewise, as noted, you will typically need to meld or mix styles or methodologies on most projects rather than adhere rigidly to a single style throughout every scene. Therefore, if you ask yourself with each cut if what you are doing is helpful to telling your story in a way that connects emotionally with your audience, then you are well on your way to making a good editing decision.

In his writings and lectures, Walter Murch has offered up some baseline concepts for film editing that, like Dmytryk's, are widely respected and adhered to around the industry. Murch proposes the following six basic criteria for deciding where to cut, widely referred to as Murch's Rule of Six:[6]

1. Emotion—How will the cut impact the audience emotionally at the moment it happens?

2. Story—Does the cut move the story forward in a meaningful way?

3. Rhythm—Is the cut at a point that makes rhythmic sense?

4. Eye Trace—How does the cut impact the audience's focus in the scene?

5. Two-Dimensional Place of Screen—Is the axis being followed properly? (This relates to the 180-degree rule.)

6. Dimensional Space—Is the cut true to established physical and spatial relationships?

Murch went on to assign in what he calls a "slightly tongue-in-cheek" manner specific mathematical percentages to these ideas to indicate how much value each should be given in the course of a narrative film. He elaborates today that the assignment of specific values such as 51 percent to emotion, 23 percent to story, and 10 percent to rhythm was "not an ironclad regimen" in that "it is impossible to really quantify any of this exactly, and also it is rare that we can achieve all six at the same time."

However, Murch adds that such value assignments do have meaning as "a kind of abstract goal" in the sense that if an editor needs to sacrifice or minimize something, he or she should logically minimize from the bottom of the list rather than from the top. "Let go of 3D continuity before 2D, and 2D before eye trace, and so on," he suggests. In other words, especially at this stage of your career, focus on the *ideas* behind Murch's criteria. Understand clearly what he is suggesting is of primary importance—emotion, story, and rhythm—and do the best you can with everything else. If you manage that kind of balance, chances are you are on the right track in terms of editing your narrative in a compelling and impactful manner.[7]

Breaking the Rules

All of the principles discussed here are solid, nuts-and-bolts concepts that good editors routinely know, consider, and frequently follow when cutting movies. The problem, of course, is that a rigid adherence to them in all situations can result in mechanical cutting that does not always fit the emotional intent of your scenes. Since editing is a highly creative and instinctual endeavor, you need to develop a framework for comprehending when to rigidly adhere to a rule and when to ignore it entirely.

The basic principle, of course, is to make sure you have good reason for violating a rule, such as the 180-degree axis or the eyeline match. Related to that, verify that the reason is a positive one—that your decision in either direction is being guided by an understanding of what your desired audience will, or will not, get from what you are doing. Indeed, many editors suggest that your deciding factor on whether to cross the 180-degree line or break another rule is whether or not the audience will be able to follow what is going on if you do it. So you need to ask yourself if you are confusing the audience or making it easier for them to follow a point you are trying to make or an emotion you are trying to convey. In that sense, it is about common sense. Therefore, as the editor, feel free to experiment with breaking a rule and the consequences of doing so. Once you have tried it, does the scene work? Can the viewer follow along? Is the emotional connection still there or even stronger than before? If so, it was probably a good move. If not, you probably made a mistake and should switch back to adhering to the rule.

As you go through this process, be aware that certain ideas can evolve out of basic editing rules that may ironically provide your basic defense for violating those very rules. For instance, a big point is made out of emphasizing performance over style. That, however, may cause you, as an editor, to linger on a shot or sequence longer than you otherwise would. Similarly, poorly executed or ugly shots may cause you to move on more quickly than you would otherwise do, or to resize or reposition the shot. Also, there is an understandable urge to take advantage of master shots as you set the scene for certain sequences—you might want to linger on a particularly beautiful master shot if you think it will help you hold the audience's interest.

More generally, you may want to violate a particular rule if the *intent* of the rule is *not* what you are trying to achieve creatively. The 180-degree rule, for

Tip **TRY EVERYTHING**

Within reason, try everything. By that, we mean use every available take, angle, and element at your disposal within your timeline and resources, and experiment with each of them in the early rough cut to discover your best options.

How Do I . . .
Show Point of View through Editing?

Go to LaunchPad to find out: **macmillanhighered.com/filmmaking**

William Goldenberg
EDITOR: ARGO, ZERO DARK THIRTY, PLEASANTVILLE

NAME:	**William Goldenberg**
TITLE:	Editor
SELECTED CREDITS:	*The Imitation Game* (2014); *Argo* (2012); *Zero Dark Thirty* (coeditor, 2012); *Transformers: Dark of the Moon* (2011); *Pleasantville* (1998); *Heat* (1995)

Earlier in this chapter, editor William Goldenberg discussed a pivotal decision-making scene acted out by Ben Affleck in his 2012 drama *Argo*. The scene works because the filmmaking conveys this character's point of view—a crucial component of storytelling. Goldenberg talks more about how he uses editing to show what's "going on in [a] character's mind and heart" in a video interview available only on the LaunchPad for *Filmmaking in Action*.

ARGO

Discover

- Why a character's point of view affects the editing process
- How even great performance footage doesn't always fit the direction of a particular scene
- When to value your instincts over endless thought

Visit the LaunchPad for *Filmmaking in Action* to learn more—and to explore how you might use this advice.

In this scene from *The Shining* (1980), director Stanley Kubrick and editor Ray Lovejoy deliberatly break the 180-degree rule to disrupt the audience's expectations.

instance, is all about not disorienting the viewer. In Stanley Kubrick's *The Shining* (1980), the legendary director strategically wanted to disorient the audience during the famous bathroom scene, and so he violated the 180-degree rule to accomplish that goal. In other words, the best reason to break an important rule in the editing process is the same reason for following the rules—to evoke a desired emotional response from the audience.

Transitions and Cuts

Throughout this chapter and book, and indeed throughout the film-making universe, the terms *cut* to describe edits and *cutting* to describe the discipline of editing in general have been commonplace. However, to be precise, those terms are also somewhat misleading.

Editing is more specifically about transitions—how to move from one thing to another thing most efficiently by joining shots. In that context, cuts are but one kind of a film-editing transition method, albeit the most ubiquitous method. To be fully accurate, **cuts** are actually no more than the physical or digital splicing of two different shots or pieces of shots together to make a seamless transition between the images. The term obviously comes from the original, analog process of physically cutting film pieces with razors and then taping them together with clear strips of tape on a flatbed film-editing platform—the way things were done for generations until the digital era came along. The method switched from physical media to digital, but the concept of "cutting" into shots and then connecting them remains.

There are literally dozens of different kinds of basic cuts and variations of cuts for you to learn about, and in the next section we will detail the most important ones. Before we do that, however, it's important to learn about the other ways to make a transition that do not involve making a cut, per se. In digital filmmaking, these other transition forms, like basic cuts, are all executed using digital editing software.

Practice
DO IT THREE WAYS

Propose three scenarios for how you could edit the following basic scenes, using a different order or style or approach that would subtly change the meaning or impact of the scene: (1) a close shot of a breathless man running, eyes wide in horror; (2) a house exploding and bursting into flames; (3) a car driving slowly along, with the driver's window slightly down and someone watching.

The original, analog editing process involved physically cutting pieces of film and taping them together. This was quite literally "cut and paste."
George Konig/Keystone Features/Getty Images.

Keep in mind that whatever transition methods you employ, you need to use the right kinds of elements for that method—elements that, hopefully, you captured during production as part of your larger strategic plan. Inserts and cutaways, for example, are elements that editors frequently use in continuity editing (see Chapter 7). Therefore, during production, you should have considered that fact for key scenes that would benefit from such shots.

This dissolve in *The Godfather Part II* (1974) indicates a time passage of two decades.

Types of Transitions

One quick word of caution: because the following transition methods were born out of special-effects techniques during the analog era, they tend to call attention to themselves. The dissolving of a shot or a burst of stars or the shrinking of an image down to a small oval are, by their nature, things you are going to notice when you watch them. Therefore, as we have urged throughout this chapter, it is crucial that you only use them when you have a good reason for doing so; otherwise, the viewer's focus on your story will be disrupted. And even when you find them useful, you should not be using them constantly. If you are, you likely have a shortcoming somewhere in your editing plan or in your material itself. Unless you are making an experimental or avant-garde film, there is no good reason for dozens of *dissolves* or wipes under typical circumstances.

With that said, here is a rundown of the most basic transition approaches that do not involve cuts:

- **Dissolves.** The most common, **dissolves** are sometimes referred to as "overlapping." They happen when you strategically replace one shot with another—one fading out as the other fades in. For a brief time, they might overlap, but they are traditionally used to indicate the passage of time or a change in location. Dissolves can last as long or as short as you want, with the duration impacting how the audience reacts to it. Obviously, short dissolves are used when the pace is faster, and longer ones are used when the pace is slower.

- **Fades.** Essentially a kind of dissolve, a **fade** is used to mark the beginning or end of a scene or a film itself. Often, filmmakers will fade not to another shot but to a color, usually black. Hence, the famous expression "fade to black." Depending on when the fade is used, editors will fade out of or fade in to a scene. Fade-outs are usually used at the end of a movie or scene, whereas fade-ins start with a solid color and eventually dissolve into an image from the start of the picture or scene.

- **Wipes.** This transition method is more forceful. Rather than dissolving one image into another, a **wipe** essentially involves one image pushing another image off the screen. The direction could be vertical, horizontal, or diagonal, but

in any case, there is a visible line between the images where one pushes in as the other departs. In some types of filmmaking, editors might also turn the image into a shape, such as a star, or digital blinds that turn from one image to another, slide-show style. Or they might use a *particle wipe*, in which the picture turns into dots or bubbles before it reassembles with different images. Typically, wipes are used to emphasize action, but in some cases, they are used almost like curtains in a theater, to illustrate one section ending and another beginning.

- **Iris or iris wipe.** This is an old-fashioned technique that was popular in early films and cartoons. The **iris** (**iris wipe**) is no more than the reduction of a full image down to a circular mask or oval showing part of the remaining image, forcing audience attention to what is in the center of the oval, while the rest of the screen is masked by black. Digital editing tools can now create irises in all sorts of shapes, not just circles, but they are not popularly used much in major feature films anymore.

- **Light flash.** A **light flash** involves rapidly dissolving the screen to white for a very short time so that it evokes a camera flash before switching to another image. Flashes are usually used for over-the-top emphasis and, as such, are not popular in major films. Family videos, slide shows, and the like use them routinely.

- **Superimposition.** This method involves combining two or more images but not, as with the dissolve, for the purpose of moving from one scene to another. As such, a **superimposition** is not technically a transition but a way to introduce another element or subjective or emotional concept from the one you started from. Traditionally, it might place a graphic over a picture or bring two characters together. In the analog era, it involved exposing more than one image on a filmstrip. With today's digital tools, of course, it is simpler to achieve if it fits your creative needs.

- **Morph.** The term **morph** can refer to a visual effect (see Chapter 13, p. 305), but in editing, you can use it as a dissolve of sorts. Rather than blending two shots together, you would digitally reshape the primary object or image within the frame and transform it into something else to begin a new scene. For example, you could morph a child's face as you transition from your prologue into the face of that child as an adult when your primary story begins.

Types of Cuts

Now that we have examined other transitions, let's look at the myriad of cuts you can use to help tell your story. Whatever choices you make, remember to make them as fast as is feasible within your creative framework, and as efficiently as possible. Your cuts are, for the most part, your preferred method of telling your story, and so they will determine the pace and therefore the connection your audience will make, or not make, to your material.

Keep your approach as basic as possible—not boring or mechanical, but no more than you need to make the point or evoke the emotion you are striving for. It's common for beginning editors to overuse different kinds of flashier cuts in an effort to illustrate creativity and energy, but this is a fine line. Fundamental cutting techniques are still the principal way to edit most scenes. Only resort to something that may call attention to itself for creative reasons, not style or ego

Tip SHOW, DON'T TELL

When it makes sense, even if you have marvelous dialogue and wonderful performances, in most cases you are better off showing or illustrating an event or a major point rather than having your characters spend too much time pontificating about it. Your goal after all is to create a motion picture, not a radio show.

reasons. If you use flashy transitions repeatedly over the course of your film, you will call attention to your editing and away from your story, which is the last thing an editor wants to do.

Here are the basic kinds of cuts you should consider:

▌ **Straight cut or hard cut.** This is a basic cut. In a **straight (hard) cut**, one shot ends and another shot begins, without any fancy effects, time distortions, and so on.

▌ **Contrast cut.** A **contrast cut** involves using your cut to juxtapose two people or elements—cutting from a man sleeping peacefully in bed, for example, to his alarm ringing loudly and chaos ensuing all around him.

▌ **Cross cut or parallel cut.** We have already discussed parallel editing, and it is with that methodology that you would use a **cross (parallel) cut**. This form of cutting (also called **intercutting**) essentially alternates images from two or more parallel plot lines.

Top to bottom: A straight cut in *The Departed* (2006), wipes in *Star Wars* (1977), a form cut in *The Truman Show* (1998).

- **Form cut.** As the name suggests, a **form cut** puts together two images that are of similar shape or in similar positions. For example, if you were showing a piece of newsreel footage on a movie screen and you wanted to illustrate that other people were watching the same footage on a different screen, you could use a form cut between the two movie screens.

- **Match cut.** This type of cut also joins similar shapes or elements together, but a **match cut** does not let the audience comprehend that there was an edit there to begin with.

- **Cut-in/cutaway.** A **cut-in** involves an instant transition from a distant view of an image to a close view of that same image, and a **cutaway** is the exact opposite—a move from close to far away.

- **L cut or split edit.** An **L cut** (**split edit**) is a technique in which your edit results in a shot's audio and visual components occurring at slightly different times to achieve dramatic or emotional impact. For example, you might cut a horror sequence so that the audience hears a woman's scream a beat or two before they see the woman who is screaming, or the other way around. It is called an L cut because, in the analog era, editors had to make an L-shaped cut on the film itself to splice in a different piece of film with the audio track in the appropriate position.

- **Jump cut.** A **jump cut** is typically to be avoided in traditional filmmaking because it is only used if there is an error in continuity in your available footage and you have no other choice. It is essentially an elliptical cut because it makes clear that some amount of time has passed—a single shot is being changed or interrupted in some way. Jump cuts are avoided by most major filmmakers but are used in avant-garde filmmaking and music videos.

- **Cheat cut.** A **cheat cut** involves deliberately matching shots that are intended to be continuous even though some element within the shot—a background element, a wall, a piece of wardrobe—is mismatched, with the goal of executing the cut so efficiently that the difference can't be noticed. It is typically done when the dramatic or emotional impact of the cut outweighs the reality of the mismatched elements, or to compensate for some other element that is lacking, to hide a blemish or difference in height between actors, and so forth.

- **Reverse cut.** As noted earlier, a **reverse cut** involves crossing the axis line during a conversation scene, thus deliberately violating the 180-degree rule. You want to do it rarely, but when you have a good reason, the reverse cut can be a powerful storytelling tool.

Practice
IDENTIFY THE CUTS

Pick a favorite classic film from any era and take notes while you watch it. Identify the basic editing style or approach, then call out at least 8–10 transitions in the movie. Name the scene and the transition or specific kind of cut used. As a bonus, offer up a couple of paragraphs analyzing the filmmaker's editing approach, and mention a couple of alternatives—different types of transitions you might have liked to have seen tried in a particular scene or sequence.

Editor's Emergency Kit

- Copies of Walter Murch's *In the Blink of an Eye* and Edward Dmytryk's *On Film Editing*
- Subscriptions to *CineMontage* magazine and *Cinema Editor* magazine for deep insight into how today's working editors get their work done
- Notebook and audio recorder for taking notes and keeping track of ideas
- Patience and an open mind

CHAPTER 12 ESSENTIALS

■ After organizing workflow and files, the editor embarks on a process of building the narrative, starting with a rough initial cut and moving through any number of iterations before the picture is locked and a final product emerges.

■ Editors carefully develop a plan for pacing their film, depending on the nature of the material and their creative goals. A quicker pace evokes more intense reactions from viewers, and a slower pace makes them more thoughtful about the material.

■ There are different styles of editing, depending on the material and your creative agenda, ranging from linear continuity editing to thematic or montage editing, and everything in between. There are some basic principles, or rules, for how to edit a narrative story together, but virtually all of those rules can be violated if the editor has a compelling creative reason for doing so. The most basic principle the editor needs to adhere to is having a good reason for every cut made, or not made, along the way.

■ Good editors analyze the material in depth, strategically searching for the best takes and preferred transition points, and then use a variety of techniques to transition from one shot to another.

KEY TERMS

Cheat cut
Continuity editing
Contrast cut
Cross cut (parallel cut) (intercutting)
Cutaway
Cut-in
Cuts
Dissolves
Elliptical editing
Fade

Final cut
Fine cut
Form cut
Iris (iris wipe)
Jump cut
L cut (split edit)
Light flash
Match cut
Montage editing (thematic editing)
Morph

Parallel editing
Post-classical editing (MTV style)
Relational editing
Reverse cut
Rough cut
Straight cut (hard cut)
Superimposition
Wipe

> **"If you can imagine it, we can make it."**
>
> – John Dykstra, visual effects designer and Academy Award winner on many films, including *Star Wars* (1977), *Stuart Little* (1999), and *Spider-Man* (2002)

Visual Effects and Animation

Stargate (1994)

KEY CONCEPTS

▌ Visual effects ("VFX") constitute an art form almost as old as the medium of filmmaking itself, and a discipline that has relevance for almost every major motion picture in the modern era. In modern filmmaking, the label has come to represent digital effects with a heavy reliance on computer-generated, -lit, and -composited imagery; more generally, however, the term refers to the creation and incorporation of any elements that cannot be captured during principal photography.

▌ Practical effects, called special effects these days, remain part of the picture in some cases—effects achieved in-camera using more traditional methods, including the use of models and miniatures or other effects, such as explosion, that are created live, on-set. But today, the combining of digital and nondigital elements into final shots is almost always done by computer.

In 1994, Jeffrey Okun had a close brush with getting fired while working as digital effects supervisor on Roland Emmerich's film *Stargate*. Okun was responsible for designing the look of the mysterious Stargate portal that sits at the plot's center—a portal that opens and closes for intergalactic travelers. Okun eventually came up with a basic look that Emmerich was excited about. But Okun says his blind spot was the fact that he couldn't describe to Emmerich's satisfaction what the Stargate would look like as it turned on and off.

"Roland hated about 150 ideas I had, but then I shot one more test—filming a three-foot diameter Plexiglas tube with iced tea in it, which I stirred with a drill with a piece of wood attached to get a

nice, soft spin," Okun, now a well-known industry visual effects supervisor, recalls.[1] "Then I shot reflections of sun rays through the iced tea, which I could then pull out as a matte or use digital photography to add onto the [*Stargate* set]. When I showed Roland the footage, he was really excited about the stirring motion—the funnel, or the 'strudel,' as he called it. As you stirred it, it formed a 'V' in the water. He said that is what the Stargate should look like. He loved what we ended up with, but before that, I almost got fired because there was no real way for me to communicate what I was thinking in terms of organic things that you had seen before in the real world, but not in the way I had in mind—I had to show him."

- A solid understanding of the basics of computer-generated imagery (CGI) is crucial to understanding modern visual effects. The processes, workflow, and tools for doing CGI work are now everyday elements in the modern filmmaking paradigm. Some of the creative principles of computer animation, however, are no different from the time-honored concepts of traditional hand-drawn animation.

- Character animation is an art form that dates back to the beginning of modern film—an art form in which the animator "acts" by putting an emotional performance into a character that would not otherwise exist. In the digital world, characters can range from cartoony to photorealistic, and be created using a variety of techniques, including hand-drawings, digital motion capture or performance capture techniques, and frame-by-frame performance animation methods.

- Using digital elements requires you to carefully manage data during the visual effects process. This includes tracking data, using and sharing correct files, naming files correctly, and backing them up. The central requirement in this regard is to always protect original data so that you have pristine backup elements in the event you need them.

The point of Okun's example is that the communication process with his director trumped any technology or technique he had at his disposal. He suggests that creativity, an understanding of real-world visuals, communication, and problem-solving skills are more important to achieving success in visual effects than technical proficiency. Industry professionals agree that the best visual effects training involves studying organic things in the real world in what Okun calls "an interactive way." Indeed, famed visual effects supervisor Ken Ralston insists you won't get far in manufacturing artificial shots "if you don't understand what the final image is supposed to be in your head."[2]

Visual effects wizards have been dazzling audiences ever since the legendary Georges Méliès essentially invented the concept of visual effects when he made 1902's *A Trip to the Moon*. From Méliès to Ray Harryhausen's stop-motion animation tricks to the pioneering work of the original *Star Wars* visual effects team to *Jurassic Park*'s dinosaurs to industry-advancing achievements seen in *Terminator 2*, *Matrix*, *Avatar*, and *Life of Pi*, visual effects have been helping filmmakers tell stories effectively for generations. At their core, all effects emanate from a single need—to build images you can't create during routine photography. Perhaps they are impossible to film in the real world, perhaps you can't afford to do it, or perhaps they aren't safe or logical to capture on-set. Whatever the reason, your solution will involve some part of the visual effects process.

Thus, specific techniques are crucial to comprehend, particularly computer animation, as we will discuss later. Understand that we will use *visual effects*, or *VFX*, in this chapter as shorthand, since today, it is really an umbrella term that is largely built on the foundation of computer-generated imagery (CGI)—a term that incorporates the more specific functions of creating moving images in the computer. As you will discover, the creation of moving images in the computer is also a wider, general label that covers the more specific, but creatively different, disciplines of digital effects generally—the art of adding or combining digital imagery with other digital images or live-action images—and *digital character animation*, which is the art of cre-

A Trip to the Moon (1902)

The Visual Effects Society Award, designed as an homage to the pioneering, seminal visual effects created by George Méilès in 1902.
Top: Photo by Hulton Archive/Getty Images. *Bottom:* Brandon Clark/Alex Berliner/Visual Effects Society.

ating acting performances for digital characters or creatures, giving them life and emotion.

The visual effects department has evolved into a filmmaking hub—almost all departments are connected to, or interact with, the visual effects unit. Today, members of a visual effects department will be on-set for testing and preproduction, as well as through principal and second-unit photography, and they will likely be involved in all aspects of postproduction. Visual effects are no longer a specialized process to worry about "later."

This means that there is now more information than ever to digest regarding what visual effects are, how to create them, and how to use them effectively. Some of the technical nuance and science behind all this are things you will learn later in your education. For now, though, you can certainly grasp the fundamentals of how to create photo-realistic or near photo-realistic images outside of principal photography, and how to blend them with real-world images to create a seamless result. These basics will be the prime focus of this chapter.

VFX Overview

There was a time when visual effects were naturally limited in the greater film-making workflow because they were difficult, expensive, and time-consuming to create in the analog era. Back then, a variety of in-camera tricks and complicated optical printing and projection techniques were developed and used with great skill by talented filmmakers. But even they were restricted by the physics of lenses, reduced camera movement, substantial costs and time pressures, and the need to have scientists put their negatives through laborious photochemical processes—which in most cases were not generally feasible for students and independent filmmakers and by definition resulted in the final effects shot's quality being at least once removed from the original negative, often calling attention to itself.

All that has changed with the CGI revolution. Computer animation, character animation, performance capture, and digital composition have taken over and improved the tasks that were once handled optically in a laboratory. Of course, this has generated a whole new set of complications for you to eventually understand as you move further into your education—data management, backup, and archiving; computer-processing power and infrastructure such as air conditioning and electrical power; workflow design, security, and remote collaboration, and much more. We will discuss certain issues related to data management and protection later in the chapter, but most of the technical details are beyond the purview of this book—especially since the industry is still creating and evolving standards for digital formats, workflows, and techniques. For now, be aware that those issues are looming for you as you move further into filmmaking.

Meanwhile, let's focus on the basic processes of crafting visual effects. It all starts with marking up the script and planning how to use visual effects in your film.

Planning Visual Effects

Before you can get to work on a single visual effects shot, evaluate your script in detail and make hard choices. First, assess with a dispassionate eye what effects, if any, you really need, what your resources are, and what compromises you are willing to make in order to balance visual effects needs with economic and scheduling realities. All the while, have a conviction about what you want your selected final shots to look like.

But you should be decisive earlier rather than later. Many leading visual effects professionals caution against putting off hard decisions on visual effects needs. Do not rely on a general assumption that you can add or change things quickly and smoothly in postproduction. Famed Industrial Light & Magic visual effects supervisor John Knoll, in fact, urges filmmakers at any level, as they evaluate scripts, to aggressively "question assumptions" when it comes to potential effects shots, as "a lot of what they think they can do later turns out to be harder, more time-consuming, or more expensive to accomplish than they think."[3] (See Producer Smarts: Affording Visual Effects, p. 301.)

Tip UNDERSTAND REALITY

Leading visual effects professionals say the best animators are those who have an organic understanding of real-world physics, textures, and movements—how waves break on a beach, what rocks feel like, how sand blows in the wind. Similarly, they recommend taking art, photography, life drawing, and acting lessons to further one's visual effects education.

Therefore, as you evaluate your script, some basic things will quickly become obvious—namely, that there will be some things you won't be able to do. You may not have the funds to build, for instance, an entirely digital city or a period background. In these cases, you might choose to adjust your script; alternatively, you might turn to some of the 2D alternatives discussed later in this chapter or to the strategic use of sound and editing to weave your way past shots you can't fully build with visual effects.

In any case, you will need to do the following:

■ Go through the script and make a rough count of the effects shots it calls for. Strategically eliminate any you think your movie can survive without.

■ Take stock of the tools and manpower you have available. Do you have multiple workstations or just one? professional software or freeware? colleagues or fellow students with skills to help with some of this work, or are you on your own?

■ Categorize shots based on degree of difficulty of the effect and what tools you will likely need to accomplish them. Plan on starting the difficult shots early in your schedule to allow the time needed to create each shot.

■ Make plans for simple effects and fixes—wire erasures and the like (see pp. 304–06)—which are largely things you can accomplish with some practice and with off-the-shelf computer software in some cases.

■ Evaluate where digital matte paintings (see p. 309) or digital set extensions (see p. 304) may allow you to create much broader environments or sets than you can afford to build practically.

■ Create hand-drawn or digital storyboards or previsualization reels to illustrate the basic needs of the effect (see below). These will help you figure out the length and choreography of each shot and allow you to more completely understand what resources you will need to execute them.

Tip GO ANALOG

CGI should not necessarily be the first technique you turn to. Although certain older analog techniques are not used as frequently on the professional level anymore, don't be afraid to use proven techniques, such as the use of things like hanging miniatures and glass paintings, which may be useful and viable on student projects. The trade-off is that they may take up more time during image capture, but cost you less in the end. Consider *all* possibilities when pondering what techniques to use. Bottom line: bring the right "tool" to the job.

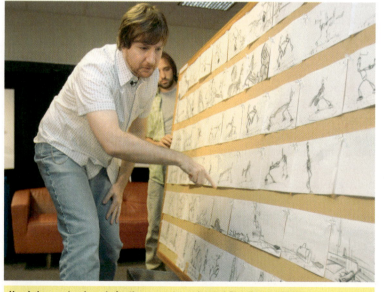

Hand-drawn storyboards for the computer-animated film *Robots* (2005).
Photo by Daniel J. Barry/WireImage for 20th Century Fox/Getty Images.

Storyboards and Previsualization

Your ability to plan shots, solve creative questions, estimate costs, and figure out options sharpens if you have a road map for your visual effects work—a visual idea of how you want shots and elements to look and move: their design, timing, blocking, shot length, and so forth. Since the dawn of filmmaking, some form of previsualization has been routinely used to figure out the basics of shots before committing to them. Even today, hand-drawn storyboards are the starting point for achieving this.

As you learned in Chapter 4, storyboards and other previsualization techniques are frequently used for planning entire films. But they are of

Affording Visual Effects

On major productions, visual effects producers typically handle planning and budgeting chores, working with the director and visual effects supervisor. They rely on complex formulas based on time estimates, typical labor and overtime costs, rendering time, and hardware costs for each shot. Based on those estimates, they budget what they can afford per shot, get bids from various visual effects facilities, and make the best deals possible for their project.

You, however, will likely have a slim or nonexistent budget for visual effects work, no visual effects producer, and no supervisor. You will be handling those jobs yourself and looking for ways around spending money you don't have. And yet you will need some effects shots to achieve your creative goals. How do you figure out how far down the visual effects road you can go? First, think like a visual effects producer and remember that at any level, uncontrollable costs for shots can often be traced directly to poor planning or poor execution during the image capture phase or during the process of executing visual effects shots. To avoid pitfalls, remember the following:

- Understand the process of calculating what shots cost, even if you have no significant money to spend. Figuring out costs and options will lead you to solutions. Therefore, assign an average cost to shots based on the amount of personnel or time you think you will need, the amount of computer-rendering infrastructure you think they will require (a major limiting factor), whether you think you can do the work yourself or will need help, and so on. Keep in mind that capturing elements for visual effects shots can often slow down your production shoot and increase your budget during image capture, so consider those potential costs, as well. A good guideline is that a significant effects shot in major movies these days can typically cost five figures to execute at major facilities—anywhere from $10,000 to $50,000. At the professional level,

such estimates include careful calculations for overhead and profits for facilities or artists. For a student, do away with all that and think only about time and materials to concoct estimates.

- Discuss these estimates with whomever your advisers are—director, classmate, professor, facility representative, supervisor, friend, or parent. Revise and refine the numbers. Drop some shots. Find out who can help you, and barter labor and equipment with fellow students. Strategize your workarounds for other shots, as mentioned earlier.

- Because modern tools are often affordable off-the-shelf, you *will* in many cases have the technology to get basic shots done. But will you have the time? Plan a detailed schedule for yourself and whoever is helping you each day, and be sure to stick to it. Keep in mind that work on visual effects is often done concurrently with image capture and editing, so plan accordingly.

- You likely won't have funds to enlist a facility or professional artists, but conceptually, the idea is the same—you should figure out what you can realistically afford to do yourself. Estimate as best you can based on research, guidance from professors, and a highly conservative approach to picking the digital shots you really need to make your story work.

- The basic concept is this: the more complicated the shot is, the more difficult it will be to execute in terms of both capturing the elements you need and the postproduction process required to put it all together. For example, a human actor being assaulted by an alien creature on a digital spaceship, using real props and computer-generated backgrounds in the windows, will logically be more layered, and thus more complicated, than a shot of a human actor being menaced by a shadowy creature, sounds of an attack and screams, and then a sharp cutaway edit showing the aftermath.

particular importance in figuring out the animation and visual effects processes—indeed, the very tools used for previs today are, for the most part, CGI tools. For modern animated features or effects-heavy movies, storyboards for visual effects look similar to those for any project—a sequence of drawings of one type or another that frequently include dialogue, directions, and notes about each shot. On today's fully animated movies, storyboard artists are effectively becoming cowriters of your story in the sense that their concept drawings will help the filmmaker answer nuanced or detailed questions: Will the character crouch or stand erect in the rainstorm? Will the wind be blowing? Most important, what is their emotional motivation and are they thinking?

These tiny details are not always in the script and, at some point, need to be figured out. Typically, at the concept stage, where storyboards come in, you will begin the process of answering these questions. On animated features, storyboard artists present entire sequences to the director for approval, and frequently, competing imagery will be tried out in storyboard form to finalize concepts. An editor will often cut approved sketches or panels together into a video sequence—complete with temporary voices, sound effects, and music—called a *story reel*, which can be viewed on a big screen. Thus, you effectively make a rough template of the film before you even start shooting or animating.

What has changed in recent years is the ability to create not just still images for storyboards or story reels but also rough animations—previsualizations, as discussed in Chapter 4. In today's film industry, there are entire companies that do nothing but previsualization for major projects, particularly for visual effects work. However, the beauty of the concept is that you can make it as sophisticated or as simple as your goals and resources allow.

So if you don't have time or money for sophisticated animation sequences, you can simply film your hand-drawn storyboards and edit them together as a story reel, much like an old-fashioned flip book. You can also use low-end software to create simple animation—even stick figures will do. With off-the-shelf editing tools, you can combine in an evolving story reel all of these things—previs animation, still photos, paintings, and even rough photography from tests or other movies.

In other words, there is no specific rule for previsualizations beyond the simple notion that they be designed to guide you to finding creative, financial, and technical solutions. In animated films, such techniques are priceless, because the basic nature, amount, rhythm, and flow of all shots in the movie will be approved off the previs reel, often called an *animatic*, leaving less room for errors and changes along the way. In live-action films, a particularly complex effects shot that might take until the very end of production to produce and cut into the final movie correctly can be seen, known, and understood by filmmakers while they put other elements together. Like a construction blueprint, animated features and sequences can now be fully digested by those making them in advance of their actual creation—a particularly handy tool in the visual effects world.

Typical Visual Effects

Throughout this chapter, we refer to *visual effects*, *digital effects*, and *special effects*. In earlier years, the term *visual effects* was used interchangeably with *special effects* in the sense of referring to the photochemical/optical processes that were used before the advent of CGI. Today, however, the terms *visual effects* and *digital effects* are used interchangeably, whereas **special effects** and **practical effects** are used interchangeably to describe the manufacture of elements outside the computer in the real world. Let's discuss digital effects specifically in the con-

LEARN ALL STAGES

Although many visual effects facilities want artists to specialize, learn as much as you can about all stages of computer animation. You will be a better visual effects artist or character animator if you know how the model should be lit, a better compositor if you understand the nature of the elements you are working with, especially light, and so on through the many stages.

text of their most common modern uses. Here's a look at some of the basic *types* of effects you can achieve with CGI:

■ **Natural phenomena.** Rarely will filmmakers be able to shoot exclusively in the weather that their script happens to call for at every particular moment. Digital effects are thus frequently used to create rain, snow, wind, smoke, tornadoes, landslides, tidal waves, and so on. Classic examples of digitally created major environmental effects would be Jan de Bont's *Twister* (1996) and Wolfgang Petersen's *The Perfect Storm* (2000)—two movies where digitally created environmental effects were at the center of the plot. On smaller projects, such as *Snow Falling on Cedars* (1999), filmmakers used digital effects more subtly to sprinkle snow on the landscape, since there was no snow at the location where they shot the film. Keep in mind that you can effectively use digital technology to make subtler enhancements to weather phenomena in this way.

■ **Fire and explosions.** When scripts call for fire or explosions on a scale that is simply too dangerous, expensive, or time-consuming to film, a wide range of digital techniques exists to create photo-realistic equivalents. Sometimes the fire is entirely digital, sometimes a small fire element is filmed on a special stage and then digitally cloned and enhanced to grow in scale, and sometimes significant pyrotechnic effects are used and then enhanced or tweaked in the computer, where the effect is simulated through complicated simulations.

■ **Creatures and characters.** Digital technology has allowed filmmakers to create creatures, monsters, robots, animals, and aliens for years, but there is a distinction to be made between digital creatures and digital characters, an art we discuss later in this chapter (see p. 312). In 1993, *Jurassic Park*'s dinosaurs brought creature work to new heights with stunning, photo-realistic movement, and the industry has built on that work ever since. Then, believable characters, featuring the central element of character animation—emotion—in combination with realistic movement, the character developing empathy from the viewer, rose to the fore with breakthroughs like *Stuart Little* in 1999 and, of course, the incorporation of motion-capture techniques into the paradigm for 2001's *The Lord of the Rings: The Fellowship of the Ring*. Next, James Cameron used performance capture techniques to animate photo-realistic characters for an entire feature film in 2009's *Avatar*, and now, creatures and characters are so commonplace that creature work and character animation have become crucial parts of modern filmmaking.

■ **Backgrounds/environments.** The use of digital environments and backgrounds in live-action films is even more prevalent. This capability, and the wide range of techniques for executing it, can be seen in a large swath of today's motion pictures. Sometimes the background is for particular shots or sequences, sometimes digital environments are used to establish or enhance a point, and sometimes digital backgrounds have been used for entire live-action

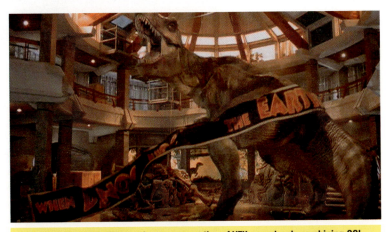

Jurassic Park (1993) pioneered a new generation of VFX, seamlessly combining CGI and animatronic dinosaurs.

movies. The methods for achieving these backgrounds—from the creation of all computer-animated environments to the combination of CGI with real environments to the use of matted or tiled photographs—are continually evolving and are a rich area of advancement in digital effects today.

■ **Set extensions.** This is a technique now routinely used even by filmmakers who largely focus on non-effects-oriented dramas, such as Martin Scorsese, Clint Eastwood, and Ron Howard. The technique is particularly useful for period films, or for any movie in which an entire realistic set or location cannot be used for shooting. Filmmakers simply shoot on whatever set or portion of a set or a location they have available, and/or against a green screen, and task their visual effects department with "extending" the location. That might mean taking out modern buildings or wires or environmental factors captured on the photographic plate, or building computer-generated continuations of sets or buildings in which photography took place. This method is frequently cost-effective in that it reduces the need to build elaborate sets or travel to far-flung locations.

■ **Digital makeup.** This technique involves the ability in postproduction to digitally create, fix, or adjust wrinkles or spots or wounds on the flesh of real human actors or animals to replace or enhance real-world makeup. Also, younger actors playing older characters, and vice versa, benefit—check out *The Curious Case of Benjamin Button* (2008) for a radical example. With the introduction of increasingly higher definition cameras capturing more detail, this technique is becoming a large part of work of "invisible" effects.

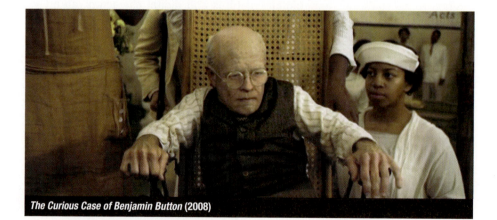

The Curious Case of Benjamin Button (2008)

■ **Wire removal and motion blur.** The ability to use computer graphics to fix real-world photographic plates by removing or adding photographic anomalies is a time-honored tradition. **Wire removal** simply refers to the fact that elaborate stunts or special effects sometimes require the use of special rigs, wires, ropes, or harnesses for safety on-set that cannot be hidden during filming. In these cases, visual effects teams use computer software to erase the out-of-place items and fill in the background where they once stood, so that viewers will never know they were there to begin with (see Action Steps: Wire Removal, p. 305). Similarly, manipulating **motion blur** revolves around making certain types of moving images appear more organic and natural to the human eye. When objects move fast in real life, the human eye sees a modest blur of movement as the object moves from one point to another. This phenomenon is missing when computer-animated items move unless it is in-

tentionally added, and so filmmakers now use computers to do just that.

- **Fantastical effects.** This term refers to the notion of creating phenomena that do not really exist. In addition to producing fire, explosions, and various environmental effects, **computer animation** is the logical tool for manufacturing any magical, mystical, or fantastical effect that a filmmaker's mind can conceive. It might be something as simple as the legendary *Star Trek* transporter effect or *Tron*'s neon-glow-hued clothes and weapons, or something more complex, such as *Terminator 2*'s "morphing" effect and some of the magic seen in the Harry Potter movies.

- **Visual language.** Due to the physical limitations of cameras and lenses, such as weight or imperfections in lens glass, imagery contains certain visual anomalies—unwanted artifacts from the photochemical process—which the audience may or may not notice on the surface but which they are used to at a subconscious level. An example would be *lens flare*—the phenomenon of light scattering through lens glass in such a way as to produce multiple unplanned light reflections. This does not happen in the digital world because no physical lenses, with their imperfections, are involved. And yet the human brain and eye expect to see such "reality" at some subtle level; thus, the visual effects team is sometimes tasked with adding those anomalies to make digital footage more realistic, as though it were filmed with a real-world camera.

Practice

CONCEIVE AN EFFECT

Conceive a short movie sequence that takes place somewhere you most assuredly cannot shoot—an alien landscape, the bottom of the sea, the top of a mountain, and so on. Compile a list of detailed bullet points explaining what the shot is and precisely how you would propose affording and executing it on a student filmmaker's budget and timeline. Will you be able to previsualize it or create your own storyboards? Will you be able to shoot your actors in front of a green screen and composite them together with a digital background, or will you use stock footage or tiled photographs? Describe the sequence, your plan, and how you would allocate resources to achieve your creative goal.

ACTION STEPS

Wire Removal

Wire and rig removal is an important use of visual effects because a director's options would be severely limited if he or she could not permit wires to be captured in a shot. There are dozens of methods and tools for this kind of work, but here are the basic approaches:

1. **Patching.** With this technique, digital artists search through photography from the set, both final shots and outtakes, to find frames showing the same background but without any wires present. Using their software, they essentially cut that piece of the background out from the extra footage, and patch or paste it over the wire or rig in the original frame. If your camera is static and there is little or no movement in your frame, this approach can be quite effective; however, this technique does not work well if there are cameras or actors moving around, since such movement causes blur, grain, and other types of anomalies. Shooting a *clean plate*, the set without the actors on it, can often make this task easier.

2. **Stabilization.** For frames in which there is movement, there are software tools you can use to stabilize the image, and then "paint back" to a frame in which the wire is not present and patch it into the necessary spot.[4] In this case, however, you are painting back to a frame that also had movement, and so you need to use software to massage the resulting motion blur until the difference between the two pieces is difficult to see.

Continued

Continued from the previous page

❸ **Roto cloning.** This technique involves *rotoscoping* (see pp. 314–15). Certain powerful compositing tools are able to automate much of this process, whereby you cut out an accurate matte of the wire and then the software minutely shifts into that cutout a piece of the background from earlier or later in the shot, when the wire was not present. This method can usually make motion blur and lighting shifts appear seamless, but artists need to be careful about making sure sharp edges of the matte are not visible with the movement. The other difficulty with this technique is that it requires highly sophisticated and expensive compositing tools to achieve the best results.

❹ **Background replacement.** This is a method used when the nature of the shot, the amount of wires, and logistics make it hard to cut out mattes cleanly and either rotoscope or replace tiny pieces of frames, as was the case in the fantastical martial arts battles in *Crouching Tiger, Hidden Dragon* (2000). In such cases, filmmakers cut out actors and objects as mattes themselves, and composite them back into an entirely fresh live-action or computer-generated background without wires. This technique can work with 2D backgrounds, in which artists cut out pieces of the live-action background from any frames that were photographed without action in them, and then create a wide shot of the background into which they can insert and track their actors and action. When 2D replacement is not feasible, they can opt for a full-on 3D environment reproduction.

Special Effects

Today, special effects are generally considered to be physical real-world techniques—things you can photograph in front of a real camera, as opposed to digital effects. For decades, special effects typically fell into two basic categories: **mechanical effects** and **optical effects**. As we shall discuss, some mechanical techniques remain important in terms of creating certain elements for visual effects shots, including *pyrotechnics* (explosions, fires); *animatronics*; car crashes; artificial wind, rain, and fog; and the photographing of *models* or *miniatures* (see p. 310).

Optical effects involved methods of photographing images using camera and laboratory tricks. For years, the industry relied heavily on **optical printer** technology for much of this work. Optical printers were specialized pieces of hardware that were used to combine positive or negative images into new compositions on an entirely new piece of film. They were essentially movie projectors connected to movie cameras and, for decades, were the most powerful tool Hollywood visual effects artists had at their disposal.

FIGURE 13.1 The Linwood Dunn optical printer, named for the pioneering visual effects specialist

The device itself was awarded an Academy Award.

Photo by Kirsten Dowling/Getty Images.

How Do I . . .
Embrace Simplicity in Visual Effects?

Go to LaunchPad and find out: **macmillanhighered.com/filmmaking**

Ken Ralston
VISUAL EFFECTS SUPERVISOR: ALICE IN WONDERLAND, MEN IN BLACK, STAR WARS

NAME:	**Ken Ralston**
TITLE:	Visual effects supervisor
SELECTED CREDITS:	*Alice in Wonderland* (2010); *Forrest Gump* (1994); *Who Framed Roger Rabbit?* (1988); *Back to the Future* trilogy (1985–90); Original *Star Wars* trilogy (1977–83)

As we've discussed throughout this book, as a student filmmaker or even as a professional, you may not always have access to as many resources as you would like. This doesn't necessarily have to be a problem. Having worked on many huge studio films over the years, award-winning visual effects supervisor Ken Ralston now often has access to near-limitless resources, but he stresses the importance of believability over expensive effects. Ralston talks about his experience creating believable special effects in a video interview available only on the LaunchPad for *Filmmaking in Action*.

RETURN OF THE JEDI

Discover

▌ How some effects in the Star Wars trilogy are simpler than they appear

▌ Why inexpensive tricks can be as convincing as more expensive shots

▌ How Ralston takes inspiration from visual effects pioneer Ray Harryhausen—and how you can, too

Visit the LaunchPad for *Filmmaking in Action* to learn more—and to explore how you might use this advice.

FILMMAKING

Batman Begins (2005)

Computers have taken over and expanded on these functions, however, and so the optical printer has faded into the past, although the types of illusions it was used for march on in the digital era. Mechanical techniques, by contrast, retain an effective niche to help digital artists craft a greater whole consisting of both real-world and virtual images. The strategic linking of certain practical and digital methods, in fact, lies at the heart of modern visual effects.

Even if your work largely relies on digital tools, understanding practical techniques will be useful, many industry professionals say, because they will give you a frame of reference for relationships and interactions between physical objects based on real-world physics, which you will need to consider as you craft shots. Plus, prominent filmmakers like Christopher Nolan (the modern Batman franchise, *Inception, Interstellar*) still rely heavily on mechanical techniques. And Ken Ralston insists that his own "understanding of spatial relationships comes from working for years with miniatures and being physically on set, getting tactile experience. Work that information into your brain, and then you will rely on that information later, even when you are working with computers."[5]

Therefore, on the high end, practical effects remain a useful piece of the puzzle; and on the low end, they are sometimes more affordable to execute than digital alternatives. Either way, major industry names feel mechanical techniques remain important to understand in a digital filmmaking world. Well-known visual effects supervisor Jerome Chen, for instance, calls them "essential—I can't do my job without them. It's always a good idea to get some of the real world into shots to create the best illusion."[6]

In other words, understanding how practical and digital effects are executed independently, and how they can be combined and used in tandem, will make you a better filmmaker.

Mechanical, or practical, effects take lots of forms; often require a wide variety of equipment and expertise; and, in some cases, cannot be attempted without proper training, licensing, safety procedures, and supervision. Staging a straightforward car crash safely, for instance, is certainly something no first-year film student should attempt. Here is a brief overview of several key techniques:

- **Animatronics.** This term refers to the physical animating of puppets, robots, or other inanimate objects on-set using carefully calibrated and controlled motors and other mechanical methods. **Animatronics** have been used for decades, but became less popular after the CGI revolution. Today it is often augmented by computer-generated imagery to digitally remove flaws or imperfections in the automated character, but the technique can be quite expen-

sive and, at the professional level, is typically handled by niche companies that specialize in animatronics.

▍**Front and rear projection.** These are in-camera processes of projecting previously filmed or created foreground or background elements in front of or behind an actor or a scene you are photographing on-set to create the optical illusion of those separate layers being combined as you film.

Oblivion (2013)

This scene includes use of a high-tech, modern version of classical projection techniques using powerful digital projectors.

▍**Matte paintings.** Originally, matte paintings were done by hand on glass or on background screens that were photographed with live action to create the illusion of actual backgrounds—essentially artistic renderings of a landscape or location. Today, computer matte paintings have taken over to a large degree, but hand-painted mattes are still an effective artistic choice with certain kinds of materials and on low-budget projects for which computer backgrounds are not feasible.

The Wizard of Oz (1939)

A classic example of a traditional matte painting technique.

■ **Miniatures and models.** This is essentially the building, manipulation, and filming of scale-size models to create illusions that, when combined with other elements and projected from the correct perspective, appear to be life size and real. This was a great art in Hollywood for generations and is still used today, often in combination with computer-generated effects.

Star Wars (1977)

The original Star Wars films made extensive use of models and minatures.

■ **Hanging miniatures.** This is a popular way to use models to create special-effect shots in-camera. In this case, miniatures are used instead of a matte painting in the foreground of a shot, with action taking place behind the miniature. This is a **forced perspective** optical-illusion technique—a way of showing the audience a point of view that appears to make an element seem closer, farther away, larger, or smaller than it really is, when photographed from certain angles.

■ **Motion-control photography.** Once common for special-effects work, this method remains in use today, although only for specialized applications due to cost and logistical limitations. The basic idea is to establish mechanical or computerized hardware command of a camera in order to precisely control its movement to repeat or copy previous camera movements. In the analog era, motion control was done with expensive and laborious mechanical systems; later, computer control systems took over. Today, the expense and time it takes has largely forced the industry to move toward digital camera tracking techniques, discussed later in this chapter.

■ **Pyrotechnics.** This is basically the art and science of using explosive or flammable materials in a controlled manner to safely create and film manageable fire and explosion elements. This technique is usually strictly regulated, and typically requires special licenses, permits, and, sometimes, safety equipment and personnel, depending on the nature of the stunt and the jurisdiction where it is being conducted. On a student project, you should *never* attempt a pyro effect without first obtaining permission from your professor and school, and all appropriate authorities, as it can be extremely hazardous if you don't know what you are doing.

■ **Stop motion and go motion.** These are forms of a time-honored animation technique that effects pioneers Willis O'Brien and Ray Harryhausen made famous in the pre-digital era. They involve the photographing of models, puppets, props, and other elements one frame at a time, moving them minutely for each frame so that when they are edited together, they give the illusion of

Tip **USE OPTICAL ILLUSIONS**

Understand how the human brain processes imagery. Many optical illusions can be used on-set to trick the brain, if you know how they work.

motion. Go motion is a variation on stop motion in which motion blur is strategically mixed into each frame by slightly moving the animated object during exposure of each frame in-camera, resulting in a naturalistic motion blur.

- **Squibs.** These essentially function as tiny explosive devices configured with electrical triggering mechanisms. They can be used to generate small explosions or bullet holes on-set or be filled with liquids to simulate blood spurts.

- **Weather effects.** These involve the use of sprinklers, hoses, water tanks, air hoses, fans, and special fog and smoke machines to emulate real-world weather conditions.

Computer-Generated Imagery

As mentioned at the start of this chapter, the foundation of modern visual effects is the art of manufacturing **computer-generated imagery (CGI)**. CGI started as a revolutionary scientific breakthrough that eventually altered the entire motion-picture industry in a fundamental way. After all, CGI methods are used to make an entire genre of modern movies—CGI-animated films, which are among today's biggest performers at the box office—and to routinely make chunks of *many* live-action movies, chunks that are then strategically combined with live-action material.

The ability to make, move, blend, and alter images in the computer is a process born out of a series of breakthroughs in recent decades in the creation and use of complex mathematical algorithms that, at their most basic level, instruct a computer what operations to perform—and how to perform them—in order to produce different types of shapes, surfaces, and images. There are many types of shapes and forms the computer can create, such as basic *polygons* (plane figures with three straight sides that, when joined together, form more sophisticated images). If you pursue computer science or go deeper into animation, you will learn more about the other forms, but for now, the mathematical underpinnings of CGI are not nearly as important to your training as the creative uses of the art form. At this stage, focus primarily on the basics of computer animation generally, character animation, and compositing. We will devote the rest of this chapter to these topics, starting with computer animation.

Think about the process of computer animation in the same way you would think about physically creating real models for animation purposes, regardless of whether you were creating animated characters or simply objects or elements. (A bit later in this chapter, you will learn techniques for putting performance and emotion into characters during the character-animation process.) In the real world, you might start with a lump of clay and build a flexible wire frame that sculptors call an **armature**. You would put clay on top of the frame; hone the surface and details and colors until you achieve your desired creative result; and then put it on your real-world set, light it, move it, and film it. If you were creating a character, perhaps you would build a marionette. First you would create the puppet, then you would attach strings, and then a puppeteer would take the marionette and create a performance with it. (Animators are puppeteers in this sense, taking over after other technicians have built and configured the "puppet.")

Essentially, these are the same concepts behind the creation of basic digital elements or characters, except you do them in a computer. Following are the primary technical steps in the computer-animation process for movable objects (you will obviously skip the animation steps if you are dealing with a background or static image):

Modeling Based on your designs, you will use computer-animation software to build a digital model of the objects, background, creatures, or characters you want to create. The software creates a rough wire frame based on parameters you provide. (This is essentially a digital armature.) It then calculates the geometry necessary to produce your basic wire-frame model. Once the armature is set up, you can add rough surfaces to it; this embryonic model is what you will use to program basic characteristics, including animated movements if needed, in the next stages. The thing to remember is that, as a modeler, you are creating a skeleton for the physical object.

Rigging Riggers, also known as character TDs (technical directors) or setup artists, essentially take rough CGI skeletons and decide how creatures or characters should move by building bones, joints, and muscles onto the model and programming them with controls (instructions) on how they'll move when triggered by animators. To take our puppet analogy further, they are essentially putting strings on the object. Those instructions can be programmed by hand, although in some applications they consist of imported motion-capture data (see p. 318). The process of **rigging** (**setup**), in other words, is all about how the character or creature will be *capable* of moving. The rigger determines how filmmakers want the character's "physical" systems to move—in as realistic a way as possible or in an exaggerated way, depending on the filmmaker's wishes. The rigger uses the software to program joints and movable areas of the body with various mathematical instructions that will tell the model how to respond to virtual controls that the rigger has built into the model—how to jump, turn, run, and so on. If you are rigging an animated character, then the rigger and character animator will collaborate closely during this process, since the animator will eventually be the one who decides exactly how the character *will* move in the final product.

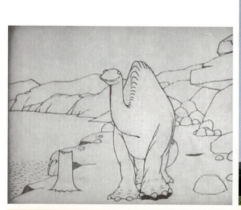

Gertie the Dinosaur (*left*, 1914) was the first animated dinosaur in motion picture history. Its descendent, *Jurassic Park* (*right*, 1993), ushered in an entire new era in filmmaking.

Layout For environments and character positioning within those environments, your next phase will be layout, which is generally done in two stages—rough and final. During the rough layout phase, you will essentially use hand-drawn storyboards or digital previs material to guide creation of preliminary 3D environments in the computer. You will use the software to decide on initial camera placement and motion, and staging and blocking for where the digital characters will be located within the environment. In a sense, the layout artist is blocking out how digital cinematography will work in computer-generated sequences. After you approve the rough layout, you will move into final layout, which means you will eventually replace rough characters and environments with final characters and other assets as they become available. Once final layout is done, character animators will finalize character performance choices.

Animation After models are rigged and the environment and camera-movement approach are laid out, animators can make computer models move in a realistic manner to create the motion necessary for the model to move through the frame. They do this by working closely with the director to figure out what creative movements and paths are preferred, and then using hundreds or even thousands of digital controls built into the model to achieve those movements. If the model is a digital character, then, of course, the animator will be functioning as a character animator or actor, who will be directed by the film's director just like any other cast member. (See p. 317 for details on the character-animation process specifically.)

Surfacing In most animation-software packages, computer models are dull gray, looking somewhat like actual plain clay. When **surfacing**, your job is to add texture and color to the mix. What you add depends solely on your script, the creative desires of your director, and logic—animals need fur, robots need a metallic sheen, and so on. Typically, surfacing artists work closely with lighting artists to tweak the final look of surfaces and textures. In fact, one of the exciting developments in

Movies like *Life of Pi* utilize both practical and digital effects: the Oscar-winning *Pi* used practical effects to shoot water-bound sequences in a giant tank, while digital effects added to the illusion with new backgrounds and CG characters.

computer animation in recent years has been the advent of various breakthroughs in texturing surfaces.

Lighting As discussed in Chapters 8 and 9, live-action filmmakers use light as a painting tool to emphasize surfaces or skin, bring out colors, illuminate action, and impact the audience emotionally. The goal is exactly the same with digital lighting. Using animation software, you will position digital lights in certain locations, at certain angles, at certain levels, and at certain hues. Most major software packages give artists a wide range of lighting tools, as well as tools to analyze and compare positioning and use of lights in the live-action plate of a visual effects shot so that the animation team can emulate real-world lighting. It is critical that you, your visual effects supervisor, or some team member do your best to record the physical lighting setups used during production, in order to give you enough data to replicate light conditions on-set in the computer.

Effects You will also need to add any effects your story calls for. An effect is anything that moves of its own accord in a scene without involving an actor or an animator doing any acting. In some cases, you will be adding live or practical elements you have photographed on a stage or location; in other cases, you will be adding digitally created elements; and in still others, you will be adding both. If the effects are digital, they will be designed and animated in the same process we have described. If they are live action, you will scan the image into the computer so that you can combine it with your scene using digital compositing tools (see below).

Tracking The **tracking** process is also called *match moving* or *motion tracking*. It is linked to the compositing process described next because it helps you combine live and digital imagery seamlessly—you will need some sort of tracking solution if any elements are, in fact, moving. The general idea is to track the movement of a real camera through a live-action shot so that an identical camera move can be created during the animation process. Tracking is a way to record the exact position, scale, and movement of elements in live-action footage, and apply that data to the virtual camera. Over the years, the process could be painstaking because accommodations had to be made both during filming and in postproduction for data to be captured accurately. Sophisticated 3D camera trackers have been developed, however, that can analyze and track every element in a piece of live-action photography once it is scanned into a computer, down to the pixel level in many cases, making the process less laborious.

Compositing The general definition of **compositing** is the seamless combination of two or more images into a new, final image. Digital compositing is the computerized version of the original optical method of doing this task. Some composites involve dozens, even hundreds, of elements—or *layers*, as they are often called. There is a crucial production element to compositing—the acquisition of live-action plates that will eventually be combined with other live-action plates, digital plates, or both. Typically, a **blue screen** or **green screen**, often called a *chroma-key*, are used on-set to allow capture of only what you need for the composite by photographing an element against a color background from which it can be digitally cut out as a matte, then stitched and tracked together with other elements similarly cut out for placement into a new background (see Action Steps: Plate Photography on the next page). A **matte painting**, then, is an isolated element that can be used as a puzzle piece to be strategically combined with other pieces. A specialized

technique that is part of the larger compositing process is called **rotoscoping**, or **roto**. It evolved out of an animation technique used for early cartoons by which animators traced over live footage by hand, frame by frame, and then lifted those elements, or rotoscopes, out of the frame and added other elements or drawings before putting the shot back together. Computers have taken over the chore, but digital rotoscoping remains an important process today.

Rendering In computer graphics, **rendering** is the digital "baking" of a raw animated or wire-frame image so that it fully forms the textures or surfaces that are intended to be part of the final product. This is generally the final step for computer-generated images. Today, there are numerous software tools that offer rendering techniques that range in degree of complexity and methodology, as well as in the quality of the final image—you will learn about these different options later in your film education. For now, keep in mind that in all these cases, rendering is the one area of computer graphics that remains particularly hardware intensive, because large digital files require lots of computer processing power to render efficiently. Major facilities have *render farms* for this purpose—rooms filled with processors that run day and night, rendering shots as they are finalized. For smaller projects, rendering can sometimes be done near real time for modest-sized files. Indeed, that reality is the key to breakthroughs in modern-era video-game platforms, which now have the ability to render images in real time while you play the game. But for major visual effects, rendering remains one of the most time intensive parts of the process.

> **Tip USING BLACK SCREENS**
>
> Under certain conditions, you can use black screens to shoot elements, since black is neutral. If your photographic exposure is just right, you can sometimes use the element without having to extract it as a matte first. Frequently, filmmakers have used black backgrounds to shoot organic elements, such as smoke.

FIGURE 13.2 Left to right: a wireframe model, a pretextured computer model, and the final rendered version

Images by Kevin Temmer courtesy of Ringling College of Art and Design.

ACTION STEPS
Plate Photography

The term *plate* refers to any isolated image, whether a still or a moving picture, created specifically to be merged with other elements to build a visual effects shot. At the basic level, you acquire a background plate on-set and one or more foreground elements to create a typical shot. Capturing visual effects plates on-set can be quite challenging. Important aspects include the following:

❶ Choosing your background. Today, filmmakers typically use green screens because modern digital cameras tend to be extremely sensitive to the color green due to the nature of their imaging chips. The exception is when you are shooting an element that has a lot of green in it. In that case, use a blue

Continued

FILMMAKING

Continued from the previous page

screen to make sure edges of the green element won't be lost. In any case, the concept is to end up with a chroma-key that will have nothing from the background attached to it. Professional screens can be expensive to rent or buy. You can paint a blank wall using chroma-key green paint that is relatively affordable, or you can make a hanging screen. If you make a screen yourself, you can use paper, muslin cloth, or foam-backed cloth. Keep in mind that your goal is to have a green screen that scatters light evenly, and certain materials scatter light better than others.

2 **Choosing your camera.** Photography of elements against your background needs to be of the highest quality possible because the image will be manipulated in a computer later. Therefore, the best camera, deepest resolution, and highest pixel count will help avoid an element that degrades as it is manipulated. Thus, even today, some filmmakers still shoot background plates on fine-grain film stocks, even if the rest of the show is being acquired digitally. Newer digital camera systems, however, have made this less of an issue because of technical improvements. But with digital cameras, filmmakers try to capture plates as full-bandwidth 4K uncompressed images when possible. When that is not feasible, try to capture at least a compressed 4:2:2 image for a quality chroma-key.

3 **Positioning.** When shooting elements, think carefully about positioning them, as well as your camera's positioning and shooting angle. Normally, you want to position your subject far enough away from the screen that no shadows are visible. Then, position the camera so that the subject appears in perspective and not distorted as it relates to other elements. When possible, you want your camera to match the height of the camera or virtual camera used to capture foreground elements. Additionally, make sure you are shooting your background image from the same horizontal angle as you plan to show your foreground element. If both background and foreground are not shot using the same camera system, be careful about using similar lenses to match the viewing angle for each element. Also, camera tilt is important if you have characters moving in three-dimensional space. This is because the horizon—sometimes called the vanishing point—in the foreground needs to match the horizon in the background.

4 **Lighting.** When shooting either foreground or background elements, take note of the lighting configuration if you are on a stage or the sun position and angle if you are shooting outside, and any other lighting data (color temperature) you can calculate, so that you can match them when shooting other elements. Think about lighting to satisfy how two separate things will come across when the image is captured—the screen itself and the element you are shooting. Generally, it is best to shoot the background first and try to match foreground lighting to what you used for the background. Also, light carefully to avoid shadows and light bouncing from unintended sources. It's good practice to light the screen first before adding elements to your frame.

Character Animation

Now that you have the technical overview of the basic steps in the computer-animation process, whatever software tools you use should allow you to create models and rig them with the controls and capabilities you will need as the animator to achieve story goals. But when it comes to **character animation**, manipulating any digital character to have emotional impact successfully will require much more than mere technical proficiency—it will require you to think like both an actor and an artist in order to merge several goals together in your creative work. Character animation, whether done by computer, by hand, or by photographing stop-motion puppets, is about one thing and one thing only—the illusion of life. Achieving this goal to a level sufficient for satisfying an audience depends far more on your ability to create and "perform" the character as an actor would, than on any of the mechanical techniques previously described.

Key Techniques

The first step in character animation is actually a question: Why do these characters need to be animated? Once you're sure that the creation of an animated character is driven by the story, it's important to understand what the digital character is thinking and feeling at a particular moment in the story—just like an actor. You will also need to know how to externalize that emotion with the tools at your disposal. To do that, you must determine the *purpose* of every single movement you intend to program your character with.

All this is precisely why experienced industry professionals routinely urge those who wish to be animators to take acting classes. They also suggest keeping a mirror at your desk so that you can see yourself physically acting out particular movements you want to put into your character. In addition, you should become an observer of others, sketching and photographing people and animals in movement, and taking note of movement in other movies or videos. Even if you are animating an alien or a monster, it will need to interact with some kind of environment and other characters in a way that the viewer needs to comprehend from his or her experiences in the real world. It's also a good idea to watch classic 2D animation; after all, the goal for an emotional connection and movement the audience can accept and enjoy (and not be distracted by) is exactly the same whether you are using a computer or a pencil.

Learning all the techniques behind character animation takes years of hard work, but here are a few key principles based on ideas from longtime Disney animators Frank Thomas and

Tip **PRINCIPLES OF ANIMATION**

If you are interested in character animation, it's a good idea to read *The Illusion of Life*, by former Disney animators Frank Thomas and Ollie Johnston, which is still considered an animator's bible. Among other things, Thomas and Johnston suggest 12 principles of character animation one should follow, involving character positioning, building anticipation into the action, overlapping action, and making sure acceleration follows the laws of physics.

Pixar's *Luxo Jr.* (1986) uses character animation to lend personality to a pair of desk lamps.

FILMMAKING

Ollie Johnston out of their seminal 1986 book on character animation, *The Illusion of Life: Disney Animation*, and also from Pixar founder John Lasseter:

- Every movement of any body part needs to have a specific purpose and appear to the audience to occur out of some kind of thought process on the character's part. The thought and personality of the character should impact its movement, and how the character physically acts should always help the audience understand what the character is thinking or feeling.

- Leading with the eyes or head is an excellent technique for illustrating that the character's upcoming motion is something it thought about first.

- The exception to the notion that the character should first think about an action is when the character is reacting instinctively to some unexpected force. In such cases, unless you are going for exaggerated movement, studying and comprehending real-world physics is an excellent way to illustrate the character's response to an external action—falling down, flipping over, ducking instinctively, writhing in pain.

- Mix it up—do not have the character act or move exactly the same way when in different emotional states. The gait of the walk, the facial expression, and so on, should be different when the character is happy, sad, bored, angry, and so forth.

- Similarly, when animating multiple characters, do not have them all act and move the same way, unless a particular story point requires it. There needs to be the same kind of uniqueness in each character as there would be in real life.

- Timing is everything. Allow the audience to *anticipate* actions or prepare them for actions, and likewise give them time to react to actions. For example, a second action should start a fraction of a second before the preceding action has finished. This helps make sure there is continuity and that the audience's attention will have no time to wander away.

- As Lasseter says, "In every step of the production of your animation—the story, the design, the staging, the animation, the editing, the lighting, the sound, etc.—ask yourself why? Why is this here? Does it further the story? Does it support the whole?"[7] Knowing *why* your character moves, he says, is much more important than knowing how to move it. If you take that as a guiding principle for character animation, you will be off to a solid start.

Motion Capture

In recent years, the art of character animation by computer has been greatly impacted by the proliferation of another digital breakthrough—the so-called motion-capture process, sometimes called *performance capture*. At the simplest level, **motion capture**—or **mocap**, as it is often called—is a process of using sensors and specialized cameras to record the movement of a living person or creature, translate those recordings to data, save that data, import it into a computer-animation system, and apply it to the digital controls for CGI characters to permit them to have more realistic movement. The process has been around for years and has become more popular as the technology has evolved, as demonstrated by James Cameron's *Avatar* in 2009. That film advanced the art and science of the technique at the time, using motion capture to animate dozens of detailed digital characters for the entire movie, and breaking box-office records along the way. *Dawn of the Planet of the Apes* (2014) took mocap's ability to portray highly believable crea-

Tip

CAPTURING THE CAMERA

Camera movement itself can be mocapped by placing markers on a camera taping a performer, giving animators access to data of the camera's exact movements in order to replicate them in the virtual world. On the Academy Award–nominated animated film, *Surf's Up* (2007), this approach was taken to an entirely new level by allowing the film's director to view the animation through a real camera viewfinder and then record the movements of the camera to create a "handheld" documentary feel to the camera's movement.

tures on a big screen even further, and the technique continues to play a growing role on major Hollywood films.

Indeed, mocap is relatively commonplace today and is almost ubiquitous in video games. Mocap's rise certainly brings up issues regarding the role of the actor in the digital era, and how all-digital films can be made more efficiently in the future. Many directors certainly like it because it gives them the ability to "direct" animated characters down to the smallest, most nuanced movement. On the other hand, dedicated motion-capture hardware and the staging of mocap sessions can get expensive and often be technically complicated. Remember that mocap is not exactly "plug and play," and should not be thought of as a shortcut; in fact, animators are frequently needed to tweak raw mocap movements in animated characters to meet a project's specific needs, particularly those concerning **facial capture**—relying on mocap systems specifically designed to capture subtle motion of facial muscles.

But no matter how you feel about those issues, mocap is a useful tool under certain conditions and a permanent part of the CGI industry. Indeed, many film schools and media centers now offer students and professionals motion-capture equipment and stages. As such, it will be useful for you to learn the basic aspects of the technique:

▌ Outfit actors in special skin-tight suits, which have reflective markers or lights stitched into them at various locations, particularly at the joints. Set up special infrared camera systems on a specially configured stage to bounce light off the markers so that computer sensors can record the light patterns bouncing back and save that data to hard drives. Alternatively, in recent years, mocap suits have been developed that can work with high-quality video cameras without bouncing infrared light. In those cases, special software tools analyze the movement and light reflections involving an actor on a mocap stage direct from a video recording and interpolate that analysis into movement data.

▌ Stage performances with actors in the mocap suits, asking them to go through motions specific to what the story calls for.

▌ Typically, special computer software saves and analyzes the data and applies it to stick-figure, animated characters, allowing each figure to replicate the actor's motion. The data is then mapped to the computer model's digital controls, giving the animator control over those movements via animation software packages.

Practice

FINDING AN ALTERNATIVE

In 2009, Zack Snyder's superhero epic, *Watchmen*, featured almost 1,000 visual effects shots. For that giant-budget film, Snyder's team concocted an ultracomplex methodology of transforming Billy Crudup, who played the big, blue Dr. Manhattan, into a realistic all-CGI character, whose very body was also a light source. They not only motion-captured Crudup's movements but also used a special suit on him with LED lights to record light emitting from his body at the same time, and then combined that element with the computer-generated version of the character. But suppose you needed your own Dr. Manhattan and had no giant visual effects team and huge budget? Offer up alternative suggestions for ways to bring Dr. Manhattan to life on a student's budget and timeline. Don't worry about whether you would achieve the same level of quality as the Hollywood filmmakers. Just focus on methods you think might work, and list the tools and techniques you would incorporate. There is no right or wrong answer for this exercise—it's designed to help you understand the importance of using creativity and ingenuity when faced with major challenges.

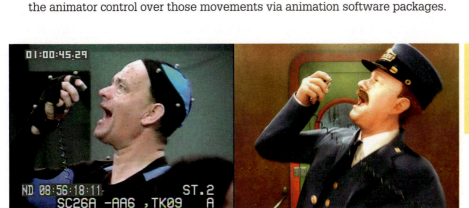

Tom Hanks in a motion-capture suit during production of *The Polar Express* (2004), alongside his finished performance from the final film.
© Warner Brothers/Courtesy Everett Collection.

Managing Data

As mentioned earlier, the importance of the visual effects department to the overall filmmaking workflow has increased in recent years. Today, major facilities sometimes handle the additional job of data management on all-digital shows, the development of look-up tables (LUTs—customized algorithms that apply chosen color schemes automatically to digital-image data to allow better color management from on-set dailies through the final digital intermediate process), and other tasks. That is why we used the term *filmmaking hub* earlier in this chapter.

On your projects, however, it is unlikely that there will be any expensive facilities participating to help with your file management and color needs. But conceptually, if you are shooting with digital cameras and creating digital elements, a certain amount of unification among your editorial workflow for dailies, editing, final color, and visual effects workflow will be in order. You need to find a method of making sure you are correctly tracking all data, using the right versions of files, applying logical naming conventions to files, and so on. If you don't make a strategic data management plan based on whatever your resources are, you run a great risk of losing elements or taking too long to get work done.

The first thing to comprehend is that as you create, capture, or download digital elements, you must back them up as soon as possible, preferably to multiple locations. You could back up to off-board hard drives, solid-state storage media, DVDs, cloud-based storage, or preferably some combination of these.

The second basic idea is to make sure you *never* work with or manipulate *original* data files. As you engage your backup process, come up with a plan for automatically copying all files to be used for actual work. Leave your raw files and original data alone, and work with their clones. This way, you will have survival options if something goes awry.

Third, pay attention to file-naming conventions, particularly if you will have other artists, friends, or colleagues working with your data. You need a strict naming process to make sure that each person involved is working on the right version at the right time. Having two or more files with the same or similar names, on a tight deadline, is a potential recipe for disaster. Also, make a plan for how you are going to track metadata—particularly file names, descriptions, and timecode. Whether you use one of the many digital asset–management tools now on the market, a simple spreadsheet, or even a scratch pad, you need a way of tracking, reading, accessing, and reaccessing metadata to find correct files and information.

Fourth, it's a good idea to test your pipeline. Take a file, copy and back it up, and pass it through your proposed pipeline—no matter how sophisticated or simple—and make sure it comes out the other end as you intended. Remember to test for compatibility issues—verify that the equipment you hope to use can work on the file formats you propose to work with, or that you have a tool and methodology for converting files to different formats. The short history of digital filmmaking is rife with tales of file and data mismatches and presumptions falling short.

As you formulate your workflow plan, also think about archiving your digital data. At the studio level, this is a huge issue because original, pristine image data and computer models are assets owned by studios that might be used for future versions of the movie or sequels. At the student level, you are probably not thinking about future iterations of your movie per se, but on the other hand, if you have even the slightest belief you will ever work with any particular elements again, then you need to preserve them beyond the immediacy of your current project.

Tip **TRY OUT ASSET-MANAGEMENT SOFTWARE**

Numerous manufacturers offer sophisticated digital asset–management software tools and apps aimed at indie filmmakers and smaller projects, some of which are available at consumer-level prices. Regardless of the price, most manufacturers sell them online, and many offer limited free-trial downloads so that you can check out the software before buying. Download a couple trial versions of tools that look interesting to you, and become familiar with their functionality in order to make you more comfortable with the steps you will need to take to back up and protect your image data. As with any other aspect of filmmaking, no matter what approach you are attracted to, remember to focus on your specific goals in this area as you investigate your options.

Whether you store them through a cloud-based service or an off-board hard drive, thumb drive, or DVD, remember that future media platforms, and the hardware to read and show media, are likely to change over time. So if your project and its digital assets are particularly important to you, think not only about storing them now but about archiving them long term.

Also, keep in mind that these days, stereoscopic 3D movies are all the rage. At the studio level, this means the movie will be made one of two ways. It might be shot on-stage or in the field in stereo, using digital cameras on special stereoscopic rigs. This was the process Cameron used on *Avatar*, but as that project showed, it can be a hugely time-consuming and expensive way to do it. Alternatively, a traditional 2D picture could be shot with digital cameras, and then in postproduction, an artist or a facility converts the 2D image to stereo using a range of specialized software tools and the expertise of a *stereographer* to adjust imagery to better serve the stereoscopic viewing experience.

However, this early into your filmmaking education, it is doubtful you will be making a stereoscopic film any time soon, and even if you attempted it, you would likely not have the benefit of high-end professional stereo rigs for shooting or, alternatively, an experienced stereographer and all the tools needed to convert the imagery. Therefore, we will leave the detailed discussion for how to craft stereo imagery for another day. What you should understand for now is that any kind of 3D effort will, by its nature, double your data requirements and the logistical challenges that go with that.

Practice

BACK SOMETHING UP

Take stock of the tools you currently own or have available to you that could potentially be used for file storage—a computer, an off-board hard drive, solid-state media, DVDs, CDs, Blu-rays, data tape, videotape, or an affordable consumer-aimed cloud-storage service, such as the ubiquitous Dropbox (www.dropbox.com). Choose a fairly substantial moving-image file of good size and decent quality, and copy that file to as many of these mediums as you have access to. Near the end of this course or school year, return to and access those backed-up files and take note of which ones were easiest/quickest to use; which were the most affordable or convenient; and which left you, at the end of the day, with the cleanest, most pristine version of your file. Then, write down a plan for how you would use that media, or combination of media forms, to back up assets from an entire student film for long-term security.

Visual Effects and Animation Emergency Kit

- A sketchbook, a pad of paper, or an iPad or another tablet to take notes and draw pictures or diagrams of things you encounter in the real world that may provide good reference for a visual effects element you are thinking about

- A still or video camera for the same reason. Pictures or videos of animals and textures in the real world can be particularly useful reference material

- A laptop or another web-enabled device for research in the field and for experimenting with, examining, or sharing images

- A light meter for the same reason a cinematographer needs one: to get lighting data for digital shots that will match light from the field

- A wide range of tape, markers, and items you can use as tracking markers in shots for plate photography, ranging from tennis balls to strips of Velcro

- Measuring tape

- A mirror for character animators to study various facial expressions and body movements that they may want to emulate in characters they are working on

CHAPTER 13 ESSENTIALS

▎ Visual effects tools and techniques are essential to modern filmmaking, and not just for big effects-driven studio pictures. Being familiar with the capabilities of visual effects and how they can help you complete your illusions and tell your story is crucial to being a well-rounded filmmaker.

▎ So-called practical, or mechanical, techniques—real-world photography of models or miniatures and various in-camera tricks—remain useful in modern filmmaking and increase options for filmmakers in creating elements for their imagery. But in most cases, digital technology and methods will be required to sew real-world elements and digital elements together seamlessly.

▎ Computer-generated imagery (CGI) is an umbrella term for all digitally created material that might go into a feature film, including backgrounds, static objects, and computer-animated objects that move. There are several important stages in the computer-animation process, and you need to be familiar with all of them.

▎ Character animation specifically lies at the heart of modern visual effects. The principles behind computer-based animation are similar to those of traditional animation, where your agenda is to "perform" the character in such a way that they show or evoke emotion and connect with an audience just as an actor would. At the end of the day, animators need to emulate actors to do the job right.

▎ One of the new requirements increasingly entrusted to the visual effects team is the management, backup, and long-term protection of digital assets. Some kind of digital asset–management plan is crucial in modern filmmaking.

KEY TERMS

Animatronics

Armature

Character animation

Compositing

Computer animation

Computer-generated imagery
 (CGI)

Facial capture

Forced perspective

Green screen (or blue screen)

Matte painting

Mechanical effects

Motion blur

Motion capture (mocap)
 (performance capture)

Optical effects

Optical printer

Practical effects

Rendering

Rigging (setup)

Rotoscoping (roto)

Special effects

Surfacing

Tracking

Wire removal

PART **4**

FILMMAKING AND BEYOND

The end of your filmmaking journey is really the beginning. Now, at long last, you will move out of the more private, creative space in which you've made your film and go public, sharing your work with the people you made it for in the first place: your audience. From this interaction, a new cycle begins—screenings online, in your classroom, at festivals, and at other venues; reaction to your film from peers, investors, critics, and the public; the possibility of praise and awards; and commencement of your next project.

There are two aspects of meeting and attracting your audience: *marketing*, which means making them aware of your film and what it offers in a way that makes them want to see it; and *distribution*, which means finding opportunities for them to see it through an ever-expanding choice of screens and distribution mediums. Audiences are extremely picky because they have many ways to spend their entertainment dollars. Therefore, today's savviest filmmakers think of the audience before the first shot is taken—before the script is even written—and embrace the idea that the audience is an invisible collaborator in the

moviemaking process. You may conclude your audience is a broad swath of the filmgoing public, or you may be targeting a specific niche. Either way, defining and "getting to know" your target audience will directly impact, as we have discussed, how you develop your story, budget, schedule, and production methodology throughout the filmmaking process.

Just as a film must eventually meet its audience, so, too, will you "go public" one day if you decide to pursue a career in filmmaking and media arts. In the final chapter of this book, you'll discover a spectrum of resources and paths you might take as you begin your professional journey.

"The movie business is a business of hits, and the big hits pay for everything.**"**

– Amy Pascal, Co-Chairman, Sony Pictures Entertainment, 2006–2015; Chairman, Sony Pictures Entertainment Motion Picture Group, 2003–2015

Marketing and Distribution

The alien autopsy scene in *Sirius* (2013)

KEY CONCEPTS

▌ Every movie's audience is different and needs to be defined *before production begins* for a successful marketing and distribution experience.

▌ Once the target audience is identified, you reach them through various promotion and marketing efforts.

▌ You get your movie to your audience by distributing it to them using some basic practices you can do yourself. It's also a good idea to seek exposure through film festivals.

▌ Studio distribution is a large-scale operation involving the interplay of places and dates where and when the movie can be seen.

Director Amardeep Kaleka and executive producer Steven M. Greer, MD, faced a dilemma. Their movie, *Sirius*, a documentary about Dr. Greer's quest to prove the existence of UFOs, had a large potential audience—fans had been following its production through regular social media updates—but no traditional distributor would touch it. Early word from a movie critic who had seen the film at a private screening was not kind. TV and cable networks turned them down. How could Kaleka and Greer get their movie in front of ticket buyers, to share their message and recoup their financiers' investment?

With money running out and no theatrical release in sight, they turned to Yekra (www.yekra .com), one of several new platforms that allow filmmakers to upload a movie, set a fee, and market a film through social media and peer networks. On opening day, everyone was nervous. Would audiences show up to this virtual theater? Within hours, the answer came: a resounding yes. In its first week of release in May 2013, the producers netted half a million dollars with no advertising budget. The following week, theaters in New York and Los Angeles had contacted them to arrange a theatrical run.

Kaleka and Greer's story proves that new models of marketing and distribution work and that what was unconventional only a year ago is viable today. But their original concern of "Will people show up to see our film?" is one that virtually all filmmakers face. Audiences have many possible

options for entertainment, including seeing other movies, hanging out with friends, reading, and watching television. For your movie to sell tickets, people must want to see it on its opening day; if they are willing to see your movie on the day it opens, it means you have succeeded in creating anticipation and urgency for what you are offering, as in the case with *Sirius*. If you get a similar result, your movie will have good attendance (whether that attendance is virtual or physical), the website or theater will likely keep your movie on its marquee, and people will be able to keep buying tickets.

Of course, filmmakers don't always get this happy ending. A frequently repeated bit of advice for aspiring filmmakers goes like this: "Two years in production, two weeks in a theater, two-for-one at Wal-Mart." That fate, common to films both good and bad, only serves to remind us that after all the work you put into your film, the audience will decide its future in just one day.

Still, as noted, there are more possibilities for today's filmmakers. Ten years ago, it cost millions of dollars to advertise a movie, and audiences could only see it at venues tightly controlled by several dozen film distribution companies, predominantly the major studios. All that changed in February 2005 when YouTube launched and made video sharing ubiquitous, democratic, and free. Now, it is easier and cheaper than ever to share your movie with the world: you can show it immediately through free social media and content sites.

At the same time, there have never been more movies competing for audience attention. How will you get people to know your film exists, and then watch it? While democratizing distribution, this movement has created a virtually limitless number of choices for the audience.

This chapter provides some of the tools you will need to get your audience to react positively to your film and spread the word to their friends—from how to define your audience and "message" your movie to how to place it in front of their eyeballs. You'll learn how marketing and distribution work, both for your student film and for big studio movies, since some of what they do may help you in the future.

Defining the Audience

Marketing is the process of offering your work to your audience with two goals in mind: to create *awareness* of your movie and to drive their desire to buy admission when it opens (this is called *want-to-see*). This means the first step in constructing any marketing plan is answering the following question: Who is your audience? In other words, who did you make your movie for?

In a classroom environment, perhaps you made it for your teacher or your peers; either way, you knew who you were making it for before you began. Outside of class, you will likely hope to reach a larger (and paying) audience, and the same should also be true—you should know who your audience will be from the moment you begin the script and while you are making the film.

Unfortunately, not all filmmakers define their audience beforehand. They believe that if they are interested in a story, other people will be, too, but that does not always prove to be true. Then they find themselves trapped because they have a movie that no one wants to see. Although it is essential to tell a terrific story, if that story is one that people aren't interested in watching, no one will be able to experience your talent. Make a movie for a specific audience, large or small; don't make a movie and then try to figure out who the audience is.

With the audience identified early in the process, it becomes important to learn more about them and connect with them as the film gets closer to release. Doing so will allow you to define them even more specifically, which will help you target your marketing more effectively. To help you do this, you first need to screen your movie.

AUDIENCE FIRST!

Have your audience in mind at every step of your process—from idea, to screenplay, through production, and when you are finishing up. Guide your decision making by asking, What does the audience need or want at this point in the movie?

Learning from Your Audience While You Work Your Movie

Before you send your movie out to be seen by the general public, you'll want to make sure it works the way you want it to work. **Playability** is how well the audience responds while watching the film—how well the film plays. Do the jokes land where you want them to? Is the action sequence suspenseful enough? Is the main character relatable and sympathetic? The easiest way to answer these questions, and others, is to show your movie to a select, private audience in a **test** or **preview screening**.

You can accomplish a test screening in several ways. You can gather friends in a room and show the film, or even screen it privately in an auditorium. This early feedback will be helpful but not determinative: they are your friends, after all. To get better information, you'll want to do a screening for people who don't know you and therefore have no stake in preserving your feelings. This is called a *recruited screening*, which is a type of screening that movie studios conduct regularly (see Action Steps: Preview Screening, below).

At a **recruited screening**, audience members are invited (recruited) to come to a special screening of a new film; more often than not, they are given only a generic, two- to three-sentence description of the film to pique their interest. It is best to recruit audience members who are most likely to fall into the film's intended audience (the audience you defined before you began filming). You can find these people on campus or in online forums; studios do their recruiting outside movie theaters.

The goal of the screening is to figure out what you can learn from your intended audience. Depending on their feedback, you may need to go back to the editing room and improve the film, in which case you'll want to test again. Studios frequently do iterative edits and preview screenings five or more times. You should do as many as you want (or as many as you have time for) to make your project as good as it can be.

Screenings also allow you to learn more about who your audience is. You may find that your movie appeals more to one kind of person than another—men or women, people in a certain age or ethnic category, or people who identify with certain opinions or causes. Age, gender, and ethnic information are collectively called **demographics**. Opinion and cause identification are called **psychographics**. Combined, demographics and psychographics allow you to identify your **target audience**.

ACTION STEPS
Preview Screening

❶ **Recruit audience members who don't have previous connections to the film (this includes friends of friends).** You need at least 20 people to discern a general sentiment. Studios routinely do preview screenings for 200–400 people; though they get everyone's feedback, they will often hold a small percentage of the audience back for more in-depth questions.

❷ **Recruit about 20 percent more people than you need; it is inevitable that not everyone will show up.** At the time of the screening, if less than 80 percent of your invited audience show up, that tells you something: the movie

Continued

Continued from the previous page

doesn't seem compelling enough to them. Think about how you described the movie, and resolve to consider this issue based on the test audience's reaction. A less-than-full theater can also cause those in attendance to be predisposed not to like the film.

3 **Welcome the audience.** Keep in mind that the greeter should be someone who has nothing to do with the film, so that the audience does not feel as if they have to be polite in their reactions. A typical welcome speech is, "Welcome to this special screening. The film you're about to see isn't finished yet—you may notice some imperfections in color and sound, and some of these things are temporary. Don't worry, when the film is finished, all those problems will be corrected. Enjoy the show!"

4 **Screen the film.** Watch closely for the audience's reactions, both verbal and nonverbal. Do they lean forward to watch, or do they seem distracted? Do they take out their phones and start texting, get up and go to the bathroom (or leave altogether), or stay involved? Where is their interest keen? Where does it wane? The experience of watching your movie with an audience for the first time is a powerful source of information. To study and preserve the recruited-screening experience, many studios use infrared cameras to film the audience's reaction. They then edit a special version of the film together—the film playing in one screen window, and the audience's reaction playing in synchronization in another window.

5 **Get audience reaction.** There are three ways to do this:

A. Watch and listen to what they are saying to one another. This approach is the easiest to do but provides the least information.

B. Have a group discussion or a focus group, led by someone not connected to the film. (You can sit in the back and listen.) The discussion leader should ask if there were any parts that didn't seem clear, what the audience liked and didn't like, and what they would tell their friends about the film.

C. Do a survey. Studios often combine a written survey (for the whole audience) with a focus group of about 20 people. The two most important pieces of information to get from an audience can be gotten through the following questions: *How did you feel about the movie?* and *Are you likely to recommend this movie to your friends?* These are generally put on a scale of 1 to 5, with 5 being *The movie was excellent* and *I will definitely recommend this movie to my friends.* The "definitely recommend" is the best gauge of how people really feel about your movie.

Kinds of Audiences

At this point, you are probably realizing that your movie is analogous to a product—a consumer good, like laundry detergent or toothpaste—and that it will need to be "sold" like one. The process for selling begins with a deep understanding of whom you are selling to.

Marketing is a sociocultural activity, and marketing professionals often use the sociocultural constructs of gender and race to describe audiences. The traditional understanding of movie sales breaks the audience into four sections, or

quadrants: men under 25, men over 25, women under 25, and women over 25.

Hollywood movies usually find their predominant audience in one of the four quadrants. Although the following four examples may appear as age- and gender-biased generalizations, they reflect the way marketers would describe audience composition of some movie genres in the past decade:

■ Action movies with younger lead characters (such as the *Fast and Furious* franchise) appeal primarily to men under 25.

■ Action movies with older lead characters (such as *The Expendables* franchise) appeal primarily to men over 25.

■ Romantic comedies (such as the 2014 remake of *About Last Night*) appeal primarily to women under 25.

■ Period dramas (such as the 2010 Oscar winner *The King's Speech*) appeal primarily to women over 25.

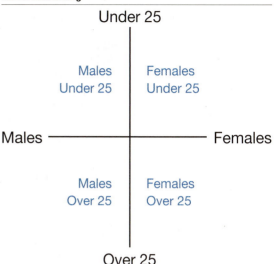

FIGURE 14.1 The four quadrants as designated by movie marketing

Of course, there are many genres beyond these, and audience interest in any film will be from a mix of quadrants. Some movies—those that are highly financially successful—have significant audience interest from more than one quadrant. A movie everyone goes to is called a "four-quadrant movie." *The Hunger Games* (2012) and its sequels are examples of four-quadrant movies. Often, major studio projects may not be able to justify their budgets or even get greenlit unless studio executives decide they have potential to be true four-quadrant films.

However, for student and independent films, those four quadrants offer little in terms of specificity or information you can really use. In fact, many independent films are often made at a low budget because they target a very select group. Enter the power of niches. A **niche** is a narrowly defined slice of the audience. In the world of niches, there are no longer four quadrants; there might be 44, or even 444, different audience segments, each of which can be targeted, or communicated to, with the utmost specificity. For example, one niche might be African American families who go to movies with their elementary-school-age children. Another might be college students with an interest in independent music scenes. As you can see, niches cut through and beyond the traditional four quadrants to define audiences with more nuance and specificity.

Once you learn your movie's niche (or niches, because some films appeal to more than one niche), you can use the information to your advantage. Rather than trying to reach out to millions of people, you may only be trying to reach a few hundred or a few thousand. The niche can become your movie's core audience and core fans. They won't be the only audience, but they will be the people who show up on opening night because the project speaks directly to them and their demographic or psychographic needs, and they will be the ones who tell their friends and spread the word. By targeting your audience effectively, you maximize the potency of your film's marketing message (see the next page). And every once in a while, a niche film becomes a phenomenon and attracts audiences that were never expected, such as occurred with the ultra low–budget movie, *The Blair Witch Project* (1999). But be cautious about "the phenomenon phenomenon,"

Tip **WHAT'S YOUR NICHE?**

Follow the marketing mantra, "Go big, go niche, or go home." And, because only big Hollywood movies have the advertising budget to "go big," you should generally make sure to "go niche."

because it is far more difficult to strategically create one than to see one organically grow when you least expect it. Concentrate, instead, on your niche strategy, and if things evolve exponentially beyond those specific targets, all the better—chances are your expert handling of your niche strategy had something to do with getting the whole thing going, whether you planned it that way or not.

Practice
DETERMINING YOUR AUDIENCE

Using your class project as an example, identify the audience that might go to see it if it were playing in a local theater. Support your audience choice with evidence by citing commercial movies that are similar to your class film, correlating the audience that attended those movies with your project.

Reaching Your Audience

Once you have defined your audience, you must determine how you will communicate with them about your film. You'll need to figure out the marketing message that conveys the film's **value proposition**, a term that answers the question, What will I get if I see this movie? The audience might get thrills, laughs, greater awareness of an issue, emotion, or a feeling of romance. The value proposition for a movie is always about the *experience* of seeing the film—how that experience will affect or transform the audience (see Action Steps: Messaging Your Movie, below).

The best way to communicate a movie's marketing message is in a **trailer**, a 90-second to two-minute commercial for the film (see p. 333); however, there are many other marketing strategies that you can employ. As noted, the marketing plan, or marketing campaign, for any movie accomplishes a twin purpose: informing people (creating awareness) and getting people to want to see your movie ("want-to-see"). These are two distinct functions, and you need both to sell tickets. Similarly, **marketability** is how easy it will be to get people interested in seeing the film.

Publicity and Promotion

Most students have little or no money to buy advertising for their film. Does this mean there's no way to create awareness about it? Of course not. Welcome to the word of publicity and promotion. **Publicity** is news that gets out about you and your movie and by definition is for free—generally conveyed by others, whether it is an article in your student newspaper or in reaction to a "publicity stunt." Word of mouth, which takes place mainly though social media these days, is one of the most powerful kinds of publicity. **Promotion** is the process of developing relationships with organizations or companies that will help you spread the word and sometimes create incentives for your audience to see your movie. The following elements of a marketing campaign are for student, indie, and studio movies alike,

ACTION STEPS
Messaging Your Movie

Every product—whether a movie or a MoonPie—is a message waiting to happen. The message for a MoonPie is pretty obvious: it's tasty, sweet, crunchy, chocolaty, and marshmallowy. But how do you find the message for a movie?

❶ **Start with a single image.** What one strong picture would convey what the movie feels like? This image will become the core of your messaging, and it will show up on the movie's poster, or *one-sheet*, and in advertisements.

❷ **Add a few words to the image—the fewer the better.** These words are called the *tag line* or the *cut line* and, together with the image and your film's title, form the basic message you will convey.

because even studios like to try to get things for free! (See How Do I . . . Market My Movie Like a Pro?, p. 334.)

1. **Start social media before you begin the movie.** Obtain and create a website, Facebook page, or YouTube channel, or use another social media tool. Employ these resources to tell your audience about what you're doing. Audiences love to look behind the scenes and feel included in the moviemaking process.

In this version of the one-sheet for *Deliverance* (1972), the tagline and the contrasting images tell the audience this is a story about four friends who embark on an adventure gone very bad.
Courtesy Everett Collection.

Where possible, capture their email addresses or phone numbers (for text messages). Remember, you are creating your *platform*—your audience base of supporters and fans. These are people you want to invite to the opening or people who will be the vanguard in generating positive word of mouth.

2. **Create a blog, and post to it regularly.** Use it to update your fans about important events, like a particularly great day of shooting or the end of image capture. SPOILER ALERT! Be careful of and monitor the rumors that can come from the production set. Nasty rumors can doom a movie before it is even finished. Also, be especially careful about who has access to your materials and what they do with them, so no one posts excerpts, or anything else from your movie, without your approval. This will also help you avoid piracy (see p. 345), because many films that leak online are "inside jobs." **Send special offers to your fans**, such as early notification of screenings or discounts on tickets, if possible.

3. **Create a trailer** (see Action Steps: Making Your Trailer on the next page) and put it online—on your blog, YouTube channel, Vimeo, and any other social sharing platform you can. Make it easy for people to share and like your trailer.

4. **Create press releases, and send them to blogs and media outlets.** Make sure to include JPEG photos to run with your article.

EMBRACE PUBLICITY

When it comes to publicity, in most cases, even if it makes you feel somewhat uncomfortable, go with it. Getting yourself out there is difficult for most artists, but it is a necessary aspect of the job.

FIGURE 14.2 Official synopsis and poster released by Sony for *22 Jump Street* (2014)

5. **Create a physical press kit and an *electronic press kit,* or *EPK*.** An EPK should be shot in the 4:3 aspect ratio so that it can be shown anywhere. It should include, at minimum, the film's trailer; behind-the-scenes footage, showing preparation or shooting in progress; two or three fully edited scenes (visual effects or action sequences are great if you have them); and interviews with at least two people, chosen from among the director, the principal actors, and other important members of the creative team. Shoot only the interviewee, not the person asking the questions. Make sure a question is audible before the person answers, so that TV shows can edit it easily. Some media outlets will run clips from an EPK if it is topical or has recognizable actors.

6. **Make the film's director and stars available for interviews by media,** whether for your school paper or, if possible, in a tour of key major cities or in conjunction with major film festivals.

7. **Seek sponsors for promotional screenings.** For example, a local restaurant might donate pizza for a screening party if you put its name on the invitation. This helps you—you get pizza and a sign in the restaurant or on its website— and it helps the restaurant by promoting its brand. Studios do the same thing but on a larger scale often before image capture even begins: McDonalds Happy Meals were built on promotions with summer family movies.

START EARLY

Movies that do well build a relationship with the audience long before they are released.

ACTION STEPS
Making Your Trailer

Just like a good screenplay (see Chapter 2), a good trailer has three acts— except, of course, these three acts take much less time to play out. Here is how to translate the three-act structure into a good trailer:

❶ **Introduce the characters and the environment.** Show who the protagonists are and the time and place of the story. This first act usually sets up "normalcy" for the characters and how they find themselves in their everyday world.

❷ **Present the problem.** In act 2, the situation changes: there is danger, a threat, suspense. This section, usually the longest in a trailer, shows the problem the protagonists must face. At the end of the act, they engage with their problem. Note that the end of act 2 in your trailer is the end of act 1 in your movie.

❸ **Show the highlights.** Act 3 is often a montage—a collection of shots or short sequences that promise the *emotional experience* of how the protagonists will confront their problem without actually revealing how the movie ends. In this section, you want to give the audience a taste of the best parts of the film: the funniest lines, the most stunning visuals, or the best acting moments. You want to leave them hanging in suspense, so that they will buy a ticket later— always leave the audience wanting more. This act ends with a call to action— typically, information about the film's opening date, where it will play, or how people can buy tickets.

How Do I . . .
Market My Movie Like a Pro?

Go to LaunchPad and find out: **macmillanhighered.com/filmmaking**

NAME:	**Dennis O'Connor**
TITLE:	Head of Marketing, Roadside Attractions
SELECTED CREDITS:	Marketing for *Dear White People* (2014); *The Skeleton Twins* (2014); *All Is Lost* (2013); *In a World* (2013)

If you have a chance to compete with bigger studios as a student or as an independent filmmaker—assuming you are smart enough and creative enough—it might be in the area of marketing your movie. Film marketing veteran Dennis O'Connor has lots of experience promoting smaller movies with the buzz and creativity of much bigger projects. O'Connor talks about making the most of your marketing resources in a video interview available only on the LaunchPad for *Filmmaking in Action*.

Discover

▌ How independent filmmakers can raise awareness about their projects before they're even on the market

▌ How viral marketing can help your movie at low cost

▌ Why you need to figure out your movie's audience in advance

Visit the LaunchPad for *Filmmaking in Action* to learn more—and to explore how you might use this advice.

The Producer's Role in Marketing

There is frequently a tension between how a director sees a movie and how the marketing department wants to sell it. Producers need to mediate this difference: to stand up for what's right for the movie and, at the same time, to sell tickets. More often than not, marketing professionals have a better sense of what will sell because they are closer to the marketplace and have more frequent contact with it . . . but not always.

Producers spend a great deal of time working with the marketing department to create marketing materials. Even while making the movie, the producer must deliver footage and still images to the marketing professionals so that they can begin their work. The producer will then review initial materials, often in advance of the director, and provide notes and perspective. Sometimes the marketing department asks the producer for certain elements that will best serve the marketing plan; this may require shooting special scenes, prioritizing the image-capture schedule to include "trailer shots," or finishing visual effects shots early to make them available in time for trailer distribution.

Paid Marketing

Up until this point, we have been using the term *marketing* in its general sense, to mean the product or message you are marketing to your audience. In its more narrow sense, however, marketing refers to *advertising*—paying for media to tell people about your movie. Studios routinely spend anywhere from $30 million to $200 million advertising their movies (usually in correlation to the budget of the film and the results of test screenings)—amounts so high they would border on the ridiculous were it not that such spending is necessary to create awareness about a particular movie above the noise of all the other entertainment offerings. Often, the marketing budget correlates to the production budget in the sense that the more that is at risk, the more the studio will spend to protect that risk and ensure a successful release. Plus, there is a small window of opportunity to get your audience's attention before someone else does. The paid marketing budget is called *P&A*—short for *prints and ads*. *Prints* refers to the cost of creating copies of the movie for distribution, whether the copies are on film or digitally distributed. *Ads* refers to advertising in any form.

The most effective way to spread the word about your movie is to get people to see the trailer. Trailers are commonly shown online and before full-length movies in theaters. A full-length trailer should run between two and two-and-a-half minutes, whereas a *teaser trailer* may be as short as 15 seconds and should come out several months before the full-length trailer (sometimes as much as a year in advance, to whet the audience's appetite). Trailers are highly constructed marketing tools; it is typical to try several versions of a trailer until you find one that you think will make the audience want to see your film. Advertising often turns trailers into paid commercials—generally a 30-second television spot—enabling you to reach a much wider audience. Studios also employ every other possible form of advertising, including outdoor media, such as billboards and

Tip BE MOBILE-FRIENDLY

When you upload your trailer to the web, make sure it is encoded and formatted to play on mobile devices, not just laptops.

Practice

ANALYZING MOVIE MARKETING

Write an essay inspired by the following prompt: *The most recent movie I saw in a theater on the day it opened was _____.* In your essay, describe the movie and what motivated you to see it. Explain the value proposition this movie offered you and what made you see it that day as a way of describing how movie marketing works.

FILMMAKING

bus benches, as well as online, radio, and mobile ads (see Producer Smarts: The Producer's Role in Marketing, p. 335).

Distributing Your Film

Distribution answers the question, *How* will your audience get to see your movie? It is the physical and technical process of getting a movie from its original film negative or hard drive to its audience. Your audience cannot see your movie unless it is distributed to them. In the past decade, new forms of distribution have emerged while traditional models have transformed. This is both good and bad news for filmmakers: it has never been easier to put your film in front of an audience, and it has never been harder to get an audience to watch and pay for it. We'll start with a general overview of how distribution works and look at ways you can distribute movies yourself.

Distribution Basics

Once upon a time, there were two categories of distribution: theatrical (into movie theaters) and in-home entertainment, which includes physical media such as Blu-ray discs, DVDs, and television. Then, after YouTube launched in 2005, technology evolved and media converged with online and mobile devices, and the traditional model changed. People can now watch films when and where they want, on their computers, game consoles, tablets, or phones through netcasting, podcasting, or streaming from public sites like YouTube and Vimeo.

In today's world, where devices are becoming interchangeable, some home screens can look almost as good as theater screens, and audiences want movies the way they want them, film distributors are shifting their model away from a focus on the *places* you can see a movie to strategic approaches toward the ways you can *make money* from a movie.

It's worth noting that getting money for a movie is generally possible only if the film is feature length; there is little commercial market for short films. Although there are many ways to experience a feature film, there are really only four ways to make money from it; after all, selling the movie is the most important aspect of the *business* of filmmaking. Again, it's important not to let technology—the means or the device through which you experience a film—get confused with how you might make money from it. The technologies keep changing, but the selling principles remain constant. Here are the four ways to sell a movie:

1. **You can *rent* your movie.** When you buy a theater ticket, you are "renting" the seat in the theater. You are also renting a movie when you get it from a physical rental source for a few days, watch it on an airplane or in a hotel, purchase it on your TV for streaming video-on-demand (VOD), or rent it from the iTunes store.

2. **You can *sell* your movie.** People can buy movies on DVDs, or via digital downloads and cloud lockboxes. Movies can also be bought from the iTunes store for about double their rental price. These films never need to be returned; the purchaser owns them forever.

3. **You can let audiences see your movie *for free* and collect advertising money.** Advertising-supported platforms include basic cable and free television, Hulu, and YouTube. Filmmakers can make money from advertising-supported free screenings; for example, several thousand people have made more than $10,000 from their share of YouTube advertising on their channels. Sponsored

Tip WATCH YOUR TRAILERS

Studio distribution executives typically go to theaters where a film's trailer is playing to see how the audience reacts. If the trailer doesn't play well, they'll make a change. Also, exhibitors sometimes promise to play a trailer but don't; executives need to be on their toes to make sure exhibitors honor their agreements, sometimes employing "checking services" that do just that.

screenings, in which a company or foundation pays for a screening, is another way films can make money even when the audience sees them for free. The Corporation for Public Broadcasting, or PBS, has been doing this successfully for decades.

4. **You can offer your movie *on subscription*.** This can be done through premium cable, such as Showtime or HBO, or via Netflix, Hulu Plus, iTunes, or Amazon Prime.

As you can see, when you sell your movie, you'll use one or more technologies to get it to your audience. An audience member might see a movie on a mobile phone for free (if it is sponsored), for pay (if it is a digital download), or for rent (if it is being streamed for a one-time-viewing fee), or pay for it multiple times to access it in different venues and formats.

Distribution takes into account all of these factors and seeks to share a movie with its audience for the maximum amount of money possible. Studios and independent distributors have well-worn mechanisms for doing this. But what if you need to do it yourself?

DIY Distribution

There are far more movies made than get any form of distribution. For example, at the 2015 Sundance Film Festival—a bellwether of independent cinema—4,105 full-length, completed films were submitted. Of these, 118 were screened as part of the festival. Perhaps 100 will get distribution. What happened to the other 3,987 movies? For most of them, nothing: no DVD sales, no Netflix, no cable TV. This sad squandering of creative capital also represents an incredible loss of financial resources; we estimate more than $3 billion a year is spent on movies that get no distribution whatsoever.

The alternative is DIY distribution—doing it yourself. Increasingly, independent filmmakers are not waiting for deals with distribution companies or agents but are pioneering ways of getting movies in front of audiences, most frequently by using online and mobile distribution techniques. Often the first step is to decide how you are going to sell—get money for—your movie. Although there are four possible ways to do it (see the previous page), you only have three realistic options. Your choices are to rent it, sell it, or offer it to audiences for free with advertising or sponsorship support; you won't be able to sell it on subscription since you likely have only one movie to offer up.

If you are going to sell your film, you can do so via digital download or DVD. DVDs can be burned on your computer, or you can get them commercially produced for as little as $1 each. If you want to offer your film as a paid digital download, there are several emerging websites that will encode and host your film, and even let you set the purchase or rental price for your customers for either a monthly fee or a percentage of your sales income. Amazon.com also offers a service in which they will sell your movie for VOD or on DVD for a percentage of sales. Because the opportunities for this kind of distribution are expanding daily, we recommend you research the possibilities yourself and find the solution that will best meet your needs.

You can also do it yourself by creating a website with e-commerce capability, which allows customers to pay with PayPal or a credit card. (PayPal accounts are free, although they charge a small percentage of each sale; you can easily set them up online.) You will need video hosting, which may be available from your school or inexpensively through Google, Amazon, or other providers.

Tip ANALYTICS

If your movie is premiering online, make sure you have analytic tools installed on the download website so that you can track how many people are visiting the site, as well how they are finding it—through direct searches, social media, or recommendations from friends or other sites. This information will help you refine and improve your distribution and marketing strategies.

If you are planning to rent your film, that means you want a good old-fashioned theatrical release. Go for it! Nothing is as impactful as a movie on the big screen with a large live audience enjoying a shared experience. You should approach any venue that has a screen—a museum, a civic center, a gallery, an auditorium in a business center, a place of worship—and don't be afraid to try regular movie theaters, too. Smaller theaters often like to support local filmmakers, and many of the larger theater chains are beginning to offer similar arrangements, especially if you plan to screen on an evening when there is not much business, like Mondays or Tuesdays. Based on some initial success, you may be able to arrange more screenings. If you have some budget, you can actually rent the theater exclusively for your screening, a practice called *four-walling*. When you four-wall a theater, you get to keep all the box office income, so you may be able to cover your costs if you sell enough tickets.

If you want to offer your film for free, two common solutions are YouTube and Vimeo. Vimeo is a more respectful community that does not have advertisements, but it does offer a "tip jar" for filmmakers. The video quality on Vimeo is better than that on YouTube; you can preserve your aspect ratio and more easily choose your starting frame. You can also keep your copyright on Vimeo, and you have more control over who sees your movie, as opposed to YouTube, where you give up more rights and control. In addition, there are newer sites that offer similar services. Because video-uploading opportunities are expanding, do some research to determine which site will be the best fit for your movie. But remember: *always read the site's terms and conditions before uploading your film anywhere.*

To upload a movie, simply create a free account and follow the directions. If the site allows, you should make a new channel for yourself or for your film—this is also free. If the film is longer than a single permitted upload, you will need to split it into two or more parts; title these Part 1, Part 2, and so on. After you upload your film, the service will process your video so that it is web-ready—meaning that it will play on web and mobile devices—and after several minutes, it will appear on your channel. At that point, your video is actually being hosted by the site, which means it "lives" there, and when someone watches it, your film will be *streamed*, or sent through the Internet in real time, to his or her viewing device.

In some cases, you may also be able to offer your film to a local television station or to a cable broadcaster that provides public-access airtime. Alternatively, your school may have its own television station or online channel. If any of these opportunities are available to you, contact the appropriate person and ask about requirements; every station or channel will have its unique process for submission.

No matter what form of distribution and sales you have chosen, get the word out. Move your publicity and marketing machine into high gear, and start building up excitement for opening night!

Festivals

Even if you distribute your film on your own, you may still opt to submit it to a **film festival**—an organized, curated presentation of movies. Although some festivals occur online, most take place in physical locations and last anywhere from one weekend to two weeks. There are more than 8,000 film festivals worldwide, specializing in everything from new films by local directors to animation, shorts, and any form of video expression imaginable, including the ultimate in independent film creation: the iPhone Film Festival (www.iphoneff.com). If you're looking to get some attention for your movie, consider achieving festival recognition.

Distribution Rights

A film is sold to a distribution company by a sales agent, representing the producers or financiers. Through negotiation, the sales agent and the distribution company agree on contract terms. Following are the components of a distribution deal for an independent movie:

▌**Minimum guarantee.** This is cash that the distributor pays up front for the film. If the movie does not make any additional money, this is the amount you will actually get. The minimum guarantee can range from zero to millions of dollars. Indie films often sell in the $20,000–$100,000 range.

▌**P&A and release commitment.** Sometimes the distribution company will commit to spending a minimum amount of P&A (marketing) money to support an advertising campaign. The distributor may also agree to release the film in a minimum number of theaters or cities or to release a minimum number of prints. This promise protects a filmmaker who wants to make sure the movie gets a wide enough release and ample marketing support; however, P&A and a release commitment are rarely volunteered by the distribution company unless they are in a bidding war with other companies that also want the movie.

▌**Rights granted.** The distribution company will seek all rights to exploit the film in all media and with all technologies "now known or hereafter devised." The company will also get remake and sequel rights, as well as the right to be involved if your movie should ever become a TV series, although in these cases the filmmaker usually gets additional compensation.

▌**Territories.** The rights will be sold by *territory* (a territory is a specific country or part of the world). Sometimes a distributor buys worldwide rights; other times, the distributor buys rights for the United States and Canada or all English-speaking countries. Selling territory rights is often subject to some negotiation, because the sales agent may feel it is possible to get more money in aggregate by selling the rights to different distributors in different countries.

▌**Distribution fee.** The distributor will charge a fee for distributing the movie. This may range from 15% to 30% or more. This is money that will come off the top, *after* P&A costs have been recovered.

▌**Length of term.** Typical distribution deals last for 20 or 25 years; in other words, 25 years from now, you could get the rights back. Distributors will often require additional 5- or 10-year extensions if they have not recouped their entire investment at the end of the initial term.

▌**Final cut.** The distributor will often have the right to cut or change your movie in any way it wants, unless your last name is Eastwood or Spielberg.

At first, getting distribution rights may make it seem as if there is a lot of money flowing toward a movie, but by the time the money reaches the filmmaker, it will only be a trickle. *Waterfall* is a term for what happens to the money. Imagine water cascading over a rocky waterfall. At the top, there is a lot of water, but as it passes over the rocks, little by little the water splashes away. At the bottom of the waterfall, there is less water than before. The typical money sequence is as follows:

▌The film's producers or financiers advance the cost of making the movie, sometimes by preselling distribution rights.

Continued

Distribution Rights, *continued*

- If the movie sells, the film's producers get the minimum guarantee. This is often less than the cost of making the movie.

- The distributor markets the film, advancing money for prints and ads and spending administrative money for booking theaters and its own business operations.

- Tickets sell. The distributor gets 40–45% of the sales price.

- The distributor pays itself back for its marketing costs.

- The distributor takes its distribution fee.

- What's left over, if anything, gets split 50/50 between the distributor and the film's producers—unless a big-name star or director is higher up the waterfall.

MANAGE YOUR SUBMISSIONS

The best resources for applying to festivals are the websites Withoutabox (www.withoutabox.com) and FilmFreeway (filmfreeway.com). These free services provide submission information for more than 6,000 festivals, allowing you to keep track of application requirements, deadlines, and fees.

GET REPPED

If you get into a major festival, you may choose to work with a *producer's rep,* who is experienced at guiding young filmmakers through the festival process and negotiating distribution deals. Before you agree to work with a producer's rep (or anyone else), make sure you read the contract carefully, understand it fully, and have your lawyer go over it.

Of course, the number of festivals is daunting; almost 100 of them can qualify you for a shot at an Academy Award. But be aware that if you ever want your film to be considered for an Academy Award, especially a short film, the Academy's rules generally specify that the film *must* be shown theatrically before any other nontheatrical distribution method. Therefore, let's divide the festivals into categories. There are the large festivals you have probably heard of, like Sundance and Cannes. These prestigious festivals are also *film markets*—places where filmmakers and international distributors meet to make deals on movies that are currently being made or are already completed (see Business Smarts: Distribution Rights, p. 339).

It is hard, though not impossible, to get into large festivals, so you should also explore smaller, more local festivals. (You may want to be a large fish in a small pond, after all.) Smaller festivals, and the avid audiences that attend them, love discovering new filmmakers and forging the filmmaker-audience bond. These festivals take their application process and curatorial role seriously.

Most film festivals require a processing fee of $10–100 for each entry; plus, you will need to bear the cost of sending your application materials. Some festivals will watch your movie online, whereas others will ask you to send a DVD (which also costs money). It's best to be judicious and only apply to the festivals you're really interested in attending or those that target the subject matter of your film, as these costs can add up (see Action Steps: Entering a Film Festival, below).

ACTION STEPS

Entering a Film Festival

Following are some tips to keep in mind when selecting festivals for your film:

❶ **Before you finish your movie, start researching festivals, noting their deadlines, categories, and fees.** Many festivals have a series of deadlines, from early bird to late, and the fees increase along the way. If you plan your schedule carefully and submit early, you may be able to enter twice as many festivals for the same amount of money.

2 **Know the rules.** Some festivals will want to be the first to screen your movie, whereas others won't have such limitations. All festivals have specific rules about application forms, length and format of entries, and other submission requirements.

3 **Decide what matters to you in a festival.** Do you need something nearby, or are you able to travel? Are you hoping for a distribution deal, in which case you'll seek out festivals that film buyers attend, or are you just looking for an appreciative audience? Do not overlook less famous festivals, as they often get fewer submissions. You should also consider niche-interest festivals, since your film may find greater acceptance there; for example, some festivals cater to movies shot in particular locales, and others focus on films with specific themes or genres. A festival's website is a good place to gather this information; you can also see how many screenings each film gets, and what movies won in prior years.

4 **Consider entering at least one qualifying festival for the Academy Awards.** If it is a student film, think about submitting it to the Student Academy Award competition. (The Student Academy Awards—which are different from the televised Academy Awards—are also administered by the Academy; you need to check the rules carefully if you are interested.) Remember that if your film appears on television or on the Internet before it is screened in a theater, it cannot qualify for the Academy Awards; it is perfectly acceptable, however, for it to screen at festivals. Those rules are in flux given the fundamental shifts in distribution. It is advisable that you check each year's Academy Award rules at www.oscars.org/oscars/rules-eligibility.

5 **Apply early.** Send in your film and other materials as soon as you can, along with the application fee if there is one.

6 **Try to develop a relationship with the curator or selection personnel.** Although some will rebuff applicants, most enjoy the personal contact.

7 **If you get into the festival, congratulations!** As Woody Allen has said, "Ninety percent of life is just showing up." Go to the festival!

8 **When you're there, remember you are at the festival to grow as an artist, not to party.** Enjoy yourself, but also enjoy being a member of the filmmaking tribe. Meet other filmmakers. Meet the audiences, and learn from their responses to your work. Meet distributors and film producers. If you're a filmmaker, you may find the producer for your next movie; and if you are a producer with a film in the festival, every contact you make is part of your marketing strategy. Build relationships! Build relationships! Build relationships!

9 **Have all of your collateral material at the ready.** This includes a good online presence and a trailer for your movie (in case a potential distributor asks, "How would you market it?"), a press release about the movie, and biographical information about yourself.

10 **If your film is well received, ask the festival director about other festivals that may like it, too.** Film festival directors communicate with one another, and a single film can play in many festivals.

Studio (Theatrical) Distribution

Although it's rare for a student film to get studio-level theatrical distribution, it's worthwhile to understand how it works. After all, studio distribution has brought you the movies you grew up with and may one day bring your film to millions of people. DIY distribution can never attain the audience reach of full-scale studio distribution, which is why the studio system, honed over more than a century, holds so much allure.

There are four components that make up studio distribution: setting the right release pattern; determining the right venues; finding the right date; and finally, playing the film out through every form of audience experience—each one of which is called a *window*.

Distribution Patterns

The first question in studio distribution is how the film should be released. Should it open simultaneously on 3,000 screens? Should it open on one screen in a major city, and then slowly in more theaters as the audience builds? Should it open in a few theaters in 12 major cities? There are three models for releasing a movie: wide, platform, and limited. Let's look at each one.

A **wide release** opens on 2,000 or more screens on the same day. The widest release to date was *The Twilight Saga: Eclipse* (2010), which opened simultaneously on 4,468 screens on July 30, 2010—meaning it was playing on one out of every eight screens in the country. Wide releases are reserved for big studio movies with massive marketing budgets. In this release pattern, the opening weekend is the highest-grossing weekend, and ticket sales decline after that. *The Twilight Saga: Eclipse* earned over 21% of its total box-office gross on the first weekend. The steepness of the decline reveals how well the film will do overall: a decline of 60 percent spells economic gloom, whereas a decline of 50 percent has become almost standard, and a decline of less than 30 percent makes distributors ecstatic. (Movies that decline slowly are said to have "legs" because they can "run" for a long time.) *Twilight* ran for over 16 weeks. After a wide-release opening, most films lose theaters each weekend. As an example, four weeks after its record-breaking release, *The Twilight Saga: Eclipse* was down to 3,121 screens. Films will typically make about 40 percent of their total box office returns in their opening weekend alone. Pirated copies of films often begin to circulate after opening weekend, which may also take a toll on box office revenue (see Business Smarts: Piracy, p. 345).

A **platform release** goes the other way. The film starts in a small number of theaters—10 or less, and perhaps even just one. Often in a platform release, a film is shown in one theater each in Los Angeles and New York City. The strategy is to pack those theaters with excited fans so that the shows sell out. This builds anticipation and greater awareness. The next weekend, the film may expand to 20 screens, and the weekend after that to 100. Platform releases work best for movies with a small niche audience: documentaries, specialty films, and foreign language films. In contrast to wide-release films, a platform release's box office grows each week. This type of release is a good alternative for smaller distribution companies because they can monitor sales figures closely and spend their marketing budget judiciously; when sales start to fall off, they stop spending advertising money.

Tip OPENING DAY

On opening day of a studio release, when your movie is playing on multiple screens, try to go to as many theaters as possible—moving from location to location for each show time. You will learn about the composition of your audience and have an early, anecdotal indication of how your movie is playing. As in politics, there are exit polls and statisticians that can fairly accurately predict the opening of a film based on a few key screenings on opening day on the East Coast.

A **limited release** is the smallest release of all; a film may play in only one or two theaters for just a week or two. Limited releases have two purposes. The first is to get reviews from movie critics in advance of releasing the film on VOD, where the distributor anticipates making the most money; most critics won't review a movie that's only on VOD, but they will write about a movie that's in a theater. The critics' reviews may provide legitimacy, awareness, and some good endorsements. A limited release costs the distributor very little, often $50,000 or less. Of course, in the event of wild success and sold-out houses, the film's run may be extended or even expanded into a platform release.

Many of the widest releases of any given year tend to be franchise entries, like *X-Men: Days of Future Past* (2014) or family-targeted movies like *The Lego Movie* (*shown*, 2014). An especially popular film may increase its screen count later in release even if it started out on thousands of screens. *The Lego Movie*, for example, reached its peak number of screens (3,890, up from 3,775) in its third weekend, after establishing itself as a surprise smash.

The second purpose for a limited release is to achieve Academy Award qualification, which requires that a film be screened in a certain number of theaters for a certain number of days. These rules change every year; if you're interested in qualifying your film for the Academy Awards, you need to check the Academy's website *before you show your film publicly in any form whatsoever*. Filmmakers are heartbroken when they discover they have inadvertently transgressed the rules and disqualified their films!

Exhibition Venues

After the release pattern is determined, the next question involves which theaters the movie should be released in. Where will the audience go to see this movie? Not every audience will go everywhere. Some movies appeal to more urban populations than rural populations; some play better in art houses for niche audiences, and some fare better in the multiplex for wide audiences.

Companies who operate theaters are collectively referred to as **exhibitors**. Exhibitors may see a movie as a way to sell popcorn and Diet Coke; most filmmakers will disagree: they'll say the film is there to give the audience an escape or to entertain and inform them. Indeed, audiences do not go to the theater for the overpriced popcorn!

The largest theaters or multiplexes are operated by a small number of exhibition chains. The top four chains in North America are Regal Entertainment Group, AMC Entertainment, Cinemark Theatres, and Carmike Cinemas. Combined, these chains operate half of the 39,000 screens in the United States. (The term *screens* refers to the number of physical screens, not the number of sites. Because many screens are in multiplexes, the 39,000 screens are only in approximately 6,000 sites or locations.) These venues are the most important for big studio movies that need to open on thousands of screens on opening day.

There are also a number of smaller chains with dozens to several hundreds of screens as well as single-operator, independent theaters. Some of the latter are called *calendar houses*. **Calendar houses** book their schedules months in advance, and generally show a movie for only one week at a time. Many art house or specialty films are only shown at calendar houses.

As you may intuit, the choice of release pattern often determines the choice of exhibition venue. Wide releases must secure screenings with the large chains; limited runs can do well in independent theaters, small chains, and calendar

houses. A platform release will need a hybrid of both, perhaps beginning on a single screen with a small chain and then moving to many screens with the large chains. Thus, platform releases must be handled with extreme care by distribution professionals who have strong relationships with all the exhibitors, so that they can secure the big-chain screens if and when they need them.

The Right Date

Now that you know the release pattern and the screens you're aiming for, when will you release your movie? You must weigh two factors to answer this question: When will the audience want to see this particular movie, and when will the screens be available because they have not yet been committed to other movies? If the film is in a special format, such as 3D, will the right format screens be available? Once again, you will see the value in knowing who your audience is. A film directed at students won't sell many tickets if it is released when they are studying for final exams; on the other hand, if the film is released in June, when school is out and everyone is looking for a joyful escape from academic pressure, the movie will stand a better chance. A specialty film aimed at older audiences may fare best in the spring or fall because it will have access to more theater screens (during summer and holiday seasons, Hollywood blockbusters occupy a far greater share of the screens). A holiday-themed family movie will be well received in November and December but won't make sense in July.

Typically, studios create their release schedules based on two to four "tentpole" movies each year. A **tentpole film** is a big, wide release—the metaphor suggests that other movies on the studio's slate will be protected under the big movie's tent—that gives the distributor an opportunity to play trailers for its other movies and get audiences interested in them as well. Tentpole films come by the seasons: spring, summer, and holiday. You may have noticed that the most expensive wide-release films generally premiere at these times.

The second factor that studios consider when coming up with their release date is competition, from similar movies and for movie screens. For example, if you are distributing a horror movie, you probably wouldn't want to release it on the same day as another horror movie that has already claimed the date and started to advertise itself: both movies would be vying for the same audience, and the pictures would cannibalize each other. On the other hand, you might choose to release your film two weeks after the other one, and try to place your film's trailer in front of the competitor's movie; by doing so, you would lead the horror audience from one movie to the next and reap the benefits. It is not uncommon for a studio to claim a date two or even three years in advance for a tentpole, even before the film is in production. The release date of July 3, 2012, for *The Amazing Spider-Man* was announced in February 2011. Six months later, well before the first film came out, *The Amazing Spider-Man* sequel was set to be released on May 2, 2014. The strategy serves to warn the competition: Get out of our way, or you will be crushed!

Similarly, movies compete for screens. There are certain venues that do particularly well for specialty films, and distributors jockey for position on those screens. The same is true for wide releases. Tentpole releases space themselves a week apart in the summer so that they can have available screens and, their distributors' hope, easier access to their audiences. This is a big gamble. A tentpole movie can cost $300 million or more, with a marketing budget that can exceed $200 million worldwide. That means studios wager nearly half a billion

Piracy

The Hurt Locker is a riveting film about a three-man bomb disposal unit in the Iraq War. It was made and financed independently for $15 million and first screened in September 2008 at the Venice Film Festival. Later that month, Summit Entertainment, a recently formed distribution company, acquired the film and gave it a theatrical release on July 26, 2009. *The Hurt Locker* went on to win the Academy Award for Best Picture.

Despite its acclaim, the film only made $17 million at the U.S. box office. One reason may be that by the time the movie hit theaters, tens of thousands of people had already seen it by illegally downloading it from peer-to-peer file-sharing sites like BitTorrent. The financiers claimed they had lost millions of dollars because of these pirated downloads and filed lawsuits against BitTorrent and thousands of its users. Five years later, *The Expendables 3* (2014) suffered more than 2 million illegal downloads in advance of its opening day.

Piracy—the illegal uploading, downloading, or copying of intellectual property—remains a stubborn problem in the film industry. Filmmakers look with fear at the example of the music industry, which has suffered steadily declining sales since 2001, when pirated music downloads became popular. The Motion Picture Association of America and other organizations have launched public awareness campaigns designed to deter illegal downloads; there is as yet no evidence the campaigns have had much effect. Another strategy has been to release a tentpole film in China, India, and Russia *before* releasing it in the United States, as those markets are often filled with pirated copies made from the U.S. release by the time the film gets there.

You should also be concerned about piracy, because it is a big problem that will hit you in your wallet if you go into the media business. Illegal streaming can amount to 25–100% of a movie's worldwide legitimate income;[2] in other words, piracy can take that much money away from the people who created the work. As you learned in Chapter 2, when you make any creative work, you have created intellectual property, which you own. If you are going to make your living as a creative person, you need to be able to control who experiences your intellectual property, so that you can make them pay for it if you want to. This is, after all, a business.

On the other hand, some creative artists view piracy as their best friend. In these cases, they don't call it piracy—they call it publicity and encourage it, because it spreads creative work openly and freely to audiences they could never reach themselves. At a time when independent artists must compete with $100-million-plus marketing campaigns launched by multinational entertainment corporations, viral videos and free downloads offer a ray of entrepreneurial hope that their work might eventually reach larger audiences.

The battle over piracy continues, with partisans on both sides. Some point to the examples of *The Hurt Locker* and the music industry as rationale for stricter copyright-infringement enforcement; they also note that most pirate sites are for-profit, so the illegal sites are making large incomes, instead of the content creators. Others look at the success of viral videos like *Kony 2012*, which raised more money for its charity in 10 days than other similar charities raised in 10 years, and music events like Ozzfest, which have offered tickets free and made their money on merchandise, as avatars of a new business model: the more free engagement audiences receive, the more they will pay later for deeper engagement with the artists and their work.

To stay informed about piracy and how it affects you, creativefuture.org, a service organization sponsored by the MPAA, is your best resource.

FILMMAKING

dollars the weekend one of these movies opens, which is why studio executives plot the distribution strategy with the precision of a military battle plan. No wonder these are high-pressure jobs!

Windows

In order to make the most money possible with each movie, distributors will play a film out through a variety of platforms, or *windows*—in theaters, on DVD, on cable, and so on. The sequence continues to change in response to audience reactions and patterns of consumer behavior. Distributors adjust their "windowing strategy" to find the best way to make the most money from a film, taking into account the film's audience, expected levels of awareness, and want-to-see. This is the area of distribution that is most in flux. Distributors continue to experiment with different formulas for different movies and will likely keep doing so.

In some cases, a theatrical release may be the first window, followed by VOD, digital download, airline and hotel screenings, DVD sales or rentals, pay cable, free television, and so on. This strategy makes sense for a film that can collect significant theatrical box office earnings, like a tentpole movie, or a film that benefits from the prestige of a theatrical premiere, such as a high-profile specialty release. In other cases, a film might play for three weeks on VOD, followed by a limited theatrical run, with other windows following. This latter strategy has been effective at making money for some specialty films, which at times have earned over $1 million from VOD income before ever appearing on a theater screen.

Some specialty films now open simultaneously in theaters and on VOD: this is called *day-and-date* releasing, and some larger movies are also experimenting with this pattern. Exhibitors oppose this pattern, because they say it diminishes theater ticket sales. Distributors, on the other hand, contend that potential ticket buyers decide weeks before opening day if they will go to a theater to see the movie or watch it at home, and that these two means of collecting income add to each other, rather than cannibalize each other. On this matter, distributors and exhibitors continue to disagree. As technologies continue to change and audience interest evolves, the window sequence will continue to adapt and change.

℗ractice

DETERMINING DISTRIBUTION STRATEGIES

Using three movies opening this week in your city as examples, determine which kind of distribution strategy each is using: wide, platform, or limited release. You can determine this by seeing where each is playing—the kind of theater (big chain or independent)—and on how many screens.

✚ Marketing and Distribution Pro's Emergency Kit

- Word-processing software for creating and revising the press kit, plus photo-processing software (such as Photoshop or Photoshop Elements) to crop and adjust photos for public relations purposes

- An excellent record-keeping system. You will have multiple drafts of press releases and potentially hundreds of photos. You need to make sure you're using the most recent, approved press release and photos

- Thumb drives, DVDs, and a cloud locker to store and easily transfer marketing materials

- A database of all the press you've contacted, all the festivals you've applied to, and all the exhibitors and distributors you've had discussions with. There could be hundreds of these individuals and organizations to keep track of

▌Marketing and distribution complete the filmmaker-audience relationship. The audience must be precisely defined for the filmmaker and marketing-distribution team to target them effectively.

▌Audiences receive information about movies through publicity and promotion, which are free, and through marketing efforts and advertising, which cost money.

▌As a student filmmaker, you will likely handle distribution yourself. Online marketing and distribution is highly effective, and some film festivals offer the opportunity for greater exposure.

▌Studios distribute their films through a time-tested and sophisticated process of selecting the optimum date, theaters, and release pattern for each film. This process is undergoing constant change as new technologies and delivery systems offer audiences increased opportunities to watch movies whenever, and however, they want.

KEY TERMS

Calendar houses	Niche	Target audience
Demographics	Piracy	Tentpole film
Distribution	Platform release	Test screening (preview screening)
Exhibitors	Playability	
Film festival	Promotion	Trailer
Limited release	Psychographics	Value proposition
Marketability	Publicity	Wide release
Marketing	Recruited screening	

> "My passions have evolved, and change has been good. The only constant is, I will always be working on a story I want to tell you—usually in pictures."
>
> — Jay Roach, director of the Austin Powers series, *Meet the Parents*, and the HBO film, *Game Change*, among others

Careers in Filmmaking

Meet the Parents (2000), directed by Jay Roach

For a few moments, the thought crossed Jacob Pinger's mind that he might actually die at the age of 19 on his very first job in the entertainment industry, serving as an ultra low-level production assistant for $50 a day on a low-budget commercial project. Pinger was tasked with driving a gigantic and poorly maintained motor home from Los Angeles to the high desert in Palmdale, California, when suddenly, while cruising along the freeway, the vehicle went dead. After somehow wrestling the vehicle to the side of the road and catching his breath, it quickly became apparent to Pinger that this incident had nothing to do with his interest in operating a camera and hardly represented the glamorous world of filmmaking he had imagined when he originally set his sights on "breaking into the business."

Still, looking back on the event, he declares today, "I loved it! It was awesome." Pinger's harrowing ride not only didn't sour him on his filmmaking goals but actually inspired him. He knew he was in for an exciting adventure no matter how things turned out. Today, he is a busy television cinematographer (*The Real World*) and feature film camera operator (*The Lego Movie*).

Lulu Zezza, by contrast, went to NYU Film School and always had some notion of getting into the business side of the industry. When, upon graduation, a friend handed her a napkin with a list of upcoming productions written on it, she wasn't shy about poking around to see if she might find a gig with one of them. The best she could do was a $250 a week job serving as a production secretary on a small horror film, but rather than accept the notion that she might be destined for a career in the secretarial pool, she decided to strategically use the position to put herself through another round of schooling.

"Production secretary is not a bad job to have if you want to go into production management," she says. "I learned a lot, because every document on the movie crossed my desk. I photocopied them for myself, read every contract and every cost report. [In the end], I probably gave myself a better education than film school, I have to say."

Zezza is now a respected production manager and producer in Hollywood, working on such major feature films as *12 Years a Slave*, *Noah*, and *Factory Girl*.

So what do these stories have to do with you? Directly, nothing, but indirectly, everything. The point is, there is no one correct or official path into the filmmaking industry. It's a journey, and you have no idea where you will end up or even what your eventual interest or focus will be. You need to take risks, be bold, and try things that may have nothing to do with your core filmmaking agenda right now in order to make contacts, get your foot in the door, acquire additional skills, and broaden your horizons. You have, of course, started the journey by learning about the basic filmmaking process in this class. But learning about the process is a far different thing than coming to some sort of understanding about what role filmmaking will play in your future.

At this point, you might not have the slightest idea what that role will be, and that is fine—even expected right now. There is so much to the filmmaking paradigm, so many niches and disciplines and options, that you may well need more education and experience before figuring out if it is indeed the path you wish to travel, and serendipity and circumstances or events you can't possibly foresee right now will likely play important roles in determining your eventual choice. But that reality brings up a final lesson to contemplate before you complete this course: *filmmaking* and the *filmmaking industry* are two separate concepts entirely. As you evaluate your interest in filmmaking and your niche within it, as Pinger and Zezza and thousands like them have done, consider for a moment that you need not be a film director or craftsperson in order to work within the filmmaking industry.

"The industry" is, when you break it down, little more than an umbrella label for a host of studios, companies, individuals, crafts, disciplines, jobs, functions, organizations, guilds, activities, and advisory functions that come together to act in a symbiotic way when it comes to making a movie—to fill dozens of niches, large and small, that need to be attended to in order to properly serve the needs of the greater project. Some of them are glamorous, like acting and directing; some are powerful and permit you to wield great authority, such as producing or running a studio; some are greatly artistic, such as production design, cinematography, editing, and composing; and others can be more technical in nature, such as working as a digital imaging technician or a visual effects artist.

Still other positions have nothing *directly* to do with the product that audiences experience on their screens. These positions are unsung, not glamorous, and in many cases, it would not even occur to most people that they are related to "the industry." But they are, and they can offer you rich and rewarding careers. Before you finish your filmmaking course, let's explore some of the industry options and paths beyond the core disciplines you have already discovered. Keep in mind, however, that no matter which of these potential directions you choose to go in, if any, the basic filmmaking foundation you have learned can help you get there. The more you understand about the process, the roles everyone plays, the necessary tools, and the methods, the more intelligently and effectively you will be able to play your own chosen role.

Analyzing the Credit Roll

As you evaluate what niche of the film business may best fit your interests and talents, keep in mind the gypsy nature of the industry—productions move from place to place depending on financial incentives and logistical and creative needs. That means those involved in the nuts-and-bolts of production are bound to be away from home a lot. It also means many folks in the industry are freelancers— they don't work salaried 9-to-5 jobs and get regular paychecks, or even work 12 months a year, even at the industry's highest levels.

Dr. Walter Dishell (*left*), a practicing ear, nose, and throat doctor in Los Angeles, has some 600 television credits, including his work as medical advisor on the TV show *M*A*S*H* (*right*).
©20thCentFox/Courtesy Everett Collection.

And yet if you ever bother to sit through the final credits of a major motion picture, you will see hundreds of names scroll by—people doing all sorts of jobs in all sorts of categories just to get one major project onto the screen for your enjoyment. Are they all freelancers? Creative free spirits? Auteurs?

Hardly. Many of the people behind the names—most of which you would never recognize—hold steady jobs, or at least earn regular salaries within the motion picture industry by working in a host of support positions, in studio or production company jobs, or for outside entities or companies that contribute in particular ways to motion picture and other content creation. And they are all part of the larger film industry.

Here we give you our roster of some of the typical jobs you might see in the credit roll beyond the formal filmmaking positions you have already discovered in this book. And this is hardly a comprehensive list. Almost every movie will have variations in the credits and contributions that went into making that specific film. This list merely represents a healthy sampling to illustrate the difference between being a filmmaker and working in the film industry.

The list includes professionals from almost all walks of life, including accountants, bankers, lawyers, and paralegals; animal handlers and trainers; caterers; carpenters, construction, paint, and sculpting professionals; charitable-industry professionals; custodial service and waste-management experts; dialect coaches; doctors, nurses, chiropractors, emergency medical technicians (EMTs), and massage therapists; electricians and engineers; government lobbyists; hairdressers and makeup artists; helicopter pilots; insurance professionals; librarians; musicians; all kinds of personal assistants; public relations professionals; recycling and green-industry professionals; researchers, translators, and teachers; seamstresses and tailors; security guards; social media experts and web designers; still photographers, graphic designers, and videographers; travel agents; truck drivers, vehicle rental agents, and transportation coordinators; and weapons experts.

This is only a partial sampling of the possibilities, and as you probably noticed when scanning the list, virtually all of them are "real world" jobs that you could easily end up doing outside the film industry. Indeed, depending on your needs, passions, and desires, you might

FOLLOW YOUR PASSION

In filmmaking, as in life, follow your passion. If you want to work in the movie industry, but cinematography, directing, editing, design, and so on, are not your thing, figure out what your passion is and how you might use it in the context of the industry. If you are passionate about food and cooking, for example, explore catering opportunities within the film industry.

Practice
EVALUATE THE CREDITS

View any major motion picture and carefully scroll through the end credits. Make note of some obscure, unusual, or unexpected job titles you see that have nothing *directly* to do with putting images or sound onto the screen. Then write a short essay about which jobs surprised you or were hard for you to connect to the feature film you just watched. Include a paragraph about which of those jobs you could see yourself possibly doing as a career, and how you might link it to your filmmaking training.

How Do I . . .
Decide on a Career Path?

Go to LaunchPad and find out: **macmillanhighered.com/filmmaking**

NAMES:	**Lucy Fisher** and **Doug Wick**
TITLE:	Producers
SELECTED CREDITS:	*Divergent* series (2014–17); *The Great Gatsby* (2013); *Jarhead* (2005); *Gladiator* (2000); *Stuart Little* (1999)

If there is one takeaway from this chapter, it's that the movie industry is a large umbrella, under which all sorts of disciplines, jobs, and opportunities await. Veteran movie producing partners Doug Wick and Lucy Fisher emphasize the variety of options in a video interview available only on the LaunchPad for *Filmmaking in Action*.

Discover

▎ How to balance passion and skills in your career search

▎ Why you should remain open to possibilities you never considered

▎ How you'll know when you've found your industry niche

Visit the LaunchPad for *Filmmaking in Action* to learn more—and to explore how you might use this advice.

prefer a more stable life pursuing such careers to the unique, often transient, up-and-down life of filmmakers. You could also do them within the film industry, or do a combination of both. A catering company, for instance, may do a robust business outside the film industry but also service film or TV shoots when they come to town. Likewise, lawyers and accountants may have clients in many industries, with film-related clients representing a portion of these. Other professionals—such as makeup artists, animal handlers, and transportation coordinators—may work full time in industry service. But either way, if you are interested in pursuing any of these fields, or many others, by grounding yourself with a basic film education, you give yourself the opportunity to expand the horizons of these other careers, should you pursue them, by widening your pathway into the film industry, should that opportunity interest you and present itself.

But what is that pathway generally? How does one find a way into the industry and promote one's work and capabilities in a field in which the term "wannabe" is often used with derision?

Navigating the Industry

How to "break into the biz" is an age-old question and the basis of many jokes and stereotypes in Hollywood. By pursuing the foundation of a basic filmmaking education, you have already taken a practical first step beyond the stereotypes. Eventually, as you start looking for practical working experience, the general answer you will hear everywhere—including here—is that there will be no shortcuts and no substitute for hard work; networking; working for little or no pay to get valuable experience; and being aggressive in promoting yourself, your work, and your skills.

These things are true in most industries, of course. One specific advantage of the film industry, however, is that it is particularly open to young people and new talent. The concepts of mentoring, formal and informal training programs, seminars, internships, networking platforms, and industry events are commonplace and encouraged. Such pathways do exist, but finding them—and how you choose to navigate them—will be entirely up to you.

One well-known path is to enter your work in film festivals and to aggressively pursue student festival awards and notoriety, as you discovered in Chapter 14. Work hard enough and bring enough factors into alignment, and you could even earn yourself a Student Academy Award, probably the most prestigious student film award in the world. Indeed, most of the major guilds, trade organizations, film festivals, and critics' circles that give out awards each year also have student categories, as do dozens of smaller events across the world. Beyond awards and prestige, the mere act of entering and participating in such events is a great way to network and make contacts.

And making contacts should be one of your paramount goals as you work toward transitioning from learning about filmmaking to learning how to make the world aware of what you can contribute to the greater filmmaking industry. Networking is an art, no matter where you are employing it or under what conditions. Let's take a look at that art as well as other paths you might travel en route to making connections and learning how to navigate the film industry.

Networking

Networking is both a formal and an informal process that is ultimately about raising your profile to the point where the people who might hire you (or the people who know people who might hire you) take sufficient notice of you. Assuming the experience is a positive one, once they interact with you, word of mouth and referrals will kick in.

Your initial networking process can start now, in this class, with the student next to you, your professor, the staff in the film school office, social media contacts, and your presence at local screenings and industry events. What will you need for your networking toolkit? A professional résumé, references, business cards, a website (see p. 359), a reel (see p. 357), a suitable wardrobe, and a good attitude, as well as the fearless confidence to introduce yourself to people; inquire about jobs, projects, events, and relationships; and offer your services.

In addition, networking means developing a system of organization for keeping yourself constantly informed about what is going on, communicating with others about you, and being able to receive and transmit information about your capabilities and what you are looking for efficiently and seamlessly. It also means being willing to strategically put yourself in situations where you can meet people and learn, and then taking maximum advantage of those opportunities. Tips for accomplishing these things include the following:

- Have a specific goal for each event or encounter you pursue. People are busy and are doing other things in the places and at the events where you will be encountering them, so know exactly what you hope to accomplish when you ask for their time. If you want to be a camera operator, for example, you might approach a famous cinematographer by asking if he or she has suggestions for the best way to go about finding a training program or getting an internship or part-time gig in a camera rental house for experience.

- Read key industry websites, trade publications, directories, and job forums.

- Join, when you qualify, student or professional industry groups and associations. Some professional trade associations have student divisions or units that you can join or, at least, hold events you can attend. Interact with instructors and fellow participants and share contacts and information with them.

- Attend trade shows and film festivals, and look for networking opportunities. Don't hesitate to participate in Q&A sessions and to approach speakers after sessions to ask questions and seek advice.

- Create a database of your contacts and calendar to record, update, and remind you about industry contacts you make, and when to follow up with them.

- Learn where productions are being shot in your area, and where those crews socialize and dine. Introduce yourself to industry professionals when opportunities present themselves, offer to buy them coffee or lunch, and ask for advice or suggestions.

- Avail yourself of resources and educational opportunities periodically provided by local guilds and associations as well as by local studios, production, postproduction, and rental companies. Check their websites and calendars for upcoming events.

- Always have your business cards, reel, and website information readily available and easy to access.

Internships

In the old Hollywood studio system, studios had apprenticeship programs for young people, who were hired as trainees to learn their crafts at the feet of the masters, who were long-term studio contract employees. Today, on the profes-

**GIVE HELP
TO GET HELP**

When you encounter industry professionals while networking, offer to do them favors, volunteer, share contacts, and give advice of your own when you can. Don't forget that networking goes both ways: you need to offer help if you expect to get help. In the early stages of your career, you are looking to make relationships—not necessarily money.

sional level, most master craftsmen are independent and unionized workers, and while their guilds do offer many training programs and seminars for students, it is often difficult for non–guild members to find actual work on big studio projects, as they are typically union projects structured staff-wise by established labor agreements. However, there is experience to be gained on nonunion projects around the industry on smaller, non-studio projects of various types and descriptions. But whether union or nonunion, you won't get hired on a legitimate production if you don't know what you are doing; in either case, internships are an excellent way to learn the ropes.

Around the industry, the internship concept is alive and well. Studios, guilds, production and postproduction companies, technology companies, and industry associations all offer internships of one type or another for young people, and many of them have relationships with major film schools and regularly reserve such positions for film students specifically. The keys are finding out about them, figuring out if you qualify and how to apply, and competing with numerous other qualified candidates for the limited number of positions that might interest you. Keep in mind that competition for the summer positions can begin as early as January 1. As soon as classes begin, your first stop should be at your school's film office or career counseling center, or at least schedule a conference with your professor, to find out what internship possibilities your school may be affiliated with or be able to help connect you to.

Beyond that, the onus is on you to scour the industry for programs that might help you get the experience and connections to supplement your education and help launch your career. And make no mistake—internships can be a valuable tool in building a career in the film industry. For one thing, they literally give you the opportunity to spend some time inside it. You may not get to actually work in the ultimate job you dream of doing on a film, but you will get real working experience in the industry. Second, and more important, they allow you to take networking to the next level because you will have the opportunity to meet and work with people who might themselves be in a position to hire you as a professional if the internship is successful or, at least, give you a professional reference. Third, being an intern allows you an avenue for exploring the company, project, or institution you are working for in a way that a regular employee cannot. A typical paid employee is bound to his or her regular duties only, while you, as an intern, can almost certainly see different facets of the organization, meet people in different departments, and be exposed to various aspects of the work.

Can you get paid for an industry internship? Some internships pay, and others do not. Various legal actions targeting some industry internship programs over this issue have caused more stringent administration of these programs in recent years, so that technically, if you are not being paid, you must receive school credit. This practice is not always observed, however, and you will need to make the best practical choices for yourself. Even if the position is a paying one, it will most likely be low paying or offer just a stipend to cover expenses. Some programs offer *deferred-pay internships*, in which smaller companies or production companies offer to pay you a modest sum after a movie or TV show is produced or sold in return for your work. This allows them to put all available resources into the project, and you to get experience as well as a possible financial reward for your labor if the project is successful. Often the deferred payment never materializes, but you aren't there to make money anyway—you are there to learn, first and foremost. Thus, an internship is a bit of a dichotomy in the sense that you are expected to treat it like a serious job while often being asked to do menial chores, like pouring coffee or running errands, for little or

no financial return. Don't be dissuaded by this reality. Merely being in the room while serving food, for example, gives you an invaluable opportunity to listen to high-ranking industry professionals as they plot strategy and make creative, business, and technical decisions. If you diligently soak up such opportunities, it will prove more valuable to you than any possible stipend might in the first place.

With all this in mind, where might you search for internships on your own, beyond the resources and assistance you might hopefully get from your film school's career resource center? Here are some suggestions:

Practice

FIND AN INTERNSHIP

Starting at your school's or film department's career office, and then spreading out to do your own search, if necessary, begin investigating internships that might interest you. Although you may or may not end up following through with the internship, depending on your needs and plans, at least you will gain experience in discovering what is possible.

- Daily and weekly trade publications and websites, including *Variety*, the *Hollywood Reporter*, *Indiewire.com, Backstage.com*, and *Below the Line*, periodically run listings for major film and television shows currently in production around the country, or by region in some cases. These listings frequently include contact information for the production offices of various shows. You can call the productions directly, ask to speak to the production coordinator, identify yourself and your film school affiliation and area of study, and inquire directly about possible internship opportunities. Particularly if you are not demanding a paid internship, you will find certain productions to be quite receptive because, after all, they can always use the help if there are no union or legal restrictions preventing them from taking on interns.

- Most studios and other types of media companies list both job opportunities and internship programs somewhere on their corporate websites. Where they are located on the site may vary, but they are there—check the "about us," "corporate information," "employment opportunities," or "job board" sections, and you will find them. Major studio internship programs are sometimes paid, and they are often organized and offered for undergraduates and graduate students separately.

- Some job-seeker websites, such as mandy.com, cater to the filmmaking community and include sections on internship opportunities around the industry. Other general job or internship websites, such as www.summerinternships .com, break down offerings by industry or profession, and in many cases, "film," "television," and "media" are included categories.

Helping Yourself

There is one final lesson to consider as you strategize about a potential career in the film industry. This lesson involves the necessity of aggressively taking the initiative to propel yourself in whatever direction you wish to go, rather than waiting for circumstances or others to do it for you. You also need to keep your mind open to opportunities that may not be your first choice but get your foot in the door. For example, one of the authors of this book got his big break by obtaining a position in accounting at a major animation studio and was able to quickly move over to the production side. You have already expanded your skills in this course. Be-

Darren Aronofsky maintains a personal website where he can keep colleagues and fans up to date on his newest projects.

yond that, you will need to gather particular tools that will promote yourself and your work, and lure not only employment but also an audience.

In Chapter 14 you learned about defining and learning from your audience. With digital technology and social media communication tools, you can also start *building* an audience for your work right now, even before you are a professional filmmaker who has sold, exhibited, or officially distributed (at least through formal industry channels) something. Thus, even as you continue to pursue your filmmaking education, you may begin plotting your strategy for what comes next. Creating tools and using them effectively right now, and onward into your career, will give you a platform on which to base your filmmaking endeavors.

What tools do we mean? What components will make up your platform? The following elements, when combined, are a great start for your personal platform:

- Demo reel

- Website

- Strategic use of social media

- Résumé, portfolio, references, headshots, and other physical media

Demo Reel A **demo reel** is a video reel you create that showcases your finest work, edited and presented to highlight whatever aspect of your talents you want to emphasize. (See Action Steps: Creating a Demo Reel, p. 358.) The reel is a tool designed to maximize your chances to impress the folks you are distributing it to. Therefore, it is more than worthwhile to spend the time necessary to cut it together effectively; you may also want to consider making multiple versions, or different reels altogether, if you are pursuing different types of work in various sectors of the industry. For example, a design-dominated reel won't be much help if you are pursuing a cinematography job, and vice versa. It is convenient to have an online version available for people to easily access, but remember to always make sure that it is, in fact, accessible; that the link works; and that the video looks good when viewed on all browsers, mobile devices, and laptops.

Tip YOUR REEL SELLS YOU

Make sure your reel reflects not only your filmmaking skills but also your personality. If you enjoy humor, include humor. If you like color or loud music, try those things. Don't shy away from being who you are—you, after all, are the person you are selling with the reel. But don't include any profanity, nudity, graphic music, or extreme violence—even if you go in for such things, such elements will merely distract your viewer from the filmmaking skills you are trying to promote.

FILMMAKING

ACTION STEPS

Creating a Demo Reel

The basic technical skills you have learned in this course are more than enough to give you the tools and ability you need to construct a sharp demo reel, but you still need specific goals for the reel and a plan for executing them. By "goals," we mean: At whom are you targeting the reel? What kind of impression are you trying to make, and what kind of work are you trying to land with it? Obviously, your focus will be different depending on what kind of work you are pursuing. Here are some general guidelines for the elements you choose, how you put them together, and the philosophy you take in constructing the reel.

1 **Start with a bang.** Most professionals or recruiters won't watch a reel for more than 15 seconds—and that's being generous—unless it really grabs their attention. Even then, they will stop it and recommend that you be brought in for an interview. Therefore, lead with your best work. Do not spend time on an elaborate opening merely to introduce your name. The only reason people look at your reel is to quickly assess your abilities. Many young people miss opportunities because they organize their reel in chronological order.

2 **Focus the reel to your desired job area.** Be as specific as possible with the material you choose. If you are pursuing different types of jobs, make multiple types of reels, rather than relying on a single, generic reel. Target the reel for editing, cinematography, or whatever your specific goal is.

3 **Limit the reel to your best work.** This means limiting the length—generally keeping the reel short rather than trying to jam as many highlights as possible onto it. Go with your elite work only, even if the reel is shorter, rather than trying to pad it out.

4 **Be careful with your editing.** Even if your goal is not to pursue editing work, make sure your reel is cut professionally. Cut images to the beat of the music, don't mix video imagery of different aspect ratios, use clean cuts, and don't repeat footage. You can get help editing your reel, but be sure to credit those helping you—it shouldn't hurt your chances as long as editing is not the job you are pursuing. At the same time, however, don't overdo it by trying to impress with fancy cuts, unless doing so is crucial to what you are trying to illustrate. Keep things as simple as possible for the viewer to follow.

5 **Emphasize technical abilities.** If you are pursuing technical work, it may be a good idea to split the screen and show before and after images to illustrate your color grading or visual effects abilities.

6 **Avoid work that isn't yours.** Some people have been known to mix in the work of others or collaborations that highlight areas that did not involve their efforts without making clear that is what they have done. For example, if you created only the sound effects for the scene, make that fact clear—don't try to take credit for the dialogue editing or the cinematography. Not only is this dishonest, but it never pays off in the end, because it will eventually become clear if you don't have the skills to do the work you are advertising. Further, outright plagiarizing someone else's work on your reel is effectively a death sentence on your career. It's a small community, people talk, and they have long memories. In the same vein, never use copyrighted music to spice up the reel unless

you have received authorization to use it. There are tons of royalty-free options available, and there is no reason to take that kind of costly risk.

7 **Slate the reel, label clips, and avoid spelling errors.** In other words, do quality-control work. Make sure your name and contact information appear on the slate at the beginning and end, label each clip that appears so that the viewer knows what project or client it was for, and make sure everything is spelled correctly and the graphics are neat and presentable.

8 **Accessibility.** Make sure the reel is available both on physical media, such as a flash drive or a DVD, and online—on your website, a video-sharing site, or some combination thereof. It should be easy for people to see your reel, rather than a big challenge on an old type of media or in a strange or hard-to-play format. Therefore, for example, make sure that the media is playable in the place it is sent to. Countless reels from Europe have been discarded because they were in the PAL (European standard) format, rather than the NTSC (North American) video format. And check the media—play it yourself. Don't give the recipient any technical excuse not to play and evaluate your reel.

Website Similarly, even as a student, with the availability of a host of cheap or free web-building tools, there is no reason you shouldn't have an attractive website to promote your filmmaking endeavors and interests. Your demo reel, following the same parameters we have described, can be present on it, along with still photos of you, images from your work, behind-the-scenes images of you and your colleagues at work, your résumé, references, your blog, and links to your social media. (See Business Smarts: Build Your Online Platform, p. 360.)

Social Media The website can also be an essential tool in helping build your audience. Assuming you use social media adeptly, you can easily drive people interested in you, your work, or the topics you cover to your site, where they can learn more about you and your filmmaking capabilities. So keep it updated, active, and attractive at all times—it is a public representation of you and what you want people to think about you.

Along those lines, when you make a film, enter a festival, win an award, get an internship, take photos at an event, network with someone interesting, and so on, promote these endeavors on Tumblr, Vine, Facebook, Twitter, Instagram, and elsewhere, and make sure you train yourself to use these and all other popular platforms to push out your messaging to people who follow you, your work, or the subjects you are interested in. The massive impact of social media cannot be overstated, and artists and filmmakers of all stripes—from the internationally famous to people just like you—now use it daily to promote their work and messages. You should use it routinely and, by doing so, as your career grows, so will a general familiarity with you and your work among your followers, who, as you now know, will eventually evolve into your audience.

From this course and the work you will pursue next, you will have the skills to create interesting and attractive work and get your message out—with or without traditional distribution. All you really need is the interest and determination to do so. If you have it, then now is the time to get started.

What are you waiting for?

Tip
KNOW YOUR SEO

Master the art of search engine optimization to stay in control of your online identity, including using relevant keywords in blog-post titles, lead paragraphs, and metadata tags to ensure good search engine results; using #hashtags on keywords to make sure your social media posts are searchable; and sharing useful information in social media postings on topics people are likely to be searching for.

Practice
CRITIQUE REELS

Go online and seek out some readily available demo reels, or examine a classmate's or a friend's reel. Find one you think has potential or substance, and take some time to review it critically. Then, write down a formal critique of what you reviewed. What does the reel say about the individual's personality and filmmaking abilities? Would you hire that person based on the work you see? What were the strongest areas of work, and the areas that need improvement? Offer some constructive feedback, and incorporate that feedback as you seek to create your own reel going forward.

Build Your Online Platform

In Chapter 14, we touched on the importance of promoting a movie once it is made, and how online tools can serve that agenda. Earlier in this chapter, we emphasized the usefulness of incorporating web-based tools and social media into the foundation of the general promotional platform you will use to sell yourself and your work to prospective employers, collaborators, financiers, audiences, and followers. Indeed, this should be a living, organic, online platform that you use to sell yourself, beyond any single project. This is important not just because it is a good way to show off your creativity and filmmaking skills but also because it is simply good business. You can reach thousands of eyeballs with few, if any, marketing dollars to spend, no publicist, and little experience or contacts in the film world. The Internet, after all, is a unique and powerful tool that allows you to do creative and marketing work simultaneously, and distribute it widely with minimal resources.

Obviously, much of this involves mastering the delicate art of **search engine optimization (SEO)**, so that your online materials can be easily searched for and located by people interested in you, your work, or the topics you are dealing with. (See the Tip we offer on effective SEO techniques.) But those SEO efforts won't amount to much if you don't have strategically effective material online to begin with. Here are some pointers regarding your online endeavors:

- **Build an email mailing list.** Collect and organize email addresses at every film-related event or activity you get involved with. On your website, invite people to sign up for emails, newsletters, or notifications from you for the strategic purpose of collecting their addresses, so that you can reach out to them when you have news about a film, a project, an event, or an activity.

- **Build a sharp website and keep it up-to-date.** Make sure you own your website name and register it. Ideally, your website URL should be your name if it is available, or some other easy-to-remember variation of your name, such as YourNameCinematographer.com. Take down old content, and put up your most recent work, contact information, blog postings, photos, links, and so on. Routinely check for and fix broken links, and although you might think it painfully obvious, spell-check and edit your grammar and style—make it look as if you know exactly what you are doing. After all, if you can't spell, why would anyone think you can make a movie?

- **Always present movie clips** of some type that you either made or participated in making on your site—clips from your student or independent work, trailers, even tests or pieces of unfinished projects. Although prospective employers or people who might want to represent you might not have the time to spend all day on your site or click on endless links, they are interested in finding new talent. If they can immediately see some impressive work, they will want to dig deeper. Give them something that knocks their socks off as soon as they hit your site.

- **Leverage content strategically** onto Facebook, YouTube, Instagram, Vimeo, Tumblr, and elsewhere. Social networking tools make it easy for you to move content from one platform to another, and to personalize it for each platform. Likewise, learn the art of using Twitter with short, succinct postings and effective hashtags, and how to take advantage of Twitter's Vine app for creating short videos—you can easily post six-second teaser clips that can go viral and drive people to your site to check out your work.

■ **Start a blog, and update it weekly (or more often).** This is not a blog to wax philosophical about the issues of the day; rather, it is a movie blog that features the aspects of filmmaking you care most about.

■ **Build separate promotional websites and social media pages for every movie you make.** Make sure, as with any marketing materials, that you have a hook for them—a clear and simple way to make people interested in the movie up front, whether it is a provocative picture or clip, festival acceptance, reviewer quotes, box office or award data, or an outlandish technical or creative fact about how the movie was made or who stars in it. Then, work to strategically link that promotional site or page to your main site and other social media avenues.

■ **Religiously use the Internet Movie Database** (www.imdb.com) and other online movie-credit-listing sites to list yourself, your credits, and all your current and past work, so that anyone searching for you in such venues will find you easily enough. IMDB and other sites are largely updated by the people listed themselves, or their representatives, and thus the accuracy of listings varies widely. Make sure any site that lists you as a filmmaker lists you accurately—don't count on anyone else to do it for you.

✚ Emergency Kit

■ An upbeat, positive attitude. When you're looking for an internship or a job, the mental game is the most important game you play.

■ Persistence. For many people, it can take 100 inquiries, interviews, and contacts before landing the first opportunity. If you feel depressed after 60 meetings, pick yourself up: you are more than halfway there!

■ Your personal network. Who can help you get "inside"?

■ Good manners. Always follow up, don't be pushy, and send thank-you emails whenever someone meets with you. People remember such things.

CHAPTER 15 ESSENTIALS

▋ Sorting through film credits, you will see that many of the jobs on a movie project involve professions that are not directly related to making images or sound—these are part of the wider film industry that you can opt to work in whether or not you choose to become a filmmaker.

▋ To raise your profile and pursue jobs and connections in the film industry, you'll need to master the art of networking and self-promotion, along with availing yourself of the industry's training programs and internships.

▋ Part of this process involves building an online platform to use to promote yourself and your work, as well as to build an audience and following that you can maintain as your career progresses. This platform includes strategic utilization of a personal website, social media tools, search engine optimization skills, and much more.

▋ The other crucial tool you need to create and leverage to help promote your filmmaking goals is a personal demo reel. There is an art to making a demo reel—not just in the technical sense but with an eye toward making sure that it is tailored to specific goals for your employment agenda.

KEY TERMS

Demo reel
Networking
Search engine optimization
(SEO)

Notes

CHAPTER 1

Epigraph: www.interviewmagazine.com/film/steve-mcqueen-1/#_

1. www.youtube.com/yt/press/statistics.html
2. Backstage interview with author at the ACE Eddie Awards, 2/7/14, at the Beverly Hilton Hotel. Audio of interview available from link in story on *Post* magazine website: www.postmagazine.com/Press-Center/Daily-News/2014/ACE-celebrates-the-craft-of-Editing.aspx
3. www.filmclass.net/ElementsFilm.htm

CHAPTER 2

Epigraph: Quote and source information for opener derived from the *Hollywood Reporter*, July 2002: www.wga.org/subpage_newsevents.aspx?id=1907

CHAPTER 3

1. www.rollingstone.com/movies/news/q-a-ben-affleck-on-directing-argo-and-surviving-hollywood-20121012
2. www.editorsguild.com/magazine.cfm?ArticleID=1173

CHAPTER 4

Epigraph: All Oppewall quotes from author interview on 12/2/13.

1. All Jack Taylor quotes from author interview on 11/23/13 or from updated material supplied by Jack Taylor in April 2014.
2. Vincent LoBrutto, *The Filmmaker's Guide to Production Design* (New York: Allworth Press, 2002), 1.

CHAPTER 5

Epigraph: All Tim Moore quotes from in-person interview with author on 1/24/14.

1. All Jon Gunn quotes from author interview on 1/19/14.
2. Steven Ascher and Edward Pincus, *The Filmmaker's Handbook* (New York: Plume, 2012), 358.
3. Ibid.

CHAPTER 6

Epigraph: www.vice.com/en_uk/read/our-two-favorite-cinematographers-doyle-134-v16n9

1. www.mentorless.com/2012/12/12/the-wrestler-cinematographer-maryse-alberti-talks-about-her-work-and-career/
2. motion.kodak.com/motion/Products/Production/Spotlight_on_16/Why_16_mm/newWave.htm
3. variety.com/2008/film/news/maryse-alberti-3-1117997861/
4. www.oscars.org/science-technology/sci-tech-projects/digital-dilemma
5. The Science and Technology Council of the Academy of Motion Picture Arts and Sciences is currently leading an investigation into this area. Note: The Academy has issued a second report on this topic that focuses on the challenges facing independent filmmakers, documentarians, and nonprofit audiovisual archives.

CHAPTER 7

Epigraph: www.moviemaker.com/articles-directing/50-memorable-quotes-from-our-first-50-issues-3248

1. www.rogerdeakins.com/forum2/viewtopic.php?f=2&t=2128&sid=7007765867af39c79b2cb1a2cdbf01b2
2. www.hollywood.com/news/movies/43958072/roger-deakins-on-shooting-skyfall-like-a-western-not-an-action-movie?page=all
3. www.rogerdeakins.com/forum2/viewtopic.php?f=2&t=2039&sid=7007765867af39c79b2cb1a2cdbf01b2

CHAPTER 8

Epigraph: www.theasc.com/magazine/oct04/vilmos/page1.html

CHAPTER 9

Epigraph: Quote from *Filmmaker* magazine: http://filmmakermagazine.com/75637-in-the-same-way-painters-used-their-paint-d-p-bradford-young-on-aint-them-bodies-saints-and-mother-of-george/#.UxtVUl5DH7w

1. http://youtu.be/AbchmWS5jIU

CHAPTER 10

Epigraph: All Gary Rydstrom quotes in chapter from author interview, June 2013.

1. All Lon Bender quotes in chapter from author interview, 5/28/13.

2. Tomlinson Holman, *Sound for Film and Television*, 3rd ed. (Burlington, MA: Focal Press, 2010).

3. All Walter Murch direct quotes from author interview on 7/17/13.

4. George Rush, "What You Need to Know to License Music for Film," *SF360*, March 8, 2011, www.sf360 .org/?pageid=13430.

5. Steven Ascher and Edward Pincus, *The Filmmaker's Handbook* (New York: Plume, 2012), 446.

6. Ibid, 450.

7. Philip Brophy, ed., *Cinesonic: Cinema and the Sound of Music* (Sidney: AFTRS Publications, 2000).

CHAPTER 11

Epigraph: Mindy Elliott quote from email to author on 10/13/13.

1. Michael Ondaatje, *The Conversations: Walter Murch and the Art of Editing Film* (London: Bloomsbury, 2002).

2. http://digitalcontentproducer.com/digital_intermediate/ video_final_cutting_cold

3. Steven Ascher and Edward Pincus, *The Filmmaker's Handbook* (New York: Plume, 2012), 547.

4. Ibid., 583.

CHAPTER 12

Epigraph: *Motion Picture Editors Guild Newsletter* 19, no. 3 (May/June 1998).

1. All William Goldenberg quotes in chapter from author interview, 8/17/13.

2. www.slideshare.net/newestprod/video-editing-basics

3. Walter Murch, *In the Blink of an Eye*, 2nd ed. (Los Angeles: Silman-James Press, 2001).

4. http://en.wikibooks.org/wiki/Movie_Making_Manual/ Scene_Editing

5. Edward Dymtryk, *On Film Editing* (New York: Focal Press, 1984).

6. Walter Murch, *In the Blink of an Eye*, 2nd ed. (Los Angeles: Silman-James Press, 2001).

7. From Walter Murch follow-up interview with author, 5/9/14.

CHAPTER 13

1. All Jeff Okun quotes in chapter from author interview, June 2013.

2. From author phone interview with Ken Ralston on 7/18/13.

3. John Knoll quote from author interview on July 15, 2013.

4. Mike Seymour, "The Art of Wire Removal," *FXGuide*, October 27, 2007, www.fxguide.com/featured/the_art _of_wire_removal.

5. From author phone interview with Ken Ralston on 7/18/13.

6. From author phone interview with Jerome Chen.

7. John Lasseter, "Principles of Traditional Animation Applied to 3D Computer Animation," SIGGRAPH '87, *Computer Graphics* 21, no. 4 (July 1987): 35–44.

CHAPTER 14

1. www.westbankstory.com/new/festival.htm

2. http://creativefuture.org/wp-content/uploads/2014/01/ CreativeFutureFactsheet_5-7-2014.pdf. This organization is funded by the MPAA, which conducted the research cited.

CHAPTER 15

Epigraph: Jay Roach quote from email to author on 6/1/14.

Glossary

16mm and 35mm: The two customary formats of film, referring to the width in millimeters of the filmstrip.

180-degree rule ("the line"): The principle that says when shooting a scene, there is an imaginary line separating the camera and the action, and that keeping the camera and action on opposite sides will preserve continuity across shots.

3D stereography: A process that creates a visual illusion of dimensionality by showing two different images, one for the right eye and one for the left eye, mimicking the way our eyes perceive depth with stereoscopic vision.

above-the-line (ATL) costs: Generally, the more expensive costs of studio films, including costs of producers, actors, directors, writers, rights acquisition, and sometimes very highly paid craftspeople.

acoustics: The properties of a room that determine how sound will travel within it.

adapted screenplay: A movie script or story based on material that someone else has created.

additional dialogue replacement (ADR): The process of replacing lines of dialogue that are inadequately captured by the original film shoot, frequently called looping.

ambient sound: Environmental sounds that can be added to a movie's sound mix in between dialogue, music, and effects.

amplitude: The maximum range of a sound signal when measured from a particular average.

anamorphic lens: A camera lens that squeezes a widescreen image onto a 35mm piece of film or digital-reading medium. The image is then unsqueezed with a projector fitted with another anamorphic lens.

animatics: See *story reels.*

animatronics: The physical animation of puppets, robots, or other inanimate objects on-set using carefully calibrated and controlled motors and other mechanical methods.

antagonist: The personification of a challenge to the story's protagonist.

aperture: The hole that allows a specific amount of light to pass through a lens.

armature: A flexible wire frame to which sculptors can add clay, details, colors, and so on. Also used to describe a digital wireframe model.

art director: The individual who, working for the production designer, handles creation and execution of a movie's sets.

aspect ratio: The relationship between width and height of the screen image.

assistant director (AD): A position in support of a film's director; the assistant director's job is to coordinate all necessary elements for the shooting of a scene.

automatic level control: Devices that automatically control and maintain gain: boosting it when the signal is too low and lowering it when levels are too high.

backlight: A light placed behind the subject of the shot.

barn doors: Metal flaps attached to professional lights that can be opened and closed, directing light to a target area.

baselight: The amount of light necessary for the image-capture medium to register an image properly.

below-the-line (BTL) costs: The day-to-day costs of crew and equipment that are required for the actual physical production of a movie. These include cameras, set construction, tape or digital media, and postproduction work.

best boy (electrical): The gaffer's key assistant, usually positioned on the electrical truck, who deals with such logistics as equipment, crew schedules, and rentals.

best boy (grip): The key grip's main assistant, who also keeps the grip truck and equipment organized.

bidirectional: A microphone design that allows sound capture from the front and back, not the sides.

big close-up (BCU): See *extreme close-up (ECU).*

bins: File groups (also called windows or folders) that contain all the chosen elements, takes, shots, and options for each scene in a movie in a fashion organized to the filmmaker's specifications for maximum efficiency in finding and using those shots during the editing process.

bird's-eye view: See *overhead shot.*

bit depth: The flip side of the sample rate, impacting a signal's resolution rather than its recording level.

blocking: How the actors are positioned, and how they move, on a movie set.

blue screen: See *green screen.*

boom arms: Extensions that can be attached to light stands and poles to further their reach.

boom microphone: A microphone suspended on a boom pole or arm in front of or just above the actors as they speak.

boom pole: A long pole that can lift a microphone above or to the side of the action.

boundary microphone: A small, flat microphone, sometimes called a pressure zone microphone, that can be attached to a flat surface. Its purpose is usually to record multiple people or musical instruments when conditions don't permit mics to be situated near each actor.

breakdown sheets: Individual lists for each scene in a movie, usually featuring spreadsheet-style category boxes for each element, allowing data from a marked-up script to flow into appropriate categories.

calendar houses: Independent movie theaters that book their schedules months in advance and generally show a movie for only one week at a time. Many art house or specialty films are only shown at calendar houses.

callback audition: A final round of auditions wherein actors are often asked to perform longer scenes in different combinations.

call sheets: Daily guides for each day's shoots for every crew and cast member.

capacitor microphones: Microphones that use different forms of transduction to send their signals.

cardioid: A microphone with a pickup pattern designed to capture a wide area of sound directly in front and to the side of it, but very little behind it.

casting director: The person whose job it is to know the pool of acting talent and keep an eye out for emerging performers, and assemble a list of actors who may be right for a movie's roles.

chain of title: A clear legal link between the source material and works that derive from it.

character animation: An art form in which an animator puts an emotional performance into a drawn or computerized character that would not otherwise exist.

character arc: The movement or change of a character's wants or desires through the course of a story.

cheat cut: Deliberately matching shots that are intended to be continuous even though some element within the shot is mismatched.

cinematographer: See *director of photography (DP)*.

close-up (CU): A shot framing that starts at the top of the actor's shoulders and includes the actor's head.

codec: The translation of data between a compressed and a decompressed (and therefore readable) state.

color: The way we see the visible spectrum of light.

color depth: The number of colors a monitor can display.

colored gels: Sheets that change the color of light when placed in front of a lighting fixture. They do not add color; rather, they absorb opposite wavelengths.

colorist: An artist who works closely with the director and cinematographer to address color adjustments, often digging deep into individual frames of a movie to subtly adjust nuances of color.

color temperature: The degree of blue or red in white light measured in the kelvin (K) scale. White light that has more blue in it has a higher temperature; white light with more red has a lower temperature.

completion bond: A form of insurance to guarantee that a film will be finished on time and within budget.

compositing: The seamless combination of two or more images into a new, final image, which can be done either digitally or optically.

composition: The craft of arranging people, architectural details, and objects inside the camera frame so that they look good.

compression: The process by which recording software saves space by not recording every bit of every pixel for every frame, instead recording only new information.

compressors: Devices that work with a recorder or microphone to compress the sound's dynamic range if audio levels spike too high.

computer animation: The creation and manipulation of moving imagery using digital tools.

computer-generated imagery (CGI): Any character, set extension, or visual effect created using computer software.

concept art: Detailed drawings or diagrams created as reference templates for costumes or sets, frequently drawn in pencil, charcoal, or marker.

conforming process: Reassembling a movie using original higher-resolution elements during the finishing stage, also called the online edit.

construction manager: The individual who puts together a construction team and builds sets for major film projects.

continuity: The process of making every shot in a scene match in time and action.

continuity editing: The most basic and common method of telling a fairly linear story, which leads the audience through a specific sequence of events that eventually reaches a logical conclusion.

contrast: The visual difference between light and dark.

contrast cut: Using a cut between shots to juxtapose two people or elements.

cookies: Metal panels with shapes cut out of them that cast a pattern when lit, useful for creating texture and identifiable shadows.

co-producer: See *line producer*.

coverage: Additional camera angles to give filmmakers more options later, in the editing room.

cowboy: A shot that moves in closer than a full shot and generally cuts an actor off just above the knees.

crane: A camera rig, sometimes remote-controlled, that allows the camera to be raised up high, swooped down, or pulled back a great distance.

cross cut (parallel cut): A type of edit that uses images from two or more parallel plot lines.

cross fading: Transitioning out of one musical cue into another by bringing one down and simultaneously bringing another up.

cue sheets (timing sheets): Lists, generated during spotting sessions, that show every location where a musical cue will be required and how long it should be played.

cuing: Planning for sections of dialogue that cannot be repaired during editing, to make additional dialogue replacement work easier later.

cutaway: An edit that involves an instant transition from a close view of an image to a more distant view of that same image.

cut-in: An edit that involves an instant transition from a distant view of an image to a close view of that same image.

cuts: A group of commonly accepted methods for transitioning between individual shots that are routinely used by editors.

dailies: Footage processed soon after it is shot, in order for filmmakers to review it.

data compression scheme: The type of recording format, chosen based on how much compression is needed given the amount of storage space available. Examples include the MP3 or the BWF (Broadcast Wave Format).

dBFS (decibels full scale): The maximum peak levels for decibels on digital systems.

decibel: A unit for measuring the intensity of sound.

demographics: Age, gender, socioeconomic, race, and ethnic information.

demo reel: A video reel created to showcase your finest work, edited and presented to highlight whatever aspect of your talents you want to emphasize.

depth of field: The distance within a frame that appears sharp and in focus.

development: The process of writing and rewriting a script with input from constructive readers, directors, actors, and producers in order to refine the script for shooting.

diaphragm: In a microphone, the transducer that sound hits, causing a vibration that the device turns into electrical energy, which is then converted into an audio signal by the recording device.

diffused lighting: Lighting that clearly illuminates a scene without sharp edges.

diffusion materials: Any material that gets between the light source and the subject, including grid cloth, nets, or silks, which are often used to diffuse sunlight.

digital audiotape (DAT): A recording format long used by analog field recorders, mostly replaced today by the digital audio recorder.

digital audio workstation (DAW): Any device for mixing together recorded sounds, ranging from an ultra-expensive, professional mixing console to apps for your personal tablet.

digital intermediate (DI): The final color-correction process, typically done at a separate facility or with high-end color-grading software.

digital master: A file of the basic mastered version of a movie that often lives on a hard drive or other digital media.

dimensionalization: The processes of taking 2D imagery and converting it into a finished 3D movie. Also known as stereoscopic conversion.

directionality: The directions from which a microphone can pick up sound, determined by the mic's polar pattern.

directional lighting: Lighting that comes from a clearly defined source, such as a lamp or the sun.

director: The most important single individual on a film set, who selects a script, chooses actors and other collaborators, makes logistical decisions during the filmmaking process, and expresses his or her viewpoint throughout the production.

director of photography (DP): The person ultimately responsible for making sure a movie is properly photographed. Also called a cinematographer.

direct sound: Any sound that comes directly from the source, such as an actor's mouth or a prop.

dissolves: The effect of strategically replacing one shot with another, one fading out as the other fades in.

distribution: Methods or venues for showing a movie to an audience through an ever-expanding choice of screens and physical or digital display mediums.

dolly: A camera-support platform designed to move on a fixed track, straight or curved, that allows the camera and camera operator to ride along for a smooth moving shot.

dolly grips: The people on a film set who set up and take down dolly track, camera dollies, and cranes, and push the camera along the dolly track for tracking shots.

dolly shot: A shot that utilizes a camera mounted on a device that moves around a fixed, railroad-like track.

dressers: See *set decorators*.

Dutch angle: A shot that tilts its view, placing the camera at an oblique angle to the horizon and putting the images on a diagonal.

dynamic condenser microphones: Microphones with an electrical capacitor built in to simulate a diaphragm.

echo: The reflected sound one hears after a sound bounces off an object far away, giving listeners time to mentally distinguish it from the original sound.

edit decision list (EDL): A detailed list of all editing decisions, usually generated automatically by a nonlinear editing system, used as a road map for building the final version of a movie during the online process.

editor: The individual who assembles the footage that has been shot, finding the best way to tell the story and convey character and emotion by selecting images and sounds and placing them in a specific order designed to enhance the emotional impact of the director's creative intent for the material.

effects sound: Audio elements beyond dialogue and music.

electrical condenser microphones: Microphones that use different forms of transduction to send their signal.

electrical technicians: The people on a film set who set up and control the electrical and lighting equipment, from lighting instruments to electrical generators and any other sources of electricity that may be used. See also *gaffer.*

elliptical editing: A style of editing that omits linear pieces of the sequence, resulting in the visual equivalent of grammatical ellipses.

equalization (EQ): The aspect of a signal that is altered during noise reduction work to enhance or correct the sound signal.

establishing shot: A shot wide enough to capture all important architectural or landscape details, setting up the location where the ensuing scene will take place.

exhibitors: Companies that operate theaters.

exposure: The total amount of light that falls on the image-capture medium.

exposure index (EI): A measure of the amount of light to which a film or optical sensors are being exposed.

extreme close-up (ECU) (big close-up [BCU]): A shot that frames out the actor's shoulders and often will not even show the top of an actor's head.

extreme wide shot: A wide shot in which the actors will appear much smaller, perhaps taking up as little as 20 percent of the frame.

eye-level shots: Shots in which the camera is placed level with the actors' eyes, usually between five and six feet for adult actors.

eye room (look room): Negative space where the character's eyes are looking.

facial capture: The use of motion-capture systems specifically designed to capture subtle motion of facial muscles and apply them to an animated character.

fade: A transitional editing technique used to mark the beginning or end of a scene or a film itself by dimming the picture until the screen is black, or having an image emerge from a darkened screen.

fader: Audio controls that can be used to adjust the sound level, sometimes called gain.

fading: Gradually increasing or decreasing the sound of music over a scene.

fair use: The idea that it is legal to use small portions of copyrighted works without authorization in certain contexts, such as parody or education.

falloff: The difference between the intense center of a lighting instrument and the light around its edges.

field mixer: A portable battery-powered mixing device that allows the recordist to combine multiple mic signals and mix them into a single output signal in the field.

fill light: A light positioned on the side opposite the key light.

film: A series of moving images intentionally constructed to tell a story. Technically speaking, *film* also refers to a plastic or celluloid strip coated with a light-sensitive chemical emulsion.

film festival: An organized, curated presentation of movies. Most take place in physical locations and last anywhere from one weekend to several weeks.

film stock: See *raw stock.*

filtering: Increasing higher frequencies of music while limiting lower ones.

filters: Round pieces of glass that screw onto the front of the lens of a camera or lighting instrument and are used to change the visual palette by enhancing or subtracting colors, increasing or decreasing contrast, or making the image sharper or hazier.

final cut: The locked version of a movie that will be distributed.

final mix: The process during which all audio elements will be locked and combined into a final soundtrack.

fine cut: The examination of each scene and cut in a movie to determine which ones require small tweaks and changes.

fish-eye lens: See *ultra-wide-angle lens.*

fit-to-fill editing: A technique used if a clip is too short for available space, marking inpoints and outpoints for the space, then instructing the nonlinear editing system to minutely speed up or slow down the clip to fill the differential.

flesh line: A tool that helps set proper skin-tone color more accurately during color correction.

floodlights: A lighting apparatus that covers a wide area with even light and produces little or no shadows.

floor diagram: A map of where the actors will be and where the camera angles should be.

floorplan: A map of the stage from above, allowing film-makers to see all elements and their locations before they build anything.

focal length: The distance between the end of the lens and the point at which it focuses on the optical sensor or piece of film, measured in millimeters.

focus: The clarity of an image, determined by what has sharp edges and what is blurry.

Foley: The artistic manufacturing of sound effects that directly match action within the picture.

Foley mixer: The person recording the sounds to be matched with on-screen action.

Foley walkers: Trained artists who "perform" effects in a choreographed way with the moving-picture image using special props on a special stage.

foot-candle: A standard unit of lighting measurement defined as the amount of illumination one candle casts on a surface one foot away.

forced perspective: A way of showing the audience a point of view that appears to make an element seem closer, farther away, larger, or smaller than it really is when photographed from certain angles.

formats: Standard movie sizes with clearly defined size and shape characteristics.

form cut: Putting together two images that are of similar shapes or in similar positions.

frame rate, or frames per second (fps): The number of individual images that are displayed in a single second to create the illusion of movement. With a conventional motion-picture projector, a shutter in front of the projector lamp spins around, making light flash through the frames of film as it advances. A digital projector operates differently, with no "blanking" between the images, but the illusion is achieved the same way. Most movies are projected at 24 fps.

frequency: The rate at which a sound repeats its wave per second.

frequency response: How effective an audio device is in transmitting an audio signal after receiving it.

Fresnel spotlight: A type of light that produces a bright, hard light.

frontality: The idea of staging an actor so that he or she faces the camera directly.

f-stops: The measurement of the size of the aperture, typically ranging from 2.8 to 32. The larger the f-stop number, the smaller the amount of light allowed through the lens.

full shot: A shot that frames a single actor from head to foot.

gaffer: Traditionally, the head of the lighting department on a film set, responsible for designing and implementing the lighting plan and electrical power needed to supply it. Sometimes referred to as chief lighting technician.

gain: Sound levels.

giant screen: An inclusive term that applies to IMAX and other large-format theaters, planetariums, theme parks, and dome theaters that make the viewing of a movie more immersive, with the screen filling the audience's entire field of view (and sometimes more).

grant of rights: A written and signed agreement, giving permission to use a story based on someone else's work.

green screen (or blue screen): A screen of a single color. Actors or parts of sets can be placed in front of the screen to shoot scenes, where other details will digitally replace the screen in postproduction.

greenspeople: The handlers of all plants on a movie set.

grips: The crew members responsible for operating or assisting with the tools to move cameras. See also *lighting grips*.

handles: Stored extra frames that can be easily recovered through the nonlinear editing system even after they are no longer visible on the timeline.

hard costs: Items in the budget that are essential and must be paid for, such as camera rental, location fees, food, and gas.

hard cut: See *straight cut*.

head: The first frame of a new shot.

headroom: How close the top of the frame is to the actors' heads.

high-angle shot: A shot for which the camera is placed above the actors' eye level and looks down on the action.

high-key lighting: A lighting setup that casts light evenly across an entire scene. For this reason, it feels brighter and happier than other lighting and is often seen in comedies and television sitcoms.

hypercardioid: A type of microphone similar in pattern to the cardioid, but with a narrower, more targeted front range and the ability to pick up a narrow range of sound directly behind the microphone.

incident-light meter: A device that measures light at a specific place in the scene rather than the average light in the entire scene.

inciting incident: The event that triggers a story.

inpoint: The specific point in a frame where a clip begins during the editing process.

insert shot: A shot that captures an important detail in a scene by cutting away from the main action, usually moving in closer on a particular object.

intellectual property: A legal term expressing ownership of creative works.

iris: A variable ring, located behind the focus ring, used to adjust aperture.

iris (iris wipe): The reduction of a full image down to a circular mask or oval showing part of the remaining image, forcing attention to what is in the center of the oval, while the rest of the screen is masked by black.

ISO: The number that indicates a film stock's sensitivity to light (ISO refers to the International Organization for Standardization).

jump cut: An elliptical edit implying that some amount of time has passed via a single shot being changed or interrupted in some way.

key grip: The individual who heads the grip department and works closely with the director of photography to set up and break down the elements for lighting.

key light: The main light in a scene.

latitude: The degree to which an image-capture medium can be over- or underexposed and still maintain enough detail to look good.

lavalier microphone: The most common microphone for placement on actors, which can usually be attached to an actor's lapel, hidden from camera view.

L cut (split edit): An edit that causes a shot's audio and visual components to occur at slightly different times to achieve dramatic or emotional impact.

lead room: Negative space in front of a character in a frame where a character is walking.

lens: A piece of specially shaped optical glass at the front of the camera—and the camera's most important part.

letterboxing: The placement of a black bar above and below the frame to preserve the original aspect ratio.

lift edit: The process of removing a shot but maintaining the space it took up on the editing timeline with black frames, often called filler or slugs or gaps.

light flash: Rapidly dissolving the screen to white for a very short time so that it evokes a camera flash before switching to another image.

lighting diagram (light plot): A drawing of how the lights will be positioned on a film set, analogous to an architect's drawing of how a house will be built.

lighting grips: People on a film set who specialize in rigging everything related to lighting, from adjusting set pieces and putting the camera into the correct position to setting up flags, bounces, and silks.

lighting ratio: The difference in intensity between the key light and the fill light.

lighting triangle: See *three-point lighting.*

light meter: A device that measures light intensity.

light plot: See *lighting diagram.*

light stands: Straight pipes that fit into weighted bases or metal rods that have tripod legs attached, holding up lights and allowing them to be adjusted.

limited release: The smallest type of theatrical film release.

limiters: Separate automated systems that activate if volume levels rise sharply during audio recording.

"the line": See *180-degree rule.*

line producer (co-producer): A producer who has primary responsibility for production logistics, such as casting, actor contracts, and script changes. All department heads report to this person.

location managers: Those responsible for figuring out production locations that will work practically and creatively, often in close collaboration with the director, production manager, and production designer.

logging: The process of deciding what material to download to the nonlinear editing system as possible elements to be considered while editing.

log line: A one-sentence description of a movie.

long lens (telephoto lens): A lens with a focal length of 85mm and above that magnifies the scene and lets the camera see things that are farther away.

long lens close-up: A shot that compresses the actor's facial features and brings the background closer.

look room: See *eye room.*

looping: See *additional dialogue replacement (ADR).*

low-angle shot: A shot in which the camera is placed below the actors' eye level and must be angled up to see the action.

low-key lighting: Lighting that isn't as even as a high-key setup, emphasizing shapes, contrasts, and contours, and heightening the dramatic tension and mood.

luminance: The light that reflects, or bounces off, things. Light-colored objects have more luminance, whereas dark-colored objects have less luminance.

lux: The amount of illumination one candle casts on a surface one meter away; one foot-candle is approximately 10 lux.

macro lens: A lens that can focus from as little as one or two inches away, and can produce crisp images of very small subjects.

magic hour: The time between sunset and dusk or dawn and sunrise, optimal for filming because shadows are gone and the natural lighting ratio between the background and foreground is very small.

marketability: How easy it will be to get people interested in seeing a particular film.

marketing: Making a potential audience aware of a film and what it offers in a way that makes them want to see it.

master shot: A wide shot of an entire scene, which can be used as reference when cutting in for closer shots.

match cut: An edit that joins similar shapes or elements together in a way that does not let the audience comprehend that an edit has occurred.

matte painting: A painting of something that is too difficult or expensive to build, which can be added (or "matted") onto the final image. Matte paintings may be unreal worlds, set extensions, landscapes, skies, or anything else.

medium close-up (MCU): A shot that frames the actor from the middle of the chest and moves up to the top of the head, sometimes cropping the actor's face at the hairline.

medium shot (MS): A shot composed to start at the actor's chest and move up to the head.

metadata: Specific information contained within a digital file about that file itself.

mise-en-scène: The display of every visible element in a film frame, based on the notion that everything visible has a purpose and is there to reinforce the point of the scene or aid the story.

mixing: The process of doing the final manipulation, enhancement, balancing, and control of the assembled audio track and all its elements, down to characteristics of the audio signal itself, to create a finished product that can be matched to the picture during the final mastering process.

mixing console (mixing board): The tool used to bring in different sound sources and combine them, controlling different channels and frequencies to produce the desired blend.

montage editing (thematic editing): The connecting of images based on a central theme or idea to efficiently convey information or ideas in a concise and powerful manner.

morph: In editing, a type of dissolve in which the primary object or image of the first shot is reshaped so that it can be transformed into something else to begin a new shot or scene.

motion blur: The process of making certain types of moving images appear more organic and natural to the human eye.

motion capture (mocap): The process of using sensors and specialized cameras to record the movement of a living person or creature, translating those recordings to data, saving that data, importing it into a computer-animation system, and applying it to the digital controls for CGI characters to permit them to have more realistic movement.

MTV style: See *post-classical* editing.

negative: The original images as they were captured by a film or digital camera.

negative space: Space that is not filled in a frame of a film.

networking: The process, formal or informal, of raising your profile to a point where the people who might hire you take sufficient notice of you.

niche: A narrowly defined slice of the audience.

nonlinear editing system (NLE system): A computer workstation configured with special software designed specifically for editing moving images.

offline editing: Changing files to a lower resolution, resulting in a lower-quality image on the monitor that is easier for the computer system to work with during the editing process.

omnidirectional: Microphones that pick up sound coming from any angle or direction with equal clarity.

online editing: Editing material in its native resolution and file size, typically at the size the materials were originally recorded and saved in.

open assignment: A screenplay project that is open for a new writer to work on.

optical effects: Special effects that involve photographing images using camera and laboratory tricks.

optical printer: A specialized piece of hardware used to combine positive or negative images into new compositions on an entirely new piece of film.

optical sensor: The part of a digital camera that translates the light coming through the lens to ones and zeros, which is then recorded to a hard drive or memory card.

option: A legal agreement for intellectual property rights in a given work (screenplays written independently, video games, novels, and so on), in which studios or producers pay a certain amount of money for the right to develop that project for a given period of time.

original idea: A movie idea not based on a preexisting source.

outpoint: The specific point in a frame where a clip ends during the editing process.

outtakes: Pieces trimmed out during editing.

overhead shot (bird's-eye view): A shot that looks straight down on the action from above, making the characters appear insignificant.

overlay edit: See *overwrite*.

oversight: Limitations and restrictions on a film production, including running time, rating, casting, release date, and budget.

over-the-shoulder (OTS): An extremely common shot that includes two actors engaged in dialogue, with the actor nearest the camera in the foreground with his or her back to the camera, and the actor farther away facing the camera, framed in a medium or loose close-up.

overwrite (overlay edit): Inserting a new clip and overwriting all material already on the timeline from where the new clip starts to where it ends.

pan: Moving the frame on the horizontal axis—from right to left or from left to right.

panning and scanning: A process in which a movie is altered for a different-shaped screen by recomposing shots to make sure the audience can see what is happening.

parallel cut: See *cross cut.*

parallel editing: A technique in which editors interweave multiple story lines or portions of story lines.

peak meters: Instruments that read the volume level of sound.

performance capture: See *motion capture.*

pickup pattern (polar pattern): The design aspects of the microphone that determine from which directions it can pick up sounds—that is, how sensitive it is.

pillarboxing: The placement of black bars on the right and left of an image to preserve the original aspect ratio.

piracy: The illegal uploading, downloading, or copying of intellectual property.

pitch: A meeting in which a writer tells his or her film's story.

pixels: The smallest single elements in a digital image which, when combined together, make up the total image.

platform release: A theatrical release in which a film starts out in a small number of theaters and expands to more over several weeks or months.

playability: How well the audience responds while watching a film.

point-of-view (POV) shot: A shot that shows what the actor is seeing during the scene, often shot with a handheld camera to give a sense of movement that mimics the way a character might be looking at something.

post-classical editing (MTV style): An approach to editing that involves a fast pace, rapid cuts, short shots, and more jump cuts than in classical techniques.

postproduction sound: Any elements needed after filming is over, such as voice-over narration, repair or addition of dialogue, library sounds, and music.

Pot (potentiometer): See *fader.*

practical effects: The manufacture of special-effects elements outside the computer in the real world.

preamplifiers (preamps): Devices that connect to a microphone to boost a low signal before that signal is sent to the recording device.

preview screening: See *test screening.*

previsualization (previs): Conceptual art made to visualize individual elements, designs, shots, camera angles, visual effects, or other images in a film. Media for previs art can include 3D computer animation, hand-drawn storyboards, paintings, or simple sketches.

primary color correction: The work done to impact color throughout the entire frame.

prime lens: A lens with only one, fixed focal length.

producer: The individual who brings all the elements of a film together and supervises all the staff, responsible for the creative outcome of the movie and accomplishing that outcome on time and on budget.

production board: A graphical display of breakdown-sheet information on a series of thin, color-coded cardboard charts that the production manager can manually sort and mount on a large production board for the entire production management team to see and use, forming a rudimentary schedule.

production sound: The recording of actors speaking on-set dialogue during principal photography, including pauses, silence, or room tone during dialogue sequences.

production strips: The thin, color-coded cardboard charts arranged on production boards to form a shooting schedule.

profile shot: A close-up or a wide shot conveying the intensity of the actor's gaze or the sculptural quality of the actor's face, shot with the actor's eyeline at a 90-degree angle to the lens.

program monitor: See *record monitor.*

promotion: The process of developing relationships with organizations or companies that will help spread the word and sometimes create incentives for people to see a movie.

prop master: Individual in charge of finding and preparing all primary props on a film set.

props: Items that actors will be physically interacting with and using in a film.

prosumer: A category of digital camera that is a hybrid of consumer grade and professional grade.

protagonist: The main character of a movie, usually with some kind of goal or desire.

psychographics: Measurement of an audience's opinion and cause identification.

publicity: News that gets out about a movie for free, generally conveyed by others.

raw stock (film stock): Unexposed film that can be purchased from a film supplier.

record monitor (program monitor): The part of the editing system used for basic viewing of edited sequences.

recruited screening: A screening for which audience members are invited (recruited) to see a new film before it opens; often they are given only a generic, two- to three-sentence description of the film to pique their interest.

reflected-light meters: Devices that measure the overall light in an entire scene by displaying average light.

reflected sound: The result of direct sound bouncing off walls, floors, ceilings, and so on.

reflectors: Light that doesn't need to be plugged in, generally made of reflective material like flexible aluminum foil.

relational editing: A style of editing that places a greater emphasis on directly connecting scenes by establishing a specific relationship between them.

rendering: The computer process for finalizing a raw, computer-generated image, so that it fully forms the textures, colors, surfacing, and shading necessary for the final product.

replacement edit: The editing-software process of using marked spots on an image to seamlessly substitute that image with a different clip.

resolution: The amount of detail included in a single frame.

reverberation (reverb): A sound effect (sometimes confused with echo) that involves the bounce-back of a sound from a nearby reflective surface to its source so quickly that it is heard in combination with the original sound to create a prolonged, decaying effect.

reverse cut: The practice of crossing the axis line during a conversation scene, thus deliberately violating the 180-degree rule.

reverse shot: The second half of an over-the-shoulder shot; when shooting an over-the-shoulder shot, moving to shoot the actors from the opposite direction is called a reverse shot.

rigging: The installation of anything from a set to lights, but often used to refer to the process of creating animation controls, either mechanically or digitally, for a character, creature, or object.

ripple edit: See *splice edit*.

room tone: A unique, barely audible hum, buzz, or low tone that exists due to natural phenomena or mechanical infrastructure.

rotoscoping (roto): A specialized technique, part of the larger compositing process, that evolved out of an animation technique in which animators traced over live footage by hand, frame by frame, then lifted those live-action elements out and added in other elements before reassembling the shot. Today, a similar process can be done with computers.

rough cut: A more refined version of the assembly edit, in which elements of the movie are in place but not yet finalized.

rule of thirds: The practice of dividing the frame into thirds both horizontally and vertically, and placing the subject of the shot on one of those lines. This gives images a sense of visual balance.

safety chain: A chain around any light attached by a C-clamp to an overhead grid, used in case the C-clamp fails.

sample rate: The rate at which the digital recorder captures the signal being recorded.

score: The background music of a film or television show, which may be written, licensed, or both.

scratch disk: The place on a hard drive where editing media is stored.

script breakdown: A series of formal steps for going through the script and identifying key elements for each shot or scene, accounting for schedule and budget.

script supervisor: The person who creates the collective written record of the production, ensuring a film's continuity.

scrubbing: Searching for and eliminating editing noises that are not readily audible after making cuts, such as tiny sounds caused by connecting two audio components together.

search engine optimization (SEO): The process of making sure specific online materials can be easily located.

secondary color correction: Adjustments made to specific colors in specific parts of the filmed image.

set decorators (dressers): Individuals tasked with procuring and placing on-set all props and pieces that are not physically connected to a set.

set extensions: Visual effects added to partial sets to create the illusion of a full set.

set pieces: Items that are not actually used on-screen in a film but are part of the environment in which events take place.

setup: See *rigging*.

shock mount: A mechanical shock-absorbing fastening system that connects and stabilizes two instruments to prevent vibrations.

shooting schedule: The plan for shooting particular scenes on particular days in particular places in a particular order.

shotgun: Microphones with a tubular design, used when recording whatever the microphone is directly aimed at (rather than additional sound elements nearby).

shot list: The list of camera angles and setups in a scene, which filmmakers need in order to plan their shooting day.

shutter angle: The duration the camera lens is allowed to capture light.

signal-to-noise ratio: The amount of necessary sound compared to the amount of background, distracting, or distorting sound in a recording. A high signal-to-noise ratio involves very little background or distorting noise.

slate: The board listing the shot and number of each take, used to synchronize sound and action later.

snapping: A tool in nonlinear editing software allowing clips to automatically fit together with minimal gap or space between them.

softlights: Small and portable lights that shine light indirectly. Their lamp is hidden from view and pointed at a reflector; thus, the reflected light is cast on the scene.

sound design: The overall scheme to which all sound-related tasks in a film are conceived and connected.

sound editing: The finalizing and combining of individual audio elements—dialogue, ambient sound, effects, and music—in a coherent way.

sound effects: Any sonic elements, whether recorded live or manufactured on a stage or studio, outside of music or dialogue.

sound mixer: The sound mixer (or rerecording mixer) adjusts the signal, frequencies, and effects as needed. He or she establishes final levels in the mix, puts the soundtrack through the equalization process (adjusting frequencies as needed), and filters the sound.

source material: The raw material from which an adapted screenplay comes (such as a novel, comic book, or television show).

source monitor: See *viewer*.

source music: Music that seems to be part of the environment within the story—coming from a radio or television in a scene, for instance.

special effects: The manufacture of elements outside the boundaries of real life for a film.

splice edit (ripple edit): An editing procedure by which all preexisting clips automatically move to the right of the new shot.

split edit: see *L cut*.

spot meter: A device that measures the amount of reflected light in a specific area of a shot.

spotting sessions: Meetings intended to make final decisions about the needs and specific placement of sound effects and music, and to figure out what dialogue manipulation, if any, will be required.

sprocket holes: Perforations on either side of the film, allowing it to move through the camera and projector.

stacking: The process of placing two or more clips on different video tracks within the timeline of an editing program in order to layer the images.

stand-ins: People with height and physical builds similar to the actors in a movie, who remain in place as long as it takes for the cinematographer and lighting crew to adjust the lights.

Steadicam: A special harness that fits on the cameraperson's body and holds a digital or film camera. It has counterweights and a balancing mechanism, so the cameraperson can run or walk and the camera motion will appear smooth and fluid.

stem: A single audio unit. A stem may be a dialogue track, a sound effect, or a specific instrument in a music track; stems are delivered separately so they may be audio mixed individually.

storyboards: Visualizations of sequences, frames, or entire films in the form of panels created to resemble comic books.

story reels (animatics): Comic-book style panels depicting various scenes in animated movies and then filmed "flip-book style," sometimes with music and dialogue, creating templates for filmmakers to follow as a project moves through production.

straight cut (hard cut): An edit in which one shot ends and another shot begins without any fancy effects, time distortions, and so on.

structure: The order in which a story is told, or the way the scenes are set next to each other to form a coherent whole.

studio notes: A guide, prepared by studio executives, for a screenwriter to follow when making revisions.

summing: Using the mixing board to raise or lower the level of one channel to better match the other.

super 8mm: A smaller format of motion-picture film commonly used as consumer-recording media until the widespread adoption of video cameras.

superimposition: The combination of two or more images—not as a transition (see *dissolves*) but as a way to introduce another element or emotional concept to the original image.

surfacing: The addition of texture and color to special-effects creations.

sync point editing: Lining up particular elements within multiple video clips or between video and audio clips automatically.

table reading: The practice of the cast sitting together and reading the entire screenplay aloud, giving the director important information about how scenes play for story, emotion, comedy, and character revelation.

tail: The last frame of a single shot.

take: An exact repeat of the same shot during a film shoot.

target audience: The people a distributor or producer thinks will want to see a particular movie, based on demographics and psychographics.

technical rehearsal: A final run-through of a scene, which allows the director of photography to finalize the light and camera positions, and the sound record is to determine the best way to capture the actors' dialogue.

telecine: The process of transferring and converting of film images for video viewing.

telephoto lens: See *long lens*.

temp tracks: Music used to help set a mood during the first stage of editing, usually used without official permission.

tentpole film: A big, wide release that "holds up" a studio's slate of movies.

test screening (preview screening): Showing a movie to a select, private audience and observing their reactions.

thematic editing: See *montage editing*.

theme: The big-picture thesis in a story that illuminates something about the human condition and provides a universal take-away for the audience.

three-point editing: The process used to efficiently insert clips into a destination track during editing.

three-point lighting (lighting triangle): The basic construct of all lighting plots: key light, fill light, and back light.

three-quarter back shot: A shot viewing the actor from nearly behind but leaving the actor's eyebrow and ear visible, conveying that the character is deep in thought.

three shot: See *two shot/three shot*.

tilt: A shot that moves the frame along the vertical axis, up or down.

timecode: A visible numeric code used as a tool to synchronize audio and video.

timeline: The most important visual user interface within a nonlinear editing system.

timing sheets: See *cue sheets*.

top sheet: A summary of a budget document's major categories along with the total cost of production.

tracking: The process of matching the motion of foreground and background elements using computer software. Also called match moving or motion tracking.

tracking shot: A shot that moves with the characters or the action.

trailer: A longer advertisement for a film that plays in front of other films, online, or on television, ranging from 90 seconds to three minutes.

transitions: Techniques for moving from one shot to the next.

trimming: The process used to change the length of clips on the timeline.

tripod: A structure that holds a camera steady; use of a tripod is the most basic way to control and stabilize camera movement.

Tungsten lamp: A commonly used type of light that approximates the look of indoor lighting due to the color temperature of the Tungsten filament.

turn-around: When optioned rights to a piece of intellectual property revert from the studio back to the original owner.

two shot/three shot: Shots that capture an intimate discussion in a single shot, referring to the number of objects (usually actors) in the frame. Typically, the framing of any two or three shot is close to the edges of the actors' backs and will not show as much of the environment as a wide shot or master.

typage: Using actors based on facial or body features.

ultra-wide-angle lens (fish-eye lens): A lens with a focal length of 15mm or smaller, able to show an entire scene but often with visible curves at the edges.

underscore: Music added by the filmmaker to accompany a scene.

unit production manager (UPM): The individual in a film shoot who stays focused on physical production issues, such as hiring crew, transportation, permits, scouting, business matters, schedules, and budgets.

value proposition: What the audience will get out of seeing a movie, be it thrills, laughs, greater awareness of an issue, emotion, or a feeling of romance. The value proposition is about the experience of seeing the film—how it will affect or transform the audience.

vectorscope: A tool that visualizes the levels of color hue and saturation in a graphic format.

vehicle mounts: Specialized fixtures that can attach a camera to a moving car or other vehicle.

viewer (source monitor): The part of the editing system used for marking clips while the editor is culling through material.

virtual sets: Computer-generated environments added after shooting actors in front of a green screen, in place of physical sets.

volume-unit meters (VU meters): Devices that measure and provide the average sound level but do not always indicate peak levels.

walla: Background crowd chatter in movies.

white-balance: The process of aiming a camera at a standard white card and setting this card as the white of white light in a scene. By doing so, all the footage will be correctly colored.

wide-angle lens: A lens with a short focal length.

wide lens close-up: A shot that "stretches" the actor's features and exaggerates the distance between the actor and the background.

wide release: When a film opens on 2,000 or more screens on the same day.

widescreen: Any aspect ratio wider than 1.85.

wide shot (WS): A shot that shows all or most of the actors. Typically, the master shot is a wide shot of the entire scene.

wild lines: When an actor repeats a line from a scene right after it finishes, to provide a clean recording for the editing process.

wild sounds: Sound elements recorded separately from picture elements.

windowboxing: A combination of letterboxing and pillar-boxing that completely wraps the film in a black frame so that its entire aspect ratio will be preserved.

windsock: A foam cover to fit over a microphone to help reduce wind and prevent other environmental noises from impacting the recording.

wipe: A transition in which one image pushes another image off the screen, with a visible line between the images where one pushes in as the other departs.

wire removal: Using computer software to erase the out-of-place items and fill in the background where they once stood, so that viewers will never see them.

workflow: The basic plan for the series of steps used throughout the editing process to get files into the nonlinear editing system, backed up, worked on, saved, and exported to the desired finishing media.

writer: The individual who imagines the story and its characters, and transforms them from mere ideas into a tangible, physical screenplay that can be shared with others.

zoom lens: A lens with a variable focal length, allowing it to zoom in and out.

Index